WESTERN ART AND THE
MEANDERINGS OF A CULTURE

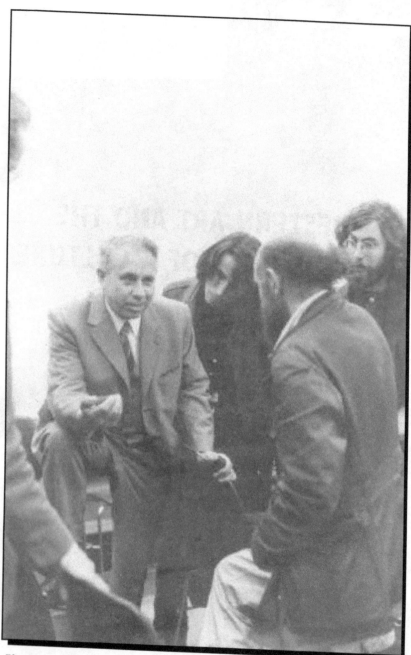

Photograph by Tricia Porter, 1971.

WESTERN ART AND THE MEANDERINGS OF A CULTURE

The Complete Works of
Hans R. Rookmaaker

Volume 4

Edited by
Marleen Hengelaar-Rookmaaker

piquant

Piquant Editions
Website: www.piquanteditions.com

First edition 2002
Paperback edition 2021

ISBN for this volume: 978-1-909281-83-7

British Library Cataloguing-in-Publication Data
A catalogue record of this book is available in the UK from the British Library.

ISBN 978-1-909281-83-7

Cover art: Marc de Klijn, detail from
Monuments in the (pre)history of modern art (2000)
Cover design: Jonathan Kearney

Overview Contents for the Six Volumes of the Complete Works of Hans Rookmaaker

The contents of volumes 1 to 6 have been organized partly chronologically and partly thematically. Most of the writings compiled in volumes 1 and 2 date from before 1960, while most of the materials brought together in volumes 3 to 6 were written after 1960. Each of the volumes contains one or more books as well as articles. Two books, previously published in Dutch only, appear in English for the first time: *Jazz, Blues and Spirituals* (1960) and *Art and Entertainment* (1962). In addition, roughly a thousand pages of Dutch articles have been translated into English: exhibition and music reviews; many short articles on art, music, and Christianity and culture written for Christian periodicals; articles that are scholarly and art-historical; and articles that are long and philosophical like the ones for *Philosophia Reformata*. Also included are the lectures given at l'Abri and Westminster Seminary. The two series of lectures, on 'God's Hand in History' and 'Revelation', have been integrated by Colin Duriez into one unit entitled 'God's Hand in History'.

Volume 1: ART, ARTISTS AND GAUGUIN

- Foreword by Jeremy Begbie
- Scholarly introduction by Graham Birtwistle
- Gauguin and Nineteenth-Century Art Theory (*Synthetist Art Theories*)
- Rookmaaker as art critic (1949–1956): exhibition reviews

Volume 2: NEW ORLEANS JAZZ, MAHALIA JACKSON AND THE PHILOSOPHY OF ART

- Philosophy and aesthetics: articles on style, world view, philosophy of art and education
- *Jazz, Blues and Spirituals*
- Music articles: African-American music, blues, spirituals and gospel, jazz, rock, and classical music

Contents of Volume 4

Acknowledgments

When my father wrote his articles on the Middle Ages and the centuries that followed them, it was still expected that readers would be able to handle the old German, the old French, the old Italian, leave alone the Latin that might occur in texts about art dating from those times. I, however, must confess that some of these passages were beyond my language skills. Therefore I want to acknowledge several people who helped me to make sense of passages whose meaning would otherwise have remained obscure: Liesbeth Razzano (old French), Franco Schultz (old German), Graham Birtwistle and Andrea van Leeuwen (old Italian), and P. Dorland (Latin).

I am grateful to Betty Spackman for allowing my father's letter to her to be included. It's just a short letter, mainly about abstraction and abstract art, but in just these few lines my father's position concerning these matters is made very clear.

Again a word of thanks to the translators. The materials in this volume were translated by Evelyn Kuntz Hielema, Herbert Donald Morton, Edith M. Reitsema, Alida L. Sewell and Marion Vorage.

Marleen Hengelaar-Rookmaaker
The Netherlands

Part I

WESTERN ART FROM THE MIDDLE AGES THROUGH THE NINETEENTH CENTURY

The Art of the Middle Ages

• About the content of works of art[1]

It is our intention to devote a number of articles to the consideration of
the problems posed by the content of works of art.[2] Anyone somewhat
acquainted with the literature concerning art will be aware of the fact
that there has been much debate about the question of what the true
essence is of a piece of art. Does it lie in the form or in the content? Does
it lie in the artistic realization or in the theme? Of course much has also
been written about a number of associated problems, such as the
relationship between form and content, style and theme, and which of
these must be given priority when we consider the creative artistic
activity itself.

One of the reasons for much unresolved conflict is also that people
keep trying to come up with a general theory that will hold true for the
art of all times and places. We called this 'unresolved' even though many
people today are of the opinion that we have finally resolved the matter,
and that it is form, style, the artistic realization as such, that forms the
essence of all art. Could it be, however, that the relationship between
form and content is not a constant? Could it be that in different times
different things need emphasizing?

To begin with, we must carefully define what we mean by the terms
we use. With 'form' we usually refer to the aesthetic aspects of the
artwork: the colour and lines, the proportions of and relationships
between the various parts, the composition and the 'handwriting', the
painting style of a painting or the modelling of a sculpture. In all these
aspects we undoubtedly find the aesthetic qualities of a work of art. Since
taste, conception, approach, and methods of problem-solving for the
aesthetic problems presented to artists vary in different times, the term
'style' is generally used to denote the typical characteristics of a certain
period. For that matter, every artist or group of artists also has a unique
method of working and can therefore be said to have a unique,
recognizable, and clearly distinguishable style.

In these articles we shall deal with the visual arts, not architecture or
ornament or typography or the applied arts. It means that the works of
art we shall be considering – apart from modern abstract art, at least for
the time being – will always be concerned with the portrayal of some
aspect of reality. The artist does this with a pictorial language, and we use
the term 'iconic' to refer to that language. A particular line is never just
a line; it can always immediately be read as the contour of a face, the fold
of a piece of cloth, the outline of a mountain or a distant forest. The
colour grey, as it gradually changes from light to dark in a drawing, is not
just a series of nuanced shades of grey but may represent, for example,

a shadow on a person's leg, and the viewer will read it as such, will understand that it represents a curve, a three-dimensional depth.

The iconic is also found outside the realm of art. Perhaps the best example of this would be a roadmap, on which green denotes a forest, a red line represents a road, etc. It is obvious that in a real work of art colour also has an iconic meaning: flesh-colour is used to represent parts of a person's body, etc. We could compare the iconic with the words of a spoken language. That is, the relationship between a line and the reality it is intended to represent – the iconically represented nose – can be compared to the relationship between the word 'nose' and the reality that it refers to. Thus the relationship of the iconic representation to reality does not lie in a kind of copying of the visual given. We need to know this in order to understand why in nearly every period of time art is referred to as depicting reality clearly and 'realistically', even in periods when art was not at all naturalistic. What is then meant is that the artist has presented a clear, vivid description in an iconic sense, one that is in harmony with reality (as it was understood in that time). We may compare this with a story which we call 'true to life' because it comes across as genuine and true in its setting.

There is also another sense in which art is not just a copying of the visual given which it represents. Think, for example, of a black-and-white drawing in which a few lines are used to depict a tree. Those lines are not really a part of the actual tree, and the omission of colour can certainly not be called accidental. What is the relationship between a few sketchy pencil lines on the flat surface of a piece of paper and a real three-dimensional tree of wood and leaves? We could rightly speak of a 'copy' only if we had produced a coloured mould. (By the way, the mimesis or imitation theory of Aristotle is closer to what we are arguing here than to any theory claiming art is just a copying of the visual given.)

We have shown that the artist, using iconic means, represents reality – a person, an animal, and so on. In some periods, one repeatedly comes across certain characteristic situations or arrangements of figures or objects; this is what we call a 'motif'. There is, for example, the motif of the reclining naked woman, of the horseman, of a man raping (or abducting) a woman, of a saintly figure sitting in the desert, of a flock of sheep in a pasture, and so on.

Just as there are all kinds of 'symbols' in spoken language, standard expressions, proverbs, which we use to express certain ideas, so too in the visual arts. Perhaps even more so (but perhaps not? – a question in itself). Thus we know that a (golden) circle drawn around someone's head indicates that person is a saint, and when we see a saint holding a key in his hand we know he is meant to represent Peter. We can call these 'attributes' and could list many more examples. With respect to colour, a blue garment often denotes Mary; a red one, the apostle John, etc. Similar attributes or designations are often associated with our

experience of reality: it would strike us as odd to see a monk who is not wearing a monk's habit, for example, or to see a king without a crown, or a woman not dressed in women's clothing. In short, in the iconic rendering the artist uses not only the iconic description but also symbols and attributes, as well as other characteristic elements borrowed from experience, to help make the finished picture as 'readable' and unambiguous as possible. Clarity is certainly one of the norms for iconic language, be it visual or spoken language.

By using these iconic means, the artist can portray figures and objects in their mutual connectedness, thus telling a story, or relating a 'theme'. That theme is derived from a given source, whether literary or religious, political or historical. It can also be gleaned from daily life, as we can see in the so-called 'genre pieces'. We would rather not refer to landscapes, still lifes, and so on, as themes but call these 'motifs'. When we speak about a biblical piece or a historical piece we are dealing with specific categories which are often called 'genres', referring to the nature of the theme. Some examples of themes would be the Adoration of the Shepherds, or Acis and Galatea, or such recognizable figures as Zeus or St Ambrose.

This brings us back to the question of what constitutes the content of an artwork. Does it lie in the style, the aesthetic qualities? In that case the theme or motif is nothing more than a pretext for the artist to create a certain composition, a work of art. Or does it lie in the theme, in the story or the figure indicated by the title of the piece? In that case it might not matter too much how the work has been put together, whether it is truly beautiful or simply fourth-rate. Clearly, to pose the question in this way simply leads to absurdity.

What does the term 'content' actually mean? If we cannot agree on that, of course, there will be no point in continuing the discussion. When we speak of the content of a work of art we are referring to the message it carries. The content refers to what the artist considers the essence, the most important element of that work, the idea behind the work, the concept that inspired its creation. In short, it indicates the meaning of the artwork, its heart, its intention.

In this article as well as the following one we wish to direct our attention to the Middle Ages: we are referring to the Romanesque and Gothic periods. This does not include the fifteenth century, the time of the Renaissance and the so-called Flemish Primitives (a ridiculous name, by the way). In the latter period we find all kinds of shifts taking place in the arts, of which the emergence of naturalism is one of the clearest. But our area of interest is the period that the Germans call *das Frühe- und Hochmittelalter*. We could easily include the pre-Romanesque period, roughly from around AD 500. But to limit ourselves, and to avoid falling into all sorts of complicated problems, we will restrict our discussion to the art produced between AD 800 and 1300. In this connection we might

mention that the way art was viewed during that period in various respects and especially with regard to religious folk art has lived on, and even today we still find evidence of this.

We want to bring this introduction to a conclusion now, but will just mention a few examples from medieval times. In a subsequent article we plan to discuss these more thoroughly, especially with respect to the question of where we find the content of the artwork, and what the relationship is between its aesthetic form and its theme.

Our first example is an antependium (a decorative hanging in front of an altar) found in the Museum of Cinquantenaire in Brussels. It is divided into several compartments, each of which depicts a certain story. The events of the story are clearly indicated, so we do not need to rack our brains to figure it out. We read, for example, 'Hic Paulus venit Romam, occurrit sibi Petrus,' and 'Hic apparuit Jhesus Petro de nubilis,' etc. We draw your attention to the recurring 'Hic' that tells us 'Here' – in this picture – you see a depiction of such-and-such a story.

Our second example is taken from Dante's *Purgatorio*, Canto X, in which he refers to a bench near some rocks, on which figures intended to represent humility are depicted in relief. Thus we see the Annunciation, concerning which Dante says of the angel figure: 'The angel before us appeared to be so cleverly sculpted as a charming figure that we could hardly imagine it to be just a dumb image.' Another of these reliefs depicts David dancing before the ark.

Finally, in our discussion we must also account for the peculiar fact that anyone even minimally acquainted with medieval art will straightaway recognize certain subjects. When we see a Madonna we do not wonder who that mother and child could possibly be – even though it would be logical to think that this woman-and-child motif could represent characters other than the Madonna. And, along with Dante, we would all have immediately recognized the Annunciation, and the Sacrifice by Abraham or the Last Judgment or the Crucifixion. Why is it that we immediately recognize all those stories? With the Crucifixion it is understandable, for it is a fairly unique story in the biblical world of ideas, but what about the other stories mentioned? Or what about David with the head of Goliath, or the figure of Peter, or of St Barbara, and so on? Have a look some time at the bronze door by Bonnanus in the Cathedral of Pisa; or, to mention a later example, the bronze door by Ghiberti in the Baptistry in Florence. In both cases the scenes depicted (or themes, if you will) will be immediately understood by anyone with even a minimal knowledge of medieval art – here the Last Supper, there the Flogging of Jesus, or Jesus being crowned with thorns, or the Adoration of the Magi, or . . .

What do we learn from these examples with respect to the essential content of the artworks mentioned? And what place does the aesthetic have here in relation to the theme? In the following article we will try to formulate an answer to these questions.

• About the content of medieval works of art[3]

The question we wish to deal with is: What is the essence of the paintings and sculptures of the Middle Ages? What is their true content? In theory these works of art could have meant something quite different to medieval people from what they mean to us today, and that is certainly true in part. A statue of the Madonna means something quite different to a believing Roman Catholic from what it means to a believing Protestant, and it will have a different place of importance in each of their lives. However, it is also true that the person who sees a Madonna sculpture in a museum and has no idea that it is the Madonna will be missing the whole point completely. But even to such an observer it will be clear that he or she is dealing with divine, or at least elevated, figures and not just with a mother and her child. (To prevent misunderstanding, we have specified in the previous article that with the Middle Ages we refer to that period from AD 800 to 1300, which means that the Flemish fifteenth-century art and the art of the Renaissance are not included in our discussion.)

It is possible, of course, to admire the purely aesthetic actualization of the work; to appreciate the beauty of the figure as it has been sculpted or cut out of wood or poured into copper or embossed in silver, to marvel at the composition, the manner in which the various parts of the work have been combined to form a whole. In short, we can value the aesthetic aspects of a work on their own merits. And that is what we will no doubt do, and any museum will try to present us with the most beautiful examples.

But the question remains – is that really the essence of a work of art? When a medieval sculptor was commissioned to create a Madonna statue, it was assumed that he would devote himself to that task. To make a Madonna was not just a pretext for making a beautiful sculpture; rather, the more clearly this statue depicted the Mother of God the more successful it was considered to be. This does not imply that the artist did not set out to create an object of beauty. But to present the issue in this way is to divorce these two aspects, and that is inappropriate. It is obvious that someone who sets out to create a statue of the Madonna will try to do that as beautifully as possible, first of all because its goal is to honour *her* – and one certainly does not do that, if one can help it, with a piece of junk, and definitely not with something that has been consciously made to look ugly. Secondly, the commissioned artist would be a craftsman who was expected to give the best he had to offer – a beautiful statue of the Madonna. But it certainly had to be a Madonna and look like one as clearly as possible. It would have been unthinkable to leave out something considered to be characteristic of the Madonna; that would have been seen as an affront to Mary, the subject. To give another example, anyone setting out to represent St Peter was required to make it look clearly like Peter, showing his characteristic attributes, such as a

key in his hand. And it would not have been acceptable to portray him as a young chap, because that is not what Peter was considered to be like, no one would recognize a youthful Peter.

The theme, the given, the Madonna or the St Peter, was of great importance to the medieval person. If we lose sight of that we will be missing an essential aspect of understanding medieval art. This is true for all the traditional representations – such as the Birth of Christ, his Circumcision, his Baptism in the Jordan, his Crucifixion, etc. These were not simply attempts to give an account of what we might have seen had we been present in Bethlehem or at the Jordan River or at any of those sites. Such naturalism was foreign to people of the Middle Ages (but we will go into that more deeply later on).

Think again of the Madonna: Mary with Child. The latter is included to show why Mary is so important, to indicate that she is the 'Mother of God'. The point of portraying her is that she represents a reality that is essential to us now, in the present. So it is with the birth of Christ: not only is it meant to portray Mary but also to represent the Incarnation. The Baptism in the Jordan is depicted for the purpose of showing Christ as a divine person and, furthermore, of revealing the Trinity. Images like these were created, in the first place, to represent Christian truths, events from the story of salvation, dogmatic givens. They represent realities which are still relevant, or better said, especially relevant for us today. They are presented as sermons, dogmatic formulations on a par with the Apostle's Creed. And they are anchored in that Creed, as well as in the liturgy of the church calendar. It is especially that calendar that prompted the portrayal of many characteristic and recurring themes, to the exclusion of other countless possible biblical subjects.

Thus, the theme is of particular importance. It is certainly never incidental. It represents and confronts people with the Christian realities that are the truth. Just as a sermon about, for example, the suffering of Christ is preached not just for the purpose of telling us about something that happened in the past, about history as such, but to illuminate God's grace and Christ's work on our behalf, similarly it was with the medieval representations of the main points of the gospel (according to the interpretation of that era, of course, which is sometimes disputable and sometimes not).

Such images, then, are never just an illustration or a 'concretizing' of a theme. They are intended to represent certain truths. And sometimes they are much more. A certain Madonna statue may, for one reason or another, come to possess an extra measure of holiness. In that case it becomes very important to own a copy of that statue. We know of instances (for example, the famous holy statue of Mary in Einsiedeln) where a copy was placed next to the original so as to come in physical contact with it, thereby creating a second statue with the same powers. These practices may seem primitive to us, and the Reformation emphatically turned away from them, but within the Roman Catholic

milieu they have been accepted for many centuries and in some places continue to exist, even today.

We have seen, then, that the theme of the artwork is of utmost importance, and that the content of the work first of all is manifested in the theme.

The practice of copying artworks was very common in the Middle Ages. This is not referring to the unusual example mentioned above but to copying as such. Books were transcribed, since printing presses did not exist yet, and the painted pictures in these books were copied along with the text. The same was true for more monumental works of art like murals and sculptures. But we notice something peculiar here. Just as in the copying of a book it was essential not to leave out or mis-copy a word – in short, to be as precise as possible – while it did not really matter whose handwriting or what style of letters were used to copy the text, so it was also with illustrations or representations. Certainly one was required to carefully reproduce the composition, the arrangement of the original, and to copy its unique characteristics, but the style in which that was done was considered of much less importance. We see that copiers carefully followed the construction of the image, but worked in quite different styles and, with respect to the details, allowed themselves all kinds of freedom, freedom which copiers today would never feel comfortable to take for fear of being reproached or punished for not copying 'exactly'.

The construction of the image then – the composition or the formula – was important. That is partly because it was through this formula that the content of the work could be understood. In reciting the Apostle's Creed we would never feel free to mix up the words or the order of the sentences, or to say it in our own words; in the same way the copier did not have freedom. If in the Creed we should recite the statements in a different order, we would immediately be challenged to justify our actions and would be asked whether we intended to change the meaning or the emphasis. With respect to the examples mentioned above, we see the formation of firmly established formulas which were considered to be fixed. If the formula was changed, or if an artist were to use a different, perhaps just as traditional, formula, it would be for a specific reason; the content of the artwork would change; the exegesis of the given would receive a different emphasis. Thus one encounters Crucifixions that are very different in character. Christ can be rendered as Christ the King, for his crucifixion earned him the position of King and Lord over us and all things; or the emphasis can be on the suffering of Christ, a formula that especially came to the fore in Gothic art, though it originated much earlier.

We have learned, then, that for medieval works of art the content lies in the theme, based on how that theme is expressed in a certain composition or formula. The style, the characteristic artistry, is not unimportant and should not be disregarded but in itself it means little

or nothing. A small print of St Jerome, for instance, would have portrayed him just as adequately as the most beautiful painting, though even the medieval viewer would not have been insensitive to the differences – which would have had more to do with place and function than with the actual content of the image.

In a subsequent article we will see that the above also applies to a certain extent to Baroque art, though a completely different concept was operative as well. But first we will have to turn our attention to the fifteenth century.

It will not have escaped the thoughtful reader that on several points I have formulated the issues, and defined the terms, in slightly different ways than in my previous article. Further research has made that necessary. I hope to explain my reasons for this in a later article.[4]

• Ecclesia and Synagogue in Strasbourg[5]

In the formation of a style, the life and world view plays an important role. In itself this term is not very meaningful, and therefore we prefer to specify it by saying that a style is connected with the particular lifestyle and understanding of life and reality of the group or movement who expresses that style. Now we shall see – or rather attempt to see, for problems thus stated are not at all easy – what this means for Gothic art.

Let us first look at the understanding of life and reality. At the time when Gothic art was born as an artistic style in the late Middle Ages, around the end of the twelfth and the beginning of the thirteenth centuries, medieval people had a view of the world and of life which did not consider daily reality around them as of great importance. Much more important was the world of ideas, the reality 'behind' the daily reality that served as a model for it. It was the world of ideas that contained the truth, reality itself. The actual world around people was solely meaningful as a reflection of this reality and was of relative value only, as it was transient; only its connection with the world of ideas made everyday reality significant and bestowed meaning upon it. Philosophically speaking, all of this was expressed in realism, strongly influenced by Aristotle, the great Greek philosopher.

In art this was expressed in the way by which the medieval artist focused mainly on the representation of universal and lasting truth, as it was then understood. This truth was conveyed by means of allegories; for instance male figures and, more often, female figures who were not individually characterized (they were, on the contrary, ideal figures who represented a universal type) but were characterized by means of various instruments, and so on, placed beside them – called 'attributes' and referred to as the symbols of certain ideas. Not only in allegory did the artist aim at the universal, the 'ideal' (to be taken literally here):

anything directly related to the supernatural world was represented in a universal, non-individual human form. For example, the figures of deceased persons were carved on graves, not with their strictly individual features but as ideal figures, according to the general idea of the ideal human being, namely a person of about 33 years of age with fine features. After all, Christ arose and ascended to heaven when he was 33 years old, and so we all shall rise in a human shape of that age – even though one may have died as an old and worn-out person.

Evil, on the other hand, was seen and observed very individually. After all, it was not related to the world of the truth; in a sense it was the negation thereof. Thus we find on one of the French cathedrals the virtues and vices characterized above each other: the virtues are all ideally beautiful ladies, referred to in a caption as this or that virtue; the vices, on the other hand, are represented by characteristic scenes taken from daily life – such as a monk who takes off his habit, two people fighting, etc. Here, in the portrayal of daily, non-ideal or sinful life, the Gothic artist is a 'realist' in the sense in which we mostly use the word, to be clearly distinguished from the concept of reality as mentioned above.[6]

As to the lifestyle of the late Middle Ages we wish to start with the remark that the scholastic system, which developed in the twelfth and thirteenth centuries and made a distinction between nature and grace, has more than once raised our suspicion of being in fact no more than a sanctioning of the division between faith and secular life. This separation is effected in such a way that the religious life finds its place as devotion, as something outside the 'normal' life, which runs its own course. We have already discussed this issue in another context. Secular life was called 'nature', and by natural reason people could find truth by themselves, outside revelation, although all this could only be truly significant and could only fully develop itself when the *donum superadditum* was added,[7] faith as an extra gift from God. Thus the medieval world is characterized on the one hand by strong devotion, a very zealous piety that is willing to give up everything for God; and on the other hand by a thoroughly secularized life that practically goes its own way. What 'life within the covenant' implied, was not at all understood.

Now, in those days, this secular lifestyle was strongly influenced by the poetry that had miraculously blossomed in the art of the troubadours in the south of France during the twelfth century. It would be straying too far off our subject to go into this any deeper and we just wish to mention that in the south of France not only did several heresies thrive (think of the gnostic Albigensians) but life was almost completely paganized or, rather, secularized: old heathen practices such as the May celebrations were still – or were again? – existent there, and everything finally revolved around a beautiful life in freedom, without rules or

commandments, bound merely by the rules of courtly life. One of these 'rules' was that a troubadour should always choose a married woman as his 'lady', the object of his songs of love. Whether the songs, with a sometimes strongly sensual, 'carnal' content, were in fact also enacted is a question about which the scholars do not yet agree. For that matter, all kinds of explanations are suggested for the content and the purpose of this poetry; whether adulterous or pagan, however, it cannot ever be called Christian.[8] These songs conquered all of Europe in the course of the twelfth and thirteenth centuries, and everywhere their influence was noticeable in the search for a more courtly lifestyle – obviously only feasible in the courts – which drew everything into the sphere of love and beauty. This had a strong influence on the ideals of beauty and love, both of which looked for extreme sophistication. Naturally this was also significant for art.

The two sculptures we now want to discuss testify to all this. We do not know the great artist who made them by name. Romanticism sometimes assumed that her name was Sabina, a daughter of Erwin von Steinbach, a master contractor who worked on the Strasbourg Cathedral in the second half of the thirteenth century and who was glorified by Goethe when he lauded German national Gothic art in 1773 in an essay entitled 'Von Deutscher Art und Kunst' on German character and art. But we should refer this accreditation to the realm of fairytales, as it is based on a misinterpretation of an inscription in the church; the sculptures date from the first half of the century.

The artist who created these sculptures on the South transept of the Strasbourg Cathedral probably spent his apprenticeship with the artists who worked on the Chartres Cathedral (southwest of Paris) at the beginning of the thirteenth century and who lifted the new Gothic art to unprecedented heights. Around 1225 he left from there (by then the main work had been done there) to complete a portal of the cathedral of Besançon which is now almost entirely destroyed. Then around 1235 he arrived in Strasbourg, from where he may have originated, in order to work there with his assistants until about 1250 on the South portal and on other sculptures for the cathedral. We call him the 'Master of the Ecclesia and the Synagogue', after his most important work, which represents a high point in thirteenth-century sculpture.

Already in the early Middle Ages the church and the synagogue, which also symbolized the New and the Old Testaments, were represented by female figures, which since Carolingian times often stood on either side of the cross of Christ. Albert Magnus, who lived from 1193 to 1280, described these two figures as follows:

> On the right-hand side of the cross a woman was depicted with happy features, a beautiful face, and wearing a crown who symbolized Church and who respectfully held the Blood of the Lord in a chalice. Because a faithful soul, turning its worldly heart to the wounds of Christ, drinks in Christ's

blood in its spirit, in deep piety. This is why she received the light and a cheerful heart and the crown of eternal glory. On the left-hand side of the cross, Synagogue was depicted, eyes covered by a piece of cloth, head bent, with a sad face and a lost crown who herself caused the blood to be shed and despised the shed blood. This portrays that she and all that is mortal have lost three good things: the light of grace, the joy in their conscience, and the crown of glory. This is what Lamentations 5 speaks about: 'Woe to us, for we have sinned: for these things our eyes have grown dim, the joy of our hearts has ceased and the crown has fallen from our head.'[9]

This is a description that almost fully corresponds to the sculptures in Strasbourg, where Synagogue also holds a broken spear and Ecclesia a cross banner. Nevertheless, we encounter this cross banner earlier in history; only the broken lance of Synagogue is new.

In treatises where – rightly – Gothic art is highly praised, one also often finds the idea that this art is extremely pious and devout. This idea was put forward especially by German Romanticism though it was often found in France as well.[10] Rather, we should say that these female figures are personifications of the courtly ideal of women. Listen to Godfried of Strasbourg, the troubadour from Strasbourg about whom Ernst Bertram composed the following verses:

> You created from foreign nation's foreign singing
> The most lovable song we ever heard ringing.[11]

This Godfried was one of the first people who transplanted the art of southern France to his country, in particular in his *Tristan und Isolde* of about 1210, in which he sings Isolde's praises as follows – and notice how this could have been as it were a description of the female figures of the cathedral:

> Sweetly formed everywhere,
> Tall, with vaulted upper body and thin
> Wrapped in robe
> As if Love had created her
> To be his stool pigeon
> There was the robe made narrow
> And pulled close to her body
> With a belt, well positioned
> As a belt should be positioned.
> The robe does fit her perfectly,
> It nestles around her body.
> It nowhere bulges out
> It searches every spot
> From top to bottom
> And drapes itself in one fall
> With many folds around her feet.[12]

There is no denying that in these sculptures the courtly ideal of women is represented; and who would deny that it is indeed a very beautiful type of woman that the artist realized with a masterly touch. Fortunately all this is not 'pious' or 'devout'; rather, the artist observed the beauties that the Lord has laid down in creation – even though we must call the lifestyle that lies behind these works unbiblical.

The sculptures are certainly beautiful, but we fear that at the time of their origin they raised another association. After all, from the thirteenth century onwards it was precisely the Rhineland that became a centre of hatred against Jews. In contrast to France and Spain, where the persecution came from those in authority, the initiative here was taken by the population, whereas the government often protected the Jews, for which they at times had to pay heavily, literally. Under the slogan that Jews, together with other heretics and heathens, were 'children of Satan', the Dominican Inquisitioners often made all kinds of wild accusations against them, such as the infamous lie that the Jews sacrificed Christian children.[13]

Probably this will often have been called to mind (that the Jews were the people who had rejected and crucified the Lord!) in seeing this sculpture, which in those days even more than today spoke a clear language!

• The art of the fourteenth century in France[14]

a) The relation between religion and faith

The direction and impulse of a person's actions, thoughts and strivings are ultimately all determined by that person's religion, by his or her religious disposition towards God. People are religious beings whose total humanity is determined and directed by their religious position of choice, a choice made in the heart of their existence, as the Scriptures teach us. The choice can be for or against God, in obedient subjection to or in rebellious apostasy from their Lord and Creator.

This religious disposition comes to expression in and determines the whole set of non-theoretical ideas and insights concerning law, subject, origin and structure of the cosmos which defines the place of humans in the universe, the meaning and worth of things, the ideals worth fighting for, and so on. In other words, it is the whole complex construction that is sometimes called 'world view'. The religiously determined world view comes to expression in all of a person's actions and thought. It determines how people do things, even if not always what they do. This is because all people are caught up in the same world order created by God and are subject to the same structural laws. And this determines, for every person, the ideas he or she may adhere to in what he or she does

– in marriage, politics, trade, art, scholarship, etc. – while the manner in which a person does that will express her or his subjective opinions.

Religion is the central spiritual sphere of human existence, the starting point of all temporal functions, where they have their unity of origin. However, people do not stand alone as individuals: the human ego as an individual, religious centre of existence, is in turn rooted in a religious community that is maintained by a community spirit. The latter works as a spiritual driving force in the heart of human existence and brings the whole attitude of thinking and acting under the umbrella of a religious ground motive.

In the apostate religious ground motive the human heart has made gods for itself. People have turned away from the transcendental God; they no longer know him. But human beings have not changed 'structurally'; they are still religious beings. They will choose idols for themselves that give meaning to their origin. They will deify and absolutize a part of the creation. Apostate people, who do not recognize God as Creator and Lord of all things, do not know the true significance of creation either. That is precisely why they can tear out of its creaturely context some thing of the created order through the process of deification. This deified part of creation then functions as the origin of everything, that towards which everything has to be directed, whereby things obtain their meaning and all norms and laws are determined and delineated.

How people come to a specific absolutization is usually difficult to determine or check out. It will often be the case that they design their basic ideas in a faith-fantasy in order to justify their own deeds and strivings. In this sense, every apostate faith is a mythology. However, the religious absolutization of a part of the creation soon turns against humans. They then become slaves to their own thoughts, which in turn sets up an occasion for choosing a new starting point, or placing a different emphasis within the existing ground motive. In this way human being itself grimaces at us from behind all apostate religious ground motives, human being that wishes neither to recognize God nor to serve him in obedience.

By tearing something created out of its creaturely context and absolutizing it, people subjectively distort all relationships – but God maintains his laws and norms. Even though they refuse to acknowledge it, people will often have to give in to reality as it is – that is, reality as God created it. For example, an artist who is geared towards psychology and who for that reason is inclined to see the meaning of the aesthetic whole as determined by emotion will still, as an artist creating works, have to stay within the framework of the supra-arbitrary modal structure of the aesthetic aspect. The absolutization of the emotional aspect in his or her practical work will result only in the analogical moment (which in this modal structure points back to the meaning

nucleus of emotion) receiving too much emphasis. This apostate attitude to life that cannot break through the reality of God's created cosmos will therefore involve a one-sidedness, an over-emphasis on certain moments at the expense of others.

We will see in the historical development how apostate humanity fall from one extreme into another as they come into conflict with reality through the process of absolutization of certain modal aspects.[15] In world history we see that actions are followed by reactions, which themselves call forth new consequences in historical causality, whereby new situations arise to which humanity must conform their ideas. Thus a following generation always reaps the consequences of what the previous generation thought or did, or it may act in opposition and choose the precise opposite standpoint. Only through conversion to the living God can this continuity in apostasy be broken, whereby then, by God's grace, the enchantment that makes a slavery of self-determination and self-assertion is broken.

Faith, even though it receives its impulse from religion, may not be identified with it. Religion is an attitude of the whole person in the heart of his or her existence, while faith in its sharply delineated meaning is one of a person's temporal modal functions. With respect to faith we can speak of it being founded on other modal functions, e.g. the historical. As an example we could point out that Abraham, Jeremiah and Paul all had the same religion, the same basic attitude towards God. But the content of their faith was very different: consider, for example, their different opinions with respect to the Law and the difference in their faith knowledge regarding the Messiah.

However, in this world, which is alienated from God, we do not know such a basic attitude that is valid and unchanged throughout all ages. The orientation of our hearts will always be changing; religion will always be organized differently. In other words, people observe different religious ground motives in the various periods of world history. Within such a religious ground motive various faith contents are possible. For example, within the framework of the modern humanistic ground motive of nature and freedom, faith will be concentrated in turn on each of the alternate poles of this ground motive and will ascribe priority to alternately the scientific ideal or the personality ideal,[16] while that faith can take on a further content of rationalism or irrationalism, psychologism, historicism or economism, individualism or universalism etc. Since faith determines the direction of the disclosing process in the normative aspects, these differences will play a significant role in the disclosing process, as we hope to show in more detail in connection with the aesthetic function.

This positive content of faith should not be confused with the Cosmonomic Idea, which we would characterize as a scientific confession. The latter, although guided and directed by faith in its positive form and therefore not independent of it, is sharply

concentrated on theoretical-scientific activity, even though it is not the result but the precondition of all scientific analysis.[17]

If we summarize the above, we should say: the manner in which people think or work during a certain period of time is determined by faith and finds its root in the religious ground motive that dominates that period. Everything coheres in a person's faith attitude: whatever one strives after, the manner in which one practices art, science and so on, the areas in and dispositions by which one develops activities and through all of these also shapes social relationships, morals and customs, etc. We should not forget that all sorts of external factors – such as natural disasters, wars, prosperity and poverty – also play a big role in all of this. But the latter will usually only determine what people do, and not how it is done, although the influence of all those factors on the formation of ideas may not be denied. We should not forget sin either, as a source of human action. Sin causes people to be guided by a desire for riches, power and the fulfilment of sinful wishes, whereby often their own ideals are broken and denied. Nor should we forget the effects of sin in sickness, character deficiencies, hereditary characteristics and suchlike. But in this too, what people desire and the way in which they try to obtain their goals depend on the culture in which they live and hence are incomprehensible apart from an understanding of the religious ground motive that dominates the era.

b) The connection between art and faith and culture[18]

In the previous section we saw how the religious ground motive and faith – or even different faith-attitudes – determine the ideals, the thinking and action of people in a certain historical period. This also applies to art. Art strives to represent reality with aesthetic certainty and in a convincing manner. That is, to represent reality as seen by the people of that period, in an aesthetically qualified structure type. Both the form[19] – the style – as well as the subjects will express the ideals of that time in accordance with the current world view. Yes, every object, even the simplest utensil allows us to sense something of the environment and sphere that produced it. How much more will this be true for works of art.

In the Netherlands the eighteenth-century family portraits, also called 'chatter pieces', show us how works of art can reflect the total atmosphere of a period. Compare these with a book such as *Sara Burgerhart* (1782) by Betje Wolff and Aagje Deken. We experience the atmosphere in which the latter places us, as it were, by looking at the portraits mentioned. We see in them the people of that time, drawn in a way that shows their attitude to life: that of the Enlightenment with its ideal of sober rationality and sober morality, on account of its rationality. We should not suppose that the people of that time saw it quite like this; they only knew that it agreed with their taste, that they experienced it as beautiful. But for us today these kinds of pieces become a symbol of those times. Even the external features of those people – we limit

ourselves to the eighteenth-century Netherlands – is in accordance with it all, i.e. corpulent with few distinctive features, although this will have been further accentuated by the art of painting. From this we can see even more clearly the unity and coherence of disclosure and positivization of all functions in a certain time period.

We will now attempt to analyse the connection of art to the religious and faith attitude of a certain period and to account for it theoretically. In its being directed by faith, the disclosure of the aesthetic aspect continually receives a new direction. In other words, the aesthetic moment that anticipates faith continually gets a new positive content: art[20] in various periods of time always displays different ideals, different *leitmotivs*. In the latter it will try to conform adequately to the faith and the religious ground motive that dominate a period and a region, and that forms a cultural unity. The leitmotiv is the positive content given to the aesthetic idea during a particular period. Since this leitmotiv expresses the artistic ideals and aims held dear in a particular period, as well as the demands made on art, people have named it *Kunstwollen* ('artistic aims'). The *Kunstwollen*[21] will have varied success in realizing itself in works of art, in satisfying the posited ideals and the demand to give adequate expression to the direction of life of that time.

Once art has solved the problem that was presented, namely to be a stylistically and thematically pure outworking of a *Kunstwollen* in which the aesthetic ideals – in conformity with faith – received further content, then art is in its mature 'classical' period. It is then able to express with aesthetic certainty and conviction what people want it to say. Thereafter art often degenerates into mannerism: the way of expression becomes manner, people start to play, as it were, with the discovered motifs, for the problems posed have all been solved and matter no longer presents resistance. People have become so confident in their technique that they can do with it what they want. There is no longer any need to seek or to strive. Then a certain rigidity in artistic development sets in, even though it is still possible for works of high aesthetic quality to be created. In general such phenomena will not be limited to the artistic area, although it is possible that the apex in artistic development, the 'classical' period, will occur somewhat earlier or later than in other cultural areas such as philosophy, science, politics etc.

Once faith and religion have found their adequate expression in this way in the various life spheres, and people have attained an artistic mannerism, the culture has passed its apex. Faith in whatever had given the leading cultural idea[22] its meaning and direction starts to disappear slowly. And because this faith loses its hold on people, this cultural ideal is robbed of its inspiring power. It is no longer confessed with conviction and becomes a kind of working hypothesis. People follow the traditional ways, since they are aware that they would otherwise have to start from scratch again, and this frightens them. The groups of people who used to take up a leading position lose their influence at this stage. All this

explains why during such periods there are usually a great number of talents but, in general, a lack of leading personalities to give direction.[23] Although the later manneristic works always excel in the area of technical expertise they show a certain emptiness and hollow gesture and thus lack aesthetic persuasiveness, that 'in this way and this way only is it good'. Not surprisingly, people readily attempt to imitate more or less accurately the works from this prime 'classical' time.

Following this, a new positive content will be given to faith. Under its leadership, groups that are inspired by new ideals will fight for cultural power. During such transitional periods, when a new faith – or sometimes also a new religious ground motive – is starting to inspire people, they will strive for a new positivization of the norms for style and beauty, which will satisfy the new direction of the anticipatory spheres of the aesthetic aspect. A new leitmotiv or *Kunstwollen* will be born, while people will have to search for new objective-stylistic ways whereby reality can be portrayed in conformity with the new ideals. Often, new (technical) means and possibilities have to be disclosed for this purpose. In the power struggle between tradition and progression, the old style will have to be finished with, though it can sometimes maintain itself for a long time alongside the new one even though the formative power has been wholly transferred to the carriers of the new faith.[24] In this way people arrive at a new style, but it is not a totally new construction from the base upwards. They use the old as a starting point, change and mould it until adequate means of expression have been created in conformity with the leitmotiv. Only to the extent that the past has nothing to offer with respect to the new demands do people develop new forms. Thus there is a continuity in the development of positive norms and forms: the *Errungenschaft* ('that which has been gained') of the past is used as building stones for the present.

When one or more artists first give positive shape to the aesthetic idea and norms in agreement with the faith of those groups who gained a powerful voice (*roepingsmacht*) in the historical power struggle, in other words, when a new style is created, it will be experienced as an aesthetic surplus value, since art here will only start to satisfy the new demands made on it. Often, such a surplus value or higher aesthetic quality will really be present, since the people who positivize the norms commonly have great artistic skill and talent. The persuasive power of the aesthetically really good works of art will be increased by the great enthusiasm that emanates from such 'first fruits'. For such a renewal of style will only take place if those who positivize the norms are deeply convinced of the new positive ideals and of the faith that dominates the latter. By contrast, the works in the traditional style will often be lacking in enthusiasm since the earlier *Kunstwollen* is now being followed without conviction. Through the realization by contemporaries that it is more satisfactory, the new style will exercise great influence. In other words, the new positivization of the norms will go hand in hand with

obtaining aesthetic power – an aesthetic analogy that points back to historical cultural power. And everyone who does not go along with the new stylistic forms but stays with the old will be regarded as 'old-fashioned' or 'traditional' and will no longer have a voice (*roepingsmacht*) as one of the positivizers of the norms in the aesthetic field – because aesthetic power will give competence for style formation to the carriers of this new power.

In general, a direction of style will exercise influence only when we can speak of its aesthetic power, founded in a present cultural power. And yet, such an influence will depend on the quality of the works that are made in that style. For generally people will only wish to imitate works of art that are of a high calibre. It will occasionally happen that a certain style direction gains aesthetic power without a true aesthetic surplus value, on the basis of great historical power alone, in which its aesthetic prestige is founded. Thus the large influence of French art in the second half of the seventeenth century can be explained as a result of the political and hence also the cultural authority of that country.

The influence exercised by an artistic direction will also depend on its leitmotiv. The latter will have to be determined by the same faith that motivates the leading cultural powers. It can happen that his or her contemporaries do not appreciate the work of a truly great artist, because it does not satisfy this demand. Only a later generation, one that does recognize his or her ideals, will engender enthusiasm for it.[25] It can also happen that very much later, by those who no longer stand in the cultural and aesthetic power struggle that was fought during that time, such works are appreciated purely and simply for their high aesthetic calibre without their exercising any positive stylistic influence.[26] Furthermore in this connection, it is instructive that through a turning of the tide a certain stylistic direction, which in its period of coming into existence and perhaps long afterwards had a lot of respect and influence, no matter how high its aesthetic calibre, may no longer be appreciated at all.[27] That means the ideals have changed so much that people can no longer appreciate this objective formation. Thus we see in the consecutive historical periods, according to the ideals that are dominant, a continual change in the appreciation of the work of various artists, from which not even the very greatest can escape altogether.

In my opinion it clarifies matters if, with respect to the aesthetic power referred to, we make a distinction between an objective and a subjective power, to which an objective and subjective influence can be correlated. Subjective aesthetic power determines the influence that an aesthetic leitmotiv exercises on people, while the objective power is shown in the influence of a certain style objectivized in works of art. It goes without saying that the manners of exercising aesthetic power which we have distinguished here can usually not be separated like this.

And yet, there are instances where they were indeed separate. In the classicism of the eighteenth century we see an obtaining and exercising

of subjective aesthetic power without it being connected directly to the already existing stylistic formation. Rococo reigned everywhere in the middle of that century, while only a few artists were striving in a different direction. But especially in all kinds of writing at that time there was a strong anti-Rococo disposition and a longing emerged for a new formation. It was especially Winckelmann who in 1755 formulated new ideals in his *Gedanken über die Nachahmung der Griechische Werke in der Malerei und Bildhauerkunst* ('thoughts about the imitation of Greek works in painting and sculpture'). In his opinion art ought to strive after *edle Einfalt und stille Grösze* ('noble simplicity and a quiet greatness'),[28] while he maintained that artists would best achieve their ideal through imitation of the classics.[29] Winckelmann's ideas were received with enthusiasm and soon various artists were attempting to work according to this new *Kunstwollen*, while during the whole time that classicism reigned, which he and others had inaugurated, the taste and manner of assessing works of art were determined by the ideals he formulated. His little book, mentioned above, in effect became a programme for classicism. Over the course of years, artists working along these lines would form a real classical style. We do not see a mature classicism until the 1780s, when David creates his *Oath of the Horatii*, and later with Thorwaldsen, Carstens and others working around 1800. While the style had not completely freed itself from the past this stylistic phase was called 'pseudo-classicism' or 'Rococo-classicism'.[30]

Undoubtedly all this was connected to the Enlightenment; this classicism was wholly determined by the subjectivistic rationalism of the humanistic scientific ideal. Winckelmann, for example, states that the Greeks had begun to form general concepts about beauty, which elevated themselves above nature: 'Their archetype was but a spiritual reality designed by reason.'[31] But that form could also be given to aesthetic ideals in accordance with the faith disposition of the Enlightenment in other, non-classical ways, appears from the fact that Diderot only wanted to see 'unadulterated nature' imitated and that he fought against strict classicism.[32]

An example of stylistic influence independent of the leitmotiv is more difficult to find. Usually we can speak of a positive stylistic influence of art from the past or from a foreign culture only when that art has a similar, or at least related, leitmotiv. However, we can point to the influence that Chinese art exercised in Europe in the seventeenth and eighteenth centuries. People were full of admiration for the porcelain plates and little figurines imported from the Celestial Kingdom and attempted to imitate these. Our [Dutch] Delftware originated from such an attempt at imitation, just as German and French porcelain from the eighteenth century originated directly from this Chinese influence. Also in other areas it became fashionable to do things the Chinese way, but these *chinoiseries* usually stood alongside the actual European artistic production without exercising a domineering

stylistic influence. The influence in this case was therefore fairly limited in scope and not profound.33

Another example of a mere objective-stylistic influence may be found in Rubens's influence on van Gogh. It was not until the period from November 1885 to March 1886, when van Gogh stayed in Antwerp, that he became acquainted with Rubens. He was enthusiastic about the way Rubens rendered skin colour, while he also admired Rubens's 'blond women', even though he had no great stylistic affinity with him. Under Rubens's influence, van Gogh's mixing of colours becomes brighter and in van Gogh's rendering of skin colour we can see the characteristic mixture of red, yellow and white appear that we also find in the work of Rubens. Through contact with the art of this great predecessor, van Gogh's brush strokes become freer and start to form a more close-fitting whole.34

In the framework of our analysis of aesthetic power, we should point out that power relationships in the various arts could sometimes be very different. The 'artistic life' of the various branches of artistic activity, to which we will return shortly, can sometimes function without any mutual connection, for ideals from one art form can usually not be transferred just like that to another art form. Imitation of the ancients was, for example, a totally meaningless idea in music, because almost nothing is known about ancient music. But, characteristically, the leimotivs of the various art forms will be mutually closely related since they are determined by the same religious ground motive. Even though this will not be the rule it is possible that they may point to different faiths. Such will be the case when the aesthetic power of the distinct art forms is founded in the cultural power of distinct historical currents, which are mutually distinguished by different faith convictions. Thus at the beginning of the nineteenth century literature was mainly dominated by the Romantic personality ideal, while the more classically oriented visual arts were largely governed by the scientific ideal. A subjective aesthetic influence from both sides is very well conceivable, but it will be difficult for one art form to exercise objective aesthetic power over the others since its 'artistic means', the founding structures,35 are so different that we cannot speak of a stylistic influence. In the area of stylistic formation the visual arts, literature, music and drama will each have to go its own way.

In order to gain an insight into the idea-formation and the positivization of stylistic norms we will have to pay attention to the 'artistic climate'. By 'artistic climate' we mean the aims and aspirations of the artists – often in cooperation with critics and art lovers – whether or not united in groups, whether or not in intimate mutual relationship and connection. What we usually find is an inter-individual relationship that is only loosely coordinated, mostly unorganized and usually based on social relationships. Artists will try to get in touch with, and will

influence, one another's ideas and style through mutual debate, discussion, writings, and especially also through their creations.[36] Even though we cannot speak of a social 'community' here, we do see a certain social unity and solidarity, separate from the rest of society. Sometimes those who contribute to the artistic climate form a kind of caste.[37] The subject-object relationship between the artist and his or her creation naturally plays an important role in all of this. Works of art can only be understood in connection with and in dependence on this artistic climate. Indeed, a work of art is the result of the struggles and labours of the artist who designed it, within the framework of the artistic climate of her or his time. Often a power struggle will develop between groups of artists, critics and connoisseurs, about which direction will obtain the competent – aesthetic – formative power. Here we think of the struggle during the second half of the seventeenth century in France between the Poussinists – who were more classically minded – and the Rubenists – who emphasized the colour element in painting. It is immediately obvious that in such a struggle the creations of a great genius will possess decisive power of persuasion.

Until now we have focused our attention almost exclusively on the aesthetic side of the work of art, emphasizing especially the connection of the latter with the faith-function and its founding in the historical function. However, we should not forget that a work of art shows a structure that functions as such in all law spheres. We wish to concentrate here especially on the historical function, on the place that art takes in culture. It is very important for the subject of this article that art, or rather the artistic climate, possesses historical power, even if closely interwoven with the objective works of art. Cultural power is formative power to shape the face of a culture and positivize its historical norms. Cultural power needs to be sharply distinguished from aesthetic power, which is modally different and founded in the cultural power. Whereas aesthetic power provides the competence to give positive shape to aesthetic ideals, as well as to the stylistic norms determined by them, cultural power relates to the formation of cultural ideals and norms. What kind of place art takes in cultural life depends on the relative strength of its cultural power. In dependence on this cultural power, art exercises a greater or smaller influence on the positivization of cultural ideals and thus on the whole culture and the subjective behaviour of people. In periods when the power of art is great, it has such an important influence on the development of civilization that the latter would be incomprehensible if we did not take art into account.

It can happen that art is progressive, i.e. that in art, more than in other fields, a new faith finds adequate expression. In its leitmotiv and style it points to this new faith: art then turns out to be a great power that propagates the new ideas and ensures that shape is given to the cultural ideals in accordance with those ideas. During the Italian Renaissance,

for instance, the cultural power of art was very great. It is significant that Pirenne, who in his *Histoire de l'Europe* pays very little attention to art, includes art in his discussion of the Renaissance, and has to do so since without it he would have been unable to give an adequate impression of the course of historical development.[38] Every member of the culturally formative elite had, in that time, a lot of interest in art, and art figured largely in the aesthetic ideal of the *uomo universale*.[39] Art was indeed one of the powers that considerably stimulated the spread of Renaissance views. The spread of humanism[40] to the North can only be explained by the visual power, the propagandistic effect and persuasion of Italian art. The fact that in the North, since the fourteenth century, artistic activity had also occupied such a superior position paved the way for all of this. No matter how much the breaking up of the medieval world view was the first prerequisite for the coming of the Renaissance, the typical form and idea in which it took shape was greatly co-determined by art.

Humanistic classicism, which played such an important role in modern history that our culture cannot be understood without taking into account Graeco-Roman influences, is unthinkable without the great power that Greek and Roman art have exercised by concentrating the attention continually on the 'lofty ideals' that inspired the ancient world and on people's humanitarian greatness.

During a period when art occupies a large place in the lives of people and possesses great culturally formative power, the artist is, of course, an important person and one who is highly esteemed. For that reason alone the enormous veneration for figures such as Michelangelo, Raphael and Leonardo da Vinci is understandable, while also the special position assigned to the artist as creative genius in the time of Romanticism cannot be separated from the great significance that art possessed in the life of that time. Artists are important culture-shapers in such a time: they know themselves to be more than mere craftspeople whose task it is to carry out certain commissions only. The French classicist painter David dared to answer a commission from the king with a painting the subject of which not only differed from what was commissioned but in which a decidedly revolutionary tendency came to expression: *The oath of the Horatii* in 1784.

And yet, in other periods art has little significance as a cultural power. In the present-day world, for example, art is struggling to have any continuing influence on civilization.[41]

Art itself is naturally influenced by other cultural power spheres: those of philosophy, economic life, politics etc.[42] In the Middle Ages art fell completely under the power sphere of the church,[43] and in the time of Louis XIV it stood completely in the service of his political power struggle. By contrast, in modern art we often note the strong influence of technology – 'functionalism', sobriety, the borrowing of machine forms (Léger), etc.

Finally we want to devote a short observation to the connection between the development of art and the disclosure of the historical function, which we have not yet dealt with so far. According to Professor Dooyeweerd, the historical process of disclosure starts when humankind leave the closed-off stage where they identify themselves with nature that surrounds them and begin to disclose themselves through a process of becoming self-conscious.[44] We will limit ourselves here, as elsewhere in this article, to the course of development in the apostate, non-Christian world. Once faith has begun to disclose itself in this manner, civilization is also leaving the primitive stage and similarly begins to disclose and deepen itself. We do not wish to analyse this process further here, but only indicate a few points in connection with art. In a closed-off culture, tradition is supremely powerful and it is impossible to speak of a development in art. But once this culture starts to disclose itself and the power of the tradition is broken, then a disclosure can also take place in the aesthetic sphere since art is no longer bound to the traditional forms but starts to develop. In this way the experience of one generation can be enriched by that of a subsequent one. Slowly, people will start to master the techniques whereby they can obtain the desired effects for the aesthetic formation with the given materials. For the technical formation depends on the degree to which humans have disclosed nature and have made it serve them. An etching can only be made when the artist has access to paper, metal styluses, caustic chemicals, etc.

Disclosure will also take place in aesthetic 'seeing'. It is not at all surprising, for example, that there are great similarities between the drawings of a child and of a primitive person. In both, perception has not yet been developed: they only have eyes for superficial characteristics, e.g. that a person possesses a head, two arms and two legs, but not for the proper relationships between these parts of the body. Primitive people work according to a long-established tradition, so that with them, as with the child, the lack of control over the material to express their intention is not so obvious. Slowly the 'artist's eye' will be disclosed and they will discover how a person, an animal, a landscape etc., are 'put together', by which elements they are built up 'anatomically'.[45] People will learn to build their works of art in accordance with the leitmotiv that dominates their art. Naturally, this disclosure of 'perception' is also determined in its direction by faith and is rooted in religion. In the Middle Ages, for example, when the *Kunstwollen* was not in any way that of naturalism – i.e. the ideal of rendering reality as precisely as possible according to its external form – people were completely blind to landscapes and the strictly individual appearance of persons and things; they directed their attention to completely different matters, to which we will get back in the next chapter. And classicism had almost no interest in the strictly individual but looked rather for general 'ideal forms'.

The place that art occupies in a culture will also depend on the historical process of disclosure, because 'free' art can only come into being once the process of differentiation has started. Only when art has differentiated itself completely can a distinction arise – as a result of various enkaptic interlacements – between e.g. ecclesiastical art, industrial art, entertainment art and a truly free art itself. People will then come to the fore who through their work and their personal style act in a norm-positivizing way that influences the development of art, artists and personalities whose names are held in awe and who continue to live on in their works and writings.[46]

c) General characteristics of the fourteenth century

The period of time to which we now wish to pay special attention is generally regarded as part of the Middle Ages. But before dealing with the Middle Ages, we should first ask ourselves what *are* the Middle Ages. It is the period starting after the Carolingians and coming to an end in around 1400.[47] So it covers roughly six centuries. Undoubtedly these centuries all have something in common, i.e. the domination of the church over all of society. But in saying this we do not mean that this whole period forms a homogenous unity in a cultural sense. In the area of art the big difference between the Romanesque and Gothic styles immediately leaps out at one. There is also a big difference between thirteenth-century Gothic art and the art of the fifteenth century, which is usually called 'late Gothic' in Western Europe. For anyone who is an expert it is clear that this late Gothic is not a final stage in which the full flowering is over, but that it shows a unique character and spirit, distinct from the earlier art although to a certain extent retaining the Gothic style motifs. The problems connected to this will be the main subject of our investigation.

The time preceding the fourteenth and fifteenth centuries was completely dominated by the church. It was the great cultural power that guided and controlled all of life. We see here in the first place the power of an idea, namely the idea that the church is a God-ordained institution that distributes grace and has, in line with the apostolic tradition, a monopoly on the determination of supernatural truths and norms. For this reason alone it is understandable that typical medieval people would not separate from the church, however much they were inclined to criticize the clergy for their way of life. It is also the reason why excommunication was such a formidable weapon. And on this basis the Roman Catholic Church finally secured the power of the sword for itself during the Inquisition, even though they had to force the secular authorities to do the dirty work on their behalf. In all of this the church got a tremendously powerful voice (*roepingsmacht*) for norm positivization and cultural formation, especially in the thirteenth century when, through the papacy, it experienced the period of greatest

deployment of power. The behaviour of Frederick II was typical in this context. Pirenne observes: 'Frederick personally was, if you like, a free thinker, but he was the opposite of anti-clerical. His political theory was not any different from that of his contemporaries.'[48] It was he, for example, who legalized the persecution of heretics.

And yet, we may not forget that paganism, or rather unbelief, was present in much larger proportions than would have been suspected at a superficial level, especially during the time preceding the thirteenth century. Think of the sketches of that time by Orderic Vitalis and William of Tyrus. Furthermore, we may especially point to the Provencal 'courtly love' with its chansons – such as Peire Vidal, Guiraut de Bornel, Raimon Jordan and many others composed[49] – which were inspired by a spirit that was a long way from being Christian.

We need to look for the difference between the 'Romanesque' and the 'Gothic' period in a difference between the dominant ideas. In very general terms we may say that the 'pre-Gothic' time is characterized by a more or less ascetic Christian faith, a faith that considers the world and earthly things as being inferior. There is no real break between the basic ideas and tendencies in the time of the Church Fathers and those of these Middle Ages. During the next period all these things changed. In philosophical and scholarly circles people became acquainted with the work of Arabian and Jewish writers – in which Spain played an important part[50] – and through them also with the work of Aristotle, of whose works only fragments were known before then. People tried to reconcile ecclesiastical doctrine and Neoplatonic theology with the 'laws of reason', i.e. with Aristotelianism. That is how they arrived at the idea of the synthesis of nature and grace. Nature was defined by leading scholastics such as Thomas Aquinas (1225–1274) as a lower preliminary stage of grace, whereas grace was considered to be a *donum superadditum* above 'nature'. In its effect this philosophy was realistic – i.e. people considered *esse*, the being of the law, as separate from *essentia*, universal being – and it was partial-universalistic – i.e. people recognized both the universal and the individual; in scholastic terminology, they distinguished between the *essentia* and the *existentia*. In this nature-grace scheme we should not see just a theological theory or a mind game. It was giving form to something that lived in the hearts of people, so that we may speak of a religious ground motive. Only in this way can we understand how these ideas found such an immediate resonance with the contemporary people.

Also in the non-scientific terrain we see similar tendencies breaking through. In anticipation of faith, stimulated by this religious ground motive, new cultural ideas gained a powerful voice (*roepingsmacht*) in history. Tremendous cultural activity developed during this time. Everywhere people were busy constructing the unitary edifice of the scholastic world view, in which each part takes its place in the larger

totality. There is no need to deny that the positivization of norms and the formation of ideas were directly influenced by scholastic science itself. We should not think that an ordinary person in the thirteenth century would have read the scholastic writings, but we should not underestimate the educational and instructive influence of the clergy in their preaching and in other ways. After all, the clergy did indeed become acquainted with these works during their training. Moreover, there is also the direct, norm-positivizing activity of these scholarly people and clergy in the areas of legislation and politics, and in their leadership in the areas of establishing churches and commissioning works of art, and so on.

The fourteenth century shows us a completely different picture.

> There is agitation everywhere, in the minds as in politics, in politics as in religion, and this agitation seems quite close to disarray. People are enduring and labouring rather than advancing, for the only sentiment that they are clearly aware of is the one of these evils. People wish to escape from them without knowing whereto, or how. They have nothing to substitute for tradition, which weighs heavily on them and from which they do not succeed in freeing themselves. The old ideas remain, even if they are weakened, and people find them back everywhere, modified, undoubtedly, or altered, but without showing any essential changes.

This is how Pirenne characterized this period.[51] The fourteenth century saw a turning of the tide, it was a time in which the old structure of society began to crumble, a time that saw the collapse of the ecclesiastical mono-culture[52] and the formation of the first beginnings of a new culture. The various non-ecclesiastical areas of life were starting to break loose from the guidance of the church. A further differentiation from what was still a largely undifferentiated, worldly substructure can be noticed in the various societal structures, above which the church had elevated itself as the only institute of advanced development. Tendencies that were at work in making the various societal structures independent can be observed much earlier,[53] the first ones being those related to the state. But it was only now that they could start to be realized. The power and influence of the church decreased visibly. The church, as an institute that distributed grace, had always identified itself with the kingdom of God, so that this loosening of its influence through various non-ecclesiastical connections involved at the same time a strong secularization. Whoever let go of the church, in fact put themselves outside of the community of believers and often abandoned their faith as well. In this way the development, although healthy in itself, often led to the formation of a robust *diesseitige* ('this-worldly', as opposed to 'other-worldly') world view. In the fourteenth century this mostly did not emerge in an explicit, sharply defined, self-conscious form. For that to happen, a development was necessary that

would take more than a century. For those who did not want to abandon their faith it often degenerated into mysticism. Only a few groups continued to have a genuine striving for reformation, a desire to listen to God's word.[54]

Looking at the religious background, the fourteenth century can best be seen as the time of decline of the scholastic world view, as the time of receding synthesis. The fact that the power of the church was waning must have aided this process. The synthesis of these two opposite basic tendencies, which by nature excluded each other and thus continually tended to diverge from each other, namely the spirit of antiquity and the Christian mindset, could only be maintained by an ecclesiastical authority that would judge every deviation as 'heretical'. The areas of 'grace' and 'nature' now moved further apart and started to live, as it were, independent lives. This even led to the teaching of dual truth by those who wanted to keep both elements valid, in complete independence. Those thinkers, who in the previous century were of subordinate significance only, i.e. those who thought in a non-realistic way, were now taking a leading role. Gradually the subjectivists began to set the tone along with them, especially those who had rejected partial-universalism. This too was not just a kind of game played by scholars. Through it all shape was being given to something that had deep religious causes. In accordance with the changes in religious attitudes, a new positive content was also given to the norms of faith. We shall see the repercussions in the area of art, where these new tendencies brought about fundamental changes.

After letting go of partial-universalism in the philosophical field, people could go either of two ways: that of universalism, which denies the independent existence of the individual, or that of individualism, which says that the universal exists only in the subjective concept or the 'name' but that it does not have a reality of its own. In general we can say that those who gave priority to 'grace', after it had been dissociated from 'nature', were mostly universalists. We then find ourselves in the realm of mysticism, which had a great blossoming in the fourteenth century. From the fact that we ended up with mysticism we can perceive immediately what deep problems of faith were involved in this development. Because mysticism has been so significant for art we wish to discuss this in more depth.

This mysticism was centred in the Rhine region, and especially in Dominican circles even though it was not limited to this region or to the Dominicans. We think of Eckhardt (d. 1327), Tauler and Suso. For them God is the One and the All who, in himself, creates by explication – whereby the divine alienates itself from himself – and, at the same time, through an opposite current in himself, by re-implication – in which the divine turns back into himself. Where there now are two, the one is not the other and that 'not' must disappear in order to arrive at divine

fullness.[55] This happens through 'rebirth'. All people should find their way to God for themselves – the church is therefore no longer considered as necessary. For the subject of our investigation, the greatest importance lies in the emphasis that was put on 'imitation', through which people experienced the passion of Christ, following it step by step.[56] They imagined themselves to be present with the suffering Christ, they drank of the blood from Christ's wounded side, etc. This devotion was characterized by a certain tenderness of heart whereby people easily dissolved into tears, which may have been caused by seeing Christ on the cross. Mary also, as 'mother of the seven joys and the seven sorrows', took on an increasingly prominent place. All this had a big influence on the development of popular devotion. The woodcuts, for example, which were being distributed in ever increasing numbers since around 1400, especially in the German regions, were an expression of this kind of piety. As far as art was concerned, this mysticism led to the emergence of all kinds of new subjects and iconographic curiosities such as, for example, the detailed rendering of the various parts of the Passion and an extensive Mary iconography. And it also had its influence on style itself, since art came to be under the guidance of a new leitmotiv.

Now we wish to discuss the direction that gave more prominence to nature (as opposed to grace). Its representatives in the philosophical area were mostly individualistic subjectivists. In general their direction of interest underwent a change. The subjective, the personal, came to the fore. The individual as a person, as a personality, received increasingly more significance. Therefore, it is not surprising that precisely during this time the first portraits were made. People also began to have an eye for the beauty of nature itself.[57] Hence the first attempts were made at real landscape painting. In addition we see during this time a strong increase in interest for profane literary works, which were being translated and illustrated in great numbers while new ones were also being produced. This resulted in a big increase in artistic subjects. The artists of this period had to prove their originality in order to conceive adequate illustrations for Livius, *Le livre de chasse* by Gaston Phebus, as well as all sorts of chronicles. Lay people were working for lay people here. Since the thirteenth century, many lay studios of *enlumineurs* (people who made miniatures for books) were established. Almost all of the Paris school consisted of lay artists. They commanded considerable respect and if they were people of competence they could be elevated to the position of court painter with the greats of their time, or as *peintre du roi* ('the king's painter'). Materially, they were not badly off either because their work, being highly prized, was accordingly well paid. Art was differentiating; it received an independent place and began to develop independently. From events such as the establishment of the Parisian Painters' Guild in 1391, it can be seen that painting and miniature art began to have their own economic position. We should not assume that fourteenth-century art was simply anonymous. The artists

were well known in their time, sometimes even famous. A large number of names has been handed down to us. The fact that they usually did not sign their works makes it often difficult for us to verify what was painted by which artist – unless the sources (chronicles, accounts etc.) provide us with definite information. From all of this it is clear how greatly the church was losing in influence, and how the courtly world and middle-class society were developing more and more independently from a cultural point of view.

'Everywhere individual people are the standard and even the aim of artistic enterprises,' remarks Weese.[58] Here the tendencies of the more mystically inclined and of the more naturalistic-individualistically directed currents were running parallel. The mystical current came to emphasize strict individual devotion, the absorption as an individual into God, while also in the naturalistic-individualistic current the individual person received increasing significance. This is obvious from the fact that the use of *Horaria* or *Heures* ('book of Hours')[59] took off in a big way, as well as paintings on panels, which were portable and hence suitable for private use. In both currents there emerged an enormous, subjective interest in beauty in nature and art. But the motives were completely different: for the one group nature was 'the witness of the love and greatness of God',[60] who is the Universal All, while for others nature was seen as something totally independent, unique, apart from God. Both currents finally undermined the authority, and with it the power, of the church, albeit in completely different ways. The great structure of the world view and science of scholasticism was also slowly demolished, in one stream from above and in the other from below. During this time the old tradition was still strong and by no means defeated; that would only occur in the following centuries. The old artistic direction still managed to maintain itself in a strong tradition – the fourteenth-century form of mannerism, with which we will deal directly – while alongside it two new tendencies revealed themselves. In certain aspects, these tendencies went together and exercised a mutual influence on each other, especially as regards style. The mystical direction was still for the greater part linked to the old tradition, while the other direction revealed itself in a total renewal. In this way it is understandable that Weese, in response to the famous *Très riches heures du Duc de Berry*, remarks: 'The two styles almost separate themselves in accordance with the contrasts between church and court and between reality and churchliness, in order to claim for nature and the present the new art of storytelling, and for the supernatural and history the old formulism.'[61] It should not astonish us to find these two stylistic directions next to each other, sometimes within the work of one and the same person. The whole society was being driven by two religious motives that were polar opposites, whereby sometimes one and then the other received the emphasis, often depending on the area in which one was active. 'There is no hypocrisy in all of this, or vain bigotry, but a

certain tension between two spiritual poles . . . In the medieval consciousness two world views are formed next to each other: the pious, ascetic view has attracted all the moral feelings to itself; the worldly view is all the more lawless, totally abandoned to the devil.' Thus Huizinga wrote in *The Waning of the Middle Ages.*[62] Elsewhere in that book he provides typical examples.[63]

d) The art of fourteenth-century France

Before we can deal specifically with fourteenth-century art in France, we need to orientate ourselves first in the art of the preceding period. What was demanded of art during the successive periods of Romanesque and Gothic art?

Prof. Dr E. de Bruyne writes in this connection:

All the texts of the early Middle Ages point to the fact that a painting was supposed to move the spiritual or the Augustinian memory: it should certainly represent, but especially it should remind: it should not allow the seen reality to be recognised by the eye, but allow the spirit to understand the narrated history. Early medieval art is illustrative, or rather signifying. If the unity of fresco[64] and titulus[65] allows the monk to explain the meaning of the figure, postures, and gestures to the people, then the painting fulfils its useful purpose. The early Middle Ages were geared towards Platonism,[66] of course: true reality is spiritual and invisible, the material images are only a distant imitation thereof ... And for this reason it is not necessary that the painter should render all the material details in order to picture spiritual reality in a tangible way: such an undertaking would be impossible for a Platonist, and unnecessary; it is sufficient that the artist evokes in an image ... the meaning of true reality ... From the twelfth century onwards a different thought current is developed. Since Abelard, an ever-greater emphasis is put on the importance of the sensual for thinking, on the unity of human substance, on the adequate externalization of being in its material forms. The development of the art of painting runs parallel with this purely philosophical evolution. Sculpture becomes less impersonal, less conventional, less signifying, and less abstract. People seek to portray the sensual particulars, the correct measurements, the true expression, individual features ... In the second half of the twelfth century and in all of the thirteenth century the harmonious unity of the intellectual and the sensual is affirmed more and more ... art also enters the way of individualization, which, because it represents rather than signifies, and speaks more to perception than to memory, no longer needs any tituli.[67]

From this extensive quotation we can see how Gothic art was distinct from Romanesque art.

Thomas Aquinas, during the High Gothic period, demanded three things from art: in the first place, clarity, i.e. that 'the sensual characteristics of things express adequately the ideas that lie at their foundation'; in the second place, integrity, 'that means perfection,

which refers to both the spiritual as well as the physical, and which, as far as the latter is concerned, is present when there is nothing lacking in the bodies of what is to be understood as their fundamental nature'; and finally, consonance, whereby 'from every beauty a reflection of harmonious reciprocity between the original thoughts of creation and their radiation in earthly things must be claimed, whose truth, beauty and goodness is to be looked for in their conformity with the divine ideas.'[68] From all of this it becomes clear that this art had a leitmotiv that was directed realistically – the term 'realistically' in the philosophical sense – whereby scholastic partial-universalism certainly also played a role, such as will be obvious in what follows. In scholasticism and thirteenth-century art, people were looking for 'a combination of all worldly and super-worldly things in a layered structure according to their significance . . . Whereby the higher layer is characterized by the general and the enduring over against the unique and the transitory. In the general validity of the higher layer, however, lies at the same time the increasing simplification' in the representation.[69] At the root of this art, as shown in its typical character and its inherent contradictions and tensions, lies the religious ground motive, which also reverberated through the partial-universalistic, realistically directed leitmotiv:

> While in figures and scenes that paint people and events in their earthly limitations, incoherent depictions of an individual reality were more common ... people tried to represent the figures that signified the enduring ideals of Christianity also in their bodily appearance as paradigms of a concentrated reality, which instead of the temporal and the individual only contains the ideal construction of a higher level of being, to which the lines, plastic forms and colours are reduced.[70]

Morey comments in this connection:

> In Gothic one is conscious, however powerful the synthesis, of the variety of notes and fundamental discords which the synthesis resolves. When Gothic artists conceived the opposition of Vice and Virtue, the latter might be a personification enthroned in lofty serene abstraction, but the corresponding Vice was a chapter of real existence ... Throughout this art a deeply rooted sense of the concrete contends with the ideal order of the churchmen and schoolmen ... of these two factors in Gothic duality, the ideal one is visible only in its ensembles, the other is revealed in innumerable details of which these ensembles are composed.[71]

However interesting it may be to subject this art to further contemplation and to investigate how all sorts of elements – such as the rendering of space, the ideas about the relationship between architecture and the sculptures that decorated the buildings etc., as well as the iconography – were determined by its leitmotiv and religious background, we have to leave it at this brief characterization, summarized by these few quotations.[72]

Gothic reached its apex in the middle of the thirteenth century. That is when it was in its classic phase and offered the perfect, adequate means by which to express what enthused this period. It had attained the desired technical mastery to shape the materials in order to satisfy the posited demands. Technique and formation were now adequate supports for making works of art in agreement with the leitmotiv. Thus people attained what they had long been striving for. Next they started to 'play' with the discovered forms and symbols, because the materials no longer presented an obstacle, no longer offered resistance, and people really had nothing new to say. Over the course of years the forms and symbols became hollow and empty and began to lose their power and import. In other words, art became manneristic. People started to use and develop all kinds of elements separately, which used to fit in meaningfully into the larger whole. In this way art at times became an extremely elegant and fashionably refined game. In the area of iconography, where every tiniest representation had its own meaning and place, the whole system of symbolism was slowly broken down.[73] As such, art at the end of the thirteenth century and the beginning of the fourteenth century was the art of the 'gracious line', of which, for example, Master Honore was representative. Although new tendencies revealed themselves quite quickly, this mannerism continued during much of the fourteenth century. Various examples could be mentioned from the beginning of that century.[74] Although this art was especially persistent amongst clergy and monks,[75] it was not limited to those circles. The manneristic style was hardly breached by the layman Jean Pucelle who worked in the second quarter of the fourteenth century, although here and there new elements started to appear. It is possible, until about 1400, to point out specimens of this stylistic direction.[76]

As we have already stated repeatedly, new stylistic directions emerged, alongside these traditional ones. We wish to focus first on the more mystically directed current. Italy, especially Siena, preceded France in this mysticism and this explains the reason for the significant influence of the Siena school. 'In such a way, a Sienese element entered into the fabric of Gothic painting, beautiful in itself, and connected itself easily and without technical difficulties or inner contradictions . . . Siena and Gothic created out of the same soul-current of "com-passion" with the passion of Christ,' says Weese in this context.[77] We know of cases from around 1300 of painters who went, or were sent, to Italy from the North, and of Italians who are invited to the North.[78] A while later, however, the current of influence goes especially via Avignon. For it was there that the popes kept a rich court during their 'Babylonian Exile', hence this place became a centre where people from all parts of Europe could meet each other. Italian artists belonging to the retinue of the pope stayed there, among them an important figure such as Simone Martini. But many French artists also worked there. Hence an important

artistic centre was constituted, which formed the link between Italy and the North, and perhaps also the other way round. Apart from this we should not underestimate the influence of imported Italian works of art. Obviously it concerned the smaller pieces such as panels, ivories and illustrated manuscripts.[79] A well-known example may illustrate this: Jeanne d'Evreux possessed a Sienese manuscript dated around 1335. The Crucifixion from that was copied, albeit not slavishly – remember, slavish copies are rare in the Middle Ages – in the famous *Heures de Rohan,*[80] which was created in the first decades of the fifteenth century.

In general we can say that especially in the area of iconography the Italian influence made itself felt, while people linked up stylistically with mannerism, even though with some masters a clear Italian slant cannot be denied. In the North people got acquainted with many new subjects, provided, among others, by a book like the *Meditationes vitae Christi,* which originated from Franciscan mysticism. We will not treat everything in detail here but want to point to the thorough investigation carried out by Mâle.[81] We could mention here by way of example the *Parement de Narbonne.* From a stylistic point of view, this work dating from somewhere between 1364 and 1377 is a pure product of the mannerist school of Paris, while in iconographical respect many Italian details can be found.[82]

Mysticism also flowered in West Germany and established many new subjects, or changed the approach to already existing representations. Although, curiously enough, there is little direct stylistic influence from West German art on the art of France we do see, in the course of this period, several of the subjects that emerged in German art settle into France. We have in mind here the Pieta (Mary with the dead Christ), the Entombment of Christ, the so-called *Gnadenstuhl* ('mercy seat'), as well as the very extensive iconography of the life of Mary, who gained an ever greater prominence in the life of faith. As example for the subject of a Mercy Seat I wish to draw the reader's attention to the magnificent tondo in the Louvre, which has been attributed to Malweel. The subject, namely God holding Christ, was not new.[83] What was new, was that God was not holding the cross with Christ, but was supporting the dead Christ himself and, moreover, Mary and John were present. In this tondo, which must have been created around 1390–1400, a strong Italian influence is conspicuous, especially in the head and figure of Mary. As a feature connected with this mystical devotion we see the heavy flow of blood coming from Christ's side. That was quite common during this period. Mâle has shown that such a conception of the subject of the Mercy Seat was connected with mysticism.[84]

We shall not discuss further all the peculiarities and subjects of the new iconography, nor their stylistic incorporation. We wish only to point out that in our opinion, in virtually all the works connected with the mystical current, it is clearly observable also in the stylistic features

themselves that this art was guided by a faith which we may characterize as subjectivistic-universalistic. Every thing or person represented was absorbed in the total picture and constituted but a small rhythmic element in the pattern of the whole. As an extreme example, we should observe how on several pages in the *Heures de Rohan* the sky, which at first glance appears to be simply blue, on closer inspection turns out to consist of a host of angels, executed in gold on a blue background.[85] In this book, which is one of the most beautiful specimens of French miniature art, we find a number of illustrations that are very exceptional, also iconographically. The artist gave us a few totally 'unique' representations, while his interpretation of various more usual subjects witnesses to his extraordinary, original vision. Although we should not exaggerate the general freedom of artists during this period to make what they wanted as they preferred it, this book does show how a great artist could express himself freely.

We now wish to consider especially that current in artistic development that was driven by the nature motive. As we already observed, people started to see 'nature' in and of itself and they became more and more interested in it. The 'natural', secular, or 'worldly' life received a meaning of its own, alongside the 'supernatural' world of God, saints and angels. During the earlier period the 'natural' was of importance only if it could be brought into a direct connection with the 'supernatural'. But now it became significant in and of itself and, therefore, it became meaningful to try and represent it for its independent worth. In this way, motivated by the nature motive, a new *Kunstwollen* emerged, 'naturalism', which has directed stylistic developments until the twentieth century despite its ever-changing definition. At this stage naturalism mainly had an individualistic orientation. People tried to convey that which was strictly individual in someone's face and, a little later, also in the person's clothing and posture. They also tried to harmonize the surroundings where events took place with their visible reality. Along with that the beauty of outdoor nature, the landscape, was discovered. Attempts to render this adequately led to the emergence of landscape painting. Initially people's attention was drawn to an accurate representation of animals, but later on also of trees and plants. In many respects this goal was something completely new, so that these artists had no tradition at all on which to draw but had to start from scratch with inventing and developing the aesthetic means. Also in illustrating the many secular works which were translated and decorated during that period artists were forced to think out new 'compositions' for themselves. The latter was obviously beneficial in overcoming mannerism. Otherwise, however, when they did have to deal with the established traditions – for example, when picturing the posture of people, their clothing, the drape of folds – artists had to overcome many obstacles. In order to show more clearly how the process developed, we will now divide our subject according to

different themes and will discuss in turn the portrait, the realistic glimpses into everyday life, and finally the forest view and the landscape.

As our first theme we will look at *portraits*, in which people started to show an interest around 1300. The development can be traced clearly by looking at memorial statues. In general during the fourteenth century, people kept to the basic type, as established in the thirteenth century, namely that of the *gisant*:[86] a recumbent figure with the hands in a prayerful gesture in front of the chest and eyes open. In this type, the dead person was usually rendered to look about thirty years old, regardless of the age the deceased had reached. The figure was always placed to face the East. A few things become clear when we consider that not dead, but living people were represented here, people as they were imagined to be on the day of Resurrection. An age of around thirty years was chosen, for the resurrection of Christ occurred in his thirty-third year and it was believed that all people would have that age at the Resurrection. As a result the deceased were presented as beautiful, ideal persons. But this view of the dead slowly started to change. More and more the deceased were pictured as dead people and were identified by as many individual characteristics as possible. However, this change came about gradually. The memorial statue of Philip III in the Abbey at St Denis, prepared by Pierre de Chelles in the years 1298–1307, for example, does have a certain personal character, but we cannot yet speak of a real 'portrait'. This statue was made some thirteen years after the death of the king, so that it is fairly certain that the artist had access to a cast of the head. And yet he did not follow that slavishly but just gave a few individual features to the traditional ideal figure. We notice real likenesses only in the statues made by Beauneveu around 1365 for the graves of Charles V and Philip VI at St Denis.[87]

Apart from the memorial sculptures we begin to see a few very characteristic lifelike sculptures during this time. We think of the statues of Charles V and Jeanne de Bourbon, probably by Jean de Liège, which can be found in the Louvre, but which were originally placed at the entrance of a church in Paris. In general, therefore, we can say that with regard to sculpture we can notice the beginnings of lifelike representations in the first half of the fourteenth century, while only during the second half it reached a stage of maturity.

This is probably also how things developed in the art of painting. Because all panels from the first half of the fourteenth century have been lost, however, it is more difficult to form a picture of this process. On dedication miniatures, which picture the patrons, we do see attempts towards portraits, but no successful specimens as yet.[88] The Flemish, who are said to have been naturalists by nature, have been credited with the first real portraits. Indeed, in a Calvarie of 1363 in the museum at Antwerp we may see a founder's portrait, but neither this one piece nor the few surviving remainders of Flemish art that have been preserved can justify the opinion of Maeterlinck, when he says with regard to the

lost fourteenth-century panels: 'It is to be supposed, however, that they represent the essential characteristics of our national art, i.e. the individualization of types.'[89] Taking into account the few surviving pieces, it is a more obvious conclusion to characterize the Flemish art of the fourteenth century as a provincial French style.[90] For the 1363 portrait mentioned above can in no way compare in quality with the famous portrait of John the Good, attributed to Girard d'Orléans, who was a full-blooded Frenchman. We note the sharp characterization and the Italian influences that clearly emerge – as in parts of the eye and mouth. This is not surprising when we consider that in Italy a few things had already been accomplished in this field – think, for instance, of Simone Martini's *Guidoriccio* of 1328 in the city hall in Siena.

A peculiar characteristic of the portrait by Girard d'Orléans mentioned above, and of many other portraits which from this time on were preserved in ever greater numbers, is that the subject always appeared in profile. It reminds us of Roman cameos and coins, and it is quite possible that the artists, who were confronted with a problem that was entirely new to them, looked for inspiration to such past examples. But then it is remarkable how little slavish imitation there was. In any case, we should always be very careful when applying theories of presumed influences that seek to identify a direct dependence. After all, cameos were known throughout the Middle Ages – we see them often applied as decorations for book covers and reliquaries, from which it is obvious how highly people valued them – without any sign of their influence on art, however. For the understanding of a stylistic development it is often just as important to point out that something had not exercised an influence as that it had done so.

Alongside portraits in profile, we also frequently meet so-called 'three-quarter' portraits, especially on the dedication pages of miniatures. Most likely this followed an old tradition. We come across this type of dedication, which pictured the handing over of the book by its maker to the person who commissioned it, already in Carolingian times, albeit not rendered in such a naturalistic manner. Occasionally we see a portrait with the face pictured from the front: one of the few specimens of that kind which has been preserved is the one of Richard II in a sitting position which can be seen in Westminster Abbey in London. It has been attributed to a French painter by the name of Jacquemart de Hesdin, who was also famous for his beautiful miniatures.[91] In the fourteenth century, heads that were depicted as portraits were still treated completely separately, i.e. with bodies that had not been designed from a living model. As mentioned earlier with regard to the clothing and the draping of clothes, people still had to detach themselves from the strong Gothic tradition, in which they succeeded only by the end of this period. It was not until the portrait of the Duke de Berry on the opening miniature of the *Grandes Heures du*

Duc de Berry, which pictured him as kneeling in front of the Madonna on the facing page, that we might suppose that also the body and posture were sketched from nature.

At the same time that portraits of living people became popular, or perhaps a little later, the features of the saints also took on more individual characteristics. It is remarkable that this applied more to the popular saints than to Mary and the angels. For example, on the Wilton House diptych, dating from the 1390s, in the National Gallery in London, Mary and the angels all have the same face, without any individuality; by contrast, the heads of the patron saints of the king – St Edward the Confessor, St Edmond and John the Baptist – are very individually characterized. The same can be noticed in the opening miniature of the *Grandes Heures du Duc de Berry*. Perhaps we, along with Mâle,[92] may attribute this to the fact that the artists portrayed the actual living people who played the parts of those saints in the processions of the *confreries* (guilds), while Mary was more a mystically coloured object of devotion. Around 1400 such individual characterization was not yet the rule but was found only with the most progressive artists. It became more general during the course of the fifteenth century, while the representation of Mary then also became more of a portrait of an ordinary woman. Clothes and bodies, however, continued for a very long time to be treated along the traditional lines of posture and draping of folds. Occasionally we do notice a sharply observed figure. But it is significant that they were mostly of common people, executioners and figures generally from the lower classes. In this connection we could point to the executioner in the *Martyrdom of St Denis* by Malweel and Bellechose in the Louvre. How well in this painting the nudity of Christ on the cross has been observed! A growing interest in a naturalistic representation of the nude body – especially in themes like Adam and Eve, the Resurrection, the Last Judgment and Christ on the Cross – is evident. This is also obvious in the tondo by Malweel, though it does not really belong to this naturalistic current. It shows again the mutual working of stylistic influences. Furthermore, the Mercy Seat on the antependium of the Golden Fleece of about 1430 – which is correctly ascribed by Troescher to the School of Beauneveu[93] – may be mentioned in this context. From this it was only a small step to the representation of the same subject by the Master of Flémalle, Campin, the teacher of Rogier van der Weyden. But with the latter we have already arrived at the Flemish Primitives.

We now proceed to the treatment of the development in the rendering of daily life. Here we have to make a sharp distinction between realism and naturalism, by which we may avoid a lot of confusion. For realism, if we understand by this the rendering of glimpses from daily life, whether funny or not, of scenes intended more or less satirically, in other words, of people in all their typical peculiarities – in general that genre that

later would be represented by Brouwer, van Ostade or Jan Steen – is not the same as naturalism, where the artist attempts to render reality as faithfully as possible to nature. Realistic representations are not at all rare in Romanesque art,[94] but we cannot speak of naturalism here. We could say that naturalism is a style-idea, while realism has more to do with what is being pictured.

In France in the thirteenth century we see realistic details occur in ever fewer instances – especially in the miniatures we hardly ever come across them anymore. In the fourteenth century they reappear as *drôleries*, or Gothic 'footnotes', e.g. in the works by Jean Pucelle. And yet we should observe that the little scenes he put in the decorative borders, especially at the bottom of the page – hence the name 'footnotes' – were more often biblical scenes than satirical ones. The origin, or perhaps better the revival, of these *drôleries* probably has to be traced to England and the Northern Franco-Flemish area roughly between the rivers Somme, Meuse and Schelde. We already see in the Bible of William of Devon of circa 1250[95] the well-known decorative borders showing dogs chasing after a hare or a deer or animals acting like people or animals from fables and suchlike. Even the motif of the archer, which became so popular later on, we already find represented here. In this motif the archer is standing at the end of a trail shooting upwards towards a hare or a bird in the decorative border. In the Franco-Flemish area mentioned above we also find many footnotes, e.g. in a missal, richly decorated by Petrus de Raimboucourt from Abbéville, which is now kept in the Royal Library in The Hague.[96] We also see well-known themes, e.g. monkeys on dogs charging towards each other like knights in a joust. This and many similar motifs were often inspired by travelling circus showmen, jugglers and actors – in the *drôleries* we find figures juggling with a plate on a stick or giving acrobatic demonstrations – or the animals they had trained performing tricks.[97] In addition we often see satirical scenes depicting the struggle between the weak and the strong. In these the roles were often reversed, showing for example a hare hunting a man and later taking him home dangling from a stick.

This inclination towards realism in this region, though pushed to the background during the High Gothic period in France, as we showed, could perhaps be regarded as a kind of provincial remnant from the Romanesque period which now, under the influence of the renewed interest in the 'natural', also started to gain significance in France again. It continued to be popular in that milieu where also comic theatre and the *fabliaux* (metrical tales in early French poetry, often coarsely humorous) found their origin, and where the fables like that of Reynard the Fox were popular.[98] It was a milieu in which citizens fought for the recognition of their rights – we think of the Battle of the Spurs of 1302 – and where the citizens, having become rich through trade and industry, began to play leading roles. This was also the region where we find the first large town halls being built.

In this realistic genre, a naturalistic tendency may be noticed during the fourteenth century. First of all we see that animals were portrayed in a more naturalistic way.[99] Then there was an inclination to represent the surroundings: trees, plants, a hill in the background, etc. But now we wish to pay special attention to interiors, for it was not long before people started to position scenes in a room or near a gate. The well-known Flemish painter Broederlam, who worked at the court of Philip the Bold around 1400, in his panel of the Annunciation attempted to situate this event in a real house. One notices the peculiarly un-Gothic, Italian character of these buildings. Also in other works from this time we see similar attempts to depict interiors or buildings. Although the artists usually did not succeed in convincing us of the reality of these 'structures', they did seriously aim for it. Meals were also rendered lovingly in great detail. In general we can say that people had a great interest in the details of their surroundings and clothing. However, they did not quite attain a coherent vision of the whole. With all that, realism slowly receded to the background again although it did not disappear completely. In the course of development the 'footnote' slowly disappeared – one could say it conquered the whole page. The decorative borders now consisted mostly of trails of flowers and leaves, composed in a way that suggests this motif came from Italy, via Avignon.[100]

People have attributed this interest in naturalistic representations of animal and hunting scenes – which was also the occasion for landscape subjects, with which we shall still deal – of costly clothing and all kinds of details, to an Eastern influence. The question is whether people in France ever saw or knew the relevant Persian miniatures. In Italy that was not improbable because there were quite a large number of Eastern artisans working there.[101] In this scenario, the influence is supposed to have come to France via Italy. But why then would we find this genre in France and Lombardy at an earlier date than in Tuscany, if it ever were there at all? And even if such a direct influence could be shown, it would prove above all that artists in France were at this time keen to make use of the given examples, while in the twelfth or thirteenth century people probably would have put these miniatures aside without imitating them, had they somehow received them – which is not impossible, because twelfth-century Persian miniatures already furnished magnificent specimens of these hunting scenes.[102]

Indeed, with regard to what we are discussing here, it was the Flemish working in France who were the innovators. But we cannot explain it by a tradition that they brought from their homeland. Possibly their greater sense for realism, as well as their sharp observation, led them somewhat quicker and easier to naturalism. Most of them are likely to have received their first education in Flanders, from where they moved to the large French centres – Paris and the courts at Dijon and Bourges – because a great future was certain to open up for a talented

artist in those places. Almost all would have added the final touches to their formation in Paris – for they all joined the Paris school – and yet they would not have been as attached to mannerism as many French artists were. It would have been easier for them to break through mannerism than for the French themselves, who in and around 1400 still showed clear traces of it.

The Flemish were the ones who showed the way, especially in the topic to be next discussed, namely *landscape*. The Northern painters had to start from scratch in this genre, unlike their Italian colleagues who had the Byzantine-Alexandrian background as heritage from which they could continue their development of the panorama and the mountain landscape. Yet, this lack had its advantages: because the artists were forced to see with their own eyes, they usually achieved a fresher vision of the landscape.[103] Undoubtedly in France the artists learned from the Italians – think of the Byzantine-like mountain heaps and rocks on the already mentioned altarpiece by Broederlam at Dijon – but in the main, people went their own way. One of the oldest preserved landscapes is the fresco in the *Tour de Garderobe* ('wardrobe tower') in the papal palace at Avignon. There is debate about whether it was perhaps made by an Italian. The hunting scene was a popular theme in France, however, while the few remainders of such work in Italy almost all betray a French hand.[104] In France it occurred on both frescos as well as tapestries. But we really should not speak of 'landscape' yet. It is more a matter of *verdures* (green patches), groves, glimpses of an open place in the greenery where the scenes take place. In other cases it gives the impression of a very enlarged 'footnote'.[105] Forest views like this were very popular. Especially Charles V (who reigned from 1364–1380) was very keen on the naturalistic direction and showed great interest in possessing works in this style. Apart from historical paintings – of which unfortunately we cannot form any impression – he had the *Galerie de la Reine* ('queen's gallery') in the Hôtel Saint Pol in Paris decorated with such a *verdure*, in which all kinds of trees are pictured, with flowers in the grass, while everywhere there are little children picking fruits or flowers. In 1380 he gave a commission to Jean de Troyes to make a panel on which there were to be pictured 'oak trees and deer made according to nature, with the whole field covered with fine green, in oil, decorated with green leaves and bushes, and in the lower part and on the sides a deerhunt and some dogs'.[106] We may especially emphasize this *d'après le vif*, made 'according to nature'. Although the artists knew how to picture animals very naturalistically, the trees and plants are on the whole not rendered so very convincingly yet. This is noticeable with the Master of Boquetaux, so named by Martin.[107] But it is precisely with this miniaturist that we see the first real landscapes, no matter how awkward they may perhaps have been executed. The name, by which this anonymous master who must have worked between 1350 and 1380 is

known, was chosen in response to the way he used to render the crowns of trees, as if they were a kind of bouquet, a kind of parasol. The horizon in his landscapes is always very high, almost against the top of the picture, because he liked to show us many things. The landscape was a kind of map, on which all sorts of very well-observed details were placed next to each other or piled on top of each other. He certainly still made many mistakes in the relations and proportions between objects. For example, a hare further away was just as big as a whole flock of sheep closer to the foreground.

The master who illustrated the *Livre de Chasse* ('book of hunting') by Gaston Phebus[108] made progress in rendering the greenery, but even with him the landscapes were mostly *verdures* and the sky was often still worked in a decorative pattern. The landscapes in the scenes of the months of the rightly famous *Très riches heures du Duc de Berry* from the hand of the Limbourg brothers (1415) formed a synthesis of what had been accomplished by various masters with the application of a much further developed perspective.[109] Even though the horizon is drawn considerably lower here, the landscape is still closed off by a castle or a forest, like the wings of a stage. The miniatures created around this time, from the *Heures de Turin*, by the brothers van Eyck are evidence of a further step forward. Here the landscape became a real panorama, possessing a real atmosphere. We also meet magnificent cloud formations. Here we see the culmination of what people had been attempting to do for almost a century. For the remainder of the fifteenth century there was essentially no further change or improvement to the art of landscape painting.

We have now come to the end of our considerations about the beginning and development of the new currents in the fourteenth century. It is not by chance that more attention needed to be paid to naturalism than to the other tendencies. This direction, which was to dominate almost the entire Flemish Primitive school, acquired an influence in the fifteenth century that reached far beyond the borders of the Flemish region. France hardly played a significant role anymore, as a result of the chaotic circumstances resulting from the Anglo-French War. The history of French painting in the fourteenth century is therefore the pre-history of the Flemish fifteenth-century art. The more mystically directed tendency receded further and further into the background and only retained a few important representatives in Germany, e.g. Grünewald at the beginning of the sixteenth century.

If we now look at naturalism as it expressed itself at the beginning of the fifteenth century in an already adequate stylistic form, then it is obvious that we should distinguish two sub-currents. The fact that the differences between these sub-currents were not already clearly noted in the fourteenth century can probably be blamed on the circumstance

that the representatives of both directions were working shoulder to shoulder in developing a new technique for that which enthused them both, namely naturalism. But once they succeeded, in the fifteenth century, both trends become more clearly delineated and we can distinguish the tradition of Beauneveu, Campin[110] and Rogier van der Weyden clearly from that of the Limbourg brothers and the van Eycks. To the latter tradition we may also count Claus Sluter, who may be considered one of the greatest sculptors of all times.

Let us now attempt to identify the characteristic leitmotiv of the last-named artists. According to Troescher, 'Sluter was the leader who paved the way, the pioneer in the struggle for recognition and representation of naturalism.'[111] By contrast he depicted Sluter's contemporary, Beauneveu, who was both painter and sculptor, in these words: 'His interest was not so much directed to the representation of the individual characteristic and the uniquely special.' Vermeylen wrote about van Eyck: 'Every part is imitated to the smallest particular ... How he loved every material, and how he relished all forms and appearances, which he summoned to life once more with a bit of paint in their bodily and essential reality! He is like the creator who gives each object its name for the first time.'[112] As we have noted before, the ideal for this direction was the precise rendering of reality, the imitation of nature and the representation of each object according to its strictly individual forms of appearance. In our opinion we may say that the *Kunstwollen* points to an objectivistic-individualistically determined *pistis* (faith). The other tendency was geared differently. We have already quoted Troescher's characterization of Beauneveu. We would like to add to that what Vermeylen says in connection with the art of Rogier van der Weyden:

> In contrast to van Eyck, he is the portrayer of emotion, in its dramatic diversity, averse to bombastic clamour, nourished by quiet meditations, purified in the soul and, no matter how tender, master of himself ... He is not driven by van Eyck's vision, intent on taking possession of reality, and in the first place obedient to aesthetic intentions. His inner lyricism is much more inclined to turn the given data into poetic beauty inspired by emotion.[113]

In my opinion it is justified to typify the leitmotiv of this latter current as subjectivistic-individualistically directed. It turns out to be the leading current during all of the fifteenth century. After all, however much his contemporaries appreciated van Eyck and even though many may feel that he was the greater artist, it was Rogier who gained the greater following. The influence of the Flemish school that spread across the border to Germany and Spain was particularly that of Rogier van der Weyden and his followers. We can discern the reason for this in the prevalence of a subjectivistic attitude in the culture of the day, for which the leitmotiv of the school of Rogier met the requirements. Consequently it also gained aesthetic domination.

e) Fourteenth-century pre-Renaissance and the Renaissance

The question we wish to pose now is whether we may speak of a Renaissance, or perhaps rather a pre-Renaissance, with respect to the fourteenth century. First of all, let us see what content we need to give to the word 'Renaissance'. Already in the thirteenth century it became a fashionable term,[114] as in St Francis of Assisi and Dante. Then the content for the word *renasci* ('to be born again') is *renovatio vitae* ('renewal of life'). By this generally a very broad idea of renewal was understood which, apart from religious, had also political and cultural overtones. It also referred to the inner renewal of the individual person. During the following centuries its meaning was narrowed to the latter idea, and the word attained a very distinct tone as for many people rebirth and renewal of the person became a central and leading idea. Both currents that arose in the period of receding synthesis were in agreement on this. And both tendencies agreed and recognized the impossibility of the scholastic synthesis, and wanted to break with it. It was obvious that their results would be very different in the respective currents. That was already clear in the early years – the fourteenth century – when both wanted to return to Christian antiquity: one current would emphasize the Christian character of that period, the other the Roman world citizenship. The current motivated by the 'grace' motive, which now was separated from 'nature', was the first to come to a sharper realization of its own aims in a mystical form, as we noted earlier. The idea was to achieve a rebirth of humanity in their relationship with God, not through the church but through themselves. This mysticism was to decrease steadily in influence over the years. In other circles, however, by the grace of God, the insight would gain ground that people could not effect a rebirth by themselves but that they had to look to God for it. Here we see again a desire to submit to God and to listen to what he asks of human beings. In many respects people were still confused by the philosophical and theological insights that dominated this period,[115] but the way to a true reformation had been pointed out because people truly wanted to submit to God's word. As far as I know, there are no traces in France of a pre-Reformation in this sense.

Of greater importance, however, is the current that was motivated by the nature motive. During the course of the fifteenth century, as people became more aware of their own aims, they arrived at the idea that human beings themselves have to effect their own rebirth. Humanity came to stand in the centre of religious life, in other words, the humanistic personality ideal emerged, where people no longer acknowledged any authority but themselves. This was what gave special meaning and content to the Renaissance. Herewith humanism was born, which as a new world view has principally guided and determined culture until our own [twentieth-century] time.

We need to make a sharp distinction between the Renaissance as a spiritual movement out of which humanism was born, and humanism in the specific sense of an educational ideal oriented to antiquity, an ideal of imitating the 'classics'. According to Huizinga, 'Renaissance is not imitation of the Greeks and Romans as such, but has a strong ethical and aesthetic emphasis. To return to the sources, to refresh oneself at the wells of wisdom and beauty, that is the main theme in the idea of rebirth.'[116] He continues: 'And if that includes the new enthusiasm for the ancients, the identification of the present with antiquity,[117] then it is because those ancients themselves seemed to have possessed those simple norms for virtue and beauty.' Hence humanism could be an expression of the Renaissance ideals but was not at all necessarily so. It is understandable that in Italy, especially in art, Renaissance and humanism went hand in hand. The works of art and architecture were a constant reminder to people of a greater past. In addition, the 'Gothic' tradition was much less strong here. On the other hand, humanism played a more subordinate role in the North, although it should not be underestimated. It was here that many classics were already translated into French in the fourteenth century – Livius, Aristotle, Valerius Maximus and others – although the fact that they were translated into the language of the people points to the fact that people were not, in the first place, chasing after a rebirth of classical literature. That only applied to a small group of scholars.[118] In this context we may think of a monarch such as Charles the Bold, who wished to equal the ancients by his great and magnificent deeds.[119]

In the fourteenth century all of this was not yet so sharply formulated and confessed. People were not yet so aware of their own not only anti-church but also anti-Christian motives. People were still searching: their ideals had not yet been given an adequate positive form. And yet, the new spirits already expressed themselves in art, literature and other areas of life. But people were usually not yet ready to break with the church and the Christian faith, even though their attitude to life sometimes stood in strong tension with it.[120] However, the 'Christian' faith itself was thoroughly apostate and mostly degenerated into superstition and fetishism. Just read the relevant chapters in Huizinga's *Waning of the Middle Ages* in order to gain a picture of this situation. All in all, it is best to speak of a pre-Renaissance with regard to the fourteenth century. The term 'Renaissance' is then reserved for the fifteenth and part of the sixteenth century. This applies to both the North and the South. The differences between these two are considerably less than would be expected, although they should not be neglected. One important difference is that in Italy the process of differentiation progressed further – possibly as a direct inheritance from the Roman era.

We have just reserved the name 'Renaissance' for the culture of the fifteenth and part of the sixteenth centuries. Judging by the leading

current with regard to the ground motive, this period stands wholly on the side of modern history: a 'this-worldly' world view with a humanistic personality ideal determines both. Yet, we should keep in mind that the 'grace' motive had not totally lost its grip on humanity. For this reason we should distinguish this period from the one following it. It also explains the spasmodic character of Renaissance people's behaviour – their falling from one extreme into another, now 'this-worldly' to the extent of amorality, then overpious to the extent of total self-denial, now full of optimistic self-confidence, then filled with pessimistic fear. These people, even when they chose nature, did not dare put grace totally aside. The behaviour of Savonarola in Florence in the 1490s and the deep though short agitation he caused, are typical examples of this.[121] The unsteadiness and inner contradiction in the attitude towards life is only intensified by the transitional character of this period. For the Renaissance was also a time of transition from the old to the new. All the old ideals and ideas were in an advanced state of dissolution, while new ideas were adhered to only with trepidation – people did not trust themselves and were afraid of the consequences – while the building of society in accordance with the new ideals was still at a very early stage. The old certainties and supports had been destroyed, but the new ideals had not yet become certainties. Hence the continual return to the church, an exaggerated attention to relics, a strong confidence in miracles performed by holy hermits or other holy people, and the like. It is not at all accidental that precisely at this time witchcraft took on its definitive form and a big persecution of the new, so-called 'witches' sect was launched. It fits in with the whole atmosphere of this period.[122] This transitional character and this as yet doubtful confession of the new faith in humanity was also expressed in the memento mori ('reminder of death'). The memento mori was not characteristic of the Middle Ages, but was one of the typical hallmarks of the Renaissance, a period in which also the 'death dance' emerged, and when people started to depict the half-decayed bodies of the deceased on graves and to write books on 'the art of dying'. Memento mori is always present in the shrill sounds that come to us from that time. Outwardly this phase still had much that was medieval, but inwardly people were already alienated from it. Only the next century would wipe away the last traces of the once so powerful scholastic cultural structure. Then the people would become more sure of themselves and, in cultural optimism, would start to look back and despise the past – which revealed itself already in the names they gave to the older direction and style in art: 'Primitives' and 'Gothic'.

One sometimes wonders why the Renaissance is claimed in the first place for Italy, and why it is understood to have started only so much later in the countries on the northern side of the Alps, and then only under Italian influence. I believe that, apart from the confusion of Renaissance with humanism, the picture that we get from art can play tricks on us. In the first place, it is conspicuous that in history books –

think for example of little textbooks – very often fifteenth-century works of art are used as illustrations for the Middle Ages. In this way, subconsciously, people get a wrong image of this period in history, without knowing it. Every object and every work of art makes us feel something of the time it was created. We may not always be able to prove that certain pictorial materials have influenced our perspective on a period and also our scholarly vision, but it cannot be denied either. What is more, when people attempt to clarify the relationship between the Middle Ages and the Renaissance by means of illustrations, they often choose works of art from the North for the Gothic period – if they do it correctly – but for the Renaissance they choose works from Italy. In this way, differences are suggested that are in fact not there. Already in the thirteenth and fourteenth centuries, art in Italy had a totally different look from French Gothic art, no matter how many mutual influences were at work. This is how people link to totally different traditions in their visual materials. A more accurate picture would have been gained if we should have compared thirteenth-century with fifteenth-century Italian art, and thirteenth-century Gothic art with fifteenth-century, so-called Flemish 'primitive' works of art. Anyway, those works of art that have come to us from the fifteenth century in Western Europe do not give us a totally correct picture of this era, since of the total number of works created a relatively much larger number of 'religious' works has been preserved than of 'secular' ones, so that the balance has moved too much to the former. Furthermore, the fact that the process of differentiation in Italy was more advanced, also with respect to art, so that the leading style-makers there took up a much more self-conscious, independent position, could have led to this misunderstanding. Then it is sometimes forgotten that Sluter and van Eyck were also great style-making personalities. It would be difficult to point to a figure like Sluter even in Italy at the end of the fourteenth century.

Let us now attempt to explore the difference between Renaissance art in the North and in Italy, or rather, in Tuscany. In both regions the new trend broke through in a self-conscious, adequate form around 1400, after a century of preparation. However much the new tendencies already revealed themselves in the art of the fourteenth century – whereby people sometimes progressed very far, for example in portraiture – we may indeed say that during the first quarter of the fifteenth century a revolution took place in this area. In Italy we see the works of Ghiberti, Donatello, Massaccio emerge, in the North the art of Sluter, the Limbourg brothers and the van Eycks, etc., even though much art of the older type continued to be created. In all these works it becomes very clear that to a large extent people had attained what they demanded from art: a naturalistic representation of reality. By this time the mystically directed current was of lesser importance for art and its development in Italy and the Burgundian-Flemish region.

When defining the difference between the Italian and the Franco-Flemish Renaissance art, we should remember that there was a much stronger Gothic tradition in the North. That is understandable: was not France the cradle of Gothic art? Many of the old forms, even if applied in a totally new spirit, still held fast. In Italy, by contrast, there was the inclination to be inspired by the 'classics'. This is very clear, especially in ornamentation. This humanistic feature was not totally lacking in the North,[123] but here it did not mean much. The Italian-Roman forms of architecture, which we encounter here a few times on paintings and miniatures, can be attributed to an Italian influence and do not prove an inclination towards antiquity.

All this is connected to the different character of the Italian Renaissance. In contrast with the North, where there was interest in rendering the strictly individual and the detail, and where people approached their work in a less scientific way when they looked for working methods, and where they were less inclined to reflect on art and beauty, the Italians were looking in a more or less scientific way – mathematics often played a large part – for the ideal relationships and proportions, and showed interest in all kinds of aesthetic problems. In the North, people only became interested in such ideals at the beginning of the sixteenth century, when Italy became the great teacher. Before it could come this far, a change had to take place in the leitmotiv that determined art in both Italy and the Burgundian regions. That is when the people in the North also started to look for the 'ideal type', ideal proportions and relationships, which was closely interwoven with a growing interest in the classics. It cannot be denied that such a turnaround took place. Rogier van der Weyden made a trip to Italy in the middle of the fifteenth century, but he certainly did not return as an Italianizing master. However, in the beginning of the sixteenth century people were so gripped by Italian art, which was then starting to be seen as ideal, that they imitated it diligently and had no scruples about casting aside their own beautiful traditions. Not only did people come to deny their own past; they even started to hold it in contempt. Thus we can conclude that the differences between Italian and Northern fifteenth-century art are undoubtedly connected with a difference in a positive faith attitude – even though they were rooted in the same religion – and a difference in the aesthetic leitmotiv connected to that.[124]

f) Conclusion

We have now arrived at the end of our observations and ask what general conclusions may be drawn from all of this. We wish to emphasize the following:

When dividing history into periods the external circumstances or seemingly similar forms may not be decisive. For this reason there is little sense in allowing the Middle Ages to end with the discovery of

America, even though this had important consequences. Rather, when defining any main period, we should look for unity in the fact that a certain religious ground motive dominates in culture and society. The various historical periods may be distinguished from each other by their life and world views. The boundary between the Middle Ages and the Renaissance should be sought in the first decades of the fifteenth century, when the new religious ground motive, which had already been undermining the old during the previous period, consciously broke through.

A further sub-division of the periods can often be found by making a distinction between the various positive forms of faith that have successively determined the disclosure of culture in its direction. This criterion may also help us to distinguish and further define the various currents, even though they are all determined by one and the same religious ground motive.

To understand the work of important figures from a certain period, we should not put too much emphasis on giftedness and character. Most important is what one does with one's talents. Character alone can usually not explain the activity of a person; at most it can help us understand the manner in which his or her efforts express themselves. With artists, neither the leitmotiv nor their belonging to a certain stylistic group can be explained on the basis of character and giftedness. It is true, of course, that the relative quality and aesthetic value of their art depend on their talent, while what is very personal in their style – just as someone's handwriting is – is surely connected to their character. The social milieu will also play a role in what becomes typical and personal in someone's work, but that should not be overestimated.

The development of art, both as it concerns style and the themes dealt with,[125] is directed in its leitmotiv by the faith of the leading cultural powers. Cultural power, which possesses a certain stylistic direction, and the influence it exercises, is dependent on the historical power of the group whose ideals it interprets, because it is founded in that. It is precisely for this reason that art history can be such an important help for the disciplines of cultural history, and thus also for the history of philosophy. We already pointed out the influence that the image we build up for ourselves of a certain period as a result of its works of art has on our scientific understanding of such a period. Moreover, art history can be an important heuristic means. In the succession of works of art we see registered and demonstrated objectively the changes in the 'spirit of the times'. If a change takes place in artistic style and/or in the themes of art, it has to be because of a shift in the leading cultural powers. The existence of various stylistic directions alongside each other also gives us an indication that, within the religious ground motive that dominates that period, there probably exist different faith directions. Or it means that various religious establishments exist side by side, as was the case in Italy in the first centuries of our era.[126]

Sometimes the art historian is confronted with the dilemma of choosing between 'the history of art as the history of style', (*Stilgeschichte*), which is Wölfflin's concept,127 or 'the history of art as the history of ideas', (*Geistesgeschichte*), which is what Dvorak emphasized.128 In my opinion, however, these two methods should not be put in opposition to each other. 'History of style' cannot really be practised without 'history of ideas' – unless people are positivistically content with the seemingly bare 'stating of the facts and details'. We do not need to argue further here that people holding to the latter scientific opinion do still approach works of art with a certain attitude and are therefore not at all unprejudiced. The course of the 'history of style' can only be understood by the 'history of ideas', while a 'history of ideas' that does not expertly treat the development of style is really no longer art history. The history of art as 'history of ideas' cannot be separated from the 'history of style'.

Finally, we should consider that a historical course of events was never unavoidably so, never necessarily so in a particular way. With hindsight, it may seem to us to have developed 'logically', but it was not pre-determined. The fact that development shows a continuous course only means that people have always been forced to submit to the norm of historical causality, that the past can never be denied and that the new can only break through after it has gained the victory over the old, over tradition. New ideas do not get a hold on people just like that; they have to be fought for. When, in retrospect, we say that whatever became directive later on first revealed itself here or there, then it is also the case that the contemporary observer, even though he or she had a tremendous insight and overview, could never have predicted that precisely this current would have become dominant. Of course, it cannot be said that the best always wins either; the most powerful does. Each case has to be examined separately in order to find out in what manner and under the influence of which factors the new trend finally obtained its historical power. Moreover, we should continually keep in mind that the leading groups and persons are responsible history makers. The fact that something belongs to history does not make it normatively indifferent, i.e. so that we no longer need to test it by the norms. On the contrary, we should always ask questions about truth, beauty, morality, and so on. Ultimately we always have to judge the past. It goes without saying that our judgment should not be pronounced lightly but should always do as much justice to each element as possible. With the help of a good philosophy and science, a disclosed insight can contribute much, but we should not forget that in the end the only norm by which everything can and must be tested is the law of the Lord: 'You shall love the Lord your God with all your heart and your neighbour as yourself.' A reading and re-reading of the Scriptures, and living close to God's word, will open our eyes more and more and will also sharpen our scholarly sight. For everything is included in those

commandments, and we may never apply any norms apart from them, let alone in violation of them. If we were to do that, or thought we could do that, we would already have attacked the heart of every Christian practice of scholarship.

• A landscape from 1380[129]

The thirteenth century was one of those rare high points in cultural life that, through the monuments it left behind, continues to inspire, delight, influence and fascinate people even centuries later. The thirteenth century was the time when Thomas Aquinas wrote his immensely influential philosophical works; it was also the time when French art was authoritative all over Europe, and the time when the still highly admired Gothic cathedrals with their sculptures and stained-glass windows were built. Undoubtedly the heritage of that time is not exhausted with philosophy and the buildings referred to, but we mention these in particular because they continue to be so significant that for the average twentieth-century person the Middle Ages evoke almost exclusively the image of French cathedrals and scholasticism.

It was a time of growth and equilibrium, combined with an all-permeating cultural activity. But we shall not discuss the latter here; we want to look under the surface and remark that this equilibrium was extremely unstable, an equilibrium of 'nature' and 'grace', of Aristotelian philosophy and Platonizing theology, of secularism and piety; all of this 'under the auspices of the church' which in those days was at the summit of its power and which knew how to maintain the balance, the ecclesiastical unity, by its authority but no less by inquisition and spiritual terror. There was only one church and those who did not abide by the cultic actions and dogmatic teachings it prescribed were immediately in danger of being persecuted as heretics by the Inquisition.[130]

In those circumstances it is self-evident that secularism is often found in the church: after all, many became members of the church as a result of the methods that applied the phrase 'force them to go in' too literally – with persecution and the sword – and they did not truly, personally love the Lord, while the church, on its part, also compromised widely. One does indeed sometimes get the impression that this time should be characterized as one of Sunday-Christianity (calibrated by the church and philosophically-theologically argued in the nature-grace scheme), a time in which one believed the doctrines of the church and thought in accordance with the schemes it prescribed but, apart from that, lived one's life in a completely secular manner.

Such an equilibrium full of contradictions and tensions cannot be maintained, certainly not when, as was the case in the fourteenth

century, the predominance of the church started to wane. 'Nature' and 'grace', the two elements that thirteenth-century scholasticism had linked so ingeniously, separated and increasingly went their own way. Thus, after the thirteenth century, apart from the traditional ecclesiastical direction – which until the present time has maintained itself without many fundamental changes in the Roman Catholic church in the form that was calibrated in those days – other currents came into existence. Alongside the mystical current that stressed the strictly personal aspect of contact with God and Christ and focused all attention on subjective piety and the experiences of the individual there was another current, which finally led to the Renaissance. It became more and more secular and increasingly detached from the church and from faith, although there were never actions against the church and no breach with it was ever enforced. The Renaissance did not fundamentally affect the power of the Roman Church: for that to happen, the Reformation had to come.

During this period individual personality also came to the fore: previously a person was in the first place the holder of a certain office or position; now also his or her individuality became important – a development that in the fifteenth century, especially in Italy, was to lead to the glorification of persons in the personality ideal. During this time anonymity slowly disappeared from history (we now often know artists by name, because of an increasing interest in their personality) and real portraits originated. Before they always depicted types, and personal features were not represented (not even of monarchs and others), but now we see that, after hesitant attempts in that direction during the early years after 1300, increasingly a person's individuality is captured.

One of the oldest portraits that survived is that in the Louvre of the French king John the Good from around the middle of this century, but there must have been many more. The first end and also the first climax in this development of portrait art we find with Jan van Eyck and the so-called Master of Flémalle, probably called Campin.[131] Their portraits were perhaps equalled but never surpassed by later painters.

In this century the interest in nature, outside of human existence, also made an appearance. One started to examine it not so much as 'evidence' in the scholastic system of concepts nor as a symbol for a higher reality of ideas or divine qualities but for itself, for the personal excitement of looking and the enjoyment of its beauty. Early in the fourteenth century there was a beginning of landscape painting in Italy. However, it did not continue in that direction there, possibly because the tradition of Giotto, whose spirit was still rooted in the thirteenth century, was supreme. In the North, however, this genre was further developed, especially in the north of France and in the so-called Flanders area, the area enclosed by the Somme, the Meuse and the Schelde. In this too, we should look for the end and the first climax of this development with van Eyck.

Sometimes one thinks, very naïvely, that a painter only has to sit outside and 'copy' nature to produce a landscape painting in the sense in which we know that now. Nothing is less true. In the first place, 'sitting outside' with one's easel was only practised for the first time in the nineteenth century. Before that, at the most sketches were made outside which then served as studies from which the paintings were composed in the studio. Apart from this, landscape art is extremely difficult and for centuries artists have wrestled for solutions to the problems that are involved in it. Not until the seventeenth century, in the work of Ruysdael and others, did artists come to control this genre completely.

The technique of conveying depth, the perspective of the play of light and colour, of composing in such a way that the details, without getting lost, still remain subordinate to the whole, of capturing the atmosphere and the character of the landscape, and of applying all of this in such a way that a 'natural' impression is created, is not to be achieved by just sitting outside and looking around.

In the fourteenth century we see how artists gradually and with difficulty broke through old habits and traditions and, instead of following old, stereotype formulas, achieved a personal, fresh outlook on the landscape. These stereotypes served as symbols, namely to indicate the place of action (one or two schematically-traditionally indicated trees for instance suggested a forest, etc.), while the new art wanted to represent an individual landscape with its own qualities, derived from reality.

Let us look at a page from the *Livre de Chasse* by Gaston Phebus from around 1380: the name of the artist who illustrated this work so beautifully, yes charmingly, is not known to us. The artist wanted to sketch the life of a hare for us. Although he had already freed himself to a large extent from the old formulas and his work in the direction of a natural representation of trees represents a big step forward, they are nevertheless no more than trunks on which, as a *pars pro toto*,[132] some branches with leaves represent the top. The mutual relation between trees and hare – the hare was most important to him – is not developed at all: the trees are still there as a memory of the older method, as a kind of symbolic indication of the environment. Although in contrast to Gothic art the scene takes place in a realistically depicted space, the background, a pattern of decorated blocks, is still a remnant of the more 'abstract' conception of space defined by the older art. Mind you, this is not an unsuccessful representation of the sky, but it is making the surface perceptible on which the drawing was done, the reality in front of which or on which the scene takes place.

In some of the other miniatures in his book the artist already paints a real blue sky, though more than once he also paints it in a kind of intermediate form with decorative golden lines. There is hardly any depth, things are stacked on top of each other rather than behind each

other, while the proportionate dimensions 'further backwards' do not get any smaller.

Nevertheless, how beautifully did he represent the hare, how well observed and finely rendered! And how successful was the composition of the entire picture, in such a way that in looking at it we hardly notice how poorly the artist controlled the technique of landscape art, compared to Ruysdael, for example. We completely follow the artist's conception; he knows how to convince us in a way by which we understand what he wanted to show to us without the need for further explanation. Through his charming manner of storytelling he succeeds in fascinating us. This anonymous master therefore has a lot more to say to us than many landscape artists (and animal painters) from later times – I do not mean the great ones among them – who know the tricks of the trade through and through but who, by applying these as 'tricks', do not succeed in creating a truly fascinating and convincing work of art.

• Les grandes heures de Rohan: what visual art can give[133]

The visual arts, especially the art of painting, are indeed *visual* arts: they portray, they represent something. This may be self-evident, but sometimes sight is lost of this. One often speaks about the sheer beauty of a painting, thereby focusing all one's attention on purely aesthetic elements, while passing by the question of what is being portrayed, to which one is rather indifferent. This was carried through most strongly in *l'art pour l'art*, art for art's sake, in which only the purely artistic factors were deemed important and it did not matter 'what' one painted – the 'how' was of much greater importance. Therefore it was thought that the essence of art lay exclusively in the 'how'.

However wrong this thought should be deemed by us, we can nevertheless understand how the artists arrived at it. It is to be understood as a reaction to the art of painting in the first half of the nineteenth century, in which only the subject, mostly of a historical nature, was important: historical precision was demanded, and the 'story' was at the centre of attention. These paintings were very often boring and indeed without any artistic meaning. Art had got stuck in the making of what the French beautifully called 'machines', for though these paintings were indeed large and, at first sight, impressive, they were big, mechanically produced things without soul, without that element which, after all, makes a work of art a work of art: the actual beauty of it.

Apart from that, there was another factor. In the nineteenth century museums were, by our present standards, very full, and paintings were far less than today selected according to their quality. It is

understandable that when one has to look through room after room filled, for example, with landscape paintings, these landscapes start to lose one's attention and one becomes increasingly focused on the way they are painted, i.e. on the purely aesthetic qualities. As a result it was not odd that the conclusion was drawn that only purely aesthetic qualities mattered in a painting.

Thus, artists attempted to avoid making pictures that were not really paintings on the one hand, while on the other hand they tried to excel precisely in the purely artistic. For, it was only through this that one could catch the attention amongst rows and rows of paintings in museums and in the increasingly important exhibitions of the nineteenth century, where hundreds and hundreds of works by contemporaries were hung together.

Nevertheless, this resulted in an abstraction. Indeed, when I see a hundred landscapes beside each other it appears that the theme in itself is in fact of no importance. But this is only apparently so. Because, after all, it was the commission or task of the artist to represent a landscape: and the best work of art is exactly the one which does not only excel in purely aesthetic qualities – qualities such as composition, colour, *peinture* (the brush technique) – but which by means of these manages to reflect something of the mood, the beauty of the landscape, its character, and so on.

In this respect the visual arts can be very well compared to prose and poetry. The representation then corresponds with the meaning of the words; the purely aesthetic qualities correspond with the purely aesthetic qualities in word-art that make a poem into a poem and a story into a piece of prose. A poem should have something to say, otherwise it is useless; and it is exactly the achievement of art to further underline and clarify its contents and meaning by stating them in a beautiful way.

After all, there is a great difference between someone saying: 'A man leaves his home and sitting on his horse he says goodbye to his mother. His mother sees him go and cries,' and the following:

> He spoke and said
> In his saddle turning:
> Farewell, oh mother,
> Never shall I return . . .
> And over the lanes
> She saw him go and
> Spoke no curse but wept bitterly.[134]

This poem, as it were, lifts out the content and, purely through aesthetic means such as rhythm and sound, makes us experience directly some of the grief, the melancholy. Thus trivial events can get a deeper meaning: they can become symbols of something greater, something that is common to humanity in the good sense of the word.

In painting it is just like this. As language joins words into sentences, so the artist joins all kinds of elements together into a representation – lines to represent a nose, a leg, a blade of grass (and the colours are helpful too). Through this we get only a picture, though, and it may not at all show clearly what the representation is in fact all about. That is conveyed by means of composition, colour contrasts which in their coherence are joined together into a harmonious unity, patterns of lines, etc., in short, by the purely aesthetic qualities.

When we look at a drawing or a painting, we do not say, 'How beautifully that light spot was put there,' but rather 'How beautifully those hands stand out and how much they have to say to us!' Precisely in a good painting we will discover over and over again that 'content' (that which is represented) and 'form' (the purely aesthetic qualities) are an inextricable unity. So the same element then is most important in the representation as well as in the purely aesthetic structure of the painting.

If you have a representation of the *Denial of Peter* by Rembrandt at hand – or if you can possibly have a look at it in the Rijksmuseum in Amsterdam – notice how the composition and the incidence of light emphasize and clarify the moment when Peter speaks to the maidservant and denies the Lord, who looks at him from the background. It is precisely by purely artistic means that Rembrandt has clearly depicted the Bible passage. Even if we did not know the story, we would still be able to understand roughly what is happening.

In this way artists can give an interpretation of the subject by means of their manner of representation. Just like a poem, a painting too can be lyrical, epical, narrative (as with the fifteenth-century so-called Flemish 'primitives'), heroic (as in the classicist paintings of Poussin), or idyllic (as in Watteau), etc. But the art of painting is not the same as the art of poetry: a poem can express things that cannot be expressed in a painting, and a painting can tell things that are impossible to say in poetry. We think, for instance, of hieratic art: paintings or sculptures that permanently stand before us as powerful symbols of something majestical, such as idols or sculptures of Mary and representations of Christ in Byzantine and old medieval art. The art of painting therefore has a function in life – either religious or otherwise – that is different from the function of prose or poetry, exactly because they are not the same. A monumental fresco in a building is simply not to be replaced by a piece of paper with a poem on it, hung in the same spot, to choose an absurd example.

We could tell a lot about the manuscript called *Les grandes heures de Rohan* ('The great Hours of Rohan', a prayerbook with prayers for each hour of each day of the year) that became especially famous because of its beautiful and completely unique illustrations. The artist who made those illustrations is not known to us by name and is therefore called the Master of the *Heures de Rohan*. This work of art was created in the first

quarter of the fifteenth century, about the same time as the famous *Très riches heures du Duc de Berry* by the brothers van Limbourg and the *Heures de Turin* by van Eyck (both made in 1415). Undoubtedly our master saw the first-mentioned work of art, as has been proved by all kinds of derivations. But the things he borrowed were translated by him in a completely different spirit. Both famous works of art are the first ones in which the new naturalistic style breaks through in its complete form after a century of preparation. The work of the Master of Rohan, however, breathes a completely different spirit: he is a mystic, who fully adapts his illustrations to the book he illustrates which also breathes a very mystical spirit. After him, we observe the complete victory of naturalistic art sustained by a more secular mentality – at least in Flanders, for in Germany we still encounter mystical works much later: just think of Grünewald at the beginning of the sixteenth century. But we shall not go into the genesis and backgrounds of the *Grandes heures de Rohan*, as we want to put more emphasis on the manner of depiction in connection with the 'content' represented.

In the depiction of the Flight to Egypt we see two realities represented simultaneously, one above the other – this is practically impossible for a poet to do. We also see all sorts of additions from apocryphal Gospels and stories. At the top we see Mary sitting on a donkey with the Child. She is wearing a blue robe, as she always does in medieval art. Joseph is walking behind the donkey with a cane. The donkey is led by a man, the 'good murderer'. For the story tells us that two robbers wanted to rob the fleeing family – the same robbers who later were to be crucified together with Christ – but the 'good' murderer took pity and guided them for the rest of their journey. The golden beams from the centre of the picture indicate the protection and presence of God.

In the foreground, or rather at the bottom, we see how two horsemen meet with a mowing farmer and interrogate him. The apocryphal story tells us how Mary instructs a mowing farmer to truthfully say to potential persecutors that they passed by when he was sowing. When these persecutors indeed arrive on the following day, the corn in one night has grown to such an extent that the farmer is now mowing. He replies to their question that they passed by during sowing, after which the persecutors return empty-handed. The expression on the face of the farmer is beautiful. The robe of the first horseman is rather orange, the same colour as the robe of the good murderer. Also the blue of Mary's robe returns in the coat of the other horseman and in the saddlecloth. These colours bring about unity in the whole picture. The sleeping man in the foreground is wearing more reddish clothing, which places an accent there that neutralizes a too great emphasis on the diagonal.

In this work we see two realities simultaneously. A supernatural

reality, represented in larger dimensions, shone upon by the presence of God, and a lower reality – separated from the supernatural reality especially by the green of the trees that are in the background of the lower part – which is the natural reality and where one mows or leads the life of a monarch or a nobleman. It is where one sleeps one's natural sleep. But those two realities influence each other and relate to each other, symbolized in the unity of the representation that originates from the effect of the colours.

We see how the artist in the depiction of this theme gave expression to a mystical understanding of life that recognizes two realities, a natural one and a higher one that is in direct contact with God. This division of life into two realities and the lifting of the religious to a higher reality is a sin that people continue to commit. In this understanding God is placed 'outside' the ordinary, everyday reality, 'for he does not interfere with that;' here it is carried through to its utmost consequence. A life within the covenant, which embraces everything, also the non-religious, also mowing, reigning and sleeping, is out of the question here.

What we wanted to stress in particular is that the artist was able to say all this by applying purely aesthetic means (colour, composition, the relative size of the figures, etc.). It is particularly through beauty, also in the expression of details (e.g. that beautiful, sleeping man in the foreground) that the Master of Rohan gives persuasiveness and power to his vision. If we were to disregard the meaning of the representation, a number of the compositional and artistic elements would become meaningless.

The Art of the Fifteenth Century

• The art of the fifteenth century[135]

In a previous article[136] we explained that for medieval people beauty in art was certainly an important consideration, and something that they had an eye for. But beauty did not form the essence, the meaning and purpose of a work of art. Medieval people's primary concern was with the content, which was to be found in the theme or subject – subjects such as Jesus' Baptism; the Suffering of Christ; the life of a certain Saint, etc.

We also learned that we should not understand this to mean that the theme, which could be expressed in words, was their only concern. Rather, it was also very important how the theme was portrayed. For the manner in which the theme was represented, the composition, contained an element of exegesis, of interpretation, of explaining the meaning of the theme, and this was not to be neglected. We use the term 'formula' for this, partly because certain compositional schemes reappear again and again, and medieval artists certainly did not try to come up with a new way of expressing the theme each time. That would have contradicted their intentions. We gave several examples of this, but offer two more here. Let us compare two Madonnas, both sculpted as *Sedes Sapientiae:* Mary as the seat of Wisdom, in which her high position and her importance in the story of salvation, in a religious sense at least, are clearly portrayed. Our two examples are thematically alike. Both are Madonnas, both are created according to the same formula (we expressed that with the name *Sedes Sapientiae*, which indicates that the content of these two Madonnas is the same because of the corresponding formula); but stylistically they are very different. The one is Romanesque, while the other is Gothic. Though if we would look carefully, we would notice that even the way in which the garments fall shows great similarity. The stylistic difference, however, does not result in a difference of content.

There are other Madonna-types as well. For example, in the fourteenth century in Italy the Madonna del' Umilità emerged, the humble Madonna, who was usually presented in a formula whereby the Madonna sat on the ground on a cushion, and seemed to relate to the Child in a more motherly way. In summary, we could say that when the formula changes, there is a corresponding change in content, in the meaning of the artwork.

The fifteenth century was a period that saw incredible changes. When we think of Italy we speak of the Renaissance; with regard to the North we speak of the Flemish Primitives (a ridiculous name, by the way) or of late Gothic art. Fundamentally, however, there is not much difference between the North and the South. The most striking distinction is that

people in Italy, or, more specifically, in Florence, were stylistically inspired by the art of antiquity (Roman art, in other words). Those in the North discovered new elements through direct visual observation and introduced them into their art. On both sides of the Alps though, there was a strong interest in humanity and their surroundings, in the natural givens – in addition to the supernatural realities of the Christian religion, which belonged to the established tradition.

How were these two elements expressed in art? When we consider two examples of the Baptism of Christ, one from the twelfth century and one from the fifteenth century,[137] we see that with respect to the formula there is hardly any difference, even though nearly four hundred years passed between the creation of the earlier piece and the time the second one was made. We could just as well have chosen an Italian example, because in this respect there is little difference between the art in the north or the south of Europe. For example, we could have chosen Piero della Francesca's *Baptism* which hangs in the National Gallery in London.

When viewing the twelfth- and fifteenth-century pieces which both portray Christ's baptism in the River Jordan, we would notice not only a similarity in formula but also some striking differences. The twelfth-century Baptism is rather sober and offers only the bare minimum. There is hardly any landscape, and even the water is symbolized more than depicted as a little 'mound of water' in which Christ stands. There is much more to see in the Baptism of Gerard David. The wonderful *cappa* (cape) of the left angel, made of heavy brocade, is a treasure in itself; the ripples in the water are depicted in a sublime fashion; behind Christ the river continues to flow through a spacious landscape in which there is much to see – trees, mountains, and much more. It is clear that these features on which we are now focusing have nothing to do with the baptism of the Lord Jesus, but neither could we say that they are unimportant. They form, as it were, a second-level content of the artwork, next to the religious one. Nature has been carefully observed, and its representation is certainly one of the essential elements of the painting.

Incidentally, we should mention that this representation of natural elements – landscape, the spaciousness, the people in their three-dimensional forms – had a peculiar consequence. For it made it almost impossible to meaningfully depict saints with halos around their heads, since they would have looked more like golden plates suspended in the air behind the heads of these figures. That would have looked rather strange! And this shows clearly what a profound difference there is between the depiction of the Baptism from the time around 1100 and the one from the year 1508; in the first, the halos do not jar us because the whole painting is symbolic – or iconic – a representation of a supernatural event in which things like landscape have no real relevance and are left out without our even noticing it. In the Flemish work, on the other hand, we see that besides the event of the Baptism which, as such,

is similar in content to the other work, there is a second reality – the reality of nature, and this reality has its own importance in terms of the content. Yes, we would have to say that in the piece by Gerard David there are two contents side by side: the supernatural event of the Baptism and the natural reality of the landscape, the space, the clothing, etc.

This is a typical feature of fifteenth-century art: there is a discrepancy as two contents stand next to each other, while they do not correspond with each together and each have their own meaning. This makes it possible for modern viewers to look at the painting by David and simply forget that the painting is about the Baptism, as they would focus their attention on one facet of the work only. That would be impossible with the work from AD 1118, because if we would not notice that this piece is about the Baptism then there would be nothing left, however beautiful the gestures of the figures are and however superb in quality.

This discrepancy, this inner contradiction, began with the work of Jan van Eyck and some of his contemporaries, and with the work of the sculptor Claus Sluter from a generation earlier. In Italy, this inner contradiction was also very clear. Especially in Florence, where painters like Botticelli and others sometimes took it to extremes. For example, when they depicted a Madonna, they held themselves strictly to the old formulas, but in reality they were painting a portrait of a sweet Florentine girl. And in the Adoration of the Magi there is so much to see – ruins, people in gorgeous clothing, and so on – that we almost forget the actual religious content rendered in a time-honoured style.

Jan van Eyck tried to solve this contradiction by ensuring that every 'natural' element in the painting also had a meaning with respect to the theme – namely, a symbolic one. The problem remained, however, since it is often hard to make out when the symbolic ends and the purely natural begins. One might respond that, in principle, there should not be an end (to the symbolic). But even then, it is a solution that only makes the inner contradiction sharper and more distinct (and at the same time more complicated and more compelling). It is interesting to see how a high-church painter like Rogier van der Weyden sometimes reacted to van Eyck's work and attempted to make his own work less strongly 'natural' *besides* the religious content. We will give an example of that in our next article.138

The tension in this art, in which the conflict of the entire Florentine early-Renaissance culture came to expression, would inevitably lead to a short-circuiting, and consequently to a solution. This occurred in the person of Savonarola, the pre-Reformational figure who called the Florentines back to the true faith and specifically satirized the art which, under the guise of religion, was in actual fact an expression of complete worldliness; it was art whose real content offered something quite different from what it purported to offer.

Botticelli himself was one of the first to sacrifice his own work up to the flames. The art he created after that time demonstrated quite a

different spirit: it emphatically brought to the fore, quite strictly and directly, the old formulas and reduced the inner contradictions to a minimum. It was, however, up to Raphael and a number of his contemporaries – for example Fra Bartolommeo, who was also strongly affected by Savonarola – to find a definitive solution for the problem posed by the fifteenth century. We will deal with their solution the next time.

• Van Eyck's St Barbara and life in the covenant[139]

It is a wonderful thing to be called God's covenant child! For then we know with confidence that we are watched over, that God stays near even when we are asleep or unaware of his presence. In his covenant God offers us rich promises. And he asks us, in turn, to love him and therefore to stop doing what he hates – i.e. sin, which is rebellion against his commandments.

This also applies to our daily lives. God is not too high or too far away to be concerned about the trivial matters of our lives. After all, look at the detailed laws he gave Israel about how to handle their animals, how hygiene was to be performed in the army camp, and how, at harvest-time, his people were to leave something in the fields to be gleaned by the poor or the stranger. God showed in this way that his covenant is utterly practical. Yet such actions were not elevated to the level of religious acts.

Again and again when people threaten to assign a lower value to the 'ordinary' things in life they start to spend more time practising religion, filling their lives with acts of worship and devotion because they have no idea what it means to live in the covenant. The result is that everything is turned into 'religion': for is this not the only way to serve the Lord and flee from sin when people see sin as an inherent element of the lower, more earthly aspects of life?

But God has explicitly told us something quite different. For example, he said about religious feast days that they are fine. But don't take more than three days to celebrate them (Leviticus 7:18). With regard to slaughtering animals for food, God said to go ahead and have as much as you want, but the only time and place for offering and eating religious sacrifices was in his Temple (Deuteronomy 12:13–15, 20–23). In Micah 6, God complained bitterly about his people's unfaithfulness, despite the fact that they tried extremely hard to be religious, to the point of sacrificing their own children – something God had not asked of them. Walk in my ways, God said, and deal justly with widows and orphans. That means: behave as children of the covenant and do not try to turn everything into religion, because then you will forget 'ordinary' life and will no longer be doing my will.

How wonderful that God has made it this way! It would, after all, be simply impossible to 'lift' everything up into the religious sphere: eating and drinking and doing politics and . . . being busy with art. The earth and her fullness belong to the Lord (1 Corinthians 10:25), and he has put all of it at our disposal. We are free, therefore, to simply enjoy art. We are permitted to walk freely through the Rijksmuseum, for example, enjoying the paintings and becoming absorbed in the lives of our forebears which they recorded with such love. We may become soberly aware of all the painted beauty that emanates from a work like *The little street* by Vermeer. There is nothing religious about that.

It is remarkable that precisely in the seventeenth century, when God's word like yeast had begun to permeate society, and when true Christian art had begun to emerge, very few explicitly religious pieces were created. Seventeenth-century art was rich in many diverse genres: landscapes, still lifes, portraits, genre pieces, etc. – there are too many to name. But the genre that portrayed biblical stories and moved in the religious sphere was relatively scarce. Our fathers understood well the gift of grace that allows us fully and freely to enjoy God's earth in all its fullness. When we have experienced all of that beauty and then come home, we must thank God – this is where religion comes in! – for the great mercy shown to us, his people, and for the gift of creativity that inspired the painting of these treasures. The whole world praises the Netherlands for its artistic treasures, but it is really the Lord they should be thanking.

Art is often seen as problematic in our circles and, if I am not mistaken, this is often the case because we too much want to view art and everything it encompasses as religion. But the truth is that we have been set free. When we are happy, we are allowed to sing – about spring, about cows, about the sea, about anything! What is not permitted, of course, is to sing songs with a blasphemous text or songs which celebrate sin – not because that would be irreligious or impious, but because our Father despises sin. And in analogy with God's commandments concerning the Old Testament sacrifices, I would be inclined to say that we are not always permitted to sing psalms or religious songs, because those are intended for worship services or for situations when we are religiously praising the Lord – for example, at the close of an evening of good Christian fellowship. Let's remain sober about these things, with a truly biblical soberness.

Thus it is all right to freely enjoy and to immerse ourselves, if we so desire, in the painting that I want to discuss in this article: Jan van Eyck's *St Barbara.* Along with Rembrandt and a few others, van Eyck is considered one of the greatest painters of all time. His earliest known works date from around 1415, and he continued working until the middle of that century. He stood at the end of a period of experimentation in which artists were exploring how they could create

art that was as faithful to nature as possible, by promptly solving the many complicated problems they faced. We referred briefly to this in the article 'A Landscape from 1380'.[140]

Let's have a look at *St Barbara*, a painting that is really nothing more than a drawing. Most likely it was intended to be a panel but was never completed;[141] if that is true, it gives us a glimpse into his method of working. How do we know that this woman sitting so peacefully in the foreground is St Barbara? In the Middle Ages, and still today in Catholic circles, saints are identified by means of attributes or symbols which usually have some connection with the way in which they were martyred. Usually they carry these attributes in their hand. Thus Barbara is often shown holding a small tower. Her father, a heathen, wanted to keep her from the faith and so he locked her up in a tower. But she heard the good news anyway and became a believer. When her father learned of this he dragged her before the judge and she was tortured in various ways to try and get her to recant her faith. When that did not succeed, her father himself beheaded her. A bolt of lightning immediately struck him dead. Barbara was greatly revered in the fifteenth century, for she was the patron who protected people from an ill-fated death – i.e. a death prior to receiving the last rites. She also protected those who handled explosives, like artillery-men, and those who worked in iron foundries.

We know the woman in the painting to be Barbara, then, because of the tower, her attribute, that we see behind her. Others, however, view this painting as representing the antithesis between the contemplative life and the active working life. Medieval people viewed the former as far superior to the latter, since it allowed one to devote oneself without distraction to religious activities: prayer, devotional acts and religious exercises. This is the spirit that inspired the establishment of monasteries, a spirit of apostasy similar to the one in ancient Israel that tried to justify itself in God's eyes through the performance of pious religious acts. The working life was seen as vastly inferior, since working people move in the earthly sphere that is not consecrated to God. Even today in Catholic circles one comes across this contradiction, which combines devotion and a thoroughly secular life, almost ignoring the law of God: so that, while Sunday is a day totally for one's own pleasure, a crucifix is placed on each street corner for people to stop a moment to pray a Hail Mary or an Our Father. For our part, we believe that the working life must never be considered inferior or less holy – for our working life too is lived in the covenant.

How beautifully van Eyck renders the construction of a medieval church. We see stone carvers, stone carriers and some sculptors under a shelter who are busy shaping the stone which will next be lifted up by a crane. Then we notice the landscape stretching into the distance, with a town built on a hill; on the other side we see hills going back as far as the eye can see. A river runs along the left, with the tower of a castle or city

wall beside it. From there a group of horsemen are making their way towards us; one of them is probably the noble lord, coming to inspect the progress of the work. In what exquisite detail van Eyck depicts everything – the tower, the woman's book, her hair, the way her garment falls, and the incredible detail of the distant town.

There are many other elements that prove this painting to be a masterpiece. But we would like you to look for yourself, because any attempt to describe a painting can only be a poor attempt at 'translation'. The artist is trying to convey something by way of the visual medium, and there is no way the same thing can be said in words; if that were possible, perhaps the artist should have written it instead, sparing us the trouble of understanding his or her visual language.

I said earlier that we are permitted to thoroughly enjoy a painting like this, to study it to our heart's content. Precisely because God sets us free from all religiosity which deems some things as not religious, as things that have come from the Devil. Yet there are also many among us (Calvinists) who question whether we are allowed to occupy our time with these sorts of things. This question is unnecessary. And we usually do not have a problem when it comes to doing politics or supporting a Christian school. Does being engaged with art not fall in the same category?

Now the next question comes up: regardless of how we interpret it, doesn't this piece of art emanate from a Roman Catholic spirit? (For that matter, I could have chosen to emphasize the secular Renaissance spirit out of which this artist is working.) Don't we need to ask whether the artist was making this piece for the glory of God?

It is a question that is difficult to answer. How do we know what lived in van Eyck's heart? There are sinful elements in his art, of course, but where could we find a human being who is free of sin?

You might respond that, yes, but his perceptions were fundamentally unscriptural. Well, that may be true, but what choice did he have, given that he lived during the time in which such Roman Catholic perceptions set the tone and there was no hint yet of a Reformation? We are on the wrong track if we are trying to judge the subjective attitude of the artist. Our job is to test the quality of his or her work, and to leave the rest up to God's judgment.

The answer to our question can be found in 1 Corinthians 10:23–33 where Paul says that we are permitted to eat everything, even the sacrificed meat (i.e. meat that was offered to idols). Eat freely, he says, without worrying about scruples. For the meat belongs to the Lord, and idols mean nothing at all. After all, you did not take part in the sacrifice yourself, and your act of eating is not a religious act.

The same is true today: enjoy art freely without questioning its source or how it came to be. The latter may be very interesting, and we are free to delve into it, but it should not influence our aesthetic judgment in principle. Enjoy art freely – yes, but that does not mean that

we are free to enjoy sin freely. For we are called to flee from sin. That is why we stay away from books that contain false prophecy or that tempt us into sin, as well as books that attempt to portray God visually.[142] However, if the book is not sinful in itself but portrays a different interpretation of reality, someone else's views (as with the sacrificed meat), then look and enjoy with abandon! In our case, we are not enjoying or admiring St Barbara herself, or the portrayal of the antithesis between the contemplative and the working life, but we are admiring the gorgeous portrait of a woman and the lively depiction of those builders, the marvellous panoramic scenery – that is, the magnificent painting that we have before us.

We must remember, however, the rest of Paul's argument. For example, if someone standing in a Roman Catholic church should say to you: 'Look, there is a picture of a saint who is to be revered, a saint who performed many miracles,' well, then you should stay away from it. Our ancestors during the Reformation were right to remove statues from the churches that fell into their hands.[143] This was done out of consideration for the conscience of others, the weaker members, and to prevent further apostasy. It was not because that statue of the woman with the child on her lap, which the Catholics called Mary, was not beautiful or enjoyable. (It is certainly enjoyable when we see it in a museum now.) But we are told that we must not give offence. Above all, we must hold on to scriptural common sense, and must remember that everything is lawful (except sin), but not everything is edifying or profitable.

• The Portinari altar by Hugo van der Goes[144]

In the 1570's the wealthy Florentine art dealer Portinari, who maintained tight trade relations with Flanders, commissioned the renowned artist van der Goes of the Southern Netherlands to create an altar depicting the Adoration of the Shepherds. The altar would be placed in a Florentine church.[145]

This altar is one of the largest masterpieces of Dutch fifteenth-century art. The central panel alone measures about three meters in width. This artwork made a deep impression on Florentine artists. Especially the landscapes depicted on the side panels strongly influenced artists like Ghirlandaio and Filippino Lippi.

Let's take a closer look at the painting. The figures standing around Mary and the Child she is worshiping form a large circle, creating an excellent and well-organized composition. The details have been painted with great precision: notice, for example, the still life with flowers in the foreground.

The scene looks so true to life that it makes one think the artist saw it with his own eyes. Actually, it is quite likely that he did see it, because

during the fourteenth century this part of the biblical story was often dramatized in the so-called 'mystery plays'.[146] During this same period (to focus for a moment on a very specific detail) there was a change in the way angels' garments were depicted. Prior to this time they were usually dressed in a sort of timeless white cloth, but during the time of van der Goes they were more often dressed in heavy, brightly-coloured priestly clothes, richly embroidered in gold. It is almost certain that the theatre costumes of those mystery plays inspired them.

We must point out that portrayals of the Adoration of the Shepherds first made their appearance in the fourteenth century. During that time people began to consider and meditate on the details surrounding the life of Christ. Mysticism placed great value on this. In this connection, the work of Psuedo-Bonaventura,[147] a Franciscan from the late thirteenth century, is very important. His book *Meditationes vitae Christi*, which contains meditations on the life of Christ, did not deal first of all with theological dogmas and treatises, as was common in the scholarship of that day, but it spoke to the heart. The author sketched the biblical scenes realistically and colourfully, inserting many details which are not included in the Gospel stories but come from the author's imagination. The book contained many dialogues which lent themselves perfectly to adaptation for the stage, and it had a great influence on the poets who wrote the mystery plays.

Pseudo-Bonaventura, for example, described Mary as leaning against a pillar just prior to giving birth; consequently, such a pillar makes its appearance in every depiction of the Birth of Christ or the Adoration of the Shepherds and the Magi. It can also be found in the painting by van der Goes. According to legend the stable where Jesus was born was a remnant of the ruins of David's palace in Bethlehem. It is a legend that likely emerged in an effort to explain the pillar that keeps cropping up in the Nativity scenes, though no one really remembered where it originated.

Another remarkable tradition is the portrayal of an ox and a donkey in the stable. We find them already in the nativity scenes from previous centuries, scenes which are completely different from the ones we are discussing, and they even pre-date the apocryphal Gospel which emerged around AD 600 known as 'Pseudo-Matthew'. In the fourteenth chapter of that book we read: 'The ox and the donkey worshipped him,' thus fulfilling the prophecies in Jeremiah and Habakkuk. We probably find the origins of this tradition in the earliest Church Fathers, who used the Septuagint translation of Jeremiah 1:3 and Habakkuk 3:2 in connection with the birth of Christ.

The fifteenth-century depictions of the events surrounding Christ's birth are thus strongly influenced by a mysticism which in turn strongly influenced the popular piety of the time.[148] This moderately mystical thought world still lives on today. We find it, for example, in the idea

which often comes up around Christmas – the idea that we should pray at Jesus' cradle, that we should kneel before the Child. Notice the words of one Christmas carol:

> ... to that lowly manger bed
> there to bend the knee before ...[149]

When you look at this painting, you need no further support for the idea that such influences caused the artist to portray the story as he did. The fact that the people are dressed in the contemporary clothing of his day also supports this. Furthermore we should remember that fifteenth-century people did not yet have a modern understanding of history and for them the anachronisms were not so glaring.

Apart from that, one might ask oneself whether events really could have appeared like this. For example, would Mary really have knelt down in prayer before her child? The gospels record nothing about shepherds kneeling down beside the Christchild either; that is only said of the Magi, and the newer translations prefer to record that they 'paid him homage'. It is not easy to answer these questions . . . we would be interested in your own thoughts on the subject.

I will leave it at this, even though I have said far too little about this absolutely gorgeous painting. One could devote an entire article to the wonderful characterization in the faces of those shepherds, for example.

• A theological treatise[150]

In 1491 the Florentine painter Ghirlandaio was commissioned to create a painting for the altar of the monastery belonging to the Barefoot order in Palco near Prato. The painting was actually produced in 1495 by Ghirlandaio's fellow townsman and peer, Filippino Lippi.[151] It currently hangs in the Museum of Munich but in 1948 was part of an exhibition in Amsterdam's Rijksmuseum.

The painting is typical of that era, produced in the years just prior to the High Renaissance when Raphael would come to play the leading role. Its composition is well organized and clear, and displays a lively symmetry. Notice, for example, how the main figures on the right and left are posed in symmetrical-reverse positions. This could have resulted in the action rotating simply around a central point, but that effect is counter-balanced by a background landscape which actually stretches out from right to left, moving towards the rocks on the left. The function of the little tree, which draws our attention because of its prominence, is to restore the symmetry which otherwise perhaps would have been lost. It is placed equally far to the right of the centre as the steep rocky cliff is placed to the left of it.

The painting is extremely precisely painted without becoming overly fussy, in a naturalistic style, which means that the artist has attempted to reproduce reality as carefully and accurately as possible. The poses of the figures are based on careful study and sharp observation and are anatomically correct down to the tiniest details. Take special note of the way the garments fall; they serve to accentuate the movement and posture of the main figures, but at the same time are rendered as naturally as possible.

The landscape too is exceptionally beautiful. We notice some influence of Flemish painting, which had risen to great heights with respect to landscape painting. The Florentine artists will undoubtedly have studied carefully the huge *Portinari altar* by Hugo van der Goes, which had been in Florence for twenty years already, and they would have paid special attention to the gorgeous spread of the landscape in that painting. We only hope that our descriptions here will suffice to give you a sense of the painting's many qualities. To that end we want to re-emphasize the incredible beauty of this work, it's refined details and the way all work together to enhance this large, carefully balanced composition.

In true art, form and content are inseparable. We will notice how all the aesthetic elements just discussed are combined to form a unity between the representation and the statement that is present in the painting.

'The statement that is present in the painting', we said, and we want to justify the use of that expression now. You have probably been wondering what this painting is trying to say, what story it is trying to portray. To begin with we should say that it is not depicting a particular story from the Bible, an apocryphal book or a legend. Despite the exquisite detailing and the artist's efforts to make everything look as natural as possible he was not attempting a sort of photographic report of an actual event from the past. Rather, what we have before us much more resembles a theological discussion or argument.

In the centre, in the valley just to the left of the tree, we see a group of kneeling figures. They are looking prayerfully up in the direction of the woman on the right, who will immediately be recognized as Mary, the mother of Jesus. These people are pleading with her to pray for the salvation of their souls. She seems to be straining her ears, her head inclined towards them slightly, while with her hand she is gesturing to her Son, Jesus Christ, who is kneeling on the left. Her left hand shows him her breast, thereby reminding him that she is his mother. And, to cite a Roman Catholic apologist:

> This expression 'Mother of God' encompasses all the greatness of Mary, and elevates her far above all human dignity. Because Mary is the Mother of God, she resides in Heaven now, closer to her Divine Son than any of the other creatures, angels, and saints. She shares in his glory, and it is her special

privilege to distribute God's grace in Jesus' name to the souls. She is the 'Mediator of all Grace', because it was God's will that Jesus Christ, the source of all mercy, was poured out to us through Mary.

According to the same apologist, it is fitting that Mary has a part in the distribution of the grace which Jesus earned through his death on the cross. After all,

> She became the Mother of Jesus because of her freely spoken 'Yes': 'Let it be with me according to your word'! Freely she concurred with Jesus' sacrifice, giving and experiencing it along with him as she stood below the cross with her bleeding heart. Thus, Mary, albeit in a subsidiary way, had a part in bringing about our salvation.[152]

When we read this, we understand more clearly why in the upper right and left corners of the painting, Mary and the angel of the Annunciation are to be seen; thus we are reminded of her merits on the basis of that freely spoken yes-word, giving her the right to become an intercessor for others.

To the left is Christ. His head is inclined toward his mother, but his gaze is directed towards God the Father standing in the centre at the top. With his left hand Christ points to the wound in his side, a reminder of his crucifixion; and with his right hand he makes an imploring gesture. Then we notice God the Father in the top centre of the painting, carried by the cherubim, who with a gesture of blessing offers his merciful forgiveness of sins to the souls who are being prayed for. Carrying this idea further, we see how Christ takes this grace that has been poured out, and with his blessing offers it to the believing observer.

A similar duality can be seen in Mary's right hand. It seems to be turned toward us, expressing the idea that she is open to our requests to be prayed for too. Thus, the application of this artistic theological argument is passed along to the viewer. Once again, note how the purely aesthetic qualities of the painting form a unity with the ideas being represented.

We said earlier that the positions of Mary and of Jesus form a circular movement in the composition. We can take this a step further by noticing that actually it is more of a spiral movement: from the valley with the praying figures, toward Mary and Christ, then moving upwards toward the centre of the painting, ending at God the Father. The circular movement is just a small fragment of an upwardly moving spiral.

We have now found that this painting constitutes a theological argument or, if you want, a sermon. Obviously we do not need to critique this sermon here. And our scriptural objections to depicting God the Father also do not need to be elaborated. It is important to note that for Catholics a painting like this takes the place of a catechism sermon. It is a discourse, a false prophecy, which is taught to the people without further explanation, and which is intended to offer comfort for their souls.

• Leonardo da Vinci[153]

In an article in *Philosophia Reformata*[154] I undertook to show how the art of the new era (following the Middle Ages) arose and developed under the guidance of a new religious ground motive that also ushered in tremendous changes in the artistic field. Whole generations have devoted all their talents to the realization of the naturalistic art ideal, whereby people seek to render reality precisely and accurately. Creating and mastering these possibilities required a difficult campaign that lasted many years – the goal of which was to create an art that would agree adequately with the new view of life. Now we want to elucidate a facet of the last phase of this style-forming activity because of the tremendous consequences with which it was fraught.

Just after the middle of the fifteenth century in Florence two artist's studios or workplaces played a leading role, that of Pollaiuolo (d. 1498) and that of Verrochio (1435–1488). What did people do there? What was the focus in the formation of young talents? Mainly two things were taught to the students (Leonardo studied with Verrochio). In the first place there were the so-called *pratica* or art skills, which included things we would consider the work of an engineer today. In the second place the young, rising artist was meant to develop proficiency in rendering things in their objective structural form. Here a final phase was inaugurated in the mastery of the new naturalistic possibilities: on the basis of what had already been attained, people turned their attention to rendering things as purely and exactly as possible, with such faithfulness to reality that one would have been able to recreate the entire external form of a thing from a drawing of it. To Verrochio himself and to Leonardo's fellow students this objectivistic naturalism was nothing more than a certain studio method, a process or technique, one could say.

This art was truly in agreement with their attitude to life and belief. For these people art was not an artistic game in the sense of 'art for art's sake'. Yet at the same time, they were not moved to work and explore in this direction out of utilitarian considerations.

Leonardo da Vinci was honoured and is honoured today still as one of the giants of the human race. And yes, he was certainly a great thinker, but one is unlikely to come across his name in most books on the history of philosophy. He was certainly a great artist (just think of the *Mona Lisa*), but Michelangelo (1475–1564) and Raphael (1483–1520) had far greater influence. People accordingly sometimes stop and ask themselves precisely what constituted his greatness. Surely it was not his essay on art, no matter how important that may have been? Yet he is correctly identified as one of the pioneering figures of the new era. And that is because he was the first to take the results of the developments in art during the preceding period and make them serviceable to the new science, which was dominated by the science ideal. People conforming to this ideal wanted to work in an exact manner, acting exclusively on the

basis of experience and reason, accepting nothing unless it passed the test of these two: experience and reason. Leonardo turned the new Renaissance art, the technical drawing system that had been developed in the studios mentioned above, into an instrument of his thought, yes, of his entire life and world view. He used the possibility of exact rendering in his attempts to solve the problems of natural science and technology. Previously, even in ancient times, illustrations had accompanied texts, including scientific texts, yet never as anything more than a symbol or aid to memory. Now, however, illustrations were elevated to one of the foundation stones of the sciences. As a result it became possible to show others, in one's scientific publications, what one had seen oneself – whereby it became possible not only to disseminate new discoveries and observations easily but also to enable a successor to build upon what a predecessor had observed or established experimentally.

Leonardo designed among other things an 'anatomy' in a great many parts, which never appeared, to be sure, but the preparatory notations and study sheets have been preserved; and of these study drawings every medical doctor will still say today that they are exceptionally exact.

Thus Leonardo's great deed and discovery was to make the results of style-forming activities, which were conditioned by Renaissance attitudes towards life, serviceable to a new science driven by the same mindset. It is unnecessary to say how important this principle proved to be. Modern technology and medical science in the first place stand or fall with it, together in fact with our entire Western 'culture', as must be evident upon a little further reflection. Well then, however 'anti-naturalistic' modern art may be today, this attainment, this *Errungenschaft* of the past is not annihilated; but if we were to get into that, we would be cutting into new problems.

• Two kinds of love and the 'carcer terreno'[155]

A study about the meaning of the placing of four Michelangelo statues in an artificial grotto in the Boboli Garden

In the estate of Michelangelo, who died in 1564, there were four unfinished statues of slaves which had originally been intended for the tomb of Pope Julius II. They were given by Lionardo Buonarroti, cousin of the great master, to Cosimo, the Duke of Tuscany, who then gave Bernardo Buontalenti the task of looking for a suitable setting for them. Buontalenti placed them in an artificial grotto in the Boboli Garden, a famous park landscaped during that time which belonged to the Palazzo Pitti at Florence.[156]

In 1908 the statues were transported to the Accademia at Florence and plaster casts are now standing in the grotto. Sebastianus Sanleolinus, who specialized in writing praises to Cosimo de' Medici,[157] wrote in a Latin poem as follows about the Boboli Garden, in which the statues were originally placed:

> Compete with each other to hurry hither: Lampsacaenus,
> Or the immodest Venus and the unrestrained attendants of
> Bacchus:
> Lascivious Satyrs and dirty Fauns
> Do not wonder in such cultivated gardens.
> But to be found here are the modest Venus,
> After she has left Idalion, playing with a chaste and young Amor,
> Artemis, after she went away from Delos and the Cynthic hills,
> The Graces, and grey-haired Fides,
> just after they departed from the high Olympus;
> ...
> These good and elevated gods
> Cosimo has given to his garden as its guards,
> Cosimo our ruler, father of our country
> And of our town, irreproachable servant of your chastity.

In this essay we wish to ask ourselves whether especially the two different Venuses mentioned here have found their residence in these gardens. And whether that had anything to do with Michelangelo's slaves. It is perhaps a good idea to start with the statues themselves.

In 1505 Michelangelo designed a large freestanding tomb for Pope Julius II[159] which was to contain statues of bound slaves in its lowest level. Panofsky supposes that these were not allegorical figures, signifying either the subjugated provinces or the liberal arts as Michelangelo's contemporary biographers Vasari and Condivi thought, but that they symbolized the unredeemed human soul, imprisoned in natural passions.[160] This would fit in very well with the design which, according to Panofsky, aimed for a synthesis between Christian and (Neoplatonic) pagan thought about death and the continued existence after death. Because of all sorts of difficulties, however, with which we will not concern ourselves further here, the design of the tomb was reduced more and more in dimensions and the programme became less Neoplatonic and more Christian in the sense of the Counter-Reformation.[161] The four unfinished slaves are supposed to represent an in-between stage, a last attempt by Michelangelo to salvage something of his original grandiose design by devising four somewhat larger slaves, which in vehemence and monumentality go far beyond what was originally intended. But these slaves, made around 1532, are all that was ever executed of the plan.[162]

However that may be, we now possess two completed slaves made in connection with the original design which are to be found in the Louvre,

as well as the four slaves that were placed in Buontalenti's grotto after 1564. The tomb as it finally came to completion is but a pitiful witness to a failed project – it stands in the St Pietro in Vincoli in Rome and is a well-known monument because of its powerful figure of Moses.[163] Already in the sixteenth century the four 'unfinished' slaves had their admirers. For example, Bocchi writes about them:

> These figures, rough-hewn with incomprehensible and admirable skill, seem, with all their might to want to escape from the chaotic ruin above them [what is meant is the grotto in which they are placed] ... Artists are astonished, and those who are experts in this matter, remain standing dumbfounded as to how such an ability can be found in a person, that he has been able, with a variety of chisels, roughly to carve human bodies out of marble, which, although they are not completed, are not lacking in clarity but, on the contrary, seem to be natural and true. The statues are probably more magnificent in this form than if they were completely finished, and they are more admired, studied and looked at by the best artists, than they would be if Buonarroti had added the finishing touches to them.[164]

In the eighteenth century it was said about these statues, undoubtedly in a very free quotation of this passage, that they were placed here in order that they 'could serve to educate the great masters, since the rough chiselling of Michelangelo, according to expert opinion, has indicated a new method of working, without ruining the marble by the standard method, and truly, these statues in this form are more admirable and more admired by artists, than if they were completely finished.'[165] We will hear the echo of these pronouncements for a long time yet.[166]

It is only at the end of the nineteenth century that we come across attempts to interpret these statues which, in addition to showing admiration for these works of art, also attempt to penetrate to the intention of the master. Perhaps that should not surprise us, for in the writing about art during the time before the nineteenth century we undoubtedly find appreciation for great works of art as clever creations by their masters, but it goes no further than an evaluation of subject matter, technique and the skill of the artisan, and it never attempts to penetrate to what Panofsky calls the 'meaning of art'.[167] The reason for this probably has to be sought in the meaning that people used to attach to art: they did not yet view art as a free expression of the human spirit, as a confession of the artist, but rather in the same way as we today still often look at architecture and, certainly, at carpets, jewellery and the like. Just as most people nowadays praise no more than beauty and the skill of the artisan in a brooch, so people then used to evaluate sculptures and paintings. Apart from the question whether this is connected with the fact that the Romantic idea of genius, in which especially the great artist is exalted as prophet and sage, only existed in its beginning stages, the most direct reason may be sought in the circumstance that in those days the visual arts indeed did not enjoy the

special position that people presently ascribe to them. Kristeller is notably the one who has done seminal research in this area.[168]

But just because people did not expressly write about it and were not concerned with it in a scholarly way does not mean that they were not sensitive to the meaning of works of art and did not see or regard the content (meaning) as such. The opposite is true. But in order to prove this we should not, in the first place, look in the old books but rather at the works of art themselves. In that sense we can often see in one work, which is based on another work from an earlier date, an exegesis of the content of the older work. If, for example, we first look at the painting *St Luke paints the Madonna* by Gossaert (Mabuse) it seems clear that for Gossaert the painting of St Luke was not just an everyday event but something that belonged to the realm of the supra-temporal, to the terrain of the supernatural, of grace instead of nature (within the medieval nature-grace order). Herein we now find an exegesis of the earlier work of Rogier van der Weyden: it is, as it were, paraphrased in it. Then it also becomes clear to us that Rogier did not at all naïvely think that Mary in Bethlehem looked like this, and that St Luke painted her like this, dressed in fifteenth-century clothes, in a fifteenth-century loggia with a view on a Flemish landscape. Such an interpretation, which makes the older painter into a childish and somewhat stupid person, is derived completely from a nineteenth-century artistic ideal – in which people used to strive for 'reports after the fact' of biblical events. The fifteenth-century person did not give proof of lacking historical consciousness when painting the holy scene using contemporary clothing and surroundings but rather proved that the aim was to represent something supra-temporal.[169]

It should be noted here that Rogier did this in a consistently naturalistic style, which above all paid attention to the expression of reality in its spatiality, materiality etc. Hence we could observe that an inner contradiction exists between content and pictorial representation, between the supernatural, theological-dogmatic approach to the subject, and the rendition in its orientation to the purely natural. Indeed, we are of the opinion that this antinomy – an artistic reflection of the tension between the poles of nature and grace[170] between which the world view of the late Middle Ages moved – is one of the most typical characteristics of medieval art, both to the north and to the south of the Alps. Precisely in order to escape this antinomy Gossaert painted his version in such a way that, by putting the Madonna on the clouds, he clearly emphasized the supernatural.

Later we will return to the problem we have already touched on in this digression. We hope to show that the grotto, which we will examine, implies an exegesis of the Michelangelo statues, to which we should now return our attention.

Bocchi already described those statues, as we saw earlier, not simply as slaves, that is to say as people finding themselves in a humiliating, possibly bound, circumstance but, he says, it is as if they wish to flee from the marble. He adds that the statues appear to him natural and true. With the latter he does not mean that these figures are like copies of real people, in this case, of slaves – that would certainly be impossible with these works of art in view. Rather, he wants to express the idea that the artist says something about reality with which a person can agree; something that appears as natural, i.e. in conformity with the structure of reality, and thus as true. That should not surprise us. Only in the nineteenth century with its extreme naturalism did the concept that art never pictures nature 'literally' disappear, or at least become problematic. Art will always be about how the subject is pictured, since in the 'how', in the artistic rendition, a vision of reality is given, something is said about the subject. People have always understood that intuitively, and all of the following interpretations have as starting point that Michelangelo had something to say through the manner in which he gave shape to his slaves: not only through the choice of subject, although certainly that too, but especially through the way in which the subject is handled.

Bocchi does not try to get to an interpretation of what he observed in the statues. We already mentioned the reason for this. Even in our time we will first have to understand what these statues are really saying before asking ourselves why the artist said it using this medium. It is indeed remarkable, and for those who are sceptical about the possibility of 'reading' a sculpture, also instructive, that all descriptions of these statues agree in the main points. We cite here von Salis, who is of the opinion that we should see the influence of the *Laocoön* group in these figures: 'Central here is this portrayal of impotent struggle and of the hopeless attempt to escape from an inescapable fate.[171]

Something of an interpretation, an explanation of the character of the statues, almost always enters into the description of the statues. So also with Rodin – on whose art they exercised a very significant influence – who said of them:

> Michelangelo is only the last and greatest of the Gothics ... the captives are
> held back by such weak bonds that it seems easy to break them. But the
> sculptor has wanted to show that their imprisonment is, above all, a moral
> one ... Each one of his prisoners is the human soul, which would like to burst
> from the shell of its bodily envelope in order to possess limitless freedom.[172]

This is a purely humanist interpretation of the meaning of these statues. More historically responsible and more generally propounded is a Neoplatonic one. However, there need not be a contradiction between those two. Neoplatonism was frequently the cloak in which the world view of humanism dressed itself during the fifteenth and sixteenth

centuries, as we shall see. At its deepest level there is an affinity between the two – in Platonism as well as in humanism people consider themselves too good to exist as material, 'external' persons – in both views this is dichotomistically expressed in the thought that the soul is incarcerated, imprisoned in matter.

One of the oldest attempts to understand Michelangelo's art as an expression of Neoplatonic thought can be found in 1879 with Hettner.[173] Two decades later Ollendorff speaks about Michelangelo's prisoners in the Louvre with an observation in a note about the Boboli slaves. About the figure with his head turned back he says: 'It's true, there is little to be seen [since the figure is incomplete], but that little shows in the way in which the figure turns his head back, such a dreadful passion of sorrow, that more is said with little here than in numerous completed, good works of other artists.'[174]

Ollendorff also sees in this a Neoplatonic vision expressed. Thode in his important study about Michelangelo's work does not think so strongly in this direction. Rather, he explains the peculiar character of this work as a failed attempt to express a Christian content in forms that are borrowed from Greek and Roman antiquity. But he does speak of 'a collapse and a writhing in agonies'[175] with respect to these slaves.

A consistently thought-through attempt to see Michelangelo's work as an artistic expression of a Neoplatonic vision of reality can only really be expected once the problems surrounding form and content have been studied more closely, once people have intensely engaged themselves with the question of how a work of art can itself be the bearer of a vision determined by a world view. This happened in the Vienna school, under the influence of Dilthey, first of all by Dvorak. The collection of essays under the revealing title of *Kunstgeschichte als Geistesgeschichte* (posthumously, 1924) was in this sense epoch making.[176] One of the most important art historians who have worked in this direction, Panofsky, has in a comprehensive essay discussed the meaning of Neoplatonism for Michelangelo as artist.[177] He starts with what the earlier scholars neglected: he begins to research the formal qualities of the sculptures. And thus he tries to understand the syntax of Michelangelo's art in order to approach its content more clearly: 'All these stylistic and technical habits have a more-than-formal significance: they are symptomatic of the very essence of Michelangelo's personality.'[178] After an explanation of Neoplatonism and its influence on Michelangelo, Panofsky continues: 'His figures symbolize the fight waged by the soul to escape from the bondage of matter. But their plastic isolation denotes the impenetrability of their prison.'[179]

Sedlmayr in his study about Michelangelo says little or nothing about any possible connection with Neoplatonism. Yet, his interpretation of Michelangelo's work is completely coloured by the same thoughts as those of Panofsky when he writes:

The root of this melancholy in Michelangelo is not a private feeling of being burdened by guilt or fate and certainly not an inability to accept life, but a conflict in the things themselves that lies beyond his power: between the material world and the absolutely divine, the spirit. Not between body and soul: the soul is only the stage and battlefield of this split of the world.'[180]

In this context he cites a line of poetry that Michelangelo wrote on a sketch page: 'Death is the end of a gloomy prison,' a quotation from Petrarch.[181]

De Tolnay in his book summarizes everything that has been said about these statues; his vision closely follows that of Panofsky. He seems to be in almost complete agreement with the Neoplatonic interpretation of the statues, while de Tolnay concludes: 'the slaves . . . symbols of the hopeless struggle of the human soul against the *prigione scura* [gloomy prison] and the *carcer terreno* [earthly dungeon] as the artist said.'[182]

The unfinished character of the sculptures

We have not touched on one of the problems in connection with the unfinished slave sculptures, precisely because it is so significant in connection with our subject, namely, the fact that they are unfinished.

If we re-read what Bocchi said about this, we observe that these statues, precisely because they were unfinished, made such an impression on his contemporaries. Even though finishing a work in an accurate and precise manner was considered a high priority, people were more impressed with this than if they had been completed. If we have another look at Ollendorff we notice the same fact: it is true that for him the statues are really not completed, we still can see but little, as he says, and yet, something has been accomplished here that is missed in many completed works. Although it would be possible to conclude that Ollendorff was of the opinion that the statues certainly could have been even better and grander had they been completed, we cannot escape the impression that it was precisely this appearance that moved him tremendously. Again and again, whatever people's opinion about whether a work of art should be finished precisely or not, when confronted with these statues they are full of admiration.

We even suspect that often the interpretation of the statues is coloured by their incompleteness, which strengthens the impression that we are dealing here with humanity imprisoned in matter. This is clear when de Tolnay discusses the similarly unfinished St Matthew.[183] He writes:

> The figure of St Matthew expresses a sort of eruption of uncontrolled and deep-seated natural forces in man, which not only determine the position of the members but seem to have produced their very forms ... Michelangelo has represented a primordial suffering, the moment when the soul is seized by super-human cosmic forces which destroy its individuality – and the conflict of submission to these forces creates the struggling sufferance of the figure.[184]

The last is especially clear in the figure as we see it now, but the question remains whether this could have been written if the figure had been finished. Completed sculptures are rarely described with such vehement expressions. Panofsky even exclaims: 'slaves which in violence of movement and in power of volume . . . have never been equalled by any other sculpture, classical or modern.'[185]

The question we should now ask ourselves is whether Michelangelo himself regarded these sculptures as unfinished or whether he purposely and with deliberate artistic intentions left them behind thus, rather than smoothly and precisely finished. This is not a simple question to answer.[186] We do come across this phenomenon more than once in Michelangelo's work, although seldom in the unfinished stage in which he left the slaves: we think for example of the head of the *Dawn* in the Medici Chapel in Florence. Here we have the impression that he left the head like that intentionally because the expression of power is much more intense than it would have been if this part had been finished. Bertini's thesis is also very attractive. He said that Michelangelo left the sculptures unfinished because it was impossible for him to realize his artistic intentions in the contemporary language of form, with its demand for clear definition in a static, classical composition. In that case it would be a matter of letting go because further work would destroy his intentions, not so much because he could not stand finishing it but because he had the feeling that he could not realize his artistic vision with the particular sculpture: 'a conflict between intellectual aspiration and artistic realization'.[187] This seems to me, however, rather evidence of the tragedy of Michelangelo's life, the fact that he seldom was able to realize his tremendous projects. For in some cases Michelangelo proved to be more than capable of expressing himself in a balanced, complete form, even if it was not in the classical spirit – we may think of his *Moses* and his *Victoria* (at present in the Palazzo Vecchio in Florence) and of various paintings.

It is indeed possible, however, to find a trace of what Bertini remarked on in that sketchy, not precisely finished work that we come across more than once, also in the figures that we can regard as finished such as the *Victoria* group just mentioned. With the reservation, however, that we are here not concerned with a conflict between artistic possibilities and intellectual aspirations, the bondage placed on a genius by the limitations of his times, but rather with the limitation of all human means of expression, to which a genius penetrates: he cannot express all that he sees and understands, the fine nuances in his thinking. Or perhaps the other way round, he has penetrated to the limits of human capacity for reflecting on problems, intellectually and artistically, and can no longer be precise since his vision can no longer be crystal clear. With Rembrandt too we sometimes find this sketchiness as a result of reaching the limit of human capability,[188] whereas the

problem becomes tangible in a totally different way with Dürer.[189] All this has very little to do with sketchiness as it has been emerging ever more strongly in the course of the last centuries in European art. This is rather the result of a strongly subjective attitude – in which the direct, untrammelled expression of the artist is supposed to be the most important thing – while sometimes we get the feeling that some wish to create the impression of working at the limit of human ability in an almost cheap way.

But let us return to our unfinished slaves. In part we should indeed call them really unfinished. In our opinion, if he had been given time and opportunity, Michelangelo would certainly have taken them further 'out of the marble' at various points. The head of one of the slaves, for example, which is now still 'hidden' almost completely in a rough, unhewn block. But for the rest it seems to us that those writers are correct who say that Michelangelo did not finish them further because he found in the sculptures as they are a purer expression of what he wanted to say than in the finished form that would have resulted had he continued to work on them.[190] From the many citations provided by attentive art viewers it is clear as daylight that the sculptures in their present state make an extraordinary impression on the persons viewing them.

Would it not be possible therefore that the Neoplatonic thought – humanity imprisoned in matter – that Michelangelo wished to express in these slaves comes to expression in a much more beautiful and clear way when the matter itself of the figures continues to speak its own language? The incomplete state, that is to say the sense that the human figure is still, as it were, imprisoned in matter, gives an effect that agrees precisely with the thought that must be expressed in these slave figures. We can imagine that Michelangelo started his project with the idea of finished slaves – like the two now in the Louvre – but as he was working he discovered that in their 'unhewn' state they expressed much more strongly what he wanted to say than in his original concept. And that is why he completed his project in this way, except for a few places where one could imagine that he might have continued his work further, like the head remaining in the block of marble, for example, which we mentioned earlier. For it is truly remarkable that we have four such figures, which turn out to possess a strong coherence and a unity of conception – exactly the four together make the intense impression reported by many witnesses. Would it not have been much more obvious had he all but completed one of them and left the others in a much earlier stage? Indeed, a certain stage of completion towards a similar effect is definitely noticeable with the four figures.

It would not be unthinkable that when he started these sculptures – in connection with a new design for the tomb of Julius, as we saw – he already conceived of them like this. For he had previously done

something similar and well knew the effect that this method evokes. We think of *St Matthew* (now at the Accademia, Florence), about which we also spoke earlier.[191]

The questions raised here can never be answered with certainty. Nevertheless, it seems to us certain that the sculptures, precisely in the form in which Michelangelo left them, make a strong impression and moreover, speak directly to the viewer of the laborious and vain struggle of humanity against the matter in which they are imprisoned. And we should certainly not lose sight of the circumstance of their being placed in the grotto.

The influence of Neoplatonism

Were people right in attributing Neoplatonic thinking to Michelangelo?[192] His youth in the Florentine milieu where Platonism reigned, and where people such as Ficino played a leading role in intellectual life, makes all that not improbable. Neoplatonism was a fairly generally accepted philosophy in the sixteenth century, as we will see. Therefore it need not seem strange that Michelangelo thought along those lines.

Apart from in his sculptures and paintings we can clearly find Neoplatonic ideas in many of Michelangelo's poems.[193] We shall cite a few loose lines to elucidate this further:

> In the dark jail in which my soul was hidden[194]

and

> To rise once more to heaven whence it came,
> Your soul descended to its earthly prison.[195]

Michelangelo's thought world is very complex, and there is also much to be found that is Christian.[196] We cannot elaborate on that and will only give a few main points. It is true that people are imprisoned in this material world, but their soul is divine, and that is why they shall never find rest in the beauty experienced by the senses:

> Had my soul not been created godlike,
> it would still seek no more than outward beauty,
> the delight of the eyes; but since this fades so fast,
> my soul soars beyond, to the eternal Form.
> Truly nothing mortal can still the desire of living man,
> nor he, in reason, expect the Eternal
> from Time in which all things change and decay.[197]

And yet, only by contemplating beautiful things can the heavenly state be attained:

> Neither my eyes searching for beauty,
> nor my soul thirsting for salvation,

possess any power that can raise them to Heaven
but the contemplation of beautiful things.
From the highest Heaven there streams down
a splendour which draws desire up towards the stars,
and here on earth men call it love.[198]

Linking love and beauty can seem peculiar; it is nothing but a pure Ficinian theory. For this reason it is necessary to turn to Ficino himself. Unlike Michelangelo, Ficino seldom, and with considerably less emphasis, voiced the idea of a human imprisonment in the material world. It is, naturally, present with him: 'How much more must the celestial soul change from its original state when it falls, at the beginning of our lives, from the purity with which it was created, and is imprisoned in the jail of a dark, earthly and mortal body.'[199] And yet we cannot call his philosophy pessimistic; he places great emphasis on the positive potential of humankind, for example.[200]

Ficino's commentary on Plato's *Symposium*, of which we wish to sum up briefly a few main thoughts,[201] is very important for our subject. He wrote it in 1474–1475, but it was not printed until 1544. This does not mean, however, that his intellectual soul mates and followers had no knowledge of its contents. The as yet unformed world was seen as chaos; and the world was seen as formed chaos. Since three worlds were identified, there had to be three forms of chaos: God, the *universorum autor*, created first of all the *mentem angelicam*, then the *mundi anima*, and finally the *mundi corpus*. The first world, the world of the angels, is the world of ideas and of heaven. Here everything is aimed at God and everything is striving for order, striving to be formed: 'This composite of all the Forms and Ideas we call in Latin a *mundus*, and in Greek a *cosmos*, that is Orderliness.' With this a decisive element is introduced: 'The attractiveness of this Orderliness is Beauty. To beauty, Love, as soon as it was born, drew the Mind, and led the Mind formerly un-beautiful to the same Mind made beautiful.' Beauty is: being formed according to the ideas, whereby order emerges in chaos; and that is to which love pulls the spirit. 'And so we may say that the nature of Love is this: that it attracts to beauty and links the unbeautiful with the beautiful. Who, therefore, would doubt that love immediately followed Chaos, and preceded the world.'[202] Thus everything is directed towards god,[203] the origin of everything, and the reflection of his being in the lower spheres is beauty: 'Goodness is said to be the outstanding characteristic of God. Beauty is a kind of force or light, shining from Him through everything, first through the Angelic Mind, next through the World-Soul and the rest of the souls, third through Nature, and fourth through corporeal Matter' (whereby a distinction is made in the aforementioned third world between nature and matter).[204]

So there are different kinds of beauty in the various, hierarchically ordered spheres used again and again by Ficino. We find the same spheres mentioned in the work of Bovillus.[205] It is evident how great the

significance of love is in this cosmological order: 'Finally, in each case, Love accompanies the Chaos, precedes the world, wakens the drowsy, lights the obscure, revives the dead, gives form to the formless, and finishes the incomplete.'[206]

This love, which is so extremely important, is the desire for beauty. Beauty is threefold, namely of the soul, of the body, and of the voice, and can be known in three ways: by the spirit, the eye, and the ear. The baser senses of taste and touch fall outside love, since they arouse only *libido rabies, voluptas,* lust.[207] The mutual relationship between these concepts is clarified in the following excerpt:

> This single circle, from God to the world and from the world to God, is identified by three names. Inasmuch as it begins in God and attracts to Him, it is Beauty; inasmuch as, going across into the world, it captivates the world, we call it Love; and, inasmuch as it returns to its source and with Him joins its labors, then we call it Pleasure [voluptas]. In this way Love begins in Beauty and ends in Pleasure.'[208]

In the second oratio, chapter seven, a subject is introduced that is important for our discussion – it is doubtful whether Ficino himself thought it was so important for it is seldom used in the following chapters, even where it could have been introduced.[209] We are referring to Venus. Ficino summarizes his thoughts as follows: 'Venus is twofold: one is clearly that intelligence which we said was in the Angelic Mind. The other is the power of generation with which the World-Soul is endowed.'[210] Two different Venuses or, if you like, Venus in two forms. Taking into account what follows, one could think of Venus as a macrocosmic concept in contrast to Amor, which is more concerned with the microcosmos. But we dare not draw this conclusion as he does not consistently use the terms in this sense; on the contrary, he almost always speaks of Amor and not of Venus. We can rather consider Venus as the personification of beauty, towards which Amor attracts us. And that would suit us very well, as we shall see.[211] We cannot consider beauty and Venus as identical, as is clear from what follows, and from the fact that he continues to use the term *pulchritudo* very frequently. It almost appears that we are here coming across an oblique thought in Ficino which he does not integrate further into his vision and which was inspired by Plato's *Symposium,* though not completely similar to it because of the introduction of Plotinian elements as well.

He continues thus: 'Each (Venus) has as consort a similar Love. The first, by innate love is stimulated to know the beauty of God. The second, by its love, to procreate the same beauty in bodies.' What these Venuses mean for us he elaborates further in what follows:

> These two powers in us are the two Venuses which are accompanied by their twin Loves. When the beauty of a human body first meets our eyes, the mind, which is the first Venus in us, worships and adores the human beauty as an

image of the divine beauty ... But the power of generation in us, which is the second Venus, desires to create another form like this. Therefore, there is a Love in each case: in the former, it is the desire of contemplating Beauty; and in the latter, the desire of propagating it; both loves are able and praiseworthy.[212]

As we have seen, Ficino did not write about aesthetics in the modern sense of the word, even though in these chapters we can find here and there a few observations about beauty in the sense of aesthetics. We will not pursue these here.[213]

Finally, though, we want to point out that Ficino says there is a definite, hierarchical order but that humans will have to aim in it for the higher levels. In his own words:

> We search for the Creator. With God's help we will attain to that highest level of nature, if only we try to keep the tendencies of our soul away from matter, which is the lowest level of nature, so that we come close to God to the same extent as we keep away from matter, and so that we, while we consider the driving force of this inferior life, as much as we are able, less important than God, live his life in eternity.[214]

This last thought was taken up again by Pico della Mirandola in his famous speech, composed as a defence of his 900 theses: *Oratio de Hominis Dignitate* (1486). People, he says, are different from all other creatures that have been assigned a definite place in the hierarchical order. People are free to choose where their sphere shall be, in the lower or in the higher level.[215]

We also find such ideas among others in this circle.[216] But we now wish to consider, albeit briefly, the development of thoughts about love. Ficino's ideas in this respect have had a strong influence, and the *trattatti d'amore*, treatises on love, are manifold. You could say that this popular, fashionable philosophy occupied a position in sixteenth-century thought and interest similar to what Freud's psychology and psychoanalysis occupies in the Netherlands in the twentieth century.[217] This doctrine gave people in those days, for whom eroticism was not a philosophical matter but something that determined their lifestyle to a high degree, the possibility to hide their often not so elevated practices behind a beautiful and idealistic façade. Furthermore, the connection between love and beauty was very important, and indeed central for the *cortegiano*, the courtier, because all this applied only in the courtly circles, a thin upper layer of society.[218]

The writings of Ficino's disciple Leone Ebreo were very important. His *Dialoghi d'Amore*, written around 1502 and published in 1535, has been republished many times, despite the difficult text. Very attractive to sixteenth-century readers, and completely in line with Ficino, was the thought that where the spirits are united by a spiritual love, the bodies also wish to unite themselves as closely as possible.[219]

In his commentary on a *Canzone de Amore* ('song of love') by Benivieni,[220] Pico della Mirandola made a modification to Ficino's theory of love which spiritualizes it still more but also makes it even more difficult for a sixteenth-century person to deal with it in a real sense. For he emphasizes that love, although it is aroused by seeing a beautiful body, does not find its source in the bodily, and that the more the spiritual frees itself from the bodily the more worthy it will be of the name love. Hence, in contrast to the thought of Ebreo, real love will not aim for bodily union. He did, however, translate into Italian a thought that was purely Ficinian and made it a slogan for the sixteenth century: 'Love is the desire for beauty.'[221]

Pico's ideas became very important, also because they were taken over by Bembo, the Venetian, in his *Asolani* written in 1496–1498 and published in 1505. He solved the difficulties into which sixteenth-century people got when spiritualizing love, if they wished to take these ideas seriously, saying that love is a desire for beauty, borne through a harmony of body, voice and spirit. In the shape of this idealistic theory, however, he preached a moderate Epicureanism, whereby the purely philosophical thoughts were largely robbed of their original meaning.

Castiglione, on the other hand, gives a practical outworking in his *Cortegiano* (1528),[222] wherein Ficino's philosophical theses have become a kind of moral rule for life. In fact, he applies Platonic ideas that relate to spiritual love, to unfeigned earthly love, so that it all comes down to the idea that when a man looks at a beautiful woman, he is contemplating God.[223] From a remark in a sermon by Savonarola it becomes clear that this was not an entirely new thought in this milieu: 'If it is said that Socrates looked at young men in order to find beauty of soul in bodily beauty, I do not recommend that you do the same: looking at a beautiful woman with the intention of contemplating divine beauty, is nothing but tempting God.'[224]

The influence of these thoughts has also been great in Renaissance France.[225] In summary, we wish to show by citing a French chanson how strong the influence of Ficino's philosophy was on the thinking of this time, also outside the circle of scholars, and at the same time make clear what a prominent place was allocated to love:

> I am Love,
> The grand master of the gods,
> I am the one whom eyes see,
> I am the one who governs the world,
> Who first, outside the budding mass,
> Gave light and split the chaos,
> And whereof was built this round machine.[226]

Mannerism

The question might be asked why the sixteenth century was so fascinated with Neoplatonic theories. Perhaps it was because people found there an answer to the many unanswered questions of the day: questions about the meaning and nature of life, questions about a more concrete formulation of a life and world view, whereby they attempted to push aside their own insecurity and unrest by accepting an ancient and respectable system. In many respects Neoplatonism expressed a vision that could barely still be called 'Christian' and that provided a possibility of giving one's own attitude to and way of life the semblance of a deep foundation, even if one did not really believe in this doctrine. One of the problems that is rarely commented upon,[227] but which nevertheless determined the face of this century, was the circumstance that the forms with which people were forced to express themselves, yes, even their view of reality, their ideas about what is true and not true, were not in agreement with the actual unbelieving attitude.[228] Only the work completed in the seventeenth and eighteenth centuries by a series of thinkers from Descartes to the Encyclopedists and Jean-Jacques Rousseau together with those artists who were kindred spirits, provided unbelief with its own form and content, its own face.

The insecurity that characterizes the sixteenth century, the feeling of being lost in an impenetrable, strange, sometimes irrational world, in a reality that is hostile to human being, partly finds its origin here. Only to the extent that this negative sense of reality is the result of a choice of position based on humanist freedom, only to that extent are the phenomena of this age comparable with similar phenomena in our own [twentieth] century.[229] In their creations an inner insecurity, which resulted from a guilty conscience and from the feeling of no longer believing and doing what was really proper, also sometimes played a definite role.[230]

This sense of life, this angst, this feeling of insecurity, that all values had collapsed, expressed itself in the way in which old familiar themes were handled. We think of Pontormo's *Hieronymus*,[231] his *Martyrium of the forty saints*,[232] his *Deposition*,[233] the *Madonna with the long neck* by Parmegianino,[234] etc. We see it in the preoccupation with violent and sometimes almost perversely cruel scenes of torture – e.g. in the already mentioned *Martyrium* by Pontormo and in Giulio Romano's *Stoning of St Stephen* ,[235] etc. – and finally in new themes or the reinterpretations of old themes. Rosso's *Moses and the daughters of Jethro*, wherein Moses fights a vehement and passionate struggle, is a typical example of this.[236] Nor can we omit mention of the *Fall of the Titans* in the Palazzo del Tè in Mantua by Giulio Romano as one of the most frightening new subjects, executed in a grandiose manner.[237]

All of the examples mentioned above originated in the first half of the sixteenth century and they are almost all the work of the generation

that followed immediately after Raphael, mainly from the Florentine milieu. We chose them specifically because we find it impossible to discuss Mannerism, as sixteenth-century art may rightly be called, as a single style or direction in the way Sypher and Hocke have done. What all these artists have in common is that they all moved away from Raphael's ideal of a harmonious, beautiful, balanced art. Their figures are not classically beautiful, not emotionally balanced. On the contrary, they sometimes possess violent passions that cannot be fully explained by the circumstances. The space in which they move is not well organized nor unified. The total impression is not natural, and certainly not of that obvious clarity and symmetry that characterized classical art of the High Renaissance. The figures are still defined in a plastic way and rendered in clear contours, but these means are used in a totally different way from a short time earlier and they often contribute to the evocation of enormous artistic tension. It was precisely because they were denied the free space in which to move around.

We could call this Mannerism of the Florentine artistic milieu of the first half of the sixteenth century 'Mannerism of principle'. It has deep roots – if that were not so, this remarkably anti-naturalistic art could never have come into being. What caused it?

To answer this question, we shall have to turn to the past. In the first half of the fourteenth century people looked for a human expression of the sacred stories that was faithful to nature, in the tradition of Giotto. In contrast with the earlier Byzantine art, which tried to picture in its icons the holy, the heavenly, and the world of ideas, so that every sacred story or every Madonna became a sign of a supersensual truth rather than the expression of a real event,[238] it was with the feelings and inner experiences of the figures that people now began to empathize. Maria, as a mother, starts to show an interest in her child; Joachim and Anna greet each other, as real older people would have done in such circumstances, with love and with emotion. The Black Death around 1350 produced a deep religious crisis. People were afraid they had approached the sacred too closely, had disrespectfully portrayed it too humanly.[239] As a result they started to portray the figures more distantly again, avoiding the representation of purely human feelings and actions on behalf of those who belonged to the supernatural sphere.

In the beginning of the fifteenth century there was another turn in the cultural mainstream. Both in the North (e.g. van Eyck) as well as in Italy (with the first generation of Renaissance painters and sculptors) an interest in humanity and nature began to dominate. However, people were keen to continue the style of picturing the sacred that had developed since the Black Death, for then they did not need to occupy themselves too deeply with the sacred, which was no longer central for them. In this way they were free to concentrate on the naturalistic rendering of all kinds of details – the rendition of space, the structures

of the human body, animals and plants, a delight in the draping of heavy fabrics, skin colour, waves of blond hair, etc.

Thus fifteenth-century art is often inwardly antinomian: through the naturalism of the method of painting one gets the impression of great lifelikeness on the one hand, while on the other hand, when one realizes what the painter is really telling us about the subject, there is unmistakably a great distance from the natural data. For example, in Hugo van der Goes's *Portinari altar* we see, if we incorrectly look at this work as a photographic representation of a piece of reality (from the past), how a mother lays her newborn child on the ground in the middle of winter in order to worship it quietly. The content of a work like this is more theological-dogmatic than historical-narrative in character. The sacred is no longer characterized as such: the halo is often omitted from saints, the wings from angels, etc. The danger here is not imaginary that everything holy will be treated as a visible thing-reality. By contrast, in the treatment of subjects the sacred is kept far from the natural in the same way as with Byzantine art.

In the beginning of the sixteenth century, when people were no longer able to deal with the sacred in such a free, naïve and unconcerned way – since the preaching and actions of Savonarola had clearly underlined the discrepancy mentioned above – it became the aim to employ the newly discovered art of portraying nature in the service of the sacred, which then had to be characterized as such. The sacred, supernal, super-temporal reality is elevated above our reality by putting it on clouds, the figures of the saints lose their more individual characteristics (as if they were just ordinary people) and their supernatural character is underlined more clearly by structure and composition.[240] A work such as the *Sistine Madonna* by Raphael[241] may be called a typical example of this High Renaissance art.

During the High Renaissance, therefore, the old synthesis of nature and grace is brought back to life again, after two centuries in which the two poles of this Roman Catholic ground motive threatened to tear themselves apart or to continue together only in great antinomian tension. The High Renaisance put nature, now understood humanistically, back into the service of grace: its art has remained, together with Gothic art, the most adequate expression of the essence of Roman Catholicism. It aimed to depict and typify the sacred as such with great beauty, naturalness and balanced harmony.

For those who continued to take the Renaissance starting point of human freedom,[242] which they attempted to realize in the domination of nature as well, art for this reason became extremely problematic. These people, who found it difficult to surrender themselves to the new formulation of the sacred, of the Christian in a Roman Catholic sense, were the first to see the lie contained in this art: for things are not so beautiful, so balanced, this naturalness is too paradisiacal, too

harmonious and not at all in agreement with the very unsettled world in which they lived. It addressed them all the more because ultimately what was represented could only be understood as an exaltation of the natural – since the sacred could not, in fact, gain a place in their thinking. Their art, built on the artistically very important legacy of the High Renaissance, was in many respects a passionate negation of all that. In the first place it was so in the purely aesthetic composition and structure of their work. Often they also had to treat sacred subjects – think of the problem related above, that these people did not yet have adequate forms with which to express themselves. In their rendering of such subjects their doubt and their tense relationship with the content of the subjects were expressed vehemently. We think of the Depositions by Rosso and by Pontormo.[243] For them this event was in truth not a beautiful, holy event but a strange story, which those present could only have experienced with great inner doubt or desperation. In other cases it is as if they caricatured the old and familiar artistic treatment of these subjects: compare Pontormo's *Adoration of the kings*[244] with Fra Angelico's rendering of this subject.[245]

The High Renaissance looked for beauty and wanted to employ it in the service of the subject matter. Since the content of the paintings had lost its meaning for them, beauty itself became the goal for these Mannerists. The sixteenth century looked passionately for beauty, purely artistic beauty, art-beauty. This aestheticism could now play with reality as rendered in the work, in order to force it into a compositional scheme. And people went after this playfulness because in it they could confess their inner freedom over the subject matter. Many examples may be given, but they would take us into far too much detail. As a typical example of how free people were with respect to content, and how they considered beauty as something autonomous, we only wish to mention the peculiar story of Parmegianino, who, when asked for a Madonna, and having only a Venus with Cupid in his studio, simply dressed her as a Madonna and thus completed his commission.[246] It may be clear that such a procedure cannot be totally defended from the charge of profanity. The Mannerists had in the course of events, as humanists, become very conscious of their relationship with nature. They could not surrender to it in the same naïve way as the fifteenth-century people had done. Nature itself, having become problematic through its service to the sacred in the High Renaissance, became an entity to be experienced as a strange power, an attack on human freedom. Hence they played with nature, allowing themselves liberties in its depiction in an aesthetic game. They rather looked for the essence of human being in its free expression, according to its own free design. Here too, a Neoplatonic outlook served them well.[247]

This aestheticism, this artistic game in which people looked for art for art's sake, was at the same time proof of an inner lack of faith in any

real values – for the person who really believes in something, really loves it, cannot play with it freely, not even in the portrayal of it.[248] As such this art is clearly a crisis-phenomenon: it is the art of humanists who dared not believe in their own deepest assumptions and, at the same time, could no longer accept the current opinions.

It is possible that the eroticism of this era is connected with this.[249] When all values are lost, and people are dependent only on themselves, then something which can still be experienced positively, which can still bring joy, becomes the centre of attention. Sex will often play that role. However, in the context of the sixteenth century it was a matter of great formality and a refined game; it is better to speak of eroticism. That is already obvious in the first generation of Mannerists. For example, is the male organ not the centre of Rosso's composition in *Moses and the daughters of Jethro*?[250] And in Parmegianino's *Madonna with the long neck* it was in fact Mary's breast that formed the centre of the composition.[251] But it was only for the next generation that eroticism came to dominate life and art, people who no longer experienced Mannerism so vehemently as a matter of principles and for whom mannerism had become a lifestyle, appropriate for a secularized, 'courtly' milieu. That next generation, amongst whom we must count Bronzino, Vasari, Giovanni da Bologna, Benvenuto Cellini and the artist who is so important for our topic, namely Buontalenti, worked during the second half of the century. They were the court artists. It was here, at the court, that the stylish, ready wit, the ingenuity, the playfulness, in short the 'courtly' formality gave Mannerism the opportunity to blossom. It possessed all the characteristics of the first 'Mannerism of principle', but now often became pure form, lifestyle and attitude. Aestheticism emerges here as the search for subtle grace, hidden and yet clear erotic allusions, the glorification of a life that may occupy itself freely, without obligations, with all values as long as they are artistically realized. Yet we may not forget that at the most profound level these artists were also nourished by the same inner impulses that motivated their predecessors, so that ideas based on principles constantly made themselves felt, right through their gracious and formal Mannerist artistry.

The grotto

Bernardo Buontalenti received a commission to make a suitable setting for the unfinished Michelangelo sculptures, which we have already discussed extensively. Who was this artist? He was a Florentine and lived from 1536 to 1608. He had the nickname 'della Girandole', as he had invented revolving fireworks. It is true he had received his initial training with a miniature painter, but he devoted his talents to the most divergent activities. He made fortifications, musical instruments, buildings, sculptures, paintings,[252] and dug canals. Perhaps the most important work was the design of decorative sets for theatres and parties. We

should not be disparaging about this: he once organized a complete sea battle on the inner court of the Palazzo Pitti[253] He was greatly honoured for this by his contemporaries – he was supposed to have surpassed even the Romans: 'Buontalenti made such beautiful masquerades with such bizarre clothing, such marvellous carriages, that not even the Romans could have made them.'[254]

Buontalenti was a typical court artist, always ready to realize every whim of his master, the Grand Duke and ruler of Florence. He certainly was a Mannerist. The biography written at the beginning of the seventeenth century, from which we just quoted, repeatedly uses the word 'bizarre', as a term of praise, of course. The nature of his work meant that not much of it has been preserved. He also designed several very special grottos, of which, however, the largest and most important ones – not counting our Boboli grotto – the ones at Pratolino, were destroyed in the nineteenth century.[255] A few of his buildings have been preserved, but we will not discuss them.

Buontalenti designed a grotto for the Michelangelo sculptures. It was not his first grotto. The ones at Pratolino were already completed when he started work on this one. Before we investigate this grotto more closely, however, we should briefly pay attention to such grottos in general. Grottos were a fairly common phenomenon in Renaissance gardens. They appear already in the fifteenth century. Perhaps the motif was borrowed from Roman antiquity. Leon Batista Alberti had a rather extensive discussion about grottos in his treatises on architecture,[256] and even describes one of them. It is not impossible that the viewing of Roman remains, in their ruinous condition, further contributed to the idea of making grottos.[257] However that may be, in the sixteenth century the Mannerists were very keen to elaborate on this idea. We know the grottos of Daniele da Volterra and of Baccio Bandinelli – a small one, also in the Boboli garden, much older than the one by Buontalenti; Vasari speaks about grottos in the introduction of his *Vite*,[258] while Giulio Romano also made a grotto at the Palazzo del Tè in Mantua.[259]

These grottos[260] gave shape to a romantic thought: they were a piece of wild, unformed nature in the midst of the strictly formalized artistry of the gardens, including sculptures and architecture. It is remarkable that contemporaries always referred to the natural, true character of the grottos, despite the fact that they were highly artificial.[261] It was precisely this concentrated and intensified randomness, this artificially chaotic formlessness that was relevant for sixteenth-century people. But Mannerism spoke even louder in the grottos that exhibited all kinds of antique motifs, as it were, in a ruinous state, caricatures of antique architecture and ornamentation.[262] All respect for antiquity seems to have disappeared; or we experience how these honoured antiquities have been assailed by destructive natural forces and have been robbed of their original meaning. In Romanticism, during the eighteenth and

nineteenth centuries, the ruin once again became a relevant and typical object of artistic contemplation, manifest artistically in the use of this motif in poetry and painting and in the fact that people sometimes even built ruins.[263] These ruins spoke in their Romantic language about human tragedy, about the cosmic powers being stronger than the human powers, which manifest themselves in culture. In the sixteenth century the matter is different: here the phenomenon is an expression of the awareness that neither the ancients nor their followers had brought human freedom and greatness. It also proves that the essence of the Renaissance was not sought in the imitation of the ancients, but that the new humanity sought support only, guidance and inspiration for their cultural rebirth, from these pre-Christian ancestors.

Kris cites Palissy as a man who expressed such ideas in words.[264] In his description of the grottos, garden houses of a strange kind, in a garden designed by him, he writes that people will find there: 'a kind of architrave, frieze, and cornice, not properly sculpted, but as if someone mocked them, while forming and sculpting them, with big hammer blows.' And a little further on, 'the said room will be curved, hunched over, having several humps and hollows, keeping no appearance or form of art or sculpture, or of the work of a man's hand: and the vaults will be so curved, that they will seem to fall down, since there will be several hanging humps.'[265]

Shortly after this was written, Buontalenti designed his grottos for new country house of the Duke at Pratolino, in many respects related to Palissy's ideas. It cannot be determined whether he knew this book, but without further proof this should not be assumed. Buontalenti has worked out in his own way similar basic ideas prevalent at the time. If he had read the book it would only have strengthened him in his own resolve to create bizarre things. Nevertheless, it is true that some elements of his Boboli grotto are remarkably close to Palissy's descriptions, especially some relief figures covered with shells, which are found between the stalactite figures, so that we are tempted to suppose that Buontalenti was acquainted one way or another with the work of the older Frenchman.[266]

Baldinucci tells us how the Duke gave Buontalenti the commission to create a suitable place for the four slaves by Michelangelo that had come into his possession after the sculptor's death.[267] We can imagine that he took a good look at these sculptures. And it does not surprise us that this young contemporary, living in a Mannerist milieu at the Florentine court where the Neoplatonic philosophy of Ficino was fashionable and the subject of courtly discussions, saw in them what later commentators, steeped in the thought world of this time, have written about them – not without effort, but very much impressed by the unique character of these works. The quality of desperate struggle, of imprisonment in matter, of wrestling to escape earthly bonds must have

spoken to him all the more because these sculptures appeared apart from the original project they were intended for. In the tomb of Julius II they would have been part of a greater whole, if executed according to the plans, and they would indeed have had the same content, which however would have found a catharsis in the rest of the memorial that, after all, was to have spoken about the triumph and victory over death. As already explained, the rough and unfinished state in which the sculptures were found, which already received general admiration, must have forced and accentuated this thought all the more.

It is not known when Buontalenti finally presented to the Duke his idea of putting them in a grotto. The work started in 1583, after he had completed his grottos in Pratolino. It was possibly while working on those that he conceived the idea of placing the sculptures in a grotto, which he was planning to make anyway.

The position for this grotto was not so difficult to determine. Considering the importance of the commission, it was not to be too far from the palace in the garden, and since there was already an unfinished entrance, built by Vasari for a vivarium (a place to keep wild animals and a fishpond, etc.) to be built behind it, that entrance was used. It was decorated and finished with relief figures covered in shells, and stalactites executed in 'spugne' – a kind of pumice.[268]

Behind the entrance he proceeded to design the grotto, a spacious rectangular hall of about 7 x 10 metres, where the Michelangelo figures were placed in the corners. The ceiling became a vaulted roof, with an opening in the middle, where he built – a typical Mannerist invention – a large aquarium, so that the light would fall through the water and past the fish into the space, the subterranean character of which was intensified by all kinds of little fountains and watercourses. This aquarium did not exist for very long, however, nor did the water supply to the sprayers – they were far too difficult to maintain.[269]

Next we will look at how he arranged this grotto. To us it may seem a bizarre and strange thing,[270] but for his contemporaries and long afterwards, till the eighteenth century, it fascintated people as an invention. In various books and booklets about Florence[270] the Boboli garden is discussed, but in nearly all cases most attention is given to a description of the grotto. The rest of the garden is summarized in a few lines. All these discussions have nothing but praise. No criticism is mentioned.

The walls of the grotto were provided with figures executed in pumice in very high relief, about which Baldinucci says:

> In the four corners ... he placed the four sketchy figures, in such a way, that it looks as if they are carrying large masses of pumice, while he thus harmonised the roughness of the natural fantasies with the coarse and unfinished figures, that it seems as if the whole was created by nature itself. He decorated the rest of the grotto himself, with figures and animals

executed in the same pumice with such expertise, that nothing more beautiful or truthful can be seen in this genre.[272]

The only thing that can be said against Baldinucci is that Buontalenti did not execute the figures of shepherds, goats, sheep, a kind of River god etc. himself. For we possess the account of a payment to a certain Piero di Tomasso Muti, sculptor, for 'Figures and masks made for the grotto of the garden of Pitti, designed by Buontalenti'.[273] Alternatively we may assume that Muti assisted him and made the secondary figures, which is very well possible. It seems that people were still working on the grotto in 1588, even though the Michelangelo figures had already been placed there in April 1585.

The vault and the walls were painted by Buontalenti's pupil Bernardo Pocetti. We read about this:

> The vault gives the impression that it is about to collapse, and that through the fissures and cracks all kinds of animals escape, such as snakes, birds, satyrs, and many plants, which look so natural, that through this appearance of veracity yet another pleasure is almost added, but then not without fear, since the total impression is that the building is about to collapse to the ground.[274]

All this preceded words of high praise for the decoration, which continued on the walls, where landscapes can be seen behind the relief figures. In the landscapes there are further figures, shepherds and anglers, etc.

The 'carcer terreno'

What would have been Buontalenti's intention when he designed and created this decoration? Without a doubt we see something completely new. In the older grottos there were occasionally stalactites in pumice, and sometimes they placed all kinds of animal and human figures, in relief or in full relief;[275] sometimes there were a few satyr-like masks, executed in plaster or clay and decorated with shells. But the meaning of the latter is different from what we see here: those masks were Renaissance ornaments executed in the 'rustic' style, while Buontalenti created his animal and human figures in pumice as if they were stalactites which just happened to take on these shapes.

It goes without saying that Buontalenti intended an adequate and special place for Michelangelo's greatly admired slaves. The question of Buontalenti's intentions for this exceptional grotto is legitimate precisely for this reason. If he intended this as a suitable environment for the sculptures, underlining and supporting them in their significance, then it follows that the figures and the grotto are geared to each other. To use modern terminology, this grotto is meant to be an exegesis of Michelangelo's figures. The respect for Michelangelo and these sculptures, together with the importance of this commission, does

not allow for any other supposition, all the more since Buontalenti's grotto has always been praised, and the slaves have always been considered fully at home there.

It is especially the extraordinary character of this grotto, described by contemporaries (or later observers) as a ruin that is about to collapse, in which one cannot remain without fear, full of coincidental freaks of nature – *naturali scherzi*[276] – beautiful, genuine and very natural, but also rough and unformed. It speaks clearly of a Neoplatonic, Mannerist concept of natural reality: nature as the chaotic, the unformed, in which people are imprisoned. Buontalenti has directed all his powers to make clear what nature is like, whereby he ultimately does not make something that looks 'natural' – everyone who looks at it experiences it as very artificial and bizarre – but that typifies nature in its own disposition in a concentrated way, according to the contemporary vision of that time.

Humanity imprisoned in nature, in *carcere terreno*, that is how we could typify this grotto. But why then would he have made those stalactite people and animals? They do not express the same thing as Michelangelo's slaves, which are human figures who want to free themselves from matter that imprisons them, while the others are more incidental shapes of nature, stalactites that received a human or animal guise without any conscious act of will. Nor is the motif of struggle anywhere present or even hinted at.

If we put ourselves in the thought world of the Mannerist courtier, familiar with Neoplatonic philosophies, albeit on a fashionable level, it is quite evident that we have to look in this direction for an explanation. And then we may again bring to mind a thought by Pico della Mirandola, from his well-known speech, namely that people can freely choose in which sphere they want to find their place. Would these figures, faithful to nature, without struggle, shepherds or women, fundamentally no different from a River god, and the animals, not express humanity on the lowest level or levels of the Neoplatonic hierarchical world order, namely that of the minerals, the materials, and of living creatures, animals and plants? In Bovillus we read on the first page of his *Liber de Sapiente* (1510–11):

> All people are by nature and in essence the same and as to the character of [their] sort they are as the one [idea] Man; however, in their way of life, in actions and abilities they are different and unequal. Since some become equal to the minerals or the simple elements, and others to the plants, and others in their roughness to the animals; only the best are equal to Men through the value of Reason, and because they are reasonable in character and action they can be called real and perfect Men.[277]

Especially this similarity with the lowest, with matter itself, has been clearly expressed in these stalactite figures. Yet it is hard to believe that

someone like Buontalenti wanted to express so directly a literary-philosophical thought in his figures, even if these popular philosophical ideas were fairly general in the Florentine milieu and could certainly have played a role in the conception of this grotto.[278] We think that we should rather view these remarkable shapes as a relevant expression of a world view about reality, more direct and deeper than Neoplatonic theory could ever describe it in words – consider that in those days people had not yet found an adequate way of expressing their own humanist, unchristian world view. In our opinion it is the negative sense of reality of that time that expresses itself in this way: reality that can no longer be comprehended, that appears to the free person as an unstructured, chaotic power, because he or she no longer has any positive contact with it. It is an irrationalism that considers every manifestation as coincidental, and that is why it likes to show how the one can be the other in poly-interpretable forms – as Arcimboldo did during that time in his own way.[279] Such a fundamental thought could not, in those days, be expressed so directly as in our time, since the many 'unmaskings' and 'liberations of the artist from all restraints'. That is, not apart from in a playful project such as this grotto, where the rules of 'decorum' were not so valid.

It is possible that we can see matters in such a way because in our time art is concerned with similar problems – although we must keep in mind that the differences are considerable, that we may not always postulate a fundamental affinity when confronted with a formal comparability. And yet we can suspect, when confronted with similar manifestations, that a similar vision inspired them, at least within one and the same cultural circle. With those stalactite figures we are repeatedly reminded of sculptures of our time, in which also the illusion of chaos is emphasized and forms are only hinted at: a human being as a collapsing, ruinous, rough-hewn rock, or as a piece of bronze, which on the one hand gives the impression that the figure is rotting and falling apart, and on the other hand that the bronze accidentally happened to find this form – we think here of Wotruba's sculptures and of Germaine Richier's *Orage* ('storm').[280] However, it is also possible to look at these figures in a different way – and this does not preclude what we just said; on the contrary, it complements it – namely, that the 'normal' image of human being is attacked, insulted or at any rate, assaulted.[281] We have already seen that something similar was not impossible in a Mannerist milieu with respect to the human body, understood and seen in a language of forms borrowed from or related to the classics. There it is a faint foreshadowing of what existentialism would come to teach in our time.

To substantiate the above let us consider a picture of Jean Dubuffet, *Le Magicien* ('the magician', 1954). In an article written by a sympathetic critic about this and similar work we read:

Dubuffet never considers Nature from the outside. He takes it to the level of its most basic states, to its lowest limit, in its function of *natura naturans*, unfinished and definitive, holding in each of its fragments all of its future incarnations, its universal designs, its themes of permutation ... the individual is no longer simply an accident of matter, an added detail, a superfluous accessory ... he carries nature within himself. He is made of it, he is marked by its imprints, masked by its savage calmness, frightened, obliterated, struck by the stamp of corruption ... This art which defiles the creature has no more respect for the Creation.[282]

It can certainly remain an open question, which is more likely to be answered negatively than positively, whether Buontalenti was aware of these matters. For him it will have been a matter of evoking, in an artistic manner, a clearly chaotic, ruinous reality, containing only the lower forms of life, in order to give Michelangelo's figures their *carcer terreno*. That does not exclude the possibility that while he was looking for figures that were relevant for his sense of reality, he hit on more profound things than was possible for a philosophical consideration and formulation of that era: contingency, irrationalism, poly-interpretability, doubt about human worth – what the twentieth-century person would call the *échec* – expresses itself in these stalactite figures as in a serious joke, a light-hearted toying with artistic and human values.

Two kinds of love

Besides Michelangelo's slaves also other statues were given a final and appropriate place here, e.g. a group by Vincenzio de' Rossi da Fiesole, portraying a pair of lovers, Theseus and Helena. Maybe this group inspired Buontalenti to continue his work following the Neoplatonic way of thinking. For with the completion of the grotto with the slaves an important Neoplatonic or, if you will, 'Michelangelesque' thought had been expressed in form. But Ficino, and after him many writers of popular *trattati d'amore*, emphasized that humanity did not have to stay imprisoned by the natural world; on the contrary, it was their task to elevate themselves and find the way back to god. The way for this was the way of love. And the first step was love for one's fellow human beings, nourished by beauty, and aimed at the reproduction of beauty. It is true that some later writers in this respect thought less openly and freely than Ficino and attempted to spiritualize love, even at this level. It is also true that especially Castiglione treated this love all the more emphatically as an erotic relationship between man and woman. In any case, this is how people generally referred to these things in the literature of the sixteenth century.

Cosimo had received this group sculpture during a visit to Rome as a present from the Florentine (Mannerist) sculptor Vincenzio de' Rossi, who worked there.[283] Indeed, this group expressed in a very typical way the love between a man and a woman in the open, erotic manner of the

time, where the love-play was performed in a refined, almost artistic, form. By the nature of things this subject was contained in a certain theme, namely Theseus, who can be recognized by the dead swine on which the couple is sitting, with Helena, whom he, so the story goes, had abducted when she was young – this somewhat forgotten saga[284] from Attica (in Greece) was pulled from oblivion by the sculptor not because of a deep interest in Theseus but because of its erotic subject matter.

Buontalenti created a second space, a smaller grotto behind the first one, for this group that was generally honoured and appreciated at that time. In this way Ficinian love, the *amore* that belonged to the *Venus terrestra*, was evoked as a purification and a human elevation after the terror inspired by the first hall, in which we saw humanity struggling to escape chaos.

Bocchi describes this group with the words:

> he made a Paris[285] abducting Helena, honoured by art connoisseurs, with such an extent of good devotion and exceptional diligence, that it is equal to the best statues ... Paris certainly shows himself in a true-to-life attitude, in natural liveliness ... Helena is especially beautiful in her face, in the breast, in the arms, and it seems – I don't know how – as if the marble has become flesh, that is how 'full' all parts of the body are, and all the rest is by everyone's judgment very fine and full of grace.[286]

But if the lower Venus had received her honour, naturally the higher love should also receive her place. For this Buontalenti designed a third, somewhat larger space to go behind the second hall with the pair of lovers. Giovanni da Bologna, the greatest sculptor in Florence during the second half of the sixteenth century, received the commission for the statue to be placed in this third hall. In his book of 1591 Bocchi does not mention this third space when describing the grotto. Perhaps we are to assume that it, as well as the statue, was not completed until around 1600.[287]

Baldinucci describes this statue as 'a beautiful woman's figure, which was placed above the bowl of a fountain; a figure that was made in such a way, that one can look at her from any side and she always appears in an admirably gracious posture'.[288] Cambiagi was also to speak about a woman's figure and not about a Venus – that name was given to the statue only in the French guide of 1837.[289]

It seems obvious to give the name Venus to a nude female figure that has no further significance than her own undressed beauty, but it seems important to us not to be too quick in writing off the older sources as wrong. For what we are shown in the last hall is not the *Venus Urania*. Nor did we see *Venus terrestra* in person in the second hall. Theseus and Helena, a pair of lovers, show love operating on the human level. And therefore in the last hall, beauty will be honoured, concretized in a woman's figure. For according to Ficino's teaching the senses point the

way to beauty, which is not sensual but of a higher, spiritual value –
beauty that becomes knowable through love. Hence a woman's figure
was a suitable image to represent beauty.

Ficino wrote: 'But that glow of divinity shining in beautiful bodies,
like an image of God, compels lovers to awe, tremble and reverence.'[290]
Further on he says of the Venus Urania: 'The first, by innate love is
stimulated to know the beauty of God.'[291] And, even more clearly, later:
'When the beauty of a human body first meets our eyes, the mind, which
is the first Venus in us, worships and adores the human beauty as an
image of the divine beauty,' which is quite different from the second
Venus, the 'power of generation in us', which 'desires to create another
form like this'.[292]

Michelangelo spoke about such matters in a sonnet. We can
certainly assume that Buontalenti also was familiar with these ideas,
possibly even this poem. The artist addresses Amor, asking him whether
the beauty that his eyes show him when looking at his beloved is really
the beauty of the woman. Amor answers him, in the last two verses:

> The beauty that you see, is certainly hers,
> but it increases when it rises to a higher place,
> and hastens via the mortal eye to the soul.
> She becomes divine, chaste and beautiful,
> since the divine wishes to make everything equal to itself:
> this [beauty] and not that [the sensual] appears to your eyes.[293]

In this way, by seeing this beautiful woman's figure, also through the love
it arouses in us, beauty itself will be known. And indeed, we may safely
say that in this sculpture, one of the most beautiful he ever made,
Gianbologna has created an adequate symbol for love, even though it is
not without Mannerist presuppositions. Baldinucci is right when he says
that this figure may be looked at from all sides and still be equally
beautiful. Seldom has the ideal of the *figura serpentina*, about which the
Mannerists spoke so often, been realized more beautifully.[294]

To summarize, in this grotto three typical facets of Mannerism are
presented in their interrelation: aestheticism, in beauty elevated as idol
in the last hall of the grotto; eroticism, in the pair of lovers; and finally,
the negative sense of reality, the spiritual malaise, in the first hall, where
we also see how humanity tries to escape from the powers that weigh
them down, embodied in Michelangelo's four slaves, which dominate
the grotto. We said 'in their interrelation' because it is clear that
eroticism and aestheticism are nothing but an escape route to a
meaningful life despite the feeling of crisis and the lack of true
principles that give people, through their outlook on life, peace and a
place in the cosmic order. It is an escape route into beautiful forms, a
refined playing with forms, of courtly love and aesthetic sophistication.

But eroticism and especially aestheticism cannot provide ultimate security. They are threatened again and again. So it is not all that remarkable that in the third grotto, where Beauty found her place, we find rough blocks of pumice in recessed corners,[295] to incorporate chaos, and that Beauty herself is standing on a rough, unformed block of stone. It may appear to be a Mannerist 'joke' that the vase of the fountain on which she is standing is carried by satyrs, which spew jets of water to her. According to this way of thinking it expresses a pure and even profound observation, for is it not true that Beauty is constantly beleaguered by the lower, sensual powers of nature in people?

The coherence between the different elements of the Mannerist world view could only be given in a Neoplatonic form, a comprehensive vision in agreement with the current philosophy that reigned within the Mannerist milieu at the Florentine court: in the first hall we saw the *carcer terreno*, in the second the working of *Venus terrestra*, and in the third that of *Venus Urania*. In this way the grotto with its three halls became a kind of Neoplatonic temple of love. We are of the opinion that something like this could never have been conceived in any other way than precisely in this form and in this manner at that time. For Christianity was still the traditional religion to which lip service was being paid. People's sense of decorum would have resisted a similar 'serious' construction. But precisely because this grotto was a playful jest, a rustic *scherzo*, precisely because all this was not intended to be taken officially and seriously, it was possible for a playful spirit like Buontalenti to express more profoundly and acutely what would not have been possible at a more official and public level. He could express himself freely here and gave a relevant articulation of what lived in his Mannerist spirit.

It was the so-called 'unfinished' statues of Michelangelo that gave the inspiration for this remarkable and in many respects unique document of this period. In this way they received an adequate interpretation, in which Sanleolinus' playful mention of the two Venuses was indeed heard.

The Art of the Sixteenth Century

• The influence of the Reformation on art[296]

It is unthinkable that the Reformation would have had little or no effect on the world of art. For Protestants the Mass as well as the choir music accompanying it had lost their significance. But along with that the altar – and therefore the altarpiece – also disappeared. Madonna statues and sculptures and paintings of saints all lost their meaning. Perhaps there were people who, after centuries of focusing their piety on these things, now discovered (by studying the Scriptures) that they had been given stones instead of bread. Sometimes they reacted in furious anger by throwing out the whole lot. At other times the reaction was much more peaceful. But in one way or another Roman Catholic cultic art disappeared.

Kuyper was right when he wrote that art was set free from ecclesiastical domination, opening the way for other subjects and for a more domestic, intimate style of art – genre pieces, landscapes, still lifes, etc. But it will not be sufficient to turn our attention only to the new subjects. The Reformation's impact was more far-reaching and profound than effecting simply some thematic or theological changes. It encompassed an entirely new relationship with God the Father and God the Son, a completely new way of experiencing biblical truth. This, in turn, resulted in a new relationship with reality and life. The Reformation brought a profound renewal in both an emotional and an intellectual sense. It was not a revolution, in the sense of breaking with something; rather, it was a return to the fountain of Life, so that the healing waters could flow in.

These changes were not immediately apparent everywhere. It was not until the seventeenth century, after the complicated and confused period of the sixteenth century, after the new had consolidated and people found the time and the peace and quiet to build on it, that we see clear evidences of the transformation in the realm of art.

This is not to say that in the early years of the Reformation there was no evidence of change. To the contrary. For already prior to Luther's public declarations the spirit of the Reformation was apparent in a few artists. (In the same way, the art of the Counter-Reformation perhaps first became apparent in 1510 in the *Stanze della Segnatura* by Raphael which is now in the Vatican.)

When we think of the Reformation, we are inclined to turn to Dürer and his famous series of woodcuts of the Apocalypse created in 1498. The young genius, who quickly became world-renowned, accomplished in a convincing way the nearly superhuman task of illustrating the images and parables from the last book of the Bible, and he did so in a

completely new spirit. He had little to build on – earlier pictures illustrating John's Revelation were meagre attempts to capture visionary language in a pictorial way. Dürer accomplished this not only magnificently but also with incredible accuracy. His whole approach betrays a deep respect for the biblical text. He also demonstrated that such orthodoxy in no way hinders freedom and creativity. On the contrary, a freer, more open creation of the same high standard can hardly be found.

It is remarkable that this series of woodcuts, apart from the scene with the horsemen of the Apocalypse, is not well known in our circles. It seems that Dürer had an incredible respect for every single word of the text and left nothing out in his depiction of the scenes. In the woodcut portraying Revelation 10 we see an angel clothed with a cloud and with a rainbow on his head, his face shining as the sun, his feet like pillars of fire, with one foot on the earth and the other in the sea. The angel offers the prophet a little book, and then raises his hand to take an oath in the name of him who lives for ever and ever.

We notice that, contrary to the custom of his time, Dürer avoided portraying God but instead used the symbol of the ark of the covenant to depict him. The voice from heaven is portrayed as an angel speaking to the prophet. Notice how the prophet obediently follows the (other) angel's instruction, takes the little book and eats it. No detail has been left out of the picture. Yet the whole does not become weird or bizarre.

Thus, this Apocalypse series is the first monument of the Reformation in the world of art, and perhaps it is the most excellent monument of scripturally sound imaginative thinking ever created. What is amazing is that all of this could be accomplished in the depiction of the most difficult book of the entire Bible.

Dürer later on became a follower of Luther. A moving proof of this is the prayer he wrote in his diary in 1521 when he was in Antwerp. On the whole his diary is a dull summary of expenses and visits, but then, on the Friday before Pentecost, he received the news that Luther had been betrayed and captured. (He was not yet aware at this point that Luther had gone to the Wartburg.) What he wrote in response to that news, allowing his thoughts to roam freely, was of course not intended for publication. The text is difficult to translate, with thought piled upon thought.

An artist who is better known for his direct connection with the Reformation is Lucas Cranach, the creator of the famous *Luther* portraits and the tireless creator of numerous illustrations accompanying Luther's writings as well as many pamphlets produced during this tumultuous time. Cranach started out as an important representative of the Danube school, a group of very expressionistic artists from the early sixteenth century. Their works were passionate and extravagant, expressing a deep spiritual crisis. It was almost as if the artists were trying

to convince themselves of the truth of what they were saying by emphasizing it so loudly and vehemently. One of Cranach's works of that period is his impressive woodcut entitled *Gethsemane*. Later, during his 'Luther period', he calmed down, while his rich fantasy diminished.

Peace and calm and joy are the promises that the gospel proclaims. We see it clearly reflected in this art. Another artist who showed that this could be accomplished without compromising the highest artistic quality and creativity was Albrecht Altdorfer from Regensburg. In his early period Altdorfer was also a passionate and fantastic representative of the Danube school, perhaps even its most important one. His drawing from 1511 showing an awkwardly positioned tree in the foreground and the Danube landscape in the background looks as if it might erupt like a volcano at any moment. In 1519 he supported the fervent, almost mass-hysterical veneration of the *Beautiful Madonna*, a work he had painted. On one of Altdorfer's prints, which was sold to pilgrims as an indulgence, Dürer wrote: 'This phenomenon appeared in Regensburg in opposition to the Scriptures. God help us not to dishonour his Holy Mother. Amen.' But two years later Altdorfer copied Cranach's well-known engraved portrait of Luther. From that time on, we see a clear movement towards greater peace and simplicity, without any compromising of his artistic creative power. Typical of his work of that period is his beautiful painting of a Danube landscape. It is one of the first free landscapes ever painted (not just a landscape as background to another subject). As such, it points clearly to the work of van Goyen and Ruysdael in the seventeenth-century Netherlands.

Altdorfer, who was a very prominent citizen in his town, never publicly converted to the Reformation. It was only after his death that his hometown in 1542 officially became Protestant. But we can certainly deduce a great deal from the fact that when he was dying in 1536 he asked to be buried in an Augustinian Church.

Did the Reformation mean anything for the world of art? We cannot go into this question in depth, but we can say with confidence that without it, the history of art would have taken a very different turn. The seventeenth-century art of our country [the Netherlands] and the art of southern Europe, where the Baroque art of the Counter-Reformation set the tone, would have looked totally different. Only those who believe that stylistic changes just occur, by themselves, would deny this. But in that case we would also not need to thank God for the great beauty that he allows to be created, as the fruit of true faith. For our part, we do not wish to deny him the praise he deserves.

• Albrecht Dürer's theory of created structures[297]

It is not necessary to state that Albrecht Dürer[298] must be considered as one of the greatest artists of all time; everyone knows that. Much less well

known, however, is the fact that he occupied himself very intensely with the theory of art and that during the last years of his life he even committed the results of his investigations to writing. The books that appeared from his hand, the last shortly after his death since he died before he could finish correcting the final printer's proofs, belong to the earliest works ever published in this field. For while Alberti had already addressed such problems in the fifteenth century and while Leonardo da Vinci had addressed the theoretical side of painting in particular, their works remained as manuscripts for a long time and only became known much later outside their very restricted circle of friends and followers.

The foremost problems that people dealt with in this period concerned especially the matter of how to render nature as accurately as possible. The questions of correct perspective, especially also as mathematically derived, and in particular also the problem of correct human proportions engaged their minds. They followed in the footsteps of antiquity! For one may read in Plinius and others that the ancients also devoted much attention to this, while in Vitruvius one could even read what the correct proportions were for the male body. The Italians adopted a chiefly rationalistic approach. They set out to discover the fixed, 'rational' measures for the human body, the fixed 'standard measure' whereby people could gain better control geometrically of the representation of the body. Dürer was also not entirely free of such notions, which had no doubt reached him via Italian influences, but he withstood the rationalistic element in it and, as a deeply believing person, adopted a more modest attitude. Thus he writes:

> Yet it seems impossible to me that someone should say that he knows which measure is best suited to indicating the human form. For the lie is in our insight and the darkness sits so deep in us that also our imitation fails. All the world should believe the person, however, who gives geometrical proof for what he says and in this way demonstrates fundamental truth. For this is binding to us, and it is right to see this person as one gifted by God to be a teacher in these things ... As we will not be able to achieve the best, does that mean we should stop our every effort? ... The sensible person will strive for the best.[299]

Dürer points out that there are some people who can find and render better and more beautiful human forms than others, but 'never so perfectly that it could not be done even better. For this perfection does not spring forth from the human mind. Only God knows such perfection, and whomever he reveals it to. Only the truth contains the most beautiful human form and measure.'[300] Thus according to Dürer there is a proportionality or measure that is the most beautiful, but this is known to God alone and we will never be able to find it in the midst of all of the diversity, where we also never encounter perfect beings. Yet despite that, 'our perception finds such an abundant beauty in the visible creatures, that no one can render this fully in his work.'[301]

Again and again he points in this direction: to investigate nature
and follow it, then we are safest. The way in which Dürer founds this
idea scripturally on the motif of creation may be clear from the
following citation:

> Do not stray at will from nature, and do not think that you will be able to find
> something better yourself, you will only be misled. For in truth art is to be
> found in nature; whoever can pull it out, has it ... But the more accurately
> your work in its forms resembles life, the better the work will seem. And this
> is true. Therefore, never intend to make something better than God has
> made possible for his creation. For your ability is powerless in comparison
> with God's creation.[302]

Hence also the advice: 'Do take care not to make something impossible
that does not spring from nature. And when one wants to create a
fantasy, then one may mingle all kinds of creatures together.'[303]

Dürer's last observation should alert us to the fact that we are not
engaged here with a plain naturalism that simply aims at the
'photographic' ideal of depicting nature uncritically. To the contrary.
For there are artists, so Dürer says, who can make good things by heart,
through their great knowledge and experience, and there are others
who, precisely because of their lack of insight, continue to portray
nature directly. And in all cases the imitation of nature must be
accompanied by deliberation and choice. Not only does he recommend
investigating the various parts of the body of many people and putting
the most beautiful ones that can be found together in a single figure, but
also 'that we should be on our guard against weaving deformation and
mutilation into our work'.[304] Thus he says not to depict the lame and the
blind and so on, 'what otherwise should be beautiful'.[305]

The question now is about the significance that Dürer attached to
his measurements and to the results that he incorporated into his work.
To understand that we want to examine what he means by *Vergleichung*.
We find it in the following citation, where he discusses the need to depict
parts of the body that are compatible with each other, since otherwise
violence would be done to nature:

> One should take special care that in every depiction a structurally sound
> (*vergleichlich*) figure is made, so that the same age or youth is found in all
> the parts of the body, and the head does not belong to a young person, while
> the breast belongs to an old person and the hands and the feet to a middle-
> aged person, or that the back of the body is young and the front old or the
> other way around.[306]

The idea is clear that Dürer expresses here with some difficulty, as he
must be reckoned among the first who discussed such scientific material
in the German language. The word *Vergleichung*, here used adjectivally,
designates something that we would call 'structure', as is evident from

the statement: 'A great structural similarity (*Vergleichung*) is to be found in different things.'[307]

It is this idea, namely to define the fixed structure of the figure and to express it in fixed relationships, that brought him to his measurements. Of course he noticed that in the process one must also take cognizance of the differences: 'Different paintings ask for different human beings.'[308] Thus one should distinguish between the two genders and, further, between races, age types and character types, stocky and lean, strong and weak. Thus he is out to find the fixed structure in that which is un-alike or dissimilar, which still has so much in common that they are comparable, of a structural type, as we would say. He is afraid to destroy the rich diversity of reality out of the desire for a system, which is why he says immediately, in this context, what we have already cited above, namely that people should not depart from nature. That can also be seen from the concept of *Verkehrung* that he uses elsewhere in a similar context and by which he wants to indicate 'individualization', the strictly individual within the structural type. For he also warns repeatedly about constantly using the same 'normal types' in view of the fact that reality is so infinitely varied and diverse.

Naturally we have come very close here to discussing the typical problems of the artist who depicts figures, because it is from that side that Dürer approaches the questions concerning the structure of reality. Our main interest, however, was to show how particularly believers can find a fruitful way in these matters if only they maintain true scriptural humility towards the Creator and his creation. As an artist Dürer thus says on the one hand that if you study the fixed structural types you can represent reality more faithfully – without falling into a plain naturalism, I would want to add – or, in his words: 'For in this way you guard the power of art against error and falsehood.'[309] On the other hand, he says, while distancing himself from every rationalism:

> But many are of a different opinion and speak about how people should be ... I, however, view in this respect nature as our teacher and the human delusion as error. Once the Creator made human beings the way they should be, and I believe that the right shapeliness and beauty can be found in the compound of all people. I want to follow the person who can extract this beauty in the right way rather than others who use a new self-designed measure that does not derive from the human beings themselves.[310]

• Dürer's Melancholia[311]

Albrecht Dürer had a deep respect for his intended public. His unsurpassed series on the Revelation of John, for example, created in 1498 – the work by which he established his name not only in that time

but for all ages – was produced as a woodcut. That was because it is an inexpensive process that allows for easy duplication. So Dürer's art became more accessible to the 'ordinary people'. He had no interest in an art by the élite and for the élite; instead, he wanted his work to be of service. He understood well that by serving one's neighbour, one is also serving God.

At the same time he found himself in educated circles where the spirit of humanism reigned which placed special emphasis on a study of history, science and art. His engravings were produced with these people in mind as they were made by way of a much more expensive and complicated method. For that circle of people he created his prints, often with deep philosophical themes. For us, as we are not familiar with the scholarship and culture of those days, these works are often very difficult to interpret.

One of these prints is his famous *Melancholia*, an engraving – or copperplate – dating from the year 1514. It is amazing how much has been written and researched in order to come to an accurate interpretation of this work of art. It is certain that astrology – a fashionable science in those days – plays a role in its intended meaning. Along with countless others, including people associated with Luther,[312] Dürer was not free from the misconceptions of his time. But our intention is not to describe and assess all those different attempts at an explanation since it would take us too far afield and would require endless research.

For it is our belief that even without these the print makes a clear statement. With incredible mastery Dürer created a mood that communicates even when we cannot accurately interpret every detail in the picture. I believe that this engraving serves as an illustration of Ecclesiastes 1:17,18. Around the central figure we see all kinds of symbols of scholarship: a complicated geometrical shape, a globe, measuring rods, a scale, a grinding stone (the last two items apparently are a reference to alchemy, the natural science of that day), a compass, and much more which the observant viewer will notice. In the middle of all that there is this figure, gazing ahead in a pensive way, having gained wisdom – specifically the wisdom of knowing that concerning the work of God, 'no one can comprehend what goes on under the sun' (Ecclesiastes 8:17), for 'whatever wisdom may be, it is far off and most profound – who can discover it?' (Ecclesiastes 7:24). The work seems to convey a kind of heaviness that expresses something of these profound thoughts. There is no despair here, just a deep wisdom and humility; no rebellion, but an understanding of our own smallness in comparison with God's creation. Moreover, is it not the rainbow, the symbol of God's covenant, that we see in the background? No, the view of the future contains no hopelessness, despite a clear understanding of one's own powerlessness with respect to the many deep, unfathomable questions with which God has burdened people to occupy themselves (Ecclesiastes 3:10,13).

It may be that no other artwork has ever struck such a profound note; even without an explanation of all the many details the piece speaks for itself. Vanity of vanities, all is vanity – that is the message of this work of art, spoken along with the [biblical] Preacher.

• Dürer and landscape[313]

The development of landscape painting in the fifteenth century introduced little that was new, other than a growing refinement of the techniques discovered by van Eyck and his contemporaries. We must not forget, though, that Hugo van der Goes, Dirk Bouts, Memlinck and Gerard David (who was already a part of the sixteenth century) were by no means just followers or imitators, but were all masters in their own right. But it is not until the sixteenth century that some new elements were discovered and developed. In this respect Dürer, who is the focus of our attention here, rose far above his contemporaries. We will discuss not only his place in the history of landscape art but also the various graphic techniques he used.

Germany experienced a period of massive turmoil and change in the early sixteenth century. Many diverse movements and trends coexisted and competed for a following. The art of this period was integrally connected with the profound spiritual struggles of the day and reflected the great diversity of world views; it is therefore difficult to capture it in a few words.

Dürer is one of the greatest artists of all time, a genius of almost incomprehensible diversity. He was a man full of conflicting tendencies who expressed himself passionately and vehemently, and yet strove to work within the rules that govern a controlled and rational style of art. He was an artist who could portray nature with great accuracy based on his incredible powers of observation, without ever becoming tedious or losing his eloquence. At the same time he sought to portray the ideal human figure, constructed according to the rules for proportion, etc. He was a man with an almost inexhaustible ability to fantasize, but he never depicted bizarre and outlandish worlds in his art (as is so common today); his monsters and his fantasy creatures are always plausible. Even his depiction of the most 'unearthly' visions imaginable, such as those from the Revelation of St John, have something self-evident and real about them without ever becoming shallow or losing their visionary qualities.

His art never lapses into 'isms' and therein may lie one of the secrets of Dürer's greatness. His art always conveys a healthy sense of reality, and the artist has a normal relationship with nature. That is to say, he never sees it as his enemy (as happens so often in modern art), but neither does he worship it, thus robbing it of its createdness (as Romanticism so often did). He presents the world as it is, without falling into a shallow

materialistic naturalism that recognizes only what it can see with its own eyes. In short: he recognizes his place as a creature among creatures, part of God's rich and diverse world in which everything has its place, and in which nothing stands alone or is a law unto itself. Every part is bound by the God-ordained order of creation.

Because of his rich personality full of conflicting tendencies Dürer is not easy to analyse or understand, but his perception of the world is rooted in a solid, Bible-believing background[314] and comes across as sound and true. That wholesome understanding is what makes his art so rich and full. Even when he allows his fantasies free rein and depicts the most unusual stories or imagines the things that John might have seen on Patmos, his art always retains a sense of 'normalcy'; it never becomes forced, weird, or contrived.

In 1595, and again from 1605–1607, Dürer travelled to northern Italy. The journey through Tyrol and the Austrian mountains had a strong influence on his landscape art. He captured some of it in a number of watercolours (most of which are housed in Vienna) which clearly show his growing insight into the structure of the landscape and especially into the portrayal of space.

In contrast with the more or less construed and schematicized landscapes of the fifteenth-century Dutch artists, Dürer's thoroughly natural representation is a large step forward in the technique of landscape drawing. He gives ample evidence of his mastery of this technique in his gorgeous copper engravings, which quickly became famous and were freely imitated. We especially want to point out his portrayal of fortresses built on rocky cliffs. He had seen these on his journeys through Tyrol and was such an expert on the subject of fortification building that he even authored a book on the topic. The picture that springs readily to mind today when we imagine an ideal castle has been largely shaped by Dürer's art. After all, have we not been familiar since childhood with his creations through reproductions and in works of better and worse quality by his many followers?[315] You should really try to see some of Dürer's original engravings and woodcuts. Enjoy especially the utterly wholesome and sound poetry of his panoramas which reveal not only the majesty of the natural world but also the most minute details – a blade of grass or a lizard. (Has any other artist even come close to Dürer's skill in depicting animals?) The many details are never imposing or intrusive but always keep to their own humble place.

Graphics

It was not only, or even primarily, his innovations in the field of landscape art that earned Dürer his fame. His incredible engravings and woodcuts will always be his most famous legacy, and it is in these that he has never been surpassed. To understand these graphic works of art, we will diverge for a moment to explain something of the technique and history of this art form.

Graphic art uses a variety of specific techniques to make multiple copies of an artwork. The oldest of these techniques is the woodcut. We know that the Chinese were acquainted with this process – in Central Asia, for example, a huge library was discovered of printed books decorated with woodcuts, probably dating back to the seventh century after Christ. Most likely, however, this technique was not directly carried from there to Europe. Rather, it was independently discovered here. The earliest known European woodcuts date back to the 1400s, although it is uncertain whether the honour of having created the first woodcuts on this continent belongs to Germany or to France. Still, it was not so much a discovery as a new application of a familiar technique, because already by the end of the 1300s people were making printed fabrics – i.e. fabrics to which the colours and motifs were applied with 'blocks'. When we remember that this technique was adopted from the Byzantine tradition, it seems possible that in a roundabout way the Chinese technique of woodcuts came to us in the West via the Byzantine route. Thus, it may be that Europeans just came up with the idea of applying this process to books and prints. It was such an inexpensive process that an almost infinite number of copies could be produced in this way.

At first this art form was used almost exclusively for making prints of devotional pictures – an unpretentious form of folk art. The woodcut was also used to illustrate books, but in this case it hardly rose above the level of a handcraft. It was Dürer who finally figured out how to use this process to create art of the highest quality. It seemed that in a very short time he developed the technique to a standard that it seldom reached again. Because of Dürer the woodcut also became Germany's art form par excellence in the early sixteenth century, and whenever this technique has been revived, Dürer and his contemporaries have served as the main source of inspiration.

The process of making a woodcut is based on the concept of relief printing. One takes a piece of wood and carves out everything that is meant to be white on the finished print. Thus the lines stand out like narrow ridges. Next ink is applied to the block, which is then pressed onto a sheet of paper so that the ink-soaked ridges make their marks on the paper.

It is fairly certain that the art of copper engraving or etching was discovered in Germany in the years just prior to the mid fifteenth century. It involves the process of intaglio, whereby the artist engraves lines in the copper plate using a burin (a kind of engraving tool). When ink is applied to the plate, it runs into the grooves, which then make black marks when pressed against the paper. This process, much more difficult than the woodcut, had already been used in the fifteenth century by a number of master artists; among them Schongauer is deservedly the most famous. Once again, Dürer managed to carry this art form to new heights of excellence, and perhaps his work set the highest standards for what can be done in this genre. He has never been

surpassed and has seldom been equalled. It is a process that allows the artist to draw incredibly fine lines and intricate details. One can do no better than to see some original Dürer prints, which can be found in the print galleries in the Gemeentemuseum in The Hague, or in Leiden or Amsterdam, for example. The treasures lie there just waiting to be discovered. Reproductions can give only a very relative impression of the actual quality of the artwork, since it seems that the precision and fineness of the lines and the deep black colours can never be satisfactorily reproduced.

Then we have etching. Apparently this technique was first used by weapon-smiths, who used it to create elaborate decorations on harnesses, etc. Taking a metal plate, one coats it with a thin layer of wax, scratches the desired image into that wax using a needle, and then immerses the plate in an acid-bath. The acid only eats away the areas where the wax has been scratched off and thus the image is engraved on the metal plate. One can then use that metal plate to make copies; this process is one that we call intaglio. The advantage of etching is that one can draw in the wax, as it were, so that the lines can be much more flowing and free than is possible with the much more difficult techniques of woodcutting and copper engraving.

The first etchings were produced around 1500. Dürer used this technique too, on occasion. But stylistically his etchings are closely related to the copper engravings. It was not until the seventeenth century, especially in the work of Rembrandt, that this technique gave rise to a new genre of art with its own unique character.

An example: Dürer's Cannon of 1518

It was hard to choose an artwork to discuss in this article, since Dürer's body of work is so incredibly vast. We selected this particular etching of a cannon in a landscape because it gives a good impression of Dürer's skill as a landscape artist.

Notice the spacious breadth of the panorama. Notice how vivid and detailed the images are without ever becoming overly fussy – is that not how we actually experience reality? It all looks so natural that there is hardly anything to say about it – explanation is not really needed. But the extraordinary quality of the work is certainly not commonplace, make no mistake about that. Notice how Dürer places the little town on the plain – so naturally, without anything being squashed – just the way things really appear to us. The wide pastures and mountain slopes spread themselves out beautifully in the distance, interspersed occasionally with a grove of trees. On the left we see a lake or the ocean with little ships sailing on it; many more lie in the harbour of a town of which we can see only the faint outlines. Take note too of the wonderful play of light and dark across the print, contributing not only to a lovely and responsible composition, but also giving each area the proper emphasis and the appropriate contrast with the other parts.

In the foreground we see a large cannon: it, too, has been rendered appropriately and vividly. Dürer was interested in just about anything, and there was no area of reality he considered beneath his dignity. He had an interest and a loving concern for the world around him – a rare thing for artists today. The cannon has been magnificently incorporated into the whole, and portrayed in a way that is not at all contrived or forced. It is anything but a technical working plan, despite the technically precise and fine details. Notice the man with the turban standing there looking at the cannon – once again we can point to the ease with which these figures move, the naturalness of their pose, the artistically flawless way in which they have been placed: they really do stand with both feet on the ground. We are reminded that during the time this print was made (1518) a war with Turkey was raging.

Undoubtedly there is much more to see in this marvellous print, which in the original measures 22 x 33 cm. We see here in a completely convincing way a portrayal of reality, in which everything is in its proper place, nothing has been overdone, but neither are there any 'empty spots'. All of the elements have been woven into a composition that ties together the individual parts, the play of lines on the surface and spatial dimensions. The landscape is not just depicted but has become a poem with its own unique rhythm and sound.

• The Resurrection theme in sixteenth-century art[316]

In this article we will consider three different artworks depicting the Resurrection of Christ. All three were made between 1510 and 1520 in southern Germany. The earliest is Albrecht Dürer's woodcut created in 1510, one of the segments of the so-called *Grosze Passion*. It was certainly not the first time this theme had been portrayed, and Dürer kept quite closely to tradition in this work. That was appropriate, because the established formula used in those days to portray this story could not have been easily modified without giving the impression that the truth represented by the image was being disparaged in some way. It would have been comparable to playing around with the formulation of the Apostolic Creed: you simply don't tamper with a document like that, even if you are not actually changing its meaning. In art it does not matter whether you are completely original or freely create something yourself, what matters is what you are trying to say with your art. Dürer, being one of the greatest artists, was capable of creating something truly original while at the same time preserving the established compositional elements; thus he breathed new life into traditional forms.

In the centre we see a tomb – a freestanding tomb, not a cave. To the right and left are soldiers who look more asleep than shocked almost to death – but here again, Dürer is following tradition. The resurrected Christ himself is seen hovering above the grave, elevated above the

mortal world. Dürer clearly portrays him as the Holy One, very different from ordinary humans, by placing him on the clouds. Those clouds seem to envelop him like a kind of aureole, and the free-floating end of Christ's robe serves to reinforce that concept. Christ himself holds the banner of the Cross in his hand, and his right hand is stretched out in blessing. A cross-shaped patch of light near Christ's head once again clearly underscores who he is.

The second example is a section of the famous *Isenheimer altar* by Grünewald, which can be seen in Colmar. If you look carefully, you will notice that this artist was thoroughly acquainted with Dürer's work: notice the position of the soldier in the left front, the stance of Christ, etc. Because of these similarities, the differences become even more apparent. In contrast to the work of the ardently dogma-confessing Dürer, Grünewald intensifies the whole scene and places strong emphasis on the supernatural. Christ looks more like an apparition than like the Man of flesh and blood portrayed by Dürer. Grünewald was a mystic, and in this painting he uses the event to render an account of his views.

The third artwork we wish to discuss is one by Albrecht Altdorfer, an artist from Regensburg on the Danube. This moderately sized painting (on display in Vienna) also shows the influence of Dürer's print: notice the form of the weapon along the left side of the painting; notice the sitting soldiers; and take special note of the position and place of Christ. But again, what differences there are! If you could see this painting in full colour, you would be struck by the red and gold sunrise above the mountain range, the mighty clouds, and the peculiar pine tree. The artist shows us these things as if we are looking at them from out of a grotto. To Altdorfer, nature was a strange and almost explosive force, and many of his drawings bear witness to his intense emotions. In this work, too, the significance of the event is expressed more in metaphorical (comparative) terms through what is happening in nature than told by the story itself. That also explains why the figure of Christ is proportionally so much smaller.

Dürer was a believer who just a few years later would become a follower of the Reformation, but in reality he had always been a reformational thinker. Grünewald is a mystic, connected with the Anabaptists. And Altdorfer certainly championed an extravagant devotion to Mary, but more to drown out his own uncertainties and doubts. In the 1520s he would become a follower of the Reformation, and his art would take on a much calmer tone, more joyful and less intense. These three works of art clearly express their artists' religious views.

In 1623, Heinrich Schütz wrote his *Historia der Auferstehung Jesu Christi*. We could call it a kind of cantata or, perhaps better, an oratorium. But we must keep in mind that Schütz was the first to write something like this, a piece intended for use in a Lutheran worship

service. He incorporated many new ideas, and this piece is very different from similar pieces from the preceding era written in the Roman milieu. It is written in German and the evangelist is accompanied by a basso continuo, a new technique for that time which the composer had learned in Italy. The delivery reminds us of Gregorian chant but, just like Dürer, Schütz succeeded in breathing new life into old forms. The text is not only recited in a lively way but is exegeted, underscored, portrayed and presented in a superbly musical way; the music at the same time expresses artistically how deeply this believing composer respects and is moved by the words of Scripture. It is a pleasure – or better said, an experience! – to listen to this piece. In faithfulness to tradition the speakers [in the text of the gospels] are not introduced as solo voices but in two or three contrapuntal voices. The text is very clear, and the music full of word painting. We want to point out especially the excitement of the apostles on that Sunday evening as they tell the two disciples returning from Emmaus that some of them have seen the Lord.

The text of this Easter story has been compiled from fragments out of the different gospels to form a continuous and complete narrative – and this is done in a brilliant way. The music is wonderfully new and fresh, and absolutely gorgeous – it is written in a seemingly natural, sober style, which at the same time represents a pinnacle of excellence in the history of song. Schütz is not just a forerunner of Bach but a great master in his own right. In a piece like this he may even surpass Bach; certainly that is the case in the evangelist's recitatives (if we compare them with similar parts in Bach's *Passions*). Though he learned much from Monteverdi, the great Italian composer of the early seventeenth century, Schütz' work has such a different content, such a unique sound and atmosphere, that on first listening it is difficult to recognize the similarities. The differences are as great as those between Altdorfer and Dürer, though we should rather compare Monteverdi with someone like Raphael or Carracci. Schütz, however, can be compared with Dürer, for a similar faith, a similar inspiration, a similar reverence for the Scriptures, for the meaning and content of the Bible, shines through in their works. We can call this truly Christian art!

Much more could be said about Schütz' work, but we were prompted to write these things in response to a beautiful new recording which has recently come out under the Archiv label (14118 APM). It is an almost flawless performance and we certainly hope you will have a chance to hear it. As is always the case with Archiv recordings the introductory notes and text of the sung words have all been produced to the highest quality. If you have a birthday coming up, you now know what to put on your wish list; if not, perhaps you can find a way to acquire this amazing recording.

• 'Expressionistic' and 'normal' in Altdorfer's work[317]

> A work of art is a world in which everything has its place, and in which each element is given the place most suited to it. It is a place in which the essential is never subordinate to the non-essential, nor the more important subordinate to the incidental or coincidental. On the other hand, it is a very limited world, appropriate to our limited human capacity.[318]

These words are very true; in particular we must never lose sight of the truth of that last sentence. For art is always a *human* expression, and therefore the artist's own perceptions about the meaning and the structure of things will be expressed in his or her art. When each part and each value is assigned its proper place, in accordance with reality, and when the structures and the proportions (in both the literal and the metaphorical sense) are in harmony with the true nature of things, then we will have truly good art.

Thus in an artwork the artists express their vision of reality in their own way. In the first place that will be evident from their choice of themes; artists are always searching for relevant subjects through which they can most clearly express their own views. In the second place their views will become apparent from the manner in which a subject is presented. In this way art is directly related to all of life, for the artist's life, ideals and disappointments, the world in which she or he moves, will all leave their stamp on the work. We could state more generally that the art of a certain period of time will always reflect the quality and depth of the societal life of that era. The diversity of trends and views in each period, and all the things that occupied people's minds, will reverberate in that era's art – the profound as well as the trivial, the deep as well as the superficial, the beautiful as well as the ugly, the good as well as the bad. That is why we can learn so much about a particular period by studying its art, assuming that we allow the art to speak to us in all its facets and not restrict ourselves to only the good art but also look at art that is of inferior quality and value.

The first half of the sixteenth century in Germany was a complicated and restless time. It is no wonder that the art of that period was very diverse, reflecting the variety of trends and movements. This makes it incredibly fascinating but also rather difficult to study the art history of that time. We will try to present a rough overview here to give you an impression of the incredibly diverse movements at work. It will not be possible, of course, to explore each one in great detail.

We have already spoken about Dürer's work several times before,[319] since he was the greatest and most important artist of the time. Besides that, we have art with strong mystical tendencies, deeply passionate and extremely colourful, vehement in its expression and stirring in its form: we think especially of Grünewald in this connection. Next, we find art that is equally passionate but much more secular. It is rich with a fierce

intensity of life, and it has a special love for the diverse and colourful life of the soldier (and his sweetheart). This art takes a special interest in the activities of the Swiss *landsknechts* (mercenary foot soldiers) and its most notable representatives are Urs Graf and Niklaus Manuel Deutsch.

Baldung Grien's work is equally intense. His work was strongly affected by the prevailing superstitions of the day, with witches being his favourite theme, but it was also influenced already by humanism, evidenced by his interest in the human body and his love of allegory. He also preferred the subject of death, but that was not uncommon in those days. (Think, for example, of Holbein's *Dance of Death*.)

Then we also see reflected in art that scholarly humanism which glorified antiquity but at the same time seems to have taken the liberty, partly due to a lack of real knowledge, of playing around rather freely with the facts. We noted that already in our discussion of Dürer's *Melancholia*. There was, however, a whole group of artists for whom humanism held much weightier significance than it did for Dürer; for them it was integrally connected with their thoroughly secular world view, and they searched for rational laws and a control over nature.

Finally there is art that is closely tied to the church; in particular we are thinking of the so-called late Gothic Baroque. (If you saw the 'Viennese Exhibition' in Amsterdam in 1947, you will undoubtedly remember the statues by Luchsperger.) But we will deal extensively with Baroque art another time.

Expressionism

We will now focus on the Danube school. Its art displayed a kind of romanticism and, at times, an unadulterated expressionism. Its main characteristics are the passionate expression of a person's deepest feelings and the direct visual representation of those emotions and feelings. Having said that, we need to explain what it is that inspires and sets into motion such passionate feelings. In the early sixteenth century the Germans reflected on their own aspirations and emotions. Most of them were nominally Roman Catholic, but their lives had become extremely secular. Although they often took their outward religious duties quite seriously, so that superstitious traditions like worshiping saints and selling indulgences reached an all-time high, these people were really just interested in following their own desires.

On the one hand the church's secularism inspired a counter-reaction: a desire for holiness and a purer form of piety. This led either to mysticism – which flourished freely – or to a hunger for the true Word. Many people desperately flitted from one preacher to another in their hunger to hear the true voice of the Master, but all too often they received stones instead of bread (as in sermons that were obsessed with speculations about the thousand-year reign, for example), and they inevitably turned away in great disappointment. Finally the Lord sent his witness in the person of Martin Luther.

On the other hand, however, one of the logical results of the church's apostasy was a desire to break free from those hollow and superficial traditions that seemed so meaningless. More and more, people left the church and everything connected with it and aimed at an ever more consistent secularism. The control of nature and the ideal of individual freedom became the primary values. Here we see the beginnings of the modern mindset, free and autonomous. It should not surprise us, then, that the art of that period often bears a strong resemblance to the art of much later times – and in particular to the Expressionism of our own [twentieth] century.

What is the nature of expressionism? Mainly, it involves a preoccupation with the natural world. But it is a natural world that has become hostile and mysterious, sometimes to the point of being demonic. Absolute human freedom is restricted by that natural world, since it limits and even opposes human efforts. When people reject and even fight all laws and norms they will be unwilling and unable to see the steadfast structures that order God's creation. Rather, they see nature as a world in which strange and mysterious primitive forces are at work. In their view, the apparently orderly, regular and controlled laws of nature are in constant danger of being upset by unfathomable, uncontrollable and completely irrational (i.e. unpredictable) tensions. Primal forces, in the deepest sense completely chaotic and senseless, reveal themselves in the observable natural world and constantly threaten to destroy it, to explode, so that all individuality is lost again in a totality that is as purposeless and cruel as a huge, stupid beast. A person's life in this dangerous world is as precarious as if he or she were living on the edge of a volcano. Nature, completely hostile to humanity and human culture, demonic in the deepest sense of the word, destroys all law patterns and order.

This is how Graham Sutherland, a contemporary British painter puts it: 'In my opinion the vision of a painter must be rooted in reality, and that which is mysterious and intangible must be made real and tangible.' And Herbert Read writes of Sutherland's work: 'His art betrays the longing to reveal the workings of a hidden germinative power, and to sketch the unexpected forms which life gives rise to in its blind creative passion.' Those unexpected forms are then, for Sutherland, the relevant forms. Sutherland himself has said that 'sometimes during a walk that I have walked dozens of times before, something that I earlier on never noticed suddenly springs into the foreground and becomes intensely real.' A similar form, which symbolizes the nature of reality as we have characterized it above, can be seen in his *Green tree form* of 1940. It is horrifying, cruel, hostile, and thoroughly primitive.

Altdorfer

A rather lengthy introduction to lead us into the topic of the Danube school! But now, when we study Altdorfer's 1511 drawing of a Danube

landscape, we can begin to see the strong connection between his sinister, mysterious, and freakish tree and the one painted by Sutherland. This connection did not come about because Sutherland borrowed ideas from Altdorfer or was being influenced by him, but because there is a similar understanding of reality at the base of their work. The rest of that vast landscape by Altdorfer is in complete harmony with the atmosphere created by that particular tree; it is a totality in which form is held in close check but threatens at any moment to break apart in chaos. This reality is perceived very romantically, but 'romanticism' in this context means nothing other than expressionism, though somewhat more moderate and still bound to a certain extent by tradition.

What do we know about Altdorfer? He was born around 1480; in 1505 he established himself in Regensburg, situated on the Danube in southern Germany. His earliest works of which we are aware were created in 1506. The early works encompass mainly humanistic themes like Mars, Flora, allegories of the Virtues, scenes with satyrs, etc. In addition, we see an affinity with the Swiss artists whose main focus was the lives of the *landsknechts*. Then we also have some biblical themes, and some scenes depicting the lives of the saints. A particularly famous work portrays the *Flight into Egypt*, with Mary sitting by a large fountain, some ancient ruins in the background. For 'romantic' artists, ruins are a common and very relevant theme, for they show nature winning out over culture. At the same time the forms of the ruins are appropriately irrational, arbitrary, wild and unsteady. Altdorfer builds some very romantic ruins into his nativity scenes too, and emphasizes this mood with a strange kind of light.

Around 1509 he took his first trip along the Danube towards Vienna and Austria. There he learned the ancient art of these countries, as well as the art of the young Cranach which displayed similar expressive qualities. (Cranach later travelled to Wittenberg, where his style underwent a radical change.) The expressionistic tendencies already present in Altdorfer's work now became more vehement and more outspoken. After a period of more restful, balanced art he entered a second period of *Sturm und Drang* with the making of his large *St Florian altar* of 1518. Around this time, a new cult emerged which venerated the Regensburg statue of the Virgin Mary, convinced that it had miraculous powers; in this connection Altdorfer received a number of commissions.

After that, however, his work became gradually more restrained, more attuned to reality and its structure. Landscapes without figures became his main focus, and along with that we see many different humanistic themes. The latter were strongly influenced by the Nuremberg Kleinmeister, true humanists who were in turn strongly influenced by Dürer. In addition, we see a growing trend towards portraying events from daily life, with the *landsknechts* and knights receiving less attention. Altdorfer began to portray the day-to-day life around him, even in his creation of the 1526 masterpiece of the story of

Susanna. In general there are fewer works on saints' lives, and a growing interest in the themes of the Crucifixion and the Old Testament stories.

By 1519 Altdorfer was a member of the town assembly and in 1526 elected to the city council. During that same time he also became the town architect. In 1528 he was asked to become mayor, but he did not accept the position since he was busy with a large commissioned work for Duke William of Bavaria, *Alexander's battle*, a masterpiece of unsurpassed excellence which we unfortunately do not have time to discuss here.

It is important to recognize Altdorfer's growing sympathy for Lutheranism during these years. During 1521–1525 he engraved a portrait of Luther after the well-known print by Cranach. In 1533 he was one of the 15 councillors who decided to call a minister to the church built especially for the Mary statue with miraculous powers that we mentioned earlier, a minister who would be instrumental in putting an end to this Madonna worship.

Altdorfer died in 1538; in his will he stated emphatically that he wanted nothing to do with the prayers for the dead in the church. Although it cannot be confirmed by further writings, it is very well possible that the stylistic change in the 1520s toward an art form that looks at reality in a more positive light is directly related to his increased interest in Lutheranism. We must remember that the break with the 'old' church was usually not so clean and sharp in these early years of the Reformation; actually people were often hardly aware of the radical principled departure from traditional attitudes displayed in the works. Gradually that became clearer, particularly as the conflict heated up.

Despite the fact that, thematically, the break was not very sharp (though it is clearly there), I believe that in this new, non-expressionistic attitude toward nature, there is evidence of a more scripturally sound attitude toward God's creation. When we look at Altdorfer's later landscapes (after 1522), we notice the calmness and the realism which had by now taken hold of him. Just prior to 1520 he produced vehemently expressionistic works; afterwards he produced idyllic and pure representations of nature, without any mystery or demonic elements, without irrationality. Instead we see nature in its wholeness, rich and warm – a scene that instils confidence. The spirit such a work evokes is so different from what his earlier work did that we can hardly attribute the change solely to aesthetic 'influences'. The only thing that can account for such a drastic change is a profound change of heart on the part of the artist. Reality becomes 'normal', free of all unnatural tension. Reality is accepted and welcomed just as it is, the natural setting in which God has placed us, which in his faithfulness he maintains and in which he draws near to us, his covenant children, protecting us from the Devil and his whole dominion. It is a world in which we, as his creatures, may work and enjoy life freely, in the fear of the Lord. A larger and more profound beauty is revealed, and God's world is no longer our enemy, but a peaceful valley, a foretaste of the new earth.

• Patinier[320]

For a long time Patinier, who worked in Antwerp and obtained master privileges in 1515, was included among the world's most famous painters. A somewhat later commentator on Dutch art grouped van Eyck, Patinier and Bruegel together, calling them the greatest of all artists. While there is no question about Patinier's exceptional talent, such praise and fame may be somewhat overstated. And it has not proved to be true, even though he has always remained a popular and well-loved artist.

Perhaps some people will base Patinier's fame on the fact that his name is often used to represent all of Flemish sixteenth-century landscape art until the time of Bruegel, who was considered the next great pioneer. Undoubtedly Patinier was the most illustrious and productive talent of the landscape art of his time, but he cannot really be called a pioneer. He is often called the first true landscape artist, and shortly we will see whether that label is justified, but he certainly was not the creator of this artistic genre.

Landscape art was born in the fourteenth century, and in the early fifteenth century it was carried to incredible heights of excellence by the unsurpassed art of Jan van Eyck. Undoubtedly Patinier linked up with this tradition established by van Eyck as well as by Campin and Rogier van der Weyden, which was taken a step further by master artists like Bouts, van der Goes, and Gerard David – who will not be unknown to those readers acquainted with the Flemish Primitives.[321] In previous articles we have explored the role of Albrecht Dürer, the second genius in the history of European landscape art,[322] who built on the foundation laid by those masters as well. And the tradition thus enriched by Dürer became the point of departure for the art of Albrecht Altdorfer, who perhaps mostly rightfully holds the honour of having painted in 1525 the first pure landscape in the history of European art

The birth of this new genre – landscape painting – was a strange affair. Although the Italians already had considerable accomplishments in this area by the fourteenth century,[323] the actual development of the depiction of landscapes was a typically Netherlandish occurrence. Perhaps we should be even more precise and say that the origins of this love for landscape and its portrayal in art was located in the Northern Netherlands. For it is very likely, even though it has not been definitively proven, that van Eyck's art ties in with Utrecht traditions. Both Dirk Bouts and Gerard David came from Holland as well, although they spent most of their lives in the South and produced their art there. As the benefits of this love for nature and its artistic development were incorporated into Flemish art, the artists named above can rightfully be seen as part of that tradition.

We were quite careful in our wording just now, speaking of the development of the depiction of landscapes. That is because in the entire

fifteenth century you will never find a work that portrays a landscape only. Rather, you will always find a biblical scene in the foreground, or a legend, or a saint's life, or possibly even a portrait – and those are really intended as the main subject of the painting, while the landscape unfolds unobtrusively in the background. The figures are seldom actually a part of the landscape; rather, they are standing in front of it. Thus, the landscape has no meaning in itself yet but serves a subservient role. In Italy the landscape played an even more minor, secondary role. There were some significant early achievements in this genre, but they remained quite isolated examples. In the fifteenth century too there was some progress, but on the whole the figures in the foreground continued to hold the primary interest. For this reason Italian landscapes were usually influenced by the Flemish, whose art was highly esteemed.

In terms of the breaching of medieval traditions and customs, however, the Italians were further along than artists in the North. Although we may also speak of Renaissance in relation to the North, the Italians were much more deliberate in their profession of the new secular humanistic ideal. Based on this ideal we see a resurgence and glorification of antiquity (their grand national Italian history). Tied in with this is another feature of the Italian Renaissance, namely aestheticism, which stated that beauty in itself should be treasured as the ultimate value and that everything else should take second place. This helps explain why in Italy, much sooner than anywhere else, people began to view paintings not for the images they showed, the content, the meaning, but purely for their aesthetic value, their quality, their beauty. And this is one of the reasons why we could expect Italian Renaissance people to look at a Flemish painting only and purely for its gorgeous landscape, basically ignoring the holy subject in the foreground, which after all was considered by these secularized people to be just a symbol of custom and tradition.

Indeed it is true that in Italy, much sooner than in northern Europe, they began to use the term 'landscape' when talking about a painting. When Margaretha of Austria took inventory of the belongings in her Mechelen Castle, for example, during 1524–1530, there was no reference to a painting as a landscape – that word never surfaced. But already in 1521 the Venetian M.A. Michiel referred in his notes to *tavolette de paesi*, i.e. landscape paintings. And then we have to remember that he is actually referring to the work of a Northerner – perhaps Albert von Ouwater, a painter from the latter part of the fifteenth century who certainly did not paint pure landscapes. In other words, Michiel simply looked past the subject in the foreground to that which he considered the more beautiful and significant part of the work, and classified the piece accordingly.

A similar perception is found in Leon Battista Alberti's work about architecture (written around 1450, and published in 1486) in which he says:

In the painted arts as well as in poetry we must distinguish various genres. The genre which portrays important people who are worthy to be remembered is different from one which depicts the daily activities of ordinary citizens, which is again different from one which depicts the lives of farmers. The first, which has an elevated character, should be displayed in public buildings and in the homes of important people, while the latter genre is more suitable for gardens, since it is the most appealing of them all. Our spirits are truly gladdened by viewing paintings which depict lovely pastures and harbours, fishing and hunting, swimming, romping shepherds, flowers and greenery.[324]

This emphasis (and you must remember that he is talking about things which hardly existed yet in his day) must have led to a deep respect for these elements in Flemish art, even if the artists themselves and the society they belonged to did not value them in the same way.

For humanists the writings of Vitruvius (the only writer about ancient architecture whose books have been preserved) on the issues which Alberti is discussing are essential and may have played a role in the birth of this new genre: the pure landscape, for its own sake. In his writing about the painted decoration Vitruvius rejected the absurd – the playful fantasies depicting impossible situations, animals, etc. which had become accepted in the decorative art of his time (in Pompei, for example). He said that it would be better to paint large panoramas on the walls – and by that he meant large landscapes. (There are other issues to be considered here, but we will leave those for now, and will come back to them in our discussion about the later landscape art.)

Knowing these things, we can understand why a typical Renaissance ruler like Federigo Gonzaga of Mantua was given a choice from no less than 300 Flemish paintings, from which he selected quite a few. It also helps us understand that around the mid sixteenth century many of the homes of ordinary citizens had northern landscapes hanging on their walls. And now, to come back to our starting point, many of these landscapes would have come from the hand of Patinier or one of his followers. Thus we can understand the reasons for Patinier's fame.

Around 1500 the Italian Renaissance and its art began to be seen in the North as something glorious and sublime, as something worth imitating. Thus was born the myth of the superiority of Italian art. For every young painter it became imperative to travel to Italy at some point. People began to copy Italian forms, though not without difficulty at first, and not without the artist's own traditions often breaking through, giving Flemish art, for example, a flavour all its own.

When Joachim Patinier established himself in Antwerp in 1515 as a master artist, he was entirely entrenched in this new movement. We can understand that he gave the landscape a much more prominent place than it ever occupied before. While it is true that all his paintings show some holy scene (sometimes very tiny), the emphasis almost always lies

on the landscape itself. Personal preference and talent will certainly
have played a role in this; Patinier was not good at painting figures, and
very often the figures in his landscapes were painted by other Antwerp
masters (Quinten Metsys, also known as Massys, for example), or were
painted by him in imitation of someone else's work. It is well known, for
example, that when Dürer visited Antwerp in 1521 he gave Patinier a
drawing of St Christopher with the clear intention that Patinier was to
use it as a model for the figures in his own paintings. (In his diary Dürer
calls Patinier a landscape artist.)

Patinier's works have a remarkably unique character. They are
often immediately recognizable because of their unusual rock
formations. We find similar rocks in older art too, in Italy (e.g. in
Mantegna) as well as in the actual Flemish landscape art (e.g. in the
work of Dirk Bouts) with which Patinier quickly associated himself. Still,
his rocks have a unique character. They are much grander, and his
landscapes are more dominating than other attempts. Some have tried
to explain this by pointing out that he came from the Ardennes, where
as a child he often saw rock formations. Nevertheless, he would never
have seen rocks quite like this, or situated this way in a landscape – not
even in his native country.

It is therefore essential to remember when we view these paintings
that we are dealing with fantasy-like images, not portraits of a specific
scenery. The latter did not appear until much later in the painted arts,
though it appeared earlier in the genre of drawings and sketches.
Think, for example, of the watercolours painted by Dürer during his trip
over the Alps. But Patinier paints these panoramic scenes so
convincingly that we can understand and forgive the Italian Paolo Pino
when in 1548, in an attempt to explain the wonders of Northern
landscape art, he wrote: 'The Northerners demonstrate a special gift for
landscape painting, since they are portraying the scenery of their own
fatherland, which lends itself to very appropriate motifs, while we
Italians live in the garden of the world, which is more wonderful to see
in reality than in paintings.'[325]

The unique characteristic of Patinier's art is the tranquility it conveys
despite the wild rock formations. He has complete control of the
medium and his landscapes are always composed in such a way that the
eye, which is directed past various objects like forests, houses and rocks,
towards the depth, loses itself in the distant view in which the symphony
of motifs finally dies away quietly. This is possible because his viewpoint
is always quite high, giving us as it were a bird's eye view. Moreover, if one
looks closely and feel like scrutinizing them, the mentioned objects
seem to be depicted from the wrong angle – i.e. not as if viewed from
above but, rather, from the side. Our attention is drawn from one object
to another – notice the ingenious way in which the artist achieves this
effect – while the whole scene thus becomes, as it were, a display case of

landscape wonders. Something similar, though more schematic, can sometimes be seen in the prospectuses one gets from travel agencies in which places of interest are indicated by tiny drawings on the maps, likewise giving a 'horizontal' view.

Then there is also a painter by the name of Herri Patinier, also called Herri with the Blaze, who came from Bouvignes and in 1535 became a member of the Antwerp guild. His relationship with Joachim Patinier is not entirely clear; he is probably a younger blood relation. There remain many unanswered questions with regard to the landscape art to which both Patiniers, the Cocks, and a few other artists devoted themselves. Many of these paintings are still listed under the name of one of the Patiniers while probably painted by one of their followers. Herri himself worked in the style of his uncle, though not at all as a slavish imitator.

In the foreground of the painting by Herri Patinier that is to be found in the Uffizi in Florence, you can see people mining copper. The woman on the horse with the man walking before them is reminiscent of the Flight into Egypt, but the fact that there is a child sitting behind the woman clearly indicates that it is not a depiction of that story. There is much in Herri's art which Bruegel would later develop further. Also the landscape in this painting seems like a halfway step between Joachim Patinier and Bruegel, and the same is true of the image in the foreground. It is not a biblical story (as Joachim would have painted), secondary in significance as it may have been, but neither is it yet a depiction of the lives of ordinary folk as we would find later with Bruegel.

There is something romantic about this landscape with its rough, bare rocks, the castles on top of those cliffs, the distant panoramas, etc. Undoubtedly there was a deep yearning for romanticism in sixteenth-century landscape art – romanticism in the sense that nature is considered a strange and alien power that overpowers humanity and in the presence of which people feel very small. The majesty and strangeness, the unsuppressed, uncontrollable irrationality that emanates from a landscape like this, appeals to the romantic person and is relevant to the romantic world view.[326]

In the Northern Netherlands that romantic tendency was breached in the seventeenth century by a more direct and sober contact with nature, nature viewed as God's creation. Elsewhere, however, until and including the Romantic era of the nineteenth century that tendency lived on, although the forms in which it was expressed would undergo a change. The unstable equilibrium[327] inherent in romanticism, between bowing before nature and attempting to realize our own human freedom, would be upset in the course of the nineteenth century. This would lead first to Impressionism, and then to modern art. But we will postpone our discussion of these problems until they come up in a later article in this series.[328]

• Philosophy and art: Pieter Bruegel[329]

Philosophy and art are often mentioned in a single breath, although in fact they are very different cultural activities. Yet there is a reason for that. We will not here enter deeply into the different ways art fulfils a task in the cultural community. We want to call attention to just one facet.

Naturally, there are in every age many artists who make light-hearted works, nothing new culturally speaking: in literature they write light fiction, in painting they create qualitatively quite good works but without the depth that would mark them as a special contribution to human culture. Often, however, works of greatest skill might also be viewed as such. The great artists are regarded as people who have attained the highest pinnacles of human achievement and they are revered as builders and leaders of culture together with the great philosophers.

And indeed we believe it is correct to grant them this status. For an artist like the one we shall discuss here does not make his way along smooth, well-travelled paths but instead discloses new perspectives, literally presents a new look 'at the matter', the 'matter' that is the creation, reality in its fullness. It is not true that a great artist just depicts what he or she sees, for art, even the most naturalistic painting, does not represent reality 'objectively'. On the contrary, artists depict reality as they see it, while we must understand with 'see' a seeing in the spiritual sense, a seeing that involves interpretation, insight and vision. Painters – for we want to restrict ourselves here to painting – present their view of reality through their choice of theme and their way of rendering it, which reveal what seem to them to be relevant and essential. And in this respect the artist is like the philosopher. Philosophers give a scientifically elaborated synoptic view of reality that at bottom is conditioned by their life and world view; artists 'think with their brush', painting what seems to them to be meaningful and significant in the totality of reality, which likewise is equally conditioned by their view of life. And when we put it that way, we can no longer consider only the subject – Diana or a woman reading the Bible or peasants – but we must consider especially the manner in which that subject is treated.

As an example we want to focus our attention here on the great artist Pieter Bruegel. We shall be brief about his life.[330] He was born in 1528 and arrived around 1550 as son-in-law and pupil of Pieter Coecke of Aelst in the studio of the engraver Hieronymus Cock, for whom he made engraved copies of Hieronymus Bosch. Soon, however, he started to travel – to Italy, and it was the Alpine landscape that had a great influence on the development of his landscape art, as we also saw with Dürer. His drawings of the Alps are tremendously impressive. On his return they were turned into engravings by his former boss, Cock, and thus they had a thoroughgoing influence on all of the later sixteenth-century landscape art. He undoubtedly learned a lot in Italy, but in no way did he become an imitator of the Italians. Besides, Bruegel was such

a brilliant master and he handled everything that we could point to as examples in such a unique way, that it seems a little pedantic to even suggest this. After his return to the Netherlands, until his death in 1569, he created a series of masterpieces that are without equal.

Bruegel is often viewed condescendingly as a painter who simply depicted peasant life. Now, one should not underestimate the meritoriousness of his having done that. Before Bruegel, who worked in Antwerp, no one had ever really painted peasants. They had been presented as vile, vulgar, uncultivated and filthy figures from the standpoint of the exalted noble classes or as more or less unreasonable criminal or comic figures, as for example in depictions of the Mocking of Christ. But to see peasants as they are, from the viewpoint of someone who stands beside them, and to know them as they are, that had never happened before. In that respect Dutch seventeenth-century art owes a great deal to Bruegel. One must not forget that apart from Bruegel and the seventeenth century, peasants, which is to say the lower class of common people, were seldom represented so soberly as seen from their own standpoint.

That Bruegel could do that, a truly renewing deed, yes even a revolutionary deed, is most probably connected with his own view of life, which located what is meaningful and significant precisely in the everyday life of ordinary folk that persisted without change throughout the centuries, in contrast to cultural life that he regarded as meaningless and perceived as but at most a ripple on the surface. However, this does not mean that he always portrayed the peasants in their full humanity as is done in Dutch seventeenth-century art. More often than not Bruegel renders his figures with their faces hidden, so that they come across as some kind of automatons, half-beasts, creatures who do the same things again and again, year in and year out. Yet happily Bruegel was a keen and sympathetic observer, and seldom have ordinary people been so fully depicted in their everyday comings and goings.

The difficulty in interpreting work from the somewhat remote past, like the sixteenth century, is that apart from the artworks themselves we have few written sources to confirm our insight or commentary. There is accordingly always some risk of speculation, of reading one's own meaning into it. Only ample contact with such works and a constant weighing and assaying of them against everything else that is known about the artist's era can keep us on the right path. Here we want to try to understand something of Bruegel in his 'thinking with the brush'. In doing so we turn our attention to Sebastian Franck as a possible source for understanding his views. This is a case of the philosopher and the artist saying the same thing, albeit through very different means.

The books of Sebastian Franck appeared between 1530 and 1540.[331] They may very well have been known to Bruegel, especially since Franck had a great influence precisely in the Northern and Southern

Netherlands. It is remarkable but true that we can expect this way of thinking all the more of an artist, since *geestdrijverij* [a strong, fanatic focus on the spirit][332] – to use the sixteenth-century term for this subjectivistic movement that is affinitive to the Anabaptists – was very often to be encountered in artists' circles: David Jorisz the great heretic made drawings and stained-glass windows; Coornhert, the renowned follower of Sebastian Franck, moved in the same environment as Bruegel and was an engraver, and one could mention more examples. Plantijn, the great printer and publisher in Antwerp, turns out to have been a disciple of the House of Love, a sect strongly orientated towards Franck's doctrines. Plantijn maintained many contacts in the art world, including contact with Cock, the publisher of prints after the drawings by Bruegel. Perhaps Bruegel was also a member of such a sect, but we have no way of knowing for sure. Naturally such sects usually practiced in secret.[333]

It is not possible to explore extensively the views of Sebastian Franck here. Suffice it to say that for him the Bible is not God's revelation but at most history and as such a symbol for the deeper meaning of life, in which all things must be repeated again and again, since life is a circle and there is nothing enduring that does not have to happen over and over again, including Adam's fall, the tree of Knowledge, and the life, suffering and death of Christ which still go on every day in their own way. Anyone who has seen Bruegel's large painting of *Christ carrying the Cross* in the museum in Vienna will find this in it. Here we have a very extensive landscape, with 'somewhere' in the large crowd Christ and his cross, as if it were an everyday occurrence, the execution of an innocent person or a miscreant . . . and in the background, on a hill above, a windmill, an allusion to the [Dutch] proverb: 'Everything goes round like the vanes of a windmill'.

An insane world

Where then is a revelation of the divine to be found, of god, written with a small g since it refers to a deification of human being and has little to do with the God of the Scriptures? In history, says Franck, for although people are apostate and hence 'spiritless', still every person is composed of spirit and flesh so that by means of the dialectical character of reality that sees for every no a yes, and vice versa, one may seek behind all flesh a flickering of the spirit. Therefore it can also be said that ordinary folk with their morals, customs and proverbs are a direct expression of the word of god, the son, of christ, all thus with a small letter to preclude any misunderstanding! To be sure, even the most devout are still fully bound to the power of the flesh – the terms spirit and flesh are of course borrowed from Paul but used in a self-determined way – but even when sunk as deep as can be, a spark of love and goodness is still present, a divine flame under the smoldering ashes. This wisdom of the divine

spirit finds utterance in proverbs, and now it is worth noting not only that Franck wrote a two-volume work recording popular proverbs but that Bruegel likewise took a tremendous interest in them and that they appear throughout virtually his entire body of work. We have already noticed them in passing in his *Carrying of the Cross*. But he also made one painting depicting some seventy-five proverbs.

In this painting of proverbs something strange happens, something that is only comprehensible if we keep in mind that we are dealing here with a dialectical way of thinking and doing, in which every yes is balanced by a no. For if you look at this painting and forget for a moment that you are looking for proverbs in a giant puzzle, then it must strike you that a totally mad world is depicted here. For when the saying, 'he cannot reach from one loaf of bread to the next' (which means he can hardly make ends meet) is depicted as a man with both arms stretched out trying to grasp two loaves of bread that are at opposite ends of a table, then such an absolutely meaningless act is pure madness. And what do you say of a figure tying a bell to a cat [daring to take the first step in a dangerous undertaking], or of a man hitting a pig with a wrench [that is neither here nor there] or puttting a spoke through a wheel [throws a spanner into the works]? An insane world!

And indeed, a similar sort of paradox, a dialectical contradiction, is to be found in Franck, who on the one hand depicts history with a great deal of love, describing a coronation with all its pomp and circumstance, and yet also despises the world and calls history worthless, bringing forth nothing good and nothing but incessant repetition. Culture, people being active in this nature and engaging themselves with the material and the external, is meaningless and at bottom foolish.

In Bruegel we encounter this perspective repeatedly. We shall not delve further into the grandiose, unsurpassed representation of madness itself in the great work *Mad Meg* (*Dulle Griet*) in a museum in Antwerp, but we do want to say something about Bruegel's painting of children's games. In Vienna, where almost all the important Bruegels are located, we find this work of 1.20 x 1.60 metres in which on a large square we see children playing in the most diverse ways: with hoops, leapfrogging, somersaulting, spinning tops, building with stones, dancing, singing, climbing, and ever so much more, too much to name. View this scene in a 'spiritless' way and it is a beautiful look at the world of the child, a worthy study of the children's games of the sixteenth century; take a 'deep' look at it, however, and see revealed the absolutely meaningless hustle and bustle of a humanity preoccupied with senseless activities. Here we see how such a work can be a symbol as it were of a deeper view of reality and attitude towards life.

Then there is the renowned painting of the *Tower of Babel*, a theme that has never since been elaborated so grandly. It is the representation of humanity's incessantly repetitive, perfectly senseless building activities

and struggle to survive, and as such it is a summary of this entire view of history and the world. Then there is the *Fall of Icarus*. In the foreground of this painting there is a farmer ploughing and in the background a vast bay located between coastal mountains. In the bay a ship is moving under full sail, and if we look closely we can still make out, near the coast, the legs of Icarus as he plunges into the sea. This remains unobserved either by the seamen serenely sailing on past him or by the shepherd who with his back to the water is gazing at the sky, or by the farmer who ploughs on. When viewing this work we cannot help but think of the ballad of Werumeus Buning: 'And the farmer, he ploughed on.' This cultural act of Icarus remained totally without further consequence; it was a meaningless deed, unobserved by anyone. Indeed, the farmer ploughed on; the unceasing repetition of that activity was never interrupted by any action whatsoever. We can of course not discuss all of Bruegel's work. We only hope that you will try to secure reproductions of his work in order to contemplate his 'spiritless-spiritfilled' world for yourself.

Finally, let us consider Bruegel's painting *The parable of the blind men*, a large work now kept in the museum in Naples. This awesome, yes horrifying painting depicts a group of blind people who are guiding each other. The leader however has groped amiss and fallen from the dike into the water. The second figure is already falling on top of him, while the third, clutching the pole that connects them, is also beginning to lose his balance. The figures bringing up the rear are still trudging trustingly onward however. Now, this is a poignant picture of human misery, a drama such as only a very great artist can convey. In the background we see a church, and this may very well be our cue that there is more going on here than 'just' the human drama in the foreground. For, as far as Franck and all the other 'enthusiasts' were concerned, the church where people confessed that the unassailable truth was found in Scripture was in fact 'the world', the enemy that always persecuted true believers who allowed themselves to be led by the spirit. In the church people maintained that Scripture is God's revelation, while Scripture really can only be understood, according to Franck, by those who look deeper and understand that in that too every yes is counterbalanced by a no, flesh against spirit. Holding on to the material, external world leads to partisanship, which ought never to be found amongst the 'true believers', namely, those who are in god and who therefore have laid aside every 'personal opinion' and do not want to accept any certain knowledge of the truth. The church, with its stubborn clinging to Scripture as God's revelation, is like the blind leading the blind. Truly 'spiritual' people stand above all factions, showing the fruit of having no personal opinion – like Plantijn, for example, who in his printing shop printed the work of the heretics, the enthusiasts, but at the same time also the *Index* of the Roman Church which proscribed these writings for the faithful.

It is remarkable but nonetheless understandable that one can judge such work, motivated as it is by a dialectical spirit, in no other way than as a paradox: this work is magnificent and its depiction of human life, suffering and work is grandiose if one does not look too deeply; for the better one comes to understand this work the more problematical its character becomes and the more difficult to truly enjoy it. I hope that you, who like myself are 'spiritless' souls, will continue to notice the tremendous expressive force in the representation of the 'external' in this work, the amazing creation of an artist of genius.

The Art of the Seventeenth and Eighteenth Centuries

• **Seventeenth-century Dutch art: Christian art?**[334]

a) Seventeenth-century Dutch art as the fruit of the Reformation

If, as in our article entitled 'Judging Works of Art',[335] we come to the conclusion that the attitude of the artist should have no real effect on our judgment of a work of art, but that we should rather evaluate the work of art itself in the light of the norms given for it, then we cannot help posing the question of what, then, is Christian art. Is it art that was made by a Christian? If we insist on that we face quite a dilemma, for do we then not need to be able to tell from the work of art itself that it is 'Christian'? We would then be unable to judge whether a piece is Christian or not, unless we are well acquainted with the artist. And how seldom do we know what the confession of faith was of an artist from the past, and whether or not he or she walked in the ways of the covenant?

A classic example of this is Rembrandt, whose work certainly is the (or, at least, is *one*) high point of our seventeenth century. Other than his artworks themselves there is no documentation available concerning his religious convictions. We are not sure which church he belonged to, although we know that he certainly was not a member of the Reformed church of Amsterdam. He may have been a member of an Anabaptist church, but we are not sure about that.

Drawing conclusions about Rembrandt's beliefs, or rather his confessions, on the basis of his works is also very tricky. That is evident from the many conflicting opinions that have been brought forward concerning this. A few people have judged his work to be that of a Calvinist. Most find in it a more liberal view of life and the Bible. One person thinks he was perhaps the closest to the so-called Rijnsburger Collegianten, who wanted to have nothing to do with church but just wanted to figure out for themselves what the Bible teaches. Rembrandt would then have had somewhat mystical beliefs. Finally there is still another author who, on the basis of Rembrandt's print of Faust, concludes that he was a free-thinker, an atheist. How can we judge who is right? But the answer to this question will not really make us much wiser in assessing the meaning of Rembrandt's art.

Let us also learn from this example that when we are talking about a 'Christian' this or that, we must never seek our starting point in a person's state of being born again, or not. For placing a human being at the centre is really a very unscriptural way of talking and thinking. And it causes us to lose all certainty and security. That great pastor – was he perhaps just a hypocrite? That reformation work – were their hearts really burning with love for God when they were making it? That

reformation or that effort – was it scriptural? – well, perhaps it was just a conflict of interests, and perhaps jealousy and envy were the real motives . . . ? And so we become mired in doubt, and in the end everything that we used to call 'Christian' has slipped out of our hands. For in truth, when we carefully examine the reformations and the events in the lives of the covenant people, we sometimes uncover a great deal that is not so pretty. Also the servants of the Lord were (and are) sinful creatures! And so we are always puzzled by the mystery of how anything good can actually happen at all! We are thinking here of our country's ecclesiastical life in the sixteenth and especially in the seventeenth centuries, the emigration of the Secessionists in the nineteenth century, and so on. We certainly should not first of all look for the great works of our forefathers, for the great Christian witness evident in the work and walk of those who are great in God's kingdom. We must not look for the essence of 'being Christian' in born-again hearts, for then we will always become entangled in riddles and doubts, and finally will have to lament, Where is all that beauty, where are all those great acts of faith which 'other people' are always talking about? Instead, we need to concentrate on the deeds of the *Lord!* We must speak of what the church of all ages experience: that the Lord is true to his word.

How would it have been if the Israelites had had to depend on someone like Aaron, who even helped them make the golden calf; or if everything had depended on the born-again actions of Moses, who more than once had to be severely reprimanded by the Lord? How would things have turned out if everything had depended on the actions of sinful mortals like David or Solomon, of John the Baptist or Simon Peter?

Similarly, if we wish to understand what was unique about our seventeenth-century art, we should rather ask what the Lord was doing in our country at that time, how he was establishing his word, how he was keeping his promise of adding all things to those who seek first his kingdom.

To explain this further we must ask ourselves what the Scriptures say about 'reformation'. That word is often used without a real understanding of its meaning. We suggest that it is most clearly expressed in Deuteronomy 30, a chapter from a wonderful book that is from beginning to end concerned with God's covenant – something which we, to our own loss, perhaps sometimes neglect.

In Deuteronomy 28 the Lord lays before his people two possibilities: 'If you fully obey the Lord your God and carefully follow all his commands I give you today, the Lord your God will set you high above all the nations on earth' and will give you many other blessings besides, but then: 'However, if you do not obey the Lord your God and do not carefully follow all his commands and decrees I am giving you today, all these curses will come upon you and overtake you.' Whoever has eyes to see, take note of this, for our times . . .

In the 29ᵗʰ chapter this is further developed in that it records how the land will be brought to waste, and what the results will be of those curses and judgments delivered to the people of the covenant. Chapter 30 takes this a step further:

> When all these blessings and curses I have set before you come upon you and you take them to heart wherever the LORD your God disperses you among the nations, and when you and your children return to the LORD your God and obey him with all your heart ... then the LORD your God will restore your fortunes and have compassion on you ... The LORD your God will circumcise your hearts and the hearts of your descendants, so that you may love him with all your heart and with all your soul, and live ... You will again obey the LORD and follow all his commands I am giving you today.

Here the promise is given that the Lord will not leave his people in apostacy and under judgment but will reawaken repentance and faith in their hearts, and so bring them to life.

The Lord kept these promises also during the time of the great Reformation of the sixteenth century. The apostacy at the close of the Middle Ages was indeed great. Superstition and unbelief had become rampant; belief in the relics of saints and others had developed so far that some spoke of fetishism, while a faith tending to mysticism, and devoted in large part to Mary and the saints, had taken the place of serving God according to his word. Clergy actually kept that word from the lay people. People served the Lord according to their own tastes and did not walk in his ways (cf. Micah 6, especially v.8). Many, especially among the scholars, held to traditional religious rituals, but at the same time reached out to realize a humanistic world in which science, the knowledge of humankind and not of God's word, became the highest wisdom.

But during this time there was also a hunger for the word, particularly among the ordinary folk and the oppressed. These were truly 'lost' sheep, wandering this way and that wherever they heard someone claiming to speak in the name of the Lord in the hope of truly hearing the voice of God and his life-giving word. It was during this time that God planted the seeds of the Reformation. People began questioning abuses in religion and in the church, and the Lord blessed his faithful word so that in an unbelievably short time the events unfolded which are now recorded in history books under the heading 'the Reformation'. Particularly Luther and Calvin were the people God chose to be teachers and prophets, but we should not become too steeped in history right now. Let us never forget, though, that what happened then was similar to what is described in Ezekiel 37!

After at least three centuries during which God's word had been nipped in the bud by the Inquisition and by rulers, there were finally witnesses who stood up and declared the clear word of the Lord. Salt became salty again (Matthew 5: 13); God's kingdom was like leaven

being kneaded through all of life (Matthew 13:33); the influence was felt in many spheres. We can hardly begin to imagine how drastically all this changed the world over a very short period of time. Manners and customs changed; more wholesome views became the rule in many areas of life; the evils of lawlessness, immorality and self-assured religion were cut off at the root. To write concretely about these things, and to document them adequately based on research of published writings, would be a useful and perhaps also a necessary occupation – but who in these days is capable of doing that? To my knowledge, there is no book that summarizes these things.[336]

Even in the Catholic Church itself these changes brought with them a new vitality. The worst abuses were abolished, and people turned away from their excessive tolerance of a whole host of sins. This cannot be called 'reformation', however; to the contrary, all of this (with the Council of Trent at the helm) is more correctly called the Counter-Reformation.

Humanism sometimes prides itself on having changed the entire world picture after the Middle Ages. People forget, however, that modern humanism had already been active for a century, particularly in Italy,[337] when the Reformation started, and that there were no deep-seated changes apparent in the world. Abuses in the spiritual realm were by no means overturned, the superstition and immorality remained at least as strong, and a love for worldliness was increasing. One must remember that the sale of indulgences so strongly denounced by Luther was especially intended to help fund the building of the huge St Peter's in Rome, a great monument to Renaissance art. The Renaissance's influence was limited almost exclusively to the higher circles, of monarchs and princes and prelates as well as scholars: the elite, in other words. Who knows what would have happened if the Reformation had not interrupted the course of events? The revolution that turns all of life into chaos would certainly have happened long before the eighteenth century. But instead (and its effects are still felt today) the brakes were put on this revolutionary movement by the influence and the tradition of wholesomeness based on God's word and awakened by the Reformation. Let us never give the credit to humanism, which in the end did nothing more than to usurp the fruits of the Reformation! Was freedom won in humanistic Italy, which is, after all, also the land of the Counter-Reformation? Not to mention Spain. In the end it was in England and, especially, the Netherlands where the great forerunners of humanism were given the opportunity to write their works in freedom: Spinoza, Descartes, and so on.

Were the fruits of the Reformation mentioned above the result of the high moral character or nobility in spirit of the leaders, or were they the result of the wholesome insights of the masses? Who would dare assert that? A closer study of this time to acquaint us with the people in

their day-to-day life and work will certainly rid us of such illusions! No, it was the word of the Lord that awakened life. It was the word that gave growth so that the kingdom of God began to spread like the mustard seed in the parable.

b) The painting of everyday reality

At first glance all of this may seem to have little to do with our seventeenth-century art. Perhaps people will say that that is stating the obvious. I certainly hope so.

Yet I believe these issues are too often overlooked and this part of covenant history is too often viewed through humanistic eyes. We need to understand these things clearly if we are to comprehend the miracle of the Dutch 'golden age', the years during which this small country played first violin in the international political scene and during which it experienced a blossoming in the world of art equal to the artistic heights reached anywhere else in the course of world history.

Certainly a 'natural' explanation for the greatness of our seventeenth-century art will always fall short. We might be able to explain the choice of themes and subject matter and the way these were portrayed on the basis of the understandings and 'prejudices' of the 'Calvinists' (although ultimately any effort at an explanation which ignores the power of God's word, by his grace, will miss the mark). But in the long run the incredible aesthetic quality of this art can never be explained simply by historical circumstances. The presence of such incredible talent can never really be accounted for by the national character, or by affluence, or by anything else. In the case of our seventeenth century, we would be blind and unjustly suppressing the truth if we did not give all the glory to the Lord, because what we are really dealing with here is the miracle of his blessing poured out in grace.

Instead we should look at this period as a fulfilment of the rich promise of Deuteronomy 30:9: 'Then the Lord your God will make you most prosperous in all the work of your hands and in the fruit of your womb, the young of your livestock and the crops of your land. The Lord will again delight in you and make you prosperous,' when people return to the Lord and hold to his clear and plain word and acknowledge that his commandments are not too difficult or out of reach (Deuteronomy 30:11ff.). This is the result when people simply do what the Lord asks of his children. It is what happens when they seek his kingdom by obeying his commands without willfully placing heavy burdens on themselves. God was keeping his promise that 'all these things will be given to you as well' (Matthew 6:33). The truth of the first part of Deuteronomy 28 was being shown abundantly.

The quality and quantity of the works of art produced during the seventeenth century in the Netherlands are astounding. Someone once said that during that time a new masterpiece was created every five

minutes. Every museum in the world boasts works from this golden age, created during a period of less than a century (1600-1675) in a country with a comparatively tiny population. It is not just that there were so many master artists (Rembrandt, Ruysdael, Hobbema, Frans Hals, Terborch, Potter, Adriaen van de Velde, Vermeer, de Hoogh, etc.), but that there were also so many lesser artists who still produced art of extremely high quality – so many that any student researching this era becomes overwhelmed by the numbers. Again and again he or she will discover new masters and new works of a sometimes astonishing quality.

Let us also not try to explain this all on the basis of the 'born-again souls' of the artists. Actually we know very little about the religious lives of these painters. Perhaps research would reveal some interesting facts in terms of the percentage of believing churchgoers among them, but even that would not really tell us much. Besides, we know quite certainly that some of them were not Calvinists. I am thinking here of Rembrandt and the Catholic artist Jan Steen. And what conclusions would we logically need to draw about artists who are deeply rooted in Scripture, but whose art is third-rate with no real aesthetic quality?

Certainly it is true that Calvinism had a great influence on the themes used in painting. That is evident among other things from the fact that biblical scenes always meant more to viewers than depictions of classical stories and myths; in the latter we often see this art at its most narrow-minded and at its most foolish (as Martin says so accurately in his work *De Hollandse Schilderkunst der 17e eeuw* [Dutch paintings of the seventeenth century].We heartily recommend this work to everyone, particularly the excellent introduction to the first volume entitled 'Frans Hals en zijn tijd' [Frans Hals and his times]). Yet, the 'religious' and biblical genre was in the minority; more common was art that depicted middle-class life through portraits, landscapes and society scenes. The Reformation freed artists to devote themselves to painting ordinary, everyday reality: aesthetic beauty was especially sought in the 'common', sober view of reality that shunned every effort to be theatrical.

The pure preaching of the word permeated all of Dutch life like sourdough, introducing a more wholesome view of life and reality. There was no need to depict a world more ideal than one's own country and time, more ideal than the world between the Fall and the Last Day. There was enough beauty to be found in that world. After all, the span of a person's life or of an artist's career is too short to do it justice and to discover all its facets. Even a century of great activity, with an incredible diversity of genres, still managed to show only a very small part of the richness of God's creation and world. People had too much common sense to paint 'ideal people'; glorifying humanity was far from their minds. They painted life and the world realistically, without frills and without pathos, without idealizing or glorifying the creature but, instead, showing things as they really were and are, not glossing over sin

but not exalting it either and especially not looking down conceitedly like a Pharisee on sinners.

These artists were aware of their calling but also of their limitations. They wanted nothing to do with humanistic self-glorification. Nearly all of them were hard workers without pretension who did not see themselves as very special, even though they sometimes possessed amazing talent. Those talents were not used as an excuse for lawlessness and unruliness (which sometimes was the case with, for example, the Romantics). These artists limited themselves to the genre in which they excelled, and in their own area of specialization they tried to deliver the best work they could. Producing excellent art and painting beautiful pictures was their goal – not being original and innovative. And least of all was it their intention to serve the revolution with their art by exposing or scornfully revealing real or imagined abuses, decay or hypocrisy in society. The latter would probably never even have occurred to them; we only mention it to emphasize the contrast between their work and that of the past hundred years.

Perhaps we can show the character of all this best by taking note of the criticism of the seventeenth-century writers, the art critics who glorified the Catholic-humanistic Baroque art. (Nearly all of them were faithful members of the Roman Catholic Church.) These writers assumed that art must *improve* on reality. For example, their criteria for a portrait was that the subject's expression should be elevated to the highest possible level of elegant grandeur. For these French authors everything boiled down to the qualities of 'decency, propriety, impeccable manners and good taste, the grand impact'.[338] In art, it was 'admirability' – *le merveilleux* – that was decisive, and admiration was at the centre of all art appreciation. To elaborate on these theories and ideas in more detail would be going too far.[339] We only mention them to help explain why in the writings of these authors the Dutch artists were singled out as a horrifying example. They looked down on the Dutch for their surrender to 'ordinary' nature without devaluating their great handcrafted qualities. Their imitation of nature and their faithful portrayal of reality were thrown back in their faces as weaknesses.

Perhaps all of this can be summarized by the idea that the Dutch art did not present humans as they ought to be but as they are. Indeed! The Scriptures teach us the norms, and through them people learn to understand themselves – and that is how humility is born, with no desire for a depiction of ideal personages in which one immediately senses the lie. Humanists, on the contrary, seek exactly such a glorification of humankind in their perfect, ideal form. But no one who has really understood Job 38 will want to have any part in this desire to improve on God's creation, this longing to beautify nature.

We have said that a wholesome view of the world and its people made Dutch art what it is, a healthy perception awakened by the word of God.

That view was also common to many artists who were not confessing Christians. We may never look at an era, a bit of history, individualistically, as if each person, based on his or her own religious tenets, determined an own attitude towards all manner of things and all understanding of norms, laws and reality. The word of God and the moral laws were known also to those who perhaps did not love the Lord with all their heart, and even they gave honour to God as the Creator and the Lord of Hosts who had freed the Dutch from many oppressive restraints.[340]

c) Christian art

So we can see that the art, for example, of the Catholic Jan Steen deviates sharply from that of his Southern fellow churchmen and that it gives a truly 'Dutch' view of things and people. From the seventeenth century we learn again that we cannot view history individualistically, and that we should not judge art on the basis of whether or not the artist is born again or on the basis of the moral superiority of the individual leading figures of the period. Rather, we are dealing with covenant history, with the acts of God who is true to his word and who will always make his faithful children be 'the head, not the tail' (Deuteronomy 28:13).

The latter has proved true not only in the political arena. When we look at Holland's position as compared to the surrounding countries, we see that also its art has been highly appraised everywhere. The incredible volume of paintings produced was welcomed abroad, in England, Germany and France. Yes, in France too, for even those French critics adhering to the beliefs mentioned above and detesting Dutch art on theoretical grounds still collected Dutch paintings. In later centuries Dutch art often had an inspiring and renewing influence. Specifically in the genre of landscape art the Dutch influence was deeply felt until far into the nineteenth century. But to expand on this would require a separate article – someone has even written an entire book on the topic.[341]

May our seventeenth-century art be called 'Christian'? If one holds to the definition that Christian art is art made by confessing Christians, the question will be very difficult to answer. And even in cases where we are certain that the artist was a Calvinist, we would still do well to ask 'Is this really Christian art?' when we view their works. We think, for example, of the Southern Netherlandish Protestant Jordaens, who was strongly influenced by Rubens. If one asserts that Christian art is art that depicts Christian subjects, like Bible stories and so on, then there is relatively little art that would fit the definition. And how then do we judge Catholic art, in cases where the images do not conflict with Scripture and our [Protestant] confession?

If, on the other hand, we say that Christian art is art inspired by the word of God, in the sense that the view it represents of humanity and the

world is faithful to the Scriptures, then we can say that our seventeenth-century art was Christian. We are not making judgments then based on the subjectivity of the artists but based on the norms and the wholesome insights that these artists display in a variety of ways.

Art of this kind will always be multi-faceted, and we have already mentioned that the variety of genres developed during our sixteenth and seventeenth centuries is astounding! Such art will certainly not have portrayed only the inoffensive, dutifully 'good souls' or ideal 'sinless' people. After all, in the Bible the heroes of the faith are shown in their full humanity, with all their faults; the Scriptures give a view of the world that is sober and utterly realistic – think of parts of Proverbs (e.g. Proverbs 7) and the book of Ecclesiastes, to mention just two examples.

Certainly, something like this does not happen by itself. It requires human beings whose hearts are burning for the Lord. It requires witnessing and preaching – reformation in the church is, after all, before anything else a matter of faithfulness on the part of the church leaders. But if the salt is truly to work as salt, then the light will be set on a lampstand, not only to shine everywhere but also to bring light to every corner (Matthew 5:15). Then the Lord will bless and his word will accomplish its renewing work, because of his holy Name: 'Then all the peoples on earth will see that you are called by the name of the Lord . . . you will always be the head, not the tail' (Deuteronomy 28:10, 13).

We have not yet had opportunity to discuss the history and development of our seventeenth-century art. And we have only been able to speak in general terms about the art itself. Therefore, in conclusion, we offer a few practical comments for those who want to know more.

Anyone seeking further information about the art of the Dutch 'golden era' should look first at the huge public collections in our museums. A catalogue will be very useful for becoming acquainted with the multitude of names and works. We can also recommend, besides the already-mentioned excellent work by Martin, the biographies of artists in the *Paletserie* [palette series]. We also would recommend the two volumes of essays by Schmidt Degener, *Het blijvende beeld der Hollandse kunst* [the enduring image of Dutch art] and *Rembrandt*, which appeared recently. We could mention many more titles, but have limited ourselves to the most accessible and useful ones, and will leave it at that.

• Baroque art[342]

In a previous article we commented on a remarkable contradiction that was unique to fifteenth-century art.[343] On the one hand the medieval formulas were preserved, formulas which were charged with a dogmatic or at least a religious, meaning. On the other hand artists painted very naturalistically and with a great concern for details and for the visual

givens, clearly much more interested in the natural than in the supernatural and religious. This contradiction was nothing more than an expression in the artistic realm of a more widespread cultural reality. And in this regard there was really no fundamental difference between the Italian artists and those north of the Alps. The only difference was that the Italians, more specifically the Florentines, let themselves be inspired, as far as form was concerned, quite nationalistically by their great Roman history; while those in the North based their work more directly on actual (visual) observations. We can see a clear continuation of the nature/grace motive of the Middle Ages, which led in the fifteenth century to great tension between the two.

By the end of the century this tension became almost unbearable. Particularly in Florence, where this spirit had been taken to its extreme, one at times gets the feeling that the supernatural or religious aspect had become nothing more than a purely traditional affair. Somehow this tension needed to find a release. It finally did so at the end of the century in the person of Savonarola. He preached against the thorough secularization and protested, for example, about the fact that when artists painted a Madonna they in fact just painted a portrait of a charming Florentine woman. Some of the artists whose works were used as examples for that reproach took his charge very much to heart. Botticelli, for example, became a confirmed disciple of Savonarola; his art underwent a sharp change in direction and took on a much stricter, almost ascetic character.

But that did not bring to an end the inherent contradictions of fifteenth-century art. What was needed was a meaningful synthesis in which the two opposite poles of the Roman Catholic life and world view of nature and grace could be brought into relation with each other again, with nature in service to grace. In other words, renewal was needed within the Roman Catholic environment. We should mention in passing that this was also the time of the Reformation, which tried to bring renewal in a completely different way through a radical return to God's word. Dürer already worked in this spirit even before Luther appeared on the scene. But we will leave that for now.

The master artist who formulated a solution and gave it magnificent artistic expression was Raphael. Thus he was the one who, for many centuries, became the shining example, who provided the inspiration and leadership, and whose influence reached far into the nineteenth century. He managed to make the new techniques developed in the fifteenth century for depicting natural realities subservient to the representation of that which is holy. In Raphael's work the Madonna truly became a Madonna again, unmistakably the supernatural Mother of God. Her face was freed from that thorough individualism characteristic of fifteenth-century Madonnas (painted by Fillippo Lippi and Botticelli, for example). And the supernatural was clearly

distinguished from the natural. In order to do so Raphael employed a method that had been used several times in earlier periods, specifically by Orcagna and Fra Angelico. These artists had tried, in their artistic rendering of the supernatural, to contrast it clearly with the natural by elevating it above daily reality and placing it on the 'clouds'. The best example of this is the *Madonna of the Sistine Chapel*, Raphael's masterpiece. To the right and left of her are two saints, and Raphael managed with a stroke of genius to depict their garments in such a way that the folds of the cloth do not seem to be a part of the material world. Mary's face is painted in a manner that from that time on would become the accepted style – realistic, but not a portrait.

After Raphael the style called Mannerism formed a short intermezzo. It is the art style of humanism in distress; artists were now forced to typify the sacred as sacred in a substantial way, in contrast with the artists of the fifteenth century who considered it sufficient to give no more than a sidelong nod to tradition.

After Mannerism there emerged a movement that built on Raphael's solution, a style that we have come to know as Baroque. It is typically an art style of the Counter-Reformation, an outspokenly Roman Catholic art. We could typify it, in short, as a realism of a super-reality, the supernatural reality in which saints move about as if on an otherworldly stage. Carracci and the Bolognese school were the representatives of this movement in Italy; Rubens, in the Southern Netherlands. In this connection we also think of the sculptor Bernini, and of the ceiling-murals in Italy and southern Germany in the late seventeenth and the eighteenth centuries.

Guido Reni's *Madonna*, a huge painting housed in the museum in Bologna, depicts three 'levels', three layers of reality above one another. At the top the Madonna is enthroned on the rainbow, surrounded by angels, unmistakably a supernatural appearance. Below her, directly related to her and gazing up at her are a number of saints – the visual reality is here a clear expression of a religious and spiritual reality. We might mention in passing that the saint to the far left was undoubtedly inspired by the kneeling papal holy figure on the left of Raphael's *Madonna of the Sistine Chapel*. The saints depicted here were not selected randomly; they are the patron saints of Bologna. Their supernatural reality (even apart from the way in which they are painted) is also made evident by the fact that they are kneeling or standing on a floor of clouds. Under these clouds we catch a glimpse of earthly reality, our own reality, in the view of the city of Bologna. The content of this work of art is clear, and the relationship between Mary and Bologna (via the saints) is visually portrayed in a Baroque style.

Besides the religious content there are other aspects to Baroque art as well. It often depicts universal human principles in a grandiose way through ancient mythology: Venus is used to symbolize love, Mars stands

for war, Mercury for trade, and so on. We think for example of Rubens's *Abduction of the daughters of Leucippus*,[344] in which the essential content is the magnificence of woman as inspiration for male activity. The erotic has a clear but not exclusive role in this painting. There is also clearly no attempt at a realistic portrayal of the world here. Rubens does not suggest that it might have been possible to catch an actual glimpse of what he is portraying or that it was ever visible in this way. Rather, it is a kind of icon, the representation of an idea, a truth that is made visible in his art but which in our day-to-day reality never actually looks like this. In that sense the painting could be called 'abstract', since it depicts an idea.

Baroque art also saw itself as subservient to the absolute monarch. We could mention Rubens in this connection again, in his grand series created for the exaltation of Mary of Medici, now hanging in the Louvre. Another good example is the ceiling of the staircase in the Würzburg Palace, painted by Tiepolo.

• Theme, style and motif in the sixteenth and seventeenth centuries[345]

The work by Rubens that we discussed in the previous article [*Abduction of the daughters of Leucippus*] presents us with a problem that occurs again and again when we study the art of the seventeenth century. Imagine that we were not acquainted with the theme. In that case it would be very difficult to figure out what Rubens had in mind. Only by chance might we be able to determine the subject. Sometimes there is a tradition of a certain theme – we will come back to that – so that one knows it from experience, but that is not the case here.

But even when we have determined what the theme is, we may get the strange feeling that we have still not learned anything essential about the work of art. It has not become clearer; we are no closer to understanding it; it has not become more beautiful or more meaningful. And we may be inclined to lament that 'the subject seems to be irrelevant!'

Such a conclusion would appear to conflict with everything that we know of the seventeenth-century artists and their patrons. Besides, if the theme were of no importance, then why would the painters so often choose biblical or classical themes? Genre painting, with its straightforward love for realism, would then have been more appropriate. But even there one often has the feeling that the paintings have an added dimension besides picturing a small piece of the artist's world. This may also be found in some works from the nineteenth century, but that art is often dull and inconsequential in contrast with the art of the seventeenth century. In short, there is something like a riddle hidden in seventeenth-century art that cries out for a solution.

Often in sixteenth- and seventeenth-century works we see a naked female figure committing suicide. To assume that it is all about nakedness is not really convincing: these dying women are after all not really a stimulating or inviting sight. We learn that the subjects in these pieces can be Lucretia or Thisbe, or Dido or Panthea, or others – all committing suicide with a dagger or, related to this, like Cleopatra, by letting herself be bitten by a poisonous adder. What could possibly be the point of all these pieces in which we are sometimes quite unclear as to exactly what the subject is?

We find the key to the solution from de Ripa who in the early seventeenth century wrote a book about allegories etc. (entitled *Iconologia*). In his book we learn that despair is symbolized as a woman committing suicide with a dagger. The conclusion becomes clear: all of those paintings are intended to denote Despair. We call that the motif, the general human concept. The themes are then taken from the Bible or from classical antiquity as settings of evidence. They also give a certain flavour to the despair: Dido was abandoned by her lover, Lucretia lost her honour, Thisbe lost her lover, etc.

Especially by studying prints (etchings and engravings) one often comes to understand more clearly the significance of certain themes – i.e. which general human motif is their source. So we find, for example, a series of prints by Galle that brings together Eve and Adam, Sisera and Jael, Delilah and Samson, Solomon's wives who led him into idolatry, Judith and Holofernes, and many more. As you may have noticed in each case we named the woman first. For the unifying motif underlying these diverse themes is that of 'the dangerous woman'.

Compositionally these representations of Old Testament subjects have nothing to do with each other. Still, it is by studying certain figures that reappear, again and again, in a particular position (which in some art history books is called 'motif', a word I avoid here because I mean something different by it) that we move forward in our understanding. I rather use the term 'formula' to indicate a certain compositional or artistic combination of figures, or a single figure in a specific position. We find such a formula, for example, in the reclining female nude figure. It was introduced in the history of art by Giorgione's famous Venus figure. Venus, symbolizing Love and Beauty, occurs again and again as a fixed formula in all sorts of different themes. And in this we find the key to Rubens's painting *Cimon and Iphigenia* – there are besides this many other examples of the same theme in this formula. It pictures a sleeping female figure and a man standing nearby watching her. The scene is taken from a story from Boccaccio's *Decamerone* and concerns Cimon, a half crazy, rough, simple, boorish character. When by chance he happens upon the nearly naked sleeping Iphigenia he is so touched by the sight that from that moment on he becomes a gallant, intelligent gentleman. We note in passing the influence of Platonic ideas on this work: Beauty and Love inspiring man towards nobility and greatness –

we could call it the motif of this theme. The formula of the reclining female figure is very often used for this idea. She might be Psyche (who inspires Amor), or Danae (as pictured by Rembrandt). The woman (in this instance his wife Saskia) as the inspiration behind his work is the actual subject of the piece. One should note that also in the work by Rubens mentioned at the beginning of this article the reclining female is seen. That work also includes the motif (and we can see it even when we do not know the theme of the painting) of the woman as inspiration for male activity. Rubens has complicated it a bit by, as it were, contaminating it with another related motif, namely that of the raid (which we also find again and again with many variations: the raid of the Sabinian virgins, Pluto and Proserpine, Neptune and Amphitrite, etc. – sometimes in the same formula, sometimes not).

In closing we shall look at one more motif, that of the endangered woman. Here we often find the formula of the sitting female figure, frequently, though not always, in the nude: Susanna in her bath (waylaid by the two elders), Pomona and Vertumnus (the young innocent girl ensnared by the man who has disguised himself as an old woman; we think of the beautiful painting by Moreelse in the Boymans-Van Beuningen Museum) and, finally, Bathsheba, which reminds us immediately of the famous work by Rembrandt that can be seen in the Louvre [see *Complete Works* 3, Plate 6].

To summarize we may conclude that the seventeenth-century artists started with a motif (pride, despair, various combinations of male-female relationships, love for the elderly, love of children, justice, generosity, etc.), and sought to express these by means of a theme that would colour the motif in a certain way. Those themes, often taken from the Bible or from ancient mythology, are also called *exempla* (that is how van Mander, for example, calls them in his *Schilderboeck* of 1604); they are, as it were, places of evidence (examples) of what the motif is expressing. Next the artist draws on artistic tradition to choose a formula. Sometimes there is a strong correlation between motif and formula, but this is never binding. One frequently finds that a certain motif can also be expressed via a very different, not necessarily traditional, formula. The motifs are always human in nature. Sometimes they also deal with people in their relationship with the spiritual realm or the supernatural. For example, they might be concerned with a person's relationship to God and use the conversion of Paul as a theme. It is not easy to draw up a comprehensive list of motifs, and new variations are always possible; yet in principle the list is limited in number. This gives seventeenth-century art its unity, its depth, despite the huge diversity of forms. But because the motifs can be presented in so many ways (with various themes, and in various formulas), there is no end to the number of possible variations – far more than, for example, in the Middle Ages with its much more limited choice of themes.

Instead of a theme from the Bible or from antiquity, a subject from the world surrounding the artist could also be chosen; in that case we are dealing with a genre piece (e.g. as to the motif of the woman being the inspiration for the man, think of the romping couple by Jan Steen exhibited in the Lakenhal in Leiden). Thus it appears that genre paintings can also possess an added dimension.

If the artist depicts the motif directly, without, as it were, a theme, then we are dealing with an allegory or an allegorical figure as, for example, the above-mentioned Despair. In one of his prints Bruegel presents the figure of Prudentia, surrounded (as *exempla* of the same motif) by genre scenes: people propping up a house, making provisions for winter by stacking wood and salting meat; calling a doctor and a pastor to a sickbed, etc.

The content of seventeenth-century artworks, then, is to be found in the motif, which one can often recognize and understand even if one does not know the theme or is not familiar with the story. For example, we might see a woman weeping over a dying man – that is clear, even though we do not realize that they are Tancred and Armida. So it turns out that the content of seventeenth-century art cannot be found in the theme as such, and also not in the style (which in that time was not a carrier of meaning in the narrow sense). That artists tried to depict the motif, theme, and formula as beautifully as possible speaks for itself: the goal of the painter, after all, is to aim for the highest achievement.

• The changing relation between theme, motif and style[346]

In this lecture I should like to concentrate on a problem peculiar to sixteenth- and seventeenth-century art. On the one hand one often has the impression that themes as such are not of great importance – often it takes much time to find out what the subject matter of a certain picture is, and as soon as one has found the solution one may feel a bit disappointed because it does not seem to enlarge one's understanding of the picture at all. On the other hand it does not seem right to say that, after all, the subject does not matter and that only the style, the formal qualities of the picture, the way it is painted, is of importance.

We hope to find a solution to this problem by considering the question of where the true content of a work of art lies. In what aspect is its real meaning and significance to be found?

To make my answer to this question clear I should like to begin with medieval art. The *Eve* of Bamberg certainly is for us, and was for his contemporaries, nothing but Eve. The nudity is only an attribute. The sculpture's content lies in its presenting Eve before our eyes. To the

medieval person what counted in a work of art was its content, which was identical to its theme. When medieval artists copied a work of art – and we know that for them copying was quite normal – they did not care to copy all the stylistic peculiarities of the original but only the composition, which clarified the theme. It seems that the content did not lie solely in the subject matter as it can be stated in words but in the subject matter as it was rendered in a certain composition. So, when we look at a Romanesque Crucifixion group its meaning is more than just 'crucifixion', because the composition, the way of handling the theme, the traditional formula, suggests a certain exegesis or interpretation. It is the crucified Lord Jesus Christ as King. Another Crucifixion presents to us the suffering Christ, a formula that became paramount in the Gothic period.

The same applies to the Baptism of Christ, an example of which is found on the font in Liège. If we compare this with an example from Flemish art – Gerard David's painting in Bruges – we see that the composition, the formula, is the same, and therefore the content is the same. But this work has also something else to offer, something that we can call a second content. We refer to the fine rendering of the details of flowers, the rippling of the water, the cloth of the angel's capa and the landscape in the background. This naturalism of the style contains a meaning that is separate from the thematic content.

Next we can turn to the period after 1500 when the dichotomy inherent in fifteenth-century art was solved. Looking at a print after Maarten de Vos[347] that depicts Lucretia, some people may say that the only real content is a nude female. And in some instances such a statement would undoubtedly be justified, but I suspect that the very fact of what we see, namely a woman committing suicide, should restrain us from jumping to such bold conclusions. If we inquire further into the art of this period we quite often find portrayals of a woman committing suicide with a dagger in her breast, for example Thisbe in Lucas van Leyden's print[348] or the *Death of Dido* by Rubens.[349] We even find a man in the same act in a little roundel in the corner of an emblematic scene in Cats's *Sinne- en Minnebeelden*. In this case the meaning must be a youth in despair because the lady he loves has rejected him. The key to what all these different themes really mean is to be found in Ripa's *Iconologia*.[350] Despair depicted as a woman committing suicide. So all these different themes do have a single meaning, even if the particular story was not of great importance to the artist and his public; in our case they all mean 'despair'.

Philip Galle once made a series of prints, all depicting stories from the Old Testament, with a common motif, namely 'the pernicious influence of women' [or 'the dangerous woman']. Eve and Adam, Delilah and Samson, the women of Solomon driving him to idolatry, and Judith decapitating Holofernes all seem to be examples, for the

seventeenth-century person surely true examples or perhaps proofs, of the truth that women can have a pernicious influence. We call this a motif – here the term is used in a sense that differs from that usually taken by art historians, but it has the advantage of bringing us closer to the meaning of the term as it is used in the history of literature and, even more importantly, it gives us a key to understand the real incentive in this period to render such themes. It helps us understand why, for example, Christoforo Allori painted a *Judith and Holofernes* (Palace Pitti, Florence) in which the man is a self-portrait and his own mistress portrays Judith. This was not just a game or proof that the theme was of no importance to the artist: the picture means to say that also his fate was to be understood as being determined by the pernicious influence of a woman. In the last example the composition itself, the formula as we may call it, did not play an important role with respect to the content of the picture. Many different compositional schemes are used in the rendition of the motif of 'the pernicious influence of women', even of the Holofernes theme. But sometimes the formula is important, as to a certain extent in our example of the motif 'despair'.

So, to summarize the principle guiding the art of this period we can say that the content is to be found in the motif. The seventeenth-century artist, after deciding to depict such a content, had many themes to particularize his vision: he could make a choice from biblical history or from antiquity or he could even give a genre scene, showing that the same truth could be found in everyday life. And having chosen a theme, a particularization of a motif, he could render it in various compositions, as many different formulas were to be found in his artistic tradition.

Confirmation of our theory is found in the example of Gianbologna's *Rape of the Sabine virgins*. This sculpture was completed before it was named. Yet there is no doubt that a rape was meant, and all the themes proposed by the learned men of Florence as a name for the sculpture concern rapes.

We can also turn to the seventeenth-century books on art, such as van Mander's *Schilderboeck*. He called the seventh chapter *Uytbeeldinghe der Affecten, passiën, begeerlijkheden en lijdens der mensen,* that is 'On the Rendition of Human Feelings, Passions, Longing and Suffering'. And he gives a list of the emotions he had in mind: love, longing, joy, sadness, rage, despondency, fear and many more. And he goes on to give many examples – and he does call them *exempla* – in which these motifs can be rendered. A very fine proof of our thesis is the fact that he says Lucas van Leyden gave a fine example of the depiction of madness in his *Saul and David* print.

De Lairesse's *Groot Schilderboeck* also goes into a discussion of motifs, speaking of the rendition of passions by means of the movements and expressions of the figures and the composition of the painting. He quotes as examples: Alexander for 'ambitiousness', Marcus Aurelius for

'clemency', Augustus for 'piety', and Scipio Africanus for 'moderation'. In going over these pages one begins to understand more of the real intentions of these painters, and in many cases one can point out exactly for which motif a certain theme was chosen.

The principles laid down here enable us to understand many peculiar prints or paintings of the sixteenth and seventeenth centuries. We feel that we have stumbled across a key to the way of thinking of that period. See the print by Goltzius[351] in which a great many themes are given, in one composition, all brought together under the heading, or motif, *dissiduum in ecclesia.* Or look at a print by Th. Galle depicting 'complacency' by many examples,[352] or themes, including an ape with its young: the ape, through the complacency of love, thinks its young ever so beautiful. This interpretation leads to the conclusion that our approach also provides a key for understanding the emblems – this ape, for example, is to be found in Cats's emblem book referred to earlier.

Perhaps we have also here found the key to an understanding of the true significance of allegories: they are a way to render a motif directly, without referring to a specific theme or a scene from everyday life. We see this, for instance, in a print after Bruegel that depicts Prudentia:[353] in the centre Prudentia is given in allegorical form, thus clarifying the motif of the many genre scenes in the print. Wierix's *Ira*[354] is also a case in point: quite different from medieval personifications, these allegories try to clarify the basic motifs themselves.

Perhaps you are interested to know what this approach may mean for later periods. Nineteenth-century art is different. When we look at a Cézanne we know that he worked *sur le motif,* as he said himself, but that the true content or meaning of the picture was to be found in its composition, in the way the motif was realized. Here the content lies in the composition, for in the art of this period the themes have almost ceased to be of any importance. In our [twentieth] century the same observation can often be made. Frequently even the motif is gone and only the composition remains as the true bearer of content, as in the works of Kandinsky and Mondrian. In some cases a particular personal style bears the content, as in almost all the works by Abstract Expressionists.

• Woman in Danger: a motif in seventeenth-century art[355]

It often seems as if seventeenth-century art places us before a strange dilemma. On the one hand, we have the feeling, from the manner in which various themes are approached, that for the artist the essence did not lie in them, while on the other hand we know that they were not indifferent to these themes. We should be wary of an anachronistic

approach to seventeenth-century art, as if the subject was simply an occasion for the work of art to be made, as is the case with modern art.

We need to determine the relative meaning of the themes. Furthermore we may assume that the meaning of a seventeenth-century work of art is usually clear to the viewer. We see a rape scene, or raid or abduction, even though we do not yet know whether it concerns Proserpine, a Sabine virgin, or another female figure.[356]

In short, our answer to the problem posed is that a seventeenth-century work of art had as its starting point a motif, which as such contained a general human occurrence. This motif was then concretized in a specific theme, taken from the Bible or classical antiquity, either myth or (pseudo-)history, or from daily life in the so-called genre piece. Or, as Karel van Mander says, it concerns the 'depiction of emotions, passions, desires and sufferings of man', which are then given in examples [*exempla*]. For example, 'To picture the emotion of love' he gives the example of Antiochus and Stratonice.[357] The truth of the motif is, as it were, 'proved' by the chosen example, which vice versa expressed a general human truth to the beholder.

De Lairesse states it like this in his *Groot Schilderboeck*: 'The Moral Scenes are true stories or incidents, presented only for edification or as instructive examples, relating the good deeds or mistakes of the people, who play their role in it, conveyed by various added meaningful Images, which express the tendencies that drove and entranced them. For example, with Alexander: Ambition, with Marcus Aurelius: Clemency, with Augustine: Godliness.'[358]

This was not just theory. Boissard (1596) always gives a specific story under a general heading, e.g. under 'Blasphemy' he lists 'Sennacherib', while *Contemptus Dei* ('contempt of God') is given the specific examples of Aiax Telamonius and Capaneus.[359]

The question now is this: how is it possible for the viewer to know almost immediately what is meant by the story – which exegesis is being given to the story – without having to look for the key in emblems, etc.? Even if we could assume that a seventeenth-century person would be familiar with the significance of the theme and with the emblems, we cannot suppose that the content would be clear to him or her just because of this, i.e. indirectly. Besides, we too immediately understand from the visual data what Rubens's *Abduction of the daughters of Leucippus* means,[360] even if we do not know the story, and even if we should not have read the title in a catalogue or in a caption. Not that one could not find further details through study,[361] but the painting is usually not a kind of puzzle to be solved laboriously.

We think that the manner in which the figures are rendered, i.e. the applied formula, often provides an immediately clear indication as to the meaning of the depiction. The formulas, associated with certain motifs, form the syntax of seventeenth-century art. They constitute the turns of phrase by which the painter made his intentions clear.

By way of illustration we wish to look at a number of themes that all fall under the motif of 'woman in danger'. Our first choice is the well-known theme Vertumnus and Pomona. One of the most beautiful renderings of this theme is found in P. Moreelse's work in the Boymans-Van Beuningen Museum.[362] A virginal young girl is depicted in profile. She looks at us without reserve and freely shows off her youthful womanliness. In fact, we see what the 'old woman' Vertumnus sees – a twisting, which is the result of a turning of the main figure such as we come across more than once in sixteenth-century Mannerism.[363] In this way Vertumnus could be placed behind Pomona, while it is yet clear what it is about. Pomona is holding a bunch of grapes, used in Cats's *Houwelijck* for the coat of arms for the Virgins and Old Maids.[364] The girl does not realize the danger she is in; she thinks it is an old woman standing behind her. It is certain that a gentle lesson is given here: 'Be careful and not too trusting.' Pomona is here undoubtedly a woman in danger.

If we look at other pictures on the same subject, we notice that Pomona is almost always depicted in profile.[365] Only in later works, such as the one by Aert de Gelder in Prague,[366] does Pomona get a more frontal sitting: we get the impression that here the meaning of the theme has faded somewhat into a genre-like juxtaposition of young and old. It can be seen from a work by Caspar Netscher how little the subject in later times refers to 'woman in danger'. In fact, it could be the portrait of a lady – and probably is that – in which the threat of danger no longer plays a role.[367]

In general we get the impression that especially art from the first half of the seventeenth century worked with motifs and the formulas connected with them. That was the time in which this manner of artistic thinking was blossoming. If we look at the work by H. Goltzius in the Rijksmuseum in Amsterdam, we must conclude that Pomona is not rendered as a woman in danger. The reclining pose, known from Giorgione's *Venus* and numerous other Venuses, and also from Danae, e.g. by Rembrandt, or from one of the daughters of Leucippus in the work by Rubens, is rather a formula indicative of 'inspiration through love and beauty'. The clearest example of this is Titian's well-known work in the Prado: *Venus and the musician*, for which 'Love and Beauty inspire Music' would be a better title.

Susannah and the Elders is undoubtedly a theme that often means 'woman in danger'. We know the theme as it was pictured by Rubens,[368] Guercino[369] or Jacopo da Empoli[370] in Italy. It always features a woman sitting in profile. A very early example is that by J. Metsys;[371] a very late one that by A. van der Werff.[372] However, we also find the same theme where Susannah is rendered in a different posture, e.g. by Honthorst,[373] whereby we notice another accent with respect to the content of the story, i.e. the fright of Susannah, comparable to the representation of women in various themes having the motif 'rape'. Several times we do

not see the woman in profile, but presented more or less sitting in a frontal position. We think of Van Dyck's work[374] and that of S. de Bray.[375] In these cases we are dealing with the 'chastity of Susannah'.

Rembrandt also painted Susannah a few times. Well-known are the painting in the Mauritshuis (1637) and the one in the Berlin-Dahlem Museum (1647). In the older work Susannah is sitting in profile, fitting in with our thesis that we are dealing here with the formula of 'woman in danger'. Even more remarkable is the work in Berlin of 1647: Susannah is walking towards the water, and yet, visually she also has a posture that seems as if she is sitting in profile. Her total posture, also her left arm for example, is related to that older work – more reason to see her as a 'woman in danger' here.[376]

Much of what we saw until now can also apply to the representations of Bathsheba.[377] This scene was understood in an earlier period as the temptation of David by Bathsheba; in the late Middle Ages the theme was even ranked as one of the *Weiberliste* (women's lists).[378] However, it is questionable whether it was still seen like that in the seventeenth century. Boissard speaks about David and Bathsheba under the heading 'Adultery' and he explains as follows:

> The glowing fire of passion rapidly robs Jesse's son of his senses. And it is not enough to defile the bed during the husband's absence. Blind Venus adds murder to adultery ... The lack of restraint is the source of all confused deeds ... David has fallen into great sin, because he gave free reign to his desires. From his terrace he saw Bathsheba, the wife of Uriah, while she was bathing. He desired her and committed adultery with her.[379]

In 1637, in a series of pictures about the life of David, Claes Jansz Visscher presents the episode with Bathsheba under the heading *Otium calamitosum* ('disastrous leisure').[380] There is every reason to accept the fact that for the seventeenth-century person Bathsheba was a woman in danger. The formula for presenting her makes the motif clear as such. This certainly also applies to Rembrandt's famous work in the Louvre. In contrast with the themes mentioned before, as to the theme of David and Bathsheba we only find a few different exegeses indicated by another formula. But we do often notice a less clear formulation and a more genre-like approach in later works, for example, with Jan Steen.[381] We even found it mixed with the theme of Vertumnus and Pomona in the case of a work by C. Netscher.[382] One might even view this as a lifelike portrait of a young woman.

Are there other themes in which we could think of 'woman in danger'? If we accept as a heuristic principle the formula 'woman sitting in profile', then we can surely expect, and also find, all kinds of instances. We mention here the depiction of Andromeda by R. Manetti,[383] and a print by Magdalena de Pass, picturing Jupiter and Semele.[384] Rubens's *Venus frigida* [385] is also rendered according to this

formula, which does not need to surprise us even though the danger for the woman here is the opposite of nearly all other instances. We come across this formula also in representations that are difficult to describe thematically and for this reason are rather genre-like 'glimpses of life'. For example, we think of the piece by G. Dou in the Lakenhal in Leiden in which the sitting figure combing her hair shows a very strong likeness to representations of Bathsheba, without us being justified in giving this title to the work.[386] Various etchings and drawings of female nudes by Rembrandt also show this formula, especially the etching of the bathing Diana which alludes in content to the 'woman in danger'.[387] Precisely in this way the realistic character of these nudes is underlined.[388]

Although it is clear that not all cases of a sitting woman figure involve a woman in danger – e.g. allegorical figures representing the liberal arts[389] – this formula will often make clear which exegesis is given of a biblical or classical story or which emphasis is intended in a genre tableau.[390]

In closing: would the posture of little Ganymede, abducted by the eagle as Rembrandt paints him, not also indicate an 'erotic threat'?[391]

• Charity in seventeenth-century art[392]

In the art of the 'great tradition' from the sixteenth to the eighteenth centuries, subject matter was never chosen at random but instead always had a specific meaning. However, this meaning goes beyond simply that of the story illustrated in the painting: the story was chosen as an example (*exemplum*) of a more general idea or thought, which I should like to call a 'motif'.[393] We find this approach e.g. in Karel van Mander's *Schilderboeck* (1604) in chapter VI where he discusses the choice of themes in relation to a more general motif – for instance, to express the affect of love[394] – and he gives several examples.

Also, much later, in Gerard de Lairesse's *Groot Schilderboeck* we find that in the same way general ideas like 'ambition' are exemplified by Alexander, 'clemency' by Marc Aurelius, 'piety' by Augustine, and 'temperance' by the story of Scipio Africanus who returned a bride to her bridegroom.[395] We find this in a passage in which he deals with 'moral stories', true history or incidents, once again as *exempla*. De Lairesse identified four different kinds of subject matter: historical, poetic, moral and hieroglyphic (in our terminology 'allegorical'). He states that in those cases were the general motif is not immediately clear one should add an explanatory symbol, either a (allegorical) figure or an animal or another emblematical image.[396]

This means that in the art of the great European tradition of the High Renaissance, the Baroque and the classical, a picture always has a

meaning that is more than just the story portrayed – a kind of double meaning by which the story painted is related to a more general idea. The books mentioned above, as well as others and, of course, the works of art themselves make it clear that in principle four different kinds of themes could exemplify a specific motif: biblical themes, classical mythological themes, classical or other historical themes, and genre pieces in which the subject is derived from daily life.

To us, living in a time in which this intricate system, related to a deep understanding of life and the world, has been superseded by new approaches to reality and by new insights,[397] this way of looking at art has become much less self-evident. So, if we could find a key to understand better, or with some certainty, how a specific work should be interpreted, this would be of great help. In this paper we should like to speak about one specific motif that has been expressed in many *exempla*, a case in which we see what de Lairesse referred to when he asked for clarification where the motif might be ambiguous. In this case the motif is clarified by a kind of 'hidden' allegorical figure or group, which in an almost emblematic way makes clear what the motif of the main story of the painting might have been for people in those days.

The motif we are thinking about is 'charity', love. The allegorical expression of the idea of love has been dealt with in different places.[398] For our purposes it is enough to recall that since the Renaissance, charity, meaning (mainly) neighbourly love ('love thy neighbour' but sometimes also the love of a person for God or of God for a person), has been depicted as a woman with one or more children whom she is usually breast-feeding. Two main types can be distinguished alongside some other less clearly defined types, namely the so-called della Quercia-type, with the woman standing, or the Tellus-type, with her sitting. Maria Wellershoff rightly points out that the types were never precisely formulated, and therefore never frozen into a specific icon. It is precisely this fact that has made it possible to use the charity group in many paintings in an almost hidden form – the group could be placed amongst other figures as an apparently natural part of the whole scene.

I am thinking of Rubens's famous *Raising of the Cross* in the Cathedral of Antwerp. J.R. Martin in his book, *Rubens, the Antwerp Altarpieces*,[399] gives not only the sources but also the most important discussions of this painting in the literature on art since the seventeenth century. It is very interesting to note that nobody took much notice of some of the peculiarities of the group of women on the left wing. Reynolds mentions them only in passing, saying that they were considered a necessary part of a composition, in order to produce variety,[400] a statement that is only partly true. Certainly it appears that Rubens gave them a more important role than that. Catching the eye directly, since they are nearest to the viewer (and on the surface of the painting in the lowest position), is a group comprising a young woman with a bare breast and

a child whom she is obviously feeding. If we want to understand this group iconographically – and so go further than making merely a general remark on the variety and colour, for which the group is just a little too prominent, then we should look at it as a charity group, placed here as the explicit statement of the basic motif behind this specific *exemplum* of the love of God seen in the crucifixion of Christ. The connection between the Crucifixion and Charity is not new, for already in the thirteenth century Charity is placed in Crucifixion scenes as thrusting the lance into Christ's side.[401]

In Rubens's work we find many more examples of this use of a charity group, a group comprising a woman (or women) with one or more children that is not an obvious part of the story told by the picture. Such a group is found at the lower right-hand corner, not taking a leading part in the action but in fact being apparently out of place if we consider purely the main action, in Rubens's *St Ignatius healing the possessed* in Vienna, and so here Ignatius' act may be seen as an example of the motif of love, either the saint's love or the love of God.

An older example that might have been instrumental in promoting the use of the Charity group to indicate the motif of the painting is the very obvious example of Fra Bartolommeo's *Madonna della Misericordia* in Lucca, in which we see a charity group in both corners.

Tintoretto is another artist in whose work we fairly frequently find this group. A very explicit example can be found in his *Last Supper* in the St Marcuola, in which the figure is clearly an allegorical figure, not to be explained as an addition for the sake of variety. But, of course, in Venice the use of the charity group as part of a composition was much older; we can mention the very special case of *The tempest* by Giorgione as explained by Wind.[402] Another example of a very playful use of the charity group is found in Tintoretto's *Presentation of the Virgin* in St Maria della Orto in Venice. As this composition is a complete redefinition of Titian's work on the same subject, exhibited in the Accademia in Venice, we should look at it expectantly and, indeed, we do find a woman with a child, a Charity of the della Quercia-type, on the left side of the painting.

A curious example of what may be seen as a kind of negative use of Charity is a painting by C.A. Coypel, *Don Quixote demolishing the puppet show* (1723/4), in which we see in the right-hand corner an older woman with children, as a kind of mock Charity, for she is plainly too old to be nursing children.[403]

In the list below, which is of course not intended to be comprehensive, we mention the place where the group is found. As it is key to the meaning of the picture, its motif, it is not surprising that in many cases the group is found in the left- or right-hand corner, more or less aside from the [main] action. We indicate this position as B.R. (bottom right) or B.L. (bottom left), and so on.[404]

Artist	Subject	Position of Charity group in painting	Location & illustration
Masaccio	*St Peter and St Paul distributing alms*	B.C.	Florence: S.M. del Carmine, Brancacci Chapel (*Enc. W.A.* IX, pl.347)
Lippi, Filippino	*St John Evangelist resuscitating Drusiana* (fresco 1487–1502)	B.R.	Florence: S.M. Novella, Strozzi Chapel
Raphael	*Expulsion of Heliodorus* (Second half of 1512)	B.L	Rome: Vatican Stanza dEliodoro (0. Fischel, *Raphael* (London, 1964) pl.102)
Bartolommeo, Fra	*Madonna della Misericordia*	B.L. & B.R.	Lucca: Pinacoteca (Freedberg II (1961) pl.532)
Peruzzi, Baldassare	*Presentation of the Virgin*, c. 1518	B.R.	Rome: S. M. della Pace (Freedberg II (1961) pl.94)
Corona, G.A.	*St Anthony preaching in Padua*	B.R.	Padua: Scuola S. Antonio, no.11
Salviati, Francesco	*Visitation*, 1538	B.R.	Rome: S. Giovanni Decollato (Hauser, pl.98)
Conte, J. del	*The preaching of John the Baptist*, 1538	B.L.	Rome: S. Giovanni Decollato (G. Briganti, *Italian Mannerism* (London, 1962) pl.56)
Conte, J. del	*Baptism of Christ*	C.	Rome: S. Giovanni Decollato (Hauser, pl.33)

Artist	Subject	Position of Charity group in painting	Location & illustration
Lombard, Lambert	*The gathering of Manna* (drawing)	B.L. & B.R.	Dusseldorf: Kunstmuseum der Stadt Dusseldorf inv. no. FP. 4749 (*Exh. Cat. Le Siècle de Brueghel*, 2nd ed. (Brussels, 1963) no. 294, pl. 278)
Lombard, Lambert	*The multiplication of the loaves*	B.L. & B.R.	Blockey (Gloucestershire): Cull. Capt. E.G. S. Churchill (*Exh. Cat. Le Siècle de Brueghel*, no.149, pl.149)
Tintoretto	*Last Supper*, 1547	B.R.	Venice: S. Marcuola (H. Tietze, *Tintoretto* (London, 1948) text p.16, pl.20)
Tintoretto	*Presentation of the Virgin*, c. 1552	B.R.	Venice: Maria della Orto (Tietze, *Tintoretto*, pl.98)
Tintoretto	*Miracle of St Mark*, 1548	B.L.	Venice: Accademia
Tintoretto	*Baptism of Christ*, 1576–1581	B.R.	Venice: S. Rocco (Tietze, *Tintoretto*, pl.204)
Tintoretto	*Moses strikes the rock*, 1544–1547	B.R	Frankfurt: Städelsches Kunstinstitut (Tietze, *Tintoretto*, pl.8)–also later one, 1577, in St Rocco (Tietze, pl.187)
Tibaldi, P.	*Conception of St John*	B.R.	Bologna: S. Giovanni Maggiore (Hauser, pl.121)

Artist	Subject	Position of Charity group in painting	Location & illustration
Sermoneta, Siciolante da	*Baptism of Clovis,* ca.1548–1549	B.R.	Rome: S. Luigi dei Francesi (Freedberg (1971) pl.216)
Barocci, F.	*Martyrium of St Vitalis,* 1583	B.L.	Milan: Brera, no.574
Cati, P.	*The Council of Trent,* 1588–1589. Here the charity group is part of an allegorical composition in connection with Faith and Hope, etc.	B.C.	Rome: S.M. in Trastevere (*Enc. W.A.* XI, pl.449)
Morandini, F. (Il Poppi)	*Christ healing the leper,* c. 1584–1585	B.L.	Florence: S. Marco, Cap. Salviati (Freedberg (1971) pl.275)
Bassano, J.	*Parable of the sower,* almost a genre piece	B.L.	New York: Knoedler Galleries (*Enc. W.A.* VI, pl.69)
Franken, F. (the younger?)	*Conversion of St Bavo*	B.L.	London: National Gallery (Knipping II, p.211, pl.149)
Bloemaert, A.	*Preaching of John the Baptist,* c. 1600	B.C.	Amsterdam: Rijksmuseum no. 525-A2 (E.R. Meijer, *Het Rijksmuseum* (Amsterdam, 1965) pl.16/17)
Rubens	*Christ carrying the Cross,* 1634	B.L.	Amsterdam: Rijksmuseum, (*Bull. v. d. Rijksmuseum* 7 (1959) no.1, pl.1)

Artist	Subject	Position of Charity group in painting	Location & illustration
Rubens	*Conversion of St Bavo*, 1624. Charity as part of almsgiving to the poor.	B.C. & B.R.	Ghent: formerly St Bavo, now Kerkfabriek St Bavo(*Exh. Cat. De Eeuw van Rubens* (Brussels, 1965) no.194 & ills.)
Rubens	*The raising of the Cross*, 1610	B.L.	Antwerp: Cathedral (J.R. Martin, *Rubens: the Antwerp Altarpieces* (London, 1969)
Rubens	*The Miracles of St Ignatius of Loyola*, 1620	B.R.	Vienna: Gemaldegalerie (*K.d.K.* (1921) pl.204)
Rubens	*Henry IV's triumphal entry into Paris*, 1628- 1631	B.L.	Florence: Uffizi (E. Micheletti, *Rubens* (London, 1968) pl.50/1)
Rubens	*The reconciliation of Esau and Jacob*, 1625–27	B.R.	Coll. Sir Felix Gassel, Luton, Bedfordshire: (*K.d.K.* (1921) pl.290)
Pepijn, M.	*St Elisabeth giving alms*, 1620	B.R.	Antwerp: Museum (Knipping II, p.125, pl.84)
Quellien, J.E. (ascribed to)	*Healing of the lame man*	B.R.	Coll. S. Hartveld, Antwerp (Knipping I, pl.202)
Guercino	*St Peter raising Tabitha*, 1618	B.L.	Florence: Pitti (*Guercino Exh. Cat.* (Bologna,1968) no.27, pl.27)
Guercino	*Presentation of Christ in the Temple*, c. 1622	B.L.	Coll. D. Mahon, London (*Guercino Exh. Cat.* (Bologna, 1968) no.53, pl.53)
Ridolfi, C., (1570–1644)	*St Peter healing the lame man*	B.L.	Treviso: S. Niccolo

Artist	Subject	Position of Charity group in painting	Location & illustration
Petrelli, G.	*Preaching of the Crusade against the Albigensians*, 1669	B.R.	Treviso: St Niccolo
Cortona, P. da	*The treaty between Jacob and Laban* (1630–1635)	B.L.	Paris: Louvre (C. Briganti, *Pietro da Cortona* (Florence, 1962) no.58, pl.158)
Poussin	*Moses strikes the Rock*, 1649	B.R.	Nat. Gall. of Scotland, Edinburgh (K. Badt, *Poussin* II (Koln, 1969) pl.107)
Ladatte, F.	*Martyrdom of St Philip* (bronze) Women are looking at Philip being tied to a cross, 1746 (1738)	B.L.	Versailles: Royal Chapel (*Enc. W.A.* V, pl.407)
Coypel, C.A.	*Don Quixote demolishing the puppet show*, 1723–1724	B.R.(satyrical)	engr., Pailly (F. Antal, *Hogarth and his place in European Art* (London, 1962) pl.45b)
Ricci, S.	*Marriage feast at Cana*	C.L.	Kansas: William Rockhill Nelson Gall. of Art (J. Steer, *A Concise History of Venetian painting* (London, 1970) pl.143)
Solimena, F.	*Rebecca takes leave of her parents*	B.L.	Gem. Gradisca: Dr. G. Piperato from Venice, Pal. Baglioni (A. Piglet, *Barockthemen* I (Budapest, 1956) p.50)

Artist	Subject	Position of Charity group in painting	Location & illustration
Natoire, C.J.	*Conclusion of the Peace of Taranto* (drawing)	B.L.	Paris: Louvre (*Exh. Cat. France in the eighteenth century* (London, R.A., 1968) no.486, fig.165)
Tiepolo, G.B.	*The gathering of the manna*, c. 1738	B.L.	Verolanuova: parish church (*Enc. W.A.* XIV, pl.58)
Bigari, V.M. (1692–1776)	*Restoration of Bologna to the Vatican*	B.L.	Bologna: Pal. Montanan (*Enc. W.A.* X, pl.503)
Asam, C.D.	*The Adoration of St James*, 1721 (oil sketch)	B.C.	Design for fresco in Jacobskirche at Innsbruck; München: Staatl. Gem. Samml. (A. Schonberger/H. Soehoer, *Die Welt des Rokoko*, (München, 2nd. ed. 1963) pl.311)
West B.	*William Penn meets the Indians*	B.R. & B.L.	Philadelphia, Penn. Acad. of Fine Arts (*Journal of the Warburg Institute* 1 (1938) pp.119)
Verhaghen, P.1.	*Presentation in the Temple*, 1767	B.R.	Ghent: Mus. des Beaux-Arts (*Enc. W.A.* V, pl.318)
Bree, M.I. van	*Burgomaster v. d. Werff offers himself to the starving people of Leiden*, 1818	B.R.	Leiden: *Lakenhal* Cat. 1949, no.46

• The Dutch landscape around 1600[405]

In the Northern Netherlands during the course of the sixteenth century landscape art was pushed more and more to the background. Artistic activity concentrated almost exclusively on the portrait and on the large genre piece or on biblical scenes in the manner of Pieter Aertsen. Important masters were scarce, and inspiration came for the most part from Italy, where the anti-naturalistic art of Mannerism[406] flourished. In the Southern Netherlands after Pieter Bruegel we find no great masters of landscape art.

Many satisfied themselves with imitating what Bruegel had expressed in such a grandiose and overpowering way, but their works lacked depth or intensity. The works of artists like Lucas van Valkenborgh are very pleasant to look at but nothing more than that. Paul Bril, a painter from Antwerp who at a young age travelled to Rome to practice his art, allied himself with the older style of landscape art, the fantasy landscape (as we came to know it through Herri de Bles) and tried to move from there to a more natural, realistic kind of art. His early work had much in common with that of his fellow townsman Gillis van Coninxloo.

This Gillis van Coninxloo was certainly no master artist but he plays an important role in the history of our Dutch landscape art. He was born in 1544 in Antwerp, descended from a family of artists whose works we can trace back to the fifteenth century. He studied under various artists of whom we know very little – most probably masters who concentrated mostly on so-called 'fantasy landscapes'. After completing his education he ventured out on an educational journey (as was common among artists at the time) – in his case to France, and returned to establish himself back in his hometown in 1570. We know little about his art in these early years and what we know indicates that he worked in the genre of fantasy landscape, allying himself with older traditions. His most mature work of this first period is *Midas' judgment* of 1588. In this painting we see that he keeps to the very high horizon and unfolds for us a truly fantastic view, with huge rocks that seem more realistic than those of the earlier Patinier, while to the right and left the scene is framed with oak trees. The way in which these trees are painted, particularly the way the leaves of the outer branches are drawn with great precision in a style reminiscent of tapestry art, continue to typify his work, even though in his later work the trees begin to look more realistic. At the centre in the foreground the judgment of Midas is depicted, but we need not pay any further attention to that now except to note that this kind of subject too had no basis in reality.

That his method resembled the methods used in tapestry art, as we pointed out in connection with his painting of the leaves, can be explained by the fact that that was a very popular branch of industry during this artist's time. For van Coninxloo, like many artists and representatives of the applied arts, was a confirmed adherent to the

Reformation. It is not surprising to find that in Frankenthal it was particularly the art of woven tapestry, the gold- and silversmith crafts and the painted arts which formed the bulk of the town's industry.

Frankenthal was entirely a Reformed town. Refugees from the Southern Netherlands who were persecuted for their faith had since 1554 fled to Frankfurt: Frederik III of the Pfalz reigned here, the same sovereign who commissioned Ursinus and Olevianus to compile the Catechism that is still in use today. In 1562, however, they had to leave, due to a variety of plots by the guilds in Frankfurt. They then received permission from Frederik to occupy Frankenthal, which had formerly been a monastery. After about sixty Reformed families had settled there the population grew so fast tthat by 1577 Frankenthal had already become a town, and the industries mentioned above were its primary sources of income.

Gillis van Coninxloo stayed in Antwerp until 1585. Then, after the city was conquered by Parma, he left for Zeeland and from there he moved to Frankenthal in 1587.

Although the *Midas' judgment* painting was created during the following year in Frankenthal, a new attitude towards his work emerged soon after that, perhaps connected with a deepening of his faith life as a result of the course of events and his close contact with fellow believers in this entirely Reformed city. During this time he began to aim at greater simplicity and truth, a more realistic way of depicting trees and the landscape as a whole. For the time being ancient mythological stories continue to play themselves out in his landscapes and seldom did van Coninxloo go so far as to paint strictly realistic landscapes.. He continued to combine the realistic elements of landscape, trees and plant-life according to a specific scheme, in which his former perceptions shone through.

Around 1590 we see a new genre unfolding in his art: the forest scene. We see, for example, a forest in which he leaves an open space here and there for a small stream in between the trees, still primarily oaks. Often we can see the full length of a forest path, sometimes with a wild animal walking along it. Gradually this type of work came to absorb all his attention.

In 1595 he went to Holland, where many of his fellow countrymen had already preceded him. Van Schelven was accurate, in my opinion, when he pointed out that Calvinism, as it manifested itself so strongly in the Northern Netherlands at the end of the sixteenth century, was for a large part the fruit of the activity of those who immigrated from the Southern Netherlands because of their faith.[407] God blessed us richly through their arrival and their work. Van Coninxloo established himself in Amsterdam and in 1597 already was awarded citizenship.

When he died in 1606 he had many admirers. The auction at which his rich art collection (including works by Dürer, Lucas van

Leyden (gravures), Pieter Bruegel, Paul Bril, etc.) as well as his books (especially Reformational writings) were sold was very well attended, especially by artists.

Karel van Mander, who published his *Schilderboeck* in 1604, and who is one of our most important sources of information about art history in the Netherlands in the fifteenth and sixteenth centuries (here we find the first descriptions of the life of van Eyck as well as many others), ends his section on the life and work of van Coninxloo with these words: 'I know no better landscape painter in this time, and I see that his style is being copied closely in Holland. And the trees, which were rather bare here, are beginning to grow according to his manner, though a number of artists are reluctant to acknowledge this.' Among the painters he is talking about we must include people like Roelant Saverij, David Vinckboons, Gillis d'Hondecoeter, A. v.d. Venne and others; these include a large number of immigrants.

It was and remains a style of art that is based on a scheme, in which all kinds of elements observable in nature are arranged. And the trees continue to be painted in that peculiar way which is more a manner of painting than a realistic portrayal.

We should also mention Jan Bruegel, Pieter's son, who was born the year Pieter died, and who may have studied under van Coninxloo before he fled from Antwerp. In the early 1590s Bruegel went to Italy where he worked for quite long with Paul Bril – this artist was definitely Roman Catholic, or at least not Reformed. But even after his return he must have been in contact with van Coninxloo, who possessed some of his works and in whose style he continued to work in a grandiose way during the seventeenth century. It is also possible that, in his turn, this greater artist again had an influence on van Coninxloo. Bruegel's later work, especially that painted in cooperation with Rubens, fits better with the story of the art of the Southern Netherlands.

• The beginning of the great Dutch landscape art[408]

The sudden blossoming of our seventeenth-century art was truly amazing. After the war with all its trouble and strife had come to a somewhat tentative conclusion at the beginning of the seventeenth century our art quickly developed a completely unique style, subject matter and character. Over the next more than 75 years an incredible number of artists created such a flurry of activity that in economic terms it could be called nothing less than 'overproduction'. Imagine, an overabundance of masterpieces!

Now we want to see how and where this artistic renewal took place. In the previous article we wrote about Gillis van Coninxloo, who had such an importance influence on our landscape art around 1600 – though we should add that, in addition to him, there was a host of artists

from the Southern Netherlands whose influence pointed in a similar direction. However, this poeticized landscape art was really just a transitional phase, soon to be almost completely replaced by a much more natural style based on nature as it can be observed directly. This style still constitutes one of our nation's greatest contributions to the formidable museum of art history, and we view it with pride, even those of us only marginally interested in art.

The most important centre for the renewal movement was Haarlem, though this was quickly followed by similar activity elsewhere. In the late sixteenth century a group of artists worked there (Karel van Mander, Cornelis Cornelisz and, especially, Goltzius were the most notable among them); this group expressed themselves in a peculiar artistic language that is usually called 'Mannerism'. Mannerism as a movement cannot be described in a few words; on the contrary, in historical terms as well as in terms of form and content it is one of the most disputed and difficult – to define artistic styles that the West has known since the Renaissance. Its most distinctive characteristics include a reduced contact with reality, an unrestrained play of form, and a subordination of reality as an observable given in favour of an aesthetic sense of composition, colour and line.

In the earliest Mannerism, which began in the early sixteenth century in Florence after High Renaissance art had found its full expression in the work of Raphael and his soul mates, there was a complex series of motives that played a role in its origins: these included Neoplatonic mysticism and a reaction to the classicism of the High Renaissance, while the aestheticism of that period lingered on. Along with these influences came, in the course of time, a thrust towards a more courtly artistic style – this art was primarily practised in service of the Florentine sovereigns and the popes in Rome – and there was a consolidation of the important social position that artists had gained during the Renaissance. Painting was no longer a handcraft, but had become a high cultural calling on the same level as scholarship and literature.

During a time when the native art of the school of van Eyck and van der Weyden was threatening to fade, people in northern Europe, under the influence of the Italian Renaissance, had abandoned their own traditions and traded them in for an Italian artistic language; now these same people quickly fell victim to the new 'fad' of Mannerism. This influence would be strengthened over the course of the century.

In the Southern Netherlands, which remained Catholic because of circumstances which we cannot go into now, the Italian style was quickly assimilated. When Italy later developed a new art of the Counter-Reformation that overtook Mannerism (which despite its abundance of 'religious' subjects was completely secular), a truly ecclesiastical Catholic art manifested itself in an overwhelming way in the art of the brilliant figure Rubens.

In the Northern Netherlands, especially after the conquering of Antwerp by Parma in 1585 broke its link with the South, Mannerism remained for the most part a play of form. The large figure paintings in the style of Italian Mannerism remained something strange and foreign here and found a worthy expression in only a few artists – Uytewaal and Bloemaart of Utrecht, and the previously named artists from Haarlem represent the best of them. The extent to which the spirit of Mannerism was internalized becomes clear in the landscape art as it was revived at the end of the century. We see it quite moderately expressed in the works of the above-mentioned Bloemaart and particularly in the followers of Gillis van Coninxloo. Occasionally it came out more vehemently and clearly, for instance in the work of Jan van de Velde. It is a remarkably strange world that this artist sometimes draws us into, a world in which everything is unsteady, in a state of decay with ruins that are truly spine-chilling. Nature wins out over the products of human culture here; humankind has no chance in the face of the overwhelming majesty and might of nature. That's the message, an excellent example of a romantic view of life.

Why does a person's imagination become so preoccupied with ruins? Because the theme is relevant – namely, it expresses something that is rooted deep in the heart of people concerning their relationship with nature, which they perceive as something that is threatening and oppressive, that interferes with and limits their highest activity – their cultural endeavour. These themes are relevant to the 'Mannerist' person because they represent a particularly meaningful connection between subject and world view – the one reveals and communicates something about the other. There is a profound connection between the expressions of this person, whose freedom-seeking heart (humanistically speaking) comes into conflict with reality, and similar expressions from the times around 1800 and in later modern art. In the latter we again come across that sense of ruin, often in an even more undiluted form. One only needs to think of the gloomy deadness that Raoul Hynckes painted in his still lifes, and of the work of the equally well-known Willink.

From van der Velde's work we see that the Mannerism of these Haarlemmers was not just a borrowed style, an imitiation of a foreign artistic language. What is typical of these Netherlanders is that they are better at picturing such feelings in landscape drawing than in figure paintings full of nudes, a genre in which their Italian counterparts were much more skilled. At the beginning of the seventeenth century wonderful things were happening in Haarlem where Jan van der Velde worked. It is remarkable that precisely in the environment of a group of artists strongly influenced by this Italian spirit, a group of younger artists should create something that expressed the exact opposite of that spirit. Or perhaps it was precisely *because* of it, as a reaction because they had experienced first-hand the foreign and 'un-Dutch' element in the art of the older generation.

So, what happened? Well, it was very simple, really. Artists took their drawing pencils and paper outside, and started to draw. No poetic, lyricized reality, no romanticism, no bizarre fantasies appeared on their drawing pads; nothing other than the plain rendering of what they saw. Plain? Yes, plain – as long as one does not understand that to mean cold, calculated, materialistic. 'Plain' here means faithful to reality. For in their work they celebrated their love for that which they observed, their fatherland – which had been wrested from the enemy after a violent struggle (and especially in Haarlem they knew about that!). Out of this quiet love for truth, borne along with an awe for the native beauty they observed, the new art came into being.

There was no longer any need to travel, to linger on mountains or wander in forests, to glorify the ruins of antiquity. And there was even less desire to violate that reality by romanticizing or poeticizing it (thereby turning it into something contrived). The 'ordinary' became relevant, meaningful, important. Out of a profound respect for their land (graciously given back to them by God, so that they could live in freedom), out of a deep reverence for this divine creation, out of a true love for reality in all its beauty and uniqueness this art was born.

We have in mind here, for example, the landscape drawings by Claes Jansz. Visscher, who later became a publisher of prints[409] and who in that role was such a great encouragement to the artists of this new direction. It was especially in their drawings that this new spirit first came to expression. In paintings, which were more often intended for sale and therefore necessarily more closely tied to current fashion, artists gradually also began to break with tradition – Essaias van de Velde, for example, who was the nephew of Jan van de Velde, and Jan van Goyen and Salomon van Ruysdael.

How did this reversal in artistic perception come about? Which spirit brought about this change? What was its deeper background – those are all questions that you may still be wondering about, and which we hope to deal with in a future article.

• The landscape art of Jan van Goyen[410]

In the previous article we discussed the origins of Dutch seventeenth-century landscape art, an art which relied on observation and built on the traditions of Bruegel and the people around him in its aim to express naturalness and sober truth.

Maybe we can start to understand something of the distinctive character of this art when we focus on the work of Jan van Goyen, who worked in the line of the founders of this art form, in general not great artists, and perfected the technique to its highest standard to arrive at an almost perfect form of landscape art [see *Complete Works* 3, Plate 1].

To understand the typical characteristics of the work of Jan van Goyen, we begin by turning our attention to the way in which he portrayed depth and space. The difficulty of such a task should never be underestimated. Artists are required to depict on a two-dimensional flat surface like a canvas or a panel something that will appear three-dimensional. They will need to employ a variety of methods for the purpose of giving the viewer a vivid, clear sense of that spaciousness and depth. Such clarity will never emerge when artists simply copy or imitate what they see in front of them, for in that situation there is the danger that all sorts of accidental elements will appear in the painting. Just think of a photograph taken casually with a camera; think of how the picture will sometimes have shapes in the foreground blending in with shapes in the distance to create amazing but entirely unnatural effects. The fact of the matter is that to paint a truly natural-looking painting, to achieve clarity in the depiction (which corresponds with the clarity of the landscape and the objects in it – boats, churches, trees, etc. – in reality) is only possible when the artist deliberately makes use of certain techniques, organizing, composing, and choosing his forms and the placement of the different objects with care. The most natural look is achieved only by those who are experts at composition and the handling of pictorial elements.

Which methods did van Goyen use to convey a sense of depth? In the first place he used simple perspective: an object that is further away looks smaller than something that is closer by. We would stray too far from our topic if we tried to explain how this is also a technique for suggesting depth, a technique that is far from self-evident. We do not see reality 'in perspective' before us: it looks natural to us in a painting because since the fifteenth century we have grown thoroughly accustomed to seeing it that way on a flat surface.

A more refined, subtle method is the so-called 'aerial' perspective. Averkamp was a pioneer in the use of this technique, which is based on the fact that something that is far away looks less bright than something closer by. The red colour in the coat of a person moving away from us becomes lighter and lighter.

A third technique is the so-called repoussoir, derived from the French word repousser, which means 'to push away'. This expression conveys how, by positioning a darker object against a light one (or vice versa), the one appears to be pushed forward (thus 'pushing back' the other one). Thus we can find in van Goyen's paintings a rowboat very deliberately placed against a light spot in the water, and a dark sail positioned against a light sky, again not by accident. When you study his paintings more closely, you will find this 'trick' applied in such a masterful way that you hardly notice it. His large landscape of a village along the river, which hangs in the Rijksmuseum, shows a man busy unloading his boat: his light hat stands out against a dark wall, but his coat is dark against the lighter road, etc.

A fourth technique for conveying a sense of depth is found in the alternating of light and dark strips. One can see for example first a dark stroke in the foreground, on which a rowboat is lying; then a light one, and then again a darker one. The remarkable thing is that in the real world this would not help to make the perspective clearer. Quite the opposite. When you look out over a polder-landscape where clouds are casting dark shadows, so that you see lighter and darker strips in succession, the distance becomes much less obvious than when the sky is clear. But in a painting, this alternation of light and dark patches has the opposite effect of enhancing clarity and depth.

Finally, there are the clouds. Salomon van Ruysdael, a contemporary and peer of van Goyen, made clouds his main focus and he painted some gorgeous skies. But – and that is what concerns us here – also the way of representing this aspect of reality was placed in service of the depiction of three-dimensional depth, for clouds which are placed vertically on the canvas help to suggest depth, whereas clouds placed horizontally suggest breadth.

Colour plays a minor role in Jan van Goyen's art: his paintings are usually done in nuances of a single colour – greys or browns – which is called tone-painting. It is only later, in the work of Jacob van Ruysdael, that colour began to play a more significant role. Maybe you were surprised when, in the discussion about clouds, I spoke about 'vertical' and 'horizontal' clouds. Indeed, this shows how direct the effect is of colour-particles on the surface of the canvas: we can hardly disconnect those from what they represent. But – and this brings us back to our comment at the beginning – we must always remember that artists are working on a flat surface on which they must capture their vision of reality. Therefore we must distinguish between *composition* and *ordonnance*. By the latter term we mean the arrangement of the objects in the foreground or background – assuming that the reality called up by the painter actually exists. How are things laid out? For example, a rowboat can be located in the foreground, a sailboat diagonally behind it, a church tower in the distance, etc. The word 'composition' refers to the arrangement of the elements on the two-dimensional surface. If we study a van Goyen painting as to its depth-representation and consider how the relationship between composition and ordonnance works in a painting like this, then we will see that they are inextricably bound together, and that the one is unthinkable without the other.

Turning now to composition, we see how Jan van Goyen builds his compositions in a very unique way. First this comment: perhaps it is because of the direction in which we read and write that we Westerners (unlike the Chinese and the Japanese) examine a painting, as it were, from left to right. Or rather, the piece is logically built up that way. Just as a poem begins with the first line, a painting 'begins' in the left bottom and is then 'read' from left to right. Of course then the eye begins to 'travel' to take in the relationships of the various elements, but that can

be compared with a poem which, when we have finished reading it, we begin to examine in more detail; perhaps we will try reading it from the end to the beginning, line by line, to help us understand how the artist put the piece together.

Jan van Goyen's style is to place in the painting's left bottom corner an introduction which draws us into the work – for instance, a dark area that leads us into the spaciousness of the painting. It has the same effect as the introduction to a musical piece. This is followed by the 'first theme', for example a sailboat in the distance. The middle of the piece usually has a transitional theme, a 'bridge passage', maybe one or two rowboats on the wide river. This is followed by the 'second main theme', e.g. a town on the river. Finally we have a 'coda': reeds, a barrel or ducks, none of which are placed there arbitrarily. You should try to see more of Jan van Goyen's work to see how frequently this style of composition reappears.

All these things are combined to create the effect, the poetry, of the work of art – which truly is a work of art and not just an arbitrary photograph of a river with boats. This also implies that we could not turn the painting around – just as we could not do that with a poem or a piece of music. After all, even if in analysing a poem we would study it from the end to the beginning, still the proper direction in which to read it is presumed. The same is true here: turn the reproduction around with the backside towards you, hold it against the light, and you will see it backwards, in mirror image. Notice that the painting does not have the same appeal and that the significance of the themes changes considerably. Think for example of van Goyen's large piece in the Rijksmuseum entitled *Village along the river*. When you look at it in mirror image, the village which was the central focus of the painting becomes a matter of secondary importance, and our eye immediately travels along the coast to the far end of the river (which in the mirror image moves toward the right).

In conclusion, we may ask what exactly Jan van Goyen portrayed here. The tower in the distance may be the one in Dordrecht, but that does not mean that the painting also portrays the river near Dordt. We might even see two towers which are actually from two different towns located a considerable distance from each other, or there might be other elements of which one can prove that in the actual place (topographically or geographically speaking) the reality is quite different, and that Jan van Goyen was not necessarily painting a specific section of the river.

We also need to realize that Jan van Goyen, just like his contemporaries, usually painted in the studio; at most he might have made a few sketches (taking notes, as it were) outside. But it is not his intention to paint a 'portrait' or something resembling a photograph of a certain piece of reality. In his paintings he shows us the structure, if you will, of the Dutch river landscape; its composition and its characteristic

elements. We can understand this best if we imagine ourselves having taken a trip down the River Waal. What do we remember when we get home? What image stays with us? It will be a picture in which a host of different images that struck us along the way seem to be blended into one whole. And that picture is exactly what Jan van Goyen is painting, taking into account the fact that he is a much more careful observer than most of us.

Or perhaps I can explain it a little differently. There are certain images that we take home with us after such a river trip; there are beauties we have noticed and remember (and the spaciousness and the distant hazy mistiness play an important role in that). Jan van Goyen was the first to show us those things artistically (and a multitude of other landscape painters followed in his footsteps). He taught us to understand and notice them. People who really immerse themselves in this art will, the next time they take such a river tour, find they notice more, enjoy more, look and perceive things more carefully.

And that is a wonderful thing. This painter is telling us in a very poetic, almost musical way, about the beauty of the Dutch rivers, the loveliness of the light, the wonder of the panoramic view, the characteristic movements of all those little boats. He teaches us wonderful things, and their value and truth are indisputable. And in so doing he deepens our love for this amazing world – God's creation – and that love becomes more specific and more defined. We will leave further conclusions up to you, and will quit now before we start preaching.

• Rembrandt's wisdom[411]

Rembrandt[412] is a remarkable artist. With respect to the nature of his art, he was quite an anomaly in his day. Although he never travelled to the South, he turned his attention more than any of his contemporaries to the art of the Baroque and his work was deeply influenced by it. Baroque was the new seventeenth-century art style which developed in Italy and Flanders in connection with the Counter-Reformation.[413] It was a style that once again took the old biblical stories and the stories of the lives of saints and tried to paint them with such beauty, magnificence, movement and grandeur that Catholic believers would be revitalized in their faith and convinced of the greatness of their church. These artists painted a world of superhumans, extremely muscular and showing superhuman fortitude, within an environment fitting for such beings; and they painted it all as if it was completely realistic, right down to the smallest details. In this art (most notably represented by the painter Rubens [1579–1640] in Flanders) it is as if we are observing a stage on which, with much colour and movement, these superhumans are performing a drama under the most incredible lighting.

This is the art Rembrandt came to know through prints (the reproductions of those days) and through viewing the fairly numerous pieces available at art dealers. He took the characteristics of this art and made them his own (to the extent that it was possible for a Dutchman, because that kind of theatrical 'heroization' does not really become us at all!).

It is difficult to say whether this interest in the Baroque was the reason why Rembrandt concerned himself with biblical scenes so much more than his contemporaries did. (He was too much of a Dutch Protestant to paint the lives of saints or scenes from Greek mythology.) Perhaps it was just the opposite, namely his interest in depicting biblical stories that drove him to look further afield, since Dutch art was at the time focused entirely upon portraying the natural reality around us.

We can explain many of the characteristic features of Rembrandt's art on the basis of the mentioned influences and interest: his striving for a 'most natural movement'; (of which he speaks in a letter from the early years in Amsterdam, the only letter of his that has been preserved); his search for sharp light-dark contrasts with an almost stage-like lighting of the painted scenes; his interest in topics like *The blinding of Samson*[414] or topics in which, because of the sudden intervention of angels and such there is a dramatic turn in the action, with much brilliance and tension. In these efforts, Rembrandt was not always convincing. His double portrait of himself and Saskia evidences a certain overconfidence, and perhaps a secret hope of some day being able to live in splendour like the grand seigneur Rubens? The result is foolish, contrived, and overly dramatic. The gesture of raising the glass, for example, does not seem realistic and, instead of elevating the middle-class character of this Dutch burgher it rather accentuates it more clearly. This is what characterized Rembrandt's paintings in years prior to 1640. They were years of fame and many commissions, and years in which he increasingly mastered the medium of paint. At the same time, we begin to see the emergence of another side of Rembrandt, though not so much in his paintings but rather in his drawings. In these sketches he notes down ideas and initial designs for large paintings which sometimes materialized and sometimes not. In addition, there are studies which also were not intended for publication or for sale. In these studies we see his interest in the ordinary events around him: people in their day-to-day lives, women playing with children, etc. After about 1636 Rembrandt was drawn to depicting landscapes, particularly the natural surroundings of Amsterdam.

We see a gradual maturing and deepening of insight, and a growing awareness that Baroque art is too superficial, with too much glitter and too little of what is substantial and genuine. In *The nightwatch,* a work that took him several years to paint, we see a last attempt to combine the Baroque movement with a more peaceful and orderly compositional style. In the composition of the etching *Haman and Mordecai* Rembrandt formulates some of the problems posed by *The nightwatch.* In the former

he attempts to offer an initial solution to those problems. Remember that an etching is printed from a copper plate, on which the original drawing has been etched; therefore the image appears in mirror image. If you turn this image around, you will see the connection with *The nightwatch* even more clearly. Here, too, you see a man who appears to be walking out of the image towards us, a portal in the background, and a procession. One detail deserves our special attention: the hand of Haman, which stands out so clearly. The artist achieves that effect by letting the staff in Mordecai's hand, the spear sticking out behind the horse, and the tail of Mordecai's robe serve as pointers to this hand. But these lines that serve as pointers have been criss-crossed with other lines, so as to hide this technique.

The nightwatch (completed in 1642) thus indicated a turning point in Rembrandt's career as an artist, as well as a milestone in his development. From that time on he did not hazard travelling this road again. This feat of artistic strength, with which he may have been not particularly satisfied, signalled the end of his interest in Baroque art. Although the death of Saskia as well as the less than enthusiastic reception of this work may have strengthened this development in Rembrandt's artistic thought, it would not be right to explain the changes in his art simply on the basis of extra-artistic circumstances.

Perhaps we should say a few words about the 'tragic Rembrandt' about whom you hear so much. If you follow the literature about Rembrandt from his own time until today, you will notice that no one in the seventeenth or eighteenth centuries ever used the word 'tragic'. The poor reception that *The nightwatch* received, and the decreased interest in his work after that by his contemporaries, are hardly ever mentioned. His bankruptcy in 1656 is simply seen as the inevitable result of financial mismanagement and living beyond his means. Neither, for that matter, did the Dutch hail him as a great national artist, just as in the eighteenth century the public had little interest, on the whole, in Dutch seventeenth-century artists, and their works were mainly used as export products. In the nineteenth century, with the debut of Romanticism and its accompanying nationalism, every nation came forward with a 'great man'. England produced Shakespeare, for example; Germany produced Dürer; and naturally the Dutch felt the pressure to come up with someone too. With little enthusiasm, Rembrandt was chosen; other than this, people just perceived him as a Dutch citizen, a personification of typical Dutch middle-class culture.

Then, with the further development of the Romantic respect for great heroes, people – in particular foreigners – discovered the 'tragic Rembrandt', presenting him as a man misunderstood and neglected by his times, a great man in the midst of a petty world. Finally today, through careful research of the real facts, we have returned to the right path and have learned to judge Rembrandt more soberly. We learned that Rembrandt's commissions did not drastically decrease in number

after *The nightwatch*, and that his bankruptcy was, to a large extent, his own fault. After all, even though you may be a celebrated artist, a debt of 3,000 Dutch guilders (it would be many times that today [over $100,000]) is no small matter!

Only one book

When he was declared bankrupt, all the contents of Rembrandt's home were sold, and the auction catalogue contains a full account of his possessions. Besides all kinds of curiosities, beautiful carpets, helmets, etc., he also owned many prints. Among others he owned nearly the entire collection of Albrecht Dürer's woodcuts and copper engravings, as well as a great many Italian prints. Other than that, he owned only one book – the Bible. Rembrandt must have had a great personal interest in the Bible, considering the fact that again and again, in paintings, drawings and etchings, he portrayed biblical stories. And he did not limit himself, like the Roman Catholic Baroque artists did, only to those stories which had become accepted by tradition. Rather, he often dealt with subjects which had never before been artistically portrayed – scenes from the life of David, Joseph telling his dreams, and others. What is striking about his drawings, and also about the etchings and paintings from his most prolific and fruitful time (the 1650s), is how soberly he depicted these biblical scenes – without any Baroque adornment or theatrical gestures. Like his contemporaries, he made no attempt at being historically accurate (that did not come until after 1800) but concentrated rather on shedding light on the significance of the event. At the most he might indicate that the story takes place in the Middle East by portraying Abraham with a turban on his head.

As we have seen, Rembrandt continually busied himself with biblical subjects; he showed no interest in producing so-called genre pieces, the glimpses into daily life that we know from artists like van Ostade and Jan Steen [for the latter, see *Complete Works* 3, Plate 2]. Apparently he did not consider those topics important enough for large compositions; in that he was faithful to the Baroque tradition, although in most respects he had broken with that movement. We do, however, find the ordinary everyday realities portrayed in his smaller drawings and etchings. An etching, after all, is a type of art intended to be sold, albeit to a very limited audience of connoisseurs. Therefore by its nature it finds its place between the 'public' painting and the sketch intended solely for personal study or notation. It is precisely in the etching technique that Rembrandt offered his very best, creating a body of works of unsurpassed excellence. There may have been artists who matched him in painting or in drawing, but as far as etching goes, he stands alone!

We cannot delve too deeply into Rembrandt's mature work, his beautiful portraits, his magnificent figure studies (for instance of an old woman reading) and his biblical scenes (the Holy family, Bathsheba,

Saul, David, etc.). In these we see Rembrandt at his best, an artist whose most outstanding quality is his humanness. It is that humanness that makes him accessible to everyone, including the 'layman'. Despite the brilliance of their construction and the genius of their design his works require no explanation. As a matter of fact, the secret of his art is that it almost defies explanation because it speaks for itself so beautifully. The means that Rembrandt used to call up his images so convincingly simply escape our analytical abilities. He offers us an unadorned portrayal of reality that never becomes flat or picturesque and is always imaginative and visionary. His humanness can be so profound that as observers we simply learn: to see, to notice and to understand people and their world. All of these qualities have earned Rembrandt his unique and matchless place among the master artists of all time.

Rembrandt had an incredible ability to vividly imagine things he had never actually seen, and then to portray them in a thoroughly convincing way. To accomplish this he also needed to have an almost perfect control of his artistic medium. But even more than that, he needed great wisdom, a deep and comprehensive understanding of reality that would never prove obsolete. Rembrandt's art has a timeless appeal. This is partly because, contrary to the work of many other artists, one does not need a great deal of historical knowledge to understand it. It is also because his vision is so rich that we don't quickly tire of his works and become impatient to move on. His work manages to appeal to scholars and laymen all over the world, capturing and drawing in people of every rank and station.

Yet Rembrandt's work is through and through Dutch; it is down to earth, never theatrical, and it never idealizes or glamorizes the stories it depicts. As a matter of fact, one Catholic viewer making his first acquaintance with this artwork actually thought Rembrandt was trying to mock the Bible and the biblical characters. Later he came to understand it very differently. What gives this art its depth and vision, its penetrating truth and honesty? Once again, it is Rembrandt's wisdom.

A person cannot write, speak or paint at a deeper or more profound level than his or her wisdom allows. No novel, study, discussion, or work of art can display greater understanding than its author possesses. We must not understand this wisdom individualistically. For wisdom, which is a combination of insight, knowledge, life experience, perceptiveness, understanding of norms, common sense and empathy, cannot be captured in its entirety by one person. The wisdom and insight, knowledge and world view of the surrounding culture always help – or hinder – us. That, by the way, is why it is so difficult to gain a proper perception, a wise understanding, of the problems of our own time, because our world is permeated by a secular vision that reduces everything to economic and technological factors. We have the Scriptures as our highest source of wisdom, but in our effort to look at

things in a scriptural way we stand alone. We first have to learn to see through all kinds of prejudices and so-called 'self-evident' truths and to recognize their poverty and their tendency to falsify the truth. We hope we have made it sufficiently clear that Rembrandt was no genius who lived in an ivory tower building up his store of wisdom in an individualistic way. He did draw from Scripture, but the surrounding world contributed to his ability to condense scriptural truth into wisdom.

Thus it is no coincidence that Rembrandt's art emerged during a time when Calvinism had left its indelible mark on our country. It was a time when the common perception of reality, the understanding of norms and the world view tended to be sober and honest and rich and biblical. This came not as something learned but as a gift of grace, as the fruit of people surrendering themselves to the Bible and allowing it to direct them.[415]

It is nearly certain that Rembrandt was not a church member. Perhaps he had only a minimal knowledge of and interest in the creeds of the church. We will not try to justify this. But it does not diminish the fact that he was clearly a man who read the Bible and accepted God's word. Building on the realm of thought of the world around him, he gained a deep view of reality – a view that was down-to-earth but not cold, and certainly not based only on economic factors (which is what passes for 'common sense' today). It was a deeply human view because it was founded on the truth and because it did justice to reality as God's creation, marred by sin. Rembrandt's limited interest in the theological questions of his day (certainly reflective of his stance towards the institutional church) did not necessarily limit his wisdom. After all, scholastic leanings and Anabaptist trends were not foreign to the Reformed milieu in those days, and they sometimes even suppressed the wisdom of Scripture.

Rembrandt's interest in biblical subjects is not typically Calvinistic. In the Netherlands artists had consciously turned away from such subjects in the early seventeenth century. Therefore, apart from Catholic painters like Jan Steen and the Utrecht school, we rarely find them depicted in the Dutch art of the time. That is where Rembrandt's art shows evidence of Baroque influences and his inclination toward the old traditions. Nevertheless, the way in which he interprets the Bible and portrays its stories – without glamorization, but soberly and with the understanding that these biblical characters are people just like us – can only be explained on the basis of the Calvinism so prevalent in his culture, even though occasionally he gives an Anabaptist interpretation of the biblical text.[416] We need to realize that every portrayal of biblical material, whether in writing or by visual imagery, offers some kind of exegesis or interpretation of the text, and we must not see this as a drawback. The only question is: is the exegesis correct?

Much more could be said about this. For example, we could explore the fact that Rembrandt never used halos in his work, with the exception

of situations where Christ reveals himself as the Son of God, as in his depictions of Christ with the men of Emmaus or with Thomas, for instance. But we will not go into this now.

In conclusion, we have seen that a study of Rembrandt's work can never be a superficial affair, because it teaches us how to see and how to understand. We can learn much from his perceptions of human beings and their activities, both in his own surroundings and in the biblical stories. He can help open our eyes to much that we, living in this thoroughly secular generation with a strongly socialistic world view, easily lose sight of. Therefore he can help us to become wise. This can only happen, of course, if we also study the Scriptures ourselves, and if we are willing to open our eyes to the realities around us as well. Then the honesty and truthfulness of Rembrandt's art will ring a bell with us, and we will be able to use it to help us grow spiritually.

Try to see Rembrandt's works in museums and exhibitions, so that you can experience his work first-hand. It's not enough to hear from others that he was a great artist. You need to experience for yourself the profound wisdom hidden in his work. It does not really matter that occasionally Rembrandt was wrong in his perceptions and that a few of his works were of less than star quality. Perhaps this art can help us recapture a little of the everyday wisdom of the Dutch seventeenth century.

• Book review: Rembrandt and the Bible[417]

It is a real treat to page through *Rembrandt, tekeningen en etsen bij de bijbel* [Rembrandt: drawings and etchings of the Bible], a book with an excellent collection of reproductions, with brief commentary supplied by H.M. Rotermund.[418] It is a treat not just because we are shown some of the best drawn and etched artwork ever created but especially because Rembrandt was such an ardent Bible reader – a man who read the biblical stories with rapt attention, and then envisioned them. In that envisioning, first in his mind's eye, and then drawn quickly on paper to be seen by his own physical eyes and, fortunately, ours too – in that envisioning we encounter all sorts of problems. What do we see? Do we really want to try to reconstruct what the bystanders of Bible times were looking at? And did *they* really 'see'? Perhaps they just saw a man walking along and understood nothing about who he was and what would happen. What do we see? Does it include the invisible? Does that have to be made visible too if we are to do justice to the biblical story? And concerning this attempt to depict scenes from the ancient past: is it really necessary that everything is as accurate as possible – with clothing, houses, landscape etc., as they really would have looked at that time? Sometimes, of course, that is essential. Take, for example, Jesus' statement about the camel going through the eye of a needle – what

could that possibly mean? Rembrandt bases his famous *Hundred guilder print* on an exegesis that says the Eye of the Needle was a gate in Jerusalem. So, on the right, we see a camel going through the gate, an allusion to the teaching of Jesus right after he has blessed the children – children whom we also see in this drawing.

Rembrandt knew, as every Bible believer knows, that truth is much richer and deeper than what the eye can see. The invisible belongs to reality too, and it becomes visible in his drawings and etchings when he indicates the presence of God (where that is appropriate) with lines that connect heaven and earth. When and where Christ reveals himself as God's Son, we see light radiating from him. And when God 'is absent', as in the drawing of the devil tempting Christ in the wilderness, we notice a closed circle which blocks the light from reaching him.

Rembrandt does not reconstruct the reality of the past accurately, as an archaeologist might do, but he tries to penetrate the deeper meaning of the story and to characterize the figures that play a role in that story. Those meticulous characterizations of Ahasuerus, of Haman and Mordecai, of the prophets and of the Pharisees witness to Rembrandt's lively imagination but are also evidence of a profound insight into human character, a knowledge of human relationships and of reality itself. There is nothing mystical in Rembrandt's faith-full understanding of Scripture. (That explains why we disagree with one of the selections in the book: the drawing #242 of Christ and the travellers on the road to Emmaus. We consider it to be the work of one of Rembrandt's pupils. Its spooky and mystical atmosphere does not ring true. A different, wonderful drawing depicting the same scene is unfortunately absent from this book – there we see how Rembrandt himself envisioned it, more sober and real.)

Rembrandt opens our eyes and allows us to really *see*, while taking into account the deeper realities that are not visible to the eye. But he also depicts people as ordinary mortals, alive and real – and that is exactly what is so profound about the gospel: that God bothers himself with this world and with our utter humanness. Herein lies the power of the 'good news': that the world is open to the supernatural, and that reality is more than atoms and people more than animals. Rembrandt does use traditional images now and then (e.g. we find here several Nativity scenes, which are particularly beautiful), but he also drew dozens of Bible stories that we seldom or never have seen depicted before. That made it possible to gather together enough works for a book like this, and it is the legacy of the Reformation – one of the richest and most profound legacies in the history of art. We find here life, sincerity, humour, relationships, love and hate. All this, and much more, can be found in Rembrandt's work, a typically and profoundly Christian heritage.

These are works that he made for himself. Sometimes it was a preliminary sketch for a painting or an etching that he was planning to

work on, sometimes something just intended for himself, a comment in the margin like the words or letters we routinely jot down for ourselves. Sometimes it was an etching to give to a friend, sometimes an etching intended to be sold. These drawings were not made in any systematic order; rather we are looking at a slice of this man's entire life work, the work of a man who truly lived and breathed the Bible. Maybe he can help us do that again too, in a genuine and fresh way; maybe he will make us realize that art does not need be stuffy or unreal. Actually there is nothing more ordinary and common than this art, which has nothing art-ificial about it; but its wisdom lies precisely in that everyday ordinariness, such a rare thing in art these days.

I am sure none of this is new to you. Good wine needs no praise. It was just a reminder. Just as this book can help to keep solid Christian traditions alive.

• Saenredam and Emanuel de Witte[419]

When the Reformation broke through in our [Dutch] corner of Europe, our towns boasted a number of large churches built in a simple Gothic style. Inside, of course, they were adorned with statues and paintings, but the overall effect was not nearly as opulent and decorated as the French and German churches. The latter had been built during the same period, but in a style much more boisterous – the so-called flamboyant Gothic style. In the Netherlands the only place you can really see an example of this latter style is in Den Bosch.

With the Reformation these churches fell to Calvinist congregations. Those congregations were then faced with the problem of how to make those huge spaces suitable for a Protestant worship service, which places quite different demands on a church interior. Of course the images and paintings and altars – anything reminiscent of Catholic liturgy – were removed. But the problem remained: how do you make such a building suitable for a preaching service? So they built huge pulpits in the naves of the churches, and gathered the pews around them in a large square, with the pews set on a gradual incline so that all could see the preacher. In many places (Leiden's Pieterskerk; Amsterdam's Oude Kerk; in Gouda, Alkmaar, etc.) these old pews can still be found.

The result was a high, spacious and fairly simple building, a space without any striking adornments. The churches were all whitewashed, although there is some debate as to whether that practice began during that time, or whether it had been done before as well. It is surprising that the buildings did not become stark and bare but took on a character of their own, with a unique beauty to be found in that multi-coloured whiteness – yes, multi-coloured, because of the many nuances of white and grey that resulted from the play of light through the stained glass windows, and because the white did not always stay white, and because

of the memorial plaques and the coats of arms (in connection with the tombs) hanging here and there on the pillars.

Thus, without exaggeration we can speak about Dutch seventeenth-century church interiors in connection with these churches. (We are not talking about the newly built churches such as the one in Amsterdam built by Hendrik de Keyzer.) Also the organs that were usually installed against the west wall contributed to the unique character of these churches.

It is a truly wonderful experience to wander around in these buildings. One cannot get enough of their picturesque beauty. The interplay of the heavy pillars, the large bright windows, the way the light falls on those pillars and on the greyish floor, with an occasional accent supplied by the dark diamond-shaped plaques, the sepulchral monuments, the splendour of the choir stall and the organ. Yes, one really needs to wander around for a while to allow the constantly changing perspectives, views, corners, and shifting plays of light to have their full effect. It is a unique kind of beauty, to be found nowhere else in the world.

We used the word 'picturesque' just now. We use that word, but it may be that we use it only because a number of painters have opened our eyes to the poetry and the beauty found here – painters who sing their songs through the medium of paint, songs about these white, but far from sterile, delights. Among those artists, there are two who deserve special mention: Pieter Saenredam and Emanuel de Witte, the greatest church-painters not just of our own seventeenth century, but of all time.

Pieter Saenredam (1597–1665) painted the Dutch churches painstakingly and with great precision, without neglecting a single detail. But he did not lose sight of their coherency, and no one has comprehended the beauty and uniqueness of these churches as well as he did. So he offered us, in these church interiors, art that is of unsurpassed excellence – paintings of small nooks and crannies of the buildings in which now this, then that delights us as we nose around.

Perhaps the most striking aspect of Saenredam's art is his feeling for colour. He transforms the apparently monotonous monochrome interiors into a rich and fascinating colour-play, in such a way that we come to see and discover its beauty along with the artist. He does not just fantasize, but he raises his paintbrush in song to this marvellous facet of God's creation.

With his intense feeling for nuances, for slight variations of hue, he pulls us into the church buildings along with him, to have us join him in appreciating their splendour. You should really try some time to get a chance to see the marvellous little painting that shows us one view inside the St Laurenskerk of Alkmaar. Here we find a great simplicity, but what variations of colour, what lyricism, what quiet loveliness! Such a work could only be produced by a master artist. This corner of the church was

not just a random choice, but it was selected with great care, to permit the creation of an outstanding composition; that one small corner, with its compelling interplay of perspectives, pulls together all the elements that make this church so unique. The whitewashed walls alone are rendered with an unsurpassed artistic excellence.

The art of Emanuel de Witte (1617–1692), a member of the next generation, is also based on careful precision and accuracy, with the emphasis (even more so than with Saenredam) on the effects of light. But de Witte takes much more liberty with his subjects. One church interior, for example, looks like the church in Delft, but the pulpit resembles one from the Oude Kerk in Amsterdam. And when we compare this piece with another one, we notice that at first glance the two paintings seem to depict the same church but, upon closer examination, we notice a host of subtle differences.

Those differences are not just accidental. Emanuel de Witte composed his painting with great precision, and the distinguishing characteristic of his work is the interplay of light and shadow, which occurs because of variances in lighting. Paintings can be inspired by the same church building, but the one can show it with the light coming in from the right, the other with the light coming in from exactly the opposite side. The one depicts the church in midday, when the sun stands high in the sky; the other depicts it in the late afternoon or early morning. But the really amazing thing is the distribution of light and dark areas, the way the composition is based on this interplay of light and shadow. And that is why these two paintings can look so completely different in their details. For example, the sounding board above the pulpit in the one is fastened to the side of a pillar (thus preventing interference with the bright white patch), while in the other that same object runs around the entire pillar, so that it will cast a shadow in just the right spot. The painting would lose much of its beauty if that sounding board had not been positioned exactly in that spot. It is remarkable; Emanuel de Witte has created two paintings of an almost identical church scene, but has managed to produce two entirely different works.

We hope that this has been helpful, not only for gaining a better understanding of the work of two of our great artists, but also perhaps for learning to see a little more clearly the beauty hidden in some of our old churches – hidden, but always perceptible for those willing to take a look, at any time of day, in any kind of weather. These are treasures that can never be stolen or taken away; they are there for all to see.

The Art of the Nineteenth Century

• Principles of nineteenth-century art[420]

We shall begin with a few remarks concerning our intention with this series of articles.[421] First of all, it certainly is not our purpose to deal with the entire history of art. Rather, we have attempted to offer an analysis of the way in which, during a specific period of art, theme and style were connected. This could help answer the question as to the content of a work of art. It became apparent that there is no possible answer that will apply to every time and place; rather, during each period art is structured in a unique way, and this determines how we assess its content and its meaning.

Furthermore, we wish to emphasize that we did not intend to explore the question of *how* that artistic structuredness developed and which deeper factors were responsible for its development. We believe that we need a pure analysis of the typical structure of the art of the various periods before we can understand how these various things came to be and why they took the form that they did.

Now we want to say something about the nineteenth century. Even more so than with the other periods we have dealt with, it is important to note that a number of different movements were at work concurrently, so that it is impossible to simply lump everything together under one label. Indeed, the art of the nineteenth century reveals an extremely complex picture. We are going to skip over the eighteenth century, during which the old died away and the new was slowly taking shape.

There are two main directions at work in the nineteenth century. The first one, which you will often find mentioned in writings on art history, moved steadily in a more realistic direction, after the work of people like Géricault and Delacroix. The school of Fontainebleau, and Realists like Courbet and Manet formed some of the stops along the way; and the movement finally found its conclusion in the Impressionist art of which Monet and Degas were the greatest masters.

It is often forgotten, however, that there was also another stream at work during the nineteenth century. It is important because it involved a much larger number of artists than the abovementioned movement, and because at that time it was certainly perceived as the proper kind of art. We are thinking of the so-called 'Salon art', often given that name because it was displayed at the large official annual exhibitions, which in Paris were called 'Salons'.

I would like now to delve a little deeper into the latter movement. It is characterized by a naturalism taken to the extreme. Artists attempted to copy visible reality as precisely as possible, making use of the methods developed for that purpose since the Renaissance but never before

applied in such a consistent way. Art became a purely photographic representation; and this comparison is all the more appropriate because the art of photography was built on those same ideals around the middle of the century.

Salon art tried to represent reality by basing itself entirely on the visual givens. In a certain sense it knew nothing more than what is observable to the eye. Or rather, if we take historical paintings as an example, it was concerned with what you would have seen had you been present on that particular day. The past is then reconstructed, as it were, so that the painting becomes a large, colourful report of what occurred. Artists handled biblical subjects in the same way: in parallel with the way in which Renan made his or her observations, artists offered a reconstruction of what happened, of how 'it really was' – that is to say, of how you would have observed it had you been present yourself. The 'invisible' spiritual elements are not given artistic expression; the observer may gather them from what the painting offers, but the artist does not deal with them in his or her depiction of the event. This principle also guided the Bible pictures that, quite recently, were so liberally used as instructional aids (and which are sometimes still used today).

The content of this art is whatever is visible and observable; it attempts to give a literal portrayal of the theme or event. This is very different from the seventeenth century, when artists searched for typical summarizing situations, for themes that concretized universal human motifs. Instead, all kinds of peculiar moments are chosen: if we are dealing with biblical stories we might see Jacob on the morning after he fought with the angel at Jabbok; if it is a historical event, we see something like the famous picture of the little British princes sitting on their beds just prior to the moment when the door is opened and they are slaughtered (a painting by Delaroche); if the painting is meant to offer a glimpse of the daily world around us, we will see people at work, street scenes, and so forth. We no longer see paintings in which the themes are chosen with great care so as to reveal some characteristic aspect of our humanness; nor do we see the use of the earlier types of images, which, despite the great profusion of possibilities, resulted in a simple, clear iconography that was immediately understood and involved universal human truths and structures.

There are many nineteenth-century paintings which one would never be able to understand were it not for their extensive titles. Every painting is completely unique, in composition as well as choice of theme – just as every photograph is unique, revealing a different frame of reality. We see how soldiers prepare themselves for war in a particular place for a particular battle. We see how a specific king in a specific situation called a meeting; we see kittens playing with each other, and an old man sitting dreamily beside his wood stove, and a group of retired soldiers playing a game together, etc. etc.

There is an endless supply of available subjects, and they are not connected together by any guiding principle. It seems that the structure which people of earlier times observed in the cosmos and in their own lives has been left out. It is as if the vision of reality presented by the older style of art gives way to a visual perception of details and chance happenings in which everything is given equal weight. In a rather brilliant way these artists leave out everything that could supply a meaning or offer any reasons. For example, we are shown a musical army brigade, not portrayed in any characteristic activity that could reveal the meaning of their work but just as a bunch of people in uniform practicing their drumming, all jumbled together and in no particular order. As a result, the paintings of the nineteenth century depict all sorts of things that previous artists would never have thought of painting; but they often take on a nondescript banality which helps explain the reaction at the end of that century that eventually leads to the birth of modern art.

The other nineteenth-century movement is the one you will find described in the literature of art history. Therefore we need not say too much about it. In the first place we may note that, technically speaking (i.e. in the painting style), this art differs from the art we just described, though at root it is not as different as has sometimes been suggested. Even Courbet refused to paint anything other than what he could see. In general it is a movement that avoids biblical or historical subjects. Its artists tended to have an eye only for that which is directly observable: a boulevard in Paris, a dance lesson (Degas), a random corner of a landscape, a barmaid, etc. Without exaggeration we can say that the idea of an actual theme has disappeared from art. Consequently these paintings do not really require titles. We see people practicing water sports, an open-air dancing party, jockeys exercising their horses, etc. There are no allegories, no references to the salvation story, no decisive historical moments, no efforts to depict characteristic aspects of human life. No, they would prefer to show people sitting in an outdoor café, or a train passing in the distance, or the sun shining through the leaves of the trees . . . Apart from the fact that the artists in this movement were sometimes much more talented than the Salon artists, their art is also often more enjoyable because it makes no pretence of being just like the art of previous centuries, of presenting something meaningful (such and such a person shown at the corpse of some famous person, for example), of presenting biblical truths, and of capturing the profound moments in life.

The art of the Realists and of the Impressionists is based on the world around them, without any false pathos, without facades, without a lot of fuss. They managed tastefully to avoid the platitudes of the Salon art; as a matter of fact, the followers of this movement were constantly battling with the Salon artists. If Salon art found its content in the theme, and often became so meaningless exactly because that chosen theme was so completely meaningless or banal, then the other

movement really had no theme at all, and its content is not even really the depicted givens – which are actually no more than *un coin de la nature* ('a sample of nature'). Those artists often gave the name 'motif' to what they portrayed, to the subject on which their art was based. Cézanne, for example, spoke of *travailler sur le motif.* That motif did not really comprise the content of the painting. The content and meaning of the work were to be found, rather, in the way in which that motif was worked out or artistically realized.

The meaning lies in the composition or the painting style. The motif of an impressionistic painting can be a rather random landscape: that landscape forms the point of departure for the artistic activity in which the real statement is the way in which that motif is rendered on the canvas. The content, in short, comes to lie in the composition and style, while the given motif serves only as an inspiration toward that. The motif is present, but one must not seek the painting's true content in that motif.

As we can see, this represents a substantial shift within the structure of the artwork. In a subsequent article we want to see how this developed in modern art, and we will make some general comments connected with that.

We will not accompany this article with any examples of art from the realistic-impressionistic movement, since they are generally well known, and examples can be readily found.

• Dutch painting at the beginning of the nineteenth century[422]

There has been little activity in the painted arts since our 'golden age'. At the close of the seventeenth century a group of Dutch artists tried to introduce *le grand style,* otherwise known as classicism, but that was only moderately successful. The art of someone like de Lairesse was not at all convincing; and even less so that of his eighteenth-century contemporaries. Jacob de Wit, who painted those famous 'witjes' (painted 'reliefs' for the area above doors), was the only painter of any stature in the early eighteenth century. The new applied arts section of the Rijksmuseum in Amsterdam displays a few of his excellent paintings of scenes from Ovid's *Metamorphoses.*

Of much greater importance are those artists who calmly continued working in the style of our seventeenth-century national art. Ouwater and other masters (or should I say 'near-masters'?) painted cityscapes in the manner of Berkheide and van der Heide. Wijbrant Hendriks's art followed the style of Metsu, and van Strij in Dordrecht continued to build on the work of Cuyp. In general the formats became smaller, and the art took on a kind of middle-class snugness. That was also true of the group portraits of prominent families, which someone once

characterized as 'chatter pieces'. The only truly great artist of this era was Cornelis Troost, but he did not manage to wield much influence.

In the nineteenth century art continued to flow along peacefully, like a babbling brook. Schelfhout painted landscapes and especially icescapes in a seventeenth-century style, but with more precision and less expansiveness. Everything became friendly and pleasant, peaceful and contented, calm and collected. It is no coincidence that during this time the term 'landscape art' emerged, because it is a term that aptly characterizes most of the Dutch art of the first half of the nineteenth century. It is certainly the most enjoyable of the art produced during that time. For although we may miss the breadth and the lively warmth of the seventeenth-century art, those nineteenth-century landscape artists certainly did create a great number of lovely and immensely enjoyable little paintings. They may not be great art but they are not without merit.

Of course there were also influences from outside our borders. We think particularly of the influence of the 'official' French classicist art. People like Pieneman, Kruseman, and especially Ary Scheffer (who lived in France for many years) excelled in portraiture, a genre in which they displayed their greatest strengths. In general their historical pieces are much less enjoyable. We would stray too far if we tried to explain why during this time, not only in our own country but elsewhere too, we see such a decline in the art of that genre. Undoubtedly it is connected with the spirit which Groen van Prinsterer outlined and exposed in his *Unbelief and Revolution*.[423]

This era did see the emergence of some greater artists; on the whole they were closely linked with the Romantic movement. The first of those whom we should mention by name is Koekkoek. He painted wide and Romantic landscapes, with heavy oak trees lit by the evening sun, often with a few farmers spurring on their cattle along a forest path. Koekkoek's studio was located in Cleves in Germany, where the surrounding woods served as an inspiration for his art. He was not at all attracted to the flat landscape which was the main subject for artists like Schelfhout, Leickert and others. Some years ago there was an exhibition in Cleves which showed that though not one of the great masters, Koekkoek was certainly an important artist and quite influential, even more so in Germany than here at home.

The second artist we want to mention is one who has often been misunderstood, and about whom we hear far too little. Johannes Warnardus Bilders worked in the vicinity of Arnhem, and the museum there holds some of his most important paintings. It is difficult to describe his art in a few words. His landscapes are expansive and mysterious, poetic and heavily Romantic. He painted scenes such as a wooded grove by a pool, often near some crumbling ruins or an ancient well. People seldom feature in these heart-warming glimpses of nature scenery that is often nearly overgrown with wild shrubbery and trees. Bilders's great powers of observation and his love of atmosphere and

mood are the qualities that give his art its unique character.

The third artist we want to mention is Nuyen. He also spent a number of years living in France, and was influenced there by the British Bonington and the young Delacroix. He was a student of Schelfhout, but his art sets a uniquely fresh tone. A deeply Romantic burst of energy expressed itself in a creative new painting style, an affection for tottering buildings and a grandeur reminiscent of the Romantic landscapes of artists like Turner or the other masters already mentioned. Nuyen's art produced during this time is on a par with the best in the world.

Nuyen's greatest masterpiece, depicting a ship in the harbour at Dunkirk, is currently on display in the Stedelijk Museum (part of an exhibition entitled '150 Years of Dutch Art'), though its home is normally in the Gemeentemuseum in The Hague. The painting has a refreshing, expansive style and portrays a lively scene. The ship is a paddle steamer with smoke swirling out of her smokestack, and the colourful way in which those little people walking along the gangplank have been portrayed is especially fascinating. In the foreground there is a sheltered area with some smaller ships, and to the right a swell of waves with a few gulls. A dark, stormy sky finishes off the picture. This painting is one of the most beautiful created during the period; there is something epic about it that reminds us of Balzac.

Nuyen returned to the Netherlands, and there his art became much tamer. It lost some of its Baroque-Romantic quality. Although his formats remained large and his work continued to be more powerful than that of most of his contemporaries, it is as if it became choked by the lethargic atmosphere of our country. Nuyen died very young; even so, it is doubtful whether we could have expected much more of him. Once he moved back to Holland, it seems that he lost his touch.

We do not mean to suggest that this was a typically Dutch problem. Artists of Nuyen's type who worked in other countries also experienced many difficulties. Delacroix spent his whole life fighting the classicist art which preferred standard formulas and rigid methods, and which considered Delacroix far too uncontrolled. It took a long time before Turner and Constable were recognized in England, and Turner was virtually ignored during the latter part of his life.

These Romantic times were filled with tension; the representatives of the Romantic movement were all misunderstood outsiders. The works of artists like Schelfhout, Springer and many others are most typical of Dutch nineteenth-century art. It is a calm and friendly, most appealing type of art, which is too unambitious to achieve a high stature. If we have opportunity to experience this art we should not pass it by, for the restful friendliness it evokes is something we sometimes sadly miss today. Often this art has also been labelled 'Romantic', but that all depends on how one defines that term. Perhaps it would be better to characterize it as an offshoot of our seventeenth-century art and to reserve the term 'Romantic' for the work of the three artists discussed above.

Themes and motifs

• The symbol of the fish in the logo of Opbouw[424]

The fish that you see as a motif in the logo of our magazine are not just there for decorative purposes. Rather, they are connected with a very old tradition. The idea of using fish to refer to Christ himself, or sometimes to Christians, dates from the beginning of the second century. At that time a scholar in Alexandria discovered that the letters of the Greek word for 'fish' sheltered a short confession. That word is I CH TH U S, and can be seen as a combination of the first letters of *Iesos CHristos THeou hUios Soter*, which means: Jesus Christ, (the) Son of God, (the) Saviour. The early Christians used this motif in times of persecution as a secret code to identify themselves to one another.

In the catacombs, the underground burial places in Rome used in the first centuries by Christians, partly because they could hold their underground church services there, one can find the fish motif in many of the wall murals. We see it used, for example, as part of the symbolic references to the Lord's Supper. Rather than depicting the moment when Christ broke the bread to institute the Lord's Supper, we see a depiction of him sitting at a table with eleven apostles, while on the table there is a loaf of bread and a fish – but no wine. Together these two items are symbols of Christ, who is commemorated in the Supper. In this context I believe one should understand the segment of one of the wall murals in the Lucila Catacombs near Rome which depicts a fish and a basket with bread and which probably dates from the second or third century. Some people have tried to explain it as a reference to the miracle of the multiplication of the loaves and fishes, but it is not clear what the significance would have been of portraying that event. On the other hand, it is the communion scenes that we come across so often which provide a much clearer and more satisfying explanation of the symbols portrayed.

The epitaph on a gravestone found in Autun in France from the same time period (preserved in the Museum of St Germain-on-Laye), written in Greek, has also this clear underlying meaning: 'Thou, of the Heavenly people of the divine Fish, be strengthened, for although you live among mortals you have received from the eternal well-spring of divine water.' This is likely an allusion to baptism. 'Revive your soul, worthy friend, with the water that streams eternally out of the Wisdom which offers great treasures. Receive the food, sweet as honey, from the Saviour of the holy, and eat with delight, while you hold the Fish in your hands. Seek your rest in that Fish.' We find here Christian words of encouragement and comfort encoded in symbolic language; apparently the cryptic words prevented the non-initiated, possibly persecutors, from

understanding the meaning, perhaps leading them to conclude that it was some kind of mysterious pagan cult. A little later, on the same stone, we read, 'in the peace of the Fish', a phrase in which we might be more likely to use the image of the Lamb. In any case, it is clear that the references are to Christ himself, as the Saviour and King in heaven who maintains contact with his children, also by way of the memorial signs of the Lord's Supper. The latter image perhaps also referred to the risen Christ, while he, after his resurrection, took his last meal on the shore of the lake, eating fish with his apostles. It explains why in these early centuries the Christians often used dishes in the shape of fish during communion to lay the bread on, for example. Items like that from the fifth and sixth centuries have been discovered in various countries, notably in Egypt.

But when the fish symbol was used alone it was often with reference to the believers themselves. As we said before, the early Christians often used that sign to secretly indicate to others that they were believers of the same confession. However, we find it in other settings too, for example during the sixth century in Ravenna among the images of important martyrs. The idea of using the fish to symbolize Christian believers can be directly linked to the miraculous catch of fish when the apostles were specifically told that they would become 'fishers of men'.

In approximately the sixth century the fish as a Christian symbol fell into disuse, partly because during that time the Greek language lost its influence in the Western church and Latin became the official language. In our own times, however, the symbol has reappeared and the ancient tradition has been revived. And that is how it comes to find a place in the logo of this magazine.

• Artistic metamorphosis of the dragon[425]

What is a dragon, actually, and where did it originate?

We do not find any representations of such a creature in the Roman-Hellenist world, and we scarcely find evidence of it in artworks from the first centuries after Christ. We find it only once, in a representation of the story of Jonah. The relief which pictures that story actually comes from the eleventh century and depicts a real dragon! A real dragon? Yes, we can speak of such a creature here. But how did that dragon find its way into European art?

The period from AD 800 to 1000 in Europe was a terrible time, fraught with invasions and wars. The horrors of that time inspired people to reach for the last book of the Bible, the Revelation of John, for insight and comfort. And they began to illustrate that book as well. In Revelation 12 the dragon is mentioned as a symbol of satanic power, reminding us of the Fall into sin with the words, 'the ancient serpent, called the Devil or Satan'. What kind of picture was that supposed to

raise in our minds? People began to search the ancient texts as well as zoological treatises and discovered a whole story about the dragon, a creature that supposedly lived in Ethiopia and India and looked like a huge serpent with legs and wings. It was told how the dragon would often take on the elephant in battle, sometimes only to be defeated. Thus ancient Greek science became a help to the artists trying to illustrate biblical stories. Shortly after the year AD 1000 a relief was created for a bronze door in Hildesheim in which we see the dragon in place of the serpent in the story of the Fall; the artist is trying to make sure we understand what really happened there.

A century later a mural was painted in a church in France in which we see the dragon preparing to devour a child (who represents Christ) as soon as the woman has given birth. Although the text (Revelation 12:3) speaks of a dragon with seven heads and ten horns, the artist sticks with the traditional image of the dragon that we mentioned earlier – the other heads are applied like manes. It is also befitting with the biblical way of thinking to depict the Antichrist as sitting on the monster Leviathan, which once again has been given the traditional form of the dragon.

The dragon did not play much of a role in the spiritual life of medieval people. The biblical world view hardly allowed a place for it, other than the symbolic usage we just discussed. In the superstitions of the people north of the Alps, who descended from the Celts and Germans, heathen ideas persisted in a minor way, and demons and monsters played a greater role. So we begin to find the dragon pictured outside of biblical imagery. But so superficial and flimsy was the belief in these dragon-demons that people had no problem using them for ornamental purposes – which they did eagerly, e.g. in twelfth-century Romanesque ornamentations.

In Gothic art fantastic monsters and monstrosities are depicted in decorations, and we also encounter the dragon there, in the carvings on choir stalls, for example. Other than that, or in conjunction with a depiction of Eve (to help identify who she is and what significance she has for us), we seldom find dragons represented.

It is extremely important (and also very understandable, from what we have already seen) that when artists tried to portray the Devil, they borrowed elements from the dragon image. He was depicted as a kind of human figure with dragon's wings (resembling the wings of a bat), claws, and a kind of dragon's tail (much like a snake). But we will try to limit our discussion here to the real dragon.

The dragon is much more common in the fifteenth century. While still often used for ornamental purposes (for example, in the illumination of the letter 'S' in handwriting), we also see the dragon as the creature defeated by the beloved St George. We think for example of the impressive, life-sized statue of *St George and the dragon* created by Bernt Notke in 1489 for a church in Stockholm. This dragon has scales and hardly any wings. Besides that, this creature is a very prickly, a

completely un-snake-like monster. Notke is an important representative of a style of art that has sometimes been called 'late Gothic Baroque', a style of grandiose effects that portrays saints as superhumans. In that connection it is not unthinkable that he might have come up with the idea of this abominable creature himself. But we consider it more likely that he was inspired by the Chinese dragon, which started to play an important role in Chinese art around the thirteenth century. It is quite possible that Notke got the idea from seeing such an image in a little Chinese statue or embroidered on a silk cloth. Also the dragon symbol which Lucas Cranach uses to sign his artworks bears a strong resemblance to the Chinese dragon. It is hard to say whether Dürer was also influenced by such examples when with unsurpassed fantasy he created the dragons for Michael to wrestle with in his series of woodcuts.[426] He certainly made them much more monster-like than they had ever been before.

The Italian Renaissance of the fifteenth and sixteenth centuries endeavoured to portray the world as realistically as possible; artists tried to present images as they would appear to the eye. That explains why the traditional type of dragon drawn by Leonardo da Vinci, such as the one fighting a lion, was such a realistic-looking creature. If dragons had ever existed, this is what they must have looked like.

The Renaissance was also extremely interested in Greek and Roman antiquity, and artists eagerly began to illustrate the old legends and myths. We seldom encounter dragons in their art, however, because dragons are hardly ever pictured in ancient art. There was a similar reluctance to depict images that arose from fantasy rather than from the real world. A rare but beautiful example is the dragon – this time a sea monster – painted by Piero di Cosimo around 1515 in his effort to picture the story of Perseus and Andromeda.

The painting just mentioned is, as we said, an exception. Also the period following this, which was based on the new ideas brought in by the Renaissance, had minimal interest in monsters, and therefore also in dragons. If artists from that period wanted to illustrate the story of Perseus, they might have shown some wildly churning water in one corner of the picture and meant it to indicate the presence of a dragon to the viewers even though they could see nothing of it. That is how Rubens does it, for example. Also dragons which belong to the Christian world of thinking (rare as they may be) are seldom pictured. An exceptional example created by the French engraver Callot is the gruesome dragon, really the Devil, that dispatches his followers to torment Saint Antonius. Notice that this dragon is tied with a chain – after all, the dragon in Revelation 20:2 is chained up so that its power is limited. Callot's dragon is beginning to look more like the monster that we twentieth-century people imagine a dragon to look like – exhibiting Chinese influences. The old traditional dragon by then has become almost extinct, and dragons in general have become very rare. Jan Steen

painted one once when he wanted to show the monster defeated by the
Angel Raphael – a story found in the Apocryphal book of Tobias.

In the eighteenth century we frequently see Chinese dragons,
especially for ornamental use. This is because people working in the
decorative arts were strongly influenced by the Chinese porcelain that
was then being imported in huge quantities.

The nineteenth century, even with its Romanticism, which certainly
did not restrict the play of fantasy, did not want much to do with dragons.
We rarely find them in the art of that century, except for an occasional
appearance in a fairytale. Even Gustave Doré used dragons in his art only
once or twice at the most, e.g. in an illustration for Dante's visionary
book. The creature there has a crest and scales; in short, it looks more
like a lizard than a snake, the way we would expect a dragon to look.

We twentieth-century people do have an image of a dragon, but we
no longer take it to be a living creature. In that sense, Greek scholarship
has been surpassed, and since the eighteenth century no one really
believes in the actual existence of dragons anymore. Even in the world
of art they have become extinct. The twentieth century brought many
monsters into art, but the dragon is not among them. This creature must
now be content with finding a place on a coat of arms or as part of a
trademark. Its modest role, which for a thousand years was certainly not
without significance, has nearly come to an end. The possibility exists, of
course, that it could be resurrected some day.

• The female figure in art[427]

I considered it rather unusual to be asked to write on this topic. After all,
art has always been the representation or expression of that which
people hold most dear, that which is relevant to them, that which
involves their most deeply held values. Art is life condensed: in art
people leave out and ignore all that they consider insignificant and
express what they consider most important. Through such artistic
activity a person builds his or her picture of the world (and I mean that
literally) and through it he or she assimilates reality in such a way that it
can be understood more clearly.

Of course women are hugely significant in the artworks of every age
– how could it be otherwise? The woman's place in art is so great that, as
a matter of fact, to do justice to the subject of this article we should really
have written a complete history of art. From the fertility goddesses of
prehistoric times up to and including the odalisques of Matisse and the
Portrait of a lady by Picasso, we would have to touch on aspects taken from
the entire history of art (which really is cultural history made visible – or
rather, kept visible).

But let us not try to do that. Let us limit ourselves to a single aspect.
We said earlier that art gives us an outlook on reality. That also means

that art teaches us to see, to notice, and to really observe. For one should not confuse *looking* with *seeing:* learning to really see is a skill that must be taught, and there are many different ways of seeing.

Let us consider the lovely portrait from the Museo Poldo-Pezzoli in Milan. Who the artist was has never been determined with certainty, but the piece certainly comes from Florence around the year 1480. Because the artist chose to depict the woman in profile, he is able to make us see the beauty of the subtle, almost simple but ever so compelling line of the contour. In harmony with this subtlety there are no deep shadows in the picture; on the contrary, the transitions are soft and gradual so that the 'relief' is indicated but not at all emphasized. Only the necklace and the edge of the cloth are sharp and distinct. One can more clearly understand how remarkable this manner of representation is when one compares this picture with the sculpture by Bernini, a portrait of a certain Constanza Buonarelli. Take note of how there are no clear contours in this sculpture and the shadows are very deep. To accomplish that effect, the artist sculpted the dress very loosely – one could even call it sloppily – so that there are no austere, uninterrupted lines; this is in clear contrast with the portrait from the fifteenth century.

One needs to understand that we are not comparing here the art of sculpture with the art of painting but rather fifteenth-century art with seventeenth-century art. If we had chosen a sculpture from the fifteenth century and a painting from the seventeenth century, the results would have been the same. Our concern in this article is not an art-historical phenomenon; rather, I offer this comparison to illustrate how the artist helps us to learn how to *see.* The contemporaries of the fifteenth-century Florentine artist saw young girls that way, and those of the seventeenth century saw them as the sculptor saw his subject. So strong, in fact, is the power of suggestion from these works of art that during a tour in Florence one student made the comment (after we had seen the Bernini which is displayed there in the Bargello museum): 'Boy, that is really weird, but I am suddenly starting to see the people around me in a different way.'

Art can, of course, do something quite different; it does not always reveal or picture reality as we comprehend it, giving emphasis to its deepest and most important aspects. For while the two portraits we mentioned are a testimony to the way those societies esteemed human being and personality, one can also use the medium of the portrait for something quite different: for a depiction of the 'dream' woman or, in more contemporary terms, the pin-up girl.

The latter has an interesting history. Its earliest origins are difficult to determine. They might relate to the perceptions underlying the first portrait we discussed. A person of later times, who did not know the girl at all, would still find it an appealing and compelling image – it has an effect on you even though you know you will never meet her and will never be able to find out who she was. We can imagine that some artists,

when they discovered that such a depiction of a young, appealing girl attracts people, would begin to paint such quasi-portraits (apparently at the beginning of the sixteenth century). For with those kinds of pictures, even more than with actual portraits, one can satisfy the desire for the woman of one's fantasy. When we look at such a sixteenth-century quasi-portrait, we notice that all truly personal characteristics are absent. But how could it be any different? Such a universal and idealized young female could never be individualized, could never be reduced to the portrayal of a certain real woman. Actually such a painting already serves as a pin-up girl, even though it is only intended for those wealthy enough to be able to purchase an original painting, and even though it has an unmistakable artistic merit and great charm.

The next and perhaps definitive step was taken in the seventeenth century, this time in England. There, Anthony Van Dyck had developed a new style of portraiture: the noble lord or lady was portrayed in a strongly idealized manner, in which great emphasis was placed on a refined, courtly elegance. While Van Dyck managed to do this without losing sight of the personality of the subject – on the contrary, he managed to capture a direct and living resemblance – among his followers it quickly was turned into a kind of formula. That was even more so when they were not portraying real personalities, but rather 'fashion dolls', the women at the court of Charles II, who lived according to moral standards which, to put it mildly, were not very high. Along with courtly elegance there was a strong emphasis on the erotic element.

Lely and other painters created a series of such portraits (e.g. the *Windsor beauties*, a series of portraits which hang in Hampton Court, London). Such portraits were often used to make prints, reproductions in black and white – and, voilà! we have the true pin-up girl, an artistic by-product, a not too indecent girl but still an erotically tinged male fantasy, a portrait of a girl that a man likes to spend an evening with, even though in his more sober moments he is aware that (fortunately) the girl does not really exist. Real girls worth anything at all, by contrast, have real personalities and are more than a universal, fashionable, erotic fantasy image.

Although these prints depicted women who belonged to the courtly ranks, they were already 'democratic' in the sense that they could be purchased by anyone. In our own time this democratizing of the model via inexpensively reproduced photographs has brought the development of this artistic by-product full circle.

We would have liked to say a lot more – e.g. about the female figure as a philosophical idea as it is found in allegory; or about the origin of present-day fashion drawings . . . But we better leave it at this for now.

• Humour in the visual arts[428]

You may think it is because the summer issue of *Stijl* is intended to be a
little more light-hearted that I am writing about caricature. But that
would be a grave error! Has anyone ever really laughed about a
caricature? Well, maybe so, but the main goal of caricature is not just to
be a 'joke', not just to be funny. If there is any humour hiding in a
caricature it will always be secondary to the primary purpose – namely
that of ridicule – and I mean it in the usual literal sense of making fun
of someone or something. That is quite different from laughing *about*
something. We are here dealing more with sarcasm or irony (if it is a
good caricature) than with actual humour.

That explains why people will never caricature the things most dear
to them, the things they respect most, the things they value. Baudelaire,
one of the few who has ever ventured to philosophize about laughter,
has written: 'A special fact that we need to consider is this artistic
element in works that are intended to show us our own moral and
physical ugliness.'[429]

Thus, it is less strange than it might appear at first sight that in the
history of art we seldom come across caricature. To my knowledge this
genre does not even exist in seventeenth-century Dutch art. We may find
it in Leonardo's work, though his twisted and deformed faces may signify
a physiognomical study as much as real caricature. During the same
period of time we find caricature in the North, in the works of Jeroen
Bosch; there is nothing 'funny' about these. Rather, it is an element of
his art intended to emphasize the hellish, the unnatural, the irrational.
Then we find it again in imitation of Leonardo da Vinci in the North, in
the work of Metsys and Vermeyen; the caricature portrait of a woman by
Metsys is an especially horrible example. We also come across it later, in
the idealistic painters like the Carraccis in Italy, and in Bernini, the great
Italian sculptor from the middle of that century. It is almost as though it
is a side effect of 'great art', art that exalts, idealizes or reverently depicts
human life. Caricature becomes a release for the artist: instead of
elevating people the artist starts to cut them down. The artist is proving
to him or herself (because such caricatures were usually intended for
private use) what contemptible characters people really are.

Caricatures besmirch that which people no longer hold dear. Thus
it would be unthinkable that in a classical milieu that deeply respected
the ancients the gods of antiquity would be caricatured. Or it would be
a kind of release, as we indicated when we mentioned the caricature
portrait. But when people begin to lose their awe and respect for the
gods, they start to ridicule them. At the same time they strike back at the
classicists around them who maintain such an exaggerated sense of
respect. From the pen of someone no less than Titian, then, we find a
caricature of the *Laocoön*: Titian drew a trio of apes in the same
positions! Similarly, in the nineteenth century we find many pictures of

the labours of Hercules and others, drawn in a way that does not suggest particular veneration for this stupid strongman, this bruiser.

The great caricaturist Daumier also used the vehicle of ridiculing sketches to mock classicism. His friend Baudelaire said about that:

> *L'histoire ancienne*, the series about the history of Antiquity seems important to me, because it is the best illustration of the words: Who will deliver us from the Greeks and the Romans? Daumier has insolently thrown himself on the false grandeur of Antiquity – he has a great concern for authenticity – and he has spat on it. All those old gods and heroes are represented in ridiculous ugliness, ... a very amusing blasphemy, and very useful indeed.[430]

There is more to this enmity against the classics. It is a hostility against everything in which people, through the centuries, have found idealism, beauty, and dignity: in the classics people were really honouring themselves and now, together with the old ideals and the *ancien régime*, the classics too would fall. Daumier (who thumbed his nose at parliament, the justice system, the king, etc. via his prints) was a revolutionary. For socialists who longed to overthrow the existing order because they considered all the established values, ideals and ideas about beauty to be just 'bourgeois' – relics of a society that had served its time – for such people the old refined ideals about human nature and humanistic values of beauty and heroism did not hold true anymore. Death to the classics!

Even where hatred was not so vehement but more just a reaction against the exaggerated glorifying of the classics, we find the art of caricature. In this connection we wish to cite a passage from Arend Fokke's *Moderne Helicon, een droom* [modern Helicon, a dream], written in 1802. He claims to have read an advertisement somewhere that said:

> *Phebus Apollon of Delos, Merchant of poetical instruments in the great store of poetry on the Helicon,* wishes to inform all Gentlemen and Ladies, all patrons and practitioners of the currently fashionable Art of Rhyming, that recently he has acquired, from Germany as well as France, a considerable assortment of the latest Poetical Devices, Rhyme Schemes, Poetry Dictionaries, etc., useful for all kinds of poetry, which, in this same Poetry Store, are available to everyone daily, and can be rented or purchased at very low prices – for the price of the postage. N.B. Lovers of such poetry are informed that the *Ship of Imagination* sails back and forth regularly.[431]

Ridicule is a mighty weapon with which to give the 'Ideal' a good kick up the backside. It is even more effective than profound and complex treatises in its power to break through this exaggerated glorification of the ancients, this unrealistic idealism. Moreover, one can keep oneself above reproach because one can always say that, after all, 'I was just kidding.' Even with a man like Fokke, who first presented this as a lecture for the Society of Merits (*Felix Meritis*), we can clearly see the background in what follows a few pages further, and we can see that it

was not simply reactionism. There he speaks to Apollo, whom he visits in his store while the latter is letting off steam about those who have defaulted on their payments, and on seeing this the writer says: 'But my lord, I cannot express strongly enough my astonishment at the idea that my perceptions were so deceived. Are you not the universally venerated Apollo, the Father of Poetry and Medicine, the lover of the beautiful Daphne, and is this not the Helicon?' To which Apollo answers: 'Yes, my goodness! What a change! Oh, I have become such a bourgeois god of late, one who really has a job to keep his matters in good order and to get through the year.'

We see that caricature does make use of humour but that, because there is so much more happening at the same time, one can hardly laugh about it – and if one does, it is more out of a malicious pleasure because one does not really care much about that which is being ridiculed.[432]

Now we want to move on to a different genre of strange humoristic drawings. The question again is whether what we are dealing with here is really humour. In this [twentieth] century the absurd and the irrational have received much emphasis, both in philosophy and in art, particularly through Surrealism.[433] Nonsense has become serious business! And as always, people try to find a connection with 'roots' in the past, thereby to justify themselves while at the same time to find there a wellspring of inspiration.

In this way people have tried to explain the traditional English 'nonsense rhymes' as something springing from the same irrationalism, a view of life that despises reason and culture. These strange little rhymes actually have a unique history. In England they formed part of what people call 'nursery rhymes' – short poems for children – while in North America they are generally called 'Mother Goose Songs'. Many of them are very old folk songs of which the text has been eroded to become nonsensical. However, we should keep in mind that there are also some which were written exactly as they still appear.

One of the oldest and most famous of these children's songs, of which the words really make no sense at all, is 'Three blind mice'. It is found in Thomas Ravenscroft's *Deuteromelia* of 1609:

> Three blind mice, three blind Mice,
> Dame Julian, Dame Julian,
> The Millar and his merry old wife,
> shee scrapte her tripe licke thou the knife.

The poem is still well-known in English-speaking countries, but the words now go like this:

> Three blind mice, see how they run.
> They all run after the farmer's wife,

> Who cut off their tails with a carving knife,
> Did you ever see such a thing in your life,
> As three blind mice?

Perhaps the most nonsensical of all such songs is the famous:

> Hey diddle diddle, the cat and the fiddle,
> The cow jumped over the moon,
> The little dog laughed to see such sport,
> And the dish ran away with the spoon.

Songs like these depend on the combination of words and sounds; they are really no more – and do not intend to be more – than a play on words. They are fun songs, sung more for the joy of singing than for the meaning of the actual words. Do we not sometimes enjoy singing nonsense, for example when we remember just snippets of a song and then, while riding our bikes, combine these bits into nonsensical combinations just so that we can sing or hum the whole melody?

Around the middle of the previous century Edward Lear, who was governor of a bunch of troublesome children, made up a number of rhymes like that; they were published much later. In our century there has been a renewed interest in them, also because they apparently fit so well with the 'surrealistic' tendencies of the age. But here again, they are really just light-hearted fun, lacking any deeper meanings, made purely for the joy of silly word combinations, while in England they have become a fitting part of an existing tradition. Lear included appropriate drawings with his poems. Here are the words of one of the songs:

> There was an old person in black
> A grasshopper jumped on his back;
> When it chirped in his ear, He was smitten with fear,
> That helpless old person in black.

This is all pure nonsense, of course, and it transports us into a kind of playful fairytale world. In the exact same spirit, and during the same period, the famous work by Lewis Carroll, *Alice in Wonderland*, appeared. It can also be described as a humorous fairy tale, one that would have provided great fun for both the author (a great lover of children) and the children themselves – and continues to enchant children. Nothing is considered too silly; as a whole it is just pure nonsense.

Grandville, who lived during the nineteenth century, can be seen as a forerunner of irrational humour and surrealistic drawings. Baudelaire already saw that Grandville's work was something more than simply nonsense and wrote about it as follows:

> This man has spent his life recreating creation with superhuman courage.
> He took it in his hands, wronged it, reorganized it, and commented on it:

and nature changed into an apocalypse. He turned the world on its head. Did he not make a book entitled *Le monde à l'envers*, the world upside down? Grandville amuses superficial folk. As to me, he scares me. When I occupy myself with the work of Grandville, I start to feel uncomfortable, as in a room in which disorder has been systematically organized.[434]

Dreams and associations became the means by which he called up these hallucinations. It is because of the fact that Grandville was not very skilled as an artist and his drawings really did not give adequate expression to his ideas that he did not become better known.

The surrealistic joke, which elevates all that is illogical, is an inescapable accompaniment to modern irrationalism. America became the great pioneer in this area. The feeling evoked and the nature of this sort of humour is quite different from anything heard or seen before. Think of the so-called 'horse' jokes, for example, which you have undoubtedly come across at some point. Their effect comes from showing us how crazy things can get.

This kind of humour is not always enjoyable. A strange and uncomfortable feeling is called up, for example, in the work of the American Chas Addams, whose drawings of scenes and situations bristle with a sinister atmosphere. It is a world where madness, crime, despair and neurotic pressures rule. As an example, there is a drawing of a little girl, skipping rope under the light of a lamppost at night, with a despairing look on her face, counting: 'Twenty-three-thousand-and-one, twenty-three-thousand-and-two, twenty-three-thousand-and-three . . .' Yes, it certainly is an irrational world that we live in.

But we said we wanted to write about humour as it is to be found in the visual arts. So just a few more comments about that. In the previous [nineteenth] century the drawing was always just an illustration accompanying the joke. Think of those charming prints by Gavarni, where the drawing is hardly funny at all and the point of the joke is found in the sometimes very extensive text underneath, a snatch of conversation, for example. Then a significant development took place in that the text became much shorter, and much less detached from the picture. Finally, we reach the stage where the main point is found precisely in the relationship between the text and the picture. For example, the drawing of a very German family showing the mother walking into the woods with her children. And the mother says, 'Come, children, let us go into the woods to hear how silent it is.'[435] The joke is funny because of the direct correlation between the words and the illustration, which in itself is not funny at all. Only in recent years, things have changed so that the whole point of the joke is found in the picture and any explanatory text would be superfluous. As an example we mention a cartoon by J.W. Taylor published in *Punch*. This cartoon has gained a certain measure of fame, if you go by the number of times it has been reprinted. Everything needed is shown in the illustration. We know

it is in a museum because of the grumpy-looking guard [wearing a uniform with the label 'museum']. We know the vase is from the Tang period of Chinese ceramics because of the caption on the base. And then the main point: a knowledgeable old gentleman lightly taps the vase and it makes the sound 'Ming!', which is the name of a much later period of Chinese ceramics. The drawing says it all, and if you try to retell the joke in words it loses its humour. The picture has its own unique way of telling the story.

We said earlier that this was a 'significant' development; that is so because it is also illustrates an aspect of the increasing importance of the visual arts. In our [twentieth] century the pictorial arts hold a rather important position compared with the situation a century ago. People have begun to understand the unique expressive power and possibilities of pictorial art – in itself that is not decadence – and thereby the visual arts have come to play a role in modern culture again that rises above mere decoration or ornaments on the wall. The fact that recently a little book was published with a large number of such 'cartoons' (as these drawn jokes are called in America) summarizes this development well. It is a book we can heartily recommend, even though not everything in it is funny. But it gives a unique, and not to be underestimated, view of the times in which we live. One might say: by a man's humour you shall know him.

• Christmas portrayed in art[436]

Once again the end of the year is in sight, and very soon Christmas will be bombarding us from all sides. It is not the sermons that we want to deal with in this article, nor all those articles that will be published in church papers or in more general Christian magazines, though all of those bear close examination. But it is impossible to deal with such things in general terms and, besides that, we wish to deal here with something quite different.

This year-end celebration has, in the course of time, inspired a great many works of art. Some of these are of very high biblical quality. We are thinking, for example, of Bach's *Weihnachtsoratorium*, and of the similar and perhaps even more beautiful piece by Schütz. Or we might think of etchings by Rembrandt, or of woodcuts and copperplates by Dürer. I would like to make a parenthetical comment here which holds for the visual arts more than for any other art form: in almost every painting and sculpture depicting the Virgin Mary with Christ, or the Adoration of the Shepherds, or the Adoration of the Magi, we find that not Christ in his incarnation is the central theme but, instead, the primary focus is on Mary.

Christmas – literally 'Christ-mass' (yes, the name still carries its Roman Catholic overtones) – is first of all a feast about Mary. Now, there

is nothing wrong or unbiblical, of course, with paying some attention to Mary, but there is a problem with placing her in front and at the centre, so that Christ is relegated to a secondary place. Today's Nativity scenes are just a direct continuation of those made over the centuries which are sometimes held up as great works of art (and often justifiably so), but when they are also presented as if they are accurate representations of the biblical story of Luke 1, that is rarely justifiable.

Earlier we made mention of the name of this feast. Really, there is something rather strange about the whole celebration. The earliest Christians did not celebrate it at all, and Jesus was not born on 25 December but most likely more than a month earlier. One might also ask why the central Christian feast is not Easter instead – the commemoration of the much more crucial fact that Christ completed his work on earth and was raised from the dead; or, perhaps even more important, Pentecost – when the Holy Spirit was poured out and the spread of the gospel began.

What we are dealing with here is the legacy of the spread of the gospel to the Germanic countries, many centuries after Christ. Missionaries who, probably with the best of intentions, wanted to connect with the existing traditions, tried to Christianize the heathen traditional mid-winter feast. In some ways their effort was successful, though it became more Mary- than Christ-centred. And to a certain extent this misplaced emphasis remains with us. And various secularizing tendencies are continually claiming this feast for themselves – the old heathen core of the mid-winter feast has proved to be stubborn and solidly grounded in human (sometimes all too human) nature.

And so this celebration has become, for those who want to hold on to at least the semblance of Christianity, a sentimental story – something like a children's story, a fairytale for grown-ups. The message has taken on the aspects of a myth ('light coming into the world') and in the current age of Mammon, where commercialism has become the highest god, people have latched on to this sweet story. They write songs about a dreamy 'white Christmas' (but why is it so important that Christmas be white? Would that be somehow related to the 'light'?) and about 'the baby in the manger' (but there is no mention of how that baby is related to the Lord Jesus who now sits at God's right hand to rule the nations – it might threaten the feel-good ambiance and mellow tranquillity of the season, after all?). And we see the creation of a multitude of Christmas pictures which speak of 'goodwill to all people'. In the previous century (and not much earlier, I think) the Christmas tree was drawn back into the festivities – a sort of dredging up of an old Germanic tradition and then coating it with a layer of romanticism. In North America they have also adapted some aspects of our traditional Dutch St Nicholas feast, such as Santa Claus coming to homes bearing gifts for the children. Folklore? Maybe a little. But this is more a matter of astute businesspeople recognizing an opportunity to make profit when they see

it! Christmas: has it not become mainly a feast of lighted storefronts, alluring gifts, and bountiful food and drink?

There are those who prefer to see Christmas as a time for indulging in rich food and drink; personally I find that more wholesome than all that sentimental, superficially Christian, Christmas mystique. At least it is honest. If only Christmas were an honest celebration: a few days off to break up the long winter, a time of fellowship with good food and merriment, and – well, why not? – maybe even a decorated tree. Then all that false sentimentality so prevalent especially in the area of entertainment – in stories, songs, and pictures – would not stand a chance. Then we could just thankfully enjoy a pleasant sociable time with family and friends.

Or, on the other hand, we could try, with integrity and honesty, to make Christmas into a truly Christian feast, with the gospel story front and centre – a gospel that spells death for commercialism and sentimentality. Does Malachi 3:2 not ask of us: 'But who can endure the day of his coming?', and does Revelation 12:5 not speak of Christ 'ruling the nations with an iron sceptre'?

Christmas and art: a rich theme for anyone seeking beautiful art, a rich inheritance of truly biblical art as much as of mariological Roman Catholic art. Unfortunately, in our times the phrase 'Christmas and art' is more likely to mean 'Christmas and kitsch' – commercial sentimentality, dishonesty, and false piety. Should we not be on the watch for these things? Could it be that many serious, thoughtful people have, out of a distaste for those mushy Christmas stories, become estranged from the Christian faith or, to be more precise, have turned their backs on the Lord Jesus? The time of fairytales and myths is past, and folklore is endearing but not to be taken seriously.

If we really wish to bring honour to the 'baby in the manger', we will have to speak about the fact that he truly is risen and lives today as our Saviour, and that he will return – perhaps very soon! And if that does not mesh too well with the mood of Christmas . . . then we better just make it an honest, non-religious feast. Art, the Christian gospel, the music and the pictures will all be better off, because then they can all just be themselves.

In short, we wish you a pleasant holiday, and may you manage to exclude every shred of phoney kitsch!

• Three works of art[437]

True to custom, we want to tell something about visual art in this issue. Our choice fell upon a trio of works for the following reasons: they can shed light for us on a historical development that is more than just interesting; and they can, we hope, in a broader connection, open our eyes to particular matters that affect us all.

The first work about which we want to say something is the golden altar front of about one meter in height of a small altar that was donated in 1019 to the great church in Basle by the German Emperor Henry II and that was intended to honour Saint Benedict (c. 525, the founder of the Benedictine order). It is an artwork of the highest quality.

We are, of course, not concerned with all the various historical particulars but want to pose the question: in what way does reality play a role in what we see before us here, namely five round arches forming shallow niches in which stand, from left to right, Saint Benedict, the archangel Michael, Christ, and the archangels Gabriel and Raphael.

In the first place we must say that all these figures have a human form and that the artist felt himself bound to the structure, and to the construction, of people as we know them from day to day. Yet that is where it stops. For no one today has ever seen any of these represented figures on earth. Neither did the artist ever see them. Only Christ and Benedict were ever once beheld by earthly eyes, 'normally', and only one or another of the archangels in quite exceptional circumstances by a very few mortals. Yet the artist was not at all interested in reconstructing some kind of encounter with these persons. On the contrary, he set out to represent a concrete and living, authentic reality that 'was there' in his time and, let us add, that is also still here for us – certainly for Roman Catholics, but also for us, although we may feel somewhat uncomfortable at encountering Benedict here with Christ and the archangels.

Yet the reality represented is not an earthly reality that we can behold as we go our earthly way; it is a celestial reality of the so-called supernatural. And the figures that we see are, as it were, only signs to illuminate this celestial reality for us. Therefore it is not a contradiction if the figures appear against a golden background and we see no physical surroundings (houses, trees, mountains, clouds) for these earthly things are not incorporated in the realm of supernatural principles, in the sphere of the divine. The only earthly things in this entire work of art are the two diminutive figures at Christ's feet, namely the emperor and empress.

In the second artwork that we now want to examine briefly – also a masterpiece about which a great deal could be told – we see that the artist has made a tremendous effort to paint everything as naturally as possible: the landscape, Mary and the Infant, the golden crown, the hall in which they are seated with the kneeling man at the left, the chancellor Rolin, a very important minister of the Burgundian rulers. This artwork was painted around 1430 by the great master Jan van Eyck (c. 1390–1441).

Yet if we pose the question again, of what the earthly, 'normal' reality is that we see here, then the answer is: the chancellor (in fact no different from the emperor and empress in our first piece, albeit he has

had the audacity to have himself painted on the same level with Mary) and visible through the arches the broad landscape, inspired by the valley of the Maas River, with the city of Luik. Yet all of this too shows supernatural, not earthly, reality. Here too the painter does not wish to tell us (with his brush) that this is a reality belonging to the here and now, once visible to us. Even less does he wish to tell us that the chancellor has transported himself with some sort of miraculous time machine to Bethlehem in about the year zero. No, Mary is meaningful now and very real, he wants to say, and she is the Mother of God. That is why she has the Infant with her, more as an indication of who she is and of the basis upon which she attained her special position than that the painter would want to assert that Mary is now in heaven with the Christchild on her lap. In short, the painting is more of an exposition or sermon, more of an indication of the pious connection between the chancellor and Mary than a tangible world that is depicted for us. Essentially there is thus not much different going on here than in the first piece. The chancellor, however, was indeed rather cheeky. That was sensed, too, by Jan van Eyck's younger contemporary Rogier van der Weyden (c. 1399–1464). He, taking his inspiration from a legend, fairly well imitated this composition in a piece representing *Saint Luke painting the Madonna.* This piece, too, is not about a reconstruction of a remote past; rather, we are shown something that transpires in the supernatural. Therefore it is not strange or incorrect that the figures in that painting, like those in the works of van Eyck, wear the garments of their time. For in essence we are viewing a timeless reality, a reality that transcends time. Yet there is a certain inner contradiction in the piece. For if the legend that inspired van der Weyden is true, then what we have before us is an event from the remote past.

This contradiction was sensed by the painters of a later generation. That brings us to our third work, a painting from the early sixteenth century (c. 1520), the time of the Reformation, of the powerful influence of humanism, of tremendous spiritual struggle (a time when all the matters we have discussed were at stake). Jan Gossaert (Mabuse, c. 1475–1536), also a Burgundian court painter – Maria was now the ruler – took his inspiration directly from Rogier van der Weyden but made it clear that there was now a difference. The figures no longer stand on one surface but many, the Madonna now appears as a supernatural reality in a cloud, and Luke is the earthly painter who draws her. Mabuse thus understood Rogier's painting in such a way that it is not about a moment of history – for then he could have placed both the figures on one surface – but about a meeting of the celestial and the terrestrial, as in the piece by Jan van Eyck. In the painting St Luke is a kind of personification of the painter in general, of the artist, who with his brush makes the supernatural visible to mortals. Through this painting we are thus able to understand much better the character of the paintings we have just considered.

As we have just seen, virtually all medieval art was focused mainly on depicting supernatural figures, ideas, dogmas and principles and not our ordinary reality. Only in the sixteenth century did earthly reality begin to play a role, which led eventually to the art of, e.g. Jan van Goyen, Jan Steen and others, art in which the painter depicts what is earthly. Is God then absent? Is the heavenly no longer there? Have the truths that were so important to medievals vanished from people's minds? Perhaps that was so for some consistent humanists, for example. Yet others, our seventeenth-century Dutch painters, saw that we are to sing God's praise by seeing his glory in his creation (Romans 1) and by engaging ourselves in its study, our task according to Ecclesiastes, for example.

No, when those seventeenth-century people painted in that way it was not because heaven was gone but because people had come to understand something else, namely that while their thoughts must be directed toward the heavenly, to be sure, they must be walking in God's ways on earth (there are ever so many supporting verses in Paul's Epistles, for example). People came to see their task in a more biblical, more sober way – although many at the time and certainly in later times did lose sight of God, Christ and angels, God's greatness in creation, and so forth (Romans 1).

So, these paintings confront us with difficult questions, but I believe they are definitely questions worth considering!

Reflections on Art

• Art and beauty in this world[438]

The Lord our God, when he created the world, gave it beauty. When Adam and Eve walked in Paradise they could relish everything beautiful. Following the fall into sin, the earthly realm too was cursed. And indeed, in many areas where people have been active the beauty of this world has been seriously impaired. Just think of some of our industrial landscapes or some of the residential districts in our inner cities. Yet even there one may notice the beauty of a little flower or grass that flourishes in an inconspicuous nook. Thus beauty did not vanish with the Fall but ugliness, that which is not beautiful, appeared alongside it in this world. Were the daughters of men not 'fair' (Genesis 6:2) and were the Jews not encouraged to take the 'choice fruit' from the branches of the fruit trees (Leviticus 23:40)? All that needs no proofs – the beauty of nature, a magnificent sunset, everyone can see these marvels day after day.

In creation the Lord not only made nature beautiful but also gave people the talent to fashion beautiful things for themselves. People can beautify their houses and the objects they use, but they can also make things simply for beauty's sake in the so-called 'free' arts. God has not explicitly spelled out in his word the laws that appertain to art and beauty, but that is not to say that we cannot know what these norms are. We have all received the ability to apprehend beauty and to enjoy it, and we can discover the norms we must obey if we want to make something that is beautiful – just as we can discover how we must treat grain if we want to grow the best harvest possible or, to put it more simply, that there are all kinds of different plants and animals with all kinds of different characteristics. So we will find that certain colours clash, that there is such a thing as aesthetic excess – of which we may say that it is too 'busy' – that there are pleasing and not pleasing combinations of musical notes, and so forth. In all of this we do not create as much as discover what the Lord has already established in his creation.

The Lord has given us these gifts so that by them we may make our lives more agreeable and our surroundings more pleasant and attractive to the eye.[439] We must use beauty to that end and not assign it too high a place. We must not idolize beauty and we must certainly not seek the meaning of our lives in it.[440] Of course it is unlikely that in our circles we would do such a thing. Yet, we must also not suppose that we are required to serve God specially with beauty and so set out to locate our service to God exclusively in the singing of beautiful songs and the making of beautiful paintings. If we were to do that, he would speak to us as in Hosea 6:6 or Amos 5:21–24, where the Lord clearly states what he desires of us above all else, namely love, knowledge of him, and

justice rather than sacrifices. Of course that is not to suggest that everything beautiful – singing, speaking, etc. – must be eliminated from our Sunday morning worship services as of the Devil; no, for beauty too *is* a gift of God, and the correct use of it can therefore never be a sin.

While the practice of art in song or whatever form is not religious in itself, this does not mean that we do not have to take the Lord and his word into account here. Religion and art, though distinct, are not separate and each has received its own God-appointed place in our lives. Also in our singing or speaking we are covenant children of the Lord who desire to walk obediently in his ways. The first thing that we must do, then, is to acknowledge that beauty and art are also gifts of God. For did not Israel sin by trusting in their own comeliness and forgetting that God had given them their beauty (Ezekiel 16:14–15)? And did not judgment fall on Nebuchadnezzar because he prided himself in having built Babylon strong and beautiful by the might of his own power and for the honour of his own majesty (Daniel 4:30)?

Again and again people who refuse to listen to God and follow their own desires instead will 'play the harlot' with art. How often have they not, in violation of God's express commandments, made gods or graven images for themselves in order to worship them? And perhaps these idols are very beautiful. Just think of the *Hermes* of Praxiteles! Nevertheless, however beautiful these images may be, God's judgment rests upon the perpetrators of such evil.

In the course of history, in the course of the development of the world, people became ever more self-aware, digging themselves ever more deeply into their apostate ways and setting their mark on their creations ever more tellingly. In the disclosure and deepening of their possibilities and in their use of the creation, the apostate direction of their hearts will attain ever deeper and more radical expression. The art that was made in ancient times, in ancient civilizations such as Egypt's for example, was often used in the service of an idolatrous religion although that did not yet come to the fore in the purely aesthetic representation or the style. Yet the further we move along in time the clearer it becomes that both beauty and style, and what is depicted acquire the stamp of people's apostate beliefs. Thus Solomon was still able to employ an artist from Tyre without objection. In the early Christian period, however, that was much more difficult. And today we must be very careful indeed since there is a great deal of art that we cannot use even if the representation itself is not wrong, simply because the manner in which the subject is executed bears witness to clear and direct rebellion against God.

Humanistic art

We would now like to clarify what we have said above with an example, for which we have chosen the art of Western Europe in the 'new era' (from the fifteenth to the nineteenth century), humanistic art. This art

is the fruit of the Renaissance, which occurred in the fifteenth and sixteenth centuries, the period during which the basic ideas and tendencies of the new art acquired the form they retained until our own [twentieth] century. Human freedom – not being bound by laws or principles imposed upon anyone 'from without' – was the crux of their thinking – freedom from every tie, for to be bound by external norms did not square with human dignity. People came to believe they could build a better world according to the laws they thought they had discovered in themselves. In a word, they came to believe in humanity themselves. And they believed that science in particular would be the instrument whereby they could exercise their lordship over creation. Indeed, if only they applied the laws of 'nature',[441] which could be discovered through science, progress would follow. So people also came to believe in science. Nature and freedom, belief in humanity and in science, these were the two poles, inherently contradictory and thus constantly in conflict with each other, between which the humanistic world and life view shifted.

All of this also conditioned humanistic art in all its expressions, with respect to the themes represented, the subjects selected, and the aesthetic form or style itself. Here we shall consider just the last of these. Love for science and belief in it led people to put art under the wing of science. They thought that by applying scientifically discoverable rules they would automatically achieve good art. As a consequence they put a strong emphasis on the element of form: it did not matter what people painted or sculpted, as long as good rules were applied in the right way. Knowledge of these rules – which people often borrowed from antiquity (like Vitruvius' 'five orders' for architecture, for example) – was the path to beauty. And people could learn the rules! Knowledge of perspective, anatomy and the mathematical foundations of art was considered enough, as if these could teach anyone how to draw a single, aesthetically responsible, beautiful line. The art that adopted this approach was the academic or classicist art.

Yet such art did not have the whole stage to itself. It was constantly attacked by or on the attack against the stylistic movement that represented the desire to give unbridled expression to human personality. The artist's personality needed to be able to express itself freely, unhindered by rules, following only the inner law of genius. Free fantasy, playfulness, the unconnected and especially the strictly personal and original: these were what ultimately made art Art. Well then, this all acquired a positive form first in sixteenth-century Mannerism, then in Baroque, and later in the Faustian art[442] of Romanticism. In all these movements people poured out their feelings of longing for remote or fanciful, illusory worlds.

As a result, the relation between the painter or sculptor and reality became a problem. Should the artist create 'from within', from his or her free fantasy or endeavour to approach and follow nature as closely

as possible? That was the dilemma that resulted from the humanistic view of life with its contradiction between 'nature' and 'freedom'. The problem surfaced again and again. Sometimes people chose radically for the one approach – 'the most individual expression of the most individual emotion' – and at other times for the other – to copy nature as precisely as possible, as in the still lifes of extreme naturalism. Sometimes, however, people adopted some middle way, a compromise based on one philosophical explanation or another of the problem they had raised and constructed themselves concerning the relation between humanity and reality and its implications for the artist's task. It is typical of the increasingly theoreticized approach to life that people constantly tried to solve the problem in a philosophical-scientific way, allowing themselves to be guided as consistently as possible by the results of their reflections, even if it involved a complete overthrow of tradition and an impoverishment or restriction of their possibilities.

One constantly encounters these two opposing tendencies, emphasizing one or the other of the two poles of the humanistic approach to life, in each case as a matter of emphasis only. For academic-classical art also sought to glorify humanity, and Baroque and Romantic art also sought to justify itself through science and also regarded 'nature' as the source of knowledge. It would be interesting and no doubt illuminating to discuss how this all acquired tangible form, but that would require too much space here.

Consider further that this essentially unchristian, neo-heathen art was not only meant for the 'world'. No, a very great many works of art indeed, especially from the period before 1750, depict biblical stories or legends of the saints and were done for churches and cloisters. The art of the Baroque was in fact very closely connected with the Roman Catholic Church and almost entirely in the service of the Counter-Reformation: the World in the service of the Woman who sits on the Beast! In previous times people used their painting skills to depict deeds of faith and the facts of salvation, but now they used ecclesiastical art to demonstrate their own artistic genius.

'He who trusts in himself is a fool' (Proverbs 28:26). With these words from the Bible one has already advanced a fundamental critique of this entire attitude. And indeed, has all of this not also damaged the beauty of art?[443] Nevertheless, we must not forget that these things do not always reveal themselves fully to the same degree or in their ultimate consequences. Even apostates do not live constantly under the 'high tension of the revolution' and do not always violate God's creation ordinances in every respect. For people simply lack the capacity to breach the creation order and their own human nature as given them by God. Every person, even the humanistic person, remains ever and always human. Likewise, the scriptural norms still make themselves felt and consciousness of their validity has by no means vanished from the world. Romans 2:14–15 has lost nothing of its truth.

The humanistic principles described above have left their stamp on art. In the case of classicist architecture the outcome was significant impoverishment: people consciously restricted themselves to a few elements borrowed from the ancients, and as a result this style of architecture, given its incessant repetition of the same elements and principles of construction, can often not be defended against charges of monotony and meaninglessness. The visual arts too show signs at times of coolness and rigidity, the result of a barren dedication to a system. On the other hand, people sometimes know no bounds or moderation in their pursuit of the strange and bizarre as they are driven by the desire for originality and the glorification of personality. A sickly pomposity, immoderation and self-glorification have led more than once to an art that has exceeded its powers, producing a hollow boisterousness coupled with a certain vacuity of elements that say nothing. Sweetness and sentimentality were sometimes the result of an unhealthy quest for sensuality and sensuous charm. And so this art manifests, more or less clearly, that it stands in the service of human delusion and self-adoration.

• Judging works of art[444]

a) Humanism

If we want to look for an answer to the question of how we should judge secular works of art, then we have to say something first about the character of this art and especially about the relation between the apostate mind and works inspired by apostate belief. Our starting point here will be humanistic art, so that the problems discussed will not be overly general and thereby too abstract – for we mean to deal not with theories of culture but with answers to concrete questions. Moreover, this art is the art we come across most, for virtually all the artworks that we see at exhibitions and in museums have been made by humanists. And who would deny that there are wonderful works among them! The question we want to pursue can therefore be formulated as follows: To what extent does the humanist's unbelief and disobedience to many of God's laws find expression in his or her artistic creations and to what extent must we speak of sin in connection with them? We shall not attempt to deal exhaustively with this theme. Would that even be possible? Humanity and art and life are so rich and varied and God's creation and works are so great, also when we consider the activities of unbelievers, that we could never be finished with studying and looking. We shall therefore present or briefly discuss only a few main points.

Humanism, which is a spiritual wickedness in the air, is an apostate attitude of faith. And on the basis of this apostate attitude towards life people set to work. This attitude by no means stays confined to the 'private chambers' to which people so like to consign Christian belief. This humanist life and world view is given concrete form in ideals and

principles they try to realize as fully as possible. Thus they undertake to alter reality according to their own insight, to make it as it ought to be or even would have been were it not for all manner of 'wrong' things such as stupidity, belief in the Bible and narrow-mindedness, intolerance towards those holding different opinions, egoism, inequality (particularly economic inequality) between individuals, restrictions on liberty, and so forth. For in their opinion it is these things that make the world into a vale of tears. Basic to their thinking is the ideal of the freedom of the human personality which must endeavour to develop itself as harmoniously and as well as possible, and the idea that science gives us a correct insight into reality and the capacity to control not only nature but also destiny, misfortune and disasters.

Yet we have still not penetrated to the heart of the matter. So far we have only talked about the shape of the idolatrous devotion. The idol to which people bow down in the new and modern era is humanity. It is not with Baal or the queen of Heaven of Jeremiah 7:18 but with themselves, their own 'inner being' that people commit their adultery. Yes, adultery, for we are dealing here not with heathens like the people at Lystra and Derbe [see Acts 14:6, 16:2] or with worshippers of Baal like the Babylonians but with people who have heard and who know the wholesome words of the gospel, with a world where a large percentage of the population have received the sign and seal of God's covenant, namely baptism; we are dealing here with apostate children of the covenant.[445] And therefore the Lord is now visiting this world with his judgments and threats, as spelled out in Deuteronomy 28:15–68, and that is the reason why the pronouncements of judgment and the warnings, once delivered against Israel (I have in mind in particular Amos 9), are so horribly timely for today. No, we do not want to compare either Western Europe or the Netherlands with Israel; yet those who think they can take comfort in that and so set the words of the prophets aside should not forget that there is even less hope for them: Israel at least was promised to be left a remnant since the Saviour would come from Judah, but for the Western world no such promises of God have been given at all.

The humanistic idea is this:

> Human beings are independent beings who have set themselves up as a law unto themselves, who recognize no higher authority than their so-called 'higher egos', who rule their world according to their will and sit ensconced within their innermost selves as gods, and who as autonomous, free and independent subjects believe they may do all, desire all and control all, and who often experience reality as wilful as they feel it should actually yield to their will.[446]

For God upholds his creation ordinances and human beings are not able to change themselves, least of all their own corrupt hearts. The Lord our God is faithful to his covenant that he once proclaimed to

Noah, and no salvation or renewal is possible apart from the Saviour Christ Jesus. Therefore the humanistic project can never be fully realized. People will have to capitulate again and again to the world order established by God and, 'compelled by circumstances', take into account their 'imperfection' (to put it in humanistic terms), not to mention the fact that an angry God often breaks the hands of their work. The world as humanists construct it will therefore manifest the character of a compromise between the ideals they want to develop in a logically consistent way from their life and world view, or 'faith', and the world as it actually is in this dispensation between the Fall and the Day of the Lord, whether they want to acknowledge this or not.

This brings us back to the question we posed at the beginning. Someone who wants to create art has to set about doing so according to the norms and rules God has laid down in his creation, apart from which no beauty and no art is possible. Now, one can very easily proceed in the privacy of one's chambers or with a few kindred spirits to experiment in this area and to set aside all norms of beauty: some Experimental [447] splotching may perhaps reach the museums, but nothing of enduring artistic value and enduring beauty – which needs to be recognized as such by everyone who loves art – will be created in this way. And it can therefore be questioned whether such 'works of art' will ever be able to exact a permanent place in the museums and whether we will ever reach the point when such products will hang on the walls of every home. In other areas, however, where we have to do with the fullness of practical everyday life, such experiments have virtually no chance of realization; it is certain that a new order will quickly arise out of the resultant chaos, since life would otherwise simply be made impossible. A clear example is the following: that in Russia, soon after the Revolution, marriage was abolished and free love proclaimed. This led quickly to such a disgraceful mess that people soon had to yield to God's reality, so that currently divorce is more difficult as they are trying to stimulate good marital relationships again! We know, furthermore, that even on the Day of the Lord there will still be marriages (Luke 17:26–30).

b) Humanistic art

Whatever one's ideas may be, to make something of abiding significance or to make works of art that can be enjoyed for their beauty, one must work in a truly aesthetic way, obeying the laws for beauty that have been given by God. People cannot high-handedly ignore these laws. Naturally artists will put their own stamp on their products. As we have already said, the results will be a compromise between subjective opinions and divinely created reality, with the latter being in the preponderance. People will never be able to do more than emphasize certain elements, thereby bringing some facets forward at the expense of others. In the framing of the problem, in the task people set for themselves, in the

demands they make, an attitude to life will also manifest itself: this will result in their discovering and disclosing certain possibilities that are present in reality – divinely created reality – and in their ignoring or perhaps even consciously passing over others.

Humanism as a modern attitude towards life arose in the Renaissance, and in that time the foundations were also laid for the art of the new era.[448] Thus in the fourteenth and fifteenth centuries people discovered and developed in the art of painting the following possibilities: the portrait, the depiction of landscape, the precise depiction of reality through the use of perspective and shadow effects, the correct rendering of the human form in the most complicated positions through the study of human anatomy etc., oil painting, the graphic arts – woodcut and copper engraving – and we could extend this list. We can certainly show that the interest in these matters was connected with the new humanist attitude towards life – that is especially clear in the case of the portrait – but who would want to deny that these possibilities are real possibilities that God built into his creation? Portraits could be made because it was a God-given possibility. And the fact that you may have a portrait hanging on your wall or that you happen to think a work by Michelangelo is beautiful does not mean you are a humanist!

Naturally the humanists believed that people created these possibilities and so proceeded to revere the great artists as geniuses, great minds, great creators and prophets. They exploited the possibilities of the portrait to proclaim their own glory, and more often than not they used the refined skill of rendering the human figure in all its forms and movements to depict all manner of more or less immoral and adulterous ancient myths in order to satisfy the eye and the senses with voluptuous female bodies. They endeavoured to depict the 'ideal' in art, the ideal, beautiful person situated in ideal surroundings performing his or her heroic deeds, deeds that speak of human freedom and greatness and that confront us with a model of the 'good' person. The task assigned to art was to glorify humanity and depict reality as humanists ideally conceived it.[449] Striving and working to fulfil this assignment, the great artists disclosed many aesthetic possibilities and, studying and labouring seriously and conscientiously, they were able to make many beautiful works. Perhaps without wanting to do so, perhaps without wanting to give the glory to the Lord of creation and to sing his praise, they did in fact, as true artists whose principal aim was to create beauty, make beautiful works of art that rightly draw so much attention in museums around the world today. For to the extent that they were genuinely aesthetically active they could do nothing other than bow before the law of God, since otherwise their work would have been immediately stamped as of inferior quality. The key artists are well-known to virtually everyone with an interest in art: van Eyck, Memling,

Raphael, Leonardo da Vinci, Michelangelo, Titian, Van Dyck, Watteau . . . well, let us leave it at these fairly arbitrarily selected names. To recognize the greatness of their gifts and the formidably high quality of their works is not to revere them as great prophets of humanity, as some aestheticizing folk perhaps do. And by no means do we intend to suggest that every single work of theirs is incomparable or that many of their works will not be able to stand up to the judgment of God's law for reasons other than aesthetic ones – but we will return to that shortly.

To be sure, the seeking and striving of these artists was in a very specific direction: the glorification of humanity and secularized human life.[450] And that lent to all this work a one-sidedness whereby certain elements repeatedly received too much emphasis while others were passed over or neglected. Watteau presented feminine grace to the eye as we have seldom seen it, but persistence in this direction soon led to rigidity and dilution. The 'gallantries' quickly decayed into platitudes or sentimentality, and the pithy feminine type of the master degenerated as a result of the constant emphasis on charm, leading to something ever less true to life and in the long run rather doll-like and boring. The same is true of the art that was carried forward under Van Dyck's influence. People sitting for portraits were idealized to the point that all the women looked equally elegant and beautiful but also always insignificant, while in the portraits of the men we encounter always the same refined characteristics and hands and poses. The same is true of the landscapes, a genre, by the way, which people generally did not hold in high regard but viewed as of significance only as the setting for 'heroic' stories. People looked for 'ideal' landscapes and a number of grandmasters worked out the formula for it. Their art is of high quality, but the ideal landscape degenerated through the years into an incessantly repeated formula, a predictable scheme. Thus the plants degenerated into an undifferentiated mass of leaves and the richness of the nature given us by God was reduced to a number of standard landscapes!

You may not see the products of the impoverishment and enervation, for they are practically absent from the museums. Humanists too know how to judge things by the aesthetic norm and likewise find products spawned by one school or another, always wrought according to the same formulas, boring and insignificant. Yes, perhaps humanists will judge even more sharply because they believe humanity is good and they always measure against the ideal person and want to hear nothing about sin and its effects. They too see that these principles are one-sided and lead to rigidity, and they too know that the ideals they espouse are just private opinions of their own. Here we see the concrete truth of Romans 1:18, namely that the unbelieving person suppresses the truth in unrighteousness, that he or she sees the unsoundness of the principle but refuses to recognize the reason for it and to convert and listen to the wholesome and ever so sober words of God. We are all too often

impaired in these matters ourselves by a subjectivism of humanist origin that assumes one is always honest in his or her view, so that we say 'they cannot see it any other way'! And then the scriptural message becomes just theological 'dogma' without any concrete, real significance.

c) Testing art against God's laws

From all that has been said above we may conclude that we should distinguish between the views and aspirations of the style-shaping leading figures and the results of their work, just as we ought to distinguish between the opinions and ambitions of natural scientists – perhaps they think they are working for world peace by inventing dynamite, for example, or perhaps they think that with their science they can control nature – and the results of their work that we see before us in the form of machines, cars, radios, etc. which we utilize every time we flip a light switch to turn on the light. Their intentions may have been sinful – who, however, would want to make that judgment in general, since we often do not even know who they were – but the result was that they discovered real laws and possibilities that were created by God. It is the same with art. We have already provided many examples.

From this it follows that we must not judge a work of art according to the attitude of its maker or the spirit of the age that gave birth to it or the subjective activity that resulted in the work. We must judge a work of art as a work of art, the thing in front of our eyes. Thus when judging art we can only say that it is good or bad, as in every other area, by testing it against the law of God. But in doing so we must keep in mind that although a painting is qualified or determined by the aesthetic function, it is by no means just aesthetic but involves also norms in the realms of ethics and faith. And we could go on to name even more functions that are distinguishable as to the painting – if we just remember that they can never be separated in reality. However that may be, an idolatrous worship service that is magnificently 'presented' with all manner of refined and well-staged ceremonies remains an idolatrous service; and a curse remains a curse, however beautiful it may be from a purely aesthetic standpoint as it is applied in a work of literature.

Now, the Lord our God has revealed very clearly the norms for faith, and he has also made the way clear for us with respect to morals. However, norms for beauty are not stated explicitly in Holy Scripture. For, however dangerous the slogan 'beauty for beauty's sake' can be and while a painting is more than just beautiful or ugly, we must certainly judge a painting in the first place on its aesthetic qualities. Scripture refers to beautiful and ugly without further ado, thus presupposing that people are able to discriminate and judge for themselves without the norms being revealed. Indeed, we usually do not make a weighty problem of speaking of beautiful and ugly. Even though the norm is difficult or impossible to state in words, we all know what it is. We can

develop or, better, exercise our capacity to discriminate, our purity in judgment, our 'feeling' in these matters. Just as one can practice swimming or speaking. We can do that by looking at works of art a lot.

If we look at it in this way we can also say that what is ugly is, as such, sinful. For when we put it like this we do not say anything about the person who made the work. His or her intentions may have been very good. This person cannot be accused of sins from which he or she should turn away. That such a person still was unable, despite every effort, to produce a truly beautiful piece or that he or she perhaps evinced a lack of good taste has everything to do with the effects of sin, with the curse on the earth; but just as when someone stutters or suffers from weak health, so here too we may not and cannot judge that person for it. But we can certainly judge the product, the ugly poem or the ugly drawing, for ugliness is in conflict with the norm laid down by God in creation.

We already pointed out earlier that beautiful works of art have also come from the hands of the great humanist artists, works that are truly beautiful. And we noted at the same time that that came about because in producing their creations these people obeyed the laws of God for this field. I spoke of 'capitulating' to the divine world order. Secular art can thus be beautiful but only to the extent that people do not put their own apostate revolutionary principles into practice. Revolution, the desire to break through God's law order and to put one's own principles into practice immediately once every tradition has been broken down, never lasts that long or is frightfully inconsistent or works only for a very confined area, among a small group of people, for example. A radical revolution would dislocate everything and destroy all 'values'. People would then soon recoil from the result, as they did in Russia. That is also the reason why the revolutionary principles, which the Renaissance proclaimed and gave root to, spread very slowly before they were applied with any consistency. Nor may we ever forget that the Reformation seriously obstructed the influence of humanism and the effect of its principles when the voices of the two Witnesses were lifted again[451] and when God's people again became salt that salts, when God's word again leavened life – while even amongst Roman Catholics many abuses were eliminated.

d) Dangerous?

In politics the revolution occurred first in people's minds and only later in bloody revolutions in the course of the eighteenth century, when apostasy from the Lord, the God of the Scriptures, revealed itself everywhere.[452] The roots of modern art are also to be sought in that period. Only in our twentieth century, however, was the revolution carried through to full completion with something approaching consistency. The less consistent [with the revolutionary principles], the more enjoyable the works of art. The artists who go furthest are those

who say that art and beauty are outdated concepts, who seek direct, spontaneous expression without any inhibitions caused by reason or moral or social judgments, and who seek their inspiration in the drawings of very small children and the insane. That is Experimental art. A consistent application of the apostate basic principles can destroy beauty – and we may justifiably ask whether this area still has anything to do with art.

We noted above that products of humanistic culture always evince a compromise between their ideals and God's reality. The better the norms have been upheld that God has given for beauty, the more beautiful and better the art will be. People will of course always still put their stamp on their art; especially their ideas will find expression in their works. Flemish fifteenth-century depictions of sacred events and the lives of the saints, the Madonnas of Raphael, etc. will clearly reveal the Roman Catholic ideas about such matters. A Raphael Madonna is a pious woman to the bone! Yet how could it be otherwise when the artist's commission was to show this as purely as possible. And it is precisely for this reason that we must ask ourselves whether such artworks might not be 'dangerous', since they might influence us in our faith life and in our scriptural vision and sense of norms. Yet this will only seldom be the case, because the manner of expression and the style will clearly bear the marks of the past. Not only Bible believers but also humanists say of such works, 'From these works of art I see and observe that people in this or that period thought in such and such a way' – perhaps with a commiserating smile at their 'primitive' conceptions. No one has ever been convinced of the truth of the Roman Catholic faith by seeing a magnificent French Gothic cathedral; no, people will stand in amazement before these grand creations of human genius and talk with one another about the remarkably strong faith expressed through them, but they will see nothing else there than the subjective opinion of people who lived long ago. In the same way, when they read works of Romantic literature they will notice what those people thought and perhaps determine that they were somewhat sentimental. Precisely because the spirit of the age and the opinions prevalent in that era speak so eloquently from the artworks and are apprehended as the notions of a time past, their power to influence 'conversion', if you will, is minimal – unless, of course, people already hold such opinions, whereupon they will only come to hold them all the more staunchly.

Now if this is so for the humanist, who lacks a light on his path and a lamp for his feet in the Holy Scriptures, how much less will the danger be for a Bible believer? Seventeenth-century figures who do godless things are and remain seventeenth-century figures, and their works, the manner in which they executed them, at least, will clearly bear the stamp of the world of their day. And in such cases even humanists know very well how to discriminate. They often know the norm very well but just do

not want to recognize it as obtaining also for them in our own day and age. Thus people continue today to deplore the so-called bigamy they incorrectly ascribe to Bilderdijk, while no one is permitted to judge similar matters in today's world!

But suppose that present-day people make a work of art in which they suggest and propagate their opinions, then that will not be so conspicuous to us precisely because the ideas are expressed in the 'language' of our times. Yet such a work will definitely, though perhaps not purposely, bear the stamp of the spirit of the age and of the conceptions of the movement from which it stems. And therefore such works can have a powerful indoctrinating force, and if they prophesy falsely there is some danger to be feared. Because an eighteenth-century figure wears a cocked hat we notice easily that it is just an eighteenth-century figure with his or her idiosyncrasies, but what the fellow in the coat and tie has to say in a twentieth-century manner about the distinctive problems and circumstances of our own day appeals to us and may convince us. The better the work of art, the more convincing it is. Just as an impassioned, well-delivered speech is more convincing than a dry and difficult argument. The strange and for many people usually incomprehensible art – happily so – of Picasso and his likes will probably do little harm, but the more everyday and commonly understandable art – that will put ideas into our heads before we know it!

We will now try to formulate our conclusion. Through the years a great deal of magnificent art has been produced that one may look at and enjoy without risk in museums and elsewhere. There is no danger in doing so when one lives close to the Scriptures and remains simply alert and in this way careful when judging performances and the like not to ignore the divinely revealed norm! Precisely because the conception, apostate or otherwise, expressed in such works is clearly manifest – which is not to say that one can necessarily state it clearly in words – and bears the stamp of a past age and a vanished world, the force of the opinions expressed in them will be minimal. Where modern artworks are concerned, however, we have to warn people to be very careful and, if one must or chooses to be occupied with them, to be very alert and to try to understand the spirit behind them. For here false prophecy has an all too ordinary face and we may perhaps not even notice that we are being served up a particular idea. Here more than ever the rule must be to live close to Scripture and test the spirits to see whether they be of God; we must determine whether the opinion or notion being offered in such an inconspicuous, matter-of-fact way rhymes with the revealed law of the Lord![453] And do not forget after perhaps having spent an afternoon in a museum or having enjoyed the fine arts in some other way to offer to the Lord, the Creator and Giver of all, the thanks due to him!

• Learning to see[454]

Too often it seems that 'people' have a kind of inferiority complex about the visual arts. One often hears a person say, 'I do not go to museums or exhibitions because I do not understand them anyway.' As if art were created for an elite group who do understand it, a sort of esoteric fellowship of connoisseurs! Certainly it is true that the more you understand about art, the more you will see in it. The question, however, is whether that increased knowledge also results in a more intense experience and a greater enjoyment. It can happen that knowing more about a work makes it more problematic; the questions can wedge themselves between the observer and the image, hindering the enjoyment. But in general we can say that the quality of a good painting will be evident in the fact that even the 'unschooled' observer will get something out of it. Explanations of and discussions about the problems of composition etc. can make a piece of art more accessible but will never be able to turn a poor piece of art into a good one or vice versa. Besides, the greatest works of art hardly allow themselves to be 'explained'. Who can really say why *The little street* of Vermeer is so stunningly beautiful, why it is one of the greatest works of all times?

By giving in to feelings of inferiority and refusing to visit art galleries one guarantees that one really will never understand art. Just as one needs to be taught how to read a novel, one needs to learn how to view a painting – it is just as hard, and just as easy! So my advice is: do not miss any chance to go to a museum – the Rijksmuseum in Amsterdam, the Mauritshuis in The Hague, the Boymans Museum in Rotterdam or . . . whichever museum is nearest to you. And do not be afraid to be led by your own tastes. Concentrate on the pieces you enjoy. You do not have to see everything. If after wandering through the first few rooms you are tired and have had enough, go home and come back another time. You may be sure that every piece you see in the museum is of at least good quality and worth looking at; experts have already sifted through the art of the past to ensure that what is presented is of high quality. Above all, take your time. There is nothing wrong with spending a long time in front of one painting, especially if it turns out that there were still more beautiful and important works that you missed at that visit, because if you do not appreciate the small things, you do not deserve the greater ones. But it is by observing a small number of artworks intensely that one can learn to see. Do not pay attention (or not much) to the year or to the artist's name. The work itself is what matters, not the period of art history. The quality of a piece of art is not determined by the year in which it was painted.

Once you have become somewhat familiar with the paintings you may want to know more about the artists and the period in which they worked. I would strongly advise you to make a habit of buying a catalogue – it will supply you with all the information you could want:

not only the names of the artists but also the highlights of their careers. And the descriptions of the various pieces in the catalogue will draw your attention to details that may have escaped you. The subject, which you perhaps did not immediately understand, or peculiar characteristics that you were not aware of, will be explained or described. Let the catalogue, together with your own growing taste and understanding, be your guide. Especially do not neglect to visit the special exhibitions often organized during the summer which are also widely advertised in the media. These are usually collections of artworks which are related by a common theme; they will broaden your vision and increase your understanding. Do not forget: those exhibitions too are not intended for a small group of experts but for people just like you – exactly like you! Here too you will find the most important information in the catalogues. By purchasing a catalogue you will be taking home reproductions that you can use later to bring back to mind the pieces that especially moved you.

In closing: if a specific piece (or group of pieces) does not appeal to you for some reason, if it turns you off or repulses you, be honest with yourself and feel free to pass by. The specialist or the connoisseur may not have that freedom, but that is your great advantage, the privilege of being a 'layman'. Finally, one more comment: do not ever be ashamed of your own opinion. There is nothing shameful about being mistaken once in awhile. Leave the professional questions (e.g. whether this work truly was painted by that master, whether it really was produced during that century) to the professional art critics – that, after all, is their task as they toil under the sun. But the questions concerning whether a piece is beautiful or ugly, enjoyable or not, acceptable or unacceptable, those are not questions for the experts. Those are issues about which you are entitled to have your own opinion, and there is nothing wrong with missing the mark occasionally, with having to change your opinion once in awhile. After all, it is only by falling and getting up again and again that one learns to walk!

• Art as profession[455]

During the Middle Ages the artist was not seen as being different from any other artisan, a carpenter, for example, or a weaver or a tailor. Artists (and we are talking about visual artists here, not writers) were usually not organized in guilds of their own but were often grouped rather arbitrarily with other artisans. Regardless of how they were grouped or classified, however, artists were seen as labourers who had to prove themselves worthy of their wages.

The painters or sculptors of that time saw themselves in this way as well. Even about the greatest artists we sometimes hear stories that are almost incomprehensible to our modern ears. Jan van Eyck, for

example, painted the court banners – that was part of his job as court artist with the Burgundian dukedom. And even a master artist like Leonardo da Vinci was kept busy planning and organizing a huge party for his patron, the duke of Milan.

But precisely with artists like da Vinci and his contemporaries the idea began to emerge that an artist should be seen as more than just another labourer. That was in line with Renaissance thought, which bestowed on the arts a highly honoured place. Through a variety of theoretical writings people tried to prove that art is a science, and that the artist must be seen on the same level as a scholar or a writer. From this emerged the institution of the academies, through which they wanted to prove their cultural equality with mathematicians, historians, men of letters and, especially, humanists, each of which had their own academies. In the following centuries we see especially in France continual debates about the social position of the artist. The struggle often centred on the question: should artists be part of a guild or an academy? This debate was finally brought to a conclusion by the French Revolution, in which the guilds were overthrown and the academy became the centre of artistic life.

Thus the Renaissance, with its aestheticism[456] gave the first push towards a new regard for artists, but the eventual glorification of the artist as some kind of extraordinary being only started in the Romantic period, a movement that was also coloured by aestheticisism. Then it became proper to consider artists as some of the highest and most important people on the cultural ladder – in their art they would reveal the unity that lies deep within the world order, that world order in which people had wrenched apart the areas of human freedom and nature with its predetermined laws. The Romantics often preached a gospel of beauty, and the artist was granted the status of a prophet.

The character of art changed too. A genius like Mozart still perceived his task to be the making of beautiful music, suitable for a particular social purpose – entertainment, perhaps, but high quality entertainment, or music for dance and for simple enjoyment – as commissioned by his duke or wealthy patron. However, when art became a self-expression of the lofty thoughts of the artists, it became the medium, or means, by which artists could lay bare their genius and the splendid depths of their soul. All their tumultuous inner emotions became important; art became completely subjective and no one was permitted a word of criticism against the brilliant artist who, after all, was a prophet and deserving of universal honour and respect.

A continual increase in the demands placed on the arts naturally followed, especially in the fields of music and literature, which now became the most important arts. They were, after all, the most suited to the expression of subjective emotions. Mozart took one day to write a symphony; it took César Franck two years. The performance of works

like this (and we are thinking, for example, of the almost unsingable *Missa Solemnis* by Beethoven) placed impossibly high demands on the musicians. More was demanded of the public too, who were expected to sit through the performances reverently. A work by Mozart is simply a musical pleasure, whereas a work by Beethoven presumes that one will acquaint oneself with the person of Beethoven and surrender to his special revelations. Wagner takes that yet another step further; today it is taken to extremes. Listening to music has now become almost a job, a cultural act, no longer just simple enjoyment.

We have moved almost imperceptibly into a discussion of music, because in music this development expressed itself most clearly; however the same things could be said about the field of literature. The artist uses art to express his or her own emotions, wrestling with the issues of life. One can hardly just simply enjoy a poem anymore such as, for example, the lovely poetry from the time of Queen Elizabeth I. Instead, one is now required to immerse oneself in the peculiar problems in the life of the poet. Notice how discussions of literature seldom speak only about the written piece and its distinguishing characteristics but nearly always direct attention to the soul of the poet and his or her experiences. As a matter of fact, this is what poets expect of their readers: in the work they lay bare their whole being and their personal struggles.

So, we come to the Romantic perception of the artist: an exalted figure, a kind of prophet, a person fraught with struggles of the soul, someone whose goal is not to write nice poetry or melodious music but to use very complicated metaphors and figures of speech to lay his or her heart bare to the reader or to use ever more convoluted sounds and styles to display his or her originality and depth as a master of sounds.

This understanding of poetry – self-revelation, an outpouring of the heart – is so entrenched that I once heard a minister at a meeting voice the question: may a believer be an artist as well? Is it justified to spend one's whole life revealing one's own emotions and feelings? It is true: if one accepts the Romantic image of the artist, then a believer is justified in asking that question. But the really amazing thing was that this minister apparently saw no other possible role for the arts.

We intended to discuss the visual artist – the painter or sculptor – but have started by dealing with the other arts because there the Romantic notions revealed themselves first and most clearly. In the visual arts the process was a bit different.

Of course, the visual artist was also given an elevated status, and the discussions that took place in the eighteenth century, for example, about the correct way to represent something artistically, about the right methods and the true character of the visual arts, again give us a taste of aestheticism. Here we frequently deal with nothing less than a purely Romantic glorification of genius: just look at the views given of figures like Rembrandt, Raphael, Michelangelo, etc.

But, as we noted, in the actual practice of the visual arts these notions were less clearly stated because this form of art lends itself to such less willingly and remains more strongly tied to the actual commission. A sculpture, after all, must be suitable for decorating a building or a park or other public place, and a painting is required to capture a particular subject on the canvas, or to fulfil some other artistic or social function.

Nevertheless, the Romantic ideals found their way into visual art as well. That happened, in very broad strokes, as follows: the Romantic art historians and art critics discovered that every piece of visual art expresses something of the time in which it was produced and something of the person who created it – her or his characteristic vision. That is certainly true, though it should not, as often happened here, be over-stated. We see that clearly with artists who themselves did not have such Romantic views about their own work. Who, for example, would with any real certainty or proof be able to make proclamations about the personality and character of someone like Jan van Eyck, or about a Gothic or Romanesque sculptor?

Even the idea of visual art being an expression of the spirit of the times is sometimes rather hard to prove. There are times when the visual arts appear to go their own way, making it difficult to find any connection between the spirit of the times and the work of art. Have a look, for example, at the works of Ingres and Delacroix, and try once (without reading their own writings) to discover how their art, so very different in spirit and in outlook, can be connected with the cultural trends of that time. If you look at the paintings of Memling and then read the history of his times, it will seem that you have landed in two completely different worlds.[457]

From a Romantic point of view, it is also hard to explain why in the genre of drawing – the most direct and least commission-bound form of artistic expression[458] – it is often hard to determine even the century in which it was created or to determine with any certainty which artist drew the picture.

Therefore, it is no wonder that in our times the visual arts have reached a crisis, now that the thesis that used to say 'Every artwork carries the stamp of its time and its artist' has been turned upside down to say 'Every artwork *must* be an expression of its time and *must* reveal the subjective personality of the artist.' The most repulsive paintings are then 'explained' – and the fact that such philosophical explanations are often needed is in itself already a symptom – by a statement that comes down to this, that we live in a terrible time filled with tensions, and therefore our art has to reflect that. And the most anti-cultural and undisciplined attempts at art, strongly reminiscent of the work of small children, are praised to the sky as being the most direct expression of the depths of the artistic soul.

Fortunately not all artists think this way. There are always a few who understand that a work of art must, in the first place, be beautiful, must have something to say – i.e. not prophesy, but sing of the beauty of creation or the fullness of the events happening around us, including the 'ordinary' things. And when I say 'beautiful' I certainly do not mean that the artist is bound to norms of the kind formulated by Greek antiquity or by Raphael, but I include works like van Gogh's *Potato eaters*, a field with cattle by Potter or a portrait by van Eyck. An artist must not just sit around waiting for inspiration to hit, for a heavenly mystery to take hold of her or him. This view has sunk countless talented careers because the artists did not feel they needed to listen to a teacher – 'Imagine, I might lose my own vision and personality!'

No, artists must be labourers, hard workers who, with all their talents and gifts, with all their wisdom and insight, attempt to fulfil a commission, which may have been given by another and which they then have the duty to complete on time, just like any other person has to – or which they have set for themselves because, for example, they have been gripped by a certain theme. But every inspiration has its norms, and not everything that insinuates itself into a person's mind needs to be brought into the open, like the filth we read by some modern poets which is only good for showing us what we may not do, no matter how honest (i.e. from the heart) it all may be. Besides, every art has a social task and a social function. For example, a painting should be suitable for hanging on your wall or mine.

Artists are hard-working men or women who know that to present something of quality they must study and study more. They are people who realize that the resulting work of art is at most 5 per cent inspiration, 5 per cent talent, and at least 90 per cent perspiration! Fortunately there still are artists like that, e.g. sculptors like Mari Andriessen and Raedeker, and a fairly large group of young painters, but also of older ones like Charley Toorop, and . . . well, I could name lots more, but you may not know them all. Try to discover them! But perhaps the art of our time is most wholesome and most powerful in those places where we do not speak of great art: in arts like typography, illustration, advertising, and in decorative sculpture and architecture. Here, after all, there is no call for a Romantic expression of the emotions of the artists but only for high quality work – otherwise they will not be hired again.

And then – and this is the strange part – when artists concentrate with all their being and all their energies not on 'me-and-myself-and-I' but on their work instead, their commission and task, then their work may become very personal but it becomes so as an added benefit, not as the primary goal. Then too, but this may not be apparent until the next generation, this work will be very firmly and clearly rooted in its own times, much more so than all the phoney, forced attempts (of sometimes good, sometimes poor quality) at being relevant; any art that sets as its

primary goal the interpretation of its times is inevitably going to look forced and artificial.

To put it differently, and to use an analogy, what is the job of a minister in the pulpit? To bring God's word purely, concretely, and to apply it to the needs of the congregation. That is his task and his commission. Not to demonstrate his own rhetorical skills, or to reveal the depths of his own faith, or to lay bare his own soul; neither is it to give expression to a movement, to a modern philosophical or theological school of thought. His own human weakness may sometimes lead him to such things, and the latter can sometimes be heard in Barthian speeches and writings. When a preacher does his job well, however, when he concentrates on his real task, then naturally he will do that in his own personally unique way; the better and more concretely he brings God's word, the more personal his way of expressing and teaching will be, and the more his own personality will shine through. Undoubtedly a later generation would be able to recognize the times in which the sermon was delivered – 'timeless' preaching is rarely the best. To the contrary! But a forced relevance is not desirable either.

The same applies to artists, who have different gifts, a different training and a different task. In their case the task is to make beautiful artworks – a melodious piece of music (like a violin concerto by Bach or a piano concerto by Mozart), a beautiful painting (like a river-scape by Jan van Goyen), a lovely sculpture (like . . . that lovely piece of decorative sculpture in your own neighbourhood which you have till now given little serious attention), or a poem like . . . forgive me for choosing an English example, but who can sing so wonderfully in their poetry as the English?

> Diaphenia like the daffodowndilly,
> White as the sun, fair as the lily,
> Heigh ho, how I do love thee!
> I do love thee as my lambs
> Are beloved of their dams;
> How blest were I if thou would'st prove me.[459]

• What is visual art?[460]

People sure can ask difficult questions. Visual art is visual art, is it not, and posing the question, 'What is visual art?' seems a bit like asking when you already know the answer. Let us be honest, everybody knows what visual art is – painting and sculpture – and everybody can distinguish between better art and worse art, the great and the banal. Imagine that this was not the case, that visual art could only be understood by experts and that we were able to distinguish a painting from let's say a poem only after we had read an extensive treatise about it. However, this does not imply that criticizing art is obvious and easy. It

certainly requires some experience – those who make no effort in this respect cannot expect their criticism will always be right.

Art is for everybody, and in principle everybody can understand it; it is definitely not for artists or experts only. As with politics, so with art too there are people who are engaged in it, people who comment on it, and people who, though they are not directly involved, can definitely develop their own insight into this field.

I deliberately did not include 'judge it', for the final judgment about the acts of the great men and women of this world has not been placed in our hands. That God has reserved for himself. So let us postpone the discussion of what judgment means and first ask ourselves what exactly visual art *is*.

For convenience's sake we will limit ourselves to the art of painting, of which we can say in the first place that the artist wants to tell us something through colours and lines. It is more or less as with poetry, in which through the medium of language something gets communicated in a certain way. Perhaps you will object that language and colour are not directly comparable. I agree, it is indeed more complicated. In our view it is like this: language uses written or spoken words; spoken language uses sounds which are organized in a certain manner and have a particular meaning. In paintings, colours, spatial forms, paint etc.[461] are used in a similar manner, all put on a flat surface in a controlled and 'organized' manner.

In language organized sounds have meaning; in paintings colours, etc., in a similar way have meaning. Thus in paintings we also have a kind of language, which we could call 'pictorial' language, a language that expresses something by means of 'pictures' or images (which could be compared to the words in a spoken language). However, we prefer to use another term for this type of 'pictorial' language, namely the iconic (from icon, meaning 'image').

In the meantime we have to realize that we also find language outside of literary prose or poetry; they are actually exceptional instances of the use of language. It is similar with the iconic. We encounter this particular medium of communication every day, outside the area of visual art. As an example of an everyday icon, think of a map. Blue lines mean waterways, red lines mean roads, black lines indicate railroads, circles or uneven blotches of red show villages and cities, green indicates forests, hills are brown, etc. Just as in spoken language an isolated word often does not mean much but only begins to speak to us, in other words to take on full meaning, in its context, so it is here too. The structure of the region that is represented on the map becomes clear only through the combination of the iconic indications mentioned above. And then it becomes clear that with the iconic we can show things that we could never express with words (the opposite is obviously just as true). Other examples of the use of the iconic are: statistical diagrams,

advertising placards, the images that we sometimes find on traffic signs (a train, a digging man, etc.), technical drawings, diagrams in electrical engineering, and finally even alphabetic characters.

From the last example it is clear that it is not necessary for the icon to (visually) resembles that which it represents, although this is usually the case. In this regard we can compare the icon with onomatopoeia in language, words like cuckoo, purring, etc. which mimic sounds. From the given examples it is obvious that this mimicking of sound is rather relative: the bird sings 'cuckoo' quite differently from the way we pronounce its name. And therefore we do not want to put too much emphasis on the notion of onomatopoeia to explain the icon, because the relationship between that which is represented, or rather, iconically indicated, and the icon itself is not necessarily a relationship of representation or imitation. Think for example of a drawing of a table: how minimal is the similarity between the few thin pencil lines on the flat surface of the paper and the real table, or between the stick figures in little Johnny's scrap book and the people they iconically refer to!

To summarize what we have said above, the iconic is nothing more than a kind of language in which only colours and lines are used to represent full realities. And just as there are many languages, there are also many iconic systems. For example, the manner in which space is represented varies widely. Our Western perspective is but one of the many possibilities. And, in reality, we certainly do not see space like that. Maybe you remember what we wrote about photography in this respect.[462]

Painters tell something in an iconic way, depict something of a particular history, of a landscape or simply a few flowers, of a person or just of daily life, like poets also do in their own way. Now, we all know that a poet uses language in a particular way, also because she or he speaks about things to which we normally do not pay much attention, as in the following short poem:

> Tender and young, like budding spring,
> but lighter still, without fruiting bud,
> with thin mist between the yellowing leaves
> autumn quietly sets in.[463]

Similarly the painter who wants to paint an autumn scene, for example, does not iconically portray this at random but does it in a particular way, using the means which are at his or her disposal. Not only do artists (poets or painters) speak about ordinary, or extraordinary, things to show the special aspects of them, to give us their view on a particular subject, but they also do this in an aesthetic manner, namely in such a way that their work contains beauty. Colours and lines are combined in a composition so that a beautiful picture emerges, with its own rhythm, its own harmonious colours, an aesthetically meaningful combination.

Read again what we stated in a previous article on Jan van Goyen's landscape art about his almost musical manner of composing. This example makes clear that the composition is not separated from the iconic but that, on the contrary, in every really good work of art there will be a close coherence between these two: the iconic elements will be positioned in such a way that they serve the aesthetic composition; and the composition will be structured in such a way that what the artist wants to say is made clear and accentuated by the aesthetic coherence of the parts of the painting. With regard to good paintings it is therefore almost impossible to speak about the composition without simultaneously saying something about the manner in which the artists dealt iconically with their subject, i.e. how and to what extent they succeeded in making their intention clear. Inversely, we will be able to say little about the iconic without simultaneously saying something about the aesthetic aspect of a painting.

The aesthetic aspect of a work of art has its own value. Sometimes it can be used with great emphasis while the subject can be more or less neglected or be treated as unimportant, yet the work nevertheless achieves its purpose fully. Think for example of decorative frescos, of a logo on a book spine, of a vignette, of the many instances in which visual art is used decoratively only. In a sense most wall decorations fall in this category!

But the true, great work of art, the important painting, offers something else: there is much more at stake, just as in an important poem or a significant novel. There a more or less grand vision is given of a specific subject. In a unique way we are told something about important or seemingly important matters, but always in such a manner that it catches our attention. For this reason a work of art can teach us something. No, I do not here want to defend didactic art that wants to 'teach' us something, but I am of the opinion that all art of some calibre teaches us to see more, broadens our horizon, shows us things of which we were not aware. Jan van Goyen made us see the particular beauty and the characteristics of the structure of our great rivers, Paulus Potter (and many others) depicted the Dutch cattle, van Ostade helped us to better appreciate the colourful country life, and so on. Especially the painters of later times – since the fifteenth century – have taught us to see (as a result of the nature of their art). Did Heda not show us the beauty of a glass that reflects light, did Kalff not open our eyes to the amazing reflections of light on silver? The paintings of our [Dutch] seventeenth century are, each in their own way, 'iconic songs' about the beauty of God's creation, poems about the joy of this earthly life – very sober and realistic, and without denying the effects of sin and the fall.

In our time it is different. Now too our artists want to show us our own world and our own times. But because of apostasy, joy has disappeared; it has been replaced by a lot of bitterness, hatred, and inner alienation from reality. Their paintings tell us about this. It still happens that artists

sometimes tell us something positive, and that they suddenly become lyrical about something beautiful that has struck them. Then we should not criticize them because they do not use the same iconic language as the seventeenth-century artists used. Just as we cannot blame an Englishman when he does not speak in Dutch. The twentieth-century language coined by modern artists, we all know very well. Nearly all good advertisements – for King Cross cigarettes, for road safety, for a beautiful exhibition in the Rijksmuseum, for Pastoe furniture or King peppermints – there is a wide choice of examples – make use of the new iconic means without anybody having a problem with it. The difficulty with modern art is only very partially due to the means of expression; it is much more due to the vision of reality, with which the artists are so much in conflict.

Is visual art important? Certainly! To a certain extent even more important – inasmuch as it forces itself upon us much more frequently – than music or literature! We are not obliged to listen to music or open a book – it is another question whether we do not harm ourselves by closing ourselves off from our fellow human beings and leaving a gift from God unused – but not to look is simply impossible. We cannot do otherwise, we have to perceive things. As soon as we look at a wall we see an advertisement, as soon as we pay attention to a building we see an ornament, as soon as we pick up an illustrated book we are dealing with visual art of better or worse quality.

Especially because it is impossible not to look we are very impoverished if we cannot look well, in other words, if we cannot 'see'. Obviously I do not mean this in the way that an ophthalmologist would, but in a deeper sense. We can overlook so much beauty and detail. We can pass by so much without noticing. We can be poverty stricken, in rags, in our looking, if we never train ourselves, if we always neglect this aspect of our being. That is why it is so bad when unimaginative, ugly paintings hang on the wall in our – your? – homes. Because such things spoil our ability to see, pull us down to the level of their own lack of fantasy. They teach us to see with the same dead and lifeless formulae by which they were made. In this way what is fresh and lively becomes grey and monotonous; because of this we see only monotony and bare emptiness, when in actual fact there is perhaps beauty all around us. Bad art is poisonous. Its effect is perhaps untraceable, its influence seemingly unnoticeable, but a person who owns only small kitsch landscapes – bought in the frame store: 'Real oil paint on canvas, sir' – and only looks at this kind of work, is like a person who only listens to bad sermons and never opens the Bible to draw living water. There is only one advantage: you will not notice that bad trash after a while. It deadens looking so thoroughly that it itself also fades away.

And what about modern art? Those strange monstrosities? Those unintelligible lines? Well, you are somewhat biased and too generalizing. But also those 'strange' things are important. Because others, who are working in the same cultural context where this art was

born, find these things important and apparently recognize themselves in them and feel spiritually at home there. Art gives a vision of reality. Surely, this vision can be a lie! But if this view of the world in which we live is shared by many, if nihilism in art is nothing but an expression of nihilism which, as the spirit of this age, reigns nearly supreme, then we may not ignore it – even if it were only in order to discover how we too are perhaps much more affected by the evil all around us than we ever suspected – and also to understand our own time so that we can fulfil our task of being salt in it.

Really, you *do* understand modern art. But you think that you have to appreciate it. Why? That was not the intention of the artist, and maybe the work could not be beautiful because the Lord our God was hated. You really do understand it, even though you may not be able to hold a discourse on it. Artists think with their brushes, and maybe you consider their thinking to be empty, chaotic, brute, unharmonic, a curse. It could well be that you are right. But, if as a result you have come to understand something of the spirit of the age, then at the same time you would have been cured of any optimism about humanity which you might have taken not from a biblical but from a humanistic source and which perhaps has held you captive against your better judgment. And you will be able to judge better what is going on in the world as well – you will be able to fathom more deeply the problems of our time. And therefore you will be able to act more sensibly, healthily and possibly more scripturally.

Let us conclude with a word about beautiful art. Consider a beautiful little painting. It can hang in a museum but also in your own home. After all, you do not have to own a great masterpiece. A 'small' piece can also be 'a joy for ever'. Or, why do we talk about a small painting at all, why not about a beautiful little sculpture on your mantelpiece, a well laid-out book, a well-formed glass, a beautiful rug? Why should we not talk about an imaginative chair? Yes, it can exist, it does exist, and if you have not discovered something like that, then you now know that you have never really looked. We can talk about a chair because I was asked to write about visual art. With these examples I only want to emphasize that we do not have to look far to find beauty of form, colour and relationships, and that anyone who wants to ban beauty from his or her life – 'politics are much more important' – is impoverishing life in a dangerous way.

We can easily live without art: throw everything out the door, sit in a bare room on a chest and eat with our hands out of the pots! What will we eat? Eggs without salt, salad without dressing, and never anything special. I once wrote that in our time we live in the wilderness if we belong to the rest of the offspring of the Woman (Revelation 12). I can tell you that when I wrote this I did not have in mind this godless neglect of God's gifts, this deadening of the *joie de vivre*, this spiritual poverty.

• The art of painting: a definition[464]

A list of titles for further reading about this topic appears in the endnotes.[465]

In every pictorial work of art one can discern two primary elements: the aesthetic and the iconic.

The aesthetic

The beauty of a work of art is given to the beholder in the seeing of the work of art, which therefore carries an objective-aesthetic character. Beauty is evoked by the colours in their mutual coherence and relationship, by the placement of larger or smaller colour areas on the surface, and by the play of lines, as much in the individuality of each line as in their mutual coherence. In every time period these elements will be handled in a different manner, and particular forms, colours and a particular distribution on the surface will be applied, whereby beauty is realized in a manner that is peculiar to that period – which is called style. Through the style the universally valid norms for (objective) beauty given in creation are given a particular form; each style is a new formation, a positivization of the aesthetic norms. Within the framework of the style of a period, subjected to the positive norm, an individual artist works in his or her own way to realize beauty to a greater or lesser extent, depending on taste, talent, character and circumstances. Great artists, the leading figures, may point out new directions and work out new forms and thus lead to the forming of a new style, a new norm positivization with respect to the aesthetic.

It is difficult to speak about these norms and, therefore, about beauty in art because it proves impossible to formulate them in words in an unambiguous way. This, however, does not prohibit their application by everyone who deals with art – the degree to which the artwork meets the norms is often called its quality. This is by no means a matter of arbitrariness or subjectivity in an individualistic way: all talk about art and good taste would lose its meaning if this were true, while the setting up of museums (where, after all, the masterpieces belong) and the practice of art history and art criticism would become impossible. It does not mean that there is no place for personal preference and that the judgment of one person cannot be more accurate than that of another. However, this is true for all human judgment and work. Because the aesthetic norm cannot be applied as a formula, the discussion of aesthetic qualities can only consist of a pointing out of these qualities while appealing to the common human knowledge of that norm and to the experience and the deepened insight of the other person.

The artist chooses colours and uses aesthetic means in order that they not only realize beauty in its objective aesthetic sense but also contribute to the achievement of a certain effect and desired expression, depending on the content of the artwork: heavy and sombre colours to

express heavy and sombre content, bright and happy colours when dealing with happy matters, etc. One could call this aesthetic symbolism. In this the intrinsic connection comes to the fore with the second key element of all painting which we call the iconic.

The iconic

Just as the objective-aesthetic can play an important role outside of the actual visual arts – we think e.g. of architecture, ornamentation, etc. – so also the iconic can be found as visual language outside of pictorial art, for example in maps, illustrative scientific diagrams as used in anatomy handbooks, graphical statistical diagrams, etc.

These all use pictorial language; facts are not described but portrayed through the use of lines and forms. In order to do so the image should respect, though maybe with some simplification, the structure of what is represented. When we think of maps, for example, it may be clear that there is not always a mimetic relationship but that contours describe something which in reality does not appear like that, and that the contour may sometimes be omitted or used in a manner not visually related to reality. If, for clarity's sake, we limit ourselves for a moment to the drawn representation we may say that the lines, which visualize the different elements of the represented object, can be compared with the words in a language. Just as in (spoken or written) language something meaningful can only be said when the words are placed in a sentence structure so also in the visual representation the whole is only represented through the mutual coherence of the various elements. We could speak of a syntax in the iconic, by which the nature of the coherence of the different elements of the representation becomes clear, for instance by giving different sizes to figures, placing them in the foreground or background, or emphasizing them by the use of darker or lighter colours, etc. Every meaningfully constructed iconic entity thus does not portray reality through mimicking the visually given – which is the aim only in the case of trompe l'oeil – but through using pictorial, iconic means telling something *about* reality. Through the iconic, things and relationships can be made clear for which words would be insufficient, for example, what a particular garment or a particular part of the body (internally, e.g. a kidney or stomach) looks like and how it is built up, while on the other hand all sorts of abstract thought-constructions cannot be given iconically – except in some special cases, e.g. in the diagram.

Also with respect to the iconic it is meaningful to differentiate between different languages and dialects: in different periods and areas of culture there sometimes are totally different ways of iconic expression. It is typical, for instance, of the post-Renaissance period in Western civilization that perspective is used to portray depth, and shadows to express the plasticity of the figures and the reality of the

depicted theme, etc. We can discern different 'dialects' in the ways this was characteristically expressed in the Dutch, German or French art of this period, but we will not develop that any further here.

The norm for the iconic is the correct use of means, the right application of the syntax and, above all, clarity. By this, to avoid misunderstandings, I do not mean that only a sharply defining, drawing-like work method is right but rather that the image must express its intentions in a clear way.

In the visual arts pictorial language is handled in a way that is similar to the way language is handled in literature: an artistically meaningful subject is given form in a particular structure and mutual coherence of its iconic elements, by means that can be compared to rhyme, scansion, the arrangement into couplets etc. [in poetry].

In the following we shall refrain from setting the iconic and aesthetic analytically apart, as in the concrete work of art the two are wholly integral to each other and the artworks exist only in the close interrelation of these functions. Just as in poetry, for example, it has little meaning to speak of a sonnet form apart from the language, so in painting the composition always means an aesthetic grouping of elements, which as such have iconic meaning.

Just as in literature, in the visual arts too we can distinguish between various composition types, often in close connection with the genre and the character of the particular work, e.g. hieratic-representative in paintings of holy people or monarchs over against intimate, non-accentuated in the so-called genre piece. And in pictorial art one will also continually come across *topoi*, certain typical configurations that have a particular content and immediately make clear to the viewer the meaning of the artwork.

This is very clear with respect to the pictorial formulae of the Middle Ages, the use of which will alert viewers at first glance that they are looking at a Madonna and not just a woman, or at Abraham and Isaac or the Baptism in the Jordan, etc. But also in later times one continually comes across set formulae, e.g. in the structure of regent's portraits or state portraits or landscapes, which immediately clarify the meaning and nature of the various persons or elements.

In a painting we can differentiate a number of 'levels': first, the level that is immediately clear, immediately at least for the contemporaries or for those who know the pictorial language used at the time. Second, after closer observation, a deeper understanding of the coherence of the iconic-pictorial elements is achieved, i.e. of the composition, for which the title (which clarifies the theme) can be helpful – just as the title of a poem can give us the key to understanding it. And third, the question of what the artist wanted to say with this theme, what she or he wanted to express by means of this subject. In practice the viewing often proceeds in the opposite manner: one understands, for instance, very well the

humanistic-poeticizing meaning of a landscape with nymphs, while the theme, in this case often a rather far-fetched mythological or literary subject, will only become clear later, and only after this do we finally examine the details and the composition of the whole out of the parts. But naturally one would not have been able to grasp the sphere and nature of the work without first having seen something of the directly visually given in the compositional structure. We will now proceed to a closer examination of the allegorical piece or the emblemata.

Painting has a very specific function in human life, socially and individually. It can have a representative function, think of the portraits of monarchs, for example; or a sacral devotional function, as in the images of saints; or a purely artistic function, for example in an epical or lyrical reflection on human reality as in the history piece, genre piece, landscape or still life; and sometimes it has no more than a purely decorative function as in wall decorations and the paintings we hang in our homes, while in these decorations the theme is not always unimportant but surely also has a suggestive meaning.

The great meaning of the art of painting for human life is finally that artists, each in their own way, not only bring us in contact with relevant realities but also open our eyes to the beauty and characteristic traits of things, and that they teach us to discern structures and to recognize their meaning for human life. We cannot easily overestimate this more implicitly rather than explicitly exercised function of the art of painting.

As painting expresses human being, in style as well as in the iconic manner of expression, and certainly in the very personal form language of the artist, whereby her or his lifestyle, world view and attitude towards life will play a role, artworks can often be very representative of the period in which they were made and can give us insight into the milieu of the artist and the leading spirit of that time. We can penetrate the modern mindset more directly by looking at modern art than by way of many abstract contemplations.

As art is an expression of the full human being, drawn from the totality of a person's human experience, we will have to include in our judgment of art more than just the consideration of quality, i.e. the objective aesthetic, and the consideration of clarity, i.e. whether the artist has used the iconic means well, so that the meaning, content and function of the artwork has emerged adequately. For an artwork, in its concrete unity of the elements, has to meet first of all the intrinsic artistic norm, and it is impossible to disconnect this, in the sense of *l'art pour l'art*, from the truth – whether justice is done to the structures and connections in actual reality – and thus from the Truth. The norm for all art may therefore be found formulated in Philippians 4:8.

• Symbolism in painting[466]

Almost nothing is harder to define than what symbols exactly are. This is not only because symbols as such virtually defy analysis and elude our wish to assign them a proper place in ontology. Even if I were able to do that, I should have to provide first an elaborate though condensed view of the philosophical system in which I wanted to locate the symbols. The discussion of the meaning and structure of symbols has become muddled. In fact, it is almost impossible nowadays to say anything about symbols without going into philosophical arguments and into the history of philosophy. One is sometimes even tempted to say that all talk about symbols is nothing but Neoplatonic philosophy and to dismiss them altogether as non-existent. But one shrinks from such extreme, risky thoughts because, after all, there are phenomena that are commonly called symbols; this would be true even if it could be proved that the occurrence of symbols in art is nothing more than the result of a very deep and long-lived influence of Neoplatonic thought.

I should however, like to make some introductory remarks before proceeding to discuss the ideas about symbols in the Neoplatonic tradition.[467]

What is a symbol? *A symbol is a peculiar kind of sign* . . . here I must stop again because we first have to deal with the meaning of the term 'sign'. A sign is a direct reference to something, and is – while referring to it – immediately connected with the thing itself. There are natural signs. Probably the best way to explain them is to give examples: smoke coming out of a chimney is a sign that a stove is burning in the house; footprints in the snow are a sign that somebody has been walking there; a dog wagging its tail is a sign that it likes the approaching person, and so on. There are also artificial signs; they are humanly constructed: a green light at sea is a sign that a ship is passing with its starboard side nearest to the observer; a red light facing me at the corner of the street is a sign that I must stop – we talk rightly of traffic signs, for they are immediately bound to the situation [on the road] and give an indication of it – something is forbidden or commanded; a skull is a sign for danger, and so on.

A symbol is a peculiar kind of sign as it is not directly bound to a thing or situation. A crown is a symbol of rule and sovereignty – it is not a sign that somebody is a king or queen, but symbolizes such a person's power and position. A flag symbolizes a country and can be a sign that a ship, for example, comes from a specific country. Often a symbol refers explicitly to what it symbolizes, e.g. an artillery badge will show cannons, an air force badge a propeller, etc. To understand a symbol we must know its meaning. It is often not related to the thing it refers to at all and its meaning has been given to it by people. So, for example, in the art of the fifteenth century many objects had symbolic meaning[468] and when we see a brush hanging on the wall in *Arnolfini and his wife* by van Eyck

(in the National Gallery), that denotes . . . and when we see a lily in a
painting depicting the Annunciation, it means that . . . To understand
this kind of symbol we must know the meaning that has been appointed
to it. However, the artist often makes use of symbols that are less
traditional. Here we are very closer to a metaphor. Something is
suggested, e.g. the inner tension of a person, by a flowing drapery; the
drama of an event by the accompanying wind and rain; and in the blues
of the African-American the fact that one is deserted by a beloved one
and therefore 'having the blues' may refer to a feeling of frustration
because of the race situation.

Signs and symbols belong to everyday reality and especially in art
their artistic use may be rich and intelligent and meaningful. But I do
not believe one word of the far-fledged theories in the Neoplatonic line
of thinking. If one would believe them, one has to accept the whole of
the world view present in this tradition too. Yet because this view on
symbols has had so much influence on the history of philosophy and
especially on art theory, I think it is important to go into it at some
length. For that reason I am reproducing here a passage on symbols
from my book *Synthetist Art Theories*.[469]

> As a matter of fact, the art-theoretical notion of the symbol is no novelty. We
> come upon it already in the time of the Romantics. Even such a man as
> Heine – the connecting link between German Romanticism and French
> literature – makes use of it and in his exposition even excels in clarity and
> lucidity:
>
> > *Tones, words, colours, and forms, phenomena in general, are merely symbols of the*
> > *idea, symbols arising in the soul of the artist when he is moved by the holy spirit of*
> > *the world, his works of art are only symbols by means of which he communicates his*
> > *own ideas to other souls ... Is the artist so entirely free in the choice and the*
> > *arrangement of his mysterious flowers?*
>
> Or does he only choose and combine because he has to do so? I answer this
> question about a mystical constraint in the affirmative ... In art I am a
> supernaturalist. I believe that the artist cannot discover all his types in
> nature, but that the most significant types are, as it were, revealed to his soul
> as the innate symbolism of inborn ideas.
>
> This thought is also clearly found in Baudelaire: 'With the most excellent
> poets there is no metaphor, comparison or epithet which is not a
> mathematically exact adaptation in the actual situation, because these
> comparisons, metaphors and epithets have been drawn from the
> inexhaustible fund of the universal analogy and cannot be drawn from
> anywhere else.' After all that has been said we need not argue any longer that
> such a pronouncement will certainly have influenced the artists of the
> generation of 1885–1890. Also Mallarmé's similar theory will have

strengthened this thought and made it almost inevitable. Ghil's *Traité du verbe* of 1885, the influential publication that explained and distributed Mallarmé's ideas, will have contributed a great deal too. Among other things he writes in it as follows: '[For the poet to compose] the sole worthy vision: the real and suggestive symbol in which the primary and final Idea, or truth, will rise in its naked integrity palpitating for the dream.'

But if it is so clear where these artists got their ideas from, the question remains where is the origin of this thought. After what we have written especially about Aurier and Morice the answer is not difficult to find. Without doubt we are dealing here with a Neoplatonic tradition. As a matter of fact they were well aware of this state of affairs. Thus Bernard, for instance, has an elaborate quotation from Pseudo-Dionysius Areopagita: 'We, therefore, have some difficulty to believe words relating to divine mysteries which we only contemplate through the veil of sensory symbols . . . the various forms in which a sacred symbolism clothes the divine, for, looked at from outside, are they not full of some inadmissible and imaginary monstrosity?' Is it not as if we hear a direct echo of such thoughts when in Rémy de Gourmont we read: 'One should seek the eternal in the diversity of the momentary forms, the truth that remains in the False that will pass away, perennial logic in the instantaneous illogical?' But we need not look for ideas like these in the works of the literary men who had hardly any contact with the painters we have been examining. Aurier expresses very similar thoughts, and that while appealing to Swedenborg – who himself derived his thoughts from similar Plotinian sources. Aurier concludes: 'Well if this has been admitted, then the possibility and the legitimacy have been granted for the artist to be preoccupied in his work by that ideistic substratum that is found everywhere in the universe and which, according to Plato, is the sole true reality.'

Indeed, when we go more deeply into the literature handled by these artists and men of letters, we again and again come upon the same considerations. We are referring to Carlyle, for instance, who in his turn started from the German idealistic philosophy, Romantic literature and art theory: 'In the symbol proper ... the Infinite is made to blend itself with the finite, to stand visible, and as it were attainable thereby.' Of this we find as it were a direct, though flowery, translation in Morice, when he speaks of 'the work of art which reveals, and whose perfection of form above all consists in effacing that form in order not to let anything persist to disturb thought but the vague and charming appearance, the charming and dominating, the dominating and fecund appearance of a divine entity of the Infinite'.

It is to be understood that they were so strongly convinced of the truth of these ideas that art was considered to be impossible without them: 'A simple imitation of material things that does not signify anything spiritual is never art, in other words there is not, there is never art without symbolism.'

If we allow the thoughts concisely summarized in the above to be impressed in our mind, the conclusion is unavoidable that art reveals a higher reality to us, *L'Infini*, the Ideas found behind reality according to the theory of Plato. And in fact the view that art is the pre-eminent instrument of divine revelation is found especially with the literary men, and is repeatedly placed in the foreground. This thought was already old and was found implicitly at least in Plotinus. But we meet with it explicitly in Ficino, for whom it was connected with the typical religious basic motif of modern times, which assumes such a clear form especially with these men, namely the theme of the freedom and independence of the human mind. Thus he can claim that art has its own laws and does not copy nature, for the exalted character of human art is rooted in the human power of self-determination. 'Thus the grapes of Zeuxis, the horses and dogs of Apelles and Praxiteles' *Venus* are works that are superior to those of nature, for they testify to the triumph of the human mind over matter.'

Via all kinds of mysticistic and occultistic movements that were strong during Romanticism (and we have to point out again the importance of Swedenborg) this kind of thought penetrated also to the world of the artists. V.E. Michelet makes this clear in the following passage of his writing in 1891:

> *What is a poet? He is one of the incarnations in which is manifested the Revealer, the Hero, the man whom Carlyle calls: 'a messenger sent by the impenetrable Infinite with tidings for us'. This conception of the Hero, expressed by a visionary genius is the direct consequence of another conception which is universally admitted by occultists and mystics and was formulated as follows by Novalis: 'Every created being is a revelation.'*

In *Noa Noa*, Morice elaborates these ideas in connection with Gauguin in his own poetical way:

> *Somewhere outside of the world, in the heaven of joy and beauty it is the day of the supreme epiphany when a great artist has crowned with his genius one of the innumerable beautiful figures of Nature, when the artist, himself the child of Nature, fed by it, living on it, rises to proclaim the beauty of his mother: when Nature allows one of the changing aspects of its mysterious visage to eternalize the word of its enigma in a work of art.*

But already some years earlier Morice had preached this gospel of beauty very clearly in his important book: 'Art is nothing but the revealer of the Infinite: for the poet it is even a means to penetrate into it. He penetrates much deeper than any philosophy, he prolongs and re-echoes in it the revelation of a Gospel, he is a light that calls up light.'

How is the truth found in a work of art? 'We sought the truth in the harmonic laws of Beauty and deduced all metaphysics from the latter – for

the harmony of nuances and of sounds symbolizes the harmony of the souls and the worlds – and all morality.'

My objection to these art theories is that they try to make art important by giving it a function that is not artistic. It is, to put it bluntly, as if art has an inferiority complex and needs an excuse for its being. The fact is that the most exalted theories in this line, making a revelation and a kind of religion of art, occur precisely in times when art and its role are endangered – as in our own time, when art is threatened by technological culture. It is strange that art should be defended by referring to its non-artistic function, in the first place because in this way we are never given a proper criterion for art. I can imagine a picture full of revelatory power – if that is possible – and yet of the poorest quality. And the reverse can also be true. Walter Nigg, a Swiss theologian and mystic, wrote a book about painters as prophets of the infinite: yet he chose only Michelangelo, El Greco, Rembrandt, Grünewald and a few others, and never said a word about Dürer, Velasquez, Constable, Rubens and such painters, who surely are as great as the others but are also much more (I hope you grasp what I mean). And in his discussion of those whom he did choose he often falsified the facts or went into questionable interpretations.

Art has a function of its own in culture and human life. Just by being art. Not autonomous, but bound by a thousand threads to full reality and human life. A thing of beauty is a joy forever, just because it is related to humanness and reality. Art can never be for art's sake, just as love can never be for love's sake or economy for economy's sake. One loves another person, and it is the other who is important, not the love as such; similarly anyone who seeks economy for its own sake is a miser or a fool. So art can only fulfil its function just by being art, offering people beauty, joy and spiritual richness. Paradoxically, all those who want to exalt art's functions of one kind or another really miss the point and deprive art of its [true] importance and function. Because more often than not those extra-aesthetic functions could be dealt with much better in other ways. If you want to prophesy, become a preacher; if you want to be didactic, teach; if you want to be an artist, make art.

• Iconography and iconology: a literature study[470]

The term iconology was used as early as the sixteenth and seventeenth centuries, to quote the title of the famous book by C. Ripa, *Iconologia* (1593).[471] This book discussed how abstract concepts could be rendered as allegorical figures. Iconology in this sense was a science concerned with the ways in which ideas could be expressed artistically. The term iconography was also used before art history as such came into being, e.g. it was used as the title of a series of Van Dyck portrait etchings

after, in 1759, biographies of the sitters had been added. Both terms were later used by art historians to indicate specific methods, retaining their earlier connotations.

Art history came into being as a scholarly discipline in the nineteenth century, and from its very inception iconography was one of its main branches (another being the study of stylistic evolution and the cataloguing of the works of artists). Iconography dealt with the subject matter of the visual arts: it described the meaning of the themes and the different figures and objects depicted, and studied their sources. Its approach to the thematic content of paintings and sculpture etc. was analytical and descriptive. A few examples of comprehensive and basic publications in this respect are: K. Künstle, *Ikonografie der christlichen Kunst* I–III (Freiburg i/B, 1926/28); L. Réau, *Iconographie de l'art chrétien* I–III (Paris, 1956/59); G. Kaftal, *Iconography of the Saints in Tuscan Painting* (Florence, 1951) etc. We can mention also the series of reproductions of Dutch and Flemish art arranged iconographically (called D.I.A.L.=Decimal Index of the Art of the Low Countries) produced by the Rijksbureau voor Kunsthistorische Documentatie in The Hague, in cooperation with the University of Leiden (Prof. Dr H. van de Waal).

In dealing with subject matter, especially the more traditional themes, scholars could not avoid dealing with the ways in which a theme was treated because they discovered the existence of traditional types and recurring patterns. So, for example, the Crucifixion can be depicted in various ways: taking only the central figure, we find that he is nailed sometimes with two, sometimes with three nails; that he is sometimes shown as the triumphant King, sometimes as the suffering Saviour, different approaches belonging to different periods, of which the origin and sources can be studied. A shift was noted between periods in the choice of themes. Almost all the books cited above contain some information of this kind, which is the central focus of interest in Emil Mâle's well-known books, *L'art réligieux en France: Étude sur l'iconographie du moyen âge et sur ses sources d'inspiration* (Fin du moyen âge, 1908; XIII siècle, 1910; XII siècle, 1922); in the same line is J.B. Knipping, *De ikonografie van de Contra-Reformatie in de Nederlanden* (Hilversum, 1939).

In all these iconographical studies, attention is given only to the themes as such and to the meaning of the figures and objects, while the true artistic problems are ignored – purposely, and to a certain extent rightly so. This invaluable work, done by several generations of scholars, enables us to easily identify the themes of most works of art, and even today our research is constantly based on the findings of the iconographers. But in some respects this analytical approach to the thematic content proved inadequate. The classic iconographer sometimes missed the real meaning of a painting because of 'reading' it too obviously, unaware of seeing it in terms of, say, his or her own

nineteenth-century artistic ideals and concepts, as has been shown for a specific case by H. van de Waal in his article 'De Staalmeesters en hun Legende' (*Oud-Holland* LXXI, 1956) p.61. Clearly it is never enough to state what is depicted; the full understanding of the subject matter of a work of art requires a grasp of what is said by and through the subject, and how its treatment expresses the artist's intention. This was illustrated in a famous article published by Gombrich concerning a painting in the Uffizi titled *Tobias and the angel*, which should properly have been called *The Archangel Raphael* (*Harvest* I, London: Travel, 1948). Art-historical work done with a conscious awareness of the problems mentioned was often called iconological to differentiate it from the older discipline of iconography.

The new method of iconology – its name setting it apart from iconography in the same ways as geology or ethnology are distinguished from geography or ethnography (this comparison was made in 1931 by G.J. Hoogewerff) – has grown slowly over the past forty years. It is now one of the main methods used by art historians, having grown out of the realization of how closely the history of art is connected with changes in spiritual climate and insights – Max Dvorak's *Kunstgeschichte als Gesitesgeschichte* (München, 1924) should be mentioned here. This does not mean that iconology has a well-defined programme so that the term is easy to define. Quite to the contrary. In the following we will attempt not so much to give a new definition as to describe the different trends covered by this term. General articles on the nature of iconology, clarifying its difference from iconography, are: J. Bialostocki, 'Iconografia e Iconologia', in *Enciclopedia Universale dell'Arte* (Venice/Rome, 1958); E. Panofsky, 'Introductory', *Studies in Iconology* (New York, 1939); D. Frey, 'Zur Deutung des Kunstwerks', in *Konkrete Vernunft: Festschrift für E. Rothacker* (Bonn,1958).

The initiation of iconology as a discipline is generally ascribed to A. Warburg. His aims, however, were in many respects still closely connected with iconography – he went deeply into the study of imagery and its sources, mainly in order to show how concepts from antiquity survived and were revived[472] – even though he formulated his programme as follows: 'To what extent is the entry of the stylistic change in the portrayal of the human figure in Italian art to be seen as an internationally determined process of coming to grips with the surviving visual depictions of the Eastern Mediterranean nations?' (*Gesammelte Schriften* II (Leipzig, 1932) p.478); see also E. Wind, 'Warburg's Begriff der Kulturwissenschaft', 4ième Congrès d'esthétique et de science de l'art, *Zeitschrift für Aesthetik und Allgemeine Kunstwissenschaft* 25 (1931). Other studies with the same approach are: J. Seznec, *La survivance des dieux antiques* (London, 1940); H.W. Janson, *Apes and Apelore in the Middle Ages and the Renaissance* (London, 1952); H. Friedmann, *The Symbolic Goldfinch: Its History and Significance in European Devotional Art* (Washington, 1946).

Much attention has been given to the specifically symbolic and allegoric ways of expressing an idea that prevailed in the late Middle Ages and the Renaissance. The studies devoted to these forms of expression are often called iconology even when they are in fact a more comprehensive kind of iconography dealing with a form of pictorial language as exemplified by C. Ripa's *Iconologia* (1593) and the many emblem books. It cannot be denied that these studies, resembling those of Warburg and his school, clarify many facets of the culture of that period. In a sense the old iconology, as defined by Ripa and found in such books as C.N. Cochin's *Iconologie ou Traité de la science des allegories à l'usage des artistes* (Paris, 1765), has been revived as a modern historical discipline. Some typical studies include: H.B. Gutman, 'Zur Ikonologie der Fresken Raffaels in der Stanze della Segnatura', *Zeitschrift für Kunstgeschichte* 21 (1958) p.1; W.K. Hekscher and K.A. Wirth, 'Emblem, Emblembuch', *R.D.K.* V (1959) pp.85-228.

There is another method more concerned with the impact of the work of art as such, one which leads to studies devoted to the function and meaning of art, to the understanding of the reasons for choosing certain themes and the ways of rendering them. H. van de Waal's *Drie eeuwen Vaderlandse Geschieduitbeelding, 1500–1800, een iconologische studie* (The Hague, 1953) goes very specifically into these problems. From this point of view studies are devoted for example to the understanding of the devotional image, such as E. Panofsky, *'Imago Pietatis': Festschrift M.J. Friedländer* (Leipzig, 1927) p.264; D. Klein, 'Andachtsbild', R.D.K. I (1937); H. Lossow 'Imago Pietatis, eine Studie zur Sinndeutung des m.a. Andachtsbildes', *Das Münster* II (1948) p.65. Other studies of this kind are: H. Keller, 'Die Entstehung des Bildnisse am Ende des Hochmittelalters', *Römische Jahrbuch für Kunstgeschichte* III (1939) p.227; F. Wind, *Humanitätsidee und heroisiertes Porträt in der englischen Kultur des 18.Jh.* Leipzig: Vorträge Warburg, 1931); P. Fehl, 'The hidden genre: a study of the Concert Champêtre in the Louvre', *Journal of Aesthetics and Art Criticism* XVI, 2 (1957) p.153; E.H. Gombrich, 'The Visual image in Neo-Platonic Thought', *Journal of the Warburg and Courtauld Society* XI (1948) p.163.

Many iconological studies put less stress on the study of the themes as depicted than on how the figures or objects are rendered in order to understand the resulting artistic expression. The motifs are studied rather than the themes, even when a particular theme is taken as a starting point, as this is sometimes just for the purpose of eliminating it to a certain extent. Publications in this category are: O. Pächt, *The Rise of Pictorial Narrative in 12th Century England* (Oxford U. Press, 1962); Kenneth Clark, *The Nude* (London, 1956); K. Rathe, *Die Ausdrucksfunktion extrem verkürtzte Figuren* (London, 1938); E. Wind., 'Penny, West and the Death of Wolfe', *Journal of the Warburg and Courtauld Society* X (1947) p.159; A Weese, *'Typenwanderung und*

Typenschöpfung': Festschrift Clemen (1936); W. Stechow, *Apollo and Daphne* (Leipzig, 1932); F.A. Yates, 'Transformations of Dante's Ugolino', *Journal of the Warburg and Courtauld Society* XIV (1951) p.92.

The term iconology is often applied to a study devoted to the analysis of the many facets of one work of art, a synthesis of the stylistic, iconographic, and iconological (in the different meanings given above) approaches, that attempts in this way a more complete understanding of the artistic phenomenon in a given period. An interesting series of studies in this connection were devoted to Vermeer's *Triumph of painting in Vienna* which gave rise to much discussion of the value of the various methods: H. Sedlmayr '*Der Ruhm der Malkunst. Jan Vermeer De Schilderkunst': Festschrift für H. Jantzen* (Berlin, 1951) p.169; J.G. van Gelder and J.A. Emmens, *De Schilderkunst van Jan Vermeer* (Utrecht, 1958); K. Badt, *Modell und Maler von Jan Vermeer, Probleme der Interpretation. Streitschrift gegen Sedlmayr* (Köln, 1961). Other studies in this line are W.S. Hekscher, *Rembrandt's Anatomy of Dr Nicolaas Tulp, an Iconological Study* (New York, 1958); H. van de Waal, *Rembrandt's Faust, Vijf eeuwen Faust* (The Hague, 1963); H.R. Rookmaaker, 'Twee soorten liefden en de 'carcer terreno', een studie over de betekenis van de plaatsing van vier Michelangelo-beelden in een artificiële grot in de Boboli-tuin', in *Perspectief*, ed. W.K. van Dijk, (Kampen, 1961) p.241.[473]

Iconology could also be defined as a type of study concerned with the typically artistic problems of a given period, combining the two last-mentioned methods. Scholars of this group often seek a synthesis of the stylistic and the iconographical approach, for exmple G.R. Hocke, *Die Welt als Labyrinth, Beiträge zur Ikonografie un Formgeschichte der europäischen Kunst von 1520 bis 1630 und der Gegenwart* I (Hamburg, 1957); W. Weisbach, *Ausdrucksgestaltung in mittelalterlicher Kunst* (Zurich, 1948); F. Würtemberger, *Weltbild und Bilderwelt von der Spätantike bis zur Moderne* (Wien/München, 1958).

If the parallel between the term iconology and the terms geology and ethnology is taken very strictly, still another type of study must be noted, of which the aim is the understanding of the 'mechanics' of artistic expression, or how the visual image is realized. The artistic elements as such are discussed. We think of W. Schöne, *Über des Licht in der Malerei*, (Berlin, 1954); R. Berger, *Découverte de la peinture* (Lausanne, 1958); E. Panofsky, *Die Perspektive als symbolische Form* (Leipzig:Vorträge Warburg, 1925); L. Guerry, 'L'Expression de l'espace dans les fresques romanes en France', *Revue d'esthétique* X (1957) p.21. This is a new approach to what was formerly called the history of style, but one that now involves a deepened understanding of the artistic importance of motifs, themes, expression and meaning and their relation to intellectual or spiritual history.

• Art and psychology[474]

A close connection is very often made between art and psychology. This is easy to understand. Since the Romantic period people have constantly claimed that art ought to be 'the most individual expression of the most individual emotion', and many continue to share this subjectivistic, individualistic viewpoint. Others claim that we can only understand a work of art correctly if we take into consideration the psyche of the artist who created it.

If this were really true it would become very difficult to say anything sensible about art and art history. We know very little about a great many artists and scarcely anything about the circumstances in which individual works originated. Even so, why would it matter to us what the psychological motivation was that drove the artist at the time he or she created the work, if that motivation is not clearly discernible in the work? If we talk about art, should we not indeed discuss art, i.e. works of art and not the class of people who are referred to as 'artists'? When we go to an art exhibition we obviously intend to look at paintings and not at the 'souls' of their makers, as if they were turned inside out in their works.

If this Romantic idea of art, to which we are referring, were true, each creation of a work of art would need to be considered a highly conceited activity – because it would mean that the person (the artist) deemed it useful to tell everybody else how she or he was doing psychologically, which feelings were moving her or him at a given moment. Then we would be correct to quote the Scripture: 'A fool finds no pleasure in understanding but delights in airing his own opinions' (Proverbs 18:2).

Let us make it very clear that there can be no psychology of art, and that psychology and art have very little to do with each other – even in the case of the Romantics, the followers of this idea of the individual expression of individual emotion. What *can* exist is a psychology of the artist. Psychology is the science that investigates how the subjective element in people is structured, what takes place in people in connection with their strictly subjective disposition and (psychological) make-up (e.g. their character). In this way it can be an immensely interesting subject to trace how the process of creation takes place in the artist, which psychological conditions have to be present and how certain circumstances can influence it. Far too few people have been working on this topic.

It is not inconceivable that someone who was occupied with such a study would also involve the results of the creative work (the works of art) in his or her investigation, and that these might be able to shed light in some respects, here and there. Obviously everything that we do depends in one way or another on our subjective nature. But we should not think that we would learn about art in this way, about the structure, meaning or nature of a work of art. Not only is it quite imaginable that

the work of a third-rate artist could be far more interesting and fascinating from this viewpoint but also that, stated more succinctly, the whole investigation would teach us nothing about the nature and meaning of a masterwork. Let us take an example from the world of psychology. If I understand – through psychological investigation – why Freud so particularly concerned with eroticism and sexuality, what motivated him and what he himself envisaged with it, then this is not in the least a guarantee that I have understood anything of the system that he created. And when I delve into Freud's work, then I can refute some of it, empirically expose the weakness of an argument and pose all sorts of objections, without having to prove my understanding of Freud's psychological structure and nature in any way. Because in such an investigation we are not dealing with Freud but with a scientific system. Freud cannot be refuted as a person – though the accuracy of our understanding of his personality and talent can vary – because that is a given. But Freud's system can be refuted, unravelled, and disputed.

Let us keep this distinction clearly in mind: it is possible to perceive art as the result of human endeavour and, with this in mind, to view works from the viewpoint of how much they can expose about the psyche of the maker. But then we are not really dealing with these works as works of art. From that perspective, nothing can be said about the quality and meaning of a work, while even its typical nature may remain obscure and incomprehensible to us.

The character of the artist

If we consider for a moment in what ways a work of art can reveal something to us about the artist who created it, then this can occur in two ways. We can attempt to understand how the work is linked to the psychological condition of the artist at the moment of creation – whether the artist was cheerful, sad, in love or mourning, etc. – or we can investigate how much the character, the psychological make-up, of the artist expresses itself in the work of art.

We will begin with the latter. And we will start by saying immediately that the work of art tells only very little about its maker in that respect; in any case that this is difficult to discern. We can immediately mention one reason for this. Imagine the investigation of a graphologist who takes pieces of handwriting, presumes that writers unwittingly betray something very personal in them, and attempts to discover what it is. That will only work if the scientist knows what the accepted norm for handwriting is. If a writer constantly makes thick downward strokes, this can only tell us something about her or him if the scientist knows that that was not the way this person was taught to write. If those thick strokes also occur in standard handwriting their presence means nothing, but if they are not normally present in standard handwriting their presence might mean a great deal. Even if I were the most brilliant graphologist,

the handwriting of, for example, a Chinese or Arab person would tell me nothing about the nature of the person in question, simply because I do not know the standard by which I have to measure it.

And what happens in works of art? Let us consider the most ideal type of work from this perspective, the pen drawing. We literally see the whole 'handwriting' of the artist before us. But it tells us nothing, absolutely nothing, graphologically speaking, because there is hardly any standard method for drawing, for example, a cloth, a cheek, trees, etc., in the way there is a standard handwriting. Perhaps this example can help us with our insight into the relationship between the work of art and the maker. Let us postpone this discussion for a moment and consider the problem we have posed from the perspective of the philosophy of art itself.

It then becomes evident that in many cases we can hardly conclude anything from the works of art about the nature and character of their makers. They do not seem to reveal themselves in their works. And we are not only thinking of Romanesque or Gothic art, of the sculptures in the great cathedrals, art in which the artists have, as it were, discounted themselves in order to fit their work into the communal creation. We are not thinking about this art because one may in fact question whether this interpretation is the correct one – upon closer inspection it might become evident that a lot of very personal and unique art was created in that era; yet unlimited individualism did not prevail and there was no deep division between the individual and the community.

If we delve into the art of Jan van Eyck, Bouts, Jan van Goyen or Jan Vermeer or the music of Guillaume Dufay, Heinrich Schütz or one of the composers of the Bach family and ask ourselves what their works tell us about their strictly personal idiosyncrasies, their character, their subjective condition, their nature and being – we are afraid that we will get no further than a few vague guesses and unprovable hypotheses.

The difficulty with such an approach to works of art is that one has to be very much at home in the art of the time and in the environment of the artist in order to sieve out the traditional elements, the general style characteristics, all that which is not strictly individual, because only in this way will one obtain insight into the peculiarities and individualities of the artist. For example, if one should interpret quick, free and spontaneous painting with thick strokes of paint as an expression of a passionate, emotional psyche, then that could be accurate. But if, as for example in our own times, that appears to be a feature one encounters in almost all works of art, then one either has to conclude that all painters are such violent, uninhibited characters or that this is in fact a general style characteristic that tells us nothing, absolutely nothing, about the personality of the individual maker of the relevant work. Yes, if one for example studies German Expressionist art from the years before the First World War, art that aimed to be a direct, uninhibited, vehement expression of the subjectivity of the artist, then

even now after fifty years it already appears to be very difficult to deduce anything about the makers from their work. Sometimes it is even difficult to distinguish the work of one artist from that of another, especially if one moves out of the circle of the leaders and style-formers. They cooperated so closely, learned such a lot from each other, were so strongly influenced by the work of certain leaders, that the general traits prevailed over the individual characteristics.

In general one can say that it is very possible to distinguish between the works of contemporaries on the basis of style, including those who are second-rate artists, but it appears to be nearly if not totally impossible to draw any conclusions about the character and nature of their respective personalities. For we might be tempted to say that tradition, the general style within a specific group of artists, is the norm, comparable to the standard handwriting in the example above, from which we would discern the individual characteristics – the question has to be answered first, however, how those individual characteristics have come into existence.

The lesser masters distinguish themselves from the greater masters by providing less brilliant solutions to artistic problems, less well considered compositions, less subtle presentations, etc. These facets of their art make clear why they are inferior and show where their talent falls short, but that all remains at the artistic level and still says nothing about the character and nature of the respective individuals.

The work of the great style-formers is in contrast to this. Their work distinguishes itself from the average, traditional and stereotyped by presenting something very personal, almost always immediately recognizable. But what makes their work so characteristically their own? This involves new solutions for old (artistic) problems, new ways of handling old themes; it betrays itself in the finding of new themes and new possibilities, and in the posing of new problems. It reveals itself in originality. But what does it say about the character, the psychological make-up of this master or that genius? Nothing other than that she or he is a genius, and very gifted. Because, as with handwriting so in art too the deviation from the norm is clear but, in contrast to handwriting, in art the deviation has a very specific meaning. To draw a thick line where others always use a thin one (to use a strange example) can betray something of the maker's character, just as thick, downward strokes in handwriting reveal something to the graphologist, but the artist might have done it that way because he or she had something new to say and chose this as a means to do so. In contrast to handwriting, which is neutral in itself and without meaning, every stroke has meaning in a work of art, and is in itself the artistic achievement.

And from where does the innovation that this leader wants to present come? Obviously also from his or her character, etc., but perhaps even more from his or her other vision, the perception emanating from another *Lebensgefühl*, better still another world view.

Unless we want to psychologize everything, we will have to talk about religion and faith and not about character and disposition here – where we enter the sphere of religion and faith, the sphere of the deepest decisions concerning a person's attitude towards God and neighbour and creation in all their facets. What determines the difference between the art of Albrecht Dürer and that of Grünewald, two contemporaries and compatriots, both highly original artists? Not primarily their character, but the fact that the one was a Lutheran, living in an environment also coloured by humanism (in the sense of the study of antiquity), and the other a mystic and maybe also a revolutionary related to the Anabaptist leaders of the Peasant Revolt (1525). Beside the impersonal factors of upbringing and environment their strictly individual dispositions will undoubtedly have played a role as well. But who will be able to sift these from the complexity of the total picture? For the understanding of their work it is an unwieldy entity that hardly helps us to comprehend what is crucial for our investigation: the character and meaning of their work.

The expression of emotion

Now we come to our second point. To what extent is art connected with the strictly individual emotion at a particular moment? That there is a close correlation is impossible or improbable for the very reason that the making of a work of art often takes a lot of time. Consider this: Mozart wrote a symphony in a short period; Beethoven took a very long time. The strictly subjective aspect (distinguishing Mozart for example from Haydn) is much smaller in Mozart's work than in Beethoven's, who explicitly looked for a strictly individual expression of strictly individual emotions. And how much time will Rembrandt have taken to paint a self-portrait? If we take a closer look we will find that especially the main works in which the great artists have expressed themselves most comprehensively and most individually, have sometimes taken years and years of preparation. In these works the moods change and all kinds of feelings are expressed, which is often the characteristic of great works of art. Consider, for example, a symphony with its movements that are of such different character. But real feelings do not stay the same for months on end nor can they be changed at will. In any case, for example in Bach's work, it is clear that the character of a specific work (say a *Brandenburg Concerto*) has little to do with the personal circumstances and the corresponding emotions of the artist. In Dürer's work, for example, it is clear that the death of his mother made a great impression on him – which we can deduce from various circumstances and utterances – and inspired him to create a number of very important works of art, the etches *Knight, Death and Devil, The studying St Jerome* and *Melancholia* in which we actually find no depiction of mourning or sorrow whatsoever.

In this case it would perhaps benefit the psychologist, who wants to find out something about the particular creative process of this artist, that the death of a mother can motivate a great man to delve again into the problems of life and death, of the meaning of our existence and the direction that we have to choose. But my understanding of those etches as such is not deepened by this, I do not understand them any better than if I did not know about those circumstances. As works of art they are not dependent on the inner emotion of the artist; at most I can understand why they are so deep and great (but that presupposes again the total artistry of Dürer, the not strictly individual elements in it).

The artist's vision of emotions

No, if we want to understand art we have to presuppose that in their work artists present their outlook on life, their insight and wisdom. A sad piece does not tell us that the artist was sad but gives us his or her vision of sorrow, the meaning, sense and content that that human emotion has. This is obvious if we think about the etch of the *Three crosses* of Rembrandt, especially if we compare it with other works of art that deal with the same theme, for example by El Greco, Rubens, Dürer and Grünewald. El Greco and Grünewald were mystics, and that explains their particular vision and the peculiarities of their art. Their character is not the cause of this. What makes a symphony a symphony is that in such a large work a comprehensive vision is given on being human or on creation, according to its different aspects, in which joy is found alongside sorrow, happiness next to seriousness.

The statement that art is the direct expression of the soul of the artist is propagated by those who have demanded a great freedom for the artist. In reality the statement means that artists do not have to concern themselves with any norm or bind themselves to any tradition. As such it is evidently Romantic in origin. A work made in this spirit in fact teaches us little more about the maker than any other work from earlier times does, but it shows us how nineteenth- or twentieth-century people viewed and understood their own position, and what their insight and wisdom were.

Indeed, art does teach us something about the human spirit, a person's religion, life and world view, and perhaps his or her very personal vision of things (it should be obvious by now that this is something quite different from his or her psychic make-up). View, for example, the statues of ancient Mexico and understand the fundamental cruelty, hate and feeling of terror; view the masks of the so-called 'primitive' people and discover their alienation from reality, their fear and insecurity; understand something of the classical spirit and investigate how this coloured the art of Poussin, for example, and others.

In conclusion, may I refer to all the articles that I have already written? Because in them, while obviously the question of truth was

posed and Scripture was involved in the study, I have continuously attempted to understand something of the vision of the artists, and to grasp its relation to reality.

• Art and politics[475]

Can there possibly be a connection between these two divergent areas of human life? Or should we suggest that it is inevitable that there should be a connection between the artistic products that a person makes (or has made), and his/her thoughts concerning politics – that is to say, the ordering (in the sense of governing) of society? Human beings are, after all, a unified whole. Now, it may not always be so easy to point out how political ideas and practices hang together with aesthetic tastes and ideas, but the connection is certainly there.

In this article we want to consider this subject. But our emphasis will be more on observing the actual state of affairs than on coming up with profound explanations and theories as to how this connection has developed.

From the outset we must keep in mind, of course, that art is as rich and many-faceted as life itself. Therefore we can only touch on a few aspects of this subject. One will always be able to find exceptions that deviate from the overall picture.

Let us begin far from home, with the ancient Egyptians. There the political situation depended in principle on the absolute reign of the pharaoh. He ruled according to regulations and laws 'which had always been that way' – strongly traditional and entirely hierarchical (i.e. the entire society was organized from lower to higher levels of status, with the pharaoh reigning from his elevated position far above everyone else). It did not matter a whole lot what sort of a man this pharaoh was, at least not in principle, because he merely embodied the absolute order of tradition. Art served to reiterate the greatness of the pharaoh (and thus, the immutability of the established societal order). When we keep in mind this state of affairs, it is not hard to understand that this pharaoh was depicted as a highly exalted being, lacking almost any human characteristics. The issue, after all, was not his person but his position.

Thus we will not be surprised to find that Egyptian art was utterly traditional and used the same formulas again and again. Egyptian art teaches us that this does not necessarily kill artistic quality, for the art displays an exceptionally high standard of excellence.

Actually, any artist who, with technical competence, kept strictly to the traditional art forms could be confident of creating something of value. But to make something truly beautiful of these traditional pieces required real artistic talent. We should keep in mind that those Egyptian artists did not create only the rigid statues; and remember that when

they did limit themselves to working according to strict regulations it was certainly not out of ignorance. Have a look at the way they depicted slaves or animals, beings who were not so elevated above the ordinary that they were required to be rendered as superhuman. They move around like ordinary creatures. Persons of high status, on the contrary, were always shown as functionaries, and as such were depicted in their full regalia. It certainly would not have been considered appropriate to show them in any other way. That would have been considered a serious crime against their dignity. We still accept similar boundaries today: we will never see a princess photographed as a pin-up girl. Now take another look at how they were able to depict slaves and animals – these creatures were allowed to move around, bend over, and in general behave as real mortal beings.

In Greece the situation was quite different. Greece had a far less severe political system and in Athens, at least, we see something resembling democracy – although it cannot really be compared with our present-day democracies. The governing was done by a small group of people from the highest stratum of society, but this group was hardly hierarchically ordered.

Art was created to benefit this upper stratum, for those were the people who commissioned the art and who tried to do whatever they judged to be good for the *polis*, the city-state, the society – and this includes 'good' in an artistic sense. They saw to the construction of temples and other buildings and had various idols built.

These idol gods took on a rather human form, almost like supermen and superwomen. They were immortal but not infinite, and had their good and their bad qualities. Thus, art began to depict something like an ideal person in connection with these gods and goddesses.

All manner of mythological stories and legends (such as the story of the Trojan Horse) were portrayed on vases, on reliefs, and in paintings (all of which have been lost). Here we see the hero, the excellent human being, and sometimes ordinary persons going about their daily business.

There was much variation in the way artists represented human beings, but they always showed special concern for their shape and figure: the Greeks were especially interested in the human figure because their religion was almost a kind of humanism. In later periods the Greek artists also began to depict more ordinary types of people: poor fishermen, boxers, sweet little girls (as in the Tanagra statuettes) – people, in other words, who did not have any divine qualities.

Thus, the Greeks, because of their humanism and their freedom from having to show homage to their rulers, became pioneers in the depiction of the human form. They presented the human form in its essence, its ideal form, and therefore often in the nude. Certainly there is something shameless about this. Think of Genesis 3, where shame is directly connected with an awareness of sin – something the Greeks

knew little about. Humanity without blemish – on the inside, and therefore also on the outside – was how they expressed themselves in self-glorification without embarrassment.

Roman art followed this period of Greek art. The Romans adopted many aspects of Greek culture and therefore their art never took on the stiff, schematic character of that of the Egyptians. Certainly their emperors were deified, and huge statues of them were placed in all the main centres of the empire, but their individual character was never completely subservient to their office as it was in ancient Egypt. The emperor's crown remained too shaky, and the power of the lower-level authorities was too great; while at the same time Greek humanism had taken hold too strongly to allow a notion of office with pretensions of immortality.

There were also so many different and powerful cultural forces at work that it was impossible to elevate any established tradition to a universal law. Roman culture was very dynamic, full of spiritual strife and lacking any universally accepted set of truths or values. Remember, too, that the Roman world was a conglomeration of many different peoples and cultures.

Thus, Roman art did know its official art, created to glorify the emperor – it flourished especially during times when the emperor was strong and powerful, as during the reigns of Augustus and Hadrianus. But alongside the official art there bloomed the art of portrait making and painting, even including genre paintings, landscapes and still lifes.

If we were to delve further into the history of art to discover how politics and art are interwoven, taking a look at the Middle Ages and modern times, we can be sure that we would see all kinds of repeating patterns.

• Art, morals and Western society[476]

It is peculiar to humankind that we not only see reality coloured by our presuppositions, or, if you wish, prejudices, but that we also always want that reality to conform to the way we see it or would like to see it. The visual arts are born out of people's vision, when they make visually explicit what they see or like to see in reality,[477] and in this way they help others visualize what they want to realize in reality. Painters in the seventeenth century, for example, painted landscape in a certain way, as a beautiful Arcadia, a kind of dream reality;[478] in the eighteenth century people wanted to change the real world according to their vision and began to make gardens and parks, even trying to make the landscape as such picturesque, i.e. using pictures as their example.[479]

In this way – which is often indirect and more related to the way of life, manners and customs, than to morals as such – art has been important in shaping the face of society. 'Whether or not the pen is

mightier than the sword, it is even more difficult to suggest that the artist's brush has ever wielded influence over the deeds and destiny of man . . . But whilst art may not stimulate action, it can be prophetic in reflecting reactions to social and political events, which in their turn provoke action.'[480] Certainly politicians in the past have tried to use art as propaganda. Even if it is doubtful whether the course of events has been changed by Rubens's *Medici* cycle,[481] the works of art made for the Medici in fifteenth-century Florence as part of their policy[482] or the works intended as propaganda for Louis XIV in France have certainly exalted these patrons and probably helped to strengthen their rule, and without a doubt continue to make their political achievements great in the eyes of history. The use of portraits of rulers to this end, begun by the Romans (or maybe even much earlier by the Egyptians), and revived at the end of the Middle Ages or the early Renaissance, is with us today still, even if it is not a very strong tradition now.

Revolutionary groups have often tried to put art to their use. This was true at the time of the French Revolution, and in our day we have seen the Surrealist group of artists deliberately trying to change the mentality and encourage a total revolution in human life. In the 1930s there was even a journal devoted to Surrealism helping the revolution. Breton wrote, in the preface of Max Ernst's *La femme a cent têtes*: 'The surreal will be a function of our desire to make everything alien.'[483]

In almost all periods of history the relationship between art and morality has been evident, as well as the importance of art in encouraging people to aspire to higher values and loftier aims, to direct their will towards God. At least this was almost invariably set down in art theory or aesthetics as a norm. In medieval theories on art we find that all 'works' divided into four levels: the literal, the allegorical, the moral, and the anagogical. By the anagogical was meant the general tendency of the work, its impact, if you wish,[484] as is illustrated in the following short poem synthesizing these aesthetic notions:

> The literal teaches what you do
> The allegoric what you should believe
> The moral how you should act
> The anagogic what you should aspire to.[485]

Since the Renaissance the idea has been prevalent that art has to be useful, i.e. didactic, and at the same time pleasing to the eye, *utile dulci*. A moral didacticism was considered to be a necessary element of the arts.[486] In a book by Luca Giordano on the ceiling paintings in the Florentine Palazzo Medici, a very late example of this approach to art, which was traditionalistic at that time, can be found. Giordano wrote:

> It is a grandiose theme, which asks for no ordinary talent to execute. We need the poet, who knows how to combine it all cleverly into a whole that

suggests the total idea without missing the aim of exalting and surprising the mind; we need the philosopher whose thinking ensures that the story will be moral, and under the veil of this the most sublime truth always be hidden; ... we need the painter to attract the eye, to please (*dilletasse*) and to persuade.[487]

Art was commonly held to have an influence on people. A curious example of this can be found in the writings of Shaftesbury, in reaction to the Rococo style: 'So that whilst we look on paintings with the same eye as we view commonly the rich stuffs and color'd silks worn by our ladies, and admir'd in dress, equipage, or furniture, we must of necessity be effeminate in our Taste, and utterly set wrong as to all Judgment and Knowledge in the kind.'[488] Indeed Shaftesbury was asking for a more austere intellectual art as is seen in later neoclassicism.

The change in the outlook on the nature of the cosmos, inaugurated by people like Descartes, furthered in eighteenth-century England by Locke and Hume and finding its culmination in Kant, afflicted the arts as well as aesthetics. The didactic element was very strongly accentuated.[489] Tischbein said that the art of a museum like the Vatican was a great school for the spirit where people were taught to behave morally, and kings to govern wisely, while Schlegel called the artist 'the higher spiritual organ of humanity'.[490] Never before in history have people thought so much about morality or tried so hard to use art to induce morality. Art 'could show moral precepts in poetic and in artistically beautified examples, through which knowledge comes alive and dry truth is changed into a passionate and sensitive perception', wrote Mendelssohn in 1757.[491]

It may seem to be, and probably is, an apparent contradiction when people at one and the same time put art on a high pedestal and claim it is unconnected with real life. Those things are beautiful that are without purpose, and art 'has retained its freedom from the reality principle at the price of being ineffective in the reality,' sums up Kant's aesthetics.[492] Yet Schiller wanted to educate people through what is beautiful and through art starting from these theories.[493] Indeed, the didactic character slowly gave way, and the new artistic aims became clearer – it was not through the subject matter but through the activity of making art that art would contribute to, even heal or change, the world.[494] Art had in fact become a religion.[495] In the words of Saul Bellow: 'A century ago when the clergy began to feel certain doubts, poets and novelists moved into the centre of the spiritual crisis and assumed spiritual obligations, . . . the cure of souls.'[496] Of course the painters followed suit.

If then art had become religion, the predicament is even stranger in that religion itself next became completely superfluous and moved away from reality, for it means that art gained its lofty position without much meaning. This is one of the strange enigmas of our age – the artist as a prophet who nevertheless stands completely aside from the realities of

life.[497] However, I want to come back later to this situation and the influence of the visual arts in our day.

In the nineteenth century the theory of *l'art pour l'art* eventually grew out of the ideas of German idealism.[498] Perhaps the best way to convey what it means is to quote Pater, who said: 'Of this wisdom, the poetic passion, the desire of beauty, the love of art for art's sake, has most; for art comes to you professing frankly to give nothing but the highest quality to your moments as they pass, and simply for those moment's sake.'[499]

In the meantime other cross-currents were active. Pugin, Ruskin, Morris, who in some way or other saw a deep relationship between beauty in art and beauty in life, gave all their energies to redeem something of the ugliness of nineteenth-century society, not only in its art but also in the social conditions. They understood that in order to have more beauty in art as well as in life one had to change these conditions.[500] It all comes down to the fact that if we had lived in the time before, let's say, the eighteenth century it would not have been difficult to write an essay on art, ethics and society, as I have been asked to do here. Yet even if the arts as a matter of course had moral implications and obligations, people in those days would not have exalted the arts together with religion to a higher plane and would not have looked to the arts for a way to redeem the moral ills of the day.

But has art any influence on society? Is there any relationship between art and the ideas on morality held by the society for which the art is made? Are we looking in the right direction if we look at those works hanging in the museum or gallery, surrounded by an aura of loftiness and respectability,[501] which are feverishly discussed by art critics; or should we rather look at the more popular arts such as posters or perhaps even the mass media? The influence of the mass media in our time has been an object of much discussion and investigation, often on a sociological plane.[502] Most of these studies conclude that not much can be concluded! I feel this to be inevitable, as the arts, in whatever form, when they exert some influence – be it the influence of one group in society on another or just the strengthening of some existing tendencies – do this within a fluid cultural situation in which differences may be felt but can never really be measured. Yet I feel that no human action ever can be of such a nature that it would have no influence. This would not only question, or deny the sanity of anyone trying to do something in this world, politically, religiously, morally or otherwise, but it would make human being meaningless in the sense of the Japanese poem:

> He jumped in the water and he caused no ripples.

To me, it seems there will always be ripples, some bigger, some smaller, that together with other ripples eventually will cause waves or even storms. Indeed, I feel that art alone, in the past and in the present, never

can alter the face of the world, or even its own position in the total complexity of a cultural situation. So, for example, the change in the position of the arts in the eighteenth century which I have mentioned earlier might also have been influenced by the growth of capitalism,[503] and certainly also by religious, philosophical and social situations and conditions.[504] Influences can only be exerted if they are strengthened by other tendencies and not rendered ineffective by counteracting forces.

Therefore, to come to a halfway conclusion, I can agree with Klapper when he writes (of the mass media):

> [sociological generalizations are] inapplicable to certain broad areas of effect, such as the effect of the media upon each other, upon patterns of daily life, upon cultural values as a whole. To be sure, we have spoken of cultural values as a mediating factor which in part determine media content, but certainly some sort of circular relationship must exist, and media content must in their turn affect cultural values.[505]

Art historians as a whole have almost never studied the impact of the arts on their society.[506] If they have not restricted themselves exclusively to style analysis, determining influences of artists on artists, they have studied meaning in the visual arts[507] even if the history of ideas is often brought into focus by that. Sometimes they have studied art in relation to a changing religious climate[508] or, influenced by a Marxist idea of culture, to its social background.[509]. In this way they have shown that art belongs to the cultural scene as a whole, in which social and economic, scientific or even natural phenomena play their role and have their impact.[510]

After these introductory remarks I should like to try to give some idea of how the visual arts are related, if not directly to morals, then certainly to lifestyles, manners and customs. I shall try to show that the arts mean something in giving a face to a culture, to a society; in giving it its own particular form.

The first question to ask is: what is art? The visual arts, in my opinion, must be located between two extremes: (1) the purely decorative, the beautiful arrangement of lines and colours that are artistically combined into a totality, and (2) pure visual communication as such, that we find in a more or less unadulterated form in maps, road signs, letters, icons and idols. Or, I can place the arts between two other extremes: on the one hand entertainment, the means whereby joy, a pleasurable mood or amusement is induced, often in a social setting; and on the other hand the loftiest elements in human life, revealed in the depiction of gods in cult images or holy stories for education or edification. As examples of the first extreme we may think of banquet embellishments, Christmas decorations, or patterns on fabrics for dresses or ties, etc. Also on that level, even if falling outside the (visual) fine arts proper, are the

entertainment programmes or documentaries on television. Film and TV – and I shall return to these, as much thought and study has been given to their possible impact – have had a great influence, and it has been said that 'Television is and has been building American ideals and abstract principles through concrete imagery. The image has in fact become more effective and affective than actuality.'[511] Here the context was the influence of another human activity, at least very much akin to the visual arts, if not a branch of it – I do not want to enter into that argument now – namely, photography, of which the 'visual image offer[s] even stronger spiritual and aesthetic experience than did the perception of visual reality itself'.[512] Maybe, as this lower end of the two extremes between which the fine arts are located has the stronger ties to daily life, it seems natural that it would have the stronger impact; if not in all ages, then certainly in our age in which fine art in its loftier expression is relegated to the museum as a kind of secularized temple.

If I approach the visual arts using this wide definition, placing them between the extremes of decoration or entertainment on the one hand and visual communication or the cult image on the other, we can perhaps be clearer in defining their influence.

Let us begin with ornament, decoration and the like. Undoubtedly we all experience much of their influence every day in all kinds of social settings. The interior decoration of our house determines something of the atmosphere in which we live, and certainly affects us, as well as expresses something of our own character. But that is not all. If we enter a restaurant, the lights may be dim, but certainly the total impact on our mood — which may induce actions — is the result of the colour scheme of its interior, and maybe even of the paintings on the wall, the decorative mouldings, etc.; so even the fine arts in a narrower definition can play a role in our surroundings which are created artistically, with or without taste. The theosophists have even made a system out of the impact of colours and shapes on people's psychological condition. In The Hague a hospital has been built and painted inside in conformity with these presuppositions. There is no need to go into a lengthy discussion of the impact of our surroundings on us, as they have become quite topical today with regard to new buildings and their effect on the people who work there, etc. But in past ages, too, people have been very aware of this. Of course I can for instance point to the rich and lavish interiors, with gold, rich mouldings and so forth, of the great Baroque churches and the grand palaces, designed to induce awe for the values that the church represented or for the monarch who was living there. I can also for instance point out a refined interior design such as that with which [Robert] Adam graced the mansion at Osterley Park: the decoration amid the colour schemes of the various rooms is expressive of the differences in character, mood and setting needed for a study, a

drawing room, a state room, or a bedroom. And certainly things like this have an influence on our lives, on the way we live; maybe even on the way we feel, think and act.

Naturally I am not implying that people could be changed completely just by their surroundings even if instances come to mind where the effect upon them has been marked,[513] but rather that environments are designed with their function in mind and so that they may have an influence on the people who use them. When considering the other side, the visual communication in a beautiful form, in statues, paintings, mosaics or frescos, we should not look for extreme cases of a direct influence on people's thoughts or behaviour. An immediate conversion, a change in moral outlook, as a direct result simply of looking at a work of art, is, I feel, asking for too much – it may even be too much in other contexts. But the repeated unobtrusive impact, or the visual image enhanced by other influences, such as speech, writing, music and living situations, may have its results in either a changed attitude or the strengthening of the outlook we already have. In this way the images around us, the propaganda made – on any level whatsoever – the presence of the icon or the idol, may work as a conservative element, confirming and building up the direction people have already taken. In a stable cultural situations art certainly works like this. Also – to take a negative example – dictators, sensing that free art may have the power to challenge their status quo, have often tried to compel the arts to be conservative and unchanging[514] for the same reason.

In a way, art can persuade without convincing. Convincing, winning an argument, converting somebody to a particular truth or insight is not what the visual arts can do – or only in extremely rare cases. Thoughts and ideas can be expressed more directly – and therefore convincingly – with words, and for that reason the Bible teaches Christians that the gospel should be proclaimed by means of words, and propagated through hearing. As an example from the field of music, Bach's *St Matthew Passion*, even though words are used, is not a good instrument for evangelizing; even so, the fact that people listen to it does at least remind them that Christianity is still there and exists as a viable option. The same can be said of church art from the Renaissance and Baroque period; I don't think anybody ever became a Roman Catholic just by looking at or studying these pictures – even the most beautiful of them – but they remind us that Christianity still plays a role in Western culture, and in this way the ideas they convey are kept alive and are shown to have at least been of importance to people at some time in history.

Art persuades. It will seldom, I think, influence people directly in the sense that they will begin to imitate the acts that are shown in a painting. But in the way it depicts, in its total impact, in the mentality that speaks through the choice of subject as well as style, in the manner of representation, in short, in the anagogical element as defined in medieval art theory, art has its influence. Similarly a way of life, morals,

and insights are taught to children not so much by overt lessons but rather by the values inherent in their parents' attitudes and social background. Art, of course, is an expression of the insights and beliefs of the artist, the group or movement or subculture of which she or he is a member or exponent, and more widely of the culture in which she or he is working. In a way art is part of that culture, and the role the arts play, the things they are asked to do, are part of the cultural patterns. Art is therefore subject to the customs and ethical norms prevalent in society. For example, in our society ('streakers' apart!) people don't show themselves nude in public, but in the artist's studio this can be done and 'nudes' are certainly a respectable part of our cultural heritage and artistic production; they range from the small bronze copy of the *Venus* of *Milo* standing on the mantelpiece to the nude sculptures in parks and decorating fountains, from book illustrations to the masterpieces in museums and galleries. These are almost always without pornographic intention or content, and exist without raising questions in our minds of whether the people who own these things are willing to parade in the nude or are immoral. On the other hand, some kinds of 'nudes' will be considered to be pornographic within the patterns of our culture – this may raise difficult legal problems, but there are no problems in practice, as those looking for pornography know very well how to discern it.[515]

Once again the arts express the insights and beliefs of the culture in which they play their part. The fine arts make explicit and visible the manner in which people look at things, what and how they see; art reveals both directly and by implication what is considered to be relevant and important – and, by omission, what is not deemed worthy of being expressed or depicted. The total impact of art is in its meaning, which reveals a mentality – the scope and nature of cultural, moral or social values. This implicitness and explicitness make clear what kind of gods a culture, a society, reveres. For the old pagan world this might be obvious, as well as for the great Christian era. It is no less clear, just walking through such an exhibition as the great one on neoclassicism held in 1972 in London,[516] that Christianity was losing its cultural force and influence simply by the absence there of Christian subject matter. These days it seems to us either that there is in a way a hole in our culture, engendered by a non-religious religion, or that slowly new gods are coming in, the gods of pleasure money and sex. Of course, if we look at present-day 'high' fine art, the modern art of the museum, we still look into the hole just mentioned – sometimes quite literally, as in Fontana's *The end of God*, merely a canvas with holes cut in it, or his *Spatial concept*. If on the other hand we widen our definition of the visual arts, as we have done, we see the other gods just by looking at the posters or at the advertisements in our magazines: pictures of holiday resorts, promising leisure and the open possibility of sex (often slightly veiled but that's also part of our culture and its morals – examples abound).[517]

A curious example of what I have in mind is an advertisement in an American paper around 1900. The design is based on Titian's *Assunta*, the world-famous painting in the Frari Church in Venice. It has been 'secularized' by showing, instead of apostles gazing at the heavenbound Virgin, fashionable women gazing at a 'heavenly' corset, a new 'god', representing beauty, fashion, pleasure and in the added announcement that money could be made by acting as an agent selling these corsets – cash. Such an example is almost a symbol of the spirit of the age.

Art creates the symbols of and for a society, the things it stands for and thinks relevant, the values it cherishes and its aims.[518] Such a symbol was, in the time of the French Revolution, not only the tricolore but also David's *Oath of the Horatii* or his *Marat*. For the Florence of the early sixteenth century it was Michelangelo's *David* and for the Gothic period not only the symbol of the Cross, but also the *Beau Dieu*, the figure of Christ in the portal of the cathedral in Ainiens or the large *Madonna* by Cimabue (Uffizi, Florence). For the nineteenth century one may think of Ingres's *La Source* or Holman Hunt's *Light of the world* or van Gogh's *Potato eaters*, or, maybe even more apt are the countless monuments of great men in almost all cities of the Western world – an example being the prevalent hero worship of the Eiffel Tower in Paris. And for our own [twentieth] century we may think not only of the $ sign or the © symbol but also of Andrew Wyeth's popular *Christina* picture, Dali's *Cross of St John of the Cross*, Andy Warhol's *Campbell soup cans* and the latest popular 'ad' for a certain brand of 'bra' or beer.[519] We may like or dislike these symbols, we may stand for the values they proclaim or reject them, we may even think they are irrelevant; yet they are there, showing the face of our era, expressing its overt and its secret thoughts and intentions. It is particularly through these symbols that the impact of art as visual communication will be made and will exercise its persuasion; maybe even more so when these works or items are 'hidden persuaders' and not recognized as such,[520] than when we are conscious of their meaning and the mentality they encourage.

Art, as I have said, can be a conservative element in a society, just because it reinforces again and again certain values. But a society is never a closed unit. At the beginning of this chapter I quoted ideas from a book of 1822 that were coined during the Baroque period. In any period of history there may be a mainstream, but there are also always side currents, counter-currents, and secondary streams. In a way the term 'culture', used to designate a certain period, only means the common denominator of different subcultures. A society is a complex whole of trends, some more advanced and some more conservative or even retarded. Now it is precisely in this interplay that art can be really influential. Where art is only expressing the prevalent cultural values, those that make up the 'common denominator', it 'works' conservatively, but at those points where it differs, certainly where it does

so with persuasive force through its high quality, it can have an influence in promoting new ideas – ideas that are probably already alive in a subculture or counter-current. As long as art just expresses professed values it only strengthens these; when it is at variance it can help towards a change. Of course, it can never do so when it is too different, when the forms or the ideas it embodies are too remote to be understood.

We may assume that art can exert the strongest influence when its message differs in an almost conformist way. The more its message is put over in an accepted artistic language (style), the better these new ideas will be understood. An example of this is Manet's *Dejeuner sur l'herbe* – we could also have chosen his *Olympia*. When Manet exhibited this painting in the mid 1860s, showing a picnic with two nude girls and some clothed men, apparently all depicting contemporaries and some even well-known characters, he caused quite a stir, even a scandal.[521] Yet his composition and the way in which he handled the paint were almost traditional: the composition of the group was derived from a print by Marc Antonio after Raphael and the conception of the scene was related to Giorgione's famous *Concert Champêtre* in the Louvre. Just because the work did not deviate from the accepted ways of making a painting, the one point in which it did differ came out very strongly, and in this way it could influence morals. The painting meant more than just that 'there are people in this world who act like this' – which I suppose nobody in those days would have doubted – but in the total context it implied that it was right and acceptable, even worthy of being the subject of a major work of art, and as such actually commendable. The same is true of Manet's other 'scandalous' picture, the *Olympia*, which portrays a reclining prostitute in the traditional composition of a Titian *Venus* or *Danae*. The values that those older paintings stood for – the allegories employed to express universals – were shown to be dead, as for Manet there were no longer any universals.[522] Of course, as we have said before, a work of art can be influential in a vacuum, and its tendencies have to be reinforced through other cultural elements – in Manet's case we can think of Flaubert's *Madame Bovary*, one of the first works of art to be brought to court on the charge of obscenity. Here again, what offended his contemporaries was the matter-of-fact and, as the prosecution maintained, photographic and uncommitted way in which the adultery of the main character was described. Certainly these works, together with the quasi-respectability of the many nudes shown in the annual exhibitions of the official Salon marked a step in the direction of today's permissiveness.

So my thesis could be said to be that art can exert influence if it differs in its message and mentality from the current views, provided the gap is not too wide and the works remain intelligible – with the added provision that other cultural factors are working in the same direction or at least not neutralizing it. And I would emphasize again that these

things can never be proved by quantitative sociological investigation. So we see the arts influencing society in a certain direction, step by step: only after the initial new ideas or values are accepted can the next step be taken. A good example of this, probably familiar to everyone, is the trend towards nudity – a form of permissiveness initially confined to depictions and gradually becoming a social reality in the last two or three decades. It cannot come as a surprise to anyone that advertisements, which are so very influential in our day,[523] have played a key role. Already in the 1940s we find advertisements of 'bras' showing women in underwear even if it was done with some degree of modesty, by using drawings rather than photographs; or, if photography was used, the images were in silhouette, or rendered vague. Advertisements are meant to attract attention, and if the current trends are favourable we find that in due course another step can be taken. Of course it is nearly always done in such a way that modesty is not offended: it is a question of playing on the very boundaries of modesty and yet these boundaries seem to grow wider as people become accustomed to each new and slightly daring step. In the 1960s we saw this evolution – or, if you wish, revolution – gaining momentum so that around 1970 almost total nudity was acceptable in respectable magazines (I am not speaking here about pornography). This trend ran parallel to what was acceptable and permitted to be shown in films. Only after 1970 when magazines like *Penthouse*, and later *Playboy*, began to show frontal nudity including the pubic region, did these things slowly come into magazines with a more general circulation, and in some countries more widely than in others. But today on TV and in 'family magazines' these things are accepted. So we see a change in morals, in this case in the acceptance of female nudity – to be followed more slowly by the acceptance of male nudity. Each step is heralded in the press, as if everybody were asking: can people really accept this, or have we now reached the limit? Now, too, the sex act has been filmed and photographed more and more openly with the result that the borderline between the 'blue' movie and the 'art' or 'entertainment' film has become much narrower. All this was preceded by an increasing frankness in displaying sexual activities in the visual arts – witness the prints done by the Dutch artist Veldhoen around 1960. But today things can be shown which would have caused a gallery to be closed on charges of indecency not more than ten years ago. Like, for example, the couple in the act of intercourse shown in a very naturalistic sculpture by John de Andrea at the 'Kassel Dokumenta' exhibition in the summer of 1972, seen by thousands, but not even reported in the press as a scandal – and the fuss caused by Manet's picture just over a century ago seems out of all proportion.

These changes in art have their impact in real life. If the sexual revolution is progressing more slowly, a change in morals is discernible which manifests a more positive acceptance of the sexual side of humanity on the one hand, and a great laxity in these matters on the

other hand – the much discussed permissiveness. In the same context we see new customs coming in, and fashions that allow more of the body to be exposed. Even if see-through blouses and the like still have not become fashionable in the widespread sense, yet great changes can be noted on the beaches. Beginning in the 1950s with the almost total acceptance of the bikini the recent trend towards nudity (total or monokini) on the beaches is now quite strong, and in some places along the Mediterranean coast or in California already an accepted fact.

Apart from the mentality inherent in visual communication that certainly strengthened this trend, I think that the visual example itself has been very important. Particularly, I feel, photographs and films of nude girls – first considered daring then later accepted – have been very influential. Twentieth-century people feel, rightly or wrongly, that photographs are showing reality as it is; so, in a way, people were just copying things that were thought to be the fashion, somewhere, maybe in the social environment of the 'jet set'. To this influence of the visual arts as setting an example I should like to apply the term 'naturalistic fallacy'.

To explain this further we must look back to the eighteenth century. Of course there were many nudes to be seen in the arts of the preceding Baroque period, but they were obviously not naturalistic: the male and female figures shown in these pictures were almost never real naked men or women but rather allegorical figures, ancient gods, beings outside our daily life and existence. The arts of those days were using natural forms, but were only in a very few exceptions naturalistic and just as seldom realistic – 'naturalism' being a term related to style, 'realism' to subject matter. When art was realistic, for example in Dutch genre pieces, nudes were almost never depicted, just because the pictures were realistic.

Now naturalism in some way begins to suggest realism; this means that when in the beginning of the second half of the eighteenth century there was a strong trend towards naturalism, people also began to look at seemingly naturalistic works of art from the past as though they were realistic. This is the naturalistic fallacy, and we sense it very strongly in the writings of Winckelmann, the great proponent of neoclassicism. He was cautious enough to add that 'sensual beauty furnished the painter with all that nature could give; ideal beauty with the awful and sublime; from that he took the Humane, from this the Divine.'[524] Yet Winckelmann was, I feel, deceived by the classical sculptures he studied, many of which show nude figures. Why the Greeks and Romans made them is one of the problems of cultural and art history which we must not go into here. But if we see a collection of classical works of art, for example that of the Vatican Museum or a collection of plaster casts like the one in Charlottenburg,[525] it might give us the impression that we are entering a nudist camp; that is, if we commit the error of the naturalistic fallacy in thinking that these things were an everyday social reality in the days these works were made. Winckelmann fell into this trap, and in his *Thoughts on the Imitation of Greek Works in Painting and Sculpture*, 1755, he

discussed at length not only the beauty of the ancient Greek people but also how their artists could daily see people in the nude all around them:

> The Gymnasia, where, sheltered by public modesty, the youth exercised themselves naked, were the schools of art. These the philosopher frequented, as well as the artist. Socrates ... Phidias for the improvement of his art by their beauty ... Here beautiful nakedness appeared with such a liveliness of expression, such truth and variety of situations, such a noble air of the body, as it would be ridiculous to look for in any hired model of our academies ... Phryne went to bathe at the Eleusinian games, exposed to the eyes of all Greece, amid rising from the water because the model of the Venus Anadyomene ... Then every solemnity, every festival, afforded the artist opportunity to familiarize himself with all the beauties of Nature.[526]

Just as an aside I may mention that the story of Phyrne, a kind of Christine Keeler of the fourth century BC, was never related before the late Hellenistic period. Its authenticity is hard to determine,[527] as is that of other stories that tend in this same direction. Here we see the naturalistic fallacy working in late antique times, when people were looking at those same classical sculptures. For Winckelmann of course these stories served to confirm him in asserting that same fallacy.[528] People who, after reading these lines from Winckelmann, written with such an enthusiastic glow, looked at the antique sculptures, and then at the modern ones in the neoclassical style (cf. the recent exhibition of neoclassicism in London) must have come to the conclusion that nudity in life was something positive and desirable. In the great revolutionary period at the end of the eighteenth century not only do we see a *mode à la grecque*, which was in a way tending towards nudity, at least in showing the body quite freely, but also we hear of nude swimming and in yet other ways of nudity entering daily life.[529] But the tide was to turn, and Victorian prudery was soon on hand to drive this all out of sight. Very interesting is the painting by F.A. Vincent of 1789, showing the girls of Crotona who are related as being asked to exhibit their beauties for the painter Zeuxis so that he may choose the most beautiful parts of their bodies in order to make a composite beauty. It shows already, in the midst of the revolutionary tendencies, a generally bashful and prudish attitude, quite different from the dream of Winckelmann.[530] The reason for this lies probably in the fact that the moral tone of the time was very much a reaction against the complete permissiveness of the eighteenth-century French nobility. It was as a sort of 'underground' movement, particularly in the artistic circles in France with their bohemian morality and way of life, that the tendencies towards nudity as a social reality evolved, at least in paintings and sculptures — we are thinking of Manet, and also Courbet, Corot, and of course the Salon painters. These tendencies were to merge once again in our own age, when the naturalistic fallacy was even more likely to prevail since the works were

either realistic or naturalistic or both. So in all these developments art has had a strong influence; on morality maybe in an indirect way, but certainly on our way of life, our customs and fashions, on the way in which the new ideas and morals (which are also very much a result of the growing influence of the idea of the social contract[531]) and Freudian theories are rendered concrete and realized.

I should like to give here another example of the impact of the visual arts on life. I have already mentioned the influence of paintings on the conception of gardens and parks. Related to this is the acceptance of high mountain scenery. In the seventeenth century people did not like the Alps and similar mountainous regions. The average traveller passing though such scenery in a coach would close the curtains in order not to see these horrors. But in the early eighteenth century we find it lies in the frontline of a new sensibility in this respect – expressed in writing as 'The wilderness pleases . . . Even the rude rocks, the mossy caverns, the irregular unwrought grottos and broken falls of water, with all the horrid graces of the wilderness itself as representing Nature more, will be the more engaging, and appear with a magnificence beyond the formal mockery of princely gardens.'[532] In this line of development we see that in the eighteenth century artists gradually began to paint such scenery – painters such as Cozens, Wilson, Towne, Sandby and others. These things were accounted for in aesthetics as well, even if they were placed in a special category – that of the 'sublime'.[533] In the years around 1800 we see the first visitors coming to Switzerland to enjoy the great mountain scenery: among them were such writers and poets as Goethe, Shelley, Wordsworth, Coleridge, the painter Turner, and many lesser known figures. In the nineteenth century this movement grew into tourism, first for the rich, and gradually in our century into mass tourism. In this case the visual arts – together with literature – has opened the eyes of people to beauties they were previously unable to see, or rather, made them see the beauty of the things they had previously regarded as horrors. Slowly, just in the depiction of these things, they lost their horror, even if the awe remained. And today the new attitude is always reinforced through that device to lure us to the mountain resorts – posters in which their beauty is exalted and emphasized, beauty which even the most common person now understands, while the 'horrors' are never shown, so that people begin to forget them. And there the basic idea of modern tourism is laid bare: adventure without danger.[534]

We may conclude then that art in many ways seduces people, even if it does not convince them. It is neither the subject matter nor the style as such but the total impact of the work that drives the message home; in McLuhan's terminology, by means of 'cool' communication. Art opens our eyes to certain values, to certain beauties, to certain realities, and in

its totality communicates more a mentality, a way of life, a way of looking at things, than specific and definable morals or norms or rules. There is quite a difference in the mentality behind Ingres's *La Source* and that behind a nude by Otto Dix, the German painter working in the 1920s who also idealized his subject, but instead of idealizing towards a heightened and more perfect beauty did so in the negative direction, dragging the beauties down. The same happens in the other arts: Mozart's *Magic Flute* will have convinced only a few people of the truth of Freemasonry, but the mentality behind it is one that seeks for a higher life and stands for higher values and for refined culture, while for example Prokofiev's *Love of Three Oranges* of 1918 drags all those ideals down into absurdity, and leaves us with very few values to uphold. In art serious values and tendencies are given form in a playful way – they are played – but a man who takes his girl out to a performance of *Il Seraglio* by Mozart will certainly be taught a better way to woo her (certainly not to abduct her) than if he takes her out to a film like *The Graduate* or Antonioni's *L'Avventura* (1960). The latter has been described in the following terms: 'Antonioni's film is an adventure story, though not of the sort that moviegoers are accustomed to. "In a cosmos devoid of absolutes," it says, "the only thing that human beings have is themselves, faults and all."'535

I deliberately took examples from our own time, as I should like to end with a look at modern art and its influence. I totally agree with the following statement: 'Whereas art objects once symbolized an ordered cosmos, they are now assemblages of parts that do not belong to an ordered totality. Indeed collages ironically juxtapose such incompatibles as make-believe and actuality. Art then becomes testimony to our dissatisfaction with our environment and our drive to snatch order out of chaos.'536

Art, as I suggested in the beginning of this chapter, at least in theory, became divorced from life in the eighteenth century and became a kind of religion, standing for deep values but totally outside reality. My response was that probably real art, the art in contact with and growing out of social reality, has found its refuge in such 'minor' arts as posters and advertising, through which its influence, as I have tried to show, has been greatest. But that does not mean that the 'high' art, the art of the gallery and museum has no influence. Just because the artist had become a kind of high priest of culture but with no real function in social reality, while the 'minor' arts were often of a very low standard indeed, people like Ruskin and others saw that society had to change. They saw that people tried to misuse the arts to give them status and respectability, and in an unusual lecture Ruskin angrily told wealthy would-be patrons that, if they were honest, the building they wanted should be 'built to your great Goddess of "Getting-On" . . . I can only at present suggest decorating its frieze with pendant purses, and making its pillars broad at the base, for the sticking of bills.'537 The artists and their

nearest friends, the true critics, became rebels and martyrs except when they accepted the role of makers of status symbols – and implacable opponents of the bourgeoisie.[538]

The protest movement became very strong at the beginning of our century. The modern movement, a kind of unorganized, strong, arid influential group alongside other twentieth-century art movements,[539] is the embodiment of protest against the dilemma of the modern person, who has been reduced by science and modern psychology to a kind of 'naked ape' without freedom. Faced with the seeming absurdity of life, people began to subvert those values that the bourgeois were professing to stand for, but for which they had no true foundation, no base, and which had therefore become empty gestures. A participant of the Dada movement wrote later,

> After the self-satisfied rationalism of the nineteenth century, an ebullience of invention of exploration beyond the realm of the visible and rational in every domain of the mind – science, psychology, imagination – was gradually breaking down the human social and intellectual values which up until then seemed so solid. All of us, young intellectuals of that period, were filled with a violent disgust at the old narrow security.[540]

The arts were showing, in their very being, that the old values were dead. They showed that 'man is dead'[541] and out of this despair these works seemed to cry 'please do something'.[542] They have had a great influence in forming the mentality of at least a minority, but it is an ever growing group of people in our times. In the sixties the volcano erupted, and to the astonished bourgeois – who never thought much about art and completely ignored modern art – a strong movement looking for a cultural revolution and related to a political revolution came into the limelight. Its mentality was perhaps best summed up by Tuli Kupferberg in a famous article in the *International Times*:

> The artistic revolution: great subverter of the hollow society. Mass your media – you are helpless before our skills. You don't know whether we are parodying you or you are parodying us any more. Beatles, Dylan, happenings, pop. Rock and Roll great continent. The Box will destroy you! Our bodies are opening. A thousand penises will bloom. Cunts too. We will force you to support us – to support the artists who are digging your dark grave. Join us before it is too late. Do not die! There is life enough for everyone! When the mode of the music changes the walls of the city shake.[543]

The revolution did succeed in many ways. The morals, way of life, fashion, attitudes, priorities and the general feeling of our times have changed. The students of today, the universities of today, the entertainment of our day, and even the political scene[544] are totally different from what they were ten years ago. Now the movement seems to have spent its energy, and at the time of writing it is relatively calm but the fire is still smouldering. For the present, what interests us most is that

in all this the visual arts have played a very decisive role.[545] Again, not in a vacuum but in conjunction with other cultural forces.

To make art is a responsible action. Even looking at it is a responsible action. Art may not seem to be very strong in its spiritual message and its seduction can work very slowly. But the mentality inherent in it – a reflection of what moved the artist's mind and spirit – does touch us spiritually. Schiller instructed artists to 'Create for your contemporaries, but what they need, not what they praise':[546] indeed, there is no sense in creating empty beauties without meaning but neither is there any sense in tearing down values that are worthwhile, or in going on to make almost pornographic things under the banner that in art everything goes. But I do agree with Ralph Pomeroy who wrote: 'Art is still basically for – protest is against.'[547]

• Art not neutral[548]

A nineteenth-century poet once jokingly said of a preacher: 'He had nothing to say, he was nobody.' But everybody is somebody and is personal in his or her utterances. Not only people's character, personal life history, knowledge and experience play a role in this but also their convictions. People who want to be neutral soon discover two things – and if they do not discover them, then their environment will – namely, in the first place there is only a semblance of neutrality, because unless you want to keep completely silent you always speak from your own subjectivity; secondly, that the attempt at neutrality brings frustration and deception to your words and deeds, because then you are not yourself anymore, and sometimes keep quiet about what is most essential, which leads to poor communication.

In art it is no different. There is no art in which the artist does not express her or himself. Sometimes artists will consciously and very explicitly depict or put in words certain visions that they have and find important. But there will also be things of which they are not so consciously aware that still become visible in their art. As with every human being, even they do not intend to bring a specific message, yet insights, views, basic assumptions, and principles inevitably come to the fore.

This also applies to science. For a long time, and still for many people, the ideal was a science without presuppositions, neutral, objective, generally valid. With regard to philosophy, Polanyi has made clear in his masterly *Personal Knowledge, towards a Post-Critical Philosophy*, that to be neutral as such is not possible and should not be pursued. In short, we should not strive for a so-called objectivity but for truth, and the latter always reveals itself in our personal statements. I myself would say: the more personal a statement – presupposing naturally that we are

honest and open – the more clearly in general it expresses the truth.

How often is it said that art has nothing to do with Christianity: art is neutral, generally valid, human, and can therefore not be Christian. However, when we read the catalogues of expositions or listen to the critics, we notice that they always speak about somebody's point of view, a disposition, attitude, character and vision. Obviously. But, why is that only allowed if it is not Christian? Or is it that anything may be expressed in art as long as it is not religious, because you cannot mix art and religion? We could completely agree with this theory, but then we would also have to say that the idea that an artist may not mix art and religion does not mean that art is neutral and that an artist's being a Christian can and may not play a role in his or her art.

I believe that a few misconceptions play a role here, and also a few old ideals which are introduced inadvertently. The old ideal of neutrality originated in the time of the Enlightenment, the eighteenth century. Science and also art were common human activities supposed to be free of presuppositions, to be without propaganda and value free. It is obvious that people were not honest here, whatever their intention, and that people were not in the least as free of presuppositions as they claimed to be. No, the real issue was in fact that they wanted to exclude God, the presuppositions of faith or any external authority. This is obvious if one looks at old writings from that time. What they pursued was in reality not without presuppositions and neutral but was simply a humanistic point of view. This was considered to be so obvious that people often did not realize that it was a deliberate position.

For humanists science was very important. They did not want to accept anything unless it could be understood by reason and experienced by the senses. Since that time – progressively so since people did not realize their inherent point of view – less and less attention was given in art history and art theory to the impact that faith and conviction, in short the orientation towards authorities external to a person, could have had in the past (if not in the present) on the work and activities of an artist. I think that we can actually say that in the last one-and-a-half to two centuries an unintentional but definitely factual falsification of history has taken place. If you want to know, for example, what an artist thought or which faith he or she adhered to, it is virtually impossible to find something about it in the records. That Moreelse was a believing Calvinist is mentioned virtually nowhere. Would that have nothing to do with his work? We are told that Calvinism was antagonistic towards art. However, in the history of landscape painting we do find reference to the school of Frankenthal. Yet we are not told, or rather, no attention is given to the fact that Frankenthal was the place where the ruler, who lived in Heidelberg, offered Calvinist refugees shelter: it is almost ironic to realize that exactly this place of refuge became a centre of art. Rubens was Catholic. Yes, there are things that are difficult to ignore.

And yet in art reviews much too little is found about the sources and the spiritual backgrounds from which these people partly drew their inspiration. In this way the thought can have taken hold that religion has nothing to do with art, perhaps with the exception of the themes that people chose. But that a Tilman Reimenschneider really would have been involved in the altar pieces that he made . . . that it meant something in the life of Dürer, not only on Sunday but also when he was at work, that he was a believing human being, and a Protestant who followed Luther with enthusiasm, is given much too little attention in the discussions of their art.

Thus the myth originated that art stands separate from matters of faith, from the deepest stirrings of our inner convictions. Of course, in our time this is deemed true by those who are humanists.

Yet there are many who are not humanists in the old sense of the word. The Marxists argue against the theory that art is neutral. Art from Brecht to Sartre, and many others, is loaded with conviction. Marxism unmasked the ideologies of spiritual leaders and followers. And they are right. Even if we would clearly lay the accents differently.

Art in the museum is in no way neutral. Even if the convictions of the Gothic artist or of the painters from the 'golden age' of European art, from Caravaggio to Rubens to Rembrandt to Vermeer to Asam and Hogarth, are interesting and captivating, they are history, their works are now old and preserved, and the direct power of their convictions has become a matter of historical understanding; but this cannot be said of contemporary artists. By the way, I still want to point out that it is not without importance that great artists such as Rembrandt, Raphael, Bach, Schütz, Palestrina, etc. worked from a Christian tradition. In this totally indirect way, witness is given in our secularized world to the meaning of Christian truths and values, even if it were only that in order to understand their art people must take note of biblical history and the theological insights of the golden era of Christianity. How could you study the work of Michelangelo without being confronted in an impressive way with the *Last Judgment?*

Now, on towards today. In any museum of modern art we are presented with many works that are loaded with revolutionary content. Picasso, Leger, the Surrealists, and many more, were people who worked from a leftist ideology. They were not ashamed of it. You will find this mentioned in the catalogues and art reviews, at least in the better ones, even though it will usually receive little emphasis. But in the history of the leftist movement it is an important factor. The falsification occurs because museums act as if their collections are only about art, art for the sake of art, artistic matters that have nothing to do with faith and attitude to life. But Marxism is also a belief. And an ideology.

This art emanated such a strong idea-propagating force exactly because it had been presented to people by the museums, the art critics, the art historians, all intellectuals working from the old ideals of

neutrality, as if it were pure art that had nothing to do with faith. For when people are presented with matters as if they are without presuppositions and are never shown the loaded focus on particular values, norms, ideas, even on the revolution itself, then people are not alert, and they swallow what they would otherwise have scrutinized much more critically.

Of course it is true: much of this art has nothing to do with faith, if by the latter we mean an exclusively Christian faith. But as we have already said, there is also a humanistic faith, a Marxist conviction, a nihilistic-mystical world view. And such convictions do express themselves. Therefore C.S. Lewis was right in saying that modern atheism has not sent out evangelists and preachers. We seldom hear preaching in that sense. But from their conviction these people did write books, compose music, paint paintings, and write and perform dramas. And thus they have convinced many.

We do not in the least want to attack the artists on this point. It was not only their proper right; they could not do otherwise. Because they were human. And had personalities. But we do take exception when the world of art leaves these things unsaid and only allows them to be mentioned implicitly. Because that is dishonest.

And we also agree with C.S. Lewis when he says that Christianity can only get a real chance to be heard again if it acts in the same way. Christian faith, just as radical as Marxism, is not just something for the soul or the hereafter but a conviction – neither left-wing nor right-wing – that influences everything Christians do. Preaching, evangelizing, theologizing is like talking in the air, a gesture without content, unless exactly in the area of art in its broadest sense, just as in science and in politics, Christian work is being done.

I want to emphasize that with 'Christian art' we do not mean painting biblical scenes or writing novels about conversion but we mean work from and in a Christian spirit, a mindset such as the one preached in the Sermon on the Mount, a wisdom that starts with the fear of the Lord.

Especially because the world of art in its many facets still adheres to the old humanistic neutrality ideal of the Enlightenment, we should not allow ourselves to be blinded and to talk along with them. Christians too cannot do anything else but express their vision, their understanding of reality, in their work . . . We are not in the least talking primarily about religious works here. Protestant worship does not ask for art – except for music and poetry for its hymns – neither do the newer movements of Catholicism, or at least not as much any longer. But we are talking here about our humanity that expresses itself in all its diversity, especially where we do not explicitly and consciously give voice to it. That is communication, one of the most miraculous of human gifts.

It is obvious that the above is of importance in our thinking about a Christian academy of art, but we will not elaborate on that now.

Book Reviews

• On paperbacks about art[549]

Paperbacks constitute a phenomenon with many aspects, about which the necessary commentary has already been written in recent years. It seems to me that it forms, as it were, a copingstone to a development that was already implied in the invention of the printed book itself. Already in the fifteenth century the printed book meant a tremendous extension of the reading public, and it occasioned a type of democratization in the spread of knowledge and literary art, knowledge understood in this case as the possibility of taking notice of the ideas of leaders, scholars and true or false prophets. How different the course of the Reformation would have been had the art of printing not yet existed. And now we stand at the end: the book has become cheap. Literature from all countries and times, of all levels, can be selected in a minute, classics can be taken home for a mere trifle, the oldest and the most recent products of human thought are equally freely available.

But there is also a downside: the paperback is really not a book. Typographically it is seldom beautiful, the paper is of poor quality, the print is often too small and the pages overfull. Nor is it strong; it does not resist the ravages of time, and it does not allow for a frequent and repeated use. However good our techniques of reproduction are, illustrations in paperbacks rarely satisfy more than the minimum demands. And that is a real pity when it concerns books about the visual arts, in which reproductions are so very welcome. I am sure you do not think like the farmer who said that he found the broadcasts of the Foundation of the Arts so beautiful that, as he added, they could keep the images, for these were so well described that one could easily do without seeing them . . . On the other hand, we are glad that most of the time people do not try to include colour reproductions. It is true that they could tell us more about the illustrated work of art, but how many people might think they have then seen the work of art while the colours are often not quite right and thus give a false impression. Besides, even the best reproduction – and only such can really be justified, anything less is a lie – is not a duplicate of the work of art but only material to aid research. The work of art is always different from the reproduction, in size, materials, background, and so forth.

However it may be, for those who are interested in the visual arts there are quite a number of paperbacks on the market that can point the way in this area, which unfortunately is for many still unknown. Introductions, reflections upon movements and artists, art-historical studies are now available in plenty. From all those we have here selected just a few, no more than an arbitrary selection.

First of all, the unsurpassed little book *Kunstgrepen* [samples of art] by Pierre Janssen (De Bezige Bij, 1961). The many reproductions are as good as can be expected in a paperback, and the typography is far above the average. It is a magnificent introduction to the viewing of paintings. That seems to be a difficult art in our times, perhaps because in the last century we expected the artist to make a copy of reality for us, so that we have forgotten how to recognize and understand poetic and artistic language. It is, by the way, only through the poetic and the artistic that reality can be observed and communicated. But only the person who has re-learned the act of looking can understand this, whereas that nineteenth-century reality was, in fact, less than reality (cultural historians talk about a positivistic-scientific view of reality). However that may be, looking at and understanding art is really the easiest thing in the world, but because we have been weaned away from it, it has become most difficult for many people. Janssen teaches us the way back, to use our eyes and our hearts again when we are looking at a picture. We are enriched thereby, not only because we now understand a bit more about those 'pictures and illustrations', but also because, miracle of miracles, we get to have a better eye for the actual, full reality around us.

Janssen is one of a few people who knows precisely how to make those difficult, most ordinary things clear to the layperson. He tries to teach us to look with our heart open, enthusiastically, honestly, to discover the world, which will open up to us as long as we open our eyes. And for those who are not too lazy this will not remain an attempt. This is a book we can recommend to everyone, even though we do not always agree with the writer – and that too is an essential part of our involvement with art: as people we cannot but have our own opinions, and the art that makes us start a discussion about real things, about deeply human realities and truths, has already earned the right to its existence twice over. By the way, I heard that a second book by the author is already due. I hope it will be just as good as the first one. And if all television programs were to be of this quality (because Janssen first discussed these subjects on television), then we would not have to shake our heads about that beautiful piece of technology that twentieth-century people put to such bad use.

Looking at art is not difficult, but it is a good idea to have the way pointed out to you beforehand. Just as you will see more in a city if you have first read a book about that city, about its buildings and its history, and you keep a map in your hand while you walk through it. That is why art-historical studies are often good helpers: they are no substitute for looking, because we have to do that ourselves, but they are guides that ensure that we do not walk past too inattentively. I shall now review a small selection out of the many paperbacks that try to be guides in this way.

To look at the art of faraway countries and nations is like living temporarily in another world, like reading a good travel book, like projecting yourself for a while into the hearts and eyes of those people – at least, if you are successful. Mario Prodan's *De kunst van China* [the art of China] (Phoenix-Pocket) is such a guide to a world that is foreign to us. It is perhaps a bit too schematic, but because it always looks at art against the background of the totality of this strange Chinese civilization, it is a good little study, whereby a walk through the Eastern art department of the Rijksmuseum or elsewhere will immediately gain in meaning and significance.

F. van der Meer's *Oudchristelijke Kunst* [early Christian art] (Phoenix-Pocket) is a very readable and very instructive little book. It could not be otherwise, for this author has long earned his credentials in this area. We are here dealing with the art of our brothers from the first five or six centuries who had to fight against classical culture and had to form their own Christian picture of the world. That does not only concern the area of philosophy or theology, or the area of customs and morals, but certainly also art. Whether we always agree with their solutions is another matter, especially as after Constantine something that can be called Roman Catholic gradually started to grow. But we will have to learn from the mistakes of our predecessors, and also from the mistakes of our brothers.

Many people, especially those who are mystically inclined, are fascinated by the Russian art of the Byzantine icons. The following books are very useful, not only for them but also for us, because these books give us the opportunity to meet the icon lover, and perhaps we will also discover, and need to challenge that person in ourselves. These books are not always equally sober in their language, which sometimes extols or imitates something of that arcane mysticism, but perhaps that is precisely why they are typical and apt in the description of the meaning of this art form. Of the two books about icons the first one is somewhat more sober and conveniently arranged than the second, and therefore to be recommended: P. Hendrix and H. Skrobucha, *Ikonen* [icons] (Elsevier-Pocket) and W.P. Theunissen, *Ikonen* (Service-Pocket). From a great authority and scholar in this area comes the following: T. Talbot Rice, *Russische Kunst* [Russian art] (Phoenix-Pocket).

Jacob Burckhardt's *Rubens* (Phoenix-Pocket) is written by the great and well-known historian from last century. From the point of view of art history, it is not up to date, but it tells us much about the historical backgrounds and is written by someone with a clear love for his subject, whereby it becomes a magnificent introduction to the art of this great painter, whose value has not been sufficiently appreciated in our circles.

In the Pelican series we also find many instructive and important books about art. We should not neglect to look at the shelf in the bookshop occupied by this pioneer imprint amongst paperbacks, which

is still going strong. We mention here Kenneth Clark's *Landscape into Art*, which provides a classic treatment of this genre. Clark is one of the few who know how to combine erudition, originality and a good popular style. Also by him is a little book *The Nude in Art*, which gives a clear picture of what this genre, which has been so controversial among us, is all about. On this subject, this little book is the very best ever written.

General problems and periods are sometimes dealt with in studies that have since become classics and which are now readily available in paperbacks. We will not enter into a critique of H. Wölfflin's principles, but only wish to recommend the reading of his *Stijlbegrippen in de kunstgeschiedenis* [style classifications in art history] and his book about the High Renaissance in Italy, *De Klassieke kunst* [classical art] (Aula-Pockets).

A person sympathetic to art will surely want to read about modern art. Werner Holman's *De schilderkunst der twintigste eeuw* [the art of painting in the twentieth century] (Prisma-boeken) is certainly a clear and well-organized introduction, which provides insight into the development and backgrounds without getting lost in the details. Finally, there are little books with reproductions of modern masters. Anybody who is interested will be able to find them. We only wish to mention the book with reproductions of the etchings of the young Dutchman Veldhoen, a man who is not at all abstract or 'wild' and yet very original, with a completely new vision testifying to a very great love and purity (Domino-serie).

But continue to look in your bookshop. In general we can say that paperbacks on this subject are good and sound. For it is the case that a large printing has to be made in order to make the paperback economical, and that is why the publishers take no risks. In this area kitsch does not sell, and that is just as well.

• E.H. Gombrich, In Search of Cultural History[550]

Gombrich is one of the most important art historians of our time. He is not only Director of the Warburg Institute in London, but also one of the most brilliant representatives of the art history school that originated out of the ideals of Warburg, although he himself studied in Vienna, at that time one of the centres of art-historical scholarship. The unique thing about the Warburg school is that the people involved do not wish to lock themselves up within the narrow walls of their own discipline, and are not restricted to a confined methodology. Rather, they wish to practise art history from the insight that art belongs to the whole cultural-historical area. For this reason there is no need to avoid excursions to related areas. In his own words, it 'may lead us to consult works on economics or social science, on psychology or the theory of

communication; unless we do, we risk talking nonsense, but for the question in hand theories are critical tools rather than ends in themselves.'

There is nobody more suited, indeed almost called, to take up the problem of cultural history. He did this – taught by many years of living in England – not in a multi-volume work, but in an expanded lecture, a pamphlet that on account of its depth, conciseness and clarity really stimulates the thinking and makes the reader aware that many of his or her ideas are culturally conditioned. He rightly points out that many art historians – and he includes Burckhardt here – are wary of philosophers, and precisely for that reason they willy-nilly work all sorts of philosophical notions into their studies.

An important and clarifying part of this study is devoted to the influence of Hegel on Burckhardt and the art and cultural historians who followed him. He shows how the Hegelian way of thinking – also, or especially, with those who do not wish to be Hegelians in the narrower sense – really involves an exegetical method whereby one tries to reduce cultural phenomena to a common denominator that lies behind it, the spirit of the times, the spiritual climate of the culture that is being studied. Gombrich shows us clearly how all sorts of dangers lurk there, of unnecessary simplification, of a kind of exegesis that wants to see everything as a symbol for something else, of a working hypothesis that has too little regard for differences within a culture – differences between the social groups or the diverse areas where people move.

There are two dangers that Gombrich especially wants to draw to our attention. The first is that where in the Hegelian way of thinking everything is an expression of the spirit of the times, it is no longer possible to exercise criticism – something that can be fatal especially when we are concerned with our own time: 'It is only the Hegelian who believes that whatever is, is right, and who therefore has no intellectual defences against the self-appointed spokesman of the Zeitgeist.'

The second danger is that the cultural historian attempts to gain status and respect by adapting the methods of the natural sciences, along the lines of the cultural anthropologists or the sociologists. He is of the opinion that the area of cultural history is not suited for this and that it should especially deal with the creations of people. One then deals with movements rather than amorphous totalities. The Renaissance was also such a movement. And it will not always be possible to understand changes in styles, for example, as indicators of a change in the psychology or the spirit of people, certainly not within a whole culture. But above all, there is a difference of approach between the natural sciences and the cultural historian, who, in the eyes of Gombrich, is self-evidently a humanist. The first tries to discover by way of research, while the humanist's foremost concern is with knowledge and insight. He says, again correctly: 'It is more relevant to know

Shakespeare or Michelangelo than to do research about them,' although he does not wish to imply that studies in these areas are unnecessary – on the contrary, Gombrich clearly rejects all amateurism.

But the most important conclusion is that he shows how essential cultural history is in our time: in order to make clear to the student of today in what manner people in earlier times used to think and work. He states that people used to not speak about the great authors and artists at university, simply because it was assumed that everyone knew them and could understand them because they belonged to the same culture of which the students were also the bearers. Today however, also because of the radical revolution we are experiencing, this is no longer true. 'Our past is moving away from us at frightening speed, and if we want to keep open the lines of communication which permit us to understand the greatest creations of mankind we must study and teach the history of culture more deeply and more intensely than was necessary a generation ago.'

It is obvious that we regard this little book as a very important contribution to an unavoidable discussion, and that everyone who is concerned with history and therefore also with culture should read this short but profound study about the presuppositions of all cultural-historical notions.

Naturally I also have some reservations, and I could expound my own insights, but I feel that this review to announce the book is more to the point for the time being.

An Unfinished Manuscript

1 Communication and the visual arts

Introduction

In the beginning of history God placed people in his creation. It was then up to them to orientate themselves, to get to know that world, to use its possibilities, and 'to tend the garden', i.e. to take care of that world as far as it was within their possibilities, and therefore also responsibilities. In short, they had to orientate themselves within the creation and gain knowledge and understanding. For there is very much that is uncertain. People cannot attain absolute, certain and true knowledge and understanding. Their work is human and therefore fallible. It is always open for discussion, and is always, to use a term of Popper's, 'falsifiable'. True, people have more at their disposal than only their senses; they have their humanity, in which they have, one could say, an affinity to this creation – they belong to it, and are also a part of it – and God has not only revealed himself to humankind, but in so doing has given people a key to understand the main principles of this creation. But much, very much, has been left to us humans to discover, to study, to form, to discuss, and to try to understand. In this sense all human knowledge is always *a posteriori*, after the fact, and never *a priori*.

In a way our discussions concerning reality, our arguments in the quest for knowledge, are intrinsic to our humanity. The history of human thinking – in philosophy, science, literature – and of human looking – or in a wider sense the use and knowledge gained by the senses, as recorded for example in the visual arts – is humanity's spiritual history. Of course we do not just talk. It is peculiar to people to be creative, to use what they know, to work with their knowledge in the world. And of course their successes and failures too form part of the discussion of the ages. Through all this, and in the midst of this, we humans give form to our lives and institutions and techniques, and also specify our vision of reality.

Philosophers and artists are active with reality in a special way: the former speak in concepts and theories in which they formulate their thinking in order to communicate and to offer it to others for perusal, verification, discussion and new thought; artists formulate their thinking in their images, their portrayals, their representations, in the way of artists, of course – and as such it is open for discussion as well. Art, in a way, is for discussion; and to look at visual art – or to experience any form of art – is never only a question of the individual in front of the work of art, never passive, but always a dialogue, no, a trialogue, in which the beholder enters into discussion with the other about the work of art. You may even expand this further: in a way, looking at art is always a

discussion in which at least four are involved, even if two (or even one) are actually present: the artist, the work of art, the viewer, and a fellow human viewer.

As this book is devoted to a discussion mainly of the visual arts, we shall restrict ourselves in specific details in what follows to painting and, sometimes, sculpture.

Now it is interesting to realize that whoever a person is, a philosopher, scholar, scientist or just an 'average' human being, who cannot but follow the ongoing discussion and in this way also be influenced by it, he or she cannot think without the arts. Especially the tie to literature will be always greater than we think, but here we will restrict ourselves to the visual arts. If a thinker is thinking about reality, it cannot but be the reality he or she knows and sees. Often neither the philosopher nor those who listen to him or her realize that the reality they are arguing about is not a simple given, a neutral what-is-before-us, but that reality has been seen and as such formulated by the arts: the arts have opened their eyes. The arts express what an artist has seen, what he or she could and wanted to see, and as such the expressions are again fallible and open to discussion. Artists are philosophizing just the same though it is with their eyes and their hands: human eyes and hands, and as such tied to emotions and thoughts and experience. And they express themselves in their work just as clearly and unequivocally as in any other kind of communication. Each kind of communication – the philosophical, the scholarly, the literary or the visual – has its advantages and possibilities, and its limitations.

The question is sometimes raised whether artistic, and specifically visual, communication as found in the visual arts can be as clear as philosophical discourse. My experience has taught me that usually people who ask this question have already made two assumptions: first, they think that seeing is easy and that visual communication is direct and without problems. They forget that people need to learn to look, certainly to learn the different systems of visual communication, just as much as they need to learn to read or to follow a scholarly discussion. In short, they are too optimistic and think that seeing is something that comes directly – a mistake that evolves out of the seemingly direct and immediate way we see – but then seeing is understood too much only on the physical level of 'using your eyes'. The second error is related to the first one: they think that visual communication is immediate, in the sense that it does not take much time. But to look at a painting, say the *Last Judgment* of Michelangelo or *Nightwatch* by Rembrandt is like reading a book. First, it takes time simply to experience the different parts and really see them and secondly to see them in relation to one another. Most people look too quickly and think they have seen the painting, while in fact they have had only a very vague and superficial experience, as one gets by browsing in half an hour through a complex

theoretical treatise. The same can be said about the other arts, but that may seem more obvious to most people.

Seeing is not an easy and 'obvious' activity. It is not true either that we are tied to our senses in making contact with reality; it is not true that we can only know what we see. Seeing is much more than just 'using your eyes' and receiving perceptions. Rather, we could say that we see what we know.

That means also we do not see what we do not know. If I take a walk with a botanical specialist in a garden, an orchard, a wood or forest, I see only trees. He does not see just trees at all, but sees birches, oaks, this or that type of apple tree, this or that species of fir. He also sees all kinds of particulars – he will say, for example, that this is a very rare tree; while for me it would be just another tree. He sees what I do not see because he is a specialist who knows. He also sees certain benevolent or dangerous insects and other small animals, things we have a hard time detecting even if we are told to 'just look'. To make the issue broader one could say that all teaching means 'opening eyes' – making people see what they did not see before. And as we all know, that is not easy. We often want to look too quickly; we often look too easily, take it too much for granted. People are often sloppy and careless in their looking and therefore they miss very much. Even more sloppy than they often are in listening or reading.

We see what we know. And that knowledge is defined by traditions – our looking-traditions – and our insights. Philosophy and scholarship and science have contributed to it, and all the teaching we have had. We see what we know. That means also that in looking at pictures the artists teach us to see: they communicate the things they have seen. As long as our knowledge is less than theirs, we learn from them. If we know more, say about ships and sailboats, we can detect their mistakes in the pictures, things they did not see because they did not understand them. Because nobody can paint that which he or she does not understand. They cannot even copy it properly, as has been proved over and over again in the history of painting and drawing.

But, one might say, if we can see only what we know, we are limited by our knowledge. We can never see more than what we understand. That is true to a certain extent, but not completely. For, as human beings, we have our creativity and our imagination.

The human way of seeing is far from mechanical and 'obvious'. And someone could add, as we in our thinking reflect on the world as we know it, i.e. as we have seen it – because, as we have said, the world is not a simple given, but something to which the artist through visual communication has opened our eyes – we are really caught in a kind of restricting cycle. We see what we know, and that knowledge is bound to seeing, even if that seeing is not restricted to the strictly physical act of using our eyes. In this way we would be kept altogether within a small boundary. But such is not the case. We do see, and can see, creatively.

Locke and many others have thought much too naïvely of seeing and perceiving: as something obvious. But they have not realized that seeing and thinking are intertwined, and that the seen reality is not always just the same.

Maybe it is good to think here for one moment of the concept of space as we find it used by Kant as a category. The question is whether we can say that this space is space that is the same in all times, just a given; or maybe it is much better to realize that space as such has a history – whether of discovery and realization or just one of formulation and definition we can leave undiscussed at the moment – and that modern space was defined at the end of the Middle Ages, and was given its formulation by the arts of the Renaissance in Italy. The 'perspective' space of the Florentine artist, as first written down by Alberti, was not just a 'scientific' discovery of a method – even if it was also that – but it was in the first place a new formulation and understanding of space as a human construction. There is more to the slowness of the Northern artists to accept this new way of constructing space in their paintings than just ignorance – in fact, many of these artists were too sophisticated and too great to apply the word 'ignorance' to them. Rather, there were all kinds of deep problems of understanding and interpretation at stake, religious as well as scientific. Anyhow, the new way of understanding space – of which we read in art-historical literature – became history. So, in the Middle Ages scientists studied optics; optics was used and formulated more precisely in perspective space by the Renaissance artists and mathematicians, leading up to the new understanding of space as we find it defined for example by Descartes as *res extensiva*, and in this way it became our modern understanding of space. This is the space Kant speaks about. He thinks it to be something *a priori*, belonging to the very structure of reality as a category, but in fact he only follows the definition of space as formulated by the arts at the moment that the new era began – a formulation that was in fact very much a part of the newness of the new era. Space is something God created, but people in their thinking and seeing discovered its peculiarity and defined that. Is the Renaissance-Cartesian-Kantian definition the right one? Is that the only way to understand space? Who knows?

But let's turn back to our argument. We are not limited in our seeing and knowing in the sense that the one is so dependent on the other that there is no way of widening our horizon of knowledge and of seeing. Quite to the contrary: to be human is to be creative and to have imagination. If we see, perceive, look intensively, we use our imagination – in fact, we cannot do it without our imagination – and by this means we discover new things, new facets, new elements of reality. We look creatively, that is, as discoverers, and with our imagination we begin to discern structural relations, principles and details that we missed before. To look creatively is to use our imagination, as Hugo of St Victor, the great philosopher and aesthetician of twelfth-century Chartres already

argued. When biologists look through the microscope at a cell, they must use all their imagination to see the structure, understand how it is built and how it works. They may construct a hypothesis with their imagination of how it might be like this, and then see whether that fits and answers their perceptions and experience, and if it does not, they imagine another set-up. Art historians have to look creatively with all their imagination, in order to discern new things, details, relations in paintings that so many people have looked at before and maybe did not see. The interesting thing is that, as soon as they have discovered something new, so one knows what to look for, it is impossible for anyone not to see it. In short, then one simply sees it. Creative imagination is needed to see what is possible to be seen, what has always been there, waiting to be discovered. Of course, our imagination can turn loose and lose its contact with reality, so that we see ghosts, or our imagination can become fantasy, creating fantastic beings like dwarves, gnomes, dragons and what not. Even that may have a function in human history and art and understanding, in myth and fairy tale, which as such is also open for debate; yet we do know that the direct ties with reality are lost and that we therefore have imagination here cut off from seeing and knowing.

So people are on their way, discerning their world and trying to understand it, explain it. They work towards widening their horizon and formulating their experience. But they are never certain. Everything is relative – nothing is absolute and certain here. Quite obviously, as everything exists only in relation to the Creator who made it all, it is God alone who is absolute.

People, particularly modern people, have looked to scholarship and especially to the natural sciences for certainty, true knowledge, of what they call objective truth. But indeed, as far back as Descartes it is doubt and dissent that have methodological priority. Just because everything is relative and no absolutes can be found within created reality, no certainties can ever be found this way. Everything is questionable and each insight is open for discussion, for reappraisal, and no theory can be found that cannot be challenged, some day, and usually is. In fact, as far back as the time of Solomon, in Ecclesiastes, people knew that everything was vanity, and all human knowledge perishable and temporary. What is left of the wisdom of Moses? Apart from what we read in the books that bear his names, we don't even know what his knowledge was about. Indeed, all our interpretations, formulations, and insights are relative, and no certainties can be found amongst them.

Many things are certain

Descartes searched methodologically to find at least one certain point. He thought he found it in the formula 'I think, therefore I am.' This starting point has been challenged and is still very much in discussion. How could it be otherwise, as it was a human search for certainties? In one way, Descartes was right: he was thinking, and there was no reason

to doubt his own existence. But he was wrong to think that only this was a set and sure starting point. In this sense there are no absolutes in this world, in which everything is relative. Yet in another sense he was right: he had no reason to doubt, as we, even after more than three centuries, do not have to question the reality of his thinking, his being. I even should like to add that there is no reason to doubt that Descartes ate – he ate, and therefore he was! – nor that he had feelings, that he talked, that he stood for righteousness, that he believed – yes, he did believe in God even if he failed to make that very God his starting point and the only absolute. Yes, he even thought it necessary to prove that God did exist, as if we from the point of our createdness can prove our Creator. Even if we speak of Descartes and his works there are many certainties. There is no reason at all to doubt that he did live, write, simply was. If not, how could we ever understand that he had such an influence? Or should we try to demythologize Descartes, as some people have done with Abraham and other people in the Bible?

No, there is very much that is certain, even if not an absolute, for us human beings. You, reader, do exist; otherwise you are not reading this passage. You do understand English, otherwise you would already have closed this book or probably never have taken it in your hand. It is certain that we are human, and that we live in this world, that trees are green, that the sky is blue, that in certain circumstances there is a rainbow, that there is a moon. Our interpretations about these things are open for discussion, our knowledge of these things is limited, our seeing of them is often only partial, and we cannot build up any certainty starting from our mind, or our feelings, or our perceptions. But we do have to accept the order of the given structures in this reality in which we live, which we see and can think about. We do not live in chaos but in an ordered reality, which is given, as it is God's creation. Even if our thoughts are sometimes chaotic, and even if we sometimes – or maybe often – do not understand how things are built, interrelated, and can be accounted for, this reality is still there, certain, as it is founded in God and his promise not to alter it, which was his covenant with Noah, of which that very rainbow was to be a sign and a token. That reality itself is the touchstone of all our thinking and all our interpretations; it is what corrects our theories when they don't fit 'the facts'. Our theories must be in accordance with given reality; otherwise we have to change them.

Descartes and so many others who have been looking for a completely certain starting point – but they are wrong, for reality is always relative – just passed by the very certainty that they were human, that they lived in a world, and that things were, as such, of an order about which they could think. They turned things upside down: the world in which people have been placed and about which they have to think was questioned, while human insights, which are questionable, were the place where they looked for certainties. Yes, the people of old were right: vanity of all vanities, to look for certainties under the sun is

like chasing the wind. But reality as such is not a question mark, and the cosmos, this world, our being, humanity itself, is not vanity but has meaning, a meaning we cannot destroy, even if we make theories that pretend to do so. What is love? Can we explain love? Some people have said love is an illusion, it does not exist, it is a nice but misleading human notion – but these very people hunger for love, and men and women still fall in love, and love is still the subject of ever so many poems, novels, songs, paintings etc., and the absence of love, in hatred, is painful, destructive and the very denial of our humanness.

People would stop thinking, even would not be capable of thinking were there not the certainty that there is a reality worth thinking about, unchangeable enough that if they say something today about a subject they can discuss it tomorrow and check their theories and their thoughts. Happily, neither mountains nor love disappear even if people in their foolishness try to think them away, explain them away or deny their existence. This is so certain that it is almost absurd to state these things. Yet, so much philosophy, beginning with Descartes, has questioned any ontology that was not based on an epistemology. But how can we make a theory of knowledge if there isn't a reality to think about and our knowledge is so small that we do not have any ontology? Some people have said that they, these philosophers, always smuggled some ontology into their epistemology. But what I am saying is that being is certain, not ontology, which is a human endeavour.

All our seeing is coloured

If we have understood the two theses above, it is obvious that our seeing experience, being closely tied to our knowledge, is never simply objective or the same for all people in all times. Seeing in this sense is much more than just the use of our physical eyes, even if it can never be without that. As our understanding and knowledge influence our experience, our perception, what we call seeing, it is obvious that our subjectivity is fully engaged in our relation to the outside world. Who we are plays a role in what we see. Our interests, our commitment, our past training, our life experiences, where we were, what we studied, the people we met, the influences, negative and positive, we have been exposed to, the time in which we live, the group with which we engage, our ideals, our insights, in short the totality of our personality is in some way or another 'in' our seeing: we see differently, we see different things, we perceive with a different focus. It is obvious that an art historian looking at a painting sees different things from somebody who as a tourist looks at it for the first time and is barely interested. If you go somewhere for the first time, you see things differently from when you have been there more often or if you have lived there all your life. You see the empty place where the house of your good friend once stood which was destroyed by fire, while somebody else barely notices the open space.

Yet this does not mean that we are trapped in our subjectivity. The reality outside is the same, in the sense that it is a potential reality that we can discover, for which our eyes can be opened. Nobody can just at random see what he or she wants to see, even if wishful thinking may sometimes lead us astray. But then we are soon called back to reality, as the wishful thinking does not fit real experience. We cannot manipulate reality in our experience – if we try to, we end up banging our heads against the walls of real reality. So even if our subjectivity can never be overcome, we don't have to fall into mere subjectivism. But neither can we ever really think of objectivism: reality as it is without our perception and experience of it can only exist as a potential reality, but before we engage in it, it has no meaning. Complete objectivity, like complete subjectivity, ends up in meaninglessness, the loss of reality.

We can try to make this clear with a metaphor. Our experience of seeing and understanding is as different from somebody else's as tea is from coffee. If we compare people's experiences in this respect, we can liken them to tea, coffee, wine, lemonade, etc. The reality of each of these drinks is very different in taste and in colour, even in their social meaning. Yet these differences are in reality small. All these drinks consist mainly of water and just a few per cent of whatever makes them different. And so it is with our seeing experience: we all, being human, living within the same world, ruled by the same structural laws, have very much in common – that is the water. It is usually more than 90 per cent. But the colouring, the result of our personality with its specific history, insight and knowledge, in a way is the most decisive. But that makes up the need for discussion, the possibility of being one-sided, of being outright wrong or right in a deep sense.

The arts speak about reality, communicate the insight and knowledge of the artists, and in that we can see different emphases and understandings of what is considered relevant and what is irrelevant. Yet the arts refer to a reality that we, having a coloured experience ourselves, know and see too. We can understand the work of art – as far as we have opened our eyes to its peculiarities – and the reality it refers to, of which we know more or less depending on our personal history. Yet, whatever we say, even if our explanations are open to discussion, human, fallible, we cannot just say anything. It cannot be done at random. We are tied to reality.

Communication, even though it is coloured, refers to real reality

There is a really amazing, almost miraculous quality to communication. Even if the communicator, the artist, is speaking out of his or her subjective insight and knowledge, and even if we, the people who receive the communication, have our subjectivity invoked – without this we would not even be able to receive the message – yet, as we are both human and living in the same universe, even if at different times, we not only can understand the message but also can see the real reality that is behind it.

There is a real miracle here. If *A* sees a play, and *B* writes a criticism of it, and *C* tells me, *D*, about that, I can, provided that all tried to be correct and were not deceiving me, come to a conclusion about both the typical 'colour' of *C*, *B* and *A* as well as the reality referred to. If *A* deals with a reality I know little about, e.g. a social milieu I have never frequented, I am informed of it, even if it is hard to judge whether *A* did justice to it; if I know nothing of the typical bias of *B*, I may make mistakes. Of course, the case I present is very complex, and has all kinds of possibilities for pitfalls that may lead to more or less serious mistakes. Communication between human beings is difficult and may sometimes be almost broken. That is not because communication as such is impossible but because we are sinful human beings who deceive, who often cut off communication, who by the lack of openness and mutual love keep information hidden.

What I want to stress is that real reality, the reality that we all see partially and which always has potential aspects we have not yet realized, nevertheless is always there in our experience. And therefore we do not strive for objectivity, but for honesty in our expression, and for truth. Truth is the real goal – to say how things are, to do justice to all aspects as far as we know them, to see things as they are. To see the truth, to do the truth (John 3:21) is the ultimate goal.

The interesting thing is that we can only reach that point if we are committed to the truth with all our being. This means that we can never have more of it than when we let the fullness of our insights, our personality, be engaged. We do not need to be afraid of this. Others will see our commitment, have their own judgment of it, but will see, just because we did say the maximum we could say, the reality we were referring to. Absolute truth will never be achieved, as we are finite and human; but this does not mean that we have to settle for mere subjectivity.

I speak about these things because I want to deal with art, which as such is always the subjective statement of somebody – with more or less originality, more or less depth of experience, more or less understanding. I speak of this too because I know that I will always speak out of my personal position. But as I know that everybody does, and as I know that I can never be better than I am, while I know that only in this way truth may be found, even accepting that mistakes can and will be made, I don't think we need to be afraid of this.

There is one thing more to be said. Often people speak of the background of somebody's thinking. The titles of many books and articles incorporate the words 'faith and science', 'faith and culture', and so on. Of course what we described as the 'colour' of our seeing and thinking has a bearing on such matters. But we are very afraid of a kind of duality, a way of discussing these things as if two alien and separate parts of our humanity are to be brought together with some effort. Rather, and that's why we used the metaphor of tea, coffee or wine,

human being is one, and a person's faith or basic insights are not separate from his or her seeing or thinking, but rather they constitute the very direction of it. To see what we know means that our seeing is itself, to say the least, influenced by our experience and knowledge, of which our faith – Christian or non-Christian, of this group or that – is an intrinsic element.

Also, we should not think that we can talk in a static way of knowledge, seeing, experience, faith, etc. We are on the way. The discovery of today colours our experience tomorrow. So what counts is the direction we take. The road we set out to go. To be human means to be committed, and to have faith means to be committed to the cause of our Lord, which is a decisive factor in the Way we take. Of course, others have their faith and go their way and that will be evident in their commitment and, finally, in their seeing and thinking. This should not make us wary. We are human and this is the way it is. Truth is not in us, neither in the other, but in the Lord we believe in, in the direction we take. There are many gods, but only one true God. In him is the Absolute – the foundation of all truth. And truth is the final aim of all human endeavour.

Revelation and the Bible

In orientating ourselves in this world, we use our senses. But we soon understand that the senses as such are not enough. There is more than the eye can see. This simply belongs to our humanity. Love, righteousness, beauty, truth – and also their negatives – are real, very real, and yet cannot be seen in the strict sense of that word. But even if we accept these we soon come to the horizon of our human experience, yet knowing, or at least supposing, that there is more – something *beyond*, something we cannot explore with our senses and thinking, even though we understand that this more is very important, also for understanding the here and the now. So we see that all humankind have taken hold of ideas about this 'beyond', about gods, demons, etc.

In old Israel, and after Christ also in the Christian world, the Bible has been accepted as God's revelation. What is revealed? God himself as the Creator, the triune God, who behind a veil, as it were, leads this world to a certain end. History is not random and is not in vain. So in the revelation of God we also see the revelation of the meaning of this world. In the revelation of God's will for our lives we also understand our calling. The Bible teaches us much more than only historical facts of God's dealing with people – it shows us that God is really acting in history, still today. But even more, it teaches us to think in terms of an open sky, in relation to those things unseen and yet of primary importance for us.

Those things cannot be seen or proven? In a certain sense, yes, but a Christian would answer that it is not God who has to be proven. Rather, we are the ones who are to be tested. In another sense, no, for God

himself asks us to prove him. The Bible does not teach us religious realities of mere spiritual meaning in a narrow sense but shows us how God has acted in history, in very very real circumstances, proving God's existence and, more, his interest in us. God asks us, nevertheless, to put him to the test (read Malachi 3:10). There is nothing irrational or fictional in Christianity or in the Christian life – Christianity, taken as it ought to be, not how it often is, but that is an old story, as the complaints of the prophets in the Old Testament make clear.

The reality of the biblical revelation belongs to the section that we headed 'Many things are certain'. It speaks of the things we can know, things that present themselves to us. Our interpretations of the Bible, our understanding of it, and certainly our theories about it may prove to be very uncertain and fallible.

Of course if we only accept those things we can see or understand with our brain, those things we can control in this way, the Bible is in principle nothing but religious fantasy. So-called higher Bible criticism has demythologized the Bible, robbing it of its revelatory character, a result that should not surprise us if we understand that the critics' outlook is so coloured never to accept anything that is beyond their direct perception. But the question is whether that principle is also totally followed in matters apart from the Scriptures. For instance, the faith in reason and the senses lacks all proof. No wonder modern people have begun to talk about the absurdity of being and a discontinuous universe, even if the very testimony of their own lives may go contrary to this.

Visual communication

I have been speaking about communication, also in relation to the visual arts. How do these communicate? What is the nature of visual communication?

Just as in language we use sounds, so in visual communication we use lines and colour. So if we draw a little circle – o – we have something equivalent to the sound 'o' in language. It does not mean much yet. But if we add other sounds to 'o' it becomes a word that can communicate meaning to other people: top, mop, soft, on, toe, etc. In the same way we may add little lines to the one little round circle, and then it can become an element of visual communication: the circle can be a wheel of a car or the iris of an eye or a drop of water or it may be used as a letter in written language, the very 'o' we used here.

There has been much discussion concerning the nature of visual communication, whether it is mimesis, a kind of copy of the visually given, or otherwise. Particularly, semiotics has been engaged in this debate. But I think we had better start from the assertion that visual communication and spoken communication both proceed in the same way, to a certain extent. There is spoken language, and there is visual language. The relation between the word 'grass' and the green things on the turf is the same as between the little green lines on the painting and

the green things on the turf. These little green lines only become 'grass' within the context of the total picture. And so do the sounds that make up 'grass'. In some cases we can only know what the word stands for in the total sentence or spoken context.

It is true that we can say things with words that we can never express with visual language, e.g. this book could never be done only in visuals, but we should realize that there are things we have a hard time describing with words that can be very easily done with visual communication, e.g. a portrait, a map, the depiction of an anchor, etc. That is why technical works are always illustrated, and a machine can be drawn but not adequately described. Both means of communication have their advantages and disadvantages

I guess that the reason why there has been so much debate on the nature of visual communication and why 'portrayal' and such words have been used is that so much of the visual arts we know are naturalistic in scope. This means that at least to a certain extent the artists have tried to describe in their works the things as one sees them. Or at least as they and their contemporaries saw them. But though it may be true that in the visual arts this is not as uncommon as onomatopoeia is in spoken language, yet it is only a borderline case. A great deal of visual communication, even today, is not naturalistic in this sense. We think of maps, diagrams, visual aids, traffic signs, etc.

If it is not true that there is portrayal, a kind of imitation of the visually given, in visual communication, what then is the nature of visual communication? To me it seems that the artist, or whoever makes a visual 'word', describes the structure of the thing. So a stick figure may stand for 'person', even if in that little drawing there may be nothing in any way equal to any real person we see – a few lines on a flat surface, without colour, depth or detail. But it is the very simplest structural resemblance that makes it if not a beautiful, and certainly very rough, yet a clear depiction of a human being. If we tried to put the horizontal line depicting the arms in the place of the legs we would 'deform' the person or turn the person into a monster and make the drawing totally unintelligible. The structural relations of the parts are depicted in the image. This is different from spoken language, where such a relation between the word and the thing denoted usually does not exist. But this is at the same time the reason why visual communication can explain things to us that we have never seen, while that is so difficult in words.

The visual arts

Certainly visual communication is an integral part of much of the visual arts, yet these two are not identical. In the visual arts we may find many visual poems, but just as a poem is more than just words – language is used, but a poem gives more than just spoken communication – so a painting will not be understood if we take only visual communication into account. There is also another use for lines and colours. They may

embellish things, they may beautify. There is a use of line and colour in a decorative or ornamental way, in which nothing is depicted. Such decoration can be beautiful just because of the relation of the colours and the lines, maybe mere patterns. We think of patterns on blankets, cloth or carpets; we think of the ornaments on buildings, picture frames, utensils, etc. We do not like to call these patterns abstract, even if they do not depict anything; if done well they usually underline and strengthen the structure of the decorated thing. They are real, even if non-figurative. Of course, there is also much figurative decoration: plant and animal ornaments, patterns on cloth made up of figures, cars, etc. Letters may be used in this way, too: they are letters, and as such denote something, even if used only for their form qualities.

But we need not restrict ourselves to the so-called minor arts to find the non-figurative. There is also much art that is non-figurative; we find non-figurative elements even in idols and such loaded images. We think of the lingam in Indian temples, and stones and such in primitive religions used as representative of the god, e.g. the Kaaba in Mecca.

So we find that the visual arts exist in between two sets of extremes: the first set is that of the purely decorative on the one hand and the loaded image, the idol, on the other hand. The second set is that of the purely formal organization of lines and colours, the non-figurative, on the one hand, and the very precise depiction, the naturalistic portrayal, on the other.

In this, there seems to be a hierarchy that we all accept and understand immediately. So we could see a small painting or sculpture and know that it stands for something very important. It has a quality that I like to call the 'icon'. It stands for something – in idolatrous religious use the icon becomes the idol. It is loaded with meaning. So, for example, the *David* of Michelangelo is an 'icon' – it stands for Renaissance Florence, it is a strong confession of faith in humanity. A particular case is the Byzantine icon, the religiously loaded Madonna picture. But the Statue of Liberty at the entrance to New York harbour is also such an icon. Sometimes we see that such an icon, if it is small, is framed in a decorative setting to enhance its importance. In that decoration there may be heads, animals, etc., sometimes even larger than the icon itself, and yet subservient to it. Size is not the final carrier of meaning.

The decorative may be extremely naturalistic, the idol non-figurative. Most works fall within these two sets of extremes and can be defined as such. Sometimes the meaning is complex and many-layered. A church portal, e.g. in Gothic times, may be decorated with sculptures – usually coloured, originally – to emphasize the importance of the building, to set its scope, to indicate the entrance. We can, but need not, look more closely: we see figures and stories depicted. We try to understand what they mean and we may find them to represent

saints, Christ, Mary, biblical and other sacred stories, etc. And we may see that these stories and figures are arranged in an order that tells us something about the particular importance of this particular building, embedded in a particular theological and philosophical system. So there are several layers of meaning which may vary from the decorative to the deeply iconic.

The meaning of the arts

In speaking about the visual arts we have unavoidably already spoken of their meaning, sometimes deeper, sometimes more superficial. The artistic belongs to humanity – the fact that art is found is one of the sure signs of human presence, e.g. in studying prehistoric sites.

It is a specific human quality, and as such there cannot be any external justification for the arts. God laid the possibility of the arts in reality, and people have realized this possibility, in creative freedom within the structures belonging to creation. The arts have meaning or, rather, the work of art has meaning, just as a woman, an animal, a tree, a mountain, a river or a flower, has meaning. It is not we who give the meaning, nor can this meaning be accounted for by analysing its functions and uses. Nor does its meaning derive from the fact that we may sometimes give these things a signifying use, that we for instance may give a flower a symbolic meaning. Of course a tree, for example, has many functions – birds can sit on its branches and nest in it, the cows can look for shade beneath it, the leaves produce oxygen, the wood can be used, when in bloom the tree is very beautiful, etc. But these functions, even in their totality, do not make up the meaning of the tree. The tree's meaning is presupposed in this analysis of its functions. And the tree's meaning is more than its functions – even when some or many of these are lacking, the tree still has its meaning, but this meaning is not autonomous, something in itself. The tree is relative to the God who made it and placed it in the total context of this universe.

So the arts fulfil functions: decorative, religious, social, symbolic, economic, structural; but these can only be understood because the arts have meaning and the existence of the arts is presupposed. Nor can the arts be autonomous. They are tied with a thousand ties to reality, exactly in these functions in which they are used. The interesting thing is that the more useful and functional the arts are, the more they are meaningful in themselves – and conversely, if we make the arts autonomous and great in themselves, they lose not only their function but their meaning also begins to wither. As we will see, these notions are quite important to understand something of the dilemma of modern art. But it is equally important to realize that when we speak of paintings etc. in the following pages, usually these works were made with a specific use in mind, they were book illustrations or altarpieces, etc. We often look at them as things cut loose from these connections, but we should

keep in mind that they were not conceived as autonomous works of art, and the artists did not see themselves as makers of something high and autonomous. Art was concrete and real, centred in life, sometimes geared for the many, sometimes for the few, yet at the same time fully connected with spiritual and material values.

2 Art of the Middle Ages, and the beginning of naturalism

The beginning of the Western history of art

I am not writing a textbook, nor do I want to give a fully comprehensive picture of the whole development of the arts. Therefore it is enough to say that – even though Christian art began in the Mediterranean region in the first centuries and found its first high point in the fifth century in Rome and Ravenna (and in the Byzantine world, which we shall also keep out of discussion) and even though this art, after some centuries of utter confusion caused by the great migration of Germanic and other tribes, started again in the Carolingian era, to be almost swept away again in the struggle against the Norman invaders – as far as the Western world is concerned the history of the arts began somewhere around the year AD 1000, when Europe had come to a relative rest and culture could start anew, when there was time for thought and work beyond the bare necessities. The new art did not fall out of the air, but was based on the achievements of the Carolingian and previous periods. Let us start by looking at some of the best works of that period.

A title page of the Gospel of St Luke. The artist who made this is unknown to us, that is, we do not know his name. But he was the genius that defined the new style that we call Ottonian. This work, one of the really great works in history, can be described as follows: the large figure is Christ, sitting on the rainbow and surrounded by the mandorla, i.e. a kind of super-halo to indicate his deity. From his feet flow forth the streams of life – he is the fountain of life – from which the deer are drinking – a reference to Psalm 42, which is also quoted at the bottom. On his knees are the books of Life. He holds up a structure in the middle of which we see a winged ox, the symbol of the gospel of St Luke and above which we see St Luke himself with a scroll in his hands. Around these we see Old Testament prophets – their names are inscribed – who have prepared the way and prophesied the things written in the Gospel. From St Luke and the prophets light rays stream forth, as the Gospel is a light on a stand shining in this world. The whole is set in a decorative kind of triumphal arch. There is a golden background, denoting light, which is the presence of God, so that all these things are embedded in God's reality.

Of course everybody will understand that the things we see here are things nobody can see with their eyes – and it has never been seen in the past, and will not be seen in the future. Yet that does not mean that this is sheer fantasy, or that it is not true. For those who were involved in the making of this – the person who commissioned it, the person who advised on the representation (the iconography), the artist himself and those who saw it in those days – there would be no discussion: this was true. And for Bible-believing Christians today this truth is still obvious. For that reason nobody feels that there is anything wrong in this depiction in an almost non-present space – what kind of space would that be but the 'golden' presence of God – nor will anybody criticize anatomical or other features of this representation.

There is no doubt that the Christians who were responsible for this type of art, or rather, whose insight and faith were expressed in this, had a mystical view of reality. Ladner has suggested that they were followers of John Duns Scotus, the great mystical philosopher of the Carolingian era.

At the beginning of Christianity, believers were rather reluctant to make use of images – they had seen too much misuse of these in the idols of the pagan gods around them. But after a while they realized that, even if idols were to be avoided, religious art was legitimate because of the Incarnation. Irenaeus and Tertullian both said that is was possible 'for all men to be represented in art, for man was not only created in the image and likeness of God, but also renewed, reformed in the image-likeness of Christ, who as the perfect image of God had nevertheless assumed a human body'. So they only tried to represent the human or physical nature of Christ and human beings. This was, in the early centuries, the general view. But another view was slowly gaining ground, the view of Clement of Alexandria who said, 'The image of God is the divine Logos, but the image of the image is the mind of man.' So here it is not the human appearance, but the inward mind or spirituality in which the likeness is looked for. Augustine worked this out in an analogical way, stressing even more that the likeness is not outward. For us, as I said, John Scot Erigena can make clear the kind of thinking that was behind the type of painting we are discussing. He also stresses that the likeness spoken of in the beginning of the Bible was a spiritual one, but he goes further in that he considers the body itself an image of the divine image in the soul. So the body is seen as a transparency of spiritual realities. If we look again at our miniature, we see that the figures are, as it were, themselves light-giving – which refers to their spirituality – and that there is no natural light that creates shadows.

A miniature showing the resurrected Christ and Mary Magdalene. This picture has a red background. In another book of this period we see a similar composition of the same story with a blue ground. Red and blue are interchangeable, and as such do not mean much: the ground is not just the ground of painting, but also stands for space – as do the broad

bands in the next example we shall discuss. This is space more in the sense of the realm in which the story takes place. Medieval people did not yet see this world in a continuous and infinite space but saw it rather in a discontinuous and finite space; they looked for the qualitative, not for the quantitative, for the substantial and not for the functional.

In the same way, it is not the exact outward appearance of the figures and things depicted that is of primary importance but their meaning in the story. And this is portrayed through the means of visual communication, with figures that are clear and precise in their mutual relationship, even if they are not naturalistic. We may say that we see a symbolic tomb, a symbolic tree, symbolic figures, according to their meaning and importance, not their outward appearance. So we can understand this composition, with its very restricted pictorial space, with its depiction of the figures in different scales according to their hierarchical values and importance.

Just because of this, as they depicted realities according to their relative meaning, but did not think reality restricted to the visual or physical, or to outward appearance, these artists could depict without problem the grandiose visions of the book of Revelation, as we see in *The Whore on the Beast* from the *Apocalypse of St Sever* from Southern France from around 1100 or, out of a book from Limoges from the same period, the magnificent depiction of the *Descent of the Holy Spirit*, or rather, the outpouring of the Holy Spirit by Christ. Note that the background is blue, which again has a low representational or symbolic value, meaning realm or space, and is just a ground of depiction. The arrangement of the figures: Christ in the upper level, as in majesty – just as in the St Luke picture we discussed, out of whom the Holy Spirit emanates – an important dogmatic notion – and the apostles and Mary on the lower level, requires no explanation or justification.

A strong spiritualism is inherent in these pictures. The spiritual is almost the only thing that counts. It is not surprising to find that in thought and action there was much mysticism in this period. We think of Bernard of Clairvaux, of Hugh of St Victor. But aside from this mysticism there were many who rather than stick to a deep-seated intellectualism turned to the realities of daily life, while others tried to find true knowledge about the world around us in empirical investigation. In fact, praxis, mysticism and empiricism were reacting against a too intellectual philosophy that was at the same time unable to really answer the questions thrown up by the more extreme people, about whom we hear complaints without their names being mentioned or their theories expounded: rationalists, people who wanted only philosophy and nothing more, and who only wanted to believe what they could prove and understand, even materialists and nihilists. But these things were still at the margins of historical reality, though it is clear that there was a marked interest growing to know the world better, to understand its structure and make-up. In Chartres and in other places

we see a new growing interest in science and in the study of nature. Certainly this was also true on the level of a wide spectrum of people apart from the scholars and monks and such. And so we see in the twelfth and thirteenth centuries a growing interest also in depicting things in a more natural way. There was no break in art, as this new tendency slowly emerged out of the very strong, expressive art of the Romanesque period.

We see, in the growth of the Gothic style, particularly taking place in the middle of France, how the sculptures at e.g. the portals of the churches or the Madonna statues or the smaller figurines that adorned the reliquaries (particularly from the Meuse region) became more and more natural in their proportions, how the clothes got more naturally falling folds and how they began to take up more space, and to free themselves from the decorative units, and to be 'in the round'. The tale has been told over and over again in ever so many art-historical books.

But it wasn't only the outward appearances that mattered. If we speak of nature, we should not restrict this to the mere physical and biological. Human life in its manifoldness began to attract ever more attention. Humanity itself gained more interest. Aside from – and more and more instead of – the Christ in Majesty, the grand Lord, the supreme Judge, the fearful Master, we see Christ taking a more human form, as in the *Beau Dieu* of Amiens. And still people were very interested in the meaning of the things depicted: if they were interested in their nature, then not just in their physical external appearance. So the shift was not to naturalism, but to a more natural portrayal: less expressionistic, elongated figures, but proportioned more as seen, with more and more precisely rendered details, and soon also a kind of courtly elegance.

Also in the miniatures we can follow this slow direction towards a less symbolic and more natural rendering of the figures, which also gain some depth, some space to move in. Yet, the red, blue or golden backgrounds remain, and buildings and such elements remain very simplified or abbreviated, more symbolic than real.

What happened was not a break in the development, namely towards naturalism, but rather that figures (and to a lesser degree also animals, trees, houses, mountains, etc.) were depicted with more natural detail: a naturalizing of the symbol without taking away its symbol-quality. As Ladner has formulated it, 'in the preceding centuries spiritualism had striven to devaluate the body, now it began to penetrate it.'[551]

The story of the gradual conquest of the natural in the rendering of figures, stories and, slowly following, also the surroundings, the buildings, rooms, trees, etc. is fascinating. It is not my aim to retell that story or add many details, well known or new. Just a few examples, in order that we, I hope, understand better the implications of what follows, and for that reason also, a few striking features.

Italy entered the scene a bit later, with the Pisanis, Cimabue and, above all, Giotto and Duccio. Giotto's main work has happily survived in the exquisite frescos of the rather small Scrovegni Chapel, painted in the years immediately after 1300. A few things must be said. Following but surpassing Cimabue was Cavallini, who due to a strong influence of early Christian, i.e. fifth-century Roman, mosaics gave to his figures much weight and volume. They are really in the round. This also applies, even if to a lesser degree, to the mountains, trees and buildings. They are usually smaller in scale, and retain much of the symbolic and abbreviated character. In a way we can speak of a naturalization of the represented things, such as the mountains of Giotto which are directly following the representation of these in the older Italian and Byzantine art, but which also have more volume and naturalness even if we cannot see them as inspired by real mountains or rendered as such. Naturalism is still far away. We also see that Giotto uses the blue ground, as was often found in early Christian mosaics, and also in earlier Italian art and in miniatures. If we connect the blue with the sky, we can do so but must be aware that he also uses it in cases where there is no sky possibly meant, and that blue 'means' sky in a symbolic way but is never a natural representation of it. The blue is the ground upon which the representation is built, even if there is now more depth and space. These frescos are as it were a kind of virtual boxes in which the stories are depicted, which take place in front of the ground.

Important to note is that Giotto and the artists who followed him, some of whom were very interested in the rendering of the natural world and of space, such as the Lorenzettis in Siena, never used perspective in the sense we know it. Their perspective, the rendering of depth and space, was done with a very intricate system of lines that were placed softly oblique on the surface so that we get receding lines that nevertheless do not break the surface too much. Where there are orthogonals, like in tiled floors or in ceilings with beams, the lines never recede to one point but to a vertical line. White, who has called this type of perspective 'synthetic', has tried to show, following Panofsky, that this type of perspective in a way is more natural than the later mathematical perspective as it appears in reality to us when we are looking around.

Nature and grace

This enlarging of the experience and interest of people to encompass also the reality of the world outside them was a gain. Too long theology and philosophy were only geared to strictly intellectual problems or the analysis of mystical experience, in both cases more concerned to develop a rather abstract theological system than to deal with the problems of the realities of this world. But as those systems were very well developed, the new interest could not be fitted in. Christianity, that is the life of faith and devotion, was as such almost outside of 'the world'. Those who sought to deal with reality and to get insight into it had to look

elsewhere. They found it soon in the newly rediscovered work of Aristotle. Great problems came out of this, and the thirteenth century became the age of scholastic philosophy that tried to solve them. Albertus Magnus and his famous pupil found a solution, in a way a rationalization of the real situation, in the dualism of nature and grace. The two great traditions that worked in medieval thought, the theology of grace, founded on the Scriptures and the work of men like Augustine, John Scot Erigena, the mystics of the twelfth century on the one hand, and the sciences that were introduced through contact with the Arab world, where the ancient knowledge of the Greeks was preserved on the other hand, were united in this system in such a way that Christianity had seemingly won the battle and tamed the troubling adversary. Of course these great philosophers, whose work we cannot try to summarize here, tried to find a unity in the duality. But the centrifugal forces were too great. The tension between faith – as defined by theology – and rational knowledge (or maybe it is better to speak of rationalism) starting from human reason and the senses could not be bridged, and the two were disunited more and more. This even led, in the fourteenth century, to a theory of the dual truths: what was true in the one realm was not necessarily true in the other, and also the other way around. The sciences were worldly philosophy, and theology became more and more unreasonable faith. The fourteenth century is a time of doubt: the very strong and deep intellectualism of the system of Thomas Aquinas was found to be too daring, placing too high a stake in human reason. In that time the truths of the church, the dogmas, were not denied, but they were thought to be unprovable: people believed them, but did not accept them as true.

If the system of Thomas put the two fields in a hierarchical order, already in the great literary work of Dante they were placed side by side: God had destined humanity equally for a worldly and a heavenly blessedness, and to the former people were led by the state through the natural knowledge of philosophy, and to the latter by the church through revelation.

This was probably the practical way in which the common people, who heard of these things from afar – with them we can count the artists and their patrons – understood these things.

We see in fact a dual way in fourteenth century culture: on the one hand an ever growing interest in the depiction of this world – the landscape, the portrait, and an ever widening pictorial space belong to the achievements of the arts – while on the other hand we see a fervently mystical tendency, in which the truth of faith was exalted, the Virgin more adored than ever, the suffering on the Cross meditated upon in the finest details and the earthly reality seen as one big symbolic reference to divine truths. These two extremes had nevertheless much in common: strong individualism – a stress on the individual person and his or her achievements, a strong personal piety – and an interest in the biblical

stories and the lives of saints spun out in great detail, often in a popular vein, fostered by the preaching of the Franciscans and Dominicans, the powerful mendicant orders. The mystical stream expressed itself in the new devotional images like the Pieta, the Virgin with the dead Christ, first created in Germany, and the Madonna dell'Unilta, the Virgin of Humility, that brought her nearer to human beings and so made her more adorable. Also we see the iconography of the Annunciation and the Birth of Christ very much enriched by new themes and details, as well as the Passion of Christ and specifically the Crucifixion.

Undeniably the fourteenth century was a rather complex time, with conflicting forces, sometimes even within one person. It was a time of strong creative progression in many directions, that spoke for instance of the *Ars Nova* in music, and felt itself searching for renewal in many ways, but was shocked in its inner being by the Black Death, the great plague around 1350. Out of this we see a strong mystical stream coming forward, and an even stronger one in a more secularizing direction that we call in Florence the Renaissance, but which expressed itself just as well elsewhere. We must realize that though these things would lead, in the course of the centuries, to a complete secularization – coming to a full maturation in the Enlightenment, in which rationalism threw off all the ties that still bound people inwardly to church and faith, or sometimes only outwardly to lip service – as a whole the new movement expressed itself within the boundaries of the church. So we should not be surprised that even though sometimes new secularized themes were depicted, like Simone Martini's portrait of *Guidoriccio riding through a landscape* (1324) or Lorenzetti's depiction of the *Good and bad government in Siena*, with its magnificent depiction of city and country life (c. 1340), most art was produced within the church, consisting not only of altarpieces and frescos with sacred themes, but also introducing all kinds of innovations in which a popular piety was expressed in a new way, with greater stress on the individual.

One of the reasons for this individualism was the fact that the church was in crisis and had lost much of its power – the battle around the papacy, resulting among other things in the long period of banishment of the pope to Avignon, was only one of its symptoms. Yet piety and faith, even if sometimes strained, remained within the tradition in which the church, even if corrupt, played an important role. One of the reasons for this is that medieval people never learned to see this differently, as all piety, no matter how personal, was in the forms set by the church, with the priest as an intermediary. The Bible was, outside of the learned theologians, a book on which the laity did not get their hands much, even if they did know the Bible stories – although mainly the ones connected with the yearly feasts in the church calendar. Only the Reformation would change this, but that came much later.

The road to naturalism

The period between 1300 and 1600 – and these are of course very rough dates – shows a very deep change in almost everything. As the older world faded a new one was moving in. The changes were deep, of a spiritual nature, and concerned the outlook of people on life and the world, and particularly on nature. Forms had to be found to express this new way of looking at things. But people are never just passive onlookers. Their seeing is creative in the sense that they also want to realize their vision, their dream. A new way of looking at things inevitably leads to new forms, to a new focus of interest, to new words, new ideas, a new direction of study and investigation, a reappraisal of values and traditions, to new organizational forms and new organizations. Of course this cannot take place on short notice. There may be gains in this but there will also be losses, things that people are slow to sacrifice. So we can understand that in those centuries changes were taking place over a long time. There was so much at stake and people, knowing that important matters were involved, proceeded slowly and circumspectly. They were afraid to lose what was valuable, and sometimes they may have had a bad conscience, asking themselves whether they were not being destructive, even though at the same time they looked forward with anticipation to the exciting things that might develop. The values, the whole world outlook, changed so deeply that most people may have had only a partial understanding of what was going on. And we, living so many centuries later but being children of that change and therefore fully involved, are still discussing these issues, while there is also much that we still understand only vaguely. Reluctance to let the old go, and eagerness to accept the new are typical of this crisis.

We see this also in the fourteenth century, an age in which the old was questioned and weighed, and new ways were sought, in preparation for the deep and in some cases sudden changes that were to take place around 1400. Side by side there existed an eager looking for the new and a reluctant acceptance of new possibilities.

This is perhaps seen most clearly in the development of the representation of space, which is, as we shall see, one of the most important changes in the years after 1400, and closely tied up with the concept of naturalism. We have already seen how people like Lorenzetti and Martini – and we could add Taddeo Gaddi and many others – built on the direction set out by Giotto. Yet their pictorial space was still limited and the ground of painting, the blue or dark background, respected. Two circumstances may have contributed to this. The first is that many of their works were frescos, that is, wall paintings. Now one of the aesthetic requirements for a wall painting is that the wall as such, enclosing the chapel and being part of the architecture, is not robbed of its function and expression. Therefore the making of a 'hole in the wall' had to be avoided – we see also later that artists were always conscious of

this problem. The second reason may be found in the perspective system that they were using, which White called 'synthetic' perspective.[552] But there might have been even deeper reasons.

These lie in the nature of the medieval understanding of reality. Their universe was finite and had a perfectly spherical shape, containing within it an ordered variety. They did not try to find exact mathematical precision in their knowledge and experience of things, but rather they were very much interested in the quality of things, their nature and their meaning, more the 'why' than the 'how'. Their world view was twofold: they conceived of a universe, with the earth in its centre, as a round ball, and, around this, a series of hollow and transparent globes, the 'spheres' or 'heavens', in each of which is one luminous body, the seven planets, one of them being the sun. The very last sphere is the *stellatum*, on which there are all the 'fixed' stars. In this way they tried to 'save the appearances', i.e. account for the movements of the stars and planets in the sky. But this spatial order is the opposite of the spiritual, and the material cosmos mirrors, hence reverses, the reality of that, so that what is truly the rim seems to us the hub. This spiritual reality has God in the centre, and around that there are the spheres of the different orders of angels. Only at the periphery do we find humanity. As things were understood in their being and relative importance, and the world was finite, they did not look in a 'perspective' way and hence also did not develop – they would not and they could not – any perspective in the sense we have today, which has in turn coloured our experience. 'Medieval art was deficient in perspective, and poetry followed suit. Nature, for Chaucer, is all foreground; we never get a landscape. And neither poets nor artists were much interested in the strict illusionism of later periods.' Also their imagination was focused on the 'sheer foreground fact, the "close up"'. For them things were loaded with an internal force, which we might call 'participation', sympathies, antipathies and striving inherent in matter itself. We might accuse them of anthropomorphic thinking, but the interesting thing is, as C.S. Lewis has said, that our way of talking is the more anthropomorphic: 'To talk as if inanimate bodies had a homing instinct is to bring them no nearer than the pigeons; to talk as if they could "obey laws" is to treat them like men and even like citizens.'

The change that we spoke about in the beginning of this section concerned exactly these points. That is why it is difficult for us to understand them. Or maybe that is not the real difficulty. I do not think that we cannot understand medieval art as, miraculous though this may be, the visual communication system imposes itself on us, and we look at medieval works in the way they are conceived and accept what they tell us in the way they tell it. This is part of the structure of human communication about which we spoke in the introduction. What is difficult for us to understand is that, as the deep change took place, it was not simply the exchange of a lesser system for a better one. We tend

to say, 'at last they discovered and began to see,' while in reality a whole world view, a whole way of looking at things, the very deep understanding of reality as such is at stake. It goes deeper than just discovering some things hitherto unknown. What was involved was a completely new way of understanding and explaining, a new mentality and spirituality.

Only then can we understand that, when some people in that transitional period called the fourteenth century began to search for more space – needed for the portrayal of so many new details, houses, trees, etc., elements necessary to give the stories a natural ambience, more detailed and with the inclusion of so many more natural elements – others were aware of the fact that something important was at stake. And so we see that exactly at this time artists began to underscore the fact that the ground of painting was really the ground. Instead of a rather neutral blue or red, or in some cases gold, they began to emphasize this ground by embellishing it with strong patterns or relief-like ornamental forms. We see the first in the elegant miniature of Gautier de Colincy's book on the *Miracles of the Virgin.* Note the position of the horse in relation to the border that encloses the picture. Compare the whole with the Giotto *Flight to Egypt,* or with the earlier Gothic miniature showing men on horseback. In the last case we become aware of how much new space was already acquired here.

A very interesting case is the following. Of course there are many more like this, and ours is but one example, namely Paolo da Venezia's *Coronation of the Virgin,* from 1324. In the foreground we see this very holy scene. The Virgin and Child are sitting on a bench. But then we notice how behind them is a cloth, then a kind of structure that might be the top of the bench, then a row of angels, and then, only then, the golden ground. It is as if the ground of gold itself was not strong enough. Much more had to be brought in in order to make clear that the whole is set in front of the ground of painting, and that the painted surface is a ground that cannot be penetrated. We might call this a nervous picture, as if artists were afraid of the consequences of the steps taken by Giotto and worked out by some other artists. They might also have been uneasy as they heard of some of the new things that were developed by the philosophers or theologians. Maybe nobody, including those highly learned people, knew or realized where they were heading. Or rather, we see that also these people tried to deal with the problems that were looming because of the introduction of a new, autonomous and 'neutral' natural philosophy – those who exposited the theory of the double truth were not just hypocrites; rather, they were faithful children of the church and, at heart, believers.

But the interest in the introduction of many details in the picture, to let it really tell a story, to emphasize not only the purely dogmatic but also the historical side of the biblical stories, to deal with reality in a new

way, to look at it closely, an interest that as we have seen was shared by the more mystically inclined people and those leaning more in a Renaissance direction, even if for different reasons – this interest led to the impossible situation that there is too much to tell, and that the pictorial virtual box in which all is placed now becomes too confined. A fine example of this is the illustration of an event out of English history, a miniature from around 1400 made by a French master from Paris. It depicts the siege of Conway by the Earl of Salisbury. We see the city, the fleet, all necessarily in an abbreviated form, for there is not space enough in front of the ground of the painting that is emphasized by a chequered pattern.

It is obvious that here was a problem for the artist to solve. But much more was at stake than just technique, a trick – namely, a new way of seeing, which enhanced a new way of understanding – and perhaps even a new way of believing? The solution to the problem was found at the beginning of the new century, first in France, then in Italy, but in each in a different way. This, and its implications, will be our next subject.

Going through the ground: the new naturalism

Around 1408 the final solution to this specific artistic problem was formulated by the Master of the *Hours of Marshall Boucicaut*, an artist whose name we do not know with any certainty, but he might be Jacques Coene. Whatever his name, he was important and influential in his time. He did the daring act of conceiving the surface on which he painted his miniatures as a window through which we look. This means that the depth can be unlimited, in fact, if necessary, infinite. We look as through a window. In fact the Boucicaut master – as we call this artist for short – often used what Panofsky has called diaphragm-arches. In Gothic miniatures we often see that the miniature is 'in' a certain kind of a structure, or rather, that it is decoratively at the top closed off by an architectural roof-like whole. In Italian paintings, like those by Giotto, we see scenes taking place in buildings, which, in order that we may see, have had their front wall removed. This all comes together here in these arches, which coincide as it were with the front of the picture space, i.e. a window through which we look.

Magnificent is the Boucicaut master's *Flight into Egypt*. We see the Virgin with her Child on the ass and the other figures as usual, but then 'behind' them a landscape that encompasses a far distant view, with trees, hills, cities, a lake, etc., and in the furthest background, as a memory to the golden ground we have seen up till now, the sun. It is very interesting to compare this with his *David adoring God*. On the ground in the foreground sits David with his harp, with behind him again a wide landscape, and a blue sky that is now really a sky – a sky in which clouds can appear, as in fact they do very soon in the work of those that followed, the Limbourg brothers and Jan van Eyck. In the sky we see God

on his throne. This makes us immediately aware of the problems that this new principle brought with it. In the older more symbolic kinds of art such a majesty of God was possible: it was represented by a symbolic mandorla set within a symbolic representation of the rainbow. But now? The whole comes into real space and becomes something in the sky. Angels have to hold up the canopy. The master avoided the problem more or less, or rather, solved it as it were provisionally, by having behind God a golden ground, at the same time a kind of mandorla. In this way there are two kinds of representation and two levels of reality.

In the way of thinking of those days there was the nature and grace scheme, two more or less autonomous realms or levels of reality. Quite naturally they began to compete against each other, with always the tendency, as Francis Schaeffer puts it, that nature eats up grace or grace eats up nature. At this time the first was the most obvious danger. We see it in the work of Jan van Eyck, one of the greatest painters that ever lived. In his early miniature, in the *Hours of Turin*, of the *Baptism of Christ* we see that happen. It is a magnificent work, with the castle reflected in the water, the coming of twilight, and the birds in the sky – and remember that these things were done here for the first time in history! There is also God the Father and the Holy Spirit in relation to the Christ who is baptized in the foreground. But the landscape overwhelmingly takes away our attention. The holy scene is still there but it has lost its preponderance. Of course not all people were happy with this, sensing that this was maybe a gain, but certainly also a loss. We can imagine that a more mystically inclined artist would protest. And so it happened.

In the 1420s a book of Hours, i.e. a book of prayers, was made for the Duke of Rohan, and in it some magnificent miniatures were included. This master knew the work of the protagonists of the naturalistic movement that we just mentioned and yet, being more of a mystic in his faith and thinking he did not like to follow van Eyck on his adventurous path. And so he conceived his *Flight to Egypt* in quite another way. The whole surface is divided in two: the lower part is painted in a smaller scale, and is not reached by the rays that we find in the upper part, where we see the Virgin with the Child on the ass. These rays remind us of the work of the Boucicaut master, where in the *David adoring God* there were rays extending from the solid gold behind God, rays 'behind' which the landscape goes on, as if these rays were the last remnant of a once solid golden ground, through which we see 'behind' the ground. So here also behind the rays, the landscape continues.

But the division in the composition shows us, as clearly as ever, the meaning of the nature and grace duality. In the upper storey we see the holy scene; in the lower one, the story which is by legend related to it. That story goes as follows: Herod sent soldiers after Mary and the baby. When they met a peasant who was mowing they asked him if he had seen them. He said yes, when he was sowing. Because, when Mary had passed

him, he was doing so and she told him to say this to the soldiers. The miracle implied is that during the night the grain grew so quickly that the next day it could already be mowed. And so the soldiers went back without finding the Holy family.

The Rohan master is a great artist, and he did show that he could portray reality if he wanted to, and that he was interested in it – note the magnificent peasant man, and the soldiers on horseback. But he wanted to keep these things in place. What we want to underline is that these changes did not simply happen just like a new technique or a new invention, and that these things were not neutral. And a spiritual battle was taking place, between different streams and, at times, maybe even within the soul of one person.

The new naturalism meant not only a new way of depicting things but rather a completely new approach to reality. In this the older ways of representation could not be maintained which made use of symbolic meaning, expressed through mandorlas and halos around the heads of saints and many other things like that. A halo was a sign of holiness, but now it became a saucer behind the head of the saint. Sometimes they solved this by making it turn into light or letting it be just a little golden circle above the head. But in fact everything that did not belong to the visible world in a way had to go. If people wanted to retain something of the old meanings, a new kind of symbolism had to be invented. Indeed Jan van Eyck did this, with the hidden symbolism Panofsky has described so well: in his paintings we see things painted very precisely, just as the rest of the painting, that have an added symbolic meaning – so an apple lying near a woman may refer to the Fall and Eve, or a sandal lying on the ground may indicate holy ground. Or the difference between one and three windows – behind the Annunciation – may refer to the Old and the New Testaments respectively – as revelation speaks in the Old about one God, and in the New about the Trinity.

What matters most to us is that we understand that a totally new way of thinking and seeing was involved: a new answer to the question, What is reality? For instance, for John Scot Erigena the universal, the most general, was the most real; the individual in which the universal came to posit itself was caused by the universal. In late medieval nominalism, for instance in the most important works of William of Occam, the individual things are the more real, and the universal is an abstraction; the first is known immediately, intuitively; the second only by using words and rational reasoning. As science deals with the first, that is promoted, a science dealing with the real, as given in perception, a kind of empiricism. With William of Occam we also find a new understanding of our way of seeing. Formerly, with Thomas Aquinas and Duns Scotus, in following the Greek, it was understood to be like this. The thing existed outside of us. In a certain sense it is also present in our eye as the seeing organ, a mode of being called *species sensibilis:* the materiality of

the thing is gone, but its substance is kept. If we think about these things, we subsume them under our intellectual activity, of which the *species intelligibilis* is the result, which means our awareness of the thing outside: it is the way of being of the known thing in the knowing. William of Occam, who lived in the first half of the fourteenth century and worked in Paris, not only promoted the sciences but laid the foundations on which later the new science would work, including Copernicus. This man also did away with this complex way of dealing with our perception and knowing: he declared the *species intelligibilis* unnecessary, which means that we think immediately about the things given to us in seeing: and perception is no longer a kind of image of the thing perceived. It means also that the world of our consciousness and thinking is different from the world of the things as such. We have in us nothing but a sign of something that is outside of us, which means also that things are different from the ideas we have of them.

This further underlined and made very explicit that our perceptions of and our thoughts about nature are not tied to our will: nature and its processes go their own way, and things go as they go.

And soon there were also new ideas about space. Instead of the older conception of space as discontinuous, we now move on to space as a homogeneous whole. It was Nicolaus Cusanus who, in the beginning of the fifteenth century, in philosophical and mathematical theory, for the first time juxtaposed the finite and the infinite, and began to anticipate the modern understanding of space as a quantum continuum – which was later developed and formalized by Descartes in his concept of *substance étendue*, extended substance. So the continuous and infinite were ideas that were in the air at the same time as the painters began to use space in a new sense.

Of course we do not think that the painters of this period were all the time busy reading these philosophical books. But today people do not read the contemporary books of similar speciality either, and yet people quote ideas from Freud, speak about atoms and molecules, and accept or discuss the evolutionary theory. Indeed, I do think that the kind of discussion that goes on in Christian circles about the evolutionary theory – whether it is compatible with Genesis 1 or not – is basically the same discussion that was going on in those days: the dicussion about the nature and grace theme and the applicability of the new way of rendering space basically deals with the same issues that we deal with now in another form.

Optics were much in discussion in the thirteenth and fourteenth centuries, and led to the discussion about the ways of seeing, as philosophically understood, which we already mentioned. Thinkers who engaged themselves in this science – in which already the Arabs had taken a great interest – were Grosseteste, Roger Bacon, John Peckham and Witelo. There were new theories about the nature of light, the

rainbow, the laws of breaking or reflecting light, etc. These scholars were as much interested in artistic work as scientists are in our days – i.e. apart from an occasional contact, scientists are not interested at all. But in the beginning of the fifteenth century, these new theories came together with the search of the artists, and so in Italy the new theory of perspective emerged. It really is a very important thing that happened. Here, for the first time in history, science and the arts joined together. But not only that, here for the first time mathematical theory and natural science joined together – and this last thing is the very basis of the new sciences. So when in 1435 Alberti was formulating perspective in a mathematical – rather, geometrical – way, he stood also at the cradle of a new way of dealing with these problems. In fact, those that contributed most to the theory of perspective were mathematicians, and some of them were also artists, like Piero della Francesca.

The man who made the next step was most probably Brunelleschi, the great artist, engineer and architect whose fame rests mainly on his work in the last-mentioned field, while he made some important churches in Florence and the cupola of the Dome of Florence, an even greater feat in engineering – with the use of mathematics – than in architectural aesthetics. In fact, artists like him, and the makers of instruments, the skilled artisans, were the people who promoted this new science with its mathematical formulations, just because they came with many questions, to which answers were needed for their work.

So Brunelleschi was the first in Italy who made one or two paintings using perspective. They have not been preserved, but maybe they looked more or less like other paintings of cities – that there are no people in them testifies to the fact that they were more exercises than works of art – that were made in the fifteenth century. Interestingly, the view chosen goes back to older paintings – a central building in the middle, streets leading into depth to the left and right – but the construction is the main focus of interest.

Brunelleschi's friend Massaccio was one of the first to use this system for his paintings. We mention the very famous *Trinity* fresco in Santa Maria Novella in Florence from 1425, a work that we find in almost all textbooks on the history of art and that is still the subject of much art-historical discussion. The way to render the *Trinity* like that was not new; in fact, one of his teachers, Masolino, made a very similar painting of the Trinity, but in this case with a ground of gold. Here, however, the Trinity is in a small painted space, a kind of chapel, the ceiling of which is constructed as if we were seeing it in reality from the place where we stand in front of the fresco. I won't go into all the details but it is interesting that, as Sandstrom noted, the Trinity itself is not quite constructed with the same perspective, and deviates therefore a bit from the whole. Massaccio was reluctant to let that participate in the perspective, i.e. in his reconstruction of the natural world. The Trinity

cannot be made naturalistic. This is the same tension that we saw in the Boucicaut master's dealing with God on his throne in his miniature. Yet because Massaccio did not take measures to underscore the different levels of reality as the Parisian-Flemish master did, there is something strange to this painting – a fact most people do not realize because they are taught and told to look at it in an abstract art-historical way – because the Trinity has become too natural: God the Father has to stand on a small stone slab in order to be high enough. But as soon as one says it, one becomes aware that one cannot say this kind of nonsense.

The fifteenth century in many ways has been struggling with this problem: how to keep the holy as holy when you paint everything in a naturalistic way. As a whole the answer is in the direction of the nature-grace duality: the holy is more on the ground of painting, but that ground is now as it were the glass – instead of the golden ground – through which we are looking to the infinite natural space, where nature expands itself, sometimes in a smaller scale. The space is often not infinite, as there is a tendency to keep the spatial realm more confined, but in landscapes they could go far. An example of the type of solution can be found in the work of Piero della Francesca, in his *Baptism of Christ* in the National Gallery of London.[553] Note the two different scales used, which become apparent where the two meet, at the feet of Christ standing in the Jordan. And one could also study, and admire, the great artistry with which he made us forget that duality. Just as the philosophers in their way struggled with the problems of nature and grace, and tried to overcome the total dichotomy to create some unity – a unity to which real reality testifies – so the painters did in their own way.

So, here, in the beginning of the fifteenth century, we see the first reluctant steps taken which would eventually lead to a totally new way of looking at and understanding reality. Quite obviously these steps were not only hesitatingly made, but also the coming to the last conclusions inherent in the new ideas took a long time. In fact, only in the nineteenth century do we see them worked out consistently – interestingly, this usually went together with a new, liberal understanding of the Bible as well.

Maybe we can use the following metaphor to try and describe what was happening. As soon as the 'painted' world was put behind the glass – of the window through which we look into the painting-space – the realm behind the glass began to work like a spiritual vacuum cleaner; in fact, the realm of 'nature' was 'eating up grace'. First we see the disappearance of halos and other signs of holiness, slowly the holy itself disappears, till we have only the natural left, but then it continues and sucks away even the humanness of human beings, and all meaning. By then we are far into the nineteenth century – we will speak about this later. But we must understand that people tried to stop this happening, and tried to counteract the effect. Maybe it took so long because,

indeed, so much was at stake. I do not intend to deal with these things in detail. But I want to give one example, just to show what came next, after the fifteenth century. But first I should like to deal with one painting that is too curious to pass by, also because I think it makes clear that the things I am talking about – in fact a new way of dealing with things that many art historians have been trying to describe – were also in the minds of the people in those days. I mean the small curious painting of the *Madonna* by a Ferrarese master around 1480, kept in the National Gallery in Edinburgh. The painting includes the frame with the broken through canvas: only so does the Madonna become visible. Another example is to be found in one of the most well-known Renaissance pictures, the Filippo Lippi in the Uffizi in Florence. In many books and on many postcards the painting is misrepresented because it is shown trimmed. If we see the full picture, we become aware that the Madonna sits in the front, and that behind her, through a painted frame as through a window, one sees the landscape in the background. But 'nature' is also here not only 'behind the glass'; it was known that the Madonna in this picture was actually a portrait of the beloved of the painter.

Things like that were too much – and in Florence we see a growing opposition to this type of irreverence, and a call to come back to true piety and faith. This eventually led to the revolution brought about by Savonarola at the end of the century. In a way this was a muddled and immature experiment to stage a reformation – but as such it can have our sympathy. Through the complexities of the political situation of that time it did not last, and Savonarola was executed, an embarrassing event even for contemporaries. But after him the tensions that lived in the fifteenth century, in art as well as in many other ways, had to be resolved. We call that the High Renaissance. We will try to make clear what happened by referring to just a few paintings.

Truth in painting – from 1430 to 1520

Jan van Eyck made a painting that showed the tendencies not only towards naturalism but also in the direction of a greater stress on 'nature', the world outside, and humankind in their place in the world, in an almost extreme way. We think of his *Madonna with Chancellor Rolin* in the Louvre, a painting not only famous today but also in its own time, and rightfully so. It shows us an open loggia in which we find a sitting Madonna with the Child, and the chancellor in a praying attitude. He is the donor. Formerly, often the donor, the person who paid for the picture as an act of piety, was shown in pictures like this, but always very small, as it were, somewhere in a corner. But here he is, the great chancellor, as large, and as important, as the Virgin herself. Is this pious? Can this be done? Isn't this a humanist attitude, human being almost equal to the holy persons? Through the open side of the loggia we see a

terrace with some people looking in the distance – there is a jump in space, caused by the smaller scale used here. Then we see a river in the distance and a city, very minutely painted. It resembles Liege, but is not an exact portrayal of that city as the river resembles the Meuse, but probably is not an exact copy from nature.

Is this painting *true*? In one sense yes: it was true to the intentions and meaning of van Eyck's patron and, as we understand things, also true to his own insights and understanding. How he and his patron worked together we cannot tell, but we may assume that Jan van Eyck, being a great and fully accepted master, would not have done things he could not approve of.

Also in another sense we have no questions about its truth. It was a true depiction of the reality outside as it was seen and understood by van Eyck and those who were of his group; there would have been no discussion about the view over the river with its city, etc. We, even if we, twentieth-century people, in some respects look differently, can follow the artist as well. We do not ask that he copies nature or that he only paints buildings exactly as they existed. We understand and accept that he does not copy, or rather, we admire him for it, and that he paints the structure of the world outside, churches, houses, the river, the mountains in the distance – resembling the Alps as seen from afar, etc. He paints it as he understands and sees it, and we not only follow him but also in many ways have to say that he sees more precisely than we do; he is our master too.

In a way these things are as symbolic as the tree in the Ottonian miniature we began with; only now the artist is not content with a generalizing scheme, only giving the bare essentials of the tree structure, but has gone much further in his analysis, and has tried to paint the tree as it appears to our eyes: the basic structure is followed to its most minute details. In this van Eyck was a master. Maybe we can say that, philosophically speaking, we see in these differences the differences between the realism of John Scot Erigena, finding the most general universal the most real, and the nominalism of Occam and van Eyck's contemporaries, who found the heart of reality in the specific thing before them, the thing in its peculiar individual existence. But even if we do not choose sides in this philosophical debate, we can accept this portrayal of nature as true, if not referring to true truth.

Another thing is the main scene with the donor and the Madonna. Maybe we do not feel the fact that the Madonna has no halo as a loss – some contemporaries might have felt so – and if you are a Protestant you may have a critical attitude towards this over-emphasis on the Virgin, who is to be revered. But we try to see things within their own framework, as judging them from that point: we do not want to be narrow-minded and we certainly want to do justice to the people in those days who perhaps understood that some things were wrong, but were not

yet in a position to see the problems involved. But we certainly can feel and accept the reaction of those contemporaries who felt that the way the donor was brought into the picture was just too much. So, in looking at paintings, we try to see the truth in them, the subjective truth in the framework of its time, and to see that truth in relation to what I would like to call true truth, reality as it is, given to us in experience plus the norms and understanding that come from the revelation in Scripture. If you are not a Christian I would like to ask you not to be completely relativistic – anything goes – but to judge, with care and with reticence. This may mean discussion, before the painting. But only in such a committed way do we really take things seriously. Art is more than just 'neutral' entertainment without deep consequences.

And of course such a discussion has always taken place in the realm of the arts. And of course it has always been more important to discuss contemporary things than things that come to us from a faraway time, like this van Eyck.

But we can understand that some people in the fifteenth century reacted maybe even very strongly to this rather extreme painting. Some might even have considered it to be almost blasphemous. Among these we may think of Rogier van der Weyden, another great painter of that period. As we so often see, the ongoing discussion in the art world is reflected in the works themselves. So Rogier reacted to the van Eyck by making another one, following what he considered good and important, and correcting where van Eyck had gone too far by placing the donor as large as the Virgin in the holy realm, the realm of grace. Distinctions are blurred this way.

It is only a short time later that Rogier painted his picture. Now we see the Madonna in a bit simpler interior, while the far view has been changed into a nearer river with houses that lead the eye into the distance. Near the Madonna sits a man who makes a pencil sketch of her; this man represents St Luke, who allegedly made such a picture and therefore has become the patron saint of painters. Panofsky thinks it might be a self-portrait of the painter, which is quite possible. Even if there can be no doubt that this is the Madonna and St Luke, in a way nothing indicates this. Only it would have been obvious for the contemporaries, as they knew this type of composition – as it is obvious for anybody who is conversant with Flemish fifteenth-century art. But there are no halos and, just judging on what you see – if you did not know more – it could have been a painter making a portrait of some important lady stilling her baby. So even if for the fifteenth century's sensibility the 'too much' was taken away, yet there is the loss that strictly speaking the holy as such had become un-see-able. One might say that this would have been what happened – if it ever happened. But that is not quite the painter's intention. The fact that the house and the figures all belong to the fifteenth century, as can be concluded from the

architecture and the clothes worn, means that the thing is shown in its importance for 'today' – the artist did not just want to show history, something that happened in the past, but something that, even if it happened in the past, is directly important for us today: the truth is not just historic truth but eternal truth, true today. For a true son of the church – and there is no reason to doubt that van der Weyden was exactly that – this was of prime importance: that these holy people were accessible to us today.

Some generations later, when Savonarola had played his role, and the inner tensions of the fifteenth century were not really solved, as either the holy was lost or, more rarely, the natural – but they did not want to lose either – the solemn but very direct way of painting reality, and the almost naïve way of representing the holy themes had to be discarded. A new solution was found by Raphael and his contemporaries in what we now call the High Renaissance. Here the old duality of nature and grace was brought to a new synthesis, comparable to the High Gothic – with the difference that 'nature' was developed on the basis of the fifteenth century's achievements. This meant that the holy had to be holy. The Madonna could not be a portrait of some beloved lady anymore. Holy scenes could not be painted as if they were portrayals of the world immediately around us. One of the ways in which this was achieved was to put the holy on the clouds – a device already used occasionally in the fourteenth century; these were of course symbolic clouds. They were used for this purpose until deep into the eighteenth century, through the whole period we call the Baroque, for which the principles were laid down by these great High Renaissance masters, in particular Raphael.

We show now how Gossaert (Mabuse), an early sixteenth-century painter who had made a trip to Italy, made his contribution to the argument: he placed the Madonna on the clouds, appearing for the painter, so that he could paint her. Much later in 1633, the Spanish painter Carducho used a comparable image in his book on painting, with a text saying that we do not 'make' Christ or the Madonna but that they reveal themselves to us.

Part II

THE CHRISTIAN AND ART

I
Art Needs No Justification

Publisher's preface to first edition[554]

Professor Rookmaaker was working on this booklet at the time of his death on 13 March 1977. His intention to write a postscript was never fulfilled.

The material has been rearranged and revised but is essentially what the author wrote. In our attempt to be faithful to his intentions we have been greatly helped by his colleague at the Free University of Amsterdam, Dr Graham Birtwistle.

This booklet is not a technical work, neither are its contents exclusively for the artist. It is for all Christians who are willing to see that their God-given talents can be used to the glory of the Giver. It is not a survey of the art-scene, nor a detailed analysis of the origins of the problems facing civilization. It is a prophetic call to Christian artists, craftsmen and musicians to 'weep, pray, think and work' before it is too late.

Introduction

Artists in our society are in a very peculiar position. On the one hand they are regarded very highly, almost like high priests of culture who know the inner secrets of reality. But on the other hand they are completely superfluous people whom the public like to think highly of but are quite ready to allow to starve. We want artists to be serious and create deep things that have almost an eternal value, things that people of culture can talk about centuries later. But if they want to be successful, artists have to bow down to present tastes, be commercial and play the clown rather than the sage. So artists are in the midst of conflicting demands.

Of course this is not a new problem. It has been like this since the eighteenth century when the old concept of art, the artist as artisan, began to be exchanged for a concept that saw the artist at one and the same time as both gifted genius and social and economic outcast.

The artist who is a Christian also struggles with these tensions. But the Christian artist's problems are often greater because it is difficult for the Christian to live in a postchristian world. An artist is expected to work from his or her own convictions, but these may be seen by atheistic contemporaries as ultra-conservative if not totally passé. On top of this the artist who is a Christian often lacks the support of his or her own community, church and family. To them the artist seems to be a radical

or an idle slacker, one branded as being on the wrong track even from the start. For this reason the Christian artist today often works under great stress.

On the other hand we very much need art that is healthy and good, and that people can understand. If Christians can do such work they may not achieve great fame, but many will love their work, and it is possible in this area to make a living. So there is no need for self-pity, and there is a contribution to be made here to an age that is often antichristian in the most outspoken way.

To the many Christian artists whom I have had the honour to know, and whose work I think is important in many ways, this little study is dedicated. In fact, this booklet is worked out of an address delivered at an arts festival held in 1975 in England, where a few hundred, mostly young, artists gathered who professed to be Christians or at least to be really interested. I must thank Nigel Goodwin and his staff, who organized this and similar conferences, for the invitation, one of the many tokens of friendship based on a common faith and a common interest. It may be clear that I speak in the first place to the painter and sculptor, the creators of the visual arts. I do this because my knowledge lies primarily in that field. But I think that the situation and problems are more or less similar with the other arts – for the musician, composer, actor, writer, dancer, comedian, or whomever you may think of.

<div align="right">H.R.R.</div>

1 Background to a dilemma

1:1 Art, craft and the expression of values before the eighteenth century

There was no sharp distinction between the art of painting and sculpture and what we now call the crafts.

The role of the artist has not always been as it is today. In most cultures, including our own before the new period that began somewhere between 1500 and 1800, the artist was primarily an artisan: art meant making things according to certain rules, the rules of the trade. The artist was an accomplished worker who knew how to carve a figure, to paint a Madonna, to build a chest, to make a wrought-iron gate, to cast a bronze candlestick, to weave a tapestry, to work in gold or silver, to make a saddle in leather, and so on. As far as organization goes the artist was a member of a guild just like any other skilled worker. Some were master artists and took the commissions for the shop. Others were helpers, apprentices, servants. A studio was in fact a workshop with a

subtle division of labour under the leadership of the person we now would call the artist, and whose name we sometimes still know.

But even if artists did not have the high honour we tend to grant them today (there were exceptions in the case of artists who were honoured by their patrons), they did make beautiful things; so beautiful, in fact, that we, so many centuries later, still go and look at their works, and often pay much to have their works restored in order to hand them down to the next generation. Their achievements are still highly esteemed. There is not a tourist brochure of a city or town or country that does not show with pride the lasting monuments of the past. And whatever those artists themselves gained in the making of those treasures – churches, statues, gravemonuments, wallpaintings, reliquaries, lamps, stalls, paintings, illuminated books, houses, stained-glass windows, and so much more – these things certainly continue to be of great economic value for the tourist trade.

Why are their works still worth looking at? Of course, some are masterpieces, but not all of them. Yet most of them have a reality, a solidity, a human value that at least testifies to the great skill of the artisans. They worked in the line of a strong tradition that handed over patterns and schemes, knowledge of techniques and tools and the handling of them; they were, and felt themselves to be, heirs of the achievements of their predecessors. What was looked for was not originality but solid and good work. Beauty was not an added quality but the natural result of the appropriate materials and techniques handled with great skill. The works were not things that asked for intellectual debate and a specialist's interpretation, even if sometimes they were discussed, praised or criticized. The great St Bernard of Clairvaux, leader of the Cistercian order in the twelfth century, took exception to the strange carved creatures, monsters or fantastic animals, that were to be found on the capitals in the monasteries; but even if he condemned them, he did take account of them and criticized their inappropriateness, not their beauty or workmanship.

This art was the expression of a common quality of life, much deeper than affluence and status, and was embedded in a common understanding of life. But within this tradition, this strong framework of skills, of rules and standards, there was freedom. Even if one was asked to copy a certain work one was not supposed to be slavish in execution but could show one's own hand and qualities. Quality rather than originality or novelty was cherished, but artists could be themselves.

Only in this way can we understand the mass of work that is still to be seen throughout Europe. Even if we do not want to romanticize those times, when certainly hard and long work was required, and usually for limited payment, all those old monuments testify to the fact that the work of art was not something to be added later but formed an integral part of the design of a building. What we call art was the natural beauty that was

expected of the things made by people. And therefore there was no sharp distinction between the art of painting and sculpture and what we now call the crafts. Skill, quality and appropriateness would be the yardstick.

1:2 The Enlightenment and Art with a capital A

Art now became fine art, and the crafts were set aside as something inferior.

The role of the artist, as well as of the arts themselves, began to change in some European countries in the time of the Renaissance. This movement gained momentum and made a breakthrough in the eighteenth century, the Age of Reason, the Enlightenment. Art now became fine art, and the crafts were set aside as something inferior. The artist became a genius, a person with very special gifts with which he or she could give humankind something of almost religious importance in the realm of human achievements, the work of art. Art in a way took the place of religion.

Descartes, in his philosophy, had counted only those things real and important that he understood as rational, clear and distinct. But Baumgarten, working from the same Enlightenment basis in the middle of the eighteenth century, wrote a book called *Aesthetics* in which he dealt with those things that were not clear and distinct, those that preceded clear knowledge and were based on feeling, the aesthetic things, the works of art. In this way the breaking of our Western world into two 'cultures', the sciences and the arts, became a reality that is still with us. Very much has been written on art in the eighteenth century, not least in England, on taste, on the beautiful and the sublime, and on the principles of art. We also see the very beginnings of modern art history. Much of this was tied to the world of the connoisseur, the person of taste and knowledge, the collector of works of art. Art became disconnected from the normal functions of life and beauty was seen as an abstract quality carrying its own meaning, unrelated to what was depicted.

With Kant and, in his wake, Schelling and Hegel, art was considered to be the final solution of the inner contradictions of the philosophical systems designed to form an integrated understanding of reality. People are free yet bound to a mechanistic universe, and it is art that can reveal inner unity and by-pass the rational tensions. Perhaps for this reason music has now become the greatest art: it overpowers us emotionally, yet it cannot easily be analysed. Its content as such is beyond what we can verbalize.

Before this time no works of 'art' were made, but altarpieces, portraits, landscapes, paintings or sculptures which were designed to fulfil a specific function, either decorative or to stand as a high metaphor for the greatest values, representations of the Holy Personages, the Virgin and the saints. But now they were to be works of

art, and somebody in the middle of the nineteenth century could write that a still life of a lobster by Chardin could be just as important as a Madonna by Raphael. In fact, subject matter slowly became more and more secondary, leading in our [twentieth] century to the rise of non-figurative art. Photography may have played a part in this, but the trends were there before photography was invented. Art in the nineteenth century expressed new approaches to reality. It showed that the old norms and values were gone, that the Christian concepts had lost their hold over people's minds.[555]

One more thing is worth thinking about. The eighteenth century was, if not overtly antichristian, certainly searching for an a-Christian world. Religion was fine as long as it was purely private and did not interfere with the important things in this world: science, philosophy, scholarship and the high arts. And so the principle of neutrality was developed: in scholarly work we should leave behind those things that are irrelevant and totally subjective, such as our religious convictions. We should look for the objective; that which is true regardless of our faith. In passing, we just note that the terms used here, subjective and objective, are themselves defined by the Cartesian trends in thinking that were the driving forces in the Age of Reason. These words only have meaning in a framework of thinking where we start from a more or less autonomous and rationalistic human being, who sees him or herself as relating to and confronted by an objective nature, ruled by 'eternal laws' like $2 \times 2 = 4$, which has its own kind of autonomy. It is a closed system, to which God or any other non-human or non-natural force has no access; a world where the principle of uniformity reigns and where no other forces than those we know in the world today – those we can see, measure, control, understand – have ever worked or will ever work. This of course influenced the vision of the artists, but also that of the art historians. So, when we today study the great artists and their achievements we are never told what the driving force in their life was, what they believed, what they stood for. Those things, being seen as subjective, are left out of the picture. We are given the impression that those great people in the past could make their masterpieces just out of their own genius, talents and insights, and that religion had not much to do with it. We must be aware of this and not fall for this inherent perversion, because it is fundamentally untrue. The modern scholar, historian, art historian or philosopher (as well as the artist), who does more than just follow trends, works from a basic outlook on life and reality. This outlook is often a kind of irreligious religion.

1:3 A crisis in the arts

Art became art for art's sake, a kind of irreligious religion, in a world where religion has no clearly defined practical role.

Out of all this came a crisis in the arts. Art was called to be a kind of religion, a revelation, a mystical solution to the deepest quests of humankind, but the artists were often hungry and alienated, and unless they bowed down to poor taste and could allow themselves to express cheap sentimental content, they were left alone. Art, high Art, was lifted out of daily reality and placed in its own temple, the museum, where the catalogue provides the guide to the liturgy. This has made life very difficult for many artists and art students. Why are they working? What are they working for? For many it has become an individualistic search for their own identity through and in their work. They are like people looking at themselves in a mirror; everything they see is an expression of themselves and all else has become unreal. Art is supposed to be the expression of one's innermost being, but what if one finds little inside? The artist is supposed to be a genius, but a genius cannot be taught, we are told, and his or her delicate subjectivity should not be upset by others who say there is something to learn, so the young artist is left to find and express him or her*self*. Some reach despair, but they are reminded that it is art itself that will bring deliverance. The poor works of these sad artists often crumble under the load and disintegrate. Basically artists are being asked to design their own religion, which we can talk about but are never asked to believe completely. Unless the artist is really strong, and endowed with great talents or filled with a powerful ego drive, it is hard for him or her to succeed in the art world.

Art became art for art's sake, a kind of irreligious religion in a world where religion has no clearly defined practical role. It means that art is such a rarefied, special thing that people need art-appreciation courses and lectures to have it all explained. Some indeed must feel as if they are looking at the emperor's new clothes, as in Andersen's tale.

As a result we see people everywhere searching for the meaning of art. The fact that so many books are published that deal with the arts is not a proof that people are sure what art is about, but rather the opposite. This quest for the meaning of art is a sign of the crisis in the arts. But too often this search ends in contradictions. Art has to have a message, but it should not be didactic; art has to enrich life, but it is only for the rich and specialized. So in a way the really good art, of class and fame, is too far away from the people, and the arts that are popular are seen as below the level of acceptability. Of course, differences in quality and kind have always existed, but the sharp division of today is a new phenomenon.

I see this as the result of placing art on too high a pedestal, lifting it out of its ties with daily realities to the level of museum art, the work of a genius. Art has suffered from this. High Art has shunned all practical demands, such as decoration, entertainment or in fact any role that might smack of involvement in real life. Yet this type of art inevitably attracts almost everybody who has some talent. So in the art colleges

there are many who study painting or sculpture as a free vocation and they will become the 'free' artists of tomorrow, most of whom will not be able to live from their work.

But inevitably also the 'low' arts have suffered. They became the 'popular' arts, sometimes called 'commercial'. It is art in the service of Mammon. As all genuinely talented people tend to shun this field, its quality has deteriorated and too often what is produced lacks all imagination or skill. And because that is usually the art that is offered for 'consumption' it means that everybody, knowingly or not, suffers. It has its share in the ugliness of our world today.

Now, at the beginning of the last quarter of the twentieth century, it is good to balance the books and ask what we are doing, and how far we have come. A friend of mine said to me some time ago, 'When you published your book on the death of a culture[556] I thought you were much too pessimistic. Today, as I look around in the field of the arts, high, low and in whatever medium, I think you are right.'

There are always exceptions, for example in the graphic arts and industrial design, even if here not much really exciting and new is to be found. But if these fields are better it is certainly the result of the work of many concerned people. Laments over the low quality of the arts that were produced, especially in the field of the crafts, the aesthetic design of things for daily use, had already begun in the last century. I can cite the names of Ruskin, Morris and his Arts and Crafts Movement, and there are many more.[557] In the twentieth century we cannot by-pass the Bauhaus, which had a healthy influence on design in general. But looking at all those efforts we cannot say that the goals set more than a century ago were achieved.

Maybe it was one-sided to look mainly at the design arts as needing renewal and strengthening. Perhaps there ought to have been more discussion about the pretentiousness of high Art. But certainly those who were involved were usually concerned for the good of society and not only for aesthetic and artistic quality.

1:4 A crisis in our culture

The quality of our lives is tainted, and words such as alienation, despair, loneliness – in short, dehumanization – are all relevant and have to be used too often.

Most of the activists, critics and artists who tried to renew the arts and give our world a more beautiful face did argue in one way or another that to just tackle problems in art was not enough. They understood, with more or less clarity, that the crisis in the arts relates to a very deep crisis in our whole culture, and that the crisis in the arts is an expression of this much greater crisis. This greater crisis is of a spiritual nature and, as such, affects all aspects of society including economics, technology

and morality. The quality of our lives is tainted, and words such as alienation, despair, loneliness – in short, dehumanization – are all relevant and have to be used too often.

This is not the place to go into an analysis of all these things. Certainly the problems are related to the fact that since the Age of Reason we have looked at the relationship between people and nature only in order to master reality and use it to our advantage. But as C.S. Lewis in *The Abolition of Man* has analysed so ironically, to master nature and to be able to use its powers is usually only the privilege of the few. The few are therefore better able to exert power over the many, the masses. Manipulation and loss of real power to live the life one wants to live are the result. Counter-efforts are made everywhere to change things or to try to overcome the evils of the system, and the Marxists are conspicuous in this. Many listen to them since they at least signal the evils. But whether their remedy is not worse than the illness is a real question. If alienation only means that our relationship to things is broken, if the overpowering of nature is still seen as a goal, if material values are still the primal aim and if the problem of sin is avoided, the most serious questions remain.

Yet, if we work for a better society and for a resolution of the crisis in the arts, changes will have to come. It is good to think these problems through and we must not expect solutions to just arrive on our doorstep. Much time will be involved. But we should be on the move, all of us, including the artists.

2 The church's response

2:1 The Christian retreat from the world
In concentrating on saving souls Christians have often forgotten that God is the God of life.

When our world began to change in the eighteenth century, as we have said, when its inner direction was set on a humanistic track, where human beings are master and pleasure (through money) and power are the ultimate values, where were the Christians? They were not few in number, and some people even call that same period one of great revival. The mainstream of Christianity turned to a kind of pietism in which the idea of the covenant, as preached in the books of Moses and throughout the whole of Scripture, was by-passed. The Old Testament was often neglected, and the meaning of the Christian life was narrowed to that of the devotional life alone. Too easily large areas of human reality, such as philosophy, science, the arts, economics and politics, were handed over to the 'world', as Christians concentrated mainly on pious activities. If the world's system was a secularized one, missing true

spirituality, the Christians' attitude also became a reduced one, missing its foundation in reality due to lack of interest in the created world. It became sometimes a ghost-like spirituality without a body. Christians have indeed been active. But they have often optimistically believed that it was enough to preach the gospel and to help in a charitable way. In concentrating on saving souls they have often forgotten that God is the God of life and that the Bible teaches people how to live, how to deal with our world, God's creation. The result is that even though many became Christians, nevertheless our present world is a totally secularized one in which Christianity has almost no influence. Our society's drive is determined by the world and its values or lack of values.

2:2 Two consequences

a) Christian standards in art are lowered. *Just as people show who they are by their clothes and the way they move, so these things, music, posters, in one word art, are the things that form our first and sometimes decisive communication.*

If we say that to work as an artist is not spiritual enough and that art has no place in the Christian life, we are open to deep conflicts and contradictions. I know of a Bible school where they had organized a course on 'Christianity and culture'. Question one was: What has Christianity to do with culture? As they were not able to answer this, the next question was: Why do we have this course? But, what happens when these students leave the school and begin their work, let's say in evangelism, and start a campaign somewhere? There may be a big tent and a fine preacher. But what about the music that will be played before this man speaks? Or will there be no music? And if there is music, what kind of music will it be? Should we not think about that? Or does that not matter? Music is also communication. Suppose this communication 'spoke' the opposite message to what the fine speaker said? The same applies to the pamphlets we are handing out, the posters we are making. These should be well designed and in good taste; they are often the outsider's first encounter with Christians and in a way they constitute our outward face and appearance. Just as people show who they are by their clothes and the way they move, so these things, music, posters, in one word art, are the things that form our first and sometimes decisive communication.

And if we have responsibility for the building of a church, should it just be bare? St Bernard of Clairvaux, the great leader of the Cistercian order in the twelfth century, wanted the monastic churches bare and simple; but the architecture was beautiful. People still go to these old monasteries to look at the fine architecture. But if we do not go that far and look for some appropriate decoration, a stained-glass window for instance, should we not look for a good artist? And who is going to play the organ? And what does he or she play? Very often we have created

barriers against the hearing of the gospel because we preached that we care for people and that this world is God's own but we did not act on that principle. Our lack of care showed that we were not really interested in people and in God's creation.

From the Middle Ages through the time of the Reformation, up to around 1800 when spiritualistic pietism began to drive beauty out of the church (as if one can have inward beauty without the outward signs of it), there may have been simplicity, but always beauty in the things the Christians did. That was not a programme, it was just the natural way of doing things; art had not yet become Art. In fact, these things were so beautiful and good that people still go and look at them. The paintings of Rembrandt (from *Christ on the road to Emmaus* to a still life), the fine churches, the crucifix, the music of Bach (church cantatas as well as the *Brandenburg Concertos*), the poems of John Donne, Handel's *Messiah*, and also his *Water Music*, indeed too much to be enumerated, all still testify in this secularized age that Christianity at least once did mean something. And these things sometimes still communicate their message. Quite without realizing it, these people, the patrons, the artist and the Christians in those days erected signs for another age that the Lord had done great things in the world. Today they are often the only witness of a Christian mentality in our public life. For that reason it is good that Christians work as art historians and museum staff, keeping alive the understanding of these old things, which point to the eternal word of God.

b) Christians fail to come to terms with culture.

In Christian circles a negative attitude can still be found towards culture (in a narrow sense) and the arts.

This is not the place to discuss all facets of the Christian faith. But we ought to realize that, in Christian circles, a negative attitude can still be found towards culture (in a narrow sense) and the arts.

We should remind ourselves that Christ did not come to make us Christians or to save our souls only, but that he came to redeem us in order that we might be human, in the full sense of that word. To be new people means that we can begin to act in our full, free, human capacity in all facets of our lives. Therefore to be a Christian means that one has humanity, the freedom to work in God's creation and to use the talents God has given to each of us, to his glory and to the benefit of our neighbours. So, if we have artistic talents, they should be used.

And the Lord knows why he is giving these. Paul in his letter to the Corinthians (1 Corinthians 12:12 ff.) speaks about the Christian community as the body of Christ. Each of us has his or her specific function therein. And not one can be missed out. Certainly some are those who play the music, draw the likenesses, photograph the movements, write the stories, and these are the artists. They have their

rightful place in the family of God and cannot be left out. Again, the life of the body of Christ, and certainly a renewal, an awakening, is impossible without these members, called by God to do their job.

As the body moves, works, thinks, speaks, not for its own sake but as called by God to be 'the salt of the earth', the artists are not just servants of a Christian subculture but are called to work for the benefit of all. Of course, at times it may be unavoidable that we work for the subculture or that we are a subculture. Sometimes we have to withdraw when the world asks us to do things we cannot do for Christ's sake, that are negative and destructive. But if we are rejected, not for being foolish or stubborn or trying to bully everybody into our own ways and customs but because we don't want to compromise our real biblical principles, we can expect the Lord to help us. Remember that he said to his disciples that to those who for his sake have forsaken these very important and basic things, near to our heart and in the centre of our life, he will give back in another way, in this life, and he will extend his care (Mark 10:28 ff.). But, although we must not forsake his ways, we are free, and not only free but called to work for the benefit of all the people around us.

2:3 A call for reformation

I am convinced that only a real reformation can lead to a renewal of our culture, a reformation not only of Christianity, even if it certainly has to begin there, but of our Western world.

If as Christians we often feel so much at home in this world, we have to ask ourselves whether we have not been influenced by the standards of the world around us. Maybe the realm of our faith is a tiny part of our life where piety and devotional literature still have a place. But our lifestyle, the music we listen to, the values we endorse in practice, are they any different from those of society around us? No wonder that to many the weekly short sermon, listened to in our easy-chairs, becomes otherworldly and unpractical, religious in a narrow sense, more a question of feeling than daily reality. We sing that Jesus is the answer; yes, but to what?

Deep inside I am convinced that only a real reformation can lead to a renewal of our culture, a reformation not only of Christianity, even if it certainly has to begin there, but of our Western world. I do not believe in the Marxist solution or a technological solution.

Christians need to wake up, and their feeling of powerlessness or futility has to be replaced by a new impetus to work. In short, Christians themselves need to be aware of the fact that the only prophetic word for today is 'turn back to the Lord' and look to him for solutions. Let us listen again to his word. The Old Testament prophets spoke to a world that had known the word of the Lord and had turned away, to live what we now would call a secularized life, light-heartedly by-passing the many

ills of their day. These prophets did not speak of a sweet, saving grace that is disconnected from a turning away from the evils of the day and a return to his commandments. The reading of the prophets is not easy these days and their words are alarmingly relevant for our times.

Of course, nothing can be done if the Lord does not go before us. We cannot make a new spirit or turn judgment and curse into blessings. The Lord has to move. Our prayer is as those fellow believers of old who composed and sang songs like Psalm 10, 'Why, O LORD, do you stand far off? Why do you hide yourself in times of trouble?' We are admonished in Zephaniah (2:3), in a situation very much like our own, 'Seek the LORD, all you humble of the land, you who do what he commands. Seek righteousness, seek humility,' and although there is no promise that Christianity will again be acknowledged as influential in our society, our task is not to shy away from our responsibilities. We are called to be the salt of the earth, working against corruption. We are admonished to be humble, not to dream of doing God's work in our own strength, but at the same time we are commanded to *be* righteous, to *do* our task, to *walk* in God's ways, and that means to care for this reality that is his creation. We have a task, if we love the Lord and therefore want his name to be hallowed, his kingdom to come. Everybody, each in his own place, must begin at this beginning. The artist is not excluded. In fact, I think she or he has an important part to play.

2:4 Weep, pray, think and work

The 'beginning' I refer to can be summed up in this formula: weep, pray, think, work.

This is what the prophet meant in his day when he wrote, 'As for me, I will look to the LORD' with the great expectation that follows (Micah 7:7–11).

Weep for the present situation. See how far we have drifted from an acceptable foundation. Let us care about the many who lead lives that seem to be empty and useless. Even the world is concerned about these things. TV shows that commercialism, violence, sex, cheap entertainment and escapism in a totally secularized world are the only realities left. Meaning has to be rediscovered and restored to our actions and endeavours. We must analyse the situation and try to find out what is wrong, and to assess our own place and role in it.

To weep is to see that things must change; to begin to care for the victims and to pray for forgiveness. Too often we have been accomplices in all that has happened. Would the Lord not speak to us as in the days of Amos (indeed, these things were written down in order that we should learn from them), 'Woe to you . . . You lie on beds inlaid with ivory . . . You strum away on your harps . . . You drink wine by the bowlful and use the finest lotions, but you do not grieve over the ruin of Joseph!'558 The question is how far our affluence today can be

considered a blessing, and how far it is a blessing turned into a curse. Can we stand easily before the Lord with all our commodities, the things invented to make life easy and luxurious? To weep is also to see our own weakness, our own shortcomings, and to see where our love and our care and our efforts have been lacking. It drives us on to prayer.

We pray in the knowledge that we cannot change things ourselves and that we need help. We pray also to ask for wisdom, strength and perseverance to work for a better solution. Perseverance certainly is the most difficult, to know that it will all take time, that it is not enough to work now but that we must go on, and that perhaps we may never see the results ourselves.

The great Reformation of Luther and Calvin was in the early sixteenth century, and the rest of that century saw a situation of confusion in the search for new principles and methods. But out of all the work done, in obedience to the Lord, listening again to his word, grew another culture, in many ways better and richer in spirit. The arts of the first half of the seventeenth century were in many ways fruits of this; not perfect, but rich. The world's museums are still full of the works of those times. To change a whole society, to reorganize thought-forms, customs and insights, takes much time and the changes were only very partially realized.[559] But interestingly, the arts were part of it all and did not tag on behind.

When we have asked the Lord for help and listened to his words we must think, think out our position, where to begin and how. I'm convinced that we will never really get out of the problems, the crisis, unless we see how we have been caught by the spirit of the Enlightenment, believing in the power of Reason and relegating any belief in God to the subjective and strictly personal. God is good in saving souls, but we have tended to keep him away from our big decisions in scholarship, science, politics and so on. We have got to understand the thought-forms of Western intellectual history and their consequences: a reduced world, relativism, neutralism, neutrality of values which are a-Christian if not antichristian. We have to think through the proposed solutions, including Marxism, and so prepare ourselves. This thinking is the task not only of the great philosophers. We are all involved, even if we have different tasks.

We must also think through what Christianity means, and its relation to cultural issues. We have been freewheeling too long on this point, taking the words of the few people who dealt with this as sufficient. Indeed, our Christianity itself must be thought through again. There is no reformation without theological renewal, or rather a strengthening of biblical insights.

And only then we can come to action and do something with perseverance. Of course, then we can start again; the sequence has its own logic; the one cannot be begun unless the other has been done.

Weep, pray, think and work.

3 The Christian artist's task

3:1 The role of the artist in reformation

We are looking for the artist who is working within society and in that way is taking her or his share in making life liveable, rich in a spiritual sense, deep and exciting.

The artist cannot wait, in fact nobody can, till the world is renewed, the crisis solved and new cultural principles worked out. We have to participate in the life of our times. In fact, the artist may perhaps stand in the most difficult place, for the spirit of antichristianity, of dehumanization, of despair is strongest in the avant-garde tradition of the arts. Maybe there is still something left of the strong old traditions that can be used as a starting point, but it must be given a new foundation so that it can be a living reality, not just a tradition.

Artists are in a crucial place. They have to take part in this movement, a movement that has no organization, that has no name, a movement that I call 'reformation', a return to the Lord, to seek the Truth, the Way and the Life that is in Christ Jesus. Artists must be part of it. The arts are in principle very concerned to protest against technocracy and to look for alternatives.

The artist is the one to create the poems, the songs, the images, the metaphors, the forms that can both express what has been gained in insight, wisdom and direction, and pass them on to others in a positive and incisive way.

Often the question has been posed whether there is a place for art in the Christian framework. Do we need art? is the question. And the answer is, it depends what you are talking about. If one means whether a certain percentage of the art produced for the museum should be by Christians then certainly one can say that it has a place, as it makes the presence of Christians felt; but that is not the main thing we are looking for. We are looking for the artist who is working within society and in that way is taking his or her share in making life liveable, rich in a spiritual sense, deep and exciting.

We should not think that this is something light or easy. To do this work is difficult. One has to make sacrifices, do things that others think irrelevant. Economically it probably means being in a weak or vulnerable position. A common-sense art theory that may be a guideline for artists without being a legalistic set of rules, one that enhances their freedom, is very much needed. But as there is little help coming from the leaders of the church, the Christian intellectuals, every artist has as it were to work it out for him or herself. Indeed, if we are not assuming our responsibility on all levels of human life, we leave artists too much on their own.

So if we want to give artists a share in the totality of the Christian life (weeping, praying, thinking, working), if we understand that without the artists and their work a reformation is not only unlikely but unfeasible,

then we have to think about these responsibilities. It will mean that we have to think through our Christian position and consider what Christianity means.

The reformation I have been talking about is not only a church reformation. The totality of our being is at stake. It certainly is not only about evangelism or church work, even if those things are important and should be done too. But to preach the gospel and to say that in Christ there is life without being able to show something of the reality of that life is to speak in a vacuum. It soon begins to sound false.

The difference must be visible, in all fields. As C.S. Lewis says so beautifully, we have enough little Christian tracts and books, but if we look for the rechristianization of Europe or the USA it will not come if people cannot look for a good book in a certain field and find that the book comes out of the Christian camp. The world did not become atheist because 'they' preached so hard but because they worked so hard, and in many fields 'they' have led the way, set the tone. Art certainly has a great influence on people. Just think of the role of rock music in the 1960s. If there were creative, exciting and good Christian music around, if there were visual art that was truly different, not strange but good, if . . . then Christianity would have more to say. It would have more to say to the world outside the West, the so-called Third World.

Often we are satisfied too soon, too easily. We pick up what the world does, change some obvious things and then we think we have arrived. Our paintings are sometimes the same as 'theirs', maybe just a little bit less shocking or radical. But to be a Christian is not to be conservative, or less exciting. Of course, the artists cannot do it alone. They need the writers of those books, the thinkers who think new thoughts, the politicians who offer other solutions, and also the preachers and pastors who help people to see the way and walk in it.

Only in such a community can we move on. But if others fail or are weak for whatever reason, we must go ahead and show what can be done. Maybe what you artists do is also weak and feeble. But let us not wait. Maybe the reformation we look for will never come if we do not weep, pray, think and work.

But I think all we have been saying is obvious. And therefore artists need no justification. God called them, gave them talents. We cannot do without them. So let's help them; in prayer, in encouragement, not just with words, but also in deeds according to what we can give. Indeed, that which we cannot afford to be without needs no justification.

3:2 How the Christian artist works
What we do will be for the benefit of our fellow human beings, but our future and our salvation lie in Christ Jesus even if we have failed, and therefore there can be peace and openness . . . work out of the fullness of your being; give the best you have.

People say to the artist (and this is done all too often), 'To be an artist is fine if your art can be used for evangelism.' And so art has often become a tool for evangelism. Now let's be precise. As such there is nothing against this. But we must be aware that art cannot be used to show the validity of Christianity; it should rather be the reverse. Christianity is true; things and actions and human endeavour only get their meaning from their relationship to God, and if Christ came to make us human, the humanity and the reality of art find their foundation in him. So art should not be used to preach even if it can help. But this is not the only way that art can be or is meaningful. All too often artists, in order to fit into the patterns of evangelism, have compromised and so prostituted their art. Handel with his *Messiah*, Bach with his *St Matthew Passion*, Rembrandt with his *Denial of St Peter*, and the architects of those Cistercian churches were not evangelizing, nor making tools for evangelism; they worked to the glory of God. They did not compromise their art. They were not devising tools for religious propaganda or holy advertisement. And precisely because of that they were deep and important. Their works were not the means to an end, the winning of souls, but they were meaningful and an end in themselves, to God's glory, and showing forth something of the love that makes things warm and real. Art has too often become insincere and second-rate in its very effort to speak to all people and to communicate a message that art was not meant to communicate. In short, art has its own validity and meaning, certainly in the Christian framework. We shall have more to say about that later.

The Christian's art must be Christian in a deep sense, showing the fruits of the Spirit in a positive mentality and excitement for the greatness of the life we were given, but that does not mean the subjects have to be 'Christian' in a narrow way. The *Brandenburg Concertos* by Bach are no less Christian than his *St Matthew Passion*, nor Rembrandt's *Jewish bride* than his biblical subjects. Indeed, to ask the artist to be an evangelist points to a total misunderstanding of the meaning of art and, for that matter, of other human activities. We are Christians whether we sleep, eat, work very concentratedly on solving a problem; whatever we are doing, we do it as God's children. Our Christianity is not only for the pious moments, our religious acts. Nor is the aim of life evangelism; it is seeking the kingdom of God.

So, to put it into a metaphor, art should not be compared with preaching. The best work of art would still be bad preaching. It may be compared with teaching, but the teacher often has to speak of mathematics, geography, history, botany, and sometimes, even if rarely, about religion. But the best comparison is possibly with the plumber. Just as plumbing is totally indispensable in our homes while we are rarely aware of it, so art fulfils an important function in our lives, in creating the atmosphere in which we live, in giving us the words to speak, in

offering us the framework in which we can see and grasp things, say a landscape, even without our noticing it. Art is rarely propaganda, but it has been very influential in shaping the thought-forms of our times, the values people cherish. So the mentality that speaks out in art is important. Its greatest influence may be right there where it is most like plumbing and we are not aware of it.

I think that we should not say that there is something 'behind' our actions, but that the deep strivings, the love and the hate, the wisdom and the foolishness, the knowledge and the insight as well as the shortsightedness and false idealism, all this and much more are not 'behind' an action but 'in' it. Therefore, to work as a Christian is not doing the thing plus something added, the Christian element. A Christian painting, if we use that term with any intrinsic, serious meaning, should not be just a painting plus an added something. Nor should it be holy in a special sense. Art has its own justification.

But because a painting is a human creation, and as such is the realization of human imagination, it is 'spiritual' in that it shows what is inside a person. These things are communicated, for art is also communication. And everything human attests to the human, for the human is never just something neutral, a void. A painting is loaded with meaning. The better the painting, the more this will be true. When we understand anything of art we know that techniques, materials, size, all these technical elements are chosen to be a suitable tool for expressing what the artist wants to do. So the spiritual and the material are necessarily closely interconnected. And therefore the saying that after all a painting is just a painting will not do. This is often said to stress the fact that our particular spirituality has nothing to do with it, which implies that one has nothing to say, and that there is no humanity expressed that lives itself out in the work.

So we are struggling to express clearly what the Christian element in the work of a Christian is, what the Bible calls 'fruit of the Spirit' (Galatians 5:22). What has to be stressed is that it ought to be human, real. The Christian element never comes as an extra. In discussions I am often asked what one has to do if one wants to work as a Christian. I have the feeling that often these questions are within a legalistic framework, as if the Christian element consisted of a following of some rules, usually of a negative kind. May I do this? Can that be done? But in that way we understand our own spirituality too mechanically. We are not human plus an extra bit called our Christianity. No, our humanity reacts to the world outside and to the word of God in a way that is specific to our particular personality.

To be a Christian artist means that one's particular calling is to use one's talents to the glory of God, as an act of love towards God, and as a loving service to our fellow human beings. It means to be on the way, preparing ourselves as well as we can, learning 'the trade', techniques

and principles, learning from the work of others and from their mistakes, finding our direction, experimenting, achieving what we set out to do, or failing. To work in such a way, with all our heart and mind and spirit, with all our potential talents, in openness and freedom, praying for wisdom and guidance, thinking before we work, is to accept our responsibility. Self-criticism is needed, of course, but to be a Christian artist does not mean to be perfect or to make things without faults. Christians are sometimes foolish, sometimes make mistakes, maybe out of their sinfulness, but maybe because the task was too difficult or because we got wrong advice, certainly because we are human, living in a broken world under the curse. To be a Christian does not mean that one is a genius.

If you are a Christian, don't be ashamed of it. Work out of the fullness of your being and give the best you have. You can never be better than you are. Be ashamed to be less, but you fall into pride and foolishness if you want to be more. This means don't be afraid, and live out your freedom. And don't let this be spoiled by your sinfulness. Sin takes freedom away. Walk in Christ's way, yes, but this must be done out of your own convictions, out of your own understanding, and in love and freedom. It is never just the application of some rules, some do's and some don'ts. It is more real, more honest. It should be a commitment.

So we must work in the best way we can and if we do so we are already participating and changing things. To be a Christian is to be different. Not totally; nobody can be totally different. If we were, we would be total strangers, speaking a foreign language, and we could not communicate any more. Also it is impossible to think through everything, so, in many ways, we will be children of our age. Unavoidably we will have much in common with all our contemporaries. We eat the same food, use the same clothes, go to the same stores, speak the same language, read the same papers, have had the same schooling, have gone through the same experiences, droughts, inflations, ups and downs, wars and peace. Yet, we are different.

There are things we hate and they love, even knowing that they lead to death, as Paul says at the end of Romans 1. There are also things we do, love, look for, work for because we find them to be part of being 'on the way', hungering and thirsting for righteousness, looking for that which is positive.

The Christian is different; she or he partakes of the framework of this time, and also adds to it. Maybe her or his total framework is larger and richer because of this. We trust it will be. And let us realize that the differences count. Not to do the obvious, or to do something nobody else does, that difference counts. And we never do that alone. We learn from our friends, and we teach them things too. We work together. And our group, our fellow travellers on the way, his way, are again part of a larger group, and that finally is part of the totality of his people, God's holy church in the wide sense, the communion of saints. And so, by

criticizing or protesting and by showing the better way, we can perhaps influence people. It may be the beginning of something God may use in a reformation; but that is his part. Our responsibility is to be good servants and to do what our hands are given to do.

So we should not lose hope as long as we do our share. Later, maybe only after the Last Day, we shall see that it did make a difference. Read Malachi 3:16, 18.

4 Some guidelines for artists

4:1 Art needs no justification

Art has . . . its own meaning as God's creation; it does not need justification. Its justification is its being a God-given possibility.

In the beginning we stated that art became Art in the eighteenth century and that the consequences of this have been disastrous for art. Yet there is some truth in the idea that art has a place of its own. We cannot try to 'justify' art, saying that it fulfils this or that function. This has been tried in many ways. But even if art sometimes fulfils one or another function, that cannot be its deepest meaning. When times change and old functions become obsolete, we put artworks in the museum; they have lost their function but they are still works of art and, as such, meaningful.

To explain what I think is the right approach, I should like to focus for a moment on a tree. A tree has many functions; it has beauty; it can cast a shadow; in its branches the birds can build their nests; it produces oxygen; when it is dead it can be used as wood, and much more. Yet the meaning of the tree, its existence and reality as a creature, is not in these functions or not even in the sum total of these functions, but exactly in its being a creature, owing its existence to the great God Almighty who is the Creator. The tree has its own meaning, given by God. It is no less a tree when some of its functions for one reason or another are not realized. Rather, being meaningful, it has many functions.

The same is true of human beings. They are meaningful for who they are, not for what they have. Their meaning is not in the possessions they have, nor in their qualities or talents. The fine preacher, who has such a talent for speaking, does not lose his or her humanity or meaning in the sight of God and other people when he or she falls ill and therefore cannot speak. The meaning is in what one is, not what one has.

The same is true of art. God gave humanity the skill to make things beautiful, to make music, to write poems, to make sculptures, to decorate things. The artistic possibilities are there to be actualized, realized by people, and to be given a concrete form. God gave this to humankind and its meaning is exactly in its givenness. It is given by God, has to be done through God, that is through the talents he gives, in

obedience to him and in love for him and our fellow human beings, and in this way offered to him.

But if art has in this way its own meaning as God's creation it does not need justification. Its justification is its being a God-given possibility. Nevertheless it can fulfil many functions, and this is a proof of the richness and unity of God's creation. It can be used for communication, to stand for high values, to decorate our environment, or just to be a thing of beauty. It can be used in the church. We make a fine baptismal font; we use good silverware for our communion service, and so on. But its use is much wider than that. Its uses are manifold. Yet, all these possibilities together do not 'justify' art. Art has its own meaning. A work of art can stand in the art gallery and just be cherished for its own sake. We listen to a piece of music just to enjoy it, a kind of enjoyment that is not merely hedonistic; it surpasses that, even if in some cases it can give great pleasure. But it has the possibility of a great number of functions, which are the result of the fact that art is tied with a thousand ties to reality. It is exactly this last element that has been underrated by those people who spoke of high Art as autonomous, for its own sake.

As art does not need justification, nobody needs an excuse for making art. The artist does not need justification, just as a butcher, a gardener, a taxi driver, a policeman or a nurse do not need to justify with clever arguments why they are doing their work. The meaning of their work and life is certainly not in providing them with an opportunity to preach or to witness.

A plumber who gives some great evangelistic talk but lets the water leak on is not doing the job. This is a bad plumber. It becomes clear that such a person does not love his or her neighbour. The meaning of a job is in the love for God and the neighbour, and each person prays in his or her own way, 'Your Kingdom come, hallowed be your name,' while working towards that in a specific job. We minimize this, and in a way destroy our understanding of what God called us to do, when we speak about 'playing a role', or fulfilling a function. There is more to it. It is the same for artists. They need no justification; not in the sense we are using the term here. Of course they need justification as much as anyone else if we use the term in its theological sense. Artists are human beings and, as such, sinful and in need of justification through the finished work of Christ on the cross. Christians work as a 'new being' in the sense of Romans 6 and their artwork is as much part of their Christian being as all the other human activities we mentioned; just as much as that of preachers or evangelists.

If we see a good work of art it is not out of place to pray 'Thank you, Lord.' It is a gift of God. Maybe we are thanking God because he answered the prayer of the artist who asked God's help and guidance. And certainly there would be no good art if Christ had not come to lift the curse from this world and to save it from becoming hell itself. Art

itself is a potential given by God. We human beings only discover this, and use it in a better or poorer way. This truth makes it also impossible to make a kind of religion out of art, as is often the case with modern art. God certainly does not want us to turn art into a god, making beauty our highest aim. Aestheticism means giving art a place it does not deserve, and it can be very destructive.

This does not mean that art can never have a place in religious worship. Indeed, the making of idols is forbidden; but just as we take good care in preparing a gift for somebody we love or think highly of (the love we have is shown, expressed, in the choice as well as in the packaging), we do our best to make our songs as good as we can, make our building as beautiful as we can. Beauty can be very simple. Taste cannot be bought with money, though money is sometimes rightfully spent on it.

4:2 Art and reality

This is reality: the potential world outside as far as we know it, in the way we know it. The interesting thing is that painters paint what they see, but as they see what they know, we can also say that they paint what they know.

Art consists of two facets, two qualities: communication and form. The communication is always through the form, and the form always communicates values and meanings.

Art can depict reality outside of human being, as understood and seen by a person. That reality can be the things we can see but also the things we experience, realities like love, faith, care, righteousness and their negative, evil counterparts.

Reality is outside us, a potential to be discovered and to be realized. For example, America existed before any European came there. Yet in a way it did not exist for people in the European world. It had to be discovered, and when that took place its possibilities had to be realized, opened up and made available. If we now look at that same America, after so many centuries, we see what Western people have made of it. They have opened it up, made bridges, roads, cities and parks. They have realized its potential to bear fruits and made a liveable place out of it. But they also destroyed much. So we see that there are many wounds in the reality of that land and its inhabitants, human and animal and plant. So the America that is there now is a realized reality, showing what people made out of it. The quality of that is what counts.

So reality is not simply (objectively) there. Reality is potentiality. The reality that we know is always a realized reality. We discovered it, named it, made it accessible. So we can make the statement that we always see what we know, or understand, of the world outside. This is reality; the potential world outside as far as we know it, in the way we know it. The interesting thing is that painters paint what they see, but as they see what

they know, we can also say that they paint what they know. In the painting, in the visual communication, we can see what an artist, as a member of the human race, standing at a certain point of its history, knew and understood of reality. But human vision of reality is not just knowledge, in the sense of knowing what is there; it is also creation, in the sense that people want to realize their vision in the same reality. The quality of that vision counts. It may be building up and opening up, positive, good, beautiful; or it may be negative, destructive, ugly, poor. Usually it is a mixture of these two extremes.

Reality is the present; it also encompasses the past. It is the things seen, and the things not seen but nevertheless very real, like love, hate, justice, beauty, goodness and evil. So when painters paint something they will always choose what they think is relevant, important for them or for us. If they paint the past they will do so because they judge that past to be meaningful for us now. And in doing so they will show their understanding of it. So if artists depict the Christmas story, they do so not only because it happened so many years ago but also because they understand it still to be of great value and importance to us. And they will show what their understanding of it is. Therefore, when we see the many cheap and sentimental Christmas cards we really have to question what they stand for. Should that be the understanding of that story now? Isn't that too cheap, unworthy of the reality of the Son of God coming into this world? Is that the quality of our Christianity? If it is, and I think it is, it raises many questions!

In this way I am trying to make clear that art is not neutral. We can and ought to judge its content, its meaning, the quality of understanding of reality that is embodied in it. Undoubtedly, there is also a second approach to quality, the way the work is done, the kind of colours used, the beauty of the lines, in short the artistic quality. Theoretically these two ways of judging art can be separated, but in actuality they usually fall together because we only know the vision and understanding through the embodiment in the composition and artistic realization of the work of art. As art is tied to reality in this way, there is a place to speak about truth in art: does it do justice to what it represents? Does it do this in a positive way? Does it show the depth and complexity of what it is talking about? Art may be simple; it must be clear, but never silly or shallow.

4:3 Art and society
Art helps us to give form to facets of our life and helps us to grasp reality.

Art has a complex place in society. It creates the significant images by which those things that are important and common in a society are expressed. By the artistic image the essence of a society is made common property and reality. It gives these things a form, not just in an intellectual way, but so that they can be taken emotionally, in a very full

sense. Emotional does not mean anti-intellectual, but more than intellectual. We think of flags, landscapes, portraits, the songs sung about the land we love; and so much more.

It is strange, but through art things are brought closer to us. In a way we begin to see things, because the artist has made these things visible for us. Seeing, as I understand it here, is closely tied with understanding, with grasping the meaning of things, with building up an emotional relationship. So it is very common to see in people's houses not pictures of things far away but, quite to the contrary, of things very near. In a Swiss chalet one sees pictures of chalets and mountains, maybe the mountain that one sees through the window. In Canada I saw in somebody's house a painting of a waterfall twenty miles away. In a riding school one sees pictures of horses, in a Dutch farm of the cows, and a lover of cars will have pictures of them. Indeed, in this way these things gain in reality. Just as things to a certain extent don't exist if they are given no name, are not verbally formulated, so things that are never depicted remain dim and vague, as we have not learned to see them.

In all this the world is opened up for us and is given form. We know things in the way the artists have formulated them for us. Art helps us to give form to facets of our life and helps us to grasp reality. Sometimes in this way even our lifestyle is formed, or at least influenced. Everybody knows how film has gone deeply into the ways people live and think, their heroes, their view of the world, their dreams, and so forth. On one level film has often played a role in the formation of a new fashion, and fashion is certainly more than just the choice of colours or the length of a skirt; it means the way we move, even feel. If we think about the new society dance that was introduced by Irene and Vernon Castle in the years between 1910 and 1920 in New York, with the early jazz music of Jim Europe, we see how that influenced a whole new way of life, a way of moving, of dressing. It meant the end of formality and the beginning of informal easy-going behaviour.

Art can also give form to our discontent, to our uneasiness with certain phenomena. It can give form to protest. If done in the right way it should not be destructive or break down what is good. In the terms of our time I should like to translate the biblical injunction of 'hungering and thirsting for righteousness' into 'protest in love'. Film, song, painting, cartoons, slogans may be the tools to do this. Certainly literature and poetry play their part. In a way art plays a large role in the liturgy of life. I chose this term in analogy to liturgy as we have it in church, the set forms in which we have moulded our services. The liturgy of life is the way we do things. Art creates the right surroundings, designs the clothes, designs the cup given to the winner, or the sculpture that is the token of praise, as in the Oscar awards. In many ways the arts help here. In a way the organization of a solemn meeting, such as the inauguration of a president, is in itself a work of art. It counts in the way

a restaurant is designed, the art of interior design, so that even the way we eat is influenced. Certainly music plays a large role in human life. That is its significance, based on its inner meaning.

4:4 Norms for art
We must know our limits and choose our genre as well as our subject since the genre itself is part of the communication.

The great norm in all this is love for God and our neighbour. In the Middle Ages they spoke of the manifold meaning of a text or a work of art. Its meaning was literal (that which was told or depicted), but also allegorical (that which was referred to, through the images or figures in the story), moral (the implications of the norms accepted), and anagogical. By this they meant the impact that the work was making, the direction in which it was leading our thoughts and emotions, the way it was moving us; in the direction of God and the life within his covenant, or away from that. Exactly here lies the truth or the lie in art. Does it do the truth? (cf. John 3:20,21). If we love our neighbours we certainly should not look down on them. Any snobbishness or elitist attitude is out of place. A beautiful example is Dr Isaac Watts, the well-known writer of hymns and metrical psalms in the early eighteenth century. He deliberately made his songs plain, abstaining from the intricate and flowery language often used by poets who were usually writing for a restricted and learned audience, with all kinds of references to myth, stories and literary figures the less educated could hardly understand. There is a place for that kind of poetry, but not if one is making church songs, hymns. Watts said he wanted the more simple church member to be able to understand them. Yet, and that is the beauty of it, he made his poetry such that it was very fine and could stand the test of time. In fact, it has stood the test of centuries, and many of the hymns he wrote are still sung today. And many people know parts of his work, without even knowing the writer or realizing that it was deliberately composed in order to be cherished by people.

If we say that love is, as in all other things, the supreme norm for art, it certainly affects the subjects we choose, the way we treat them, the forms we give them, the materials we handle, the techniques we employ. In Philippians 4:8 Paul formulated this for all of life, including art. In the last chapter of my book on modern art I tried to work this out at more length. This norm is certainly not above or beyond art. It is in the very strokes we put on paper, the beat of the drum, the way we attack a note on the trumpet, the kind of paint we use. Is art doing the truth?

Art shows our mentality, the way we look at things, how we approach life and reality. If we are among artists there may be a discussion about the details, about the techniques, about the pros and cons of this or that kind of dealing with an artistic problem, about the way we handle things.

Here we will leave that undiscussed. But we only want to point out that none of those things is neutral.

Certainly this applies to the way we deal with a subject. In the past this was called decorum. One had to choose one's forms, types, expression with regard to the subject, and the situation in which the arts were to play a role. If one sees a play by Shakespeare one knows after three minutes whether it will be a comedy or a tragedy. Just as when one searches for some music on the radio a few notes are enough to know what kind of music one is hearing.

In our times the feeling for decorum is often lost. A good example I think is *Godspell*. Here we see boundaries neglected, a mistake against the norm of decorum. To treat such a high theme as the Passion as if it were a musical, a genre by definition light and entertaining, is wrong on all sides. The form does not do justice to the subject, and the subject is dealt with in an irreverent way. It is a painful experience to sit through it. It is comparable to the example given above of the average Christmas card depicting the story at Bethlehem. No wonder that Christianity loses its force. Are these examples not a proof of how much Christianity has lost already? But many more examples could be found. Just go to the modern art museum and see how trite things are treated sometimes as if they were important and great, an exaltation of the too commonplace. Of course it can be done tongue-in-cheek. But it does show the relativism of our age, in which anything goes.

Often I have noticed among many young artists this by-passing of considerations of appropriateness and decorum. I saw a painting that depicted the column of fire at Mount Sinai. It was in the form and on the level of a poster. I saw a young artist painting *Ecce Homo*, Christ among his enemies, but it was badly done and therefore below the line. If one cannot paint a good head, how can one tackle a subject so difficult that many artists in the past avoided it, as it was so hard to do in a convincing and right way? We must know our limits and choose our genre as well as our subject since the genre itself is part of the communication.

4:5 Norm and taste

In music, and in art in general, the good artist knows what ought to be done at a certain place and time, what is appropriate. It is a matter of good taste.

'There is no discussion about taste' is an old saying. I do not deny that. One person prefers landscapes, another portraits; one likes choral music, another orchestral music, and yet another chamber music. There is no discussion whether opera is 'better' than symphonies, or blues than jazz. But even if our preferences cannot be discussed our choices can, since quality and content are not just a matter of taste but also a matter of norms. If we talk about portraits some are more, some are less beautiful, of a higher or a lower artistic quality. But our standard is not only defined

by artistic quality; on the contrary, the higher the quality the more important it is to discuss the content, the meaning, the anagogical direction. Exactly in the same way a book by a great and intelligent writer on theology is not acceptable just because it is well written or deeply thought out. Even if it is quite 'good', it must be assessed with care and perhaps refuted as heretical, antibiblical or ill-directed.

There is nothing wrong, even if it shows some narrowmindedness, when somebody says, 'I like symphonic music and dislike rock.' That is a question of taste. And within these boundaries one may prefer Haydn to Mozart, Brahms to Schubert. But not every symphony is good because it is a symphony. And there is always the question of content and meaning; what does it stand for anagogically? And also the question of decorum can be relevant.

As an example, Mozart composed several pieces of music for the mass. The music is beautiful and could be apt if we were listening to an opera. But I do not think that kind of music, its tone and expression, is suitable for a mass.

Now these examples are about old music. Whatever we think about it does not change history, even if we may argue about the influence of the content of that music on us today. It is never neutral. But when we talk about contemporary things our assessment becomes more important. If a record is at the top of the charts (I refer to rock and pop) it means that many people listen to it. Then it becomes imperative to discuss the meaning and content and the influence it has on people; not in the direct sense of one word, or one line, or only the words. The music in its total impact, through the melody, the rhythm, the harmony, is expressive as such, that is, expresses a mentality, a way of life, a way of thinking and feeling, an approach to life and reality. This is important to discuss as this music helps to form the lifestyles of those who cherish it. And how do we react to it? Our opinions are not irrelevant. We, in our reaction, create ripples which influence our time. The better the record, artistically speaking, the more important this discussion will be. And when we understand that the music we were thinking about is an expression of a mentality, there are two more remarks to be made. If that music's 'energy' is worldly, anti-nomian (law-less) expressing uncertainty and even despair, then what are we to do with it? Music we have around us forms part of our environment and our lifestyle, that is, ourselves.

The Lord said that not what goes into us makes us unclean but what comes out of us (Matthew. 15:11). The environment that we create is something that goes 'out of us'. But for that same reason we should not conclude that we can never listen to that music. It would mean that we were cutting ourselves off from our own times. That is impoverishing and would also mean that we would not understand our contemporaries, those with whom we want to communicate about our Lord and the word he has given us and what he requires from people in obedience to his word.

Another question is whether we can adapt that which is created by the world (that is, by people who do not know or love the Lord) and use it ourselves. There is no easy answer to this question, since the norm is that music or art in general should be good on the two levels we explained, the level of quality and the level of mentality expressed. Sometimes Christians make bad music, because they have no talents or do not try hard enough or because they show their sinful nature, and sometimes the 'world' produces good music, like the blues of Mississippi John Hurt. If it is good it can be followed; if not we had better leave it alone.

Finally we ask on which level, in which situation, such music can be appropriate. The marches of Sousa are very fine but totally inadequate for use in a church service. And is the rock music of today adaptable to Christian expression? Is it enough just to add other words? Music is never just words. Its expression is total, even more in the melody, rhythm and harmony than in the words. This does not mean, of course, that anything goes in the texts. Not only ought there to be a unity between words and music, the music has to 'carry' the text, underline it as it were, but the expression found in the music has to be in line with the text. However the text itself certainly has to stand up. I have heard so-called Christian rock in which the words were quite heretical and unbiblical.

In all this, questions of decorum, lifestyle, understanding, emotion and taste come in. Taste in the sense of a fine feeling for the right note, the right rhythm, the right form at the right time, together with the choice of the right word; in short, the feeling for what can and what cannot be done at a certain place and in a certain time. Also, the impact it makes on others; where it leads them, how they will understand it. Communication is complex and takes place on many levels.

Life and art are too complex to lay down legalistic rules. But that does not mean there are no norms. Although one cannot define the wrong kind of seductiveness or the right kind of prettiness and attractiveness of a woman by the length of her skirt or the depth of the décolleté, nevertheless women know the exact boundaries, especially the seductive kind of women, as they just play over the borderlines. So in music, and in art in general, the good artist knows what ought to be done at a certain place and time, what is appropriate. It is a matter of good taste.

I will add one more point. If we talk about Christian music we do not necessarily mean music with words that give a direct biblical message or express the experience of the life of faith and obedience in the pious sense. Obedience itself is not confined to matters of faith and ethics only. The totality of life comes in. It is the mentality, the lifestyle, that is given artistic form and expression. Bach's *Matthew Passion* is Christian, but so are his *Brandenburg Concertos*. Not only the words of the cantatas are Christian, but also the instrumental parts of them. Otherwise we

make Christianity narrow and leave a great part of our life that ought to show the fruit of the Spirit outside the commitment to God, our Lord and Saviour. On the other hand, I know paintings that iconographically represent a Christian theme but their content and impact are negative, blasphemous, in short, a lie. But then the other work of the same artist may express a quite unchristian mentality.

4:6 Problems of art and style

In a way, an artist does not have a style that can be changed for another, but he or she is a style. In the style an artist shows who he or she is.

Today there is a tendency, resulting from a two-centuries-old way of thinking about art as something high, autonomous, almost religious, to narrow down art to 'great art', the paintings in the art gallery, the classical music of the great Romantic composers, great literature. There is no denying that it is art or that it is important. But it often means that the crafts or 'folk' music of one kind or another are passed by, not considered worthy of our attention.

This can go deeply into the lives of people. I once met a girl who told me that she had always dreamed of becoming an artist. She asked my advice. Now, her drawings were not so good that I felt I could encourage her. But I knew that she was very good at designing clothes, at making fabrics. So my advice was not to go to the painting department of some art school. It would mean plodding on for many years; at the end maybe a little pat on the back, but a whole pile of unsold paintings in the attic. I told her to search for a good art school in the area of the crafts, textiles or fashion. She did, and when I met her later she was happy. She even felt that she was at a more challenging place, learning more, than at the 'higher' art school where people were discussing all day and doing very little; learning very little, like little geniuses without a goal.

Therefore it is good to consider what art is, again focusing on painting and sculpture, knowing that in other fields comparable distinctions could be made.

In visual art one can look for two different qualities. One is the amount of naturalness, of depicting force, of representational quality. Here one can range from zero, the totally non-figurative, the pure form, to the extreme of naturalism. At the one end one has the curve, the circle or the square, the pure colour or the simple pattern. At the other there is the precise rendering of visual impressions, as in a still life by Harnett, or the precision of Jan van Eyck, rendering things in full detail.

The second approach speaks more about the function with regard to the load of meaning that the work carries. Here at the lowest level (low does not mean less) one discerns ornaments, beautifying forms, colours, all valuable in themselves. Certainly this often has great significance. At the highest level, the icon, the loaded work that encompasses so much

meaning because it carries so many values, stands for grand realities. The idol is a specific, and in a deep sense sinful, example of an icon. It is a god. But we think also of Michelangelo's *David*, the personification as it were of all that the Florentine Renaissance stands for: the greatness of human being. Or think of Rembrandt's *Jewish bride*, which stands not just for Rembrandt or seventeenth-century Holland but also for the greatness of human married love. Of course one can think also of the Byzantine icons. Between these two extremes all works of art have a place, sometimes more loaded, sometimes less.

Every work of art is characterized by these two elements. It can be decorative, low in iconic meaning, even if it shows precisely painted flowers, as with nineteenth-century wallpapers. It can be iconically important even if its representational value is low, as with Paul Klee or Abstract Expressionist work.

The point now is that all these different kinds of art, with or without high iconic value, with or without precise representational quality, are valid. It just depends on the function it has to fulfil. Again, decorum is the norm here. When a decorative work is well done it may have less iconic value but that does not mean less artistic value or less significance, and certainly it does not mean that the person who made it is a lesser artist.

Really great art often 'works' on several levels at the same time. Consider a Baroque church in Southern Germany – Ottobeuren is a fine example. Here the arts 'work' decoratively. They are there just to adorn the church. But if one looks more closely one sees figures, fine floral ornamentation, and when one takes more time one sees the stories and, beginning to understand these, one sees their meaningful content in relation to the totality of the church and its function, and so on to a grasp of the underlying programme. Here all levels of iconic and of representational value seem to be present. It is at the same time decorative and loaded with meaning, working as colour scheme and ornamental finery and as precise representation. If we understand these things we can also grasp that the discussion whether to prefer figurative and non-figurative in the visual arts is of no great importance. I avoid the term abstract on purpose. There has always been non-figurative art, mainly in ornaments and such. And great paintings have always 'worked' also on that level, apart from the figuration they give and the meaningful story depicted. And figurativeness does not always mean great depth and loaded meaning. The question is not whether non-figurative art is right or not. Two other questions need to be taken into account if we want to discuss the matter at a meaningful level. The first is the question of decorum, the function of the work of art, in its own setting. So an ornament or the pattern on a fabric can be non-figurative. But so can a large sculpture, if it stands in a place where it is appropriate. In a way, the Eiffel tower was such a non-figurative sculpture, the landmark of an exhibition in 1889. Or, on quite another level, consider the shape of

your watch or car. We usually call that industrial design. Even here, in these forms, there is inherent meaning. A car-form can stand for luxury, for speed or for efficiency. To decorate the hall of a hotel one can choose some figurative, decorative panel but it may also be appropriate to choose some pattern with large coloured areas. Taste is here a guiding principle, a feeling for what is appropriate.

To me what is never good is the abstract, when it means the denial or the dismissal of reality, a negative attitude to reality. By negative I do not mean showing the wrong as wrong, bringing into art a sense of the curse, of sin, of the unacceptable as such. I am not asking for only sweet idealistic pictures. They can be lies too, by-passing the realities of life as some 'Christmas' pictures do. But by a negative attitude I mean that reality as such is considered negative. We often find this in modern art, but that is not under discussion here.

So what is to be taken into account is the place, the decorum; and what has to be discussed is the meaning in relation to that role. Again, art is never neutral, and always the totality of our humanness is involved if we want to discuss it adequately.

And now some words about style. Often I have been asked by a young artist which style to choose. To me this is an embarrassing question. One cannot choose a style at random, as style is part of the content, for the expression of the artwork is in the artistic form itself. In a way, an artist does not have a style that can be changed for another but is a style. In the style an artist shows who she or he is. This does not mean that within the larger framework of a style there will not be differences of style in relation to the function and place of the specific work, light at a wedding party, deep and solemn at a social occasion of great weight, tragic and dirge-like at a funeral. But style cannot be chosen at random. Certainly we should not 'choose' a style just because we want to be 'in', 'with it', make our work better saleable or popular. We should have the courage to be ourselves, to be honest. This to me is the minimum requirement for any work of art. We should never compromise our principles or deep aims. Also, we should not just follow trends and fashions as they come and go. That could be in a bad sense 'worldly' and show that we have not much to offer of our own. It can easily be understood that young artists are seeking for style, that they are experimenting with the possibilities of expression. But once a style is found, that is 'them'. Of course that does not mean that it is unchangeable. It will grow with an artist, in depth and breadth. In a word, it will become more mature. Usually that also means greater simplicity and directness, just because the complexities are mastered, and much is brought into a few images. This is the master's work.

Both elements can be seen in the history of art. In the work of one artist one sees a development, a process of maturation, of gradual changes as life goes on. Sometimes one sees rather sudden changes in style, in the forms of expression. That always means that a drastic

change in the direction of the artist's life has taken place, either a conversion to another spiritual principle or the influence and impact of a person or a movement.

4:7 Fame and anonymity

We have only enhanced the world God gave us to develop, to beautify. We have enriched the lives of and have loved our neighbours. That should be the greatest achievement.

Some artists have become famous. Some of their names are known to everybody. It does not necessarily mean that their works are really known to everybody. But there are thousands and thousands of artists who are not known. When we look into the large lexicons of artist biographies we see many names. They are at least known to the specialists. But apart from them, there are many of whom nobody has ever heard. Yet there was someone who made that particular statue that is the delight of everybody who travels with open eyes to a certain place. Maybe it is well cherished by the local people. When these people say they love their town, that particular statue is part of the image of the place, and it certainly would mean that if it were lost many people would miss it. The statue is famous, but who knows the artist? Ask people who made the statue that is the landmark of Copenhagen or who made the monument in Trafalgar Square or the lions that everybody has seen there. What I am trying to show is that much of the artist's work is anonymous. In that sense the artist shares the fate of the many who work for the public benefit. Who made the train you travel in? Who is the clever person who made the schedules for BBC broadcasts? Who designed that handy thing you use every day?

Maybe the anonymity is not a fate or a tragedy but quite normal. The praise for that monument, that handy thing, is the highest reward one can get. A good poster; who knows who made it? Who cares? Maybe the artist is known to his or her colleagues. The specialists will know. But in due time the artist is forgotten. Who knows who made this or that beautiful statue in Babylon, in Egypt, in Greece or Rome? Who made the famous Marcus Aurelius statue on Capitol Hill in Rome? Or who erected the obelisk in the Mall in Washington D.C.?

All this I feel to be right. The fame goes with the work, if it is done well. Panofsky, in his book on Suger, speaks about this in a very wise way. He compares Suger with Michelangelo. Do you know who Suger was? Suger was a great bishop in France in the twelfth century. In many ways he was responsible for the Gothic style. He was the builder of St Denis, the man who chose and guided the artists. He was a very important man in his time, though only specialists have heard of him. Yet everyone who admires the Gothic style is praising Suger's vision and great abilities.

Suger, says Panofsky, did search for fame, but it was centrifugal. The fame was in the things he did. That of Michelangelo was centripetal.

That means it always ends in Michelangelo himself. You go and look at the *Pieta*. What do you search for? A beautiful Madonna? An emotionally charged image of the dead body of Christ? Or do you see Michelangelo? The same is true of his other works. In a way we forget the thing we are looking at and we leave the monument not saying, 'How terrible and yet how joyful was the *Last Judgment*,' but, 'Michelangelo did it, and how great he was!'

Which of these two do you look for? We may criticize Suger for some of his ideals. If we say that the Roman Catholic churches are over-adorned, that the art is too much, some of that means criticizing Suger's vision. Yet I think his ideal of fame is more Christian than Michelangelo's. Or, if not Michelangelo's, then that of the people who gave him such praise.

In short, we should not look for fame. It may be kindling the sin of pride. It may mean we lose our humility. And God may miss the praise he is owed. This, I think, is the lesson we learn too in Ecclesiastes. All things are vanity and even the highest praise evaporates in the air after a while, a year, a century, or maybe hundreds of years. Yet the meaning of work done well is in the joy to have been able to make something that was of some use to somebody, and in that way to have added positively to the flow of history in the direction of the kingdom of God.

Maybe young people dream of becoming famous. But it can be dangerous, leading to compromises, to dishonesty even, just to achieve easy fame.

It is better to dream of developing one's talents, to achieve the best one can. Let others decide and judge and give praise. Do not let that fool you. In the end one has to stand before the supreme Judge, the great Lord Almighty. Probably one will say then, 'Lord, I have only been an unworthy servant of yours, but I have tried to use my talents. It was not perfect, but you gave me so much that I have to thank you for, whatever the world says I did.'

In the last resort art is anonymous. Who knows the names of the great sculptors of the Gothic cathedrals? Who knows the names of the architects of even the building that has been made quite recently? Everybody knows that a good performance is never the work of one person alone but that the performer needs the help of many others. He or she is in a way the brand name, the trademark. The paintings, the songs, the good designs of cars and other industrial products are anonymous. It is good that way. We have only added to the world God gave us to develop, to beautify. We have enriched the lives of many, we have loved our neighbours. That should be our greatest achievement.

4:8 The qualities of the artist

Four qualities determine the scope and depth and importance of the artist, any artist. They are talent, intelligence, character and application.

Talent: the term is taken from the Bible, from the story that Jesus told of the talents. Indeed, a talent is given. It is a potential which one has to use with responsibility. Our Lord has the right to ask, and certainly will ask, what we did with it. Something to give thanks for? Certainly, for without this no artist can be of any importance. Yet it is nothing exclusive to the artist. Other people have talents. Everybody has been given qualities, positive ones to use and to develop, and there are also negative ones, our weaknesses which we have to fight.

By *intelligence* we mean the quality to analyse a situation, to find the right form, to give the right solution to the artistic problem, to master the complexities of the art, to express clearly what one wants to achieve. In a way this is also a given quality. Some people may describe it as a talent. Again there is the necessity to develop this.

Character is a very important quality of the artist. It often determines an artist's greatness and importance. Many artists have failed here. Some, early in their life, have success with some work and then they go on doing the same thing. What was once a creative act, the development of a new principle, becomes in this way a trick, an easy achievement. Such artists dry up and end up quite second-rate. There have been great artists who have ended this way. Another temptation for artists is to use their talent below their level in order to make money, to be popular and acceptable. Here, to choose an example out of the history of jazz, it would be very fruitful to compare Jelly Roll Morton and Louis Armstrong. Of course, as jazz had been such a great influence on popular American music, the temptation to become 'commercial' and to 'go pop' was very great. Louis Armstrong fell for this. Somewhere around 1930 he went commercial and his work became easy and popular and full of tricks and effects. At times he tried again to do something good and creative but he almost always failed. At times he even ended up as a kind of clown on TV, singing lullabies in bad taste for children. Yet he was a great musician, a great trumpeter. But to hear it, one has to listen to his work with the Hot Fives or Hot Sevens in the years 1926–1927 or to his early work with the great King Oliver Creole Jazz Band of around 1922–1923. Happily we still have those recordings. We can understand what happened though. The years after the crisis of 1929 made it very hard for a musician to make a living, and as good quality music was not appreciated enough by the public, who preferred it sentimental and 'light', the temptation was great to cater for these bad tastes. As always, apart from personal weakness and sin, there is also the communal guilt, the situation our society, our environment, puts us in. Jelly Roll Morton, the great jazz pianist, however, refused to sell out his art to cheapness. He fought on for quality and the principles he stood for. As a result he is still a great artist who has a chapter in any worthwhile history of jazz. But his name is forgotten by the public for whom he refused to play the clown or the caterer in sounds. And he

suffered many years of poverty and neglect, just as many other great jazz musicians suffered and sometimes even died of it in the 1930s.

In the lines above one should not read that entertainment as such is wrong. In a way all art is entertainment, the God-given opportunity to relax with good music, with good art, a fine book. And there is nothing wrong with a ballad, with dance music (Mozart made quite a bit of it) or with cartoons or posters, illustrations. But whatever one does, it has to have quality. Remember what we said before about Dr Isaac Watts. He wrote popular songs at the highest level.

Or think of Toulouse Lautrec, whose posters are still hanging on people's walls, even if the performances he was advertising took place so long ago and the performers have all passed away. Most people do not even know the kind of songs they were singing. If a work is done well it survives the occasion, like the Mozart music we still listen to. We still play Bob Dylan, even if the period of protest in which his music played such an important role has gone by. One can still look with pleasure at a good entertainment film of years gone by, even if the style is dated.

Of course it is dated. Whatever we do, we can never escape being of our time. We live in the now, inevitably. But a thing of beauty survives if its qualities are not ephemeral.

The last quality of every good artist is *application*. The old saying is that any good work of art is 95 per cent perspiration, and 5 per cent inspiration. Some people may want to place hard work under the heading of character. Anyhow, no great work of art comes by itself, as a product of chance. There is no instant art. Apart from coffee nothing is instant in this world! I remember the words of a great pianist. He said, 'If I do not do my exercises one day, I will hear it the next day. If I do not do them for two days, my wife hears it. If not for three days, my best friends will notice. After four days, the public will notice.'

Then there is that charming story of Hokusai, the great Japanese painter and maker of woodcuts around 1800. Once somebody asked him for a painting of a rooster. He said, 'OK, come back in a week.' When the man came, Hokusai asked for postponement: two weeks more. Then again for two months, then for half a year. After three years the man was so angry that he refused to wait any longer. At which Hokusai said that he could have it, there and then. He took brush and paper and drew a beautiful rooster in no time. The man was really furious. Why was he kept waiting for years while Hokusai could do it in such a short time? 'You don't understand,' said Hokusai, 'come with me.' And he took the man to his studio and showed him that all the walls were covered with drawings of roosters, which he had been doing over the past three years. Out of that came the mastery.

This story of course does not mean that we can keep people waiting, and that we should not fulfil our promises. The lesson is that even improvisation and so-called spontaneous achievements can only be the

result of hard work. No artist can ever reach the top if he or she does not start the day with rehearsing, a painter drawing for a few hours, a musician practising, anybody studying. Genius is not enough.

4:9 On the way

. . . an exciting road, full of new vistas, a walk in the direction of the Promised Land, while even now we experience much of what is waiting for us to come.

Of course we pray and ask for God's help. Of course the Holy Spirit is behind us. But God, in his great mercy and wisdom, takes human beings seriously: as his creatures, made even in his own image. We never become passive instruments of God's Spirit. He gave us a personality, gave us freedom and responsibility, so we never can say that our work is directly inspired and therefore his. It would be blasphemous to say that our work is God's work. But we may praise him for the life-renewing force he gave us in Christ, and for his help when we achieve something that is full of love, life, beauty, righteousness, peace and joy, maybe after long searches and studies.

It comes down to this: Christian artists are people who work, think and act as artists, using their talents and possibilities, but maybe with a different mentality and with another priority in their lives. This mentality certainly implies that as Christians we work in freedom. We do not need to prove ourselves, since the search for fame and the preservation of our pride do not need to burden us, and we do not need to make our own eternity.

Maybe the best way to express this is to say that we are on the way. The Bible often uses this metaphor. Scripture is a lamp for our feet on the path that we follow through this dark world. Go on the narrow path. It may be difficult and will ask for effort. But going on the 'wide road of sin', letting yourself go, doing whatever you want, leads to the destruction of yourself, already in the here and now. Follow me! Those are Christ's words. Know where you are going. Christ even applies this way of speaking to himself when he says that he *is* the way. To live is to go, on a way, with him; a way of life, in a deep and very real sense, a way of truth, as he is the Truth, and we ought to do the truth, which is to love God and love our neighbours. The way is a way of freedom, love and humility, but it is God's way of holiness, where he helps and leads. The way is sometimes hard to follow and sometimes asks for sacrifices, in extreme cases even for our mortal bodies in martyrdom, but it is also an exciting road, full of new vistas, a walk in the direction of the Promised Land, while even now we experience much of what is waiting for us to come.

Articles on Christianity and Art

• We and art[560]

In a number of articles we hope to say something about art, in particular about the visual arts, about painting and sculpture.[561] The first question we must pose is that of whether God's word says anything to us about these things, whether God has given us a positive task in these matters, yes or no? This question we can split in two, for one can pose it with respect to creating works of art oneself or with respect to enjoying the beauty of art and possibly studying art. The last instance could give rise to problems inasmuch as virtually all art in the course of the centuries has been made by heathens or unbelievers or by apostate Christians. But we will reserve the discussion of that matter for another time.

For now we want to concentrate on the first question, namely, that of whether God has assigned his people a positive task in connection with art. Has he given us the vocation to create art, to make 'Christian art' in distinction from 'worldly art'? For only too often people have said, thinking things through 'consistently', that we must claim all fields for Christ and therefore also let our distinctive voices be heard in the realm of art. Yet in this way we may perhaps out of self-willed religiosity saddle ourselves with possibly irresolvable problems and heavy burdens. If we have such zeal for God yet without comprehension – since not according to God's word and commandment (Romans 10:2 ['they are zealous for God, but their zeal is not based on knowledge']) – then the Lord will also reproach us as in Micah 6:3 'My people . . . how have I burdened you?' For already in Micah's day there were some who thought to justify themselves in such matters by appealing to David's example, while at the same time forgetting the covenant (Amos 6:5). If we turn now and search the Scriptures to see where and how they speak of art, then we find that that only happens a few times and then almost in passing, and that the Lord nowhere gives us an explicit commandment, for or against.

We find that for the making of the ark, God himself designates some artisans and fills them with wisdom and understanding so that they know how to make all the work in the service of the sanctuary according to God's commandments. Yet the matter is one of a very narrowly defined commission extended to a handful of selected people. In 2 Chronicles 2 and 3 we learn of the building and furnishing of God's Temple by Solomon. And who does he seek out to be responsible for the decorating and furnishing? There is no one in the nation of Israel whom he regards as suited. And so he sends to Hiram, the king of Tyre, to ask for his help. And the king of Tyre sends him Hiram Abi, the son of a worker in precious metals from Tyre. We do not know if this smith was a believer,

yes or no, only that his mother was of the tribe of Dan. However that may be, he had learned his art, including the style, in Tyre. He was renowned for his wisdom and his understanding in making works of brass, including works decorated with figures and scenes. Naturally Solomon would have seen to it that the fonts dedicated to God were not decorated with heathen images, but for the rest this art would in principle not have differed in appearance from that of Tyre.

There is little more to be found about these matters in the Scriptures, including the New Testament, so we can conclude that God has not assigned us a special task with respect to them. God does not demand of us that we create a distinctive art or style of our own! On the other hand, it is obvious that if one of the Lord's people is an artist, one may not just go out and make anything one wants in the way a worldly person might do, in disobedience to God's commandments. Yet no great difficulties should arise here. For it is obvious that one may not make blasphemous or immoral presentations. The latter might lead people into temptation and incite them to commit unholy acts. And naturally one will also keep one's distance from art that clearly bears the stamp of an apostate way of life. I have in mind, for example, modern Surrealism, which holds up to us a world that is totally devoid of meaning, without norms, decadent and without hope: but what believer could possibly be won for such ideals? Thus it is not so much the positive task of the Christian artist to create a distinctive style from scratch unconnected with the world; it is much rather the negative task of not producing works in which the theme selected or the thought communicated is contrary to God's commandments or could lead believers, God's children, into temptation.

We have not yet addressed the question whether it would be possible at all for such a Christian artist to create a distinctively Christian style. Thus, is Christian art possible? In our opinion Christian art is certainly a possibility. That would be art that not only with respect to the subject chosen and the theme treated but also in the style and the aesthetic form would bear the stamp of a life and world view faithful to the Scriptures. Nevertheless, it is not possible to sit down and in general write out the 'rules' for it, or to discover some sort of recipe such that if it were applied it would 'naturally' lead to Christian art.

Christian art can only arise where people seek the kingdom of God, if they are faithful to God's commandments and if they seek to walk in the ways of the covenant. Where that is so, the Lord may grant us this, as well as a something added: 'But seek first his kingdom and his righteousness, and all these things will be given to you as well' (Matthew 6:33). When God's people are faithful and the Lord in his graciousness grants that his kingdom may already break through in this dispensation and the word permeate everything as a leaven, in a time thus when the Lord of Lords puts his people in a position of cultural leadership –

according to Deuteronomy 28 he will honour those who honour him –
then he will also provide talents in the field of art. He will assure that
people are found who have many gifts in this area who, because there is
a wholesome, scriptural understanding of reality and life, know how to
practice their art in such a way that one can speak of Christian art. In
such art, beauty too will be done fuller, more glorious justice than in all
heathen and apostate art! (We may go into this in greater depth later
when we look at our own [Dutch] seventeenth-century art.)

But now, in these times, as we watch the signs of the times (Matthew
24:33) and understand how the prophecies are being fulfilled that were
given by the Lord himself while he was on earth; now, when we are
compelled to witness widespread departures from the word and
apostasy, and when we see that the church lives in the wilderness
(Revelation 12:14), in these times when contempt for the Law is on the
increase and therefore love waxes cold, we have only to be and to remain
faithful and to endeavour to live according to the Lord's
commandments, and that is often difficult enough for us (cf. Mark
13:20). But we may not and also will not, if indeed we are earnest in
seeking his kingdom, set about out of self-willed religiosity to serve the
Lord in tasks with which we have burdened ourselves, in a manner that
we have 'consistently' thought through on our own. Nowhere has the
Lord given us a single commandment to serve him through some kind
of Christian art, and we shall accordingly not strive to do so in the
present time. If we just walk faithfully in his ways, also as artists, and for
the rest simply trust the Lord to supply all our needs (Matthew 10:29),
then his yoke is easy and his burden is light (Matthew 11:30).

• The Christian critique of art[562]

If we as believing Christians consider the critique of art, we must begin
by asking what the Scriptures have to tell us about it. And then we see
that though art is referred to in a general way, little is said about the
details of style and the standards of beauty, though often mention is
made of the norms of faith and morals. The Bible is not specific in
speaking of the beautiful and the ugly since it is taken for granted that
everyone is able to distinguish between the two, even as in our daily life
this presents no problem for us. Something else is apparent in this
silence of the Scriptures concerning art, namely this, that although God
placed beauty in creation and also created the talent to make works of
art, he has nowhere given a specific command concerning this gift, as he
has done, for instance, in the matter of preserving the faith and fleeing
from evil. 'But seek first his kingdom and his righteousness, and all these
things will be given to you as well,' it is written, and this has found
wonderful fulfilment in our seventeenth century.

When we consider more closely the problem of how the art of this world, namely that created by unbelievers, must be judged, then it is not a question of distinguishing between beauty and ugliness. It is rather this: in how far does the unbelief of worldly humanists affect their art? In answering this question we limit ourselves to the art of the last four or five centuries, to the age of humanism, with which we are most concerned. Roman Catholic art we shall not consider at this time nor shall we attempt to exhaust all the possibilities of our theme. People and their art and their lives are so rich and varied and God's creation is so great, also in the daily activity of unbelievers, that we shall never be done with our study of these. We can only touch upon certain facets of this subject.

The folly of the humanist

Humanism is a system of spiritual heresy that controls the whole life and the striving of its adherents. Its fundamental principle is the self-sufficiency of human being. Humanists recognize no higher authority than their 'better-ego'. They rule their world according to their own will and elevate themselves to the position of God; they imagine that from this independent position they can will all things and rule all things.

Humanists see reality as a stubborn element that must eventually submit to their will. But reality does not lend itself so easily to human control, because God governs the laws of his creation, and people can change their own sinful hearts least of all. Beyond the Saviour, Jesus Christ, no real salvation or renewal is possible. People again and again will have to capitulate to the reality laid down by God, and they will always have to reckon with their human fallibility. Thus the world, as it is constructed by humanists, will show the character of a compromise – a compromise between the ideals humanists would like to develop out of their ideal philosophy and the world as it really is. This is so whether they accept it or not. In the field of art it means that true art will be possible only when artists are willing to submit to the norms of beauty laid down by God in creation.

It is very well possible to experiment with some kindred spirits and to create works of art in which all the laws of beauty have been negated. But in this way beauty and art of permanent value will not be created. If people want to produce real art they cannot modify the laws of beauty. They will only be able to put a personal stamp on their works by emphasizing certain elements at the cost of others. All this will depend on the commission given to an artist and on the artistic problems he or she is trying to solve. These problems will in a great measure be determined by the artist's attitude to life in general. Nevertheless, certain possibilities laid down by God in creation will be disclosed although people may neglect and by-pass others.

Humanist art to the glory of humankind

This was the case in the humanism of the fourteenth and fifteenth centuries in which new things were uncovered pertaining to art. We think here of the portrait, the representation of landscape scenery, the exact painting of reality by means of perspective and the striking treatment of light and shadow, the right presentation of the human figure in the most difficult poses, the art of oil painting, of wood carving and copper engraving, etc. Who would deny that here real possibilities were disclosed? It is true that these discoveries were in the service of humanistic idealism: the portrait was used to augment the honour of individual people. The humanist sought for the presentation of the so-called ideal – ideally beautiful people who can act out their heroic deeds in ideally beautiful surroundings, deeds speaking of human greatness and independence. The task given to art was to glorify humanity and to present reality as the humanist thought of it ideally. Striving and working to meet these demands, the humanistic artists, Raphael, Michelangelo, Titian, Van Dyck, Watteau, and others created beautiful pieces of art. For they bowed, perhaps contrary to their inclinations, to the law of God. Otherwise their works would have been put aside immediately. Certainly their seeking and striving was in a very limited direction and that, too, gave to their work a certain unbalanced perspective that, especially in the works of their followers, had disastrous results.

Watteau showed us feminine grace as it had seldom been portrayed. But while working in that direction, the genre called into life by him was watered down all too soon and became sentimental and insipid, while the feminine types of the master became less and less realistic in the works of his followers. Van Dyck, the great portrait painter, made all women equally elegant and beautiful, but also insignificant. His portraits of men all show the same ultra-refined poses.

Judge for yourself but remember God's laws

We come now to the conclusion that we must make a distinction between the creative work and tendencies of the leading stylists and the result of their labour. In the final analysis we are concerned with the critique of the concrete paintings. We must not judge the artist when we are looking at a picture, but consider the painting itself. And we should do this as we judge all other things – according to God's laws.

We must speak of art as good or bad, beautiful or ugly. Certainly this is to be considered in the first place, but the norms of morals and faith should not be neglected in our critique. The concrete painting must be judged according to the law of God. And this will in no wise offer difficulties if we look at the picture objectively and with a scripturally trained discrimination. Let us not hesitate to use our judgment simply because we are not artists ourselves. To look at paintings and enjoy them is something no one else can do for you. Do not be afraid to judge for yourself.

Certainly you can learn from artist friends. Museum catalogues are also helpful. There you will find many facts concerning the pictures. Of course you can make mistakes in your judgments, but only by visiting the museums and enjoying the paintings yourself can you acquire a real appreciation for art, particularly if you compare the inferior with the superior works.

We have emphasized the objective critique of the painting rather than of the artist himself. Now you may say that art cannot be good unless it has been done to the glory of God. It has indeed been written in the first Corinthian letter, 'whether you eat or drink, or whatever you do, do everything to the glory of God.' The text speaks about eating and drinking and not about how the food was made, for notice that in this part it is sacrificial meat that is referred to. This is similar with the appreciation of art: we do not judge the artist – God will do that – but we judge the artwork itself. Let us do this to the honour of God and thank him for the good we may enjoy in art.

• The Christian and art[563]

A list of titles for further reading about this topic appears in the endnotes.[564]

The subject of art has been almost wholly neglected in Protestant circles during the last few centuries. This aspect of Puritanism was a result of a mystical tendency which, in turn, was derived from medieval and pietistic interpretations of Scripture. Art thus became a problem in Bible-believing circles. At present several Protestant scholars are seeking a solution to this problem, mainly in the area of art theory and criticism, for the purpose of showing that a Christian analysis may also present answers to questions of art. The norm for our attitude to art, however, may not be sought in an attempt to build up an aesthetic of our own since this is, of course, subjective and transient. Nor is this necessary for the topic at hand. For the issues in question actually concern the nature of a Christian way of life, and about this the Bible is explicit. From this vantage point the subjectivity of the individual (type, character, development) may also be taken into account.

A gift of God for enjoyment

It is wrong to pose an antithesis between one's professional life and the enjoyment of art in the same way that sincerity may be opposed to lightheartedness, seriousness to frivolity, responsibility to trifling, or constraint to joy. Such a distinction is humanistic. For both toil and enjoyment have their respective place and purpose (Ecclesiastes 3:1). The enjoyment of art belongs to the gifts which God presents to his children for their happiness (cf. Ecclesiastes 3:11-13).

Different Types

There are many types of art, each fulfilling its own function. In music we can differentiate between background music, folk songs, church music, concert music, etc. Each of these has its own task and laws. During a parade a concert by Bach is out of place, and a march played at a church meeting is equally inappropriate. In pictorial art the distinction between book illustrations, decorative murals and paintings is quite clear. Similar differences in function can be noted in literature and the dramatic arts. In each genre we discover various levels. Each kind requires a different programme. Thus, varying levels of understanding – depending upon knowledge, experience, education and other factors – give rise to various kinds of art.

Art thus has many facets. And that which one is seeking or presenting must be selected with tact and insight into the demands made by the particular function and level. This, too, is a norm.

Function of art

Art or entertainment (both are fundamentally the same, although the words perhaps denote different levels and functions) bring us into contact with reality in two ways. In the first place every piece of art reveals to us some portion of reality of which we were perhaps ignorant. It opens our eyes to beauties and peculiarities not experienced before. A landscape painting, for instance, may show the beauty of certain clouds or colours; a song may evoke new emotions. In the second place, any work of art has a reality of its own that may have considerable impact on our lives. 'A thing of beauty is a joy forever.'

Considering these two facets of art, it is evident that the view of life which is incorporated into a specific work of art will be of great importance. If it is borne by a kindred spirit it can be enjoyed without many obstacles (e.g. seventeenth-century Dutch art, the music of Schütz or Bach, real Christian literature). But if it expresses another world and life view there will be a kind of conversation between us and the author (not to be considered as an individual but as a member of some group or the advocate of a tendency). Even this may be an enrichment of life and may deepen one's view of reality, spiritual as well as visual. If the work of art seems to be a curse, or leads thought and imagination in a sinful direction, then we may cease the conversation by turning away. In general it can also be stated that here the word of our Lord is valid, that not what goes into people defiles them but what comes out of them (Matthew 15:11). Reading a book of an obviously non-Christian character, for example, is not sinful in itself and does not necessarily distract us from the Lord. Sometimes such reading may even deepen our faith. Christians need only guard their own thoughts, words and deeds.

Christian liberty

The Lord has given us freedom in the realm of art. This is not humanistic freedom, in which people seek to be either godless or godlike, but it is the freedom of Romans 8 and Galatians, a holy freedom to read, look at and listen to art as it speaks to us. It has often been darkened because Christians undertook to guard the children of the Lord against evil by their own means or strength, not trusting in the Lord with all their hearts. At such times they thought it proper to introduce many commandments and regulations of their own, with the result that the love due to the Lord waxed cold.[565] But the Lord has told us to trust him and, because we are 'perfect in Jesus Christ', who has delivered us from the power of darkness and in whom our sins are forgiven,[566] we must not enslave ourselves to human ordinances.[567] Paul's words in Colossians 2:23-3:17 are especially important in this respect. For his argument clearly shows that Christian liberty in matters of art does not mean ungodliness or sinful engagement in the ways of the world. Although Christians are free, they are nevertheless in Christ[568] and therefore will not *want* to engage in sinful things, even in the realm of art.

Non-Christian art

Does Scripture present any norms for art? Before answering this question it must be stressed that the Bible does not say that only believers can create good art. For instance, Solomon received assistance from a heathen king and his artists in building the Temple. As long as a person abides by the rules of art, respects nature, i.e. the structures of God's creation, his or her art can be sound. (Picasso's art, for example, is often not sound in that he pictures many parts of the body in a wrong place, i.e. in a place contrary to God's created order.) The observation that unbelievers are able to produce sound art is not contradicted by the fact that frequently their art reveals their disobedience to God's laws and their lack of love for him and their neighbours, especially in our times when artists have gained a deep consciousness of their own standpoint. The consciousness of the modern artist has been excellently described as 'the courage and honesty of a mind valiantly beating itself to destruction against the locked and barred door of an unknown and perhaps non-existing reality'.[569] The final consequence of such a viewpoint is that artists take their stand against God and his creation. Their art reveals their antipathy towards the divinely created order of nature (observe the defilement of this order in many modern works of art) and against human being (a revolutionary spirit that takes pleasure in degrading traditional or human values). But, on the other hand, even in our time the most modern of the modern, such as Picasso, sometimes produce beautiful works of art, although these works may not always follow from the artist's own world and life view. In general one can say

that in art the critic must always exercise care to criticize the work of art as it offers itself to her or his perception and to define the spirit which it represents and not to judge the artist personally, since that [judgment] is reserved for God himself.[571]

Norms

Although the Bible does not present any rules for art as such, a passage like Philippians 4:8 offers a clue to what the Lord desires art to be. This text concerns the Christian's whole behaviour, art included. The following exegesis is focused on art, showing the norms of Scripture for art.

In the first place, the Christian must consider *truth*. This means that the artist must pay careful attention to the structures and possibilities that God laid down in nature. This is not a plea for a radical naturalism that injures reality by the exclusion of the human interpretative and normative aspects of life. Nor does this mean that fantasy must be shunned, or that everything must be rendered in perfect detail. But it does mean that fantasy and fiction are to be employed for the promotion of truth – not its debasement. Truth is bound to the Second great Commandment, the love of one's neighbour, which may oblige us to clothe sin or to refrain from relating affairs which may lead others into sin.[571] Truth in art involves praise of the beauties of creation, the beauty of good works and the greatness of God, who helps, guides and may chastise the person who does not heed his commands. There must also be due respect for the subjective truth that may be incorporated into a work of art: a person may believe an opinion to be true and when relating this must be respected for it since he or she did not attempt to lie. This respect is due also if the opinion is a lie when confronted with the truth of the Scriptures. For a forthright approach is always to be preferred to half-truths hidden under seemingly correct and justified words, which are much more dangerous since they imply a more or less hypocritical attitude on the part of the author in question.

The second standard mentioned in Philippians 4:8 is *honesty*. We may – and at times must – talk about sin. But this must be done in such a way that no one is misled by it. Sin can be related in a pure and honest manner, without pedantry. Honesty demands openheartedness and clarity in speech along with scriptural dignity and restraint.

Paul further advises us in this passage that people must think about the things that are *just* [or right]. This does not mean that (in the work of art) the righteous always prosper while the sinners are unhappy. This is evident from scriptural passages such as Psalm 73. Nevertheless, a work of art should indicate what is right and wrong.

Whatsoever is *pure* is next. Purity does not mean neglect of sexual and erotic realities but rather avoidance of exhibitionism so often found especially in contemporary literature. In this respect also the Scriptures point the way to a simultaneity of realism and purity.

Art should also be characterized by *loveliness*. Artists must search for beauty and harmony. They should not unnecessarily subject their readers and interpreters to fright, fearful noise, terrifying tales, awful feelings, gruesome cruelties. In short, they may not violate the Second great Commandment by throwing their fellow human beings into a mental or psychic pit without any artistic catharsis. Fearful things need to be told sometimes, but they may never be a goal in themselves – and a dissonant passage must find a 'lovely' solution. Loveliness is a clear command, but it must not be misunderstood. For it is well possible that drama may be fine if it is truthful and reveals beauty, while comedy may be saddening if it serves sin or violates truth.

Last but not least, Paul advises attention to be focused on things of good report [praiseworthy]. Every artist who is conscientious endeavours to serve his or her neighbour, and whatever desires truth and justice deserves praise. This is true whether the artist is a Christian or not, but more so if the ways of life according to the Scriptures are observed.

Evaluation of art

These suggested principles must be employed in judging art, whether judging the work of a Christian or an unbeliever. Moreover, the observations made in the second section must be kept in mind: it may happen that a Christian has little understanding of reality and violates the law in this respect, and that an unbeliever is right. A work of art will be all the greater if the artist knows and fears the Lord, shows insight into God's creation, and is sufficiently talented to make a real work of art.

The critic must judge with understanding, not mercilessly, and never with pride. The critic must be careful to do justice to whatever qualities a work of art may have. The remarks at the end of the section on non-Christian art are relevant here also.

Indispensability of art

Art is a gift of God. It means much in our lives, for it can give great joy and enhance the beauty of life. It may bring us into contact with reality in a variety of ways and, by means of modern art for instance, we can come to a better understanding of the spirit of our times and the strivings of our fellow human beings. Art may thus increase our faith. It can deepen our insight into reality as it exists in all its fullness – in its beauty, its God-given goodness, even in its sin and iniquity. In the awareness of the ways of our time and of the spiritual problems of our fellow human beings as these are revealed in their art, we may be able to give an answer to their specific questions, opening the Scriptures with an eye to their special needs. In this way we may not only help others to love the Lord but even aid our world in solving its problems. These problems are profound, so that a mere surface knowledge of them might make us hard in our judgment and superficial in our answers.

If we seek to banish art and beauty from our lives, we not only miss very much and render our ears and eyes barren but we are also ungrateful to God and, even worse, we offend him by calling unworthy what he made for the sake of humankind. This is true even though the realm of art presents its problems and pains to the Christian, who is a stranger in this world that is still touched by unholiness.

Structure of art

It is not possible here to develop a complete theory of the structure of art. Instead, some remarks on the visual arts will be offered which are also valid *mutatis mutandis* for the other arts.

A picture consists basically of materials (paints on canvas, lines, etc.) which have an objective psychological function, i.e. they can be seen and they make certain impressions. But these lines, colours and forms denote something, be it a head or a landscape or a story. They compose the iconical facet of art, and this facet can be compared to language since it also has its 'syntax' and ways of 'speech', in short, its own laws and positive forms which make it possible for us to understand what is expressed. In the study of ancient art one must always be careful not to misunderstand it, for we are not familiar with its 'language'. For example, a common misinterpretation occurs in dealing with fifteenth-century art when people are led by the apparent naturalism of the paintings to interpret them as portraying a given reality. Therefore one wonders at the naïve way in which the old masters interpreted Bible stories, as if they supposed that in biblical times people wore clothes like those of the painter's own day and lived in the same type of environment. But the truth is that there is here no question of any portrayal of a historical reality, reporting things as they appeared e.g. in AD 30. These paintings really present homiletically a theological truth in formulations which can be compared to creedal statements in their rigidity and unalterableness. And because these truths are eternal and not restricted to a certain moment of history, the painters attempted to make clothes and environment as irrelevant as possible by merely giving them the forms of their own world. In short, painting also has its figures of speech and a changing language. Perspective and naturalism or non-naturalism in its different forms are means of expression, and these means change with the times. Here the norm is – as for language – clarity. When a picture expresses itself clearly in the pictorial language of its time, it is good in an iconical sense. This is the first critical examination we have to make. The next step in criticism concerns what is said and the truth of this message.

This iconical element is present also in other visual objects of human making, e.g. in maps, picture statistics, sign boards, etc. In a work of art these iconical elements are organized in such a way that they form a harmonious whole, a composition that has its rhythmic and relational

qualities. Beauty in visuality (in human artefacts) is also found outside of the visual arts – in ornaments, ceramics, silverware, proportion in buildings. But in a pictorial work of art this compositional beauty is directed towards the organization of the iconical elements, which in themselves are arranged in such a way that they can be bearers of beauty in that respect.

Theoretically it would be true to say that if the content of a work of art is expressed clearly but is a lie as such, its beauty will also be intrinsically impaired, since sin cannot be beautiful. But we live in an abnormal world (i.e. between the Fall and the Second Coming of Christ) and sometimes beauty exists when ungodly things are expressed. And it may happen that beauty is lacking even when the contents of the work of art are truthful in the deepest sense. For beauty is debased because of an ungodly starting point. This is true in many instances in modern art, where artists seek for ugliness just in order to express their hatred against traditional values, and in the deepest sense, against the God whose creation they knowingly detest. But these are extremes. In the main, one can say that even unbelievers will obey the laws of beauty given in creation. And they will often look at reality and tell about the things they have seen, for otherwise they will not be understood since they would be creating mere incomprehensible phantoms. So even when one does not agree with the Mariolatrous exposition given in a certain painting by van Eyck or Raphael, one may see truth in the observation of the reality of womanhood, the beauty of precious stones, or the peculiarities of a landscape.

We mention all these matters only to draw attention to the fact that the evaluation of a certain picture according to the principles discussed in the section on evaluation may be relatively easy, but that the analysis of the picture with regard to its elements will not always be so easy. The problems are complex, and the study of them is still at its very beginning.

• The Christian and art today (I)[572]

Last year while I was travelling around the United States and visiting the art history institutes of a great many universities and colleges, I was struck by the widespread interest enjoyed by the visual arts. Where just ten years ago little or nothing was done in this direction and only a few students showed any interest, there was now an extensive staff. Not only were a fairly large number of students concentrating on artistic training and art history but there was also an amazing uptake of introductory courses by young people who wanted to hear more about it.

I can add that in the Netherlands too interest in these disciplines has risen strongly, and the increase in the numbers of students far exceeds the normal percentage increase. The picture that follows applies in

lesser measure in the Netherlands, but that is no reason to suppose that the problems confronting people in the United States have no relevance here. On the contrary, in America people have to make up arrears and they are working on it very deliberately and conscientiously.

American institutions of higher education virtually always offer extensive courses in modern art. That is in contrast to our country, where such courses appear incidentally, with the exception of just one university where they are a fixed component of the programme. Practical artistic training is also focused on producing works in the modern style. That speaks in part for itself, but all these courses and training programs do more: they all propagate the Abstract Expressionism that one finds in the latest artistic movements. The growing interest combined with the direction of this education can and will have far-reaching consequences. In ten or twenty years' time the young people now being moulded will be in a position through their commissions, influence and democratic input to assure the practical triumph of their taste – in the style and form of interior architecture, the decoration of buildings, the design of monuments, and so forth. In other words, to a much greater degree than is already the case, the world will acquire a modern look. That is already true in the Netherlands to some extent, and as it expands in the United States, we will also indirectly have more to do with it here.

Modern art is not art with just a somewhat different style from earlier art but in essence the same. The heated controversies that modern art evokes prove that something more is happening. Modern art has a very specific intellectual content, even if it is not always a simple matter to determine how its forms bear its content. To propagate modern art is to preach a new lifestyle, so the moderns themselves say, and therefore it is worthwhile to pay attention to that. Modern art is more than half a century old, but it is only now acquiring significant qualitative and quantitative influence with a greater group of people.

Thus we shall be ever less able to ignore modern art. We ourselves and even more so our children will have to decide what our position is with respect to the new art. That is what we want to discuss now.

All great cultures have had their art, which for us who live so much later sometimes forms the only key to understanding their greatness and importance, and in some cases even the only way of penetrating to the character and spirituality of these cultures: their insight into the nature of human being, their depth and breadth and focus.

Is all that of the Devil? Are art and all these human activities purely worldly in the worst sense of the word, leading people astray from their true destination given them by God? Or does artistic activity belong to the created nature of people, to the possibilities given to people by God,

possibilities God wants people to develop and to employ? To pose this question is to answer it: it would be blasphemous to suppose that God would have built into humankind a trait that as such would be sinful and wrong.

Why then are Christians today so completely out of touch with what is happening in this area or often so reticent when it comes to artistic activity? Why the virtually absolute sterility in this field? Who today knows any artist of real stature or importance who is a pronounced Christian – a writer or composer or painter, sculptor or architect?

Christians have not always been so unfruitful. Old Testament times knew the Psalms and the great literary qualities of such books of the Bible as Job, Proverbs, the Song of Solomon and Ecclesiastes, to mention some. And following the ascension of our Lord there were many poets, while the mosaics of Rome and Ravenna, the illuminated books of the period of Charlemagne and the Ottonian German emperors, and the rich tradition of medieval architects and sculptors prove that Christianity has not had a destructive influence on the arts.

And the Reformation? We can mention the great Dürer, the creator of the magnificent and thoroughly biblical woodcuts of the Apocalypse, and we can think of the Geneva Psalter, which contributed so much to the dissemination of the ideas of the Reformation, in order to know that it too had a fruitful influence on the arts. And we must also not forget composers like Sweelinck, Schütz and Bach, and the painters of our [Dutch] golden age.

Yet how did it come about that this stream of artistic creativity was brought to a standstill and that artistic creativity was virtually snuffed out amongst the Anglo-Saxon Puritans and the Dutch Calvinists? Did Protestantism lose force, and was salvation 'by faith alone' fatal for art? Would the real gospel be unconnectable with art?

Or were other forces at work in Dutch and Anglo-Saxon Puritanism? The old mysticism with its contempt for everything that is not strictly religious, for everything that belongs to the earth and human life, with its exclusive concern for the 'soul' and the future in heaven may have had some influence here. This spiritualism, which via Anabaptist influences contributed to shaping the Puritan character, does not see that it is not the soul or a person's rebirth that must take first place but rather the 'hallowed be thy name', which means that as Christians we will develop all the possibilities God has given us. We will bring all our activities into obedience to him. We shall never be finished doing so until the dawning of the great Day of the return of our Lord. And sin, the spiritual forces of darkness, will have to be opposed in every field, lest the praise due to God be withheld. How shall we carry on the battle? Read Ephesians 6.

And so it is impossible for us to withdraw from the struggle. Or to restrict it to politics, science or the social and economic sphere, or purely

and exclusively to personal life. The battle is everywhere where a Christian works and is active, in the soul and in the sexual life, in intellectual labour and also in social activity, in feasting and in sorrowing. But obedience also begins in all these areas and Christian freedom and love, the praise of God and the renewing of our minds, in short the new life in the power of the gospel must come to expression in the whole of our human life, at all levels and in all areas of human possibilities. The 'new man' has received a task: to be the salt of the earth.

When we look at the arts today we are compelled to conclude that they are sure signs of a total de-christianization of our culture. They will also testify of that to future generations. They are an expression of a totally unregenerate cultural activity. Yet why is that so? Surely there are still many Christians and surely Christian principles are continuing to have a noticeable effect in many areas? One reason could be that Christians have abstained from every artistic activity, active and passive, for some two centuries. Under the banner of piety and Reformed rectitude we vacated this field; and the forces of darkness moved in to replace us. The arts today in many respects can be called an 'unsalted' human activity.

That by no means justifies our looking down on them. Compassion and love would be much more appropriate, together with a feeling of misgiving that the present unsatisfactory situation is at least in part our fault, so that we are co-responsible for it. Nowhere have Christians been so conspicuous by their absence as in matters of art. Perhaps that may help us to understand just why it is that the avant-garde of the modern world have made this field their mouthpiece par excellence for constructing a culture without God, without Christ. While doing so people are often engaged in undermining the traditions of the older humanism and thus are losing beauty, truth, harmony and civility. People are doing the opposite of what they are meant to do according to Philippians 4:8.

Here then lies the source of our own difficulty: we no longer have a tradition on which to build in matters of art, or even in the reflection on art, the activity of being critically engaged with works of art. We lost contact with the world of artistic activity many generations ago, although it is precisely there that the outposts of the postchristian movements are to be found.

In this article we cannot discuss modern art itself. We only want to note that every human activity is only possible when use is made of the human possibilities that God gave us at creation. We can use our talents for sinful ends, no doubt, but even a curse must be uttered in human language, and a curse as curse is otherwise impossible. Perhaps in modern abstract art people are nearing a point where as an expression of a nihilist spirit they have abolished their own expressive capacity. Yet a great deal of modern art utilizes a new language, which as such is

neither sinful nor wrong – even modern advertising makes use of it, for example, with some astonishingly lovely results – it is not the language as such but what people say with it that matters.

Thus we shall have to learn to understand the language of modern art if we wish to apprehend its message. Only in this way will we be able to distinguish between the spirits and try them, to see if they are of God. In this way we will also be able to discover whatever positive, acceptable art is still being made, happily so, in our day. Only in this way will we be able to see where truth and where the lie holds sway.

Is it not all that important? Is it just for intellectuals and sensitive souls, for art lovers? Can we not continue to avoid that terrain? And leave art to its own fate? Yet we ought to consider that we cannot just ignore these things. Modern art with its message has its influence. And then we do not even have to think about the fact that today's cultural formers have their outposts here, just about the much simpler truth that people today have more money, more time and more means to come into contact with this world – just think of radio and television.

But think also of modern people themselves. How shall we ever preach the gospel to them if we do not understand their language? If we do not understand their questions and thus also cannot answer them? If we do not know their needs and cares, their troubles and sorrows, from which the gospel should be able to save them too? If one would be a Jew to the Jews and a Greek to the Greeks in these times, then one must know the modern language and the modern culture. Indeed, it exists not only in Montparnasse in Paris. The modern world begins at your door, and you meet modern people every day.

It is not news if I say here that Christianity has lost its hold particularly on intellectuals, which is to say on the leading groups in the world in which we live. And to my mind the reason for this is to be found in the preceding paragraph.

Yet we must also think about ourselves and our children. We enjoy the same advantages of money, time and possibilities. Therefore we cannot close our eyes and simply carry on, concentrating our attention exclusively on so-called church activities. We and our children have to work and live in this world. We comprise a part of society and we cannot shut ourselves off from all social contacts. Our fellow Christians and our children also have intellectual needs and desires, talents and possibilities of their own, and these are not exclusively religious. We are not just converted and called to the covenant for the sake of a heavenly future, we are saved body and soul, here and now, to work as new people who put off the old Adam, which is to say who battle against sin with the whole of our humanity, by God's help.

No one can know how many brothers and sisters have fallen by the way, how many of us have been alienated, worse, alienated from the Lord just because art is rejected and every activity in this area looked upon as

sin. And how many Reformed lives have not remained cold and joyless just because they have had to repress their human aspirations and desires in this area, or because they never experienced the joy of a simple song, a simple painting, a little bit of beauty?

What will happen if we simply carry on in this way? Will our language, intellectually and as language increasingly old-fashioned, not finally become incomprehensible and insufferable to our contemporaries? Shall we simply carry on serving up to our fellow Christians and to churchgoers third-rate art of questionable alloy under the motto of its Christian message, which as such is also sometimes rather doubtful? I have in mind our Christian literature – although the situation there is the least unfavourable – and the illustrations and pictures we provide, and the pictures we give our children in school and Sunday school. Is it honouring to God that in the environment in which Christians live we are surrounded by pictures and paintings – and they have a far deeper influence on our lives than we often suspect – that are far below the minimum artistic standard? Or can we just borrow from the world here – which will be more difficult to do as time goes by.

It is truly no simple thing that we are encouraging all of us to do. A simple lecture or a little talk at a gathering will not suffice. It is also not a task for everyone. But let us not therefore put it aside or postpone it too lightly. We must be alert to a very dangerous situation and encourage and support every activity and every work in this direction.

Strong faith is required, faith in the God who truly exists and answers prayers. Or must we say that the situation of unfruitfulness and emptiness, of powerlessness and obstinacy is itself a sign of withered faith and of a total lack of true personal contact with the Lord? A strong and living faith is necessary if we want to be salt that salts, if we want to save our Christian life in the tidal wave of modernity that is crashing down on us. We can only work on a firm biblical foundation, and we shall have to make the best of the talents God gave us.

We shall have to regain lost ground. That cannot be accomplished in a day. It will take a generation. We shall have to build up a new tradition of judging and appreciating art in order to understand what is on offer. And perhaps the Lord will then hear our prayers and give us young talents who in their work will give expression at a high level to a Christian attitude towards life in all aspects of life. For the matter is not one of biblical art in the narrower sense but is broader and deeper: it is about an art that will leave not a single aspect of rich human life untouched, an art that shows that Christianity is not dead, because there is faith in a living God; that shows that biblical faith can be of importance in the present dispensation simply because this world belongs to the Lord, our Creator and Redeemer.

It is a long road and our powers are weak. Let us pray to the Lord for help, wisdom and insight!

• Art and we: CCS – the early vision[573]

Calvinism was not unfruitful in the artistic field. Just consider what was accomplished in the field of rhyming and creating a musical arrangement for the Psalms under Calvin's direct influence.

Moreover, research in the twentieth century has established that Calvin was by no means hostile to the arts in other respects either. Our own Dutch 'golden age' bears witness to that. Or if you should prefer not to believe your eyes, then there are also the writings of Cats and others to confirm the openness of our forefathers in the area of the arts.

Under the influence of mystical movements, however, Calvinists became Puritans and increasingly shunned art, particularly as an activity of their own. Partly as a result of this, our national art gradually fell under the spell of the humanistic art of our Southern neighbours. Yet this is not the place to go into further detail about that.

Willem Bilderdijk, Guillaume Groen van Prinsterer and Abraham Kuyper were interested in the arts, each in his own way. Yet as a result of the struggle for a better position for our own Calvinist part of the population – for the 'little people' or *kleine luyden* – a struggle that demanded virtually all the energy that could be mustered, and also as a result of the power of tradition, there was little real activity in the field of the arts.

Politics, science and the broad social area were integrated into the Calvinist way of life. Art was quiescent, however, either out of a lack of interest or out of a desire to avoid this aspect of the 'world'.

This history would exact its toll in the twentieth century. Many people with artistic talents have been alienated from the church and even from Christ by the hostility of their own environment. An inestimable but easily underrated number of good Calvinist youth have not been able to pursue their calling and so, in conformity to the demands of their surroundings, have shelved their talents; meanwhile, only neutral institutions have opened their doors to those amongst our youth who have persisted in going ahead.

A certain feeling of frustration, of suffocation and cultural impoverishment has been the result. What the effect of the absence of a Christian presence in these cultural areas has been for the development of art is impossible to fathom, but one should not underestimate it. Here we have simply not been salt that salts, we did not show up for the roll call. And there is more. Now that we have an affluent society and now that as a result of the activities of earlier generations and as a fruit of new economic insights and technical sciences virtually everyone has more free time and money, art and culture have been brought within the reach of many, even of those who previously had to do almost entirely without it due to circumstances; this is in part thanks to the new technologies of mass media.

To put it even more clearly, people today, no matter who they are, are confronted with heavy doses of culture and art at many levels. Yet this art is fraught with many problems itself. It has existed for many years in an ivory tower, separated from life, and it has developed into an expression of a clearly postchristian experience of freedom: it expresses feelings of uneasiness, frustration, rejection, meaninglessness, in short, a new spirit that we must call postchristian. There is a specific, fundamental rejection of Christian belief and of Christ.

If we notice what people are exposed to from day to day, it is not far-fetched to speak of constant brainwashing in an antichristian spirit. To make the problem even more complex, it has to be added that there are also positive and valuable elements to be observed in the art of our times. New modes of expression and new possibilities have developed that we cannot ignore. But who can untangle it all, and who can identify the spirits that are expressing themselves here artistically?

It is therefore more than time we did something about it – we are in fact already much too late. Undoubtedly the problems we have indicated are of a general character, but they are all the more pressing and difficult to approach for our Christian part of the population because of the lack of any tradition and of any consensus or *communis opinio* in these matters. We must get to work, in the first place by familiarizing ourselves with the various phenomena of art and culture in order to learn to understand the means of artistic expression, so that as mature Christians we will be able to assess critically what is offered and to 'test the spirits'.

Next, we shall also have to get to work in order to be able to produce responsible works of art ourselves, for our own people in the first place. Perhaps in this way we will even be able to contribute something ourselves to the culture of the near future, or even to turn the antichristian tide.

What is needed is thus:

a) learning to understand the art of the present and the past and to view it critically;

b) reflecting on our own point of departure with respect to cultural work and artistic activity and on essential norms and values;

c) arriving at activity of our own in these overly neglected areas.

We live in an age – and that does not make things any easier – when the entire Christian orthodox world is in motion. Apostasy can be signalized, but also a great deal of uncertainty, confusion, and especially lack of insight into how to develop a Christian lifestyle that fits these times. Perhaps the current confusion is in part a result of the power and influence of contemporary artistic expressions, and of our lack of the kind of familiarity with these that would enable us to deal with them in a truly Christian way.

We are convinced that there is a great deal for us to do: our Christianity – our being Christian – and our lifestyle cry out for renewal, for revival, with strong attention to the cultural and artistic facets. With respect to these it would be difficult to be broad enough; we mean by broad not the vaguely general or confessionally fuzzy, but breadth with respect to the fields and phenomena demanding our consideration.

Genuinely trusting in our Lord and acting by the light of Scripture, we must not be afraid to rethink even theology and every time-honoured principle. That is especially so for the doctrine of sanctification, for everything we have talked about concerns, after all, our Christian walk and our Christian freedom in that walk.

It is impossible to make a plan and to realize it point by point. One thing is too closely associated with the rest and everything is interconnected. Therefore we must get to work: if we set off in the right direction we shall have nothing to fear. Our wisdom and insight will grow as we go, and our knowledge and skill can take on a new form.

Therefore, and I know I do not just speak for myself, the time is ripe to establish a centre that can work at this in a positive biblical spirit. A Christian art academy is the more distant goal, to be able to provide young people with good training and to be able to serve our part of the nation with respect to the problems in question. Yet much preparatory work remains to be done. There will be rocky fields to plough; sometimes the rocks will need to be put in place. We shall have to work really hard, and all available forces will have to be mobilized. We shall have to prepare the ground for such an academy, we shall have to find, stimulate and help talented people, so that the academy can be staffed meaningfully with a reliable body of teachers.

A Christian art academy? One can desire such a thing for various reasons. Some may suppose that this terrain too must be conquered for Christ. That would be for so-called reasons of principle. A new organization would be set up along familiar lines. I believe the time for such things has passed, and that that approach would be too mechanical. The work that faces us is born of need, and we do not want to undertake it just in order to round off an organizational plan.

Some may suppose that a not unimportant group in the population has a right to such a thing simply because the group exists. Thus that would be in keeping with the well-established principle of the ideological pillars or divisions in our society. I believe this is insufficiently clear and also, again, rather too mechanical.

Some believe that today this is what our hands find to do, what God has given us to do for his kingdom. In that case we do not set to work in our own strength; rather, we expect everything from him. I do not believe we can or may do this work with pious words; we can do it only in genuine piety, in intensive prayer, expecting everything from him and waiting on his guidance. Only in that way is meaningful work in this field possible. The problems are so great, the difficulties are such, and the

consequences of this work are so unforeseeable that we could not dare
to proceed with it if God were not with us and if his Spirit did not give
us wisdom. But if we do the work with his help, we may go ahead with it,
leaving the results to him. Perhaps he will use it as a contribution to a
real reformation, a new biblical Christian élan.

Therefore I propose to you that together we establish an association,
so that with united forces we may move in the cultural and artistic field
to meet a genuine need our people face – so that, in part through this
initiative, we may learn to live, to actually live as Christians in these times.

• The CCS, towards a Christian art academy[574]

Anyone who is not a stranger in Jerusalem knows that art – in all its
branches, genres and sorts, including what people today call
entertainment – is a problem area within the larger Dutch Reformed
community. Puritanism, world-avoidance and the splitting of life into a
higher spiritual realm and a lower one that does not matter very much
because it has nothing to do with God, the world of the flesh (in
connection with which Paul is incorrectly cited), have all contributed to
the problem. Developments in the art world have not helped either. Art
in the nineteenth century became increasingly detached from ordinary
life, and the artist a bohemian, someone who not only played fast and
loose personally with the reigning morality but also demanded ever
more stridently the right to say and to portray anything and everything
he or she wanted to say under the motto 'art for art's sake'. That led to
an even deeper-seated alienation from art on the part of Reformed
people who already regarded it with grave reservations. Finally, there was
also a social reason. The Reformed people in the last century were the
common people, often even the very common people. For economic
reasons they simply never got around to art. They came to associate art
with the life of the wealthy, who understood little of the Christian lingo
and even less of the lifestyle of these people who were so well-versed in
the Scriptures.

Correct and incorrect motives lie heaped together. Yet whatever the
reasons may have been, we must not think that an avoidance of culture
and a dearth of art are inherent to biblical Christianity. Calvin himself
and our own [Dutch] seventeenth-century culture attest to that. We
must not close our eyes, however, to the fact that this negative attitude
has created a dangerous situation.

That is true in the first place for art itself. When the salt no longer
salts, all kinds of revolutionary forces appear that convey us away from
God and his word. With a play on words it is therefore possible to
characterize modern art bluntly as 'unsalted art'. Art is avant-garde in
the construction of a totally unchristian world. If modern art is

sometimes oppressive and negative in direction, then we as believers bear some of the responsibility. Yet by the same token it is all the more difficult, given the lack of critical schooling and a living tradition of assessing and associating with art, to find the connection with the contemporary art scene.

As a result of increased prosperity and the growth of leisure time, and through new media like radio and television, our Reformed community, already for a long time emancipated, are now heavily and unavoidably confronted with art, with modern culture in all its branches. The absence of critical reflection and the lack of a consensus about art in our circles have given rise to a dangerous situation – the more so since the youth, rightly so, take a great interest in it and since many of them want to be creatively involved with it.

It is not inconceivable – and in fact it can also be observed – that the negative attitude does persist, even though people cannot avoid coming into contact with art (including entertainment, as art at a lighter level). Since they do not know and cannot apply norms for this area, but instead unconsciously consume virtually everything that is within the bounds of public decency, they innocently and unguardedly swallow whatever penetrates our little world. In this respect there is mention, rightly so, of a brainwashing by modern culture. Other people, especially the youth, cannot accept this ambiguity, this negativism towards the world, unless it is based on a truly founded critical attitude. Then culturism threatens, the danger of going along with and assimilating everything the world has to offer. This entails either neutralism, the closing of one's eyes to the ideological thrust of a great deal of modern art, or a complete estrangement and detachment from the Reformed milieu.[575]

Another albeit more difficult approach is also feasible. Namely, through reflection and study to acquire insight into the character of art in general and of the art of our times in particular; to gain insight too into the norms for art and into its language and, by exerting all our strength, to arrive at a creative effort of our own leading to an art that is not negative and revolutionary, antichristian and at bottom often even anti-humanistic, as modern art is in its avant-garde expressions. Something of the sort, if combined with quality, could possibly gain some influence. We may not forget that the world too is beginning to show signs of fatigue with the constant throwing of the cat into the bourgeois chicken coop, the constant negative tearing down of everything, the incessantly persistent attitude of the avant-garde.

Biblical Christianity cannot be unfruitful where art is concerned – if art as a possibility created by God could not be practiced wholesomely and in love for one's neighbour, then Christian belief would indeed mean an impoverished life.[576] To achieve what is stated in the previous paragraph is the aim of the Christian Cultural Study Centre (CCS). This association was established in 1964 as the fulfilment of the long

cherished desire of many. The work is extremely difficult. Unfounded optimism is quite out of place. The workers are few. Thus the task is to break through a vicious circle: because there is no tradition and because there are so few workers nothing is happening, and because nothing is happening we will find ourselves in the same situation years on from today. The necessary finances are also lacking for this idealistic, but well-defined and not in the least vague, work. But with common sense and the efforts of all available workers we can no doubt realize something of our ideals. It requires an entirely new approach, a departure from the gradually outdated Kuyperian form of organization.

Our first goal is to set up a study centre. There we want to reach the orthodox Protestant part of the population, provide information, study together and gradually learn to find the way towards a community-wide consensus regarding the problems. We also hope to establish a training institute where the various arts can be creatively practiced. In close cooperation between instructors and students something new should grow there, a new style if you will, not as an application of abstract principles or theories, but as a living form and a spirited content in which something becomes visible of the cultural significance of our love for God and our neighbour. Creative work will need to unfold there based on Christian freedom, breaking through every legalism.

This may all sound vague. It is difficult to formulate definitive results already at this early stage. The work is still much too young for that. It has also become clear to us, moreover, that we are not in the least interested in chasing after the world and trying to do everything over again in a slightly different hue. Educational work in the field of art is still in its infancy everywhere. This does not make our work easier, but it does make it more interesting and meaningful.

In spite of the fact that we do not yet have our own centre, we have already started by organizing a number of study conferences this year, or if you will weekends for youth (18–40 years) where we focus our attention on concrete questions relating to concrete pieces of work. In this way, in confrontation with today's questions and in the presence of today's art, we hope to be able to help and to build.

• The influence of art on society[577]

Art with a capital A is really a product of the Renaissance, and the system of arts we still employ today only gained its definitive shape in the eighteenth century. Therefore we would rather speak of the aesthetic.

Not only art with a capital A but also everything one can call art – cabaret, pop and even tearjerkers included – is connected with society. It will often be the case that the major arts will be the first to formulate a new style and direction. This will then be copied and translated 'for the public'. More than once high art will serve only a small, snobbish coterie

while, alongside it, popular music and art will autonomously choose its own way and its own examples.

So we would rather speak of the aesthetic: a neutral term fraught more with a qualification than a judgment, a neutral term too because with it one can avoid the usual associations. At least, we hope so. The aesthetic is of incalculable weight in society. It defines the form in which we do, feel, see, experience, undergo and express things. What words rise to our lips when we see something like a particular landscape? What do we really see and what do we pass by unawares? Of what nature are the feelings that overcome us, and how do we experience the events around us? All of that is formed; it happens in a style. We talk about a lifestyle that involves not only the way in which we express ourselves – where a rhetorical gesture was once called for, a wink or a nod may now suffice – but also the manner in which we experience things. Yes, even what we experience and assign a meaningful place in life belongs to lifestyle.

We now want to present a few examples to illustrate these ideas. Medieval people did not see the landscape the way we do, and they experienced it differently. They did not know landscape. They saw the land like a peasant farmer from a developing region might see it today: 'the land is fertile'; 'it needs manure'; 'people have not weeded it well'. Only when the arts have formulated the experience of landscape in paintings and ornamental borders, in poems and popular songs, do people see it. Extending this example, one can even question whether seventeenth-century people for example could have spoken, while out for a walk, about a beautiful haze veiling the forms, as late nineteenth-century people did following Romanticism and Impressionism.

Sixteenth-century people knew mountains. Mountains were within the horizon of their experience. We see mountains in countless sixteenth-century paintings. Yet they strike us virtually always as strange, wild, desolate and dangerous. Just think of the almost irrational, monstrous rocks in the paintings of Patinier or, later, in those of de Momper. The classically oriented 'honest person' of the seventeenth century could not however deal with such horrors. Such people found the mountains repellent. When they had to travel through the Alps they pulled the curtains of their carriage shut. Yet precisely these same feelings were the reason why the Romantics found mountains beautiful. And so Romanticism discovered the Alps for us, sang of their beauties, painted them, and drew them in small and large lithographs. There is a fairly exact date to be given for this: in 1803 we find on top of the Rigi a hotel whose first guests included Goethe, Shelley, Turner and other major and minor artists. That was the start of Alpine tourism.

An interesting example of the influence of art on lifestyle – by which we thus also understand the manner in which we move, approach and address each other – strikes us in the following. The English of around 1700 saw, hanging on their walls, living and illustrious examples of their forebears: they were refined gentlemen and ladies of sublime elegance.

But those terms acquired their meaning just at this time and because of it. Who were these ancestors whom they saw portrayed in this way? They were probably anything but what they were supposed to have been. Yet Van Dyck (and naturally many after him) had painted them thus. The painters had formulated a lifestyle.

Charming and gallant – the latter in all its ambiguity – were the eighteenth-century French, full of *esprit* and ever on the prowl to enjoy life's *les délices*. Watteau's *Embarkation for the Island of Cythera*, novels and plays, poems and even music – one piece was named 'Conversation galante et élégante entre une flûte, une violon et une gambe' – had held this style up for imitation in daily life. No longer the hero, the celebrated knight of earlier days, but now the philosopher, the rationalistic hedonist was the ideal.

Art shapes people. They become different, they live differently, when art changes. The Romantic individual, heroically resisting society and fatal nature, tragic in his or her genius because the powers from outside were too strong, was not just an image that rises to meet us from the *Eroica* or *Faust*. Just think of all those tragic lives – Beethoven, Schubert, Gerard de Nerval, Turner and our own Bilderdijk, to name but a few misunderstood geniuses. No, the seventeenth-century person was ever a genius or a tragic figure in his or her own eyes or in the eyes of his or her contemporaries.

The artistic gives form to our seeing, our feeling, our style of life. But let there be no mistake: we are not saying that the artist determines the content, the thought, the idea that takes shape and is given form. That may sometimes be the case, but usually the artist – and again, by 'artist' one must keep in mind those who worked in cabaret, sang chansons, performed stand-up shows or wrote light novels as well as the 'great' artists – will only give form to the ideas that are 'in the air', so to speak.[578]

New ideas arise, sometimes in reaction to old ones whose conditionality and inadequacies gradually show through, sometimes in response to new discoveries or possibilities, and sometimes also under the pressure of circumstances. The artist will give form to the new ideas, creating frameworks and patterns that deliver our experience and activity from the formlessness and indeterminacy of the new.

Two texts, both very recent, may serve to illustrate the current problems. Last spring one could read in a hippie newspaper: 'When the mode of the music changes, the walls of the city shake.'[579] The other is from an essay on modern music; it asserts that:

> The immensity of the present-day experience of disintegration, insensitivity, and dehumanization as well as demoralization renders every effort to create beauty, harmony and unity, stability and symmetry in music an act of self-renunciation. The twentieth-century composer is in revolt against music that repeats old patterns as if nothing has changed and desperately seeks alternatives that can break through complacency and shatter all illusions.[580]

It may seem like the question about the chicken and the egg, but one that is real all the same: must art change because dehumanization and demoralization are facts, or are these not facts after all but new ideas to which the artist gives form? Have they perhaps become facts because art has testified to them for so long and to an ever wider audience, certainly since the last World War? Would you like an example of a revolutionary view in art? We will cite one from quite a minor work of art. In the children's programmes on television just a few years ago – perhaps still today, but I do not see them now because my children have grown up – one regularly saw modern fairytales. Instead of the wise king with a white beard and the loving queen and the beautiful princess, plagued of course by a wicked sorcerer, we were served up a half-baked, stuttering idiot of a king with an equally dumb queen and a retarded daughter. The sorcerer was a benevolent magician who saw to it that all the confusion caused by these royal figures, who naturally understood nothing of the common people and paid no attention to them, was resolved in a nice way. Can we still be surprised then that our children no longer has any respect for royalty or any sovereign whatsoever? Their experience has been formed.

There is a lot of truth in it: when the mode of the music changes, the walls of the city shake. Certainly that is so in such a time as ours when art, I believe, for many, certainly for young people, is more important than in the preceding period. Therefore we as Christians must get to work here. In the first place to understand what is happening. To recognize and diagnose the art and spirit of our own age. To test the spirits, as Paul called it. And thereafter to get to work ourselves. To be salt that salts by standing up for humanity, truth, love and decency. By hungering and thirsting for righteousness. So that the good is not destroyed in lawlessness, so that life remains liveable.

There is no promise for the Christian that Christianity will be great and hold sway; to the contrary. There have been times, and they may come again, when Christians could keep only their faith because everything else was taken from them in persecution, boycotts and repression. Yet if we are able to work, we must work to fulfil our mandate to love our neighbour, to do truth and so to be salt that salts. To find forms for this in the aesthetic can be important. Especially because the aesthetic is no longer gently formative but has become instead, via the present-day means of communication, virtually a brainwashing avalanche.

To conclude: have we exaggerated the place of art? We think not. For we have not said that economics, which determines our prosperity or poverty, is less important. Nor have we denied that politics has a formative influence on the social order, and certainly one cannot expect that as a professor I would want to mitigate the importance of science.

And we could easily extend this list of important aspects of life, if only we do not create contradictions by suggesting that one aspect would be more important than another. It is better to recognize that all these aspects form a very complex pattern. The direction in which one works is determined by one's life and world view, by one's choice of religious position. We as Christians ought to know upon which foundation we wish to build, in love and freedom, in the battle against sin.

What the fruits will be, that need not concern us. Our concern should only be whether we have used to the best advantage the talents given to us.

• **The Christian and art today (II)**[581]

Many have critical questions about modern art. Now of course we must realize that there is modern art, and modern art. By that I do not mean that in our day there are also some bad artists, people with little talent, or perhaps people who are more concerned with money than with real creativity. That has been true in every age, even if one does not see much of it in the museums, for the bad artists of earlier times have long been forgotten and are of lingering interest only to experts. I mean rather that on the one hand there is a living twentieth-century art in which people express their perspective, their insight, their experience of reality – art with which we are all confronted and that we call contemporary, to be sure, but not modern – and on the other hand there is modern art that distinguishes itself by its pernicious content, an art that expresses alienation, despair and anxiety and that often illustrates in an extreme way the death of the old humanism and Christianity. We could characterize this art as an expression of neo-gnosticism. We will not say more about that now.[582]

One thing is certain: people engaged in art today do not have to tie themselves to the one movement or school we call 'modern', even if it currently receives the most attention. So much more is happening in our day, and people are free and can look for other approaches. We are not the prisoners of our times.

It is more necessary than ever to think about art. That is not just because 'the world' uses art to make propaganda for its ideas – a work of art has a message, which it expresses in its own way – but also because among Christians, especially young people, interest in art is growing steadily and there are even many who would like to become artists. That is good, because art is not a field reserved for finely strung, somewhat odd people but a part of life that can give joy and beauty and that defines to a significant degree our social climate and environment. Art gives form to the things we have around us, and it is very difficult to separate form and content. Form, content, beauty, what has not already been said about them! How difficult and hoity-toity have snobbishly suave people

sometimes made art out to be! Perhaps that is why many people have been alienated from art. Indeed it is not so easy to define beauty in brief. Perhaps it is easier to define beauty negatively: beauty is not necessarily amiable, idealized, sentimental, 'pretty', sweet or mild. Yet whatever beauty may be, it is closely connected with life, love, truth and justice – and how difficult it is to define these things.

The question facing young artists in particular is that of the direction they are to take, whether to 'go modern' or else what style to follow. Naturally they want to make things that are of importance for today's world, things connected with our times. No one wants to make things that are old-fashioned and out of date.

What is (visual) art? We can distinguish two aspects. There is beauty as such – composition, line and colour. And there is the visual communication, the story, but especially also the way in which reality is represented. In its concrete form every work of art lies between two pairs of extremes. It lies between ornament (the merely decorative) and image, religiously or emotionally laden (an idol, for example); and between the non-figurative (the play of colour and forms) and very precise natural rendition. The extremes are rare, of course; yet we can have either a non-figurative ornament or else an ornament of precisely painted flowers, for example; and we can have an idol that is purely form, such as a lingam from an Indian temple or else a very precisely painted Madonna. In and through all that a work of art has a dual relation with reality. It fulfils a function – as an altarpiece, as a figure on the mantelpiece or as a portrait for memory's sake – and it depicts or represents reality. The latter entails much more than the exterior, the likeness, the outer form. A work of art expresses a view and shows something of the meaning and significance of reality and of the relations things have to one another.

It seems like such a simple statement to say, 'You know what you should do: just convey reality. Do it in any style or manner that you want, draw like all the great masters from the past have always done, draw a tree, a house, a person, an animal, a landscape, and worry about more complex matters later.' Yet this proves to be very difficult indeed for many young people today. Modernism has affected us so deeply that without realizing it we have become so alienated from reality that reality itself has become problematical to us, and we have virtually no contact with it. The dilemmas addressed by philosophy in our times have turned out to be not the hobbies of literati, who want to make simple things confusing, but rather difficult questions of vital concern to the present generation.

Thus there are no cheap solutions or quick fixes. Reality itself must be regained, as it were. Yet everything in our times points in the opposite direction. We have the drugs, the mysticism, both of the moderns with their neo-gnosticism and of the more or less Christian sectarian movements (e.g. the Jesus People), all of which draw people away from

reality as something of less importance, as something secondary at best. Biblical Christianity, however, especially in the authentic Calvinist line, is different. It tells us to enter into reality because it is God's reality, which the Lord pronounced good in the beginning. It is the reality of which ever so many songs of praise are sung in the Holy Scriptures. I have in mind Revelation 4[:11] where praises are sung to God because he is the Creator:

> You are worthy, our Lord and God,
> to receive glory and honour and power,
> for you created all things,
> and by your will they were created

Proceeding from this point we can also understand something of [Dutch] seventeenth-century art. In it we see expressed something of the deep and full experience of reality. That is its beauty and its unique achievement. It is inseparable from the Reformation.

And so there are no quick and cheap solutions. But the Christian who is an artist today has a great mandate. The task of the Christian artist today is to find the way back to reality, to gain sight, once again, of reality. One should of course not have to do that alone, in isolation, but together with all who love the gospel. Surely we will not leave our Christian artists standing alone again, as we have done all too often in the past? Rather, together we have the task of working towards a reformation, and of praying that God will truly grant it. And if such a reformation should indeed come we will be able to enjoy its fruits together. And if it should not come, then our Christian artists will have fulfilled their task, as salt that salts, to keep open the way to reality, God's reality.

Not only is there no room to develop these thoughts further here and show precisely what all this means; it is also not so easy to say. Here and there Christians are working as artists. They stand at a beginning. There is virtually no tradition to build on. And we will not get in their way by prescribing precisely what it should all look like. Spiritually speaking there will certainly be something of our seventeenth century in it, but the form and themes may turn out to be entirely different. The art in question will be an art of our times. Our gaze is fixed on the future, not the past.

Remarkably, everything that one thinks about today gives one the feeling of needing to begin anew. The old answers, even the best ones, are no longer adequate and must at the very least be reformulated, dusted off, thought through again and revitalized.

Yes, we shall have to assume a critical stance in these times. And the artist has no light task but a very heavy one. For it is precisely in art that modernism has put down perhaps its deepest roots. For the authentically

modern person, art never is a luxury or a marginal phenomenon. Nor should it be such in any new Christian movement or body of artists that is to be built up.

• Calvinism and art, an annotated bibliography[583]

The question whether Calvin and the Reformation also had some influence on art has often been answered in the negative, in the sense that Calvin would have had no interest at all in the matter or, stronger still, would have been hostile to art. By now this standpoint has been shown to be untenable by the work of Doumergue, Wille, van Schelven, Wencelius and others. Such an aversion to art is sometimes encountered in Calvinist environments, to be sure, but it stems from a later time and is a Puritan inclination possibly traceable to Anabaptist influences.

Dr A. Kuyper has already discussed this question extensively in his rectorial address, *Het Calvinisme en de kunst*, where he comes to the following conclusion:

> Calvinism, to the extent that it also put its stamp on our national life outside Calvinist circles in the narrower sense, rendered this undying service, that it restored art to itself, opened up for art a hitherto unknown world of common everyday life, opened the artist's eye to the beauty in the seemingly negligible, and fostered a love of freedom that stimulated the passion for art.

It seems somewhat odd that Kuyper should go on to argue as he does here that Calvinism never developed a distinctive artistic style of its own. Yet I think the essential features of this art have indeed been formulated in this rectorial statement. Great freedom and openness to the entire creation, love for great and small, awareness of a certain hierarchy of values, avoidance of pomp and circumstance, sobriety that on the one hand avoids all idealization and on the other brooks no glorification of sin, emphasis on the human without heroizing while nevertheless acknowledging the importance of inward and outward struggle and taking an interest in the more intimate aspects of human relations – all this is ever the fruit for art of an approach to life nourished by Scripture.

Besides our own Dutch seventeenth-century painters, one may also refer here to Albrecht Dürer, the later work of A. Altdorfer, H. Schütz, J.S. Bach, J. Cats, etc. Furthermore, a review of the writers concerned with the place of art in the Calvinistic or Reformational view of life shows that they have always avoided any form of aestheticism while granting art a definite yet modest place; here too we find respect for solidity and beauty but avoidance of all ostentation.

Given the importance of this subject and the relative lack of familiarity with its literature, we present here an extensive list that is however by no pretence complete. The emphasis is on the visual arts.

Bibliography

Guillaume de Saluste, Sieur du Bartas, *L'Uranie.* 1574; and *Brief advertissement sur sa première et seconde Sepmaine.* 1584. In U.T. Holmes, J.C. Lyons, R.W. Linker (eds.), *The Works of Du Bartas.* Chapel Hill, NC, 1938, vol. 2, pp.172–185; and 1935, vol. 1, pp.218–224. The work is not particularly original but for the most part scriptural; it had great influence in Calvinistic circles most notably in Holland in the seventeenth century.

A. Golding, *Trewness of the Christian Religion.* 1587. Originally French, by Ph. de Mornay, affinitive with the Calvinistic idea of the beauty of the world.

A. v.d. Venne, 'Zeeusche Meyclacht ofte Schijnkijcker.' In *Zeeusche Nachtegael.* Middelberg, 1623, pp.55–68. This work deals mainly with painting.

William Mure, *True Crucifixe for True Catholics.* Scotland, 1629. This work is strongly in Calvin's line and features general reflections of a positive character.

J. Cats, *Opkomst van Rhodope,* and *Houwelijck,* 4. In W.N. Woltering (ed.), *Verzamelde Werken.* Dordrecht, 1880, vol. 2, pp.240 f.; vol. 1, pp.353–354. This is typical of Cats's attitude towards art; a positive work with remarks about abuses.

P. Wittewrongel, *Oeconomia christiana ofte christelijke Huyshoudinghe.* Amsterdam, 1661, vol. 2, p.1154 passim and p.1045 passim. Here we find general reflections on the function and meaning of art in the life of a Calvinist.

G. Voetius, *Disputatio de Comediis of Twistreden tegen de Schouwburgen.* Transl. Mohr. Amsterdam, 1772, 2d edition, pp.18 ff.

John Mulliner, *Against Peri-wigs and Peri-wig Making and Playing on Instruments of Music among Christians.* 1677. A Quaker standpoint, very Puritan.

W. Bilderdijk, *Redevoering over de voortreffelijkheid der schilderkunst.* The Hague, 1794.

J. Ruskin, *Modern Painters* (London, 1909) vol. 2, p.x; and *Stones of Venice* (London, 1851) vol. 3, pp.87 ff. These are reflections by someone with a deep knowledge of art and with a biblical approach to life. In the part of *Stones of Venice* he discusses the influence of both biblical and non-biblical religion on art.

A. Kuyper, 'Het Calvinisme en de kunst', in *Het Calvinisme, zes Stonelezingen* (1899); and 'Calvinism and Art' in *Christian Thought* (1991–1992) vol. 9, pp.259–82, 447–59; and the lecture: 'De antithese tusschen symbolisme en openbaring' (Philadelphia, 1899). These articles discuss fundamental questions; emphasis is placed on the importance of Calvinism for the greatness of seventeenth-century art, and on how art is influenced by religion.

E. Doumergue, *L'Art et le sentiment dans l'oeuvre de Calvin* (Geneva, 1902). This is a study of the importance of Calvin for the art of his own times.

M. Grau, *Calvin's Stellung zur Kunst* (Würzburg, 1917). This work features a bibliography and is positive in its conclusions.

A. A. van Schelven, *Historisch onderzoek naar de levensstijl van het Calvinisme* (1925).

J. Wille, *Aesthetisch of 'puriteins'?* (1925) and *Heiman Dullaert* (1926). These books approach Calvinism historically and have as their subject the Calvinistic influence upon and view of art.

S. Anema, *Moderne kunst en ontaarding* (1926). This book opposes modern art. The conclusions bear witness to biblical insight, but the arguments must be regarded as incorrect.

K. Schilder, *Bij dichters en schriftgeleerden, verzamelde opstellen* (1927). There are some good articles here based on a Calvinistic standpoint, for example concerning Goethe's *Faust*.

M.P. Ramsay, *Calvin and Art, Considered in Relation to Scotland* (Edinburgh and London, 1938). A historical study with positive conclusions.

J.H. de Goede, 'De gevaren van de geestelijke ontwapening op het gebied van de kunst', in *Geestelijk weerloos of weerbaar?* (n.d.). This work opposes an exaggerated spirituality that underestimates the importance to people of wholesome art.

L. Wencelius, *L'Esthétique de Calvin* (Paris, 1937). An attempt to distill an aesthetics of Calvin from his *Opera Omnia*; somewhat too hypothetical.

J. Pollmann, *Calvijns Aesthetica* (1937). This is a positive reaction from the Roman Catholic side to Wencelius' book.

S. Anema, 'Wat bracht ons Wencelius' "L'Esthétique de Calvin"?', (n.d.). [See p.384: 'Christianity and Art'.]

K.J. Popma and N. Wedemeyer Krol, 'Wijsbegeerte en kunst', in H.J. and

J.M. Spier, eds., *Wijsbegeerte en Levenspractijk* (1948) pp.97–117.

C. Rijnsdorp, *In drie etappen* (1952). An overview of current Dutch Calvinistic literature containing general reflections.

H. Hasper, *Calvijns beginselen voor den zang in den eredienst* (1955).

C.G. Seerveld, *B. Croce's Earlier Aesthetic Theories and Literary Criticism* (1958). An appraisal from a Calvinist standpoint of the work of an influential aesthetician.

Philosophia Reformata. Various articles by H.R. Rookmaaker, H. de Jongste and others, all based on the Philosophy of the Cosmonomic Idea.

H.R. Rookmaaker, *Synthetist Art Theories: Genesis and Nature of the Ideas on Art of Gauguin and His Circle* (Amsterdam, 1959). A study of the art and theories of art of some forerunners of modern art, approached from a Calvinist standpoint.

J. Stellingwerf, *Werkelijkheid en grondmotief bij V. W. van Gogh* (1959). A biography of van Gogh with the emphasis on his religious ideas.

H.R. Rookmaaker, *Jazz, Blues, Spirituals* (1960). An attempt to give a complete survey of the music of the African-Americans, with an appraisal of the different genres from a Calvinist standpoint.

H. R. Rookmaaker, 'Art, The Christian and Art', in *The Encyclopedia of Christianity* (Evansville, Indiana, 1960) vol. 1.

• Christianity and art: a preliminary bibliography, 1571–1970[584]

Before the nineteenth century

S. Anema, 'Wat bracht ons Wencelius "Esthétique de Calvin"?' *K.J.P. Correspondentie bladen* (Dec. 1956) p.12 ff.

Theodorus Beza, *Icones . . . quibus aductae sunt nonnullae pitrurae quas Emblemata vacant.* Geneva, 1580. From *Praz Studies in Seventeenth-Century Imagery.* London, 1939, p.40 *passim.*

P. Bourguet, 'Notes sur le protestantisme de Rembrandt.' *Foi et Vie* (1932).

Campenhausen, 'Hans Freiheer von: Luthers Stellung zur bildenden Kunst.' *Kunst und Kirche* 17 (1940) pp.2–6.

— 'Die Bilderfrage in der Reformation.' *Zeitschrift f. Kirchengeschichte* 68 (1957) Heft I/II, pp.96–129.

Crouch, *Puritanism and the Arts.* 1910.

R. Dam, 'Karakter en functie van het lelijke naar Augustinus' De Ordine.' *Philosophia Reformata* VI (1941) p.105.

Ch. DeJob, *De l'influence du Concile de Trente sur la littérature et les beaux-arts chez les peuples catholiques.*

Emile Doumergue, *L'art et le sentiment dans l'oeuvre de Calvin Genève.* Soc. génevoise d'edition, 1902.

W. Elliger, *Die Stellung der alten Christen zu den Bildern in den ersten vier Jahrhunderten.* Leipzig, 1930.

— *Zur Entstehung und frühen Entwicklung der altchristlichen Bildkunst.* Leipzig, 1934.

C. Garside, *Zwingli and the Arts.* New Haven: Yale Historical Publications Miscellany 82, 1966.

J.E. Geesteranus, 'Idolelenchus.' In Camphuysen, *Stichtelijke Rijmen.* Amsterdam, 1647, p.215.

Martha Grau, *Calvin's Stellung zur Kunst.* München, 1917.

R. Hamann, *Christentum und europäische Kultur.* R. Hamann in Memoriam. Berlin, 1963, pp.19–79.

K. Holl, *The Cultural Significance of the Reformation.*

Constantijn Huygens, *Gebruyck of ongebruyck van 't orgel in de kercken der Vereenigde Nederlanden.* Goudswaard, Rotterdam, D.N.J. v.d. Paauw ed., 1937.

H. Koch, *Die altchristliche Bildfrage nach den literarischen Quellen.* 1971.

A. Krücke, 'Die Protestantismus und die bildliche Darstellung Gottes.' *Jahrb. f. Kunstwissenschaft* B. XIII (1959) p.59.

E.J. Martin, *History of the Iconoclastic Controversy.* London, 1930.

Georgette de Montenay, *Emblèmes ou devises chrestiennes.* Lyons, 1571.
— *Emblematum christianorum centuria.* 1584.

John Mulliner, *Against Peri-wigs and Peri-wig making and playing on Instruments of Music among Christians.* 1677.

P. Poscharsky, *Die Kanzel, Erscheinungsform im Protestantismus bis zum Ende des Barocks.* Gütersloh, Gerd Mohn, 1963.

M.P. Ramsay, *Calvin and Art Considered in Relation to Scotland.* Edinburg, 1938.

Saxl, 'Illustrated Pamphlets of the Reformation.' Saxl Lectures, London, 1957, pp.225 ff.

A.M. Schmidt, 'Abel d'Argent, poète protestant er baroque naif.' *Revue de Théologie et de Philosophie* IX (1959) p.2.

G. Schwarz, 'Saenredam, Huygens and the Utrecht bull.' *Simeolus* 1, 2 (1967) p.69.

S. Slive, 'Notes in the Relationship of Protestantism to Seventeenth Century Dutch Painting.' *Art Quarterly* XIX (1956) pp.3–15.

J. Telford, *The Methodist Hymnbook Illustrated.* London, 1924.

W.A. Visser 't Hooft, 'Le protestantisme de Rembrandt.' *La Vie intellectuelle* (1938).

— *Rembrandt et la Bible.* Neuchatel, 1947.

G. Voetius, *Twistreden tegen de schouwspelen.* Amsterdam, 1772.

H. Weissäcker, 'Rembrandt und die religiose Kunst der protest. Niederlände.' In C. Werckshagen, *Der Protestantismus am Ende des XIX Jahrh. in Wort und Bild.* Berlin, 1900–1902.

L. Wencelius, *L'esthétique de Calvin.* Paris, 1937.

— 'Calvin et Rembrandt.' 1937, diss.

Nineteenth century

R. Burmand, *E. Burmand, l'homme l'artiste et son œuvre.* Paris, 1926.

M. Denis, *Nouvelles théories sur moderne et sur l'art sacré.* Paris, 1922.

E. Hello, *L'homme: Ia vie – la science – l'art.* Paris, 1897, reprint 1970.

B.F. Westcott, *The Relationship of Christianity to Art.*

Twentieth century

R. Biedrzynski, *Kirchen unserer Zeit.* München: Hirmer Verlag, 1958.

C. Constantini, *L'art chrétien dans les missions – manuel d'art pour les missionaries.* 1949.

R. Guardini, *Über das Wesen des Kunstwerks.* Tübingen, 1954.

G.F. Hartlaub, *Fragen an die Kunst: Studien zu Grenzproblemen.* Stuttgart.

— *Kunst und Religion: Ein Versuch über die Möglichkeit neuer religiöser Kunst.* Leipzig, 1919.

A. Henze, *Das christliche Thema in der modernen Malerei.* Heidelberg, 1965.

T.F. Matthews, 'Tillich on Religious Content in Modern Art.' *Art Journal* XXVII (1967) p.16 ff.

H. Schnell, *Zur Situation der christlichen Kunst.* München, 1962.

R. Schwarz, *Kirchenbau, Welt vor der Schwelle.* Heidelberg, Kerle Verlag, 1960.

G. Simmel, 'Das Christentum und die Kunst.' In *Brücke und Tür.* Stuttgart, 1957, p.129.

K.L. Symons Dzn, *Protestantsche Kerkbouw.* 's-Gravenhage, 1946.

A. Weis, *Christliche Kunst und Kunstwissenschaft.* 1951.

Protestant (Reformed and Evangelical)

S. Anema, *Het Calvinisme en de Kunst.* Kampen, 1935.

Stuart B. Babbage, *The Mark of Cain: Studies in Literature and Theology.* Grand Rapids, Mich., 1966.

A.E. Bailey, *The Use of Art in Religious Education.* Cincinnati, 1922.

H. Bavinck, *Van Schoonheid en Schoonheidsleer.* Kampen, 1921.

D.J. Bruggink and C.H Droppers, *Christ and Architecture.* Grand Rapids, 1965.

N. Buffinga, *Religie en Kunst.* Amsterdam, before 1930.

J.F. Butler, *The Holiness of Beauty.* Epworth.

R. Chapman, *The Ruined Tower.*

R.C. Churchill, *Art and Christianity.* London, 1945.

C. Cleall, *Music and Holiness.* London, 1964.

C. Cope, *Christianity and the Visual Arts.* Faith Press.

— *Symbolism in the Bible and Church.*

J. Dillenberger, *Style and Content in Christian Art.* Nashville, 1965.

— *Sacred Art with Secular Themes.* Nashville, 1969.

C.J. Dippel, *Verkenning en verwachting: Cultuurkritische opstellen* 's-Gravenhage, 1962.

Helmut Echternach, *Kunst und Schönheit: Schrift und Bekenntnis.* Hamburger Theologische Studien I. Hamburg, pp.16–25.

F. Eversole, ed., *Christian Faith and Contemporary Arts.* Nashville, 1962.

P.T. Forsyth, *Christ on Parnassus.* Independent Press, 1911/1959.

R.M. Frye, *Perspective on Man: Literature and the Christian Tradition.* Philadelphia, 1961.

F.E. Gaebelin, 'The Aesthetic Problem, Some Answers.', *Christianity Today* IX (1965).

— 'Schools and Arts, a "Creative Outburst".' *Christianity Today* X (1965), p.73.

John Garrett, 'Church and Artist in the Non-Western World – Next Steps?' *Occasional Bulletin from the Missionary Research Library* 19, 4 (April 1968) pp.1–6.

F. and D. Getlein, *Christianity in Modern Art.* Milwaukee, 1961.

F. Glendenning, *The Church and the Arts.* London.

E. Grolle, 'Woord en beeld – een controvers?' *Critisch Film- en Televisiebulletin* 15, pp.132–134,

R. Groves, 'The Message in Modern Pop Music.' *Christianity Today* XI (1967) p.941.

R. Hazelton, *A Theological Approach to Art.* Nashville, 1967.

Jerome Hines, 'Evangelical Opera.' *Christianity Today* XII (1968) p.361.

G.J. Hoenderdaal, *Religieuze existentie en aesthetische aanschouwing.* Arnhem, 1948.

T. Howard, 'Art and Religion, they need not clash.' *Christianity Today* X (1966) p.391.

Clyde S. Kilby, *Christianity and Aesthetics.* Chicago, 1961.

J. Killinger, *The Failure of Theology in Modern Literature.* Washington D.C., 1963.

A. Kuyper, *De Gemeene Gratie in Wetenschap en Kunst.* Amsterdam/Pretoria, 1905.

— *Calvinism and Art in Calvinism,* Six Stone lectures. Grand Rapids, 1943.

G. van der Leeuw, *Sacred and Profane beauty: The Holy in Art.* New York, 1963.

A. Lehmann, *Christian Art.* St Louis, 1969.

Joseph P. Love, 'Problems of Mission Art in an Age of Change.' *Occasional Bulletin from the Missionary Research Library* 18, 7 (1967) pp.1–8.

D.F. Malherbe, 'Kuns – selfstandig en afhanklik.' *Philosophia Reformata* 12 (1949) p.67–86.

W.L. Nathan, *Art and the Message of the Church.* Philadelphia, 1961.

E. Newton and W. Neil, *The Christian Faith in Art.* London, 1966.

J. Pelikan, *Human Culture and the Holy – Essays on the True, the Good and the Beautiful.* London, 1955.

'Quiet Revolt in Gospel Music.' *Christianity Today* IX (1965), pp.52 ff.

H.R. Rookmaaker (only publications in English), *Art and the Public Today.* L'Abri,Huémoz-sur-Ollon, Switzerland, 1969.

—'Art, The Christian and . . .' In *The Encyclopedia of Christianity.* Wilmington, Del., 1964, pp.418–423.

—'Letter to a Christian Artist.' *Christianity Today* X (Sept. 2, 1966) pp.1193 ff.

—'The changing relation between theme, motif and style.' *Proceedings of the Fifth Intern. Congress of Aesthetics* (Amsterdam, 1964) pp.708–711.

—'Let's sing the old Dr Watts, a chapter in the history of Negro spirituals.' *Gordon Review* IX (1966) pp. 90 ff.

—'From Eliza to Odetta.' *Philips Music Herald* (Winter 1964–1965) pp.17–20.

—'Christian Creativity.' *Salt* (London, Spring 1970).

—*Synthetist Art Theories: Genesis and Nature of the Ideas on Art of Gauguin and His Circle.* Amsterdam, 1959.

— *Modern Art and the Death of a Culture.* London, 1970.

C. Rijnsdorp, *In drie etappen*. Baarn, 1952.

Dorothy Sayers, *The Mind of the Maker*. London, 1944.

H. Schrade, 'Zur kunstwissenschaftliche Ausbildung der Theologen.' *Das Münster* XXI, p.457.

C. Seerveld, 'Art, Temptation to Sin or Testimony of Grace?' *Christianity Today* X, 5 (Dec. 3, 1965).

— 'The Relation of the Arts to the Presentation of the Truth.' in *Truth and Reality*, dedicated to H. G. Stoker. Braamfontein, S.A., 1971, pp.161–176.

— *A Christian Critique of Art and Literature*. ARSS, Toronto, Canada, 1968.

W.S. Sevensma, *Ethisch – Aesthetisch*. Amsterdam, 1930.

W. Shewring, *Art in Christian Philosophy*. Plainfield, New Jersey, 1946.

W. Stanford Reid, 'Escapism and Realism in Christian Art.' *Calvin Forum* XVI (Oct. 1950) p.40.

W.A. Visser 't. Hooft, *Rembrandt and the Gospel*. Philadelphia, 1957.

R. Volp, 'Bildende Kunst und christliche Glaube.' *Kunst und Kirche* XXXI (1968) pp.3–8.

L.G. Wencelius, *The Word of God and Culture*.

J.F. White, *Protestant Worship and Church Architecture*. New York, 1964.

D. Whittle, *Christianity and the Arts*, Mowbray.

B. Wielenga, *Moderne letterkunde en Christelijke opvoeding*. Amsterdam, 1922.

H. Zylstra, *Testament of Vision*. Grand Rapids, Michigan, 1961.

Germany (Lutheran and Roman Catholic)

Urs von Balthasar, *Eine theologisache Ästhetik*. Einsiedeln, 1961/2, 2 vols.

W. Barzel, 'Kann es eine christliche Tragödie geben.' *Stimmen der Zeit* 73(1948), Bd. 142, pp.50–61.

Freidrich Buchholz, 'Zum theologischen Problem der Kunst.' *Verkundigung und Forschung*. München, 1949, pp.125–133.

Edouard Büss, 'Zu einem theologischen Begriff der Schönen.' *Theologische Zeitung* 7 (1951) pp.365–386.

H. Eckehard Bahr, *Poesis.* 1962.

— *Untersuchungen zur Deutung der Kunst in der Theologie der Gegenwart.* 1959.

Heinz Flügel,'Das Aergernis moderner Christusdarstellungen.' *Vierteljahresschrift der Evangelischen Akademikerschaft in Deutschland* (1957) Heft 2, pp.38–43.

Leo Fremgen, *Kunst und Schöpfung: Ethik der Kunst.* Gütersloh, 1942.

Gerhard Gollwitzer, *Die Kunst als Zeichen.* München, 1958.

C. Groeber, *Kirche und Künstler.* Herder Verl., 1932.

Hans Carl von Häbler, *Das Bild in der evangelischen Kirche.* Berlin, 1957.

R. Heckler, *Christentum und Kultur.* München, 1946.

—'Christentum und Kunst.' *Opuscula,* München, 1949.

G. Hartlaub, *Kunst und Religion, ein Versuch über die Möglichkeit neuer religiöser Kunst.* Leipzig, 1919.

Olov Hartmann, *Kunst und Christentum: Drei Essays.* Hamburg.

Johannes Hempel, *Das Bild in Bibel und Gottesdienst.* Tübingen, 1957.

A. Henze, 'Das christliche Thema in der modernen Malerei.' *Das Münster,* 1965.

— *Kirchliche Kunst der Gegenwart.* Recklinghausen, 1954.

Walther Heyer (ed.), *Evangelische Kirchenbautagung.* Erfurt, 1954/ Karlsruge, 1956/ Berlin, 1957.

G. Jacob, *Die Kunst im Dienste der Kirche.* Landshut, 1908.

Jochen Klepper, *Der Christliche Roman.* Berlin, 1940.

Joachim Konrad, *Religion und Kunst.* Tübingen, 1929.

A. Krücke, 'Der Protestantismus und die bildliche Darstellung Gottes.' *Zeitschrift f. Kunstwissenschaft* XIII (1959) pp.59–90.

Lüthi Kurt, 'Bildende Kunst ald theologisches Problem.' *Theologische Zeitung* 16 (1960) pp.120–133.

— 'Theologische Bemerkungen zum Selbstverständnis der modernen Malerei.' *Zeitschrift f. Evangelische Ethik* Heft 5 (Sept. 1961) p.268.

Marti Kurt, *Das zweite Gebot und die konkrete Kunst: Max Bill-Festschrift,* Teufen, pp.28–35.

— 'Christus, die Befreiung der bildende Künste zur Profanität.' *Evangelische Theologie* 7 (1958) pp.371–376.

— *Moderne Literatur, Malerei und Musik: Drei Entwürfe zu einer Begegnung zwischen Glaube und Kunst.* Zürich/Stuttgart, 1963.

Otto Mauer, *Kunst und Christentum.* Wien, 1946.

K. Mendelssohn, *Gott, Welt und Kunst.* (herausg. W. Ewald) Wiesbaden, 1947.

Peter Metz, *Abstrakte Kunst und Kirche: Eine Studie über die Kunst in der Heilgeschichte.* Nuremberg, 1954.

Alfred Dedo Müller, 'Der Verkündigungscharakter der Kunst.' Otto Riedel ed., *Vom Worte Gottes und den Künsten,* Berlin, 1953.

H. van Oyen, 'Zur Frage der christlichen Kunst.' *Theologische Zeitung* 7 (1951), p. 42 3–446.

Paul-Christian Paegelow, *Bildende Kunst und evangelische Erziehung: Versuch zu einer grundsetzenden Überlegung.* Berlin, 1957.

Paul F. Portmann, *Der Christ und der Kitsch.* Schriftenreihe der christlichen Kultur VIII. Zürich, 1949.

K. Rahner (ed.) 'God en Wereld' (Gott in Welt). *Kerk en Wereld,* 1965.

A. Rosenberg, *Die christliche Bild-meditation.* München-Planegg, 1955.

E. Schlink, *Zum theologischen Problem der Musik.* Tübingen, 1945.

H. Schnell, *Zur Situation der christlichen Kunst.* 1962.

L. Schreyer, *Christliche Kunst des XX Jahrhunderts.* Hamburg (Wegner Verl.), 1959.

— *Das Christusbild und die Kunst des 20. Jahrhunderts.* Salzburg (Otto Müller), 1960.

F.K. Schumann, 'Das Schöne als Frage der christlichen Glaubens.' *Zeitschrift f. systematische Theologie* 20 (1943), pp.147–163.

Wilh. Vischer, *Du sollst dir kein Bildnis machen: Antwort, Festschrift Karl Barth.* Zurich/Zollikon, 1956, pp.763–773.

H. Vogel, Die Krisis des Schönen. Berlin.

—— *Der Christ und das Schöne.* Stuttgart, Kohlhammer, 1947.

—— *Der Christ und das Schöne.* Berlin, 1955.

Rainer Volp, *Das Kunstwerk als Symbol: Ein theologischer Beitrag zur Interpretation der bildenden Kunst.* Gütersloh, 1966.

H. Vorgrimler, 'Heutige Theologie und Heutige Kunst.' *Das Münster* XVII (1964) Heft 5/6, pp.209–211.

H. Weisinger, 'The Attack on the Renaisssance in Theology Today.' *Studies in the Renaissance* 2 (1955) pp.176–190.

Klaus Wessel, 'Abstrakte Kunst und Kirche.' *Theologische Literaturzeitung* 81 (1956) p.665.

Walther Zimmerli, *Das zweite Gebot: Bertholet-Festschrift.* Tübingen, 1950, pp.550–564.

France (Roman Catholic)

G. Arnaud D'Agnel, *L'art religieux moderne.* Grenoble, 1936, pp.1–11.

G.J. Auvert, *Défense et illustration de l'art sacré.* Paris, Nouvelles éditions latines, 1956.

M. Brillant, *L'art crétienne en France an XX siècle.* Paris, 1927.

A. Cingria, *La décadinée de l'art sacré.* 1930.

Th. Corbishley, *Art and Faith, Letters between Jean Cocteau and Jacques Maritain.* New York, 1949.

V.H. Debidour, *Problèmes de l'art sacré.* Paris, 1951.

M. Denis, *Nouvelles theories sur l'art moderne et sur l'art sacre 1914–1921.* Paris, 1922.

—— *Les Nouvelles directions de l'art sacré.* 1919.

Dom Eloi DeVaux, *L'agonie de l'art sacré.* Paris: Zodiaque, 1951.

R. Gilles, *Le Symbolisme dans l'art religieux.* Paris, 1961.

A. Gleizes, 'L'art sacré est theologique et symbolique.' *Arts* (Jan. 1948).

J. Guichard-Meili, *La peinture aujourd'hui.* Ed. Témoignage chrétien, 1960.

F. Heidsieck, *L'inspiration, l'art et la vie spirituelle.* Paris, 1961.

E. Hello, *L'Homme*. Paris, 1921.

J. Maritain, *Art and Scholasticism*. New York, 1962, translated from the French edition of 1935.

G. Mercier, *L'art anstrait dans l'art sacré, la tendance non-figurative dans l'art sacré chrétien contemporain*. Paris: ed. E. de Boccard, 1964.

M. Michaud, 'La symbole a-t-il été et puit-il être encore un véhicule sacré.' *Arts* (Jan. 1948).

C.J. Nesmy OSB, 'De l'art abstrait à l'art sacré.' *Arts* (Jan. 1948).

P.R. Regamey, *Religious Art in the 20th Century*. 1963.

— *Art sacré an XXe siècle?* Paris: ed. Du Cerf, 1952.

William S. Rubin, *Modern Sacred Art and the Church of Assy*. New York, 1961.

Letters

• To Peter, on art and crisis[585]

The following exchange of letters gives an inside view of the struggle of an artist, in this case a young composer, and the counsel of his spiritual advisor, a man already well known to our readers.

Professor Rookmaaker's caring and thoughtful response will, we think, find an application in everyone's situation. At his request, we have kept the correspondent anonymous. He has, by the way, carried on with his composing.

February 14, 1976

Dear Prof. Rookmaaker,

Many thanks for your note. Your thoughts on my staying on at Meredith were precisely timed, it seems. As it turned out I resigned just a day or two before I got your letter. Sue and I had been praying about the job, together, and it just seemed to be the right thing to do. We have both been so busy that we have hardly had time to spend together, let alone for me to sit down and start applying once again for a job. So, I will be without work in the fall, and Sue will probably be going to the University of North Carolina to finish up her degree. We have enough savings to see us through another year if we live frugally, and I plan to compose then, Lord willing.

At the moment, I am writing an organ piece for my department head and am devoting all free energies to it until it is finished.

I still labour under awfully heavy thoughts for the future. Jacques Cousteau informs us that unless the industrial countries stop dumping chemicals into the streams, the sea will be dead in a matter of decades and once the sea goes, people will die too. Also, the advocates of nuclear energy are slowly winning, and it scares me so much to think of the proliferation of radioactive materials in our broken-down culture, let alone the problem of waste disposal. In the face of such deep and nightmarish problems and the possibility of life becoming extinct on earth, it seems an awfully silly thing to do to be writing a little piece of music. I can't let my pessimism paralyze me, but I can't ignore the more immediate questions either. I wonder if you've got any thoughts on this?

Peter

March 20, 1976

Dear Peter,

Your letter has stirred up many thoughts in my mind. I want to share some of them with you. First, you say it is an 'awfully silly thing' to compose music while the world is going to pieces and the future seems bleak. Now I don't feel that you put it right. It may be that pollution is a very serious problem and that we ought to work on this. That is our human calling, to tend the 'garden' that God gave us to look after. Christians should be especially aware of this. There is also the threat of nuclear war. So in fact in many ways people, just by foolishness or carelessness, lack of love, desire for power and obeying the gods of money, pleasure and sex, may severely endanger human and other life on this planet. And, of course, there are many other threats. A meteor may fall on the earth tomorrow and destroy it, or the sun may explode, or . . . well, the possibilities are endless.

Now the only people in the world that can be validly optimistic are the Christians – other people often are, but without an ultimate reason. As Christians we base our optimism on God's promise: the rainbow is the sign of the covenant that this world will go on in the way it does until the Last Day. God has things in his hand. The greatest miracle of all, which no person really can understand or explain in any way, is the simple but overwhelming reality that God created the world. He created every thing with its particular freedom, human freedom, animal freedom and so on, and yet he holds the whole in his hand. There is no chaos, only God-given and God-sustained order. So we need not be afraid. We can work. Even if it is true that our work might not be completed because of war or persecution or anything else that belongs to this cursed world, we can still be at peace in a deep sense, as God has promised that our works go with us. They are part of the making of the new earth. In a way, we just do our work as we feel it is right and then wait and see what comes of it: the fruits are not our responsibility. We are only responsible to do our work in real love, looking for righteousness, beauty, humanity, life, and truth, so that it hallows the Name of the Lord. In this context there may be peace and joy.

We cannot save the world and create a happy future. We cannot ensure a solution to the world's problems. But just because of this we look to the Lord and seek his salvation and his final redemption, the new earth he is preparing. But in it we have our calling. God does not let these things come to pass without our work being done, in freedom. We have to look at our task, to live the life God gave us to live, and to use our talents. He gave these to us too, in order to be used, according to his purpose.

So, to put it bluntly, if you don't make that composition, regardless of whether it will ever be played or not, and if you don't try to use all your talent in writing that piece in line with Philippians 4:8,[586] the world

still has to wait for the end to come. We have to wait for the 'most joyful and yet most horrible day' to come; to use Heinrich Schütz' title of his composition on this subject.

This brings me to a second remark, relating to the problem of the choice of style and subject matter. I know that this has long been on your mind, as it has been for so many others who are artists and Christians. I think we must realize that our work is subjective; it is ours, though we act according to norms and laws. Of course, we could never do anything else. If you make music, you must follow the structural norms for music, otherwise you would be making noise. These norms may be hard to define and it may be that they are in part the systems of harmony which have been developed in the past and in part norms that are deeper and wider, so that there is room for renewal, change, etc. But I am not thinking at this moment about the philosophical or aesthetic problem of how to define these norms, but rather about you as an artist, that you may know the norms and may know that musicianship means to have taste, feeling and knowledge of what is right or what is wrong in a note, a melody, and so on. You should never apply these norms in a legalistic way and impose them on others, or on yourself, nor should you be afraid or anxious to go ahead. Criticism may come if you make music that lacks musicality, but that is true of any human endeavour.

In another way this same principle also holds for our Christianity. People always ask what is the specific 'Christian' element that they should bring into their work. But if Christianity means trimming our work, not using certain possibilities even if we wanted to, giving the work a certain prescribed colour, content, form or whatever you want to call it, then I think we have a kind of legalism and not true Christianity. Christianity means freedom and life. We express ourselves. In the same way as it is impossible to choose a style (you are a style, style means the way you understand things, look at things, feel things, the way you love, laugh, hate – yes, sing, play and dance) it is impossible to make your work more 'Christian' than it is already. Christianity is not just something added, a kind of sauce, but it is the whole of our selves, we who are children of the Lord. Of course, some Christians are stronger, others weaker, some deeper and some more superficial, some wiser and some more foolish, some need some admonishing and others encouragement, some are right and some are wrong. But this is life as it is. The problems cannot be avoided unless we simply stop existing.

So I have begun to see that the terms we use in history of art or art criticism can be confusing or lead to wrong conclusions. We talk about the 'expression' of some idea, or world view in a work; we speak about the spiritual 'background'; we speak sometimes, I feel, in a wrong way about 'form' and 'content'; and in all these cases we make a division between the external and the internal in a misleading way. Even if we (sometimes) can distinguish between these we should not separate the spiritual inward background and driving force from the forms, sounds,

colours, style or subject matter of the work of art. They are one, and the form is the spiritual, the inward, the meaning made visible, audible. The mentality is in the way we do things. Of course we sometimes labour to find the right word, and I am not trying to say that art comes by itself, but I do mean that we should not think there could be a form without meaning and content, or a meaning and content without a form. Nor can we as Christians make works that are not Christian. Maybe the work expresses our selves in our foolishness and sinfulness; still it is as foolish, sinful Christians.

So I am writing this to give you confidence and to urge you to go on. If you, as an individual, for whatever reason, are a bit pessimistic and have fears you need two things: first, your personal Christian life – look for consolation and wisdom in the Scriptures, and pray to God to help you if you experience a lack of joy and peace; and secondly, just work as an artist, and if need be in your work reveal your struggles, anxieties and battles won. Your work is the outward showing of your own mentality, your own wisdom. In short: just be yourself. You never can be better than that – if you try, you end up in frustration. But don't be less than yourself. And, as a Christian, you will show the battle against sin, unbelief, lack of love, etc., in yourself and in others. Express things that you find to be relevant, music that you think is worth listening to, relevant to a situation. God gave you talents and so there is your calling.

Of course we are given brains, and we must use them. But we should not be confused by Hegelian or other art theories, nor by Freudian psychologisms, separating things that are one, the meaning, content, expression, style, form, techniques. They are one, as we are one. To 'express something' does not mean that there is a mystical inner 'background' spirituality searching to find an outlet, choosing the means more or less at random. Our life is our Christianity, and so is our work of art. Of course we try to choose with taste and knowledge, to make the work as clear as possible, as beautiful as possible, as relevant as possible.

In short, Christianity is not the sum of all the do's and don'ts but a mentality, a way of life, including the reflection, the imagination, the work, the study, the prayer. In the same way art is not random forms expressing mysterious entities. A Christian work of art is work by a Christian who is expressing the ultimate of love, wisdom, knowledge that he or she can muster. To our dismay we ought to say that that is sometimes below the standard. But we don't redeem it by adhering to certain legalistic norms; rather, by asking for a deepening of faith, a greater effort to grow and deepen in our understanding of the things the Lord gave us. In the end we can only give back what he first gave to us.

So, please don't worry. Just try to help people to have some happiness and beauty and truth in and through your work before the Lord comes back – after all, it may still be a relatively long time yet.

H.R. Rookmaaker

• To Betty, on abstract art and abstraction[587]

June 29 1970

Dear Betty,

I do not know whether you knew the answers already yourself or whether you learned these from – or by – me, but anyhow, your understanding of Picasso's dilemma is really deep; and if you learned it from me, you certainly made it your own. I could not say it better; I actually believe you said it better than I did.

About abstraction? Do not confuse this with the artistic use of lines and colours. The Expressionists used 'unnatural' colours, but they did not mean to say 'This woman is blue,' etc.; but they depicted a woman in a pictorial language telling something about the woman. In fact, almost no art whatsoever ever was 'naturalistic' to the end, except for the nineteenth-century art that was photographic, but then it meant [was built on the assumption] that only what the photographic machine could record was really real. No, no seventeenth-century art, for example, ever was in that sense 'natural'. It was natural insofar as it depicted reality in a way that was true to reality; it was natural insofar as the insight in reality that was shown was in accordance with reality. Art, being made by humans, never was able to show anything but a person's understanding of reality. Abstraction – in the sense of non-figurative – in its twentieth-century origin was a 'shrinking away from reality', a seeking of a spiritual reality beyond the real, the individual, etc. But maybe some of the later ones were only making pleasing forms, as that is the only meaning left. Great decorations.

When you paint, paint what you think is good and beautiful and true – without the pitfalls of the pastoral ideal or the horrible present. Yet it is not easy to reconquer reality.

Thank you for your paper. And greetings. Hope to see you again,

Hans Rookmaaker

• To Mr B, on nudity and art[588]

March 9, 1961

Dear Mr B,

I am grateful to have received your letter and I shall try to formulate an answer to it here. I believe I can already read the answer in the well-composed framing of the problem.

First then Genesis 3, the fall into sin and its aftermath. Adam and Eve saw that they were naked and were ashamed. It is difficult to discern precisely what that means, difficult in part because for centuries people

read that passage under the influence of the Greeks, who viewed the corporal, the sexual as lower and base. What does it mean? Could it not be that what they saw was not so much their nakedness in the sense of being undressed as it was their frailty, their being unprotected – in contrast to the animals that had fur – but even deeper their being unprotected, their nakedness, their being separated from the Lord. They were ashamed. This expression also has two meanings in our language.

God then clothes them. Being dressed gives people a sense of self-confidence, and our clothing has become fully part of our personality. The extent to which this is so you can find in a humorous yet deep way in Carlyle's *Sartor Resartus*, where he discusses the absence of clothing. Yet I believe we must also hold onto the idea that the nakedness and shame bear some connection with the sexual aspect. I sometimes feel that God made people that way for their own protection. Is the feeling of shame not a protection for a girl in our day as well, and is male timidity in this matter not its counterpart? But we must keep in mind that nakedness and shame in this sense are always connected with the most directly sexual.

It is good to reflect on these things. To say precisely what naked means in a generally valid sense is not even possible. That is a matter of custom that can change from period to period and people to people. Consider that girls as they walk around here in Holland are shameless in the eyes of the Balinese, for whom a woman may never expose her legs although there they all go around with their upper bodies exposed. Nevertheless, nakedness and shame are something that you find amongst all peoples, even the most primitive, but then only in connection with the pudenda, the 'private parts'. It is typical that with many primitive peoples a man may feel free to show his member but not the phallus, which is much more directly connected with the sexual aspect – at celebrations in antiquity and possibly also with feasts of primitive peoples this was possible, but then we are talking about fertility rites, and then the taboo on these matters is only suspended for these special occasions.

Thus our conclusion is provisionally that shame is connected with the most primary sexual aspect, and the pudenda (the things about which people are ashamed) are in fact the genitals themselves (thus not a woman's breasts); and further that shame is connected with our frailty, with our being unprotected in an everyday but also in a deeper religious sense.

That shame is directly related to the sexual, or perhaps one could better say to the erotic aspect, is clear from both practice and Scripture. A woman may show herself undressed to a physician, but there too there is usually a room where one may disrobe. Photographers' models too come on the set entirely naked, for it is not their nakedness but the act

of disrobing that has a much more directly erotic significance. Remember that the height of shamelessness is the striptease, which is directly intended to arouse. Scripture accordingly says that men are not to dis-cover the shame of a woman whom they may not have, that is, to remove her covering. What the general practice was in those times is hard to know, but in many periods, such as the Middle Ages, when nude images were seldom made and the erotic aspect was far from having the central place it is given in our day, nakedness had a matter-of-fact place in everyday life, as in bathing or in the home – people slept naked and with many in a room. The subtleties of such matters, the connection of the erotic aspect with disrobing, we may perhaps infer from our own customs: a girl may appear wearing very little at the swimming pool or beach – in some countries she may even be entirely naked – and no erotically arousing significance is attached to it, while the same girl if she had to adjust her stocking while fully dressed, would turn away or dismiss herself although revealing less no doubt than at the beach. It would be shameless however if she were not to do that. The same applies to holding down one's skirt while bicycling.

The pudenda, that is to say the parts which it would be shameless to show or exhibit, are thus in fact only the genitals or those parts of the body that because of the erotic implications one does not uncover in company where people are dressed. If we proceed now to consider sculpture and painting from this vantage point, we can establish several things. First, people have complied with this in practically all periods. Female nudes have a small cover over the primary sexual characteristic or simply do not have that feature – think of Greek statues and the statues of all eras, really, before the late nineteenth century. Then we witness the abrupt appearance of greater realism, which is to say that pubic hair and the like are painted or sculpted, whereupon the meaning of the images is also seen to have changed such that the objection based on Genesis 3 becomes operative. Shameless for example are some of Hodler's paintings, but not Praxiteles' *Venus*. The same is true of male statues. Naturally there is always a suggestion of the male member, but always very modest and with little emphasis. Here too one will encounter exceptions, but these are virtually always vulgar and unpleasant in their effect. The phallus is very seldom depicted in art – and when it happens, always either directly pornographic or else with a view to special circumstances, such as fertility rites with satyrs in antiquity (although even there people often exercised a certain reserve).

With respect to the nude we can add the following. There are two kinds, in principle, namely where the nude appears in frailty, as in the Middle Ages (remarkably enough with an indication of the pubic hair of the female figure); and there is the heroic, glorifying nude that we find in the works of the Greeks and *a fortiori* in the Renaissance, with Rubens, and so forth. Our time, with its downfall of humanism, can scarcely

indulge such glorification any longer, and we therefore see, since the late nineteenth century, the realistic nude that is a direct representation of the reality, including the pudenda, without any reference to the idea of frailty in the Christian sense. Such figures often have a crude impact and people experience them as an insult to human dignity. Yet sometimes people in our century do endeavour to uphold old and deeply seated norms in these matters, for example with nude photographs, and so retouch them in order to remove especially the pubic hair – unless we are talking about the photography of nudists, thus of people who want to give nudity a place in normal social intercourse (which usually comes across however as quite unnatural). Nudism will perhaps become acceptable at the beach or a swimming pool, and I do not believe that that has to be prohibited if custom would start to allow it, but that is quite a different matter from ordinary social activities such as volleyball and the like. And if nudity would become allowed in instances where one is now wearing bathing suits, then the distinction between chaste and shameless will remain valid, just as girls can happily move about shamelessly in bathing suits and the like.

Now, you write that it is not permitted to glorify the body. Certainly, for in art that usually means glorifying human being. In that case however our argument is not directed at the nude but at this glorification. The question in art must always be not 'Is it nude?' but 'What does the artist say with that nude?' Michelangelo's *David* of 1504 is a shameless statue, not because of its nudity but because with this nudity such a forthright confession is made of man's greatness, of the Renaissance spirit in its most profound sense, that of the emancipation of humanity from God. Michelangelo no longer has any notion of frailty. A *Venus* by Giorgione, by Titian, a female nude by Rubens, for example in the *Rape of the daughters of Leucippus*, [see *Complete Works* 3, Plate 5] have nothing to do with violating the idea of Genesis 3 in the sense that nakedness should be covered but rather they extol human nature in its erotic aspect, in its warm humanity, in its fundamental aspect of relations between the sexes. A discussion of these paintings must thus address the question whether these aspects may be extolled in this way without reference to humanity's fallen situation, but on the other hand we may not say that people must always hide these things and never occupy themselves with them because the sexual is per se sinful. That is a Victorian viewpoint and it is unbiblical. Do not forget that the Bible contains the Song of Solomon and that men are advised in Proverbs to be aroused by their wife's breasts [Proverbs 5:19: 'may her breasts satisfy you always, may you ever be captivated by her love'].

You go on to say, correctly, that with these nude figures much more is expressed than simply that which is purely sensual, or to put it more sharply, the purely primary erotic aspect. Much more, for they are about human being in the fullest sense. The male-female relation in marriage

is certainly not as in the case of animals purely and solely sexual, but there is a great deal more going on in the love relationship between a man and a woman. Also, a nude figure may even be entirely lacking in erotic implications, for instance when it is a metaphor for Truth.

Nude figures that may accordingly be judged entirely unobjectionable from a biblical standpoint, that on the contrary can be judged very positively, are Rembrandt's *Danae* and *Bathsheba*. They are songs about the joy that has been given to us in the man-woman relation, including the directly sexual (but not restricted to that) without any exaggerated glorification of humanity accompanying it.

Thus we must always ask what meaning a nude has, what is said with it. Many eighteenth-century nudes, such as those painted by Boucher, are gallant nudes, nudes directly connected with adulterous erotic play (very refined but adulterous nonetheless), with flirtations and mistresses. They are idealized images of the courtier who passes his time making 'conquests'.

And now Rodin. He stands close to the Renaissance, although he is a typically nineteenth-century figure in his emphasis on the psychological. His *Kiss* strikes me as entirely responsible, as an interpretation of a profound human value, although I am drawn more to Rembrandt's *Bathsheba*, which in essence seeks to express the same thing. In contrast I regard *L'éternelle idole* as highly questionable. As woman is glorified in it as an object of enjoyment, I find the content of the work vulgar and therefore reprehensible; if the woman is declared a deity in it, I have every objection to that for reasons that need no explanation.

I have two additional comments. The fact that an image has a stimulating effect on us can certainly be subjective; it may be attributable to a variety of circumstances, but in general we will be able to figure out whether that is due to something in the image or something in us. In my lecture I also discussed this subjectivity, which differs from person to person, in connection with the need for self-discipline – in this respect there is freedom. Secondly, we must look at art with a view to what it says: the *Rape of the daughters of Leucippus* depicts an old myth, selected by Rubens in order to sing in a lofty rhetorical way about passion, desire, heroism, the greatness of life, the central place of the woman in this, and so on [see *Complete Works* 3, Plate 5]. He was certainly not all that enchanted by the story as such (although the classical element had a different emotional value in his day than in ours), yet it is also not simply a pretext for painting a crude kidnapping in a nudist camp. Here the theme is part of the rhetoric and the glorification, which also lifts it more into the realm of principles and values than that of actual everyday life. A late nineteenth-century painter simply makes a kidnapping of it: a naked woman is carried off on a horse by two soldiers whose intentions are questionable. It is precisely the dropping away of real human values in the man-woman relation and the exclusive concentration on a randy

story without further depth that renders the painting vulgar and degrading. But that brings us close to pornography, defined by D.H. Lawrence as 'to throw dirt on sex'. There the woman is an object of lust. This surfaces already with Ingres, who painted odalisques, and later on with Picasso.

Perhaps there are people who carry on that way, but it makes a difference whether one violates a norm or lives without norms!

In conclusion, a final comment: this ultimately all has very little to do with clothing or the lack of it. The sex bombs used on magazine covers to catch the eye, with a hint that more may be revealed inside, are usually well dressed, but in their purely sexual effect or titillating intention they are violations of Genesis 2. This is shamelessness, separating sensuality from the rest of our humanity in its normativity and values.

These are a few thoughts. I went into them extensively because I regard the problem as very important for us, twentieth-century Calvinists who must emancipate ourselves from a Victorian past without sliding into the normlessness and shamelessness of the Freudians, and also because I believe that in this way we can come to understand better what art does and how it can express its message. I think it is instructive as well because when dealing with nudity in art we come into contact in such a direct way with the cultural-historical and current problem of the loss of a sense of norms and of insight into the worth of human values. I have also written it all out at such length because I hope eventually to use it in a little book that I am writing about Christians and art. I would be pleased if I could cite your letter and my reply, without mention of the name or circumstances. In that regard I would like to receive your reply, together with any additional questions, comments or objections you may have. I want to thank you already for that.

Yours sincerely,
H.R. Rookmaaker

April 11, 1961

Dear Mr B,

I am grateful to have received your letter. I had not forgotten it but was so busy that I put it aside for a while. I hope you do not find that too bad. I believe you probably no longer needed it for your paper.

Here then is a short answer to your questions. Kuyper, I believe, contradicts himself. The distinctive service of Calvinism is that it emancipated art from ecclesiastical ties. So it is not correct to say that Calvinism did not have an art of its own, for precisely our seventeenth-century art, for example a still life, reflects a typically Calvinistic view of reality. May I leave it at that? Art style and lifestyle are to my mind

closely connected. I can no longer recall what K. Schilder wrote about this, but I cannot concur in general with what he had to say about the theme of culture.

I do not reject common grace. It is an interesting theological construction, but I believe it proceeds from an entirely incorrect framing of the problem. I do not reject it because doing so would quickly draw me into these theological discussions. I simply believe that the entire debate skirts reality. It is a piece of scholasticism. As I see it, we are most easily finished with an answer in these matters if we say that the non-Christian lives in the same world, created by God, that the Christian lives in and that one can never step outside this world, not even through suicide. If we accept the theological framing of the problem, we always end up at such a theory of common grace or something similar but I just do not believe we should think in this vein.

Then the questions about the nude. The story of Noah I find difficult to apply in this matter. What were the customs in that time? Was it so terrible that a son saw his father's nakedness? Or was the bad thing rather that he mocked his father for his drunkenness and lack of self-control? I do not believe that we can conclude from this or other passages that it is wrong for children to see their parents naked. I think the direct family relationship and living together as a family make things different in this case.

In the matter of uncovering (or 'dis-covering', if you prefer), I will stick with my opinion for the moment. I do not believe that bathing naked in company as that occurs with many peoples has anything to do with glorification. It is instructive to notice that in the time that people began to glorify the human body, the Renaissance, nakedness as an everyday phenomenon disappeared. That sort of interested looking evoked the shame, but more importantly the ideal could not bear the confrontation with the sober reality. Titillation need not and will not come from an ordinary situation of nudity in a swimming pool (but we are unfamiliar with such a normal situation and so can have little feel for it) any more than from a normal clothed situation. It is instructive too that titillating magazines and the like seldom show full nudity – the partially clad is much more arousing. And a girl with a lovely figure can always have an arousing effect on a man, but that depends primarily on how she moves and behaves.

Rodin is a problem apart. His influence as I see it has not been very great. His psychologically oriented art was relatively unique in the visual arts, and so in that respect he stands much closer to the literature of the day than he does to his fellow artists, the painters and sculptors.

I hope that the above may in some way have helped you further.

Kindest regards,
H.R. Rookmaaker

• To David, on popular music[589]

September 6, 1965

Dear David,

Many questions that came forward during the long discussion we had, ask for careful consideration. Not surprisingly, they very often touched on problems that I discussed in my lecture on the cultural situation.

1. What is the relation between the gospel songs of the 1950s and 1960s and rock-and-roll and music of that kind (popular music with a strong emphasis on a simple beat)? Originally none! Rock-and-roll began as commercialized blues, stemming directly from the also rather commercial and at least shallow 'rhythm and blues' of the 1940s. Performers like Elvis Presley got their inspiration directly from there – the schemes of their songs are really very simplified blues forms and rhythms. When I use the word 'blues' here I do not refer primarily to a certain musical form, as also used in jazz, but to the soloistic folk songs of the African-American people, the kind of songs I illustrated in my lecture with an example by Leroy Carr. The new religious entertainment forms in the early 1940s developed quite differently and from completely different sources, as I also showed in my lecture.

 Another thing is that since around 1960, when gospel songs became quite prolific and all the rage within the African-American community, especially in their commercial forms, gospel songs have had quite an influence on the music of teenagers, colouring and changing the earlier rock-and-roll patterns. Another influence on popular music of the top hit kind is found in folk music of the Pete Seeger type.

2. Should we consider this music (gospel songs, etc.) at all? Would it not be better to dismiss it as just popular, commercial, shallow or even unmusical, with as main argument against it that it is rhythmical, sensuous, repetitious, simple in form and musically below standard? My first answer would be that we must never ignore things that so many people live with and enjoy. Then we have already fallen into the trap of our times, that there is a division between the elite and the masses – of course we then hasten to take our place amongst the elite. I find that there are things in the music of the lower level that are extremely interesting, especially when we consider it as a cultural phenomenon. Dismissing it or criticizing it from the elitist point of view of art music is just too easy and leads nowhere. The

popular music, as a kind of denaturized folk music, is something that demands attention and some explanation of its worse aspects. Only then can we find a way out of the cultural problems of today. Many of the things that happen are sheer tragedy – good folk music misused for commercial purposes, adding to this the debasing of ingredients from the specific African-American culture to infuse some life into the otherwise dead and dull repetition of popular formulas. But there are also things that within their own field are quite good – popular music too can be good, or to put it more strongly, if we want to have a healthy culture, good music must be popular – as it was e.g. in the seventeenth and the eighteenth centuries. Popular should not stand for vulgarity but for that which appeals to many. Again we must keep in mind the problems I raised in my lecture on the cultural situation.

Now to address some criticisms: *a) It is all shallow and musically irrelevant.* I underlined the fact that many of the gospel songs as produced today are commercial and shallow, even if sometimes technically quite good. This is part of the tragedy just mentioned, here with the specific overtone that good Christian music is sometimes perverted by the pressure put on the best groups to commercialize their music and become in that way acceptable even to white society. We must have compassion on these poor human beings who, amidst all the stress of living in the USA today have to face this assault on their life of faith as well. For many of them it is all simply too much. Yet we must note that also much good is produced – some of which I demonstrated with my tape. We must encourage that which is good and not kick at those who in faith try to keep up their standards. If the theological content of their songs is often poor, if their Christianity is weak (though not liberal) we must have compassion. And we must try to find ways of helping. The church situation is nowhere very good, and American white Protestant Christianity also does not offer us a sight of a healthy, strong, creative, intellectual and deep spirituality – the white hymns and spirituals of our days are often even shallower and musically thinner, adding sentimentality that is happily almost always absent from the black folk music.

b) It is rhythmical. Yes. And happily so. I said in my lecture on the cultural situation that often in modern music one has the impression that the music is made to sound quite 'cultural', in the sense of being elitist and far from the popular mass productions. That is one of the reasons, I guess, why rhythm is often avoided, or if there is any it is as far away from simple

popular rhythm as possible. I feel this not only as culturally false or hypocritical but also poor. There is nothing wrong with rhythm. The music of Bach and others also has rhythm in the basso continuo. If this rhythm is offbeat it does not mean that it is per se bad – I shall come back to the discussion on eternal laws in music later. That it asks for an abandonment, a lowering of our critical standards, for a slackened responsibility, I cannot see. I have the feeling that in that way we start from the standard that people ought to be self-encompassed, highly self-conscious, and remain individually closed within themselves. This is not a Christian virtue but a humanistic one. Does not the English say that a melody 'catches' you, and is it not Christian to 'give yourself' in love to something or someone? So if the rhythm really overtakes you, that is not bad as such. Just as in the case when a melody catches you or you give yourself to something, it does not mean that you have lost control over yourself to the point that you are not longer responsible for your deeds.

c) It is sensuous or even erotic by nature. If it is fully human it has to have an emotional and a sensuous element. Otherwise we have to look for the ideal in the completely 'spiritual' – in the sense of 'out-of-this-world' – music of the late Middle Ages. That also did away with any hint of rhythm.[590] (In talking about rhythm we do not mean 'melody-rhythm' but always explicitly played rhythm.) Of course much of the modern commercial music has an erotic overtone, as an emphasis on sex is quite typical of our age. And of course some of this is to be found in the rhythms of rock-and-roll and such. But it can also be found in music with a much less strong beat, as e.g. in the mood music by orchestras like Mantovani's, which often produce music that is sensuous to the extreme.

d) It is simple. David, you said you could write the music down almost immediately. I hope you can. Many musicologistst have said that African-American music almost totally defies any notation. Of course the main lines are quite easy and can be notated, but just what gives this music its own flavour is not so easy to grasp in notation. But whether or not it is possible to write it down does not make the music any the better or the worse for it. Simplicity is an artistic virtue if it is meaningful. If you meant to say that it is too simple, I would refer you to what I already said about the mass vs. elite dilemma, and urge you not to fall in this trap.

e) I personally have the feeling that we must try to search for the wheat among the tares, a typical cultural activity that has to be done in any historical period. What we now know as classical in music

was found in this way. Sometimes the selection was too severe and significant music was ignored too long – as new studies in seventeenth- and eighteenth-century music has shown. But we as contemporaries must begin this task and really must throw out – after careful listening – what is no good. My estimate is that in gospel songs that amounts to 80 per cent or more; adding that in white spiritual singing today it amounts to an even higher percentage. But I must also add that what is left is something of a living folk art, a living, creative Christian cultural activity, and as such worthwhile. If that would be crushed completely so that nothing of real worth would remain, how great the tragedy would be. Really. Our time is short if we want to do something as Christians in this world in the fields of artistic or cultural activity.

3. It seemed strange to me that you said all music could be analysed, and that if the ingredients were the same the music would be the same – and vice versa. You meant to say that all music is open to scientific analysis, and that if someone said that there are things not to be caught in that analysis it means that there are mystical elements in the arts. I feel that here again we fall in the wrong cultural break, typical of our times, between scientific and mystical, or irrational.

I would answer that if there are elements in music that defy scientific analysis it does not mean that they are mystical or irrational and beyond human apprehension. That we can talk about these things means that they are human and real. Maybe it is precisely because they are human that they cannot be analysed to the very end. I think here of the differences between the performances of the same piece of music by different musicians. I think also of the difference between Bach's music and the interpretation it by the Swingle Singers. Though the latter do not – or almost not – alter the written score, it is yet obvious that their music is quite modern, and completely not in the spirit of Bach. Not because they sing an instrumental piece – Bach might have approved of that – but because they bring a completely different content into their music. We can talk about it even when the written score does not tell us much about this.

On the other hand, if similarities exist between Bach and e.g. the Spirit of Memphis Quartet, this cannot be done away with by mentioning the fact that they use different harmonies and so on. You said that if the *polyphony* was an argument in favour of my thesis then I had to realize that polyphony has existed in many different times in history, so that it does not mean anything. But here again we have to realize that there *are* things

like meaning, content, expression. Polyphony in the late Middle Ages (Dufay, e.g.) is quite different from the polyphony of Bach, and the only music of later date that is akin to Bach's is that of the King Oliver band of 1923 (and the rest of genuine New Orleans jazz) and some of the performances of the Spirit of Memphis Quartet – the quality of whose music only a quite prejudiced person can deny.

You mentioned that there have been experiments to investigate the psychological influence of *rhythm* on people's behaviour. And that these confirmed what you believe. Now I do not regard these experiments very highly. Because even if they did show that rhythm had some influence on human beings, that result still needs to be interpreted but with the interpretation, value judgments will come in and these will be conditioned by the cultural vision of the one conducting the research. And besides, if some rhythms are proved to take hold of people, I guess the question to ask then is in what sense this happens? To what end? It all depends on what a person does with it, how he or she uses these realities in a given situation. We all know the positive effect of marches (brass band music) on people parading. There is nothing wrong with that, I feel. But it can be used in the wrong way, e.g. in the religious pagan services in Africa in which gods are called in and trances are sought.

4. Much of all this also bears on the specific racial issues in the USA. Can the gospel songs ever be used in our church services? I feel no, in the first place because we cannot naturally sing or perform that way. It would be hard work for us to imitate the African-Americans here. So what is natural to them – a culture of their own, at least as far as music is concerned – is alien to us. Also, I feel that for many people – wrongly or rightly – there are many connotations that make it impossible to use even the good or best kinds of gospel songs. In fact, not only are these songs not to be used for church services but even outside of that they seem to defy imitation by white people – who, by the way, almost never tried to do so.

But gospel songs do seem to me to be positive – referring only to the best examples – in the fact that they represent a truly folk-type, popular (in the good sense of the word), simple and yet not dull or cheap, creative music that shows at least that creative Christian activity can exist and that a call for a new culture that breaks through the divisions between the elite and the masses, between mystical irrationality and scientific technocracy, is not completely utopian.

Much more can be said. I hope to have been clear. I have not carefully constructed my arguments here but simply responded to some of your questions.

Dr H.R. Rookmaaker

Part III

MISCELLANEA

Miscellaneous Articles

• The International Council of Christian Churches (ICCC)[591]

The questions the Revd Vogel posed [in connection with the recent congress of the International Council of Christian Churches] in the last issue of the 'Church Messenger' (*Kerkbode*) certainly delineate very important matters of conscience. Indeed, it was precisely at that congress, where I had the privilege of being present for several days, through both the entire atmosphere in which the congress was held – which was good – and the contributions of various representatives of the Reformed Churches in the Netherlands, that I was strengthened greatly in my opinion that cooperation between us[592] and the Reformed Churches in a congress like this is absolutely impossible.

That the Reformed Churches were represented at this congress thus sometimes caused discord in the otherwise so gladdening whole. Yet I believe we may not judge the organizers of the congress too harshly for this. For what was the situation? Last year the American Council of Christian Churches (ACCC) called upon Bible-believing churches around the entire world to hold a congress to establish an International Council. Since the various churches would be able to decide to join it or not only after it was established, this congress was a congress of representatives of the various churches. Except for the representatives of churches affiliated with the American Council of Christian Churches, others were there just as advisers or observers without a right to vote.

Now, what churches could send representatives? All the churches which were not members of the World Council of Churches (WCC) and which were faithful to the Bible. Faithful to the Bible means churches where it is confessed that the Bible is God's word and the rule of faith and practice and where other opinions about that are not tolerated. The organizers, inasmuch as they were not church judges, could implement these conditions only formally. It was not their task to judge whether the Reformed Churches claimed correctly to be a denomination faithful to the Bible. Thus it was possible for the Reformed Churches to be represented.

The speakers were invited in their personal capacity and not as members of a church. The intention was to invite only persons whose personal insights could be called faithful to the Bible. Thus people thought they could invite Prof. K. Dijk. Without judging the person I regard this however as having been wrong, given the ecclesiastical situation here in this country. Yet let us not condemn the Council or the congress just on the basis of that!

As matters now stand the Reformed Churches cannot, even from a purely formal standpoint, join the International Council of Christian Churches (ICCC), since they are members of the Missionary Council, a part of the International Missionary Council (IMC), a daughter organization of the World Council (WCC). Moreover, it is clear to me from conversations with various leading American representatives that they are well aware of various issues and often have a very keen feeling for how matters stand. Thus they regard the Revd Overduyn's presentation on cooperating with 'modernists' as a highly questionable symptom, especially since the Reformed Churches tolerate it.

These Americans experienced personally not so very long ago what a great danger this sort of toleration is for the churches; they therefore regard this as absolutely inadmissible. And people say the same thing in connection with the attitude of various leading personalities towards the movies. However that may be, people can be sure that should the Reformed Churches apply for membership – which remains to be seen – and even if they were to have withdrawn from the Missionary Council, people will discuss and investigate these things seriously. Finally, let us not be led in our attitude by what the Reformed Churches do. We know that we belong to the ICCC and they do not, so it is also up to us to act first, which will not be difficult since our synod meets later this year. And if we are a member, then we will also have a full voice in any discussion that may arise about admitting them to membership or not, should the occasion ever present itself. Therefore we can, as I see it, certainly hold membership, in obedience to what Christ meant when he said: 'That they all may be one' (John 17:21).

• The present apostasy[593]

If we research the meaning of the word 'apostasy' in the Scriptures, then we will find that the word is used to denote apostasy from God by people who know him. The word apostasy is not used in connection with the heathen. It is always an act of falling away from God by a person or, and that is most often the case, by groups of persons who belong to God's people, the people of the covenant. Apostasy pertains in the Old Testament to Israel and the Israelites, in the new dispensation to the church and the Christians.

What then is that apostasy of which the Scriptures speak? Today when someone stands up to speak about apostasy, people rob the word of its power by saying: 'Oh well, sin still clings to all Christians. Are you so arrogant as to think that you are dead to the law of sin that works in your members? And just why, and from what, should we convert ourselves? Is not all human work sinful through and through? After all, God is only interested in whether we have good intentions.' Such

objections were already familiar to the prophets,[594] although the view that only our intentions are important and that real deeds are secondary probably arose under the influence of humanistic subjectivism. In this mindset there is no longer a place for 'apostasy', because all people are of very good intention, are they not? And if it is pointed out that in the Scriptures there is often mention of 'apostasy' and that it is also predicted that there will be apostasy in the new dispensation,[595] then people say, 'So you want to impute to your opponents all those acts and all that hypocrisy and all that deceit of which the prophets spoke?' I believe we all imagine far too frequently that those against whom the prophets spoke were notorious gangsters, hardened criminals, sensational murderers and profiteers or hypocritical actors. Were the people of Jerusalem in exile, the Pharisees and scholars of the Scriptures, not nice, likeable people whose intentions were actually really good? Did Paul himself not say of the Pharisees that they had a zeal for God?

It is striking that the Scriptures virtually never speak of the apostasy of a single person. From this too it is apparent that we have been strongly influenced in our views by various individualistic notions. The matter in God's word is seldom if ever about independent persons but always about communities, in which the individual is placed who in that case is also responsible, not only towards God but also towards his or her neighbour. A person's sin is not only individual sin against God but is all the more sin because by it a neighbour is led into temptation or can be kept from conversion. No matter how much particular persons can be guilty of unfaithfulness, and no matter how much they will have to account for their own deeds personally before God, apostasy is still the sin of a group, the sin of a community. Yet because everyone is required to search and keep the Scriptures, the law of the Lord, and because everyone is obligated to admonish one's neighbour if need be, no one can therefore ever 'unload' his or her guilt onto an impersonal group – the church or the community.

Yet we have still not answered the question of what apostasy is. It is not apostasy when the people of the covenant sin by going astray. Even the 'seven thousand' are no saints. For such situations there is reconciliation. For such situations there is the prayer, 'Forgive us our sins.'[596] It is also not apostasy when God's people fall but acknowledge their sin and confess it before the face of the Lord and call upon him for forgiveness, as Ezra did (Ezra 9) or as the leaders of the people did in Nehemiah 9. We may not even speak of apostasy when the congregation have strayed far and no longer honour God's law but after repeated admonition, chastened by the hand of the Lord, finally repent and beseech God to look upon them graciously once again. Then we may not only not speak of apostasy but we must rejoice that there has been a return to the Lord, that there can be reformation again. No, in all these

cases there is no apostasy. There is apostasy only when the people will not listen to the teaching and the admonition of the ones God sends them,[597] when they continue to walk in their own way, when they harden in their sin, when they will no longer see the hand of the Lord (Isaiah 42:25), yes, when they go so far as to deny that they are living in sin and believe themselves to be justified before God because they are, after all, doing their best. Did the Pharisees have no zeal for God, did those to whom Micah 6 speaks not believe they were doing their utmost to serve the Lord? Did the Jews not say: 'We are wise and the law of the Lord is with us' (Jeremiah 8:8)?

Thus we must distinguish sharply between sins that are still being committed by those who live in the covenant, to their great sorrow, and the sin of apostasy. The people of the covenant know very well that by themselves they have nothing good to bring before the Lord: discovering themselves in sin through the reading of God's word and his commandments puts an end to all trust in themselves. They are sinful, and precisely for that reason they pray to God again and again for forgiveness, beseech him again and again to look upon them graciously and strengthen them in their fight against sin. But we may not put these sins on the same level as the great sin of covenant breaking. That is manifest primarily in this, that the sanctification and walking according to his word which God demands of his people, which was the very reason he has bought and chosen them, are reduced to lucre with which Christians want to buy themselves off. In that case people become self-righteous (Romans 10:3), they start to trust in their own righteousness and to decide for themselves what God requires of them,[598] and to put their trust in their wonderful Christian organizations. 'My people have committed two sins: they have forsaken me, the spring of living water, and have dug their own cisterns, broken cisterns that cannot hold water' (Jeremiah 2:13). People try to put the stamp of 'God's will' on their own ways: after all, they are acting and working according to principles based on the Scriptures. These principles, which were originally a personal vision of one or more leaders, become a 'shared opinion', then an unwritten dogma, and finally are proclaimed with a 'thus says the Lord'. Christian people begin to put their trust in such organizations and principles: when these principles are applied, they are doing what God requires, are they not? And surely God then cannot withhold his blessing? The blessing follows automatically, as it were, from their doing and working – often performed in a cramped attitude of obedience – since God surely must be 'satisfied' with that! Life is then lived according to 'scriptural' theories – which are, however, nothing other than stones for bread. And if people notice that, then they take it to be a shortcoming in the theories and set about studying and discussing them even harder. But in the process the wisdom of God, in which alone we may glory,[599] recedes further and further away and the salt becomes

increasingly saltless. Finally, as all this unfolds – and as a result of it – they are no longer able to see their own sins and straying. Even praying for forgiveness of sins then degenerates into a curse, for even such praying becomes nothing other than an attempt to justify themselves, since people no longer know concretely what sin they have committed. God will then no longer hear their prayer,[600] for it is not enough to say 'Lord, Lord'(Matthew 7:21). And God will also withhold his Holy Spirit from them; for while they may ask for him with their lips, they in fact believe they can cope by themselves – after all, they are applying such good principles that everything must go well. Many people have pinned their expectations on principles and organizations – which in themselves may be good – while they no longer really trust in the Lord. And if something goes wrong, if everything that people regard so highly is threatened, then they do not call upon him, who can give deliverance, but seek help from earthly powers. In this too they believe they must do it themselves, and they undertake deft diplomacy and the like in order to get help from the world. Did not Israel thus call upon the Egyptians for help against Assyria? Read what the Scriptures have to say about that.[601]

There are also stages in apostasy, and there is a development. Do not suppose that apostasy always goes hand in hand with heresy, by which we mean a departure from the norm of belief given in Scripture. No, it begins precisely with that, with the anxious attempt to avoid every heresy. It is precisely in their own purity of doctrine that Christians want to present themselves as righteous before God. We might call this the apostate stance of the Pharisees. They definitely uphold the Law and the Prophets – with their mouths – but because they do not truly trust the Lord, their wisdom will perish and they will understand the Scriptures less and less.[602] Does Christ not say they even fail to listen to the prophets (Luke 16:31)? Because people walk in their own ways – even if their doing so is covered with a scriptural 'sauce' – they have actually crossed the line of the antithesis and stand on the side of the world, though they often oppose the antithesis sharply themselves. Yet there is no real antithesis between their ideas and those of the world, and so it comes about that they, or the generation following, begin to see their own belief as relative, as just one possibility amongst many others, even if it is then held to be the best possibility. In this way people become Sadducees, or even Herodians. In the former case they rob Scripture, or parts of it, of its authority, intent upon deciding for themselves what God says; and in the latter case they set out to compromise with the world. Is one simply to abandon the beautiful fruits of culture, is one not meant to enjoy with everyone else all the goodness and beauty that the world has brought forth, covenant people then ask.

During periods when apostasy rules amongst the people of the covenant in this way, people no longer understand what the Lord requires of them. They no longer truly know the Lord. They may still

uphold the theory that God will come with his judgments, but then not upon them. In such times there is an abundance of false prophecy: 'The Lord's Temple is here,' so how can anything happen to us! People do not discern God's works and judgments any more but say: 'Let us be careful about thinking God will come with his judgments, since we have been wrong so often' (Ezekiel 12:27–28). 'So he poured out on them his burning anger . . . yet they did not understand; it consumed them, but they did not take it to heart' (Isaiah 42:25). At such times anyone who preaches conversion is viewed as a fool, a dangerous person, for such a person proclaims God's judgments and, after all, 'which of them has stood in the council of the LORD to see or to hear his word?' (Jeremiah 23:18–22).

In Scripture the leaders are always held responsible for such an attitude, for such talk. They are the ones who through their teaching and false prophecy put the people onto paths that lead them astray. One can read about it throughout the entire Old Testament and in particular in the books of the major prophets. That is Christ's judgment too when he speaks of the blind leading the blind. He says to them: 'You blind guides! You strain out a gnat but swallow a camel' [Matthew 23:24]. I think here of the Roman Catholic Church in the Middle Ages which persecuted Waldensians for advocating a more Christian walk of life while allowing teachers who proclaimed all kinds of unscriptural theories to carry on undisturbed. Christ says to them that they persecuted the prophets and wise men and scribes that God had sent to them (Matthew 23:34); everyone knows a legion of examples of such persecutions. Yes, God has also revealed to us that in the last days his faithful witnesses will be killed by Jerusalem, i.e. the false, apostate church, a church that acts just like the synagogue did in the days of Christ.[603] The world has persecuted the church, the people of the covenant, many times for many reasons – heathen religions, political advantage, science, etc. – as in the days, for example, of the Roman Empire, but much more often we see that the true prophets and wise men, the true believers, are persecuted by the apostate church, by unfaithful children of the covenant. This is 'all the righteous blood that has been shed on earth, from the blood of righteous Abel to the blood of Zechariah . . . whom you murdered between the temple and the altar' (Matthew 23:35).

Judgment

In Old Testament times God always acted concretely – through world events, through natural disasters – with his judgments upon his apostate people. It would be incorrect to think that in the new dispensation that would no longer be so. If God – or rather Christ, to whom all power now is given – still gives his blessing today, then he still also executes judgment. Just remember the way he speaks to the seven churches in Asia

Minor, in the letter to Ephesus or to Pergamum (Revelation 2:1–7; 12–17). And the history of our own country may also convince us of this.[604] Yes, even today Christ exercises his kingship in very concrete 'everyday' events, including the less pleasant ones. Just read what he says about the last days in Matthew 24 or read how Paul talks about that time and it will be clear to us how 'amazingly' concretely God still intervenes in world history and in human lives today. These judgments are not just general but always have to do – as the Scriptures teach us – with an apostate people, with the apostate church, the Babylon of Revelation or, after he has used them to carry out his judgments, with the world powers.[605]

Every one of us, just like every believer in every age, has to discern who among all those claiming to be doing so is actually speaking the word of the Lord. The Jews in their days had to discern who was speaking the truth: though they could not tell from outward appearances whether it was Hananiah or Jeremiah who was the true prophet, yet God demanded that they should listen to the one who spoke according to God's word, the one who proclaimed God's word. The people were by no means held to be guiltless, although – or rather precisely because – they claimed to be so (Jeremiah 2:35). And we, yes we too, must test all the words we read and hear every day and we ought to know who is truly speaking as God requires. And we can certainly do that. Does not Christ himself say that we are greater than the people of the Old Testament (Luke 7:28)? Shall we not be able to distinguish the truth if he is with us by his Spirit (1 Corinthians 2:12–16)? And if we say we cannot know it, are we not cursing God's Spirit (Matthew 12:32)?

And how are things today? That is something each person must decide for him or herself. Yet we need to test the spirits, to find out whether they are of God. For it applies to us too that we are not to have fellowship with people who call themselves 'Christians' but . . . (1 Corinthians 5:11; John 17); and it applies to us too that we are commanded to leave Babylon and commit no adultery with the harlot, the great apostate church, as it is described for us in Revelation.[606] We are to 'turn away' from those 'having a form of godliness, but denying the power of it'.[607] We must watch out for wolves in sheep's clothing. We need to keep this in mind when talking about ecumenical cooperation with the World Council.[608] Furthermore, we need to discern who is right: those who say there is apostasy – in whatever measure and to whatever degree that may be – manifesting itself amongst the Reformed (*Gereformeerd*) people, or those who say everything is as it should be. We must know whether there are Pharisees or Sadducees amongst us. We must judge who is right: those who say that God rules the world with his judgments, through wars, rumours of wars, famines, unfavourable weather conditions, economic exigency; or those who say that Christ is preparing to return at the head of his armies to execute judgment on an

apostate Christianity, by means, for example, of Russia (cf. Jeremiah 51: 7, 20); those who say it will be with us as in Ezekiel 7: 24–27 ['When terror comes, they will seek peace, but there will be none']; or those who say this is 'only' a judgment on the world in general and that it will therefore not affect us, or those who say that there is not even any judgment at all. We ought to know what the judgment of the Holy Spirit is on the world today, on the different churches today, so that we can understand what the Lord is doing. Yes, not only must we pay attention to it, we must strive ourselves for the gift of prophecy, a gift of the Spirit, so that we may thereby speak to people edifying, admonishing and encouraging words (1 Corinthians 14:1–3). For if we can indeed approach God with boldness, if we know that we do not carry the sign of the Beast, if we can say that we have endured to the end, that we are among the seven thousand who have not bowed the knee to the Beast, then we know too that we will witness the destruction of the instrument with which God executed his judgment, and that in all judgments we have nothing to fear since he is with us, even though we too at times may eat 'the bread of adversity' (Isaiah 30:20), and that the ruler of this world can only kill the body (Luke 12:4). But woe unto us if we neglect to warn when that is not the case, for then we will be held responsible (Ezekiel 3:18, Luke 12:48).

There is only one way in which we can fulfil the task that has been given to us. That is by reading the Scriptures, and reading them again, and again, and by opening our hearts to the teaching and warning that God gives us there. Let us above all not see the Scriptures as some kind of theological manual or codex from which we can infer principles. Naturally, theology needs the book, and a Christian science will not be able to get along without this book and the light it sheds on the creation. But let us in the first place, through and with our searching of the Scriptures, learn to understand God's works, let us see again that he is not a God enthroned far away in heaven who bothers with us only after we are dead in order to judge us, but that he is still the same God who rewards those who walk in his ways and lets his judgments – very concretely, on earth, here and now – fall on those who fall away from him and do not place their heart and confidence in him (Deuteronomy 28, Leviticus 26). Let us fear the Lord, remember his name, and listen to his word, for then he promises us that we will be able to see the difference between the righteous and the godless, between those who serve God and those who do not serve him (Malachi 3:18). And so we shall know what the Spirit judges about our time, and what God is doing . . . whereby we shall come to understand clearly what we must do, what he requires of us and what we ought to leave undone.

• We and the kingdom of God[609]

It has already been more than five years since the Reformed Churches (Liberated) came into existence. As the years have passed, we have learned to see that the 'liberation' was not the work of men but that the Lord himself did it, that he led us out.

How have prophets and teachers in our churches not struggled for reformation in the years since round about 1920! And how has their work not been thwarted and made more difficult time and again by open resistance or even by simple slackness! People could not get started with the real work of reformation because they had to expend all their strength on making reformation possible in the first place. For how is a reformation possible if hearts are not on fire for the cause of the Lord and if people are bogged down in all kinds of 'current doctrines' and do not even want to examine these critically?

And then, at a time when the Lord with his judgments was visiting Europe and the Netherlands, then, in 1944, a 'dispute' broke out in the churches. Then the non-reformational group proceeded to 'extend' the confession along the lines of the insights they had been preaching for years and to throw out the faithful servants of the Lord.

Looking back on the 'disputes' and conflicts of those days, we can scarcely comprehend the how and the why. Why did the Synod act as it did, why did people have no patience, why did they push through such daft ideas so dictatorially and quickly – ideas so daft that many who stayed behind then no longer understand them today and in fact ignore them – and push them through so far that people even had to throw out their own brothers with grave accusations? Yes, why? How did all this come about?

Now, with the first years of confusion and obscurity long behind us, we can at last see why: the Lord our God himself was in it, verifying that he keeps, gathers and protects his church. Now we begin to see what it all meant, now that we have regained the joy once again, and again feel ourselves to be one, united together in our churches as people who want to get to work, who want to serve the Lord and be liberated from all sin and error.

There is even more that we can see better now. Namely this, that we still have a long way to go, that we have barely taken the first steps in the right direction. The Lord our God shows us our sins. He opens our eyes so that we discover and see ever more sharply how far we fall short . . . we discover so many shortcomings in ourselves that every trace of vain self-glory, every notion of 'being well on the way and making good progress' dies on our lips and we see once again that we are safe only when we trust in our Lord and seek our success in our Father in the covenant, who will not abandon us, who has numbered the hairs on our head, and who watches over us. We see that we ourselves, our principles, our activities are stained with sin, that in all this we have put our

confidence in broken vessels and not honoured and served the Lord our God as he asked us to do.

The Lord our God himself liberated us from all manner of ties and attachments, from many more than only the so-called 'Fourth Formula'. We were liberated from our concern for our organizations, our so-called 'reformational' activities, for our great name in the world and for our posts of honour according to the standards of the world. We learned to listen to the word of our Saviour where he says: 'Therefore take no thought, saying, What shall we eat? Or, What shall we drink?' and all the other things that the world worries about, 'But seek first the kingdom of God . . . and all these things shall be added unto you.'

Seek the kingdom of God, what is that? It is being obedient to him, knowing that we are his slaves, purchased with his precious blood, slaves who at most do only their duty, new people who die more and more to the 'old man'. Seeking his kingdom is being faithful, persevering to the end, not loving our lives but loving our God with all our heart and mind and all our understanding, and loving our neighbour. Seeking his kingdom is fulfilling our calling as children of the covenant according to the rules our Saviour gave us for life under the New Testament covenant, such as we find, for example, in the Sermon on the Mount, in Matthew 5 to 7. For seeking the kingdom of God is nothing other than living as good subjects of the King should live, separated from all rebels and apostates who are revolutionaries and insurrectionists within his kingdom.

For his kingdom has already come! Not in principle, as a kingdom still to be won, no, for now that kingdom is already here! It was already here in AD 33. For when Pilate asked the Lord Jesus whether he was the King of the Jews, he answered in the affirmative, although he by no means meant that all the Jews were his followers – the situation he was in made that very clear. He does not need to confirm his majesty and his kingship with many soldiers because he already possesses the power, although not in the manner of an oriental despot or western sovereign. His kingship is not of this world, so he says himself, but it is positively over the world, as may be plain from his answer to Pilate. For he claims that Pilate would have had no power over him were it not given from above.

No, the kingship is in the possession of the Lord Christ Jesus, who sits at the right hand of God, not in principle but in promise, let us say as a crown prince. For in 1 Corinthians 15:24–26 we read that he will deliver up his kingdom to God the Father when he has put down all his enemies. If there is then no terrain of which the Lord has not said 'mine,' as Kuyper phrased it, then that ought not to be understood as the triumphal cry of a conqueror or as an ultimatum or as a wish that will of course certainly be fulfilled, but as nothing other than concrete reality. And if people are believers they will call his rule sweet. His yoke is easy and his burden is light, while unbelievers will blaspheme him who rules the heathen with a rod of iron (Revelation 12:5).

Yes, our Lord Jesus Christ rules the nations with a rod of iron but does not yet destroy them. He will do that in his own time. Then he will judge his rebellious subjects and pronounce eternal punishment upon them. That is why his faithful followers must still live amidst those who hate him. They wait, for they know that the victory is sure. They know that one day all the injustice that has been done to them will be judged and that they will then reign with him as kings [and queens] in the New Jerusalem that the Lord their God has prepared for them.

Life in the wilderness

Believers need not fear their time as strangers in exile, for the Lord cares for his people and protects them. He sustains his people out of the sight of the dragon, in a place prepared by God in the wilderness (Revelation 12). The wilderness, the place that lies outside the 'world,' outside the 'culture zones' of this world, is the place where the Lord keeps his people. He gives them no task at all to conquer this 'cultural world'; he says only to be patient and persevere, to keep their lights burning and to do what he has clearly and plainly instructed them in his word. For it is according to that word that he will judge (John 12:48). The wilderness is the place the Lord has designated for us as a refuge and we must not try to go and live in the 'city', in the abode of the rebellious. For if we should seriously endeavour to do so, we would have to compromise in one way or another with the revolutionary party[610] and so deny our Lord. Only by being unfaithful to the King of kings and Lord of lords can those who call themselves Christians be great in this world and receive honour and renown in it. The Lord and Mammon cannot be served at the same time. Let us therefore know our place in this world, where we are not people of the 'city' but people of the 'wilderness' (cf. 1 Corinthians 5: 9–13).

In the wilderness, and that is inherent in the concept, there is no abundance, no excess and blossoming culture. There one finds no cinemas and theatres and dance halls and all the other things that make a city a city. Yet we may be sure that we will be fed there with the bread of heaven, that we shall live there by the Word of God, and so also be bathed in the fountains of the water of Life. We shall lack nothing, just as the children of Israel lacked nothing in the wilderness. For our Lord knows very well what we need and he will take care of us – see Deuteronomy 8!

So if someone who is truly of the covenant, who is in the world but not of the world, as a person of the wilderness enters the 'city of the world' where the spirit of this century holds sway, he or she will feel like an outsider. Covenant people will not be at ease in the 'city' and in particular in the places of entertainment and everywhere else where worldlings have arranged things to suit their own wisdom. They will feel like country bumpkins in the big metropolis. And the worldlings will

stare at them and perhaps mock them and even curse them for being stiff and 'unworldly'. For the creation that was made for the faithful children of God is sometimes so corrupted that the faithful and real children of the Creator can make no use of it. And someday a little sign may go up posting all such places: 'No Admittance to those who worship the Lord' (Revelation 13:17) – yes, such signs are sometimes 'there already and much is taboo and closed for us even now.

Thus we are not meant to turn from 'wilderness people' into 'city people'. We must not try to adapt or get used to it. O, let us guard against ever getting used to it and growing to feel at home there. After all, we are strangers in this world. But we also do not have to conquer this world, for the Lord has retained judgment in his own hand (Romans 12:19) and it is therefore not necessary to set out like guerrillas to unleash a guerrilla war to conquer all these terrains for our King. For he rules over all, even with a rod of iron. Our only task is to endure, to not yield to temptation, and to serve our King and Lord in faithfulness – if we do that we necessarily will find ourselves in the wilderness.

Our only task, so I said. For our Lord has not assigned us heavy and difficult tasks, tasks so difficult that we should virtually collapse beneath them. 'My yoke is easy and my burden is light,' he said. For what is more ordinary and normal and pleasant than to walk in his ways, according to his commandments and his creation ordinances? 'This is love for God: to obey his commands. And his commands are not burdensome' (1 John 5:3). For isn't the ploughing of a piece of ground, the tending of cattle as a simple fulfilment of our duty better than the struggle of the revolution with all its attendant dangers, shifting chances and uncertain ends? God gave us our place. He promised to protect and keep us. And he asks of us only this: to listen to him and follow him according to the ways that he has laid out for us as our good Shepherd and Teacher.

If we will learn to see our place in this way then we will be freed from many contrived and difficult and tiring activities that have been laid upon us not by the Lord but by ourselves in our own wisdom. Especially in times like these, when God has sent a delusion over the world, when the Devil with his two henchmen, the beasts of Revelation 12 and 13, is preparing to establish his kingdom, in times like these when apostasy and unfaithfulness are so widely rampant, when we see how true it is that as disrespect for the law increases the love of most grows cold (Matthew 24:12), in such times it can be a tremendous comfort to us that the Lord does not demand great things of us but that he has directed us to a place in the wilderness. In times like these, when the Lord passes through the earth with his judgments and the prophecies of Revelation are fulfilled, we turn to the word once spoken to Baruch in Jeremiah 45:5: 'Should you then seek great things for yourself? Seek them not. For I will bring disaster upon all people, declares the LORD; but wherever you go I will let you escape with your life.' Obedience is what God desires, not self-

willed sacrifices (Micah 6:1–8). But if we are obedient, he will be near us and keep us (Romans 8:31–39). He gave us many wonderful comforts in his word, just read the Sermon on the Mount about those who are blessed, and just read about fearing not because the very hairs of our head are all numbered.

• Coming to conversion – some comments[611]

Not so long ago I was shown a letter written by a recently converted young man to his father. This intelligent student became a believer during a visit of several weeks to Dr Schaeffer at Huémoz in Switzerland, where he made use of the facilities at Farel House, a study centre associated with Schaeffer's work. I would like to share this letter with you. The young man is an American, but what he writes and his reaction are not at all typically American. It could just as well have been written by a Dutch student, for the problems of the culture around us are the same, with slight adjustments, wherever one looks in the Western world. And when the angels in heaven rejoice over one lost sheep that found the Way and the Truth and the Life, we will rejoice with them. If only we do not suppose that that can just happen to foreigners and that we as Dutch people are so different.

On the contrary, one does not need to look very far to find the kindred spirits of this young man before his conversion. Perhaps we will have to look somewhat longer to find someone like him after his conversion. But let us first have a look at the letter:

> I have been here for two weeks now; I came with the idea that it would be a waste of my precious travel time. I was critical of everyone and regarded the people here as a lost cause, but since I had promised to come, I decided to make a good impression and not be impolite or sarcastic.

> I was shown my room and the next day began some studies by listening to Mr Schaeffer's taped lectures. I was busy with this for about a week and a half; in addition I read things connected with these studies and of course engaged in conversation with the people here.

> One of the young people with whom I spoke, also a student, showed that if one believes in the supernatural at all – in spirits, ghosts, soothsaying, levitation, apparitions – as I did, since I had once been involved with these things, then one cannot deny the existence of God without being inconsistent or dumb.

> In the studies to which I was listening I began to find the answers to questions about creation, evolution, law, sin, primitive nations, war, money, godlessness and so forth. I discovered that there are good answers to these questions and

not just emotional or superstitious ones. In essence I discovered that Christianity could hold its own in the face of all these contemporary questions, while I had always assumed that Christianity was just good for emotional people or nut cases. Believe me when I say that I was surprised – and still am surprised. Where now was all that childish drivel that I had always associated with Christianity?

I was free to ask questions and I did so. Are Christians not bound to dogmatic laws and therefore not free? The answer to this is no, the principle of free will continues to exist for everyone personally. Ethical rules are given to a Christian that he must keep and it is his personal responsibility to do so – there is perfectly free will controlled by the power of the individual. Naturally he is bound to ordinary social laws; these are the moral laws, which he does his best to obey.

Just as I tried to find a direction in life before coming here, so the Christians have found a way, which they are convinced is good and which they want to follow as far as possible. The difference of course is that I have not been able to find a satisfying solution while they have a brilliantly clear life and world view.

Are Christians then not all half-baked and boring? I have discovered here that this is not the case. It takes a great deal of courage to go counter to your family, your upbringing or society and to become a Christian and most cowards would not be able to do that. It also turns out that Christianity does not make people weaker. I only wish you could meet some of the people here and talk with them. You would see that there is nothing boring about them. Instead you would find people with good ideas and a readiness to take on any challenge concerning their faith and even to challenge it themselves. I even think that most non-Christians would be disconcerted to find that their knowledge is hung out to dry by these people as a lack of knowledge. I know that my arguments did not hold up when challenged by Christianity, nor have I heard that those of others held up.

I was surprised to find something here that seems to be missing in present-day America, something the history books talk about, namely conviction, and powerful conviction at that, based on knowledge and on belief in the truth of this knowledge. I and many like me felt that culture means first an attitude of not wanting to be attached to anything and second not believing in any 'answer' that would contain 'Truth'. 'Truth' was the most absurd of all words (or so I thought).

This attitude could hardly produce a forceful personality because it was self-destructive and denies the importance of the human personality. In a word, laziness was the consequence. Here I find that these people have thought

and studied a great deal to determine the truth of the Bible and then to live uprightly by it. The result is amazing to see. Both the men and the women here can tell you clearly what they believe; their deeds speak of their conviction, their behaviour speaks of strength. These people know that every one of them is important in the eyes of their Creator and in the midst of other people; they are ashamed of nothing, and yet are humble – humble because of everything God has given them. One finds here the inner desire to love other people. As is generally known, no one is perfect and these people acknowledge this. The most important thing is not that they are sometimes angry or jealous notwithstanding their earnest efforts to do good, the important thing is that they make the effort. How many non-Christians can say this?

I discovered that Christianity does not mean tasteless art, art being a field I am naturally very interested in. That there is a surfeit of tasteless and miserable art produced under the title 'Christian art' I do not deny. But it does not have to be that way. Nowhere in the Bible does it say that art has to be traditionalistic. Christian art is not tasteless, but the artists who make the art are the problem. I have practiced modern art and I value and understand the forms used. There is no reason why I could not be a Christian artist and still an artist of the present time. This is the case in all areas of life. The idea that people are Christians and therefore boring is wrong-headed.

Before coming here I thought I had armed myself fairly well with the ideas of Bertrand Russell and his book *Why I am not a Christian*. Now I think his ideas are meant sooner for people who want to read what they wish to believe than for people looking for an objective assessment of Christianity. I thought at the time that he was objective, but now that I have read something of the Bible myself, I see that he has missed the point entirely. I wonder if he has even read the Bible in the last 20 or 40 years. Perhaps he has never read it. What he says is nonsense that can be easily refuted by anyone who knows something about the Bible. I always thought that when someone was confronted with something touching his life and world view he would first try to make an intelligent evaluation of what he already had and then look at whether someone else had anything better, thereupon to accept or reject the new. I expected this of Russell, but I see now that he only expressed his prejudices in a way that those who agree with him like to hear. He has not made an objective study of Christianity nor does he support his point of view with anything concrete. He complains that Christians are emotional people, but this seems to me to be a case of the pot calling the kettle black. Therefore I have set Bertrand Russell and his childish prejudices aside.

What does this all mean? It means that I now believe something new and that I will try to live in conformity with that belief. I have not become a different Bruce, a steely fanatic. You will not see any differences in my physical

disposition, but you may notice a change in my attitude. I have accepted Christianity, and I am happy with what I have accepted, because I believe it, I know that it is true. I will soon be home to see you and I expect many discouraging objections, but I know why I have chosen this path and I will happily explain it to anyone who wants to listen and who will try to understand.[612]

That was the letter. I now want to make two comments. In the first place I believe that as Dutch Christians we have no room to pat ourselves on the back thinking that we are better than those American Christians whom Bruce so sharply criticized before learning that what he rejected about them before his conversion has actually very little to do with the gospel. American Christians sometimes are sweet, sentimental, amiable and bland. We are unfamiliar with that here in our country where Christians instead tend to be hard, brusque, unceremonious and possessed with the jarring self-confidence of a sectarian. One could sometimes wish that we would display in our lifestyle something of that hearty friendliness even though it can at times degenerate there into feckless goody-goodiness. But we too often make a far from attractive impression on our surroundings. I am not telling fairytales. The simple fact that one is a Calvinist of Reformed stripe puts some people off,[613] preventing them, for example, from joining in a Bible study group to look more closely at the issues of life. It is a fact that for many the greatest obstacle on the way to Christ is the idea that they might have to become Reformed. If there were nothing more to their attitude than hostility towards God and his revelation, then we could live with that, but there is too much with respect to which we have to admit that their observation may be right.

'Love and unity' will be the marks of my disciples, the Lord Jesus said; and honesty, hospitality, love of one's neighbour, joy and peace belong to the fruits of faith. Is it any wonder that the world asks itself whether the God of the Scriptures exists when they see so little of these fruits and it is so difficult to detect this unity and love? The world is keenly aware of it when Christians try to approach them in an almost worldly fashion by striving for external uniformity, by simply hiding differences. No, if we desire to become once again 'readable epistles of Christ' [cf. 2 Corinthians 3:2] then we shall have to return to a biblical lifestyle, seeking our power not in ourselves and our cleverness and politics but in Christ, living out of the power of the Resurrection (Romans 6).

The second thing I wanted to say (and perhaps this is more closely connected with the first comment than immediately apparent) is that it saddens us that we can find so few people like Bruce in our country and in our circle, people who came to believe because through their contact with Christians they learned to find the gospel. One could fill volumes with sad tales about how our [Christian] people simply ignore their neighbour, the worldling in need, without a resuscitating or encouraging

word. One sometimes even wonders if they themselves indeed do have a living faith from which they could witness and help another to find the way. Do we sometimes just live by traditions and sacrosanct beliefs? Intensive contact with the unchurched through Bible study groups and discussions often marks a Reformed person as the odd one out, sometimes even places her or him under a slight whiff of suspicion.

When people have an opportunity to present the gospel, they sometimes nonchalantly let it pass. I have in mind, for example, preachers who have an opportunity at wedding services to let family members from outside the church hear the living Word. And sometimes when people have contact with someone who has just been born again or, still worse, a seeking soul, the only thing they know to talk about is all manner of Reformed idiosyncrasies, so that one cannot help but think of the passage: 'You travel over land and sea to win a single convert, and when he becomes one . . . [you make him twice as much a son of hell as you are]' (Matthew 23:15).

Let us not lull ourselves to sleep with the notion that we have our own evangelistic organizations. It is a fact that there is dreadfully little happening. The story about the person who took up a position in an evangelistic organization and was given these words by his predecessor: 'This is an easy assignment – once a week you go along to a few houses where they will not let you in and with that you are finished.' How is that possible? Perhaps the following can shed some light on it.

Recently I saw an American magazine, nicely presented, in which the following was written about our country: 'Many in the Netherlands have turned their backs on a dead, formalistic religion and live an empty, godless life. We are free to work there, but . . . we need many more workers, and especially also prayer.'

Is that not shameful? There are Americans who see our country as a mission field and who feel they have too few workers to carry out the work. I personally know of three such organizations that work here. Even in places where there are large Reformed churches.

If we want to mean something for the world around us, which will be lost if God's word does not reach it in time, then this is our programme: first we must know personally the certainty and joy of faith. Next we must know our Bible and be people who are truly alive and who are engaged with the problems of our time so that we can answer the questions. To be a Christian does not mean simply to preserve what is traditional, it means living, working, being engaged also in the problems that our age manifests in excess, forming new things, open, knowing that it is meaningful to work as servants of the living God. It means being alert to the needs of our neighbours, approaching them in love, not walking past them just because they do not join us and do not or cannot understand our idiosyncrasies. It means above all that we must pray to the Lord for wisdom, the power of the Holy Spirit, hearts aflame, and

guidance in our work, so that we may work where he sends us. May God grant that in the coming years we will encounter many Bruces in our country, for the gospel is still the only answer to all human need.

• Bible study groups[614]

I was very happy with the request to write something in *Opbouw* about holding Bible study groups, based on 'real-life' experience. Here then are a few guidelines.

There is no difference in principle between a Bible club that we organize just with people from our own church and one aimed at evangelization. We will focus here mainly on the latter, but there is only one gospel, and not one gospel for our own use and another aimed at the unchurched. Every stranger should always be welcome also at the gatherings we hold 'for ourselves'. The meetings should not be closed off and we must never be afraid that others may hear something that does not concern them. One of the fundamental laws of the gospel is 'truth', and we must never try to present ourselves as nicer than we are or hide something about ourselves on purpose. Even though it is true that for many the greatest stumbling block on the path to the church lies in the church, the churchgoers themselves, as we emphasized in an earlier article,[615] the solution is not to present a nicer face to the outside; rather, be honest and open. Blessed are those who hunger and thirst for righteousness – that is what we must show, and if a stranger knows ugly things about matters or people in our circle, then we should not try to justify them but seek with that person the causes and ways that could lead to a solution. For the rest, we must of course keep in mind what righteousness means in the Scriptures. It refers not to legalistic precision or doctrinal correctness but to mercy, purity in loving relationships, helpfulness where there is adversity, and so forth.

It should actually be the case not only that there would be many Bible study groups amongst us as centres of active study of the Scriptures in fulfilment of the office of all believers but also that after a while all these clubs would have a number of members from outside the churches who were simply invited to come along by members of the circle because it is so pleasant to investigate the gospel together, the living word of the living God.

If we set up a Bible study group to help those from outside the churches to learn about the gospel, then we must start at the beginning. And that is prayer. Not just as a formality but as a real and genuine first. Without prayer it will not work. Not a general prayer that God will make his kingdom come and make many his children but very concrete prayers for our own activities. Without prayer the strangers will not come and will not stay. Without prayer we will not have the wisdom, for we are

not preaching intellectual arguments or theological theories but the real gospel. Without prayer we will not have the strength to endure setbacks and disappointments and keep on going.

Prayer is not something one talks about but something one does. It is good to do that together. Perhaps one of the causes of all the difficulties and conflicts in our churches is to be found in our falling far short in this regard. We simply do not bring our burdens and cares together to the Lord. And this is certainly one of the causes of a great deal of fruitless work in the field of missions and evangelism. Did you notice that Paul's beautiful passage in Ephesians 6 about taking the helmet of salvation and the shield of faith leads to his asking for prayer for his work! And the apostles held prayer meetings. Why then not we? Let us pray together, laying our questions very concretely before the Lord. It is wonderful to experience how he hears us. And even before the Lord gives us work to do in answer to our prayer, we have received a blessing. By praying we learn to understand that nothing is possible without him, that we cannot bring anyone to faith, that we cannot draw anyone. We can only pass along what we have received, but the Spirit of God must give conversion, an open heart that listens and accepts.

Then when guests come to our gathering in answer to prayer, we may know that their coming is meaningful, that they did not just come because they had to come out of politeness after we twisted their arm a bit, but truly because God has already begun a work in them. 'How' is something we will experience as we go along.

Prayer is also needed in meetings when we are just 'on our own', since otherwise no blessing will flow from them and they may even lead to our growing apart rather than into unity and love, the marks of the fellowship of the children of God.

This is not pious talk but fundamental and absolutely necessary. And the prayer must not only be the prayer of the participants; the work must be borne by the prayers of the congregation, both by the office-bearer during the church service and by the members of the congregation who for whatever reason do not participate in the group. We have a small circle of people who pray for our Bible study groups and we can tell that it makes a difference in the work. Still, even more doors would open if people prayed even more (concretely) for us.

We must simply begin with a Bible study group. Do not wait for visitors – first there must be a group and then the others can be invited. Announcements in the press, invitations and the like usually do not work well. Our invitations must be extended personally to people we know. And then not insistently. Ask once, give a reminder, and for the rest wait, wait prayerfully.

So we begin with a small group, naturally at someone's home (not in an inhospitable hall somewhere). And it is okay for it to be cosy, with something extra to go with the coffee; but be careful that the

serving does not interrupt the flow of the discussion. It may be better to start the evening with coffee and then wait till the end to serve something else again.

It is preferable always to meet at the same address and on a fixed evening, for example once in fourteen days. What then are we going to read? Essentially every choice is good, yet we may be somewhat thoughtful here about our decision. In our experience the Gospel according to John is a very suitable book because the Christmas story that people already know is not in it and so it is not fraught with associations of Christmas sentimentality, and because it does not contain too many stories that people usually also know and that always require explanation and application, which can be difficult and which can open the way to errors and futile discussions. The Gospel according to John gives the word of the Lord Jesus in discussions with 'ordinary people', with Pharisees, and with his disciples. The point of departure is virtually always Jesus' claim to be the promised Messiah, the Son of God. And that is still always the point: that is why Jesus' utterances have a penetrating directness and currency for everyone who reads them.

The Bible only

A definite prerequisite for any Bible study group must be that the participants in it want to discover what the Bible has to say about various questions, life's questions and other questions. The group leader must therefore take care that no answers are given other than what people can find strictly in the Bible. It must say so there, and not just be 'inferred' through some line of reasoning or derived from a different source, no matter how respectable. If we want to convince people that we accept the word of God because we believe that he exists and is our Father, then we too must begin, with Paul, to deem all human findings rubbish [Philippians 3:8] – so that God's word truly may go out, which will not return to him empty [Isaiah 55:11]. For that reason it is good to draw other parts of the Bible into the discussion. If there is a reference to the Old Testament in the passage the group is reading, they should look it up. If there is a reference to the Law, then the group could very well take a look at the first six chapters in Deuteronomy to see what that law really meant. That could even be done on a separate evening. By choosing thoughtfully the fragments to be read – not too short – that would work well. One can also refer to the Epistles in connection with certain questions. Compare Scripture with Scripture: listening only to Scripture must not be treated as a slogan but as solid reality – a wonderful reality, during the course of which some 'generally held opinions' may fall! That is not bad, as they often do not come directly from Scripture.

The Reformed – *Gereformeerden* – have always been a theologizing folk. Therefore it is prudent to leave all other books closed. Even in the

preparation, whether by a group leader or by taking turns. It must be genuine Bible study and not the preparation of a sermon or a theological study of a theme that may be touched upon in the passage to be read. That is why I do not recommend the reading of Romans, as beautiful as that book is when one reads it together with others who have also studied things a little deeper; for Romans gives purely the doctrine of the gospel, and not a theology, although many among us will slip all too easily from the one into the other.

Then, an important point: all questions may be raised and all must be answered. Never say of any question 'That should not be asked.' Also do not say, 'Yes, but one can only see that with the eye of faith.' Paul put it differently in Romans 1! We must search for the truth, and speak it, and then show what the reality is we live in – God and the Holy Spirit and the Lord Jesus in his redeeming work are reality, whether we believe in God or not. The focus should not be on our faith but on reality, which we may know because we believe. There is nothing in it that is incomprehensible or strange or absurd. We do not believe because what the Scriptures say is 'absurd', as Tertullian once asserted, but because we see that God's word gives an answer to all the questions that are raised and gives a better account of the reality we live in than any human construction of thought.

This does not mean that we always know the answer. We do not have to be ashamed when we do not. We can say that we would like to look into the matter or think it through. It is not bad if we do not know everything.

We begin by calmly reading a passage, preferably an entire section. The group leader needs to place this passage in the context of our earlier readings, briefly making the situation clear, perhaps explaining some historical particulars, for example that the Romans had occupied Palestine. Then we read the passage again, verse by verse. Real exposition is then often no longer necessary, since Scripture is clear and comprehensible. If the group leader then asks whether anyone has a question or comment there is usually a hush. Certainly that is so when we are together with 'our own'. A good method in that case is to paraphrase what has been read. By retelling things in our own words, we make clear what we think we have read. And then someone will hasten to state: yes, but that is not exactly what it says. So the discussion gets going: does it say this or that, is this or that the intention. Then all attention is really concentrated on the Scripture text. We need to guard against getting bogged down here in all manner of futilities. Often we will have to say: whether you read it this way or that detracts little from the message, for that is the same in both readings. It will of course often be necessary to have a look at other, related texts as well. Then knowledge of Scripture is helpful. One cannot really be a good member of a Bible study group (as a Reformed person) without studying the Bible regularly on one's own, on the basis of the same principles.

Our guests may not always ask much. That is not bad, just let them listen. Let them read along and look up other texts when these are cited. Never may we simply say these texts by heart; we must really read them, in their context. Sometimes it then turns out that we were on the wrong track. That does not matter.

Another time our guests may be full of questions. With a group of students I have not managed to read through four chapters of Romans in a year and a half because we simply cannot get to the reading for all the questions. But we may take the time to address them and always show: this is the answer the Scriptures give. If we state our own opinion – even if properly Reformed – then we should always say so: this is my opinion, but it is possible to think differently about it, for Scripture does not provide the answer here, or at least I do not see it.

The amazing thing is that when we involve our guests in the study like this they will sometimes make wonderful observations of which we have to say: yes, it is as you say, here it says this or that, and I have always failed to notice it.

We must be prepared that a guest may not always be informed about matters that seem very familiar to us: the Fall, the work of the prophets, the exodus from Egypt, these are things about which one sometimes has to provide an extensive account. Feel free to do so, where possible by reading a portion of Scripture.

We shall have to keep in mind that Scripture does not offer us a system, a theory of elusive truths, that it also does not preach faith but speaks about tremendous realities: God, Creation, the Fall into sin, blessing, curse (really concrete), salvation, resurrection. If the last were not really true, Paul says, then he might as well throw away the Bible and stop being a Christian. That is how we must talk about it, that is how we must show that we accept it ourselves. And therefore it is not enough if someone just says at a given moment: I believe in the Bible, I believe that Christ arose. That does not always mean that that person has become a believer; sometimes it just means that he or she accepts the truth of the historical fact. The devils believe too, so the Scriptures teach us [James 2:19]. Besides simple acceptance of the word of eyewitnesses that Jesus, for example, really arose, there must be a life lived in accordance with that, a walking 'in newness of life' (Romans 6). We must not only accept God's existence as sure but also, as the Scriptures teach us, love him as our Father. And that is more.

A few suggestions. If someone asks us why we accept the Scriptures, for they are strange and bizarre, then we do not need to point to our faith but can ask in response: 'If the Scriptures are not the work of God how are we to understand that Abraham received the promise so long before Christ and that the prophets already talked about him?' Just look at Isaiah 48:5, for example! How can we ever understand how the New Testament came into being if we do not accept that it is a fulfilment of

the Old Testament? In that case the apostles would have been a group of deceivers and the Lord Jesus would have been justifiably crucified – it was a capital offence to claim to be God, and rightly so unless one really is God! We can also point out that all human systems proceed from assumptions that remain unproved, for example, that human beings are good or that human existence arose from protoplasm that accidentally evolved into a person.

We may discover, while working along, that we should perhaps study some more, not in theology but in the things of the world around us: sects, politics, communism, and ever so much more. That is all for the better, for ourselves first of all. We will become better acquainted with what is really going on in the world. It will force us to live fuller lives as people. And that is wonderful.

When you have finished with the Gospel according to John you can go on to one of the Epistles of Paul, such as Ephesians. Or to a few key chapters from Jeremiah or Isaiah.

A good guide for anyone who finds reading the Bible difficult and who does not feel strong enough to provide leadership may be found in the great Bible studies of Dr Schaeffer (they have been translated into Dutch).[616] These are meant to be read by people who are young in the faith or by people who may not feel they dare to provide leadership themselves, as we mentioned above. These Bible studies present important chapters from our Christian faith – the Trinity, salvation, and so forth, 25 studies in all; the texts are arranged by subject with a brief explanation. A fine guide to reading the Bible (you have to look up the texts mentioned yourself), especially suited for people gathering in small groups 'among ourselves' or in the company of a few people who are not from the church. These Bible studies are very clear and extremely well suited for the purpose of introducing someone in a rather short time to the main points of our faith. You may order them from me.

• Life's questions – on suffering[617]

What questions do young people ask nowadays? Do we really think that the questions today are different from questions of earlier times? All literature from Dostoyevsky to Shakespeare, from Camus to Elckerlyck tells us that at bottom people have always asked questions and always wrestled with answers. I would almost say, naturally so, for they were people, were they not?

So what is different? Perhaps a conflict with the older generation, many of whom have forgotten how to raise questions or perhaps – that seems more likely – have suppressed their questions out of despair. Perhaps the so-called generation conflict is a conflict with a generation who are so despairing that they think you should not raise questions but

just accept the world as it is (after all, what more do you want than enough to eat), a generation who go along with a kind of optimistic, romantic attitude that everything is okay or will turn out that way. For what more could one want? Perhaps the pursuit of affluence, a good position, status and all the rest is nothing more at bottom than an escape aimed at putting up a façade so that you do not have to face questions. In some countries, America, the Netherlands, some parts of England where the War did not really come too close, that even seemed to work. Often, even where it did come, people treated it as a kind of nightmare – do not talk about it, at least we now again have something to eat. But behind all this do we not find desperation itself?

Many young people can no longer accept this. They reject the lies the previous generation lived with, the reality they ignored. Yet their rejection is only human. For to be truly human means also this: to want to know the truth and to accept nothing less than the truth.

And so life's real question comes up, the deepest question, the question humanity could never and will never draw a line under as 'finished', the question of suffering. Sometimes you hear young people passionately sum up all the suffering: Vietnam, the Jews in the war, Korea, the murder of the people of Tibet – and if they are not too much under Maoist influence – Czechoslovakia, Poland, the blacks in South Africa, and so on. In the process they often forget to look closer to home – for you have to do that too if you want the question to be real – the man on the corner, that family there, that dealer, that girl, that person so very close to you. Do not forget the suffering you can see all around you, there where there is perhaps even more stultification because it is no longer just a matter of happiness or unhappiness, of real life or plodding on in misery, but of life and death.

So, is God there? And if there is a God, does he permit this? That is the question posed. It is not an academic question to bat around over a glass of beer but a question that screams for an answer. Anyone who can bring it up as something 'interesting' does not know the question and is as bad as the generation that forgot how to question.

In the first place – if we want to try to give an answer – Christianity is really not some kind of optimistic affair that wants to ignore this question, even if there was once a generation of church folk who took on 'bourgeois' characteristics or at least seemed to do so. Yet was that really Christianity or was it tradition, a seeking of certainty in the church, in creeds, in superficiality? No, if we really want to talk about Christianity, we must not look at this or that person. Indeed, what do we really know about these people, about what goes on behind all the façades? Uncertainty? Unbelief? Whereby God perhaps becomes Fate and there is no real love for the Father? Or perhaps certainty, linked with the despair that there is nothing more to be done anyway about this world that is sinking away into unbelief. How can we get through to these stone-hard bourgeois figures? Well, let us not always be looking at others.

If we want to know what Christianity says then the first thing we have to do is look in the Bible. Just open it, on any page. The book is nowhere romantic, evades no question, does not preach resignation or acquiescence, and does not preach a God called Fate. No, the Bible is full of suffering, full of questions, full of horror, full of real human misery. The Bible does not present dry, arid doctrines. Nowhere does it do that. It is full of life, of suffering and misery, although it also knows joy and delight.

God and suffering

And what does the Bible say about suffering? Two things, and much more. First, that suffering is an alien thing, and that there ought indeed to be none; a strange mystery, something we can and may never accept. Read the Sermon on the Mount [Matthew 5–7]: a call for a mentality that does not accept evil, that does not ignore injustice, does not just let suffering be. 'Hunger and thirst after righteousness,' says our Lord Jesus Christ. Translated into our language that means: protest, protest, and protest, but in love. Read also Job, about how he revolted with his entire being against evil, about the suffering that he felt all the more keenly since he experienced it personally. Job never stopped raising questions. And the answer he received was: it is too great and too deep to be understood by humans. Remember my greatness, and that you do not know what is going on behind the scenes. In Job's case, it was the Devil, evil itself. But God does not offer lame excuses.

But read on, and then especially in the fulfilment and completion of God's revelation in the New Testament we begin to understand that God can also not stand the sight of evil! We human beings protest. But that is weak and pale. God protests too, much more deeply. God cannot stand evil and suffering. It is God who takes his own creation seriously, who does not make a joke of it, who does not say it is not so bad after all, and who also takes people seriously and wants them to be truly human. God does not want people to be machines. He wants them to show love in freedom and to pursue the good. God weeps at the sight of evil. Read the prophets – was there ever such protest against evil, against self-righteousness, against injustice, against hypocrisy? Check them out! Hear how Christ wept for the people of Jerusalem who simply would not listen and would not face their own evil deeds. Hear how he not only wept but also was angry when he saw how Lazarus had died. He could not stand the sight of it.

Do we not understand then, when we ask angrily about all that evil – which indeed is meaningless and which we therefore also cannot explain away – that it was for precisely that reason Christ came into the world? That his suffering on the cross was not just an incremental addition to the full sum of suffering in this world but that Christ in this way wanted to overcome evil, suffering, sin, wickedness and death, yes, that too. For God does not just protest, he does something about it. That it demanded

this sacrifice, and – just look at Revelation – that there is still a long way to go before the triumphal end comes only shows that dealing with evil is not simple and that God does not want to dispense with it as if by magic – he takes his creation seriously and wants people to be as he intended them to be – but wants to overcome it really. Suffering must not be forgotten but dealt with and overcome. Christianity is not optimism. No, it shows us that God himself found it worth the effort, through all the suffering, to overcome the Devil, the misery, the injustice, death. And that was not easy. But it was real. So we Christians look forward to the final victory, but not as optimists as if everything must turn out well of itself. Again, read Revelation, the last book of the Bible. It may be a difficult book, but one thing is as clear as day: that it speaks of suffering, of horror, of woe, woe, woe. Because only in that way can evil be overcome and justice be done to a stiff-necked and sinful, really malevolent humanity.

God is love. Yes, but love is not something sentimental, like that which goes under an artificial Christmas tree. Love is real and deep and sympathetic and cannot exist without righteousness. Otherwise it is not love. How could there be love without the other side, without judgment? If one person treats another person unjustly, murdering them mentally or physically, shall we not, if we know love, help the victim and be angry with the murderer? Anyone who pats them both on the shoulder 'in love' and says it's okay does not know what love is and is acting cheaply. God is not cheap. Judgment without love is cruelty and a horror, and love without conflict and without judgment against evil or the Evil one is not love but sentimentality.

Further, John's Revelation shows us God's judgments on this earth against people who have desecrated this beautiful world and turned it into a horror. God tells us – again, read the Old Testament prophets – that he will judge where unrighteousness reigns. Now, when young people protest, crying out against all the emptiness, all the hypocrisy, all the injustice of our day, does God then not say: you are right, but that is why I come with my judgment. Is the misery of our times not already a judgment of our self-righteousness and our oh so smug Western world? But then God also calls people to be converted, and if one protests, do so in love. Resist evil and fight at his side. He is God, and therefore judgment belongs to him. Judgment is not ours. We are told to do good and to take up our cross, to suffer if necessary, so that good may come, because we love.

God does not say, when we ask about evil in this world, that it is nothing or that suffering has its own meaning. He tells us to be converted and to join him in the battle, following Christ. He does not ask us to stop asking, but to do something about it. In that he has preceded us. Are there then no questions left? Certainly there are, for why did it all have to be this way? God says: humans, it surpasses your

understanding, but do you not see how tremendous it is that I have gone before you in the battle and that my Son was willing to shed his blood for it. No, it is not cheap and not easy, and least of all 'interesting' or just one of life's questions. It is life itself.

• Book review: Moa Moa, Modern Thought and Primitive Wisdom[618]

'The Polynesian word *Moa* means "bird"; the word is also used for the human soul and for the giant statuary on Easter Island placed there in a mysterious way by earlier generations. Therefore I have used this word as a symbol for the archaic world to which we must now return.' That is the explanation Prof. Dr C.H. van Os gives of the title of his book. He wants to lead us, so he assures us, to the archaic tree of life.

'The doctrines of the official Christian churches have little to say in this day and age to many an earnestly seeking person,' so his argument begins in the first chapter. What are we to do in this situation? The only possibility is to make a distinction between the essence, the core of Christianity, and the forms in which it wraps itself, he states. But how are we to determine the essence? The best way is through regression, the way back to the origin.

In van Os's fundamentally subjectivistic approach that naturally does not mean going back to the Origin, the Lord who revealed himself in his Word, but going back as far as possible in history to the wisdom of the people from the very remote past of which – he readily admits – we know nothing but can infer something, based on the mythologies of the oldest historical nations, the Babylonians, Egyptians and Greeks.

And in this way he arrives quickly at the thesis that the archaic feeling and experience on the one hand and modern thinking on the other, that is, the results of modern natural science, fit harmoniously together. He then proceeds to address that archaic thinking and to identify its most important characteristics as animism and the idea of 'mana'. Thus he comes to the bold thesis that 'Besides mana tied to particular objects or beings, there are also freely floating concentrations of mana, a force or energy that permeates the entire cosmos. These then are the spirits and gods of ancient belief. How these archaic representations have maintained themselves through the centuries may be clear from what the Bible and the Christian church teach about the Holy Spirit.' Here a fact of revelation is simply equated with opinions held by the most primitive peoples. Moreover, here the thesis is uncritically assumed that the opinions of primitive peoples living today would be those of the fabled archaic people. Van Os works with data from the modern science that occupies itself with such primitive civilizations and that often evolutionistically avails

itself of such a hypothesis.[619] For such a starting point is a hypothesis that one cannot refute, at least if one leaves one's Bible closed, but also never can prove or even render plausible. It is an item of faith of modern apostate science.

Just how far such speculations about the belief in (mana) can go may be clear to us when we see how van Os is struck by its agreement with the basic idea of Christianity. He writes: 'What, after all, is this basic idea? That a divine being, which represented an enormous mana-concentration, descended into this world and offered itself: which freed the mana and poured it out in the cosmos, flushing away as it were everything wrong and sinful. This idea fits perfectly in the archaic sphere.' In this way we see that what never arose in any human heart and was never conceived by any person is then nothing other than an archaic way of thinking. Once we have recovered from our astonishment and indignation at such blasphemous and in essence nothing other than foolish ideas we still also have to accept the following pronouncement: 'I do not believe that the future of our civilization is conceivable without Christianity, although this Christianity will have to learn a lot not only from natural science but also from the oriental religions.' This is to say that Christianity will be graciously accepted if it has first been denatured, when the foolishness of the Cross can no longer give offence, since it has been declared a vestige of archaic thinking and has absorbed everything that has arisen in the human heart.

Since with archaic people the physical processes lay much closer to the threshold of consciousness, to the extent at least that such a threshold was present, van Os seems to say they must have had something of a sorcerer who according to his own wish could 'change form'. Perhaps this is an overstatement, but he clearly states that 'We come in any case to the notion of a primal man who had a much closer inner tie than we do with the mysterious, divine life which is everywhere active in nature.'

How did we ever lose that? Well, through the fact that 'according to different mythologies and philosophies present-day human existence was preceded by a fall from earlier happier circumstances.' According to the Bible that happened through eating from the tree of Knowledge: 'By the word "knowledge" we can understand knowledge that we acquire by means of the senses and that was preceded by the intuitive paranormal knowledge of primal man.'

We are strongly reminded here of the ideas of Gauguin, which we discussed earlier in connection with his large painting.[620] Gauguin defended almost fifty years ago now, in his book *Noa Noa*, the proposition that primitive people bore a greater resemblance to the original good human being than modern people do and that that same primitivism is still alive. The difference between Gauguin and van Os is that van Os tries to base his insights on modern natural science and to show that it goes

very well indeed with the world picture of that primal humanity. From *Noa Noa* to *Moa-Moa* is no great distance. Although van Os's book seems much more scholarly, in Gauguin's one recognizes genius – the artistic qualities aside, it does not attempt to pretend by using all kinds of mental leaps and hypotheses that are neither here nor there that it presents a scientifically defensible thesis. There is undoubtedly more wisdom in Gauguin as well, namely this, that he also recognizes the fears of the primitives, who feel threatened by everything in nature, that is, by everything having mana. Van Os lacks this wisdom, for in spite of everything he still stands on the optimistic viewpoint of natural scientific thought that believes it can solve all the riddles of the world.

We do not want to follow the rest of van Os's reflections, for fantasies, erudite nonsense and toying with the great knowledge that modern science has indeed won will bring us little further. Nor will it bring this world much further. It can only teach us how foolishness reigns where sobriety is lost, where the truth is suppressed in unrighteousness. That this book should be called a 'guide' and that modern people should derive comfort and direction from it can only sadden us and teach us to understand the depth of the apostasy. That a learned mathematician with a name can be satisfied with such loose speculations is characteristic of the times.

A cobbler should stick to his last. And be converted!

• Book review: The Prodigal Son as Literary Motif[621]

It is remarkable to have to observe that fads can rule the day even in scientific life. Certain problems, certain fields of inquiry sometimes rather abruptly become the centre of interest. Weary of fields that have been investigated to the limit in which they see no ways open to find something really new, people throw themselves upon entirely new themes to delve into freshly and unhindered by lots of older publications. The new beckons them and taking unbeaten paths exerts a special attraction.

So too in the field of the sciences which occupy themselves with art. For a decade now there has been a great interest in studying the themes handled by artists. Not the style but the subject has become a focus of scientific interest. People are attempting in this way to get out of the dead end into which stylistic criticism has been threatening to lead art history. Thus we can understand very well the choice of theme in J.F. Kat's dissertation about the Prodigal Son and certainly also can appreciate it. The writer shows how people have used the biblical given – the parable of the Prodigal Son – for literary works, how some have seen no more in it than either an excuse to paint all kinds of immoral scenes or a pretext to paint moral sermons. He shows moreover how

people have sometimes made the biblical content serviceable to the spiritual struggle of the day, as in the sixteenth century in particular, when Reformers, humanists and Catholics all in turn had the story tell their own tale, while (how could it be otherwise) it was sometimes used very freely or abused. In passing Kat also shows us how visual art often 'trifled' with the theme. Correctly, however, he identifies the renowned painting by Rembrandt as the greatest and deepest interpretation where, in contrast to so many who offered no more than a brothel, the gospel content of the Scriptures is fully preserved and underscored.

After that Kat shows us how the eighteenth century adapted the theme to fit its own apostate lifestyle: the son who stays home becomes, even more than in the older treatments, the hypocrite and Pharisee, while the other is forgivably frivolous and charmingly honest. This process continues into the nineteenth century, although from time to time one can still hear a note struck that is faithful to the Bible.

The emphasis in Kat's book is mainly on the twentieth century. Here he centres the various 'applications' on André Gide and, in the Dutch language, on Geerten Gossaert. Gide makes the son who has returned give as the reason for his departure that the house (the church!) weighed him down, that the dogma was too narrow, to which is added that that house is not the Father's. This prodigal does return, but reluctantly, since he is horrified by all ties: 'The old notion that the Church is based on the Gospel must yield to the idea that the Church murders the Gospel.' The older brother is the misguided one who puts order and preservation of the status quo above love! And if in that case the youngest son (a third figure unknown to the biblical account) also leaves home, then the prodigal who returned helps him, filled with admiration because he has grown too weak himself and can no longer cope with the dangers. Modern people's problem with the church is depicted here in an (alas!) model literary way. Together this intellectual attitude and this little work have slain their thousands.

We find a similar conflict in Gossaert, although the basic dilemma posed here is to be either a poet or a Christian – a dilemma that is a false one even if it sometimes appears that amongst Reformed Calvinists art (if it is really worthy of the name) is hardly allotted a place. More scathing, but not imprisoned in such a dilemma, the theme reappears in Mérode, where more than once the meaning of the biblical story is violated in the poems – although we believe that in the final analysis the struggle to 'appropriate' the scriptural word of grace does form the constant background in his work.

All things considered, the parable is constantly used here to fight out private conflicts before the eyes of the literary public, some of the reactions of whom have also been registered by an indefatigably sleuthing Kat. The part on the twentieth century is by far the strongest in this interesting dissertation: the analysis goes deeper and forms a

genuine argument, while the treatment of the older periods sometimes has the feel about it of a *catalogue raisonée*, a summary with some commentary thrown in.

A few observations: we found distracting the use of the terms 'natural' and 'supernatural' in the typical Roman Catholic sense of the nature-grace scheme, although that would hardly seem a problem for a Catholic. A certain predilection for Catholic writers is discernible, but that remains within acceptable limits and since the writer is openly Catholic himself it is also justifiable. Nowhere did we detect any distortion of history, and happily the work has also remained free of any all too partisan approach to Protestant writers. On the contrary, they are often treated with admirable sympathy.

On another point, however, we do not understand why nineteenth-century artists have been placed between seventeenth-century figures. Legros and Holroyd are not seventeenth-century personalities, although the context suggests they are. This work, illustrated with carefully chosen reproductions, will be available in a trade edition (Bussum: Brand) in February 1953. It is certainly to be recommended.

• How do we travel?[622]

It will soon be the holiday season, and then many of you will go on a trip travelling in one way or another. But how will we travel through the foreign regions or countries? I can already see cyclists, their backs bent, eyes fixed on the cycle path as they churn off as many kilometres as possible every day. When they get back home they will be able to report only on the condition of the roads and what the roadside hostels looked like in Belgium or France. Other travellers may have spent a day or two in Frankfurt, and when asked to write a report about it will be able to tell only of what they have eaten and in which restaurant – and it will not even have been a very special meal or something a little out of the ordinary. Still others have been in Reims, Chartres and Strasbourg and will not even have heard that there are famous cathedrals in those cities. As if one could just walk past them, unless of course you only look at the pavement and the traffic.

Now understand me well, eating is important. It belongs to the manners and customs of the region and country you plan to visit. And for that reason when in Milan you must not order beefsteak and baked potatoes and in France you should let them serve you in the French way. Then you not only get to eat the most delicious food but you also learn a bit about the people's lives. You get to understand that Italy, for example, has only been a national political entity for a short time, for about a century [since 1860] and that the various regions were all states with their own culture. The cuisine in Bologna is quite different from

that in Tuscany, and in Lombardy they serve you something else yet again. Try the unfamiliar things on the menu. If you order lasagne in Bologna you will have an experience to remember for a lifetime.

But there is more than eating and sleeping. In Europe, no matter how you travel, you will seldom find yourself in a primeval jungle. All the forests have been planted, the mountainsides cultivated, the fields fenced in, sown with this and that. Europe is one large garden and the 'nature' that you see is a landscape tended by human hands, we might almost say it is composed. That is particularly clear when you compare north-west France with southern England. The hills and soils are similar 'by nature', but how different they look, how unlike each other they are. Just notice how the French build their houses somewhat carelessly almost anywhere while the English have such a fine feel for the beauty of the landscape and the possibilities for situating a house in it that southern England has practically grown into a single great park.

Of course what nature has provided, the kind of soil, the geological configuration and much more, will sometimes have a significant impact on a country, on what people do there, what they grow, how they live, and so forth. Therefore it is often good to read up a bit beforehand on these things. Then you will see these things and not just drive past without noticing them. If, for example, you take the train through the Pyrenees you will notice that the mountains suddenly change after you have crossed the Spanish border. That is because a number of centuries ago the Spanish disastrously cut down their forests, but also because there is a different type of mountain formation, a different rock type and structure. You will also notice that near the border there is a little village called Igl-Alp, a name with a Swiss ring to it. The reason for this is that 'Alp' is the Celtic word for mountain and that very long ago, say before Christ, Celts lived in both Switzerland and the Pyrenees.

That brings us to something else: you will understand and notice a great many things if you know something of the history of a country. Where the borders used to be, where the people came from, what the people stood for (which is connected with the fact that in Germany for example some regions are Roman Catholic and others Protestant), which princes ruled and how . . . it is all too much to tell. There are some areas in France where you can still discover traces of the invasions by the Huns and later the Moors. And in Switzerland, at Brig, you can still see a Moorish palace, the seat of a Moorish prince who reigned there a number of centuries ago!

Such things are really not so difficult to discover. Before setting out you just have to read a little bit about the region you are going to visit and check a map to see where one thing or another is located. Never forget to take along a good map. The best thing is to buy a good travel guide, such as the *Guide Bleu* for France. For many regions of Europe outstanding *Baedekers* have been compiled, which you can sometimes still

pick up at a reasonable price at a book market; they are always very good (keeping in mind that they may be somewhat outdated on some points). In the guides you will always find an introduction to the things I have mentioned above, so do not forget them. They also mention the monuments you can see in the cities, villages and places you visit. They make it possible, if you do not set up too tight a schedule before you set off, to avoid missing that little ancient church, that old country mansion that looks so beautiful, that lovely panorama which can only be enjoyed from one particular route. In short, you not only enjoy more but you also see much more, and your travel experience becomes the richer for it, and in a playful way you are richer too because you have really come to understand something of the country, people, culture, and more. Also very good are the French *Michelin* guides, very practical and always precisely what you need. Do not be afraid to spend a little money on a good travel guide – it will pay for itself many times over.

To conclude, do not forget the museums. I do not mean that you should scoot through them as if that is the duty of a tourist. No, visit museums to discover things that are really beautiful and that you are going to love. It is better to look closely at two paintings and a single sculpture than to scurry past a few hundred of them. To do the latter is just tiring and very boring.

In short, make your trip in our own country or abroad an experience. If you are just going to ride right past everything you might as well stay home. You will have enjoyed so little and seen so little that it will not have been worth all the money and effort. But certainly you will not do that. Turn your trip into a journey of discovery. Discover things that elude others, things that many simply walk past because what is not known is not loved. To accomplish that, however, you will have to tear yourself away from the snack bar in the tourist resort.

Have a nice trip!

• Chinese landscapes[623]

Till now we have discussed various facets of the development of landscape painting in Western Europe.[624] It is not feasible to devote extensive attention to Chinese landscape art though, which is far, far older. Already before Christ, people in China were making portraits, landscapes and the like, as we know from written sources, but no artworks from that remote past have survived. During the same period these branches of art were also known in the Graeco-Roman world. Yet here in the West this was all lost as a result of the barbarian invasions that accompanied the fall of the Roman Empire and the entirely different focus of attention in the early and late Middle Ages. Then eventually it was rediscovered.

The earliest paintings we know from China date from around AD 1000. Compared with Chinese landscape art, our Western art is very prosaically descriptive. The former are lyrical outpourings occasioned by the experience of nature's beauty. Definitely not in detachment from Buddhist and Taoist mystical conceptions, these landscapes have something immaterial about them, something that points to pure spiritualization. These landscapes are not concerned with a correct rendering of given natural phenomena but they offer dreams of beautiful landscapes, which are suggested more than they are described in an exact manner.

Great care was always bestowed on the composition, which organizes the different elements artistically on the surface of the paper instead of aiming at depth and three-dimensionality. Perspective is unknown to the Chinese, and they also have no need of it. Characteristically they 'fill' only one corner and thus create a vast empty space that possesses great artistic power. There is never a clear horizon, the depicted land gradually blurs in order to slowly dissolve into the 'all' of space.

Trees, foliage and the like are brushed in very skilfully and the influence of the calligraphic style of rendering Chinese characters is very noticeable. Indeed, trees and the like sometimes almost have the form of these Chinese characters. When one has looked at a number of similar landscapes, one wonders to what extent the Western style of writing influences the 'handwriting' of our own painters. That we virtually never notice it and that it is even extremely difficult for us to do so is certainly attributable to our familiarity with the Western way of working. Yet it remains a worthwhile question. Perhaps writing has much less influence on our painting because it is much less an artform with us than with the Chinese, who sometimes seek aesthetic satisfaction even in the making of their [writing] characters.

The distinctive way of composing, which is characteristic of Chinese visual art and so different from our own, eventually had a tremendous influence on Japanese art, including the renowned and familiar woodcuts, and in that way had an indirect and fertile impact on modern art. We hope to say something more about this on another occasion.

• Is the photo natural?[625]

The notion that photography reproduces reality very precisely and correctly is almost generally held. Why, recently there was even a writer in the *Calvinistisch Jongelingsblad* who compared a given scriptural fact with a photograph in order to compare instances of later textual corruption and subjective distortion with so-called retouches or even with a 'man-made' painting. The question now is whether that view is correct. For is it true that the photo is so natural?

It is known that a black person from the interior of Africa spent three months in the service of a photographer developing photographs – he had learned how to do this relatively mechanical work – before being elated one day to discover that there was indeed something more than splotches to be seen on those black-and-white sheets. And when we stop to think about it, it is quite astonishing that the photo should be considered so 'natural'. A flat piece of paper featuring patches in nuances of grey – we will leave colour photography aside for the moment – could that resemble reality as closely as some believe?

One can of course reply that the naturalness consists in this, that the camera sees the same thing our eyes see and records it on a sensitive surface. This results in a similar image. The colour continues to be something of a problem, but even so . . . is it true that the camera 'sees' precisely what a person sees? After all, a camera has a single eye that looks rigidly ahead, while a person looks around with two eyes. That makes quite a difference. And then we are leaving aside for the moment the question whether we do indeed see like a machine, for in the end, that is what a camera is.

Therefore it makes sense to ask how it is that people have come to regard the photo as something natural. We believe our answer must be that this is what we have been taught by the art of painting, which has incorporated such a tremendous amount of vision, outlook and opinion into itself.

In the fifteenth century naturalistic painting arose. This art had as its defining characteristic the intention of designing a picture that agrees with what our eyes see and observe. Thus it was no longer the idea of the thing that mattered but what people could actually see. It was accompanied by the intention of rendering the general composition of the space as 'naturally' as possible, which is to say in agreement with what we see when we look around us.

One of the technical means that people developed in order to accomplish this was perspective. Perspective was discovered and developed by mathematics, and it involves a great deal more than the little 'trick' of parallel lines that come together in one point on the horizon. It was based on the cone of vision, a cone of lines created by drawing lines from the different sides of an object to the eye. Next a plane surface is placed between the object and the point of observation, and all the points of intersection are marked. The multiplicity of points are then joined into a drawing that is based on the various laws for reproduction in perspective which have been applied by painters almost universally since that time.

But is this theory correct? Is visible reality actually reproduced in this way on the flat surface 'as the eye sees it'? To level criticism at the theory is in fact not at all difficult. In the first place we look with two eyes and not with one. Secondly that eye – those eyes – are not rigidly fixed but

we move it (them) around. Look at the room in which you are sitting. Try to do it in a single glance with your eyes fixed in one direction. You will not succeed, certainly not if you want to really 'see' the room. And if you look with your eyes moving, there are already many remarkable phenomena that the perspective theory simply did not and could not take into account. For example, that a straight line such as the line formed by the wall and the ceiling is in fact perceived by us as a curved line. (The explanation of this remarkable phenomenon I leave aside since it would take up too much space and is not directly relevant at the moment.) Further, as a third point of criticism we must observe that the rays of light do not strike our eyes on a flat surface. For our eyes are convex. If I wanted to improve the perspective theory, then I would have to begin by basing it on projection (the intersection of the lines of the cone of vision and the surface) not onto a flat but onto a convex surface. And that brings many additional difficulties with it. The manner in which people in Greek and Roman antiquity attempted to reproduce depth rests in part on this projection, but we cannot go into that here.

Thus the correctness of the perspective theory is very debatable, so that we can hardly cling to the proposition that in this way depth is reproduced exactly and truthfully, just as we see and observe it. However, the remarkable thing is that the camera satisfies precisely the assumptions on which the perspective theory is based. Here is a single fixed 'eye' (the lens) and here is a flat surface for projection. The conclusion accordingly can be that we regard the depth as it projects itself onto the photographic surface as so self-evident because for centuries before the invention of photography painters were constructing their depth in precisely the same way.

The depiction of depth in paintings is thus indeed attained by a sort of symbol. I know – for I have been educated since my earliest children's books to know – that when I see the ground line and the roofline run towards each other in a depiction of a house, that it is not a crooked house but a house that intersects at a certain angle with the surface in the space that is suggested by the painting. I know that, I experience it, I recognize it, but very strictly speaking that is not what I see. That that is indeed the case is confirmed by the fact that the Japanese, when they first obtained Western prints about a century and a half ago, could not stop laughing at the Westerners who built their houses so higgledy-piggledy. They indeed did not understand the suggestion of space by means of perspective and they even made caricatures of it. (Japanese artists also depicted depth, but by entirely different means.)

In short, the photo thus has for those who are schooled in the Western way of looking at pictures the appearance of naturalness, because for some four centuries now the naturalistic way of painting has presented or symbolized depth in a way similar to the photo. The accidental correspondence with the starting point of the perspective theory is the reason for this.

But let us not stop here. Let us assume for the sake of convenience that the way in which depth 'lands' on the surface of the photo is indeed in agreement with our seeing. Is the photo in that case 'natural'? In short, do we see reality as the photo sees it or, to preempt all intermediate questions, as the modern cinemascope reproduces it – while it takes into account our objections against perspective theory and its application in photography – in colour and motion and correct depth?

And then we must answer, whether we are talking about photos or about shots made with a cinemascopic camera, that we do not believe that this is the case. For we simply do not see in a machine-like manner. We are living people and in our seeing many factors play a role, some of which we may be wholly unaware of but that are there nonetheless. My knowledge, my interests, my mentality, my mood, all that and much more play a role.

Imagine that you have visited a person in a room for an hour. When you come out someone asks you what the wallpaper looked like? What kind of paintings were on the wall and what were they about? What kind of material was used to upholster the chairs? And so on. I think that only the decorator with you would be able to say how the wallpaper was hung, because of his or her knowledge and experience in this regard. I could probably say something about the paintings, but then that belongs to my profession. And the furniture salesman would be able to say something about the chairs. But you probably did not see all those things yourself. That is, you saw them in the sense that your eyes picked up the light, but you simply banished them from your observation as irrelevant. You just did not pay attention to those things. Happily so! After all, to see everything is impossible. And senseless!

Perhaps you noticed that the man had certain books on his bookshelf – books by Klaas Schilder and an old Dutch Authorized Version of the Bible and the like – and from this you drew your conclusions about the person you were visiting. Those very same things were not noticed, however, by other people who visited just half an hour earlier, that is, they did not observe them. For although they were just as capable of seeing them as you were, it simply meant nothing to them. And we could go on in that way.

Our looking is always directed, always selective. We choose from the multiplicity of images the eye provides us only that which is meaningful and valuable for us at any moment. It is possible for you to walk along lost in thought, and then you 'see' nothing – although you also do not stumble over the bucket on the porch, for example. You did not notice it but your reaction was instinctive. And a good thing too!

Thus when two people look at a particular object, a flower for example, they will see different things depending on their knowledge of flowers. Have you never had the experience of taking a photo, of getting everything set up and adjusted precisely, only to discover when the print

comes back that an important part of what you wanted to photograph was simply hidden by a leafy branch? You had not seen the branch, for in your observation you had mentally discarded it as irrelevant. On subsequent occasions you do see and pay attention to that sort of thing of course, because in a certain respect it has now become important and meaningful to you.

Yet the photo of a room or of a flower or whatever gives everything, because that camera is a machine that simply registers the rays of light from everything within the cone of vision that strikes the sensitive plate.

So, is the photo natural? No, there are all kinds of things in the picture that you as a person having various and sundry idiosyncrasies and interests simply do not notice and so exclude from what you see. Of course the photo is natural in the sense of the natural sciences, since all the physical light rays traceable to things in the space in question are registered. Indeed, the photo is natural in the most literal sense, but for that very reason not real and true in the human sense, not natural in the metaphorical sense. For a person's seeing far exceeds the physical process that occurs in one's eye. One observes as a person.

What is natural?

From this angle too then the question can be raised: how has it come about that people regard the photo as 'natural'? Would it not be because people (probably without knowing it) adopt a criterion of truth derived from the natural sciences? Because people regard truth and correctness to be present only when matters are registered according to their physical, 'natural' (in a literal sense) aspect? Because that alone is real and true which can be measured, weighed and, in a word, established by physics, as it were, as to its mode of being? So that we are always compelled to call all human seeing in some respect a distortion, an adulteration or an inexactitude. Which in fact is what the writer cited at the beginning of this article did. For certainly a painting reproduces reality as the painter saw it, which is thus to say including her or his view of things, interest and lack of interest, in short, the reality of the matter in question as observed, being the person with the knowledge and insight that she or he is. Thus the painting does not present a natural scientific reality but a human reality in which belief, knowledge of the norm, insight and wisdom play their role.

We spoke above about a criterion derived from the natural sciences. But where did that come from? From this, that in our looking at things we are much more conditioned by the distinctively Western tradition than we think, a Western tradition that indeed has said for a long time that only the natural, which is to say the physical and what people consider to belong to the physical is real and true, while all the rest is subjective opinion lacking certainty. And this leads us far away from a believing acceptance of the Scriptures, to mention just this one and undoubtedly central concern.

Would this view of reality and truth, which is so strongly defined by Western humanism with its natural scientific orientation, have influenced only our notions concerning the character of photography (also in relationship to paintings)? Or does it extend deeper and further? Is it not remarkable that we as Reformed people, when we speak about knowing God from the creation or about his government and preservation of the universe,[626] often point in the very first place towards plants, animals, rock formations and the rest? In short, towards the awesome majesty of nature. Indeed, the Scriptures do that too. They speak about the facts of nature and say: 'There is no speech or language where their voice is not heard. Their voice goes out into all the earth, their words to the ends of the world' (Psalm 19:3–4). But the striking thing is that people leave it at that. Indeed, the heathen, who are estranged from God and his word, can know God from his works, the works about which Psalm 19 speaks, and are therefore without excuse according to Romans 1:20. But believers have more than the heathen because they also know God's word and the mighty acts of God it tells, sings and rejoices about, which involve much more than natural events alone. Why do we talk so little about these things among ourselves? Why do people say so readily of anyone who does talk about them that he or she is speculating and judging subjectively?

We believe that in this common way of thinking a powerful but all too little recognized influence of worldly thinking can be discerned. Someone who is estranged from God and his word no longer has anything certain to hold onto, so that whatever that person says about the 'invisible' things is just an opinion, subjective, and hence unreliable. Therefore such a person will also not say that faith comes by hearing – of God's word – but from what can be seen and touched! But whoever turns to Scripture in faith and listens to what the Lord says to us knows many things for certain and can also talk about 'invisible' things without doubt. Without being subjective in the sense of unsure, doubting, hesitating. It is not easy to cite proof texts for this from Scripture, because there are so many that one does not know where to begin. Read the last part of Psalm 18, just before the passage cited above, and notice how David speaks of the fact that God gave great deliverance. Now, would our Lord have changed since those days and must we say that that no longer holds for our time? On the contrary, the so-called 'Old Testament' element also holds for us and we may pay attention to it. Does Paul not clearly write in 1 Corinthians 10:11 that 'these things happened to them as examples and were written down as warnings'?

Scripture tells of the wonderful works of the Lord in his saving grace to humans – Psalm 107 – and sings the praise of him who preserves those who love him but destroys the wicked – Psalm 145. Too often we say that sin brings no judgment with it, which means that we also deprive ourselves of the comfort that God blesses his children here and now, in

their holy walk (Malachi 3:13–14) and beyond! But we must also see the acts of the Lord in his work in history, in his judgment of nations that did not fear him, so that not only may we see in the situation of the French government [in 1957] a fulfilment of Hosea 7:7 but also we may say that the Lord took away 'our' [Dutch] East Indies that he once gave us to administer, or, to give yet another example, that he delivered us in 1672 [from the invasion by the French king Louis XIV, who captured Naarden but could not get across the flooded Water Line to take Amsterdam]. And must we not, in the midst of wars and rumours of war, in the midst of all the terrors that still overcome humanity today, think about what he caused to be written about the course of history and his judgment of the nations in Revelation? In order that we may also test ourselves, so that the Holy One will not have to complain that we, in spite of the fact that he had spoken, did not turn from our sins, or, even more, did not even prophesy (see Amos 3:6–8).

No, we must never attempt to fathom the secret things, to know why in his providence our God and Father ordered events as he did, why he hated Esau and loved Jacob. Yet that is not to say that by the same token we should close our eyes to the mighty work that he did and does in history, in the life of nations and individuals, and in our lives too. If Scripture in both the Old Testament and the New, and particularly in Revelation, is so full of the dispensation of judgment and blessing here, in time, visible and, for those who know the Word, understandable, then it does not befit us to act as if while listening to him we are speculating or merely broadcasting an opinion.

The nations will ask, when they travel through the country of those who fell into apostasy and that he visited with his plagues: 'Why has the Lord done this with this country? What does this great anger mean?' And people will answer: 'Because they departed from the covenant with the LORD, therefore he brought upon them all the curses that are written in this book.' That is what we read in Deuteronomy [29:21–27], just above the text that says the secret things are for the Lord and the things that are revealed are for us and our children [Deuteronomy 29:29]. That firm manner of speaking that Moses puts in the people's mouths, referring very specifically to 'this book', evidently did not belong to the realm of speculation!

But enough about that! We shall have to see the acts of God by the light of his word and then speak about them with certainty and assurance, witnessing, prophesying, and calling to conversion. With assurance, fearing him and trusting him, that he will keep his word and fulfil his promises, and that he will give to his children here and now on earth what they need, if they pray to him for it with holy hands [1 Timothy 2:8]. With assurance also because when we see the acts of the Lord we are strengthened in our faith, seeing that he is the same yesterday and today. With assurance that gives us rest [in the day of trouble], (see Habakkuk 3:16).

To conclude: Are we saying anything here that is new? No, we are only following Article II [see also Article XIII] of the Belgic Confession of Faith. Neither De Brès nor Calvin ever doubted it, any more than did Groen van Prinsterer when he wrote his manual of Dutch history, *Handboek der geschiedenis van het vaderland* [1846], a work all too often forgotten or vilified even in our own circles. They all had certainty and assurance not only concerning what our God and Father does in nature but also in the history of people and nations and generations, certainty because he does not change and is faithful to his word.

• Reproductions[627]

Reproductions of works of art have always been important. Through them countless thousands of people have been brought in indirect contact with major masterpieces. This is as true today as it ever was, if not truer.

In all periods we can distinguish two basic types of reproduction: those in which the most accurate possible re-creation of the original has been aimed at – on a diminished scale or, if necessary, in another technique – and those in which the approach is more subjective, seeking to catch from an earlier work those qualities that speak more directly to the later age. This last method is to be seen both in reproductions from Michelangelo dating from the beginning of the last [nineteenth] century and in those chosen by Skira or Malraux in their works.

It is clear from these modern reproductions that present-day artistic taste is little interested in subject matter but seeks instead the concentrated, transcendent picture. It is also characterized by the emphasis it lays on colour, as is clearly evidenced by the great preference for coloured reproductions. That this goes hand in hand with present-day methods of expression may be deduced from Schrofer's landscape, for example, of which the essential characteristics are lost in a black-and-white reproduction.

The subjective manner of reproducing works of art, concentrating more on the effect than on accuracy of reproduction, is also to be seen in the way in which statues or sculptures are often photographed.

Artists wishing to reach their public through the medium of printed work will naturally try to communicate something of themselves as directly as possible. For this reason they will sometimes choose lithographic techniques or reproduce drawings in a technique that approximates as closely as possible the spirit of the original.

In any case, the study of reproductions, and the creation of them, is fascinating because we are always dealing to some extent with human understanding and interpretation of given facts.

'Dialogue with the visible,' said René Huyghe, speaking of visual art. 'The imaginary museum,' specified André Malraux, thinking of the many reproductions we are given to look at that for many people define their contact with art, surrogates for the works that hang on the walls of museums.

'Revolt of the masses,' adds José Ortega y Gasset bitterly. And he was right to the extent that the way contemporary people become acquainted with art – namely through countless reproductions of differing quality and kind – has tremendous cultural, social and even artistic importance. How many people do not judge modern art without ever having seen a work by Picasso, Appel, Riopelle or Pollock! Today we talk about art, thereby including in our scope works of all times and places even though we have seen only a miniscule percentage of it in reality. And when we do get a chance to see something at a special exhibition, we hurry through it because we lack the time. Even more, we are not really that interested. After all, we already know the works exhibited. The shock of the initial confrontation is often absent. But perhaps we are laying all this on too liberally and are looking at things too pessimistically. We hope so. And we certainly do not want to short-change the droves of visitors to the magnificent exhibitions that are being held in our day, a phenomenon that in itself is worthy of our attention.

Well then, a 'revolt of the masses'? Let us be rather more positive in our assessment and be happy that beautiful things are now within reach, accessible for many, even if only in the imagination as evoked by means of reproductions.

Certainly, Malraux is right when he says that a great devaluation has taken place of the themes, of the distinctive meaning and function of the works in question. An Apollo, a demon, a coin, a reliquary, a saint, a Baptism of Christ have lost their meaning as such and are no longer anything more than just works of art. Yet we believe there are more and other reasons for this than just the availability of numerous and inexpensive reproductions.

In all eras there has been a desire to copy great creations that are meaningful and important and to make them accessible and available elsewhere. Much medieval art is based on the more or less free imitation of a given valued example. Copies, replicas, imitations, anyone occupied with old art knows them. That was possible in an age when the work itself and not its creator appeared in the foreground, when artists were not yet individually revered as unusually endowed creators of culture.

Then, with the coming of the new era, the works of the great masters were multiplied and made available to their admirers in the form of reproductions made on the printing press. These reproductions were engravings in which the effort was made to translate the qualities considered most essential in the original into a play of black and white

lines. The spatiality of the forms was suggested in this process by a pattern of lines of greater or lesser density. Eventually other processes were developed as well: the black artprint, the aquatint etching, the dotted engraving, and more, all intended to render the tonal values of the artwork being reproduced.

Now, tastes change with the current style, with the times and circumstances. And so it is not surprising that we can distinguish in principle between two approaches to the making of reproductions. The first always applied itself to transferring the original as faithfully as possible, to rendering the Raphael or the Michelangelo or a given portrait as precisely as one's own understanding and insight permitted. The other approach, in contrast, endeavoured to copy given works in such a way that what was deemed essential in connection with one's own age and taste came out as clearly as possible. Thus a Michelangelo fresco could be made in the beginning of the nineteenth century in a typically classicist style, resulting in a lot of white, while the plasticity of the figures, their roundings, was indicated as summarily as possible by slightly thicker lines. It is an almost abstract art, which in the manner of Malevitch reduces the facts given to white on white. This style is called classicist, and people believed they had derived it from Greek (then still called Etruscan) vase decoration.

It is remarkable to see that in our time Malraux, in contrast to the classicists at the beginning of the nineteenth century, chooses an entirely different facet from the same past for reproduction: it is now the colour, the careless splodgy effect that fascinates the reproducer. For although Ivins may rejoice in his *Prints and Visual Communication*[628] that photographic reproduction has delivered us from the subjective interpretive techniques of reproduction, from the engravings and the like of earlier times, the two approaches mentioned still persist. Malraux expressly puts it as follows: 'Geniuses impose their language on their century, which thereby changes again and again, responding to them like an echo in succeeding voices. A masterpiece does not conduct a sovereign monologue but an unavoidable dialogue.'[629] Huyghe's 'dialogue with the visible' is reduced here to a dialogue not with the given reality but with artworks of all ages.

This dialogue, which is probably much rather a monologue whereby we must observe in silence how our view is trimmed back and forced into the straitjacket of our 'Malraux era', leads to the old works being robbed of their meaning. Their content and original meaning are simply shouldered aside and attention is paid instead only to those details that can appeal to modern people. It is typical that what is original and renewing is constantly put into the foreground – our own historical period seems interested primarily in the formation of the new, the cultural act. Or to say it with Malraux: 'Our taste for the isolated detail is not just a game. Precisely because the great artist seeks to renew his style and because he cannot do so other than very slowly, one finds

traditional elements in many masterpieces; yet also, in some less important works, details in which fundamental discoveries are made.'[630] And when we browse through Malraux's books we see how he applied this idea consistently. Skira, his publisher at the time, is thoroughly inspired by this idea, and in the well-known books with many reproductions we see many details, yet the whole from which the details are taken is usually withheld from us. Thus Giotto is typified by a seemingly abstract interplay of forms in red and blue. It is most remarkable how Skira, the friend of avant-garde art in Paris, is able to lift a modern painting out of a fourteenth-century fresco through the choice of a certain detail that in its construction and colouration is utterly of this day. Of fourteenth-century art, however, we learn very little in the process.

Two observations are in order. First, through the selection of such details the real theme is entirely lost to us. For example, we cannot discover from Skira's reproduction of it the theme handled in a certain work by a fourteenth-century Bolognese fresco painter. Just as in the Giotto reproduction, one recognizes here the strongly abstract interest of our contemporaries, for whom the subject of an artwork is irrelevant. And second, this shows how in our day people are much more interested in the concentrated detail than they are in extensively narrative and broadly designed compositions. Striking for example is the comparison of a drawing, *Danube landscape,* made by Altdorfer during his expressive period in about 1511 with a painting having very affinitive content, namely the Englishman Graham Sutherland's *Green tree form.* In his earlier work Altdorfer was very expressionistic.[631] Severe tensions are expressed both in the execution of his lines and in his choice of theme. In *Danube landscape* these tensions are in evidence throughout the entire landscape, which seems to be about to explode into a violent volcanic eruption, but they are specially concentrated in the strange tree with its cleft trunk. The emotions of the twentieth-century artist are similar, but he expresses himself in a much more concentrated manner. Yet it is interesting to note that Sutherland's *Green tree form* says something analogous to what is conveyed by Altdorfer in his tree.

Striking is the great interest in colour reproductions since 1945. In principle not much has changed in the technique of making reproductions, whether coloured or not. Very good results could be achieved already long before the War. But now, in our time, colour is going to play a much greater role in our judgment of art, given the much greater emphasis on the effect of colour in contemporary art. Economic possibilities certainly also play a role, but the artistic requirement seems to us a much more important motive.

The increased interest in colour reproductions may also be accounted for when we see what is lost in a black-and-white reproduction

of a contemporary work. Consider two examples. First, take a painting by Willink reproduced in black-and-white and in colour. Something is undoubtedly lost in the black-and-white reproduction; yet however serious that loss may be, it is still unmistakably the case that in the work of this painter, whose technique and concept coincide with older art, the atmosphere, construction, significance and anything else that can be considered essential are clear to us. Thus the black-and-white reproduction is a weakened representation of the original, to be sure, but one that does not damage it essentially.

The situation is entirely different in the case of a painting by Willem Schrofer. He did the little harbour in Zeeland in the fall of last year. In the black-and-white reproduction of this typical colourist, a painter who builds his work up entirely in colour, not only is the expression vitiated but what is distinctive in the work is spoiled to such an extent that many passages in it are rendered entirely obscure to us. The wharf, in front of which there looms the mast of the boat in brown, becomes a hodgepodge of lines, the meaning of the rhythmically distributed white patches is lost and, above all, the sky becomes a dull grey mass in black-and-white, while in colour it acquires vitality and movement, meaning and content. To digress for a moment, notice how this sky is saturated with tints of the same kind as the sky painted by Salomon van Ruysdael in a painting like *The ferry* which can be seen in the Mauritshuis.

After 1945

We now have arrived at our actual subject, reproductions in the Netherlands since 1945. In general it can be said that the very subjective approach that translates works to accommodate contemporary, modernist interests is hardly represented with us. Dutch art books are distinguished by a greater respect for what is given. I have in mind publications such as the following magnificent works printed by Meulenhoff. First, under the direction of Th.H. Lunsingh Scheurleer *Camera Studies of European Sculpture and Craftsmanship* presents in greatly enlarged details the small sculptures and jewellery displayed at the exhibition of 'Art Treasures from Vienna'. Each time we see the whole first, and then the details are chosen in a way that features the main points of the work as intended by the maker. Then there is A. van Schendel's *Oog in oog met meesterwerken der Hollandse schilderkunst* which presents fragments of old Dutch masterpieces. Here attention is sometimes devoted to a detail that tells us more about the way of painting and the approach of details than it does about the theme. In the back one finds small reproductions of the works in their entirety.

A Dutch innovation, as one may call it, is the collage page that gathers many artworks together on one page in order to evoke the picture of an era. Here too an abstraction is made from the artworks as such, and only their style and atmosphere are projected and allowed to

speak in the collective pattern. The principle was first applied by Dr F. van der Meer in his *Atlas van de Westerse Beschavingd*[632] where he notes in the foreword: 'The illustrations, which purposely form no complete art historical documentation . . . are intended to connect a recollection of the familiar and less familiar with the surprise of what people sometimes call suggestive confrontation. For a clear suggestion of much at once presupposes composition and a certain over-illumination of the most important aspects.' Malraux's idea of the imaginary museum is very fruitfully applied here in an entirely unexpected way.

People have often applauded the possibilities of photography since it would reproduce our artworks 'objectively'. And that is true, in part, and with the restrictions discussed above; but if one also thinks about reproducing sculpture, many questions arise. For what the photographer 'does' with a sculpture is much more than reproduce it 'objectively'. And in this respect the subjective approach to reproductions reigns supreme today. Around 1900 people made 'dry' photos using diffuse light in order to present to the eye as clearly as possible the complete sculpture with all its details. Nowadays photographers aim through their choice of angle and lighting to accent the facets of a sculpture that they consider important, or even to make something typically photographic that has little to do with the given sculpture. The photographer H. Sibbelee stuck fairly strictly to his commission when he made photographs of recent Dutch sculptures for A.M. Hammacher's *Beeldhouwkunst van deze eeuw* ([sculpture in this century] in the series *Schoonheid van ons land* [beauty of our country], the last book in the beautiful series made by the typographer J. van Krimpen. We must concede that he presented a characteristic facet in his photo of Mari Andriessen's group, but the question may still be asked whether he did not lead our eye in the direction of his own preference. Are there perhaps still other relevant facets? A comparison with a 'dry' photo may serve to make certain matters clear. In fact, Sibbelee focused on a detail in that photo, so that the group as a whole says less to us.

As I said above, the predilection for viewing the detail is typical of our time. An Englishman, Bacon, even makes a painting entitled *Fragment of a crucifixion*. Therefore it is understandable that people nowadays like to incorporate full-page reproductions, as in the catalogues of Amsterdam's Stedelijk Museum of Modern Art. For the piece thereby speaks the most clearly and the concentrated focus on a particular detail that is found in a 'small corner of life' is brought out most powerfully that way. As an example of the contemporary focus on details consider a painting by Lucila Engels, *Child on stairs*. Similarly eloquent moments are to be found in the old art, but then indeed somewhere in a small corner in the margins of a greater whole, whether a historical or genre piece. But our age seeks in such a detail the essence of things. Full-page printing strengthens this view of the small and eloquent.

There is still another reason that explains full-page reproductions. If we ask ourselves why reproducing paintings is so difficult, then the answer lies in this, that even apart from the format, the original acquires its distinctive character not only from the material with which it is painted but also from the surface on which it is executed. In printing not only is the ink different in kind and characteristics from paint – it reacts differently to light as its surface has a different structure – but also the paper is entirely different from canvas. Hence a reproduction in the middle of a page may be 'bothered' by the paper around it, since this background forms a separate element of its own in what we observe.

We want to illustrate such considerations by looking at Mondrian, an artist whose works are notoriously difficult to reproduce. In Mondrian the means of expression are reduced to a minimum and therefore all kinds of elements are more noticeable than they would be with other painters. Particularly bothersome for example in a reproduction of a Mondrian is the glossy printing paper. A great deal is gained if we reproduce the background as well, for then we see the work as if it were hanging on a wall, and there it speaks its own language. But the most favourable seems to us reproduction with copperplates on non-glossy paper and full-page. Just as a real Mondrian does not bear framing and is not a composition closed in itself, thereby working as a detail that consequently extends its artistic operation across the wall on which it hangs, so the full-page reproduction will approximate the effect of the Mondrian more closely than it otherwise would.

Artists naturally have always tried to inform the public about their work. They could accomplish that through exhibitions but also by distributing reproductions of their own work. Rubens already had a studio that reproduced his works. But modern artists, who attempt to express so much through the material in which they work, in the nuances of their way of painting, can hardly be happy with a reproduction. They will try to show the public originals. That is why the Experimentals incorporate lithographs in their publications, a graphic product that facilitates making originals in large editions that do no violence to the quick and refined strokes of the lithographic crayon that are each artist's signature. And so we want to mention here with commendation the periodical *Zwart en Wit* [black and white]. It restricts itself to pen drawings, which permit good reproduction in line block on less smooth and glossy paper. An autotype perhaps provides more nuances and miniscule details but ultimately is much further removed from a real drawing than a line block on coarser paper. It is remarkable but the most difficult works to reproduce turn out to be drawings, even those in black-and-white, perhaps precisely because in the reproduction not only the paper but the colour can be virtually or entirely identical to the original, so that the tiniest deviation and the slightest nuance in this genre, based on fine effects as it is, will be instantly noticeable.

Ivins in his book mentioned above was jubilant because photographic procedures would finally supersede the interpretive and explicatory reproductions of gravures and the like. The screen of the autotype disturbed him less. For our part we sometimes, even often, do see a loss here. Precisely the element of interpretation that the reproducing artist could once provide, could bring out more clearly the distinctive character and meaning of a work, however deprived of colour it might have been. That in photographic procedures the process became mechanical has not been all gain. And the loss of colour does not seem to bother Ivins, while it is just there that the most important difficulties lie in the making of reproductions. Even in our day!

Perhaps our discussion will have shown how much interpretation, how much of a personal touch goes into the work of a reproducer even today. Certainly the debate remains open concerning the question whether a work has been well understood and its essence grasped or whether it has been falsified. We are happy about that, for in this way this field is preserved from the robot, so that taste, insight, value, judgment and technical mastery continue to be of decisive importance even today. That is, if we remain alert to the fact that in looking at a reproduction a tripartite discussion is waged between the artist, the reproducer and ourselves. Huyghe's dialogue with the visible becomes more complicated as a result, but all the more fascinating.

Miscellaneous Exhibition Reviews

•Unique exhibition of Etruscan art[633]

Nothing is more inspiring for the art historian than to find a subject about which little is known and which contains problems that seem to defy every attempt at explanation. What else could explain the fervour with which scholars have thrown themselves into a study of Etruscan art? According to the introduction to the excellent catalogue, this fervour has not come close to answering all our questions but, on the contrary, has just served to emphasize our lack of knowledge. Yet these scholars have come a long way, for it is all their efforts that have made possible the very gripping and beautifully arranged exhibition currently being shown in the Gemeentemuseum of The Hague. Because of its excellent layout, this exhibition manages to hold our rapt attention from start to finish, and the viewer is not inclined to by-pass even the smallest works of the approximately 300 pieces shown.

Surprises

This exhibition is full of surprises. For, according to many scholars, Etruscan art (i.e. the art of mid-Italy of the Etruscans, who ruled that area before the Romans) remained strongly and very characteristically Etruscan – as opposed to the art of the Greeks, which always leaned towards the universal. It is not until you get to the second hall, when you reach art of the sixth century BC, that you see unmistakable Greek influences, but they are still incorporated in a wholly unique manner. Perhaps those very unique characteristics are the least evident in the great stone sculptures, but they are clearly seen in the ceramics with their fantastic forms (e.g. the vases with three spouts, or the vase in the shape of a fish, with a playful liveliness that is not hampered by a need to be functional, logically formed, or to be a unified whole – all of which were priorities for the Greeks).

Death cults

The goldsmith work is incredible; it comes from the seventh and eight centuries before Christ, which could be called the golden age of Etruscan art. We call it 'incredible' and with that we will abandon any attempt to give you a more detailed description of these beautiful works (large clasps and diadems, richly detailed, sometimes set with tiny stylized lions with small granular adornments). You really have to see it to believe it. The fact that these pieces are still in existence is largely because of the remarkably luxurious burial rites of the Etruscans, who showered the burial chamber with treasures for the deceased to take along. Also the wealth of bronze treasures, in rich variety, is captivating from beginning to end. They are all full of movement and convincing

straightforwardness, gripping not only because they are so unusual but also because of the rich fantasy and perceptiveness that lie at their heart. Because of these qualities, you do not easily tire of this exhibition.

Then we get the ceramics, huge sculptures in baked clay, taken from the temples, which were always made of wood rather than stone. We will not even attempt a detailed description – the overall impression is of an entirely un-Greek spirit, more daring, more direct, less harmonious, less controlled, but perhaps more appealing to us twentieth-century people.

There is one hall entirely devoted to gravesculptures, and there you get an idea of what the results are when Etruscans attempt an imitation of real classic Greek art. It is almost as if everything that the Greeks held dear in their quest for harmony, universality and purpose is turned upside down here, to become a sort of cult of ugliness. Was this due to a lack of ability, or to a conscious rejection of Greek characteristics? We will never know.

It is remarkable that the gravesculptures of a somewhat later time (which you can see further along in this exhibition), which are strongly stylized and reduced to expressive main forms, almost in concentrated form, are much more controlled and realistic, more alive and meaningful. In the same hall we find that gorgeous memorial statue from approximately 200 BC; in it we see the truly Etruscan art of the portrait in a style that helps us understand why the Romans were so particularly skilled in this – these Etruscans, after all, were their teachers. And does that head not remind one of Emperor Nero?

A historical section completes the overview of this unique culture, which has only recently been rediscovered and studied. Compared with Greek culture, it has a character all its own: less harmonious, more problematic but also richer in fantasy, livelier, more expressive. Our acquaintance with this art not only enriches our knowledge of the past but opens entirely new perspectives. In it we see entirely new, unfamiliar interpretations of human emotion, interpretations that are nevertheless thoroughly and universally human.

• The Roman portrait: classical realism[634]

It is remarkable that we actually know very little in general about the development of Roman art – and by 'we' I am referring to the interested layman, not the specialist. Could that be because we have trouble liking those Romans? Or is it related to a kind of bias, a prejudice that their art is not really worth our attention? The justice or injustice of the first reason can be tested by paying a visit to the exhibition of 'The Roman Portrait' now being shown in the Museum of Antiquity in Leiden, because the portraits shown there are of very high artistic quality. It cannot be denied that the artists who made these portraits were very, very skilled.

Two traditions are relevant to the entire development of the Roman portrait from the time of the republic in the first centuries before Christ until approximately the time of Constantine the Great: the Greek-Hellenistic tradition, which completely determines the artistic medium and technique, and the portrait's own Italian heritage. The latter determines the character of these portraits; they are geared to the exact representation of the persona – not the character, but rather the person as he or she characteristically presented him or herself in bearing, facial expressions, physiognomy. It is remarkable that sometimes you even get the idea that you have met these persons before and that you know them from somewhere. These are people just like those we see around us every day. I am thinking, for example, of that young woman: it is as if she is talking and gesturing, and we get to know her as she typically appeared; after studying this statue we would be able to tell a lot about her character and her attitude.

After Augustus, who had a preference for the Greek tradition, we see a row of emperors' busts from the first century. That Emperor Domitianus is a good-looking man, we would say today. Hadrianus is very different again, a typical nineteenth-century figure, you might say, and this portrait reminds us very much of the busts of nineteenth-century political figures. His wife Sabina had a lovely, refined appearance, but she looks like a rather capricious character. The emperors that follow are truly romantic figures: Lucius Verus even looks a little like Beethoven! However, we thought the most beautiful to be the statue of Crispina. It is a magnificent work; whether due to the natural beauty of the subject herself or because of the sculptor's expertise at creating such a captivating and fine portrait is difficult to determine.

This exhibition has been arranged very conveniently, with just a modest number of works, so that one can give each piece the attention it deserves without drowning in quantity. It is very worthwhile, particularly on Tuesday and Thursday evenings, when the evening lighting even further accentuates the unique features of each sculpture.

• Art treasures from the Vatican: early Christian art in The Hague[635]

A question often asked these days, especially in professional circles, is whether it is desirable to hold so many exhibitions of artworks from foreign museums. Besides arguing that such exhibitions expose the art to too many risks, and that with paintings, for example, there is an inevitable deterioration in the condition of the canvases, there is also the argument that a work of art has its own value. If we want to enjoy it, we have to be willing to sacrifice something for that enjoyment.

In addition, there is the drawback of seeing works of art that are inextricably bound to a certain place or surrounding out of the context in which they belong. This element cannot be replaced, no matter how well the exhibition may be arranged.

These kinds of concerns will enter the minds of many people who hear that there are now a number of art treasures from the Vatican on display in the Gemeentemuseum in The Hague. However, when you wander around and view the pieces of art, which are very diverse and from many different periods, these concerns pretty much disappear. In the first place, in this case, excellence has not been sought in the *quantity* of the pieces. There are not more than 45 works of art represented here; it is quite possible to see and absorb each one of them. In the second place, the exceptionally beautiful arrangement deserves wide recognition. We see here exceptional specimens of ecclesiastical art, arranged in such a way as to allow for close examination, an opportunity that is hardly available locally.

The pieces in question have been borrowed from the treasures of the Lateran Palace, where over the last two centuries works have been stored for which the Vatican itself scarcely has room anymore, and others which have been newly discovered by excavations, etc. Besides those, there are pieces (and these represent some of the most valuable specimens in this exhibition) that were taken from the Sancta Sanctorum, the popular name for the Laurentius Chapel, because of the wealth and special nature of these pieces; they consist of gifts and such that were given to the popes in the course of time. These include the most beautiful and valuable products of Byzantine and early Christian craftsmanship as well as the work of gold- and silversmiths.

It would be impractical for us to try to deal with every piece here. We will just direct your attention to a few notable works. There are a few very important specimens from the early Christian era, such as the famous *Good Shepherd* from the early third century, a few gravemonuments and some lamps from the catacombs. Those who have a special interest in the roots of Romanesque art will note especially the very important Byzantine applied art products from the fifth to the tenth centuries. Stylistic features like the ones found on the cross-shaped box and other pieces can be found again in Romanesque art. And a cross like the one given by Emperor Justinus in the sixth century can intrigue us not just because of its art-historical significance but also because of its unusual combination of a 'barbaric' form of art (due to the influence of the invading Goths, etc.) with an extremely refined aesthetic taste.

For that matter, the other examples we mentioned also have more than just archaeological or art-historical value; they are so gripping because we recognize them as representing some of the best art of all ages. Ancient weavings, an eighth-century choir screen (which actually would warrant an entire article of its own), goblets and reliquaries – we pass them all by without comment, and will mention only the very

special panel by Fra Angelico. Do not forget to look here at the brilliant little scenes on the predella which distinguishes Fra Angelico as a great colourist. In closing we wish to mention the famous carpets by Raphael which were woven in Brussels.

• Hokusai exposition in Eindhoven[636]

Gwakyojen – 'old drawing maniac' – that's what Hokusai called himself when he became a little older and began (as he himself put it) to finally understand something about drawing. In his opinion, it was not until the age of 63 that he started to understand the proper way to draw. And indeed his later years, which for other people often signify the 'evening' of their life, were Hokusai's most fruitful ones. With that remarkable sense of calling that truly great people can have, he devoted himself entirely to his art, ignoring everything that might increase his fame and honour, and with undiminished zeal strove to bring his art to ever greater heights of perfection.

How amazingly versatile this man was! Visitors to the exposition of Hokusai's drawings in the Van Abbe Museum in Eindhoven will be deeply impressed by that fact. Notice how he takes traditional subjects – gods, lions, mythological and legendary warriors – and draws them with a multitude of crawling, crooked lines that belong to the age-old tradition (though it must be said that he is completely at home in this technique); while beside this he is able, with an economy of means, to depict animals as they appear in nature with unequalled skill. His pages with birds, for example, are gorgeous, never excessively fussy, always suggesting swiftness and motion without sacrificing the details.

But right after making a realistic painting of a rat, he draws a centipede with an arrow in its mouth – pure fantasy. Then there are drawings of which the atmosphere and subject are reminiscent of Goya – especially in the demon stretching himself or the priest burning the scrolls. And then again we are touched by the tender poetry of nature on pages where, with quite different means, he depicts for us a butterfly on a piece of fruit, or a few insects in the water.

Also ordinary people, in all their comings and goings, draw his attention. There are drawings that give a small glimpse into a kitchen or show a scholar at his studies or portray with wonderful precision the movements of a dancer. Everything is infused with style, with pure artistry.

It is not surprising, then, that this most Japanese of the Japanese artists stands closest to the most universal of our Western artists – particularly to Rembrandt. There are surprisingly strong similarities between Rembrandt's quickly drawn studies and Hokusai's own roughly sketched figures that served the same purpose. He knew how to compose, like few others, but was also an expert in his exact representations of nature; a few quick, passionately drawn lines could

capture a human figure, and next to that he could bring to life the most delicate butterfly or a tranquil still life. Precisely because of his inexhaustible wealth of methods and subjects, because of the deeply human aspect which will not allow itself to be limited to any formula or style, because of his ability to construct as well as to imitate nature, as well as to just play around with images – because of all those things he is an artist who speaks to every viewer, and one whose significance rises far beyond the confines of place and time.

Although it was his own opinion that it would take him another twenty years of diligent study to reach his peak, Hokusai left behind (at his death in 1849, aged 89) a vast collection of almost incomprehensibly excellent quality.

So we don't have to prove that this exhibition of about 170 drawings is an event of great importance. We trust that, although there are Rembrandt and Cézanne exhibitions showing at the same time, this outstanding master artist will not be overlooked.

• Eskimo sculpture: unaffected characterization of the surrounding world[637]

In the most barren climate that you can imagine, in a land where snow and ice hardly ever disappear, not even in summer, and where almost no trees can be found, live the Eskimos. They make their living by hunting. Because by necessity they spend so much time at home – just imagine those long, dark winters – it is almost natural that they end up creating small sculptures from stone, which is the material at hand. This genuine folk-art has drawn a lot of attention in recent years, and today we can see the results when we visit the exposition in the Gemeentemuseum in The Hague.

This is true folk art, whereby the 'artist', using very imperfect tools, captures in very simple, appealing forms the everyday things that are so familiar to him. An effort is made to depict what is characteristic and significant; there is no attempt to create a narrow realistic image that is precise in the smallest detail. But there is also no attempt to create form for its own sake; the image is always faithful to reality, true and unproblematic.

The works we see here are tender, and quite inconsistent in their quality. The expertise and the talent of the artisan, of course, play a significant role. There are real masterpieces among them. Think of that mighty walrus with its young or of the bear raised up on its hind legs or of that amusing family group: an owl with its chicks.

It's not just the animals that are observed so keenly; the humans, too, in their daily comings and goings, are often very strikingly

portrayed. How sensitive, how exquisitely real is the hunter, his whole posture and every fibre of his being poised for the hunt. We could call attention to countless other details.

This art contains something unaffected and honest that cannot help but touch us deeply. You won't find here an artistic stance, a would-be attitude, a deep profundity; instead plain commonsense and down-to-earth-ness, a warmly human reaction to the surrounding world, viewed always in relation to humankind and through the eye of the hunter.

Therefore, too, these images do not have a dull scientific precision to them; but these small sculptures are charged, and the folk artist has succeeded in creating art of high quality, exactly by a carefully chosen posture and refined balancing of forms that serve the purpose of achieving the desired effect, the striking characterization of the data of reality.

This art is not primitive in the current sense of that word – the artist has perfect control of his medium, simple though it may be. There is no suggestion here of fear in the face of unknown forces of nature that so often characterizes this type of folk art. Could that be because these Eskimos are, for the most part, christianized? That would explain the positive view of their surrounding world, harsh and severe as it is.

• Wonderful Chinese art[638]

This year again the art dealer Bier (Groot Heiligland 66, near the Frans Hals museum in Haarlem) is showing a unique collection of Chinese artworks.

The appeal of this type of exposition is exactly the 'disorganization' of it. We do not find here a collection grouped by theme, style or time period but rather a lively collection consisting of interesting pieces from different eras – similar and not so similar, important and less so (though even the latter can be beautiful).

It's fascinating to sample not only the vitality of an energetic art dealer but also the beauty that was produced in such different times and in such varying styles. Among the pieces we wish to mention are some ancient symbols that served as house altars: these include the very elemental symbols of earth, sky and firmament carved out of jade.

The belt-pendant, a stylized tiger – which dates back to the Han dynasty around the time of Christ – is worthy of our careful attention not just for its beauty but also because of its affinity with the Scythian art of Siberia and regions still further west. Jade was a favourite medium of the Chinese, and there are several very delicately carved bowls that help us understand why this is so: what colour and light we see in them!

There is much from various eras that can fascinate us – for example, that funny little figure, a potter, from a much later time – but at the

pinnacle of art of all times and places, unsurpassed and accounting for the fame of Chinese art, are the gorgeous gravesculptures of the Tang period. We are thinking, for example, of that small female figure looking ahead of her with such a calm, utterly restful spirit; and of that watchman, so bellicose and anything but friendly, yet composed in such fragile beauty. But even more wonderful than all of those are the unexcelled horses, Tang horses. (For anyone who knows something about art, these were from the period that coincides with the Merovingian and Carolingian periods in Europe.)

These Tang horses are made in endless variety – sometimes glazed but often left unglazed. They display a noble power and measured calm, a controlled movement and a royal posture – monumental despite their relatively small size, with a playful airiness that has no superficiality and does not disturb their peace and earnestness. These marvels of sculpted art, with their breathtaking beauty, are always enthralling. One wonders how it is possible that something like that can still be for sale – one would have expected them all to have been sold by now?

• How do others see us? How do we see them?[639]

Art is an expression of our knowledge of, and our relationship with, the people and things around us.

This is clear in the interesting exposition showing in the Rijksmuseum for Folk Art in Leiden – an exhibition that is fascinating from beginning to end. At the start, we are shown how strangers see us, the Dutch – and we discover that their knowledge about us doesn't extend much beyond Volendam, an Amsterdam canal, and windmills beside tulip fields.

Wild fantasies

Then we come to the second level, which shows how our view of the non-European nations has changed throughout the ages. We discover that even until far into the sixteenth century there was a real lack of any true knowledge, and the wildest fantasies abounded. Here, too, we see that our perceptions of them (e.g. Indians, Indonesians and the Chinese) slowly took on the character of a stereotyped view just as they have of us. People have an eye for that which is peculiar and typical, for the strange and unique – and for little else. And then, especially in the nineteenth century just past, the interest and insight grew, so that the images we portrayed in our illustrations, paintings, sculptures and ornaments gradually reflected the shift of attitude towards those people. Think, for example, of Indians, who were first regarded as rather strange creatures, then as interesting strangers, and finally as the heroes of children's stories and adventure novels for boys.

Lie

It also occurs that lies take the place of ignorance. The artist who recorded Cook's discovery voyage in the eighteenth century presented Tahitians as noble savages equal to Homer's heroes, as pure and noble beings – whereas actually they were people living in the deepest paganism, believing in offering human sacrifices. No, anything that might disturb the idyllic image of the basically good person of the humanistic Enlightenment is not to be found in these illustrations; the truth is consciously suppressed.

Discovery

But perhaps most interesting is still the perception that other ethnic peoples have of us; in this connection, the halls with statues of Europeans as sculpted in Africa and elsewhere have a lasting power to captivate us. We see how sometimes their knowledge, too, was faulty, and that their relationship with us made true human contact quite impossible, so that the white person remained a curiosity. Yet, sometimes with acute observational skills and a masterly rendering, there is a clear understanding of Europeans, crafted in, of course, a completely indigenous style. We are thinking of that lazy man in his hammock, carried by two Africans, beautiful in its unwittingly mocking characterization. Or we think of the missionary in the Lower Congo or (and this is the one we prefer) the figure at the lectern – presumably also a missionary – from Nigeria. Naturally we often see government officials, always portrayed in their official roles. Truly impressive is the aggressive cavalry-man, so accurately characterized by an indigenous South African artist. And then we have the American pioneer with wife and child, carved by an Indian from the American Northwest – truly the picture-perfect Puritan pioneer.

Unfortunately we cannot mention everything, but we do wish to single out the Japanese artists who, though they found little grace in the Europeans, yet did not sketch them unsympathetically. The climax is the portrait of one of the founders of the ethnological collection in Leiden; we are not sure if perhaps it does an even better job of representing the man than the little Dutch portrait does, which is more in the rather dull fashion of those times.

In short, this is an exposition that sometimes confronts us with a mild but true critique of ourselves; that sometimes beautifully depicts Europeans in a completely different way from how we see ourselves; and that sometimes reveals how little those others have understood about us and how we, from our vantage point, have had a very poor insight into their nature and character. This is partly a testimony to human weakness and narrow-mindedness, but yet more often it shows a gentle understanding and love of human nature.

• Russian icons: mixture of mysticism and realism[640]

As something of an 'extra' added to the 'Pro Arte Christiana Exhibition 'now showing in the Stedelijk Museum in Amsterdam, a few rooms have been set up to display some Russian icons. These pieces, so seldom seen here, are certainly worth study and some careful attention.

On first glance they won't speak to us very much, especially because they come from a culture so foreign to us. But upon closer inspection we will be able to unlock their great beauty. Certainly a few of the pieces seem rather provincial as compared to older Byzantine art, but on the other hand it is exactly their almost folk-art character that makes them so appealing. It is hard here to distinguish between folk art and 'great' art, especially with the works from the seventeenth and eighteenth century.

What exactly is an icon? In the first place, the creators and users of these paintings distinguish them from the *jivopis* – i.e. paintings that imitate life and nature, a style discovered and imported by the West. For icon-painting is principally a traditional activity that tries to stay faithful to the images handed down through the ages and considers every change to be almost a heresy.

So we should never forget that these are devotional pieces; these icons are revered the way Catholics revere their statues. There are also miracle-working icons which, because of their fame, are often copied; these copies are made as faithfully as possible, of course, since the point is not just to have a picture but to have the icon, that venerable painting.

Strongly narrative

The oldest school is the one of Novgorod, which especially flourished in the fourteenth and fifteenth centuries. There has been much dispute about the origins, the roots of this art. It is now quite certain that its origins are found in the Byzantine art of the Palaeologist era – i.e. the end of the thirteenth and the fourteenth century. Although this art arose out of a strong tradition, it did have a very unique character due to the strong narrative element – one which we also often find in the Russian icons.

This art is shaped by a strange mixture of mysticism and realism, which in a special way form a unity. It is of a kindred spirit to fourteenth-century Italian art; this has also led to the search for a connection between the art from Novgorod and that of Tuscany, but there has been no direct connection.

Connected with early Russian frescos was the icon of Elijah from the Novgorod school at the beginning of the fourteenth century, a figure that also reminds us of German Romanesque figures; perhaps their affinity is to be found in their common source of inspiration, namely that of Byzantine art. The Christ Pantokrator icons of different eras are very expressive pieces, and they are interesting to compare. The narrative element we mentioned above is seen in the different panels

and iconostases – choir stalls meant to screen the choir of priests from the common folk assembled in the pews; smaller copies of these served as house altars.

In the sixteenth century the Moscow school would continue the tradition, while since the sixteenth century a kind of refined aristocratic school emerged under the influence of the pieces created for the lineage of Stroganov in which the aesthetic element was brought more to the fore. Finally, there were icons from the Jaroslav school, which culminated in the frescos in churches in Jaroslav at the end of the seventeenth century, where all kinds of Western influences were permitted to play a role. These icons excel in the fine modelling of the faces. In conclusion, one must remember that these icons have darkened in the course of time. Only a few pieces give us a true idea of the original colour.

• Homage to Lion Cachet[641]

It is a rare experience these days to find a Calvinist artist, a Calvinist visual artist. This is understandable, though, when one realizes that in no other field are the direction and style so dominated by the most outspokenly non-Christian trends. It should not surprise us either, then, that when we do discover a Calvinist artist, we find that he has concentrated his energies on, and found his sense of purpose in, the area of decoration and the applied arts.

A Calvinist artist

In the applied branch of art – creating designs for calendars, bookjackets, banknotes, carpets, etc. – artists are, after all, in public service, and their emphasis here, after creativity, is on skill as artisans, accessibility, and honesty of the material – all traits which Reformed people naturally possess.

Lion Cachet was such a person, and a recent book by A. van der Boom sympathetically discusses his work and purpose.[642] He follows Cachet in his maturing process as artist and in his most impressive achievement, namely the design of ship interiors. Any reader who has travelled to Indonesia will certainly have encountered Cachet's work as he was responsible for decorating the dining areas, smoking salons, music halls, etc. on ships like the *Johan de Witt*, the *Huygens*, the *Coen*, the *Johan van Oldenbarnevelt*, and the *Aldegonde*. In the period from 1920 to 1935, Cachet left his unmistakable mark in this field of interior design and was perceived as a leader and a pioneer.

It is because Lion Cachet's work had such an important influence in the history of interior design that we so appreciate the publication of this book. It is a pity that, for the most part, Cachet's work was done on

such temporary, transient structures – not to mention the fleeting nature of banknotes! – so that today there is little to be seen of his masterpieces. All the more reason to preserve this all in a book, for to lose the memory of this leading pioneer would be to fail a skilled artist, one whose genius may have had its limits (limits that he himself probably recognized better than anyone else) but who, within those limits, produced some spectacular work. The layout and the illustrations – essential in a work about Lion Cachet – appropriately give the artist his due. No one interested in this particular branch of the arts should be without this book.

• Beauty in miniature: coins from the past and the present[643]

Sometimes the opposite of a proverb is true as well: not only can small causes produce great effects, but great causes can have (literally) small effects. For when the Byzantine Emperor John Palaeologes came to the West at the eleventh hour in an attempt to heal the rift between Greek Catholicism and Roman Catholicism in order that the West might assist in the defence of his country against the invading Turks (who nevertheless did manage to conquer Constantinople two decades later, thus leaving Europe vulnerable to Turkish attack for more than a century) – during that visit an artist named Pisarello created the first coin. This coin carried the portrait of the Byzantine emperor, who had directly inherited his position from the Roman emperor; just like that round penny with portrait was directly inspired by the Roman coin!

That little piece of bronze from the year 1438 was just the beginning. Coin art flourished greatly in the years that followed, being practiced and cherished everywhere until finally, with the close of the eighteenth century, it also suffered the general decline of the sculptural arts.

The Stedelijk Museum currently is showing an exhibition in honour of the 25th anniversary of the Society for Coin Art, and its display cases give us a good idea of the best work of the fifteenth to eighteenth centuries. But these wonderful little works of art (and by 'little' we are referring only to the dimensions) are really just an introduction; the exposition as a whole attempts to give a complete overview of what has been accomplished in this field in the past 25 years. For at the end of the nineteenth century in France there was a renaissance of this branch of art, and that soon served as an inspiration to other countries, including our own.

The Society was established for the purpose of stimulating and promoting this art form by keeping alive the enthusiasm for it, and by giving artists commissions and putting them to work. What they managed to accomplish, and what levels of excellence they reached and

maintained, is clearly demonstrated by this comprehensive overview. We see the works of well-known sculptors . . . but resist the temptation to name them here, hoping instead that you will go and look for yourself.

The idea of also showing some foreign work was a good one. Not only does this help to highlight the importance of this branch of art; it also shows what style and character differences there can be despite all the limitations imposed by the relative smallness, the restriction to a round shape, and the bas-relief. The differences between the products from different countries are rather striking – but again, we will not pull the rug out from under your feet by describing it all; rather, we give you the chance to discover these things yourself.

It is certainly true that we find here one of the most pleasant expressions of modern art: the coin places high demands on the skill of the artisan and the inventiveness of the artist, and thus shuts off every inclination to childish-inane experimentalism, to bizarreness and to irrationality. Rather, we see modern art at its best and its most congenial. No one would deny, however, the truly modern nature of this work; it certainly does not just rely on old shapes and styles. Nevertheless, it knows how to keep tradition alive in a wholesome way.

• Dutch ceramics from 1500–1800[644]

Is there any person who has never heard of Delft blue? For many, however, their knowledge is limited to the name and possibly to one or two pieces, or perhaps even just to a copy. The Gemeentemuseum in The Hague is currently showing an extensive collection of Dutch ceramics, which certainly includes a great many Delft blue pieces but also many pieces made in other locations in the Netherlands.

The Dutch production of ceramics began when a few Italians settled in the southern part of the Netherlands around 1500 and set up workshops for the production of a kind of earthenware called majolica. This is a type of pottery with colourful decorative motifs which were, of course, typically Italian. Over the years Dutch people too began to produce household earthenware. In the long run these plates and other household articles succeeded in replacing, for the most part, articles made of tin.

During the years of war and religious strife (which resulted from the influence of the Reformation in these countries), certain centres in the Northern Netherlands like Rotterdam, Haarlem and Amsterdam, as well as Delft, saw a great deal of activity in this field. The polychrome character was maintained for the time being. Despite a measure of 'Dutch-ifying', the Italian and Spanish influences were still the primary determinants of the character of this work.

This changed gradually in the first half of the seventeenth century, for Europe began to import porcelain from China that became very popular – so much so, in fact, that local potters began to try to imitate it. Since they did not yet know the secret of how to produce such fine china, they tried to give their pottery a porcelain look. Therefore they copied the Chinese motifs and the technique of painting designs in just a single shade of blue. There were also imitations of the many-coloured Chinese style, but this was less common. Gradually Delft set the tone and became increasingly the main centre, though similar industries were instituted in other places as well.

In later years we see, besides the Chinese influence and imitations, influences of the German Meissener porcelain, and we frequently find French motifs as well. Towards the end of the eighteenth century, the competition of British ceramics became so great that our own country's industry declined in importance. Yet still to this day, production of this type of earthenware continues in Delft and in Friesland.

• Dutch tiles: applied art in Arnhem[645]

One of the most unusual and at the same time one of the most appealing museums in our country is the Open-Air Museum in Arnhem, where one has opportunity to view representative works of our own (rapidly disappearing) native art. When we speak of our native art, we are referring to the unique beauty of farms, farm wagons, horse sleighs, farm implements, etc. This is an art that above all serves [utilitarian purposes] while searching for an efficient form that is at the same time artistically pleasing and responsible, with much attention paid to decorative and ornamental qualities.

It was a great idea to choose one of the Zaandam houses for an exposition of ceramic tiles. For although tiles are, of course, also used in the larger cities, and although Delft was one of the centres of this artform, yet in nature and character one discovers here the typical artistic flavour that is so unique to folk art. This art is not concerned with profound thoughts or with refinement but rather with an eagerness to make something decorative; with the effect and the charm of the familiar. And at the same time (and, in the era when tile-making was at its height this would not have been perceived as a contradiction in terms) we are dealing with one of the oldest industries around. For in those times industry stood entirely separate from art in the narrower sense of the word. It certainly had its own artistic value, but it was artistry in the sense of folk art.

It is striking that it was our country that became a centre of the ceramic tile art. The tile was actually 'discovered' in Mesopotamia and with the spread of Islam was brought to Spain. From there these ideas

were carried to Italy, and from Italy to the Netherlands where finally they branched out into a large number of local industries all around the country. Perhaps our Dutch sense of neatness had something to do with that, for tiles are easy to keep clean and always have a fresh look.

It is remarkable that throughout its development the dimensions of the tiles stayed fairly constant: around 13 x 13 cm. It is more interesting still to notice the evolution of the decorations on those tiles. First they were extremely colourful, following the Italian example. The colours used were much like the typical colours of Italian Faience earthenware. The style of decorating also followed the basic lines of that pottery style, though fairly quickly people began to do what has become typical here in Holland: to incorporate animal figures. We also see some Spanish influences in those quadrate tiles with a diamond-shaped frame around the picture, but again the details remain typically Dutch. Moreover we must also note some French influences, especially in the ornamental corners which often depict French lilies; this style of ornamentation was long-lived, though often in an adulterated form, but sometimes it had to clear the field for ornamental corners with meandering figures taken from Chinese earthenware.

Those are the sorts of adornments we find most frequently on the blue tiles, often with an animal or human figure in the centre. But the height of this art is found in the gorgeous tiles with oranges, pomegranates, grapes, etc. painted in a great variety of colours. In themselves these tiles may not be as charming as the blue tiles with the figures we were just discussing, but when they are used to decorate an entire wall the total effect is extremely beautiful and gives a surprisingly restful impression. This exposition also includes a number of ensembles like this, and everything has been arranged for the utmost convenience of the visitor.

Of course there are also a number of tile pictures which form entire paintings, but these are really an adulteration of the unique character of the tile, and the result is seldom more than a rather provincial imitation of the great masters.

No, the true Dutch folk art must be found in the industrially produced tile with its charming and appropriately decorative ornamentation. There we find the most captivating pieces, the very characteristic works which, along with our old paintings, form a legacy from our past that should never be underestimated.

• Art fair in Delft[646]

'Beauty has been woven into the creation.' You might read that in a scholarly treatise somewhere, but you will only really understand what that means when you begin to notice how people of all the ages have

occupied themselves with the creation of beautiful objects; how they sometimes threw all their energies and talents into creating things that have no purpose for existing other than to be beautiful; or how they would work to create utilitarian items in such a way that they display great beauty without their practical usefulness being compromised.

Diversity and quality

The thing that makes such a deep impression on you when you first visit the art fair in Delft is the unexpected wealth of beauty, an unbelievably rich diversity, with works of art in all shapes and sizes. The variety is just awesome: Merovingian jewellery, Roman glass, Egyptian trinkets, a Congolese mask, Javanese-Buddhist art. You will see products from cultures completely foreign to us or from many centuries ago placed side by side with 'ordinary' Delft blues, Gothic sculpture, Romanesque sculpture (the profusion of sculptures from the Middle Ages is especially striking), and so on. We would draw your special attention to the Chinese porcelain. In particular, have a look at the Aalderink booth to be readily convinced of the superior quality of that art. Is that little Chinese dog on its cube-shaped base not an absolute jewel? That little dog is hardly five centimetres tall, but elsewhere you see Famille Rose vases that are more than a metre high, and if you keep looking you will be sure to see pieces of every size in between.

There are paintings too, of course. World-famous art dealers such as our own De Boer, Douwes, Cassirer, Hoogendijk and others have brought together a truly unique collection. We are especially struck by two gorgeous Salomon van Ruysdaels; a rare and beautiful Albert Cuyp painting of roosters; a lovely Terborch; and an early landscape by Adriaen van Ostade. We should also mention the important Aertgen van Leyden in the booth of the firm Nijstad. These are all names that need no further introduction for the art lover.

Museum pieces

Even if a piece of art has no practical usefulness for daily living, such as a piece of furniture or a jug or a plate would have, it nevertheless has a function in our lives. Some pieces are directly related to the political events of their time, and in such a case they will also hold special historical interest. Who would not be curious to see what the necklace looked like which Prince Maurits presented in 1606 to the King Sahib of Ternate – or, rather, what it *looks* like, for it can be found here in the booth of silversmith specialists, the firm of Premsela and Hamburger. It is remarkable that this necklace has such an oriental flavour. Then there is a goblet from West Germany, created for the occasion of the Twelve Years' Truce, apparently commissioned by the Dutch. In the Cramer booth you can see more of that type of thing – for example, the unusual decorative pitchers made up of two thick intersecting rings. Even if you find the shape too contrived, the gorgeous material and the

workmanship will certainly win you over. In the Cramer booth you will also see an absolutely unique piece of bronze entitled *Horse with rider* – a stunning Venetian piece from around 1500. From that same region, though it was created nearly a century earlier, there is an ivory cabinet of rare beauty, a so-called Embriachi cabinet, impressive and grand, a real museum piece. For that matter, there are a great many objects here that really belong in a museum.

Quality

It is striking that all those divergent works of art, each one of good or exceptional quality in its own right, do not become a chaotic curiosity collection when they are all mixed together at this fair. If it were so that each genre of art had its own completely unique set of standards for beauty, its own unique character and structure, then such a diverse group of pieces would not really be enjoyable at all. If there was nothing at all that tied them together, it would just become a chaotic mess. But the truth is that with these products of applied art and these small works of art we discover that there really is just one criterion which can be used to judge them all, and for lack of a better word we use the word 'quality' to describe this – or, if you will, 'beauty'. This art fair offers a rich diversity of concrete examples of such quality.

• L'italia splendida: life as a feast[647]

It was a great idea for the Gemeentemuseum in The Hague to call our attention for once to the beautiful object, and it did so via a gorgeous exposition of Italian ornamental art. We see here how human beings are inclined to decorate, to make the things that surround them rich and beautiful, in particular those things that are close to their hearts. These things are thus elevated above everyday, common life by the richness of the materials and the skill of the artists.

So we find beautiful religious objects from Romanesque times – rich, tasteful, and always sober; in these objects the images of saints etc. are subordinate to the whole, which derives its meaning and significance from these things. In Gothic times the decorations became more and more exuberant; at times we must almost say that the decorations show a childish excess. What saves the chalices and procession crucifixes from being called kitsch is the artistic style of presentation, the stylish composition of the subject, although occasionally we are tempted to use words like 'bombastic' or 'barbaric taste' to describe them.

But it's always genuine, and that cannot always be said of the pieces of Baroque art made during the Counter-Reformation. At that time, every object had to proclaim the power and greatness of the church, and they did not shrink from presenting glittery façades. We think, for example, of those lecterns that were richly decorated with Scriptures

and radiated a sense of gold, wealth and beauty, while the thing itself turned out to be just made of wood. Yet there is something grandiose in this ecclesiastical style that expresses itself in such a pure and self-controlled way in these overdone and yet artistically responsible objects (worldly as they may be).

Perhaps we find this grandeur of life, this testimony to wealth and power, and also the sense of beauty, more clearly expressed in the objects with which the greats of the Renaissance (and later) surrounded themselves. Indeed, anyone living in a palace furnished with the most beautiful frescos and the most splendid sculptures can hardly sit at a table that holds, next to a magnificent bronze inkpot, anything less than the vase made of splendid and expensive lapis lazuli and decorated with gold and enamel. They are luxurious items that fit with the grand lifestyle of the powerful in this world; they testify to the pomp and style with which such people play their role. We think of that incredible sculptured throne, that splendid mirror from the eighteenth century or that family crest in beautiful coloured earthenware – each a work of art in its own right.

Those ornaments, those objects – testify to a taste for quality, so that despite all their excess they are never showy but rather always responsible and classy, always artistic and a delight to the eye.

It's a different world from that of the Calvinists; different also from that of the democracy we live in. But what should hinder us from finding enjoyment in it, indulging in it, if you will, even if just for a few moments? What we can learn from this is artistry and good taste, a feeling for beauty and its meaning in our life; and those are qualities which we, the people of the twentieth century, too often lack.

• The English landscape in Sussex[648]

If you ever have the fortune of visiting the magnificent late sixteenth-century country home Parkham Park in Sussex (in southern England) you will, after the official tour, be given the following worthy and memorable advice: 'Make sure you go into the park. But note: nobody knows where the garden ends.' Truly, that's how it is in southern England – the landscape is like one huge park, a park that contains nothing forced or contrived but just naturally looks like that.

It won't be surprising then, to learn that in the eighteenth century it was the English who invented the art of 'landscape gardening' – the unrestrained, natural garden that just looks like a piece of nature. This was in sharp contrast to the over-cultivated and far too mathematically organized French gardens. The gorgeous landscape, for which the English already had a special eye and a deep love in earlier centuries, evidenced by the placement of their country homes, their village

churches and farms, and the arrangements of their gardens, which always blend in so beautifully with the surrounding landscape (forming, in a sense, a unity with it) – that landscape must have been a deep inspiration to them.

When you drive through Sussex or Hampshire or Somerset you get the impression that generations of artists have been busy for centuries, placing each tree in just the right spot and carefully rearranging and softening the contour of every hillside.

This demands a love for tradition – a love for what previous generations made and devised. Sometimes it's easy to make the perhaps exaggerated English desire for the traditional look ridiculous, but it also has its positive side. Tradition provides stability, solidity. Old habits don't seem like relics to the English in the way they do to us; they don't see them as piously cultivated, useless vanities. Rather, here the old is still a living, daily reality and is not just for show. Old customs, historical locations, old churches and homes are not seen as museum pieces. Instead, they are part of modern life and, as a matter of course, serve their purpose. Continentals feel clearly how the many wars and revolts experienced in our own country have taken their toll, cutting loose and destroying things, breaking ties.

Tradition have its dangerous side, but we must not close our eyes to much good that is kept intact by tradition. The English landscape, preserved in all its beauty and not defaced by ugly dwellings, is the expression of a way of life, a way that purposefully allows beauty its rightful place.

Notes to Volume 4

Part I: Western Art from the Middle Ages through the Nineteenth Century

1 *Ad Fontes* 11 (1963) pp.37–42.

2 For other articles belonging to this series, see in this volume: 'About the Content of Medieval Works of Art'; 'The Art of the Fifteenth Century'; 'Baroque Art'; 'Theme, Style and Motif in the Sixteenth and Seventeenth Centuries'; 'Principles of Nineteenth-Century Art'. See also in volume 5, 'Form and Content of Modern Art'.

3 *Ad Fontes* 12 (1964) pp.65–72.

4 For the 'previous article', see 'About the Content of Works of Art'; for later articles in this series, see 'The Art of the Fifteenth Century', 'Baroque Art', 'Theme, Style and Motif in the Sixteenth and Seventeenth Centuries', and 'Principles of Nineteenth-Century Art' in this volume of the *Complete Works*.

5 *Stijl* 1, 11 (1952) pp.241–246.

6 C.f. C.R. Morey, *Mediaeval Art* (New York, 1942) p.253 ff. This is one of the best works about medieval art.

7 An additional gift.

8 See R. Briffault, *Les Troubadours et le sentiment romanesque* (Paris, 1945). Furthermore, underlining the pagan aspect, but in contrast to Briffault considering this entire poetry as a kind of sacred art, dissociated from any existing reality: C.B. Lewis, 'Survivals of Pagan Cult – the Loved one far away', in *Evangelical Quarterly* (October 1934).

9 Albert Magnus in *De Sacramento Altaris*, ch. 31, cited in Prof. Dr J.J.M. Timmers, *Symboliek en Iconografie der Christelijke Kunst* (Roermond-Maaseik, 1947) no. 820. I attempted to translate the Latin.

10 E.g. Emile Mâle, in his four-volume standard work about *L'art religieux du moyen âge en France*.

11 Du schufst aus fremden Volkes fremden sang, / Das liebeschwerste Lied, das uns erklang.' In 'Strassburg' (1920) cited in H. Haug: *Le Musée de l'oeuvre Notre-Dame à Strasbourg* (1931) p.14, note 1.

12 "Süss gebildet überall, / lang und hoch gewölbt und schmal, / Gestellet in dem Kleide, / Als hätt de Minne sie geschaffen, / Sich selbst zu einem Federspiel. / Da war der Rock geengt, / Und nah an Ihren Leib gedrängt, / Mit einem Gürtel, der lag wohl, / Wie ein Gürtel liegen soll, / Der Rock, der war ihr heimlich, / Er schmiegt sich an den Leib. / Er trug an keiner Stelle auf, / Und suchte allenthalben an, / Ganz von oben hin zu Tal, / Und legte sich in einem Fall, / Mit vielen falten um den Fuss.' Taken from an article by D. Roggen, in *Gentse Bijdragen tot de Kunstgeschiedenis* XIII (Antwerp, 1951) p.259. In this article he shows how Eve in Van Eyck's Ghent *Altarpiece* was also painted in accordance with the courtly ideal of women of the beginning of the fifteenth century.

13 See e.g. S. Dubnow, *Weltgeschichte des Jüdischen Volkes* (3 vols., Jerusalem, 1937) II: p.184 ff. about Strasbourg, see also p.244 ff.

14 *Philosophia Reformata* 14 (1949) pp.58–100, 'An Investigation into the

Relationship of Religion and Faith to Culture and Art'.

[15] Cf. Prof. Dr H. Dooyeweerd, *Wijsbegeerte der Wetsidee* (Amsterdam 1935), hereafter: *W.d.W.* II, pp.266, 267. In English: *New Critique of Theoretical Thought* (Philadelphia 1954), hereafter: *NCTT* II, pp.336–337.

[16] The term 'ideal' always indicates a pointing to, and an anticipation of, something.

[17] The Christian Cosmonomic Idea is not the same as the confession of faith, but is not independent of it. The confession of faith is the positivization of the faith norm. All 'other' confessions receive their positive form in anticipation of the faith norm. Thus it will be impossible for the Cosmonomic Idea to come into conflict with the confession of faith, since the first is dependent on the last. Both the Christian confession of faith – the confession of the church – as well as the Christian Cosmonomic Idea, are ultimately rooted in God's word, without which they would have no meaning.

[18] It is neither possible nor necessary, within the scope of this article, to subject the historical law sphere to further analysis. The reader is referred to *W.d.W.* II, pp.139ff. (*NCTT* II, pp.192ff). A more concise, clear discussion can be found in Prof. Dooyeweerd's *Inleiding tot de encyclopedie der rechtswetenschap*, a stenciled publication from Hanenberg, N. Keizersgracht 46, Amsterdam, pp. 67–94.

[19] When discussing the aesthetic and art-historical questions in this article we have limited ourselves exclusively to the visual arts. Definitions and examples are specialised in this area. Of course the general states of affairs analysed here are also valid for other types of art, allowing for the necessary changes.

[20] Strictly speaking it is incorrect to speak of art here, as it really concerns only the aesthetic function. Considering the all-dominating place that the latter occupies as the leading function in a work of art, we think we can use the term here and below without possibility of confusion. In this term we include both the aesthetic activity of the artists as well as the objective works of art directly connected to them.

[21] The term was first used by Riegl and Tietze, and has been applied generally by the Vienna School of art historians. Cf. W. Passarge, *Die Philosophie der Kunstgeschichte in der Gegenwart* (Berlin, 1930) pp.6 ff and pp.50 ff.

[22] The cultural idea may be defined as the positive form of the anticipation to faith. Cf. *W.d.W.* II, pp.185, 199–200, 219–220 (*NCTT* II, pp.246–248, 268–270, 291–292).

[23] Compare, for example, H. Pirenne, *Histoire de l'Europe des invasions au XVI siècle* (Brussels/Neuchatel, 20th edition) p.296.

[24] In the sixteenth century, for example, Gothic art continued to be effective for a very long time and, especially in the area of ecclesiastical art and architecture, was still almost always normative.

[25] As examples we could perhaps mention Cézanne and van Gogh.

[26] Think of the work of Rembrandt after c. 1650.

[27] In this connection we may perhaps cite the schools of the Carracci and of Caravaggio.

[28] See his *Gedanken über die Nachahmung,* § 79.

[29] Ibid., § 6.

[30] See Hamann, *Die Deutsche Malerei vom 18. bis 20. Jahrhundert* (Leipzig, 1925) pp.38, 39 and P.F. Schmidt, 'Der Pseudo-Klassicismus des 18.

Jahrhunderts', in *Monatsheft für Kunstgeschichte* VII (1915) pp.372 ff.

31 *Gedanken über die Nachahmung der Griechische Werke in der Malerei und Bildhauerkunst* , §32.

32 As to the classicistic doctrines see also L. Hautecoeur, *Rome et la renaissance de l'antiquité* (Paris, 1912) and Justi, *Winckelmann und seine Zeitgenossen* (2nd edition, 1923, 3 volumes).

33 It is true that sometimes people very intently thought about influencing ideas in the 'Chinese' direction. For example, Henri Bertin suggested that to Louis XV as a means of 'reformation'.

34 See Dr M.E. Tralbaut, *Vincent van Gogh in zijn Antwerpse tijd* (Amsterdam, 1948).

35 See *Philosophia Reformata* (1946) p.151.

36 We find a clear example of what we mean by the *schildersbent* ('painters' gang') of Dutch painters in Rome during the seventeenth century. The so-called 'school of Fontainebleau', which originated in 1848, is also a clear example.

37 This was especially strong in the nineteenth century when the bohemian idea came into existence under the influence of Romanticism. This idea implied inter alia that the artist was a special kind of person, who was not subject to the usual rules of convention, custom and morals. It expressed itself in an eccentric way of dressing, amongst other things. Cf. T. Craven, *Modern Art* (New York, 1940) ch. I: 'Bohemia'.

38 See Pirenne, *Histoire de l'Europe*, p.400 ff.

39 Ibid., pp.428 ff.

40 It is strictly speaking possible to distinguish between humanism as the educational ideal of the ancients and humanism as the world view that has been dominant for all of modern history since the Renaissance. We will return to this distinction later.

41 It could be argued that film has great cultural power. But it takes up its powerful, and therefore dangerous place more as a means of recreation than as art. It is precisely as a generally accepted means of distraction and entertainment that film possesses such significant cultural power. On the most important elements of modern film, see A. Comfort, *Art and Social Responsibility* (London, 1946) pp.63 ff. By the way, this book is written in an existentialist spirit.

42 See *Philosophia Reformata* (1946) pp.154 ff.

43 This is especially the case in the Byzantine Empire. See P. Lemerle, *Le style Byzantin* (Larousse) pp.20 ff.

44 On this topic, see *W.d.W.* III, pp.319 ff. and *W.d.W.* II, pp.237 ff. (*NCTT* III, p.346 ff. and *NCTT* II, pp.309 ff.)

45 Sciences such as anatomy and biology can make a real contribution to the disclosure of naïve experience. Without a sound knowledge of anatomy Rembrandt could not have painted his famous *Anatomy lesson of Dr Tulp*. And yet, such a disclosure does not necessarily have to happen through science. It was certainly not the case with the Greeks. See, for example, W. Deonna, *Du miracle grec au miracle crétien* (Basle, 1945) I, p.220.

46 Cf. *W.d.W.* II, p.191 ff. (*NCTT* II, pp.259 ff.). Such a course of events can be observed in the Middle Ages. Very few artists' names have been handed down to us from before the thirteenth century. It is, in a certain sense, quite accidental that we know these names. It is not of great significance

whether or not we know that someone with such and such a name made this or that work of art. From the thirteenth century we know more artists by name, so that they become more 'accessible' as creative, artistic personalities. From the fourteenth century onwards a great number of names have been handed down to us. The fact that we cannot do much with these names, especially those from the other side of the Alps, can be blamed on the circumstance that it is often difficult to assign works to a specific artist. Also, the number of lost works of art is too big to enable us to get a clear picture of the life and work of such a personality. Only with respect to the fifteenth century are we able to get a clear picture of the life and works of artists.

47 We do not wish to go into the differences of opinion about the boundaries of the Middle Ages. Unless it is possible to define the unique character of this period, that in which it deviated from what came before and afterwards, such a discussion has very little meaning.

48 Pirenne, *Histoire de l'Europe*, p.241: 'Frédéric personellement, était, si l'on veut, un libre penseur, mais il fut le contraire d'un anticlérical. De théorie politique, il n'en a pas d'autre que ses contemporains.'

49 Cf. R. Briffault, *Les troubadours et le sentiment romanesque* (Paris, 1945) especially pp.87 ff. C.B. Lewis, 'Survivals of Pagan Cult' in *Evangelical Quarterly* (Oct. 1934), where a totally different vision than that of Briffault is presented, but in which also the pagan character of this art form is put forward.

50 On this subject see, e.g., Simon Dubnow, *Weltgeschichte des Judischen Volkes* (3 volumes, Jerusalem, 1937) pp.94ff, pp.101ff, and the work by Briffault, cited above, passim, esp. pp. 24ff and pp. 141ff. Furthermore, it needs to be remembered that in Toledo, from c. 1150 till c. 1250 a busy translation activity was developed, in which Arabs, Jews, as well as Christians cooperated.

51 Pirenne, *Histoire de l'Europe*, pp.295–296: 'L'agitation est partout, dans les esprits comme dans la politique, dans la politique comme dans la réligion, et cette agitation parait bien proche du désarroi. On souffre et on se remue plus qu'on n'avance. Car le seul sentiment dont on ait nettement conscience, c'est celui de ces maux. On veut y échapper sans savoir par où, ni comment on n'a rien à substituer à la tradition, qui pése sur soi et on ne parvient pas à s'affranchir. Si ébranlées qu'elles soient, les vieux idées subsistent et on les retrouve partout, modifiées sans doute ou alternées, mais sans présenter des changements essentiels.'

52 This term is by Troeltsch, who uses it to indicate the time when the church was the all-dominating factor, i.e. when the whole culture bore an ecclesiastical imprint.

53 Pirenne, *Histoire de l'Europe*, p.183.

54 Ibid., pp. 316 ff., for example.

55 See Prof. Dr D.H.Th. Vollenhoven, 'Christendom en humanisme van middeleeuwen tot reformatie', *Philosophia Reformata* (1946) p.116.

56 E. Mâle, *L'art réligieux en France III: L'art religieux de la fin du moyen âge en France* (Paris, 1931) p.89 passim.

57 Cf. among others: J. Boheim, *Das Landschaftsgefühl des ausgehenden Mittelalter* (Berlin, 1934).

58 Dr A. Weese, 'Skulptur und Malerei in Frankreich XIV-XV. Jahrhundert', in *Handbuch der Kunstwissenschaft*, p.99: 'Ueberall sind die Einzelpersonen Masstab und sogar Zweck für künstlerischer Unternehmungen.'

[59] Horaria are shortened editions of the psalters, which also included prayers. They are intended for personal use. 'Piety in the fourteenth century was ... seeking comfort elsewhere than in the church,' says Morey, *Medieval Art* (New York, 1942) p.350.

[60] E. Hintze, 'Der Einflusz der Mystiker auf die ältere Kölner Malerschule' (Breslau, 1901, dissertation) p.28.

[61] Weese, 'Skulptur und Malerei in Frankreich', p.83: 'Fast scheiden sich die beiden Stile nach den Gegensätze von Kirche und Hof, von Wirklichkeit und Kirchlichkeit, um für Natur und Gegenwart die neue Erzählungskunst, für jenseits und Geschichte die alte Formelhaftigkeit in Anspruch zu nehmen.'

[62] J. Huizinga, *Herfsttij der Middeleeuwen* (6th edition, Haarlem, 1947) pp.254–255. An English edition (*The Waning of the Middle Ages*) was first published in 1924 by E. Arnold in London.

[63] Ibid., p.227 ff, pp.224, passim.

[64] Panels were not yet common during that time. We already mentioned the reason for their popularity.

[65] A titulus is an explanatory text or name that accompanied the pictured history or person, in order to indicate what or whom the picture represents.

[66] We would prefer to say 'realistic', in a philosophical sense.

[67] Prof. Dr E. de Bruyne, *Hoe de menschen der middeleeuwen de schilderkunst aanvoelden* (Antwerp/Utrecht, 1944) pp.27–28.

[68] M. Dvorak, *Kunstgeschichte als Geistesgeschichte* (Munich, 1928) pp.72 ff.: Claritas: 'die sinnliche Merkmale der Dinge zum adaequaten Ausdruck der ihnen zugrunde liegenden Ideen gestaltet sind.' Integritas: 'das heisst Vollendung, die sich sowohl auf das geistige als auch auf das körperliche bezieht und die, was das letztere anbelangt, vorhanden ist, wenn den Körpern nichts mangelt, was ihrer Natur nach als wesentlicher Eigenschaft aufzufassen ist.' Consonantia: 'wobei von jeder Schönheit eine Spiegelung der harmonischen Reziprozität zwischen den Urgedanken der Schöpfung und ihrer Ausstrahlung in irdische Dinge geforderd werden muss, deren Wahrheit, Schönheit und Güte in der Uebereinstimmung mit den göttlichen Ideen zu suchen ist.'

[69] Ibid., p.72: 'Zusammenfassung aller weltlichen und überweltlichen Dinge in einen nach ihrer Bedeutsamkeit abgestuften Aufbau ... wobei die höhere Stufe durch das Ausmass der Allgemeingültigen, Bleibenden gegenüber dem Einmaligen und Verganglichen charakterisiert erscheint. In der Allgemeingültigkeit der höhere Stufen liegt aber zugleich die aufsteigende Vereinfachung.'

[70] Ibid. p.72: 'Während in Figuren und Szenen, die Menschen und Ereignisse in ihrer irdischen Begrenztheit schildern, zusammenhangloser Andeutungen einer individuellen Wirklichkeit häufiger waren... versuchte man überall wieder die Gestalten die die bleibende Ideale der Christenheit bedeuten, auch in ihrer körperliche Erscheinung als Paradigmen einer konzentrierten Wesenhaftigkeit darzustellen, die an Stelle des zeitlich und individuell Bedingten nur das der ideellen Konstruktion einer höheren Daseinsstufe enthält, worauf die Linien, plastische Formen und Farben reduziert werden.'

[71] Morey, *Medieval Art*, p.259.

[72] See Dvorak's article: 'Idealismus und Naturalismus in der gotischen Skulptur

und Malerei' in his book already cited above, *Kunstgeschichte als Geistesgeschichte.*

[73] Cf. Mâle, *L'art réligieux en France* III, p.224ff., passim. This mannerism in iconography, whereby people often adapted old symbols, themes and ways of representing while no longer understanding their deeper meaning, continued for a long time, even to the sixteenth century – alongside the new that mysticism brought. In the ecclesiastical sphere, the new tendencies could not effect inspiration, so that people allowed themselves to be led by the old schemes when decorating churches and such. At most, the repertoire of allegorical and symbolic motifs was somewhat enriched. For example, the number of 'sybils' was increased considerably.

[74] See illustrations XXVIII, LII, LIV, XXIV and XCV in H. Martin, *La miniature française du XIIIe au XVe siècle* (1923).

[75] See e.g. the miniature of the Crucifixion in the missal of Senlis of 1393 and the same subject in the missal of St Généviève, illustrations LII and LIV respectively in Martin, *La miniature française du XIIIe au XVe siècle.*

[76] So also, e.g., in the *Petites Heures du Duc de Berry*, the work by Jacquemart de Hesdin, which is linked to the school of Jean Pucelle.

[77] Weese, 'Skulptur und Malerei in Frankreich', p.53: 'Ein sienesischer Einschlag kam derart in das an sich schöne Gewebe gotischer Malerei und verband sich mit ihm leicht und ohne technische Schwierigkeiten oder innere Wiedersprüche ... Siena und die Gotik schöpften aus dem gleichen Seelenstrom der Passionserfindung.'

[78] See the introduction of the article by Paul Durrieux about the art of painting of that period in Michel, *Histoire de l'art* III, 1.

[79] For example, the Duke of Berry imported from Italy old-Christian ivories as well as contemporary ivory work – e.g. an 'Embriacci' altar – as well as all kinds of other works of art of smaller proportions. In this connection, see Troescher, *Die Burgundische Plastik des ausgehenden Mittelalters* (Frankfurt am Main, 1940) ch. III.

[80] See Mâle, *L'art réligieux en France* III, pp.32, 33. He gives various other examples.

[81] Ibid., pp.28 ff.

[82] Ibid., pp.12.

[83] See Prof. Dr J.J.M. Timmers, *Symboliek en iconografie der christelijke kunst* (1947) no. 71/75.

[84] Mâle, *L'art réligieux en France* III, pp.85 ff.

[85] See the magnificent publication with coloured reproductions of the most important miniatures from this work, *Les Grandes Heures de Rohan*, in the series *Les trésors de la peinture française* (Geneva: Skira). For the provenance, etc. see: J. Porcher, 'Two models for the "Heures de Rohan"', *Journal of Warwick and Courtauld Inst.* VIII (1945) p.1 ff. Of course, there are more instances of a stylistic formation determined by a universalistically directed leitmotiv, e.g. with William Blake, often with Eastern art – see e.g. *Studio* (Febr. 1948) p.41 passim. – also more than once with the modernists – as one example among many, see Michael Ayrton, illustration in *Studio* (March 1947) pp.80, 81.

[86] An exception is the memorial statue of Isabella of Aragon in the cathedral of Cosenza, dating from the thirteenth century. Here a death mask was copied for the head, and the figure is in a kneeling position. See Mâle, *L'art réligieux en France* III., p.422.

[87] Troescher, *Die Burgundische Plastik des ausgehenden Mittelalters*, ch. II.

[88] See Durrieu, in Michel, *Histoire de l'art* III, p.127.

[89] Maeterlinck, *Le genre satirique dans la peinture flamande* (Brussels, 1907) p.158: 'Il est à supposer cependant qu'elles présentèrent les caractères essentiels de notre art national, c'est à dire l'individualisation des types.'

[90] Cf. also Prof. Dr S. Leurs, *Geschiedenis der Vlaamse kunst*, 1941, p.105, and Durrieu, in Michel, *Histoire de l'art* III, p.115.

[91] Morey, *Medieval Art*, p.378.

[92] *L'art réligieux en France* III, p.177 passim.

[93] Troescher, *Die Burgundische Plastik des ausgehenden Mittelalters*, ch. V. The antependium referred to was shown at the Viennese Exhibition, Amsterdam 1947, catalogue no. 317.

[94] E.g. on a capital of St Hilaire de Poitiers. See the illustration in M. Denis, *Histoire de l'art réligieux* (Paris: Flammarion) p.44.

[95] See Millar, *English Illuminated Manuscripts* I, ill. 77.

[96] Koninklijke Bibliotheek 78 D 40.

[97] Alexander Neckam already described such training of monkeys and dogs in the twelfth century. See L. Maeterlinck, *Le genre satirique dans la peinture flamande*, pp.52, 50.

[98] See Reau-Cohen, *L'art du moyen-âge et la civilisation française* (Paris, 1935) pp.385 ff. and Maeterlinck, *Le genre satirique dans la peinture flamande*, pp.46, 69, 103, 110, 122.

[99] For example, we see an eagle catching a hare in a 'footnote' in the breviary of Belleville from the hand of Jean Pucelle, ill. In Martin, *La miniature française du XIIIe au XVe siècle*, XLVII.

[100] See Durrieu, in Michel, *Histoire de l'art* III, p.124

[101] Cf. G. Soulier, *Les influences orientales dans la peinture toscane.*

[102] A. Bey Sakisian, *La miniature persane du XII au XVII siècle* (1919) ill. III ff. However it may have been, this chapter on art-historical coherence still needs further careful study.

[103] Morey, *Medieval Art*, pp.385 ff.

[104] According to recent research, the *caccia*, the musical hunting piece, is also of French origin. In general, we may say that the music of this time certainly should not be underestimated with respect to its place in society. Music ensembles were started at the courts. The music that was composed for them is of the highest importance for music history. Many of the elements noted in the visual arts can also be found in music. Unfortunately, this art is practically inaccessible for the non-musicologist, since these works are hardly ever presented, and certainly not often enough to enable an independent judgment to be given. For this subject we refer to Prof. Ch. van Borren, 'De Franse en Italiaanse Ars Nova in de XIVe eeuw', in *Algemene muziekgeschiedenis*, edited by Prof. Dr A. Smÿers (Utrecht, 1940) p.74 ff.

[105] See, e.g. the illustration in P.A. Lemoisne, *La peinture française à l'époque gotique* (Paris/Florence, 1931) plate 8. For those who wish to view this and other examples, and form a picture for themselves of the art of painting of this period, we recommend an easily obtainable little book, *Peinture française des origins au XVIe siècle* (Editions Braun & Cie).

[106] Durrieu, in Michel, *Histoire de l'art* III, p.112: 'Des arbres de chênes et des

daims d'après le vif, avec tot le champ de la litière glacée de fin vert, à l'huile, tout orné de feuilettes et de fongeres vertes, et sur le bais et les côtes, une chasse de daims et de chiens.'

107 Martin, *La miniature française du XIIIe au XVe siècle*, p.43 ff, ill. LXV and LXVI.

108 Bibl. National Paris, fr. 616.

109 During this period we also see a renewed interest in the problem of perspective, strangely enough first with the theoreticians. The *perspectiva* derives from Alhacen: in this manner the Hellenic knowledge about perspective is given to the Middle Ages via the Arabs. Already at the end of the thirteenth century the various theories are summed up in Peckham's *Perspectiva communis*. This work was consulted till far into the Renaissance period. See Prof. B. de Bruyne, *Hoe de menschen der middeleeuwen de schilderkunst aanvoelden*, (Antwerp/Utrecht, 1944) p. 44 ff.; Kern, *Grundzüge linear-perspectivischen Darstellung in der Kunst der Gebrüder van Eyck und ihre Schule* (1904); and R. Muther, *Renaissance der Antike*, p.23 passim.

110 This is most likely the name of the Master of Flémalle, who is considered with great certainty to be the instructor of Rogier van der Weyden

111 Troescher, *Die Burgundische Plastik des ausgehenden Mittelalters*, p.141 ff.: 'Sluter war wegbahnender Führer und Vorkämpfer in dem Ringen um de Erkenntnis und Wiedergabe des Naturalistischen.' 'Die Interesse von Beauneveu galt nicht sosehr die Wiedergabe des Individuell-charakteristischen und einmalig Besonderen.'

112 Prof. Dr August Vermeylen, *Van de catacomben tot El Greco* (Amsterdam, 1946) p.178.

113 Ibid., p.185–186.

114 J. Huizinga, 'Het probleem der Renaissance', in *Tien Studiën* (1926).

115 See Prof. Dr D.H.Th. Vollenhoven, 'Christendom en humanisme van middeleeuwen tot reformatie', *Philosophia Reformata* (1946) p.137–138.

116 In 'Het probleem der Renaissance'.

117 This Romantic inclination can also be found with e.g. Petrarch and Cola di Rienzi.

118 Huizinga, *Waning of the Middle Ages* ('Herfsttij der Middeleeuwen', 1947) p.460).

119 Ibid., Dutch edition, p.93.

120 Ibid., Dutch edition, p.253 passim.

121 See R. Muther, *Renaissance der Antike*, pp.49 ff.

122 J. Hansen, *Zauberwahn, Inquisition und Hexenprozes im Mittelalter* (1902) pp.435 ff. The first edition of the famous and infamous *Malleus malleficarum* by Institoris and Spenger appeared only in 1487.

123 See, e.g. J. Adhémar, *Influences antiques dans l'art au moyen âge Français* (London, 1939).

124 For the time being I suspect that fifteenth-century Italian art was guided in its main currents by an objectivistic partial-universalistically directed leitmotiv. At around 1500 subjectivism gained the leading position with the work of Leonardo da Vinci, Raphael and Michelangelo. In the North, around this time, partial-individualism would win over individualism. The growing interest in the classics will have to be ascribed to Italian influences: for Italy received a tremendous aesthetic power – both subjective and objective – as a result of the respect it gained in the North for its art.

125 See e.g. R. Hamann, *Die deutsche Malerei vom 18. bis zum Beginn des 20. Jahrhunderts* (Leipzig, 1925) p.391.

126 See M. Dvorak, 'Die Anfänge der christliche Kunst' in his repeatedly quoted *Kunstgeschichte als Geistesgeschichte* .

127 Wölfflin, *Kunstgeschichtliche Grundbegriffe* (Munich, 1924).

128 In his repeatedly quoted work, i.e. *Kunstgeschichte als Geistesgeschichte* (Munich, 1928). Dvorak belongs with regard to his concept of history to the school of Troeltsch.

129 *Stijl* 1, 3 (1952) pp.37–40.

130 One may be inclined to apply Revelation 11 – where the time is mentioned when the two witnesses lie dead in the streets of Jerusalem, which has degenerated into Sodom and Egypt – to the thirteenth to sixteenth centuries. The resurrection of the two witnesses should then be seen in the Reformation.

131 If the name of the maker of a certain work of art or a group of works is not known, they are often given temporary names – as it is often difficult to irrefutably connect the names from written sources with certain works of art that were handed down to us unsigned. Thus, the artist of a certain group of works was given the name 'Master of Flémalle', and one supposes that he is identical with a certain Campin, but complete agreement about this has not yet been reached.

132 A part for the whole.

133 *Stijl* 1, 8 (1952) pp.161–166.

134 From *Experimenten* by Geerten Gossaert.

135 *Ad Fontes* 12 (1965) pp. 137–143.

136 See in this volume: 'About the Content of Medieval Works of Art'.

137 A comparison is made here between the Baptism of Christ of AD 1118 on the baptismal font in the church of St Barthélémy in Liège and the work with the same theme by Gerard David of AD 1508.

138 See in this volume: Baroque art: 'Van Eyck's St Barbara and Life in the Covenant'.

139 *Stijl* 1, 4 (1952) pp.60–65.

140 See in this volume: 'The Art of the Middle Ages.'

141 This artwork, like so many paintings of that era, was painted on wood.

142 In the first issue of this journal I showed a painting which depicted God the Father. With hindsight that was wrong, because in doing so I was (we were) sinning against the Second Commandment. God may never be portrayed visually – not even in a reproduction.

143 We are not speaking here of the sixteenth-century iconoclastic fury, which had an Anabaptist background, but of the more 'normal' transition.

144 *Calvinistisch Jongelingsblad* 6, 34 (1951) pp.273–274.

145 The painting is now kept in the Uffizi Museum in Florence.

146 Cf. the first chapters of E. Mâle's *L'art réligieux de la fin du moyen-âge* (Paris, 1931).

147 The writer is not known. Because it was previously thought that it was Bonaventura, the writer is now often known as Pseudo-Bonaventura.

148 Cf. Huizinga's *Waning of the Middle Ages*.

[149] HRR originally quoted from a Dutch carol; the editor here selected a similar sentiment expressed in the English carol 'As with gladness men of old'.

[150] *Stijl* 1,1 (1952) pp.4–7.

[151] The painting discussed is *The intercession of Mary* (1495) by Filippino Lippi.

[152] Prof. Dr Ignatius Klug, *The Catholic Faith* (Heemstede, 1939) pp.242–243.

[153] *Correspondentiebladen van de Vereniging voor Calvinistische Wijsbegeerte* 14, 1 (1950) 1, pp.37–38.

[154] See in this volume 'The Art of the Fourteenth Century in France'.

[155] In Dutch: *Perspectief* (Kampen: Kok, 1961) pp.241–280; in German: *Zeitschrift für Ästhetik und allgemeine Kunst Wissenschaft*, Band XIV/1 (1969) pp.55–91.

[156] F. Baldinucci: *Notizie de' Professori del disegno* ... (Rome/Florence, 1688) p.93.

[157] He wrote, amongst others, *Serenissimi Cosmi Medycis primi Heturide Magniducis actionis* (Florence, 1578).

[158] Certatim huc properate: Lampsacaenus, / Obscaena aut Venus, improbaeque Bacchae: / Lascivi Satyri, malique Fauni, / Tam cultis minime vagantur Hortis. / At casta Idalio Venus relicto / Cum casto, teneroque Amore ludens / Delo Cynthia, Cynthioque colle / Desertis; Charites, Fidesque cana / Vel pridem supero relicto Olympo;... Hos inquam superos, bonosque Divos / Custodes dedit esse Cosmus Hortis, / Cosmus Dux, patriae Parens et Urbis / Vestrique integer obsequens pudoris...' Cited by Gaetano Cambiagi: *Descrizione dell' Imperiale Giardino di Boboli* (Florence, 1757) p.72, originally in Sanleolinus' *Libri Cosmarum Actionum*, p.35. [Translation by P. Dorland and the editor.]

[159] E. Panofsky: 'The First Two Projects of Michelangelo's Tomb of Julius II', *Art Bulletin* XIX (1937) p.561.

[160] E. Panofsky, 'The Neoplatonic Movement and Michelangelo', *Studies in Iconology* (New York, 1939) p.194.

[161] Ibid., pp.198, 199.

[162] Ibid., p.190.

[163] For more about the tomb and its history, see 'The Tomb of Julius II', in Ch. de Tolnay, *Michelangelo IV* (Princeton, 1954).

[164] 'Abozzate con incredibile e maraviglioso artifizio monstrano queste figure con ogni sforzo di volere uscir del marmo per fuggir la rovina, che è loro di sopra... Stupiscono gli artifici, e quelli, che sono intendenti, restano confusi, come sia stato racchiuso in uomo tanto sapere, che con lo scarpello, e con la mano, anzi con la gradina rozzamente abbia cavati del sasso corpi umani, i quali non finiti, ne equivochi, ma naturali, e veri si demostrano. E di vero più sono queste statue maravigliose in questa guisa, che se del tutto fossero pompiute, e più da migliori artifici sono ammarate, attese, e comtemplate, che se dal Buonarroto l'ultimo artifizio avessero avuto.' Francesco Bocchi, *Le Bellezze della Citta di Fiorenza* (Florence, 1591) p.69.

[165] 'Potessero servire d'ammaestramento a Professori, giacchè il bozzare di Michelangelo, secondo l'opinione degl' intendenti, aveva scoperto un nuovo modo per operar sicuro, e non storpiare sul bel principio i marmi, ed in vero sono queste statue più maravigliose in questa guisa, che se del tutto fossero compiute, e dagl' artefici più ammirate,' Cambiagi, *Descrizione dell' Imperiale Giardino di Boboli*, p.22.

[166] E.g. *Nouveau Guide de la Ville de Florence et ses environs* (Florence, 1837) p.500.

[167] See his: 'Iconography and Iconology, an Introduction to the Study of Renaissance Art', in *Meaning in the Visual Arts* (Garden City, N.Y., 1955) pp.26 ff.

[168] P.O. Kristeller, 'The Modern System of the Arts', *Journal of the History of Ideas* XII (1951) pp. 496 ff; pp.17 ff.

[169] F. Würtenberger, *Weltbild und Bilderwelt* (Vienna, 1958) p.25 passim.

[170] H. Dooyeweerd, *Wijsbegeerte der Wetsidee* I (Amsterdam, 1935) p.145. In English: *New Critique of Theoretical Thought* I (Philadelphia, 1969) pp.181–183. Also by Dooyeweerd: 'Grondthema's in het wijsgerig denken van het avondland', *Philosophia Reformata* VI (1941) pp.169, 170; 'Het wijsgerig tweegesprek tusschen de Thomistische philosophie en de wijsbegeerte der Wetsidee', *Philosophia Reformata* XIII (1948) pp.26 ff., 49 ff.; *Reformatie en Scholastiek in de Wijsbegeerte* (Franeker, 1949) Inleiding, p.35 ff.

[171] A. von Salis, *Antike und Renaissance* (Zurich, 1947) p.148.

[172] 'Michel-Ange ... n'est que le dernier et le plus grand des gotiques ... les captifs sont retenus par des liens si faibles qu'il semble facile de les rompre. Mais le sculpteur a voulu momtrer que leur détention est surtout morale ... Chacun de ses prisonniers est l'âme humaine qui voudrait faire éclater la chape de son enveloppe corporelle afin de posséder la liberté sans limites.' A. Rodin, *L'Art, entretiens réunies par Gsell* (Paris, 1911) pp.262 ff., 181 ff.

[173] H. Hettner, *Italienische Studien. Zur Geschichte der Renaissance* (Brunswick, 1879) pp. 247–272.

[174] O. Ollendorff, 'Michelangelo's Gefangene im Louvre', *Zeitschrift für bildende Kunst* IX (1897/8) p.273, n.1.

[175] H. Thode, *Michelangelo: Kritische Untersuchungen* I (Berlin, 1908) p.213.

[176] Cf. R. Hedicke, *Methodenlehre der Kunstgeschichte* (Strasbourg, 1924) p.132 ff.; H. Sedlmayr, *Kunst und Wahrheit, zur Theorie und Methode der Kunstgeschichte* (Hamburg, 1958) pp.71 ff.

[177] E. Panofsky, 'The Neoplatonic Movement and Michelangelo', in *Studies in Iconology* (New York, 1939) p.171 ff.

[178] Ibid., p.177

[179] Ibid., p.181

[180] H. Sedlmayr, 'Michelangelo, Versuch über die Ursprunge seiner Kunst', in *Epochen und Werken* I (Vienna, 1959) p.239.

[181] 'La morte è'l fin d'una prigione scura.' Ibid., p.240. The line of poetry is on drawing no. 7, Ch. de Tolnay, 'The Youth of Michelangelo', in *Michelangelo* I (Princeton, 1947).

[182] De Tolnay, *Michelangelo* IV, p.25.

[183] A much earlier sculpture, now in the Accademia at Florence.

[184] De Tolnay, *Michelangelo* I, p.113.

[185] Panofsky, *Studies in Iconology*, p.190.

[186] A. Bertini: 'Il problema del non finito', *L'Arte* N.S. II (1931) pp.172 ff.; idem, 'Ancora sul non finito di Michelangelo', *L'Arte* N.S. II (1931) pp.172 ff.

[187] 'Un conflitto tra aspirazione intellettuale e realizzazione artistica,' *L'Arte* N.S. II (1930) p.134.

[188] Cf. e.g. G. Knuttel, *Rembrandt* (Amsterdam, 1956) p.205.

[189] Cf. H. Wölfflin, *Die Kunst Albrecht Dürers* (Munich, 1908) p.340 ff.

[190] De Tolnay, *Michelangelo* IV, p.62.

[191] See note 184, above. In that connection De Tolnay also speaks about the Boboli slaves, which artistically stand so close to this older sculpture.

[192] See on this subject (with many literary references) Panofsky, *Studies in Iconology*, p. 179ff.; also H. J. Hak, *Marsilio Ficino* (Amsterdam, 1934) p.126 passim.

[193] C. Frey, *Die Dichtungen Michelangelo Buonarrotti* (Berlin, 1879); and Michelangelo, *Rime* (Milan, 1954). The latter edition follows the numbering of Frey.

[194] In LXXIII, 19: 'In che carcer quaggiù l'anima vive.'

[195] In CIX, 105: 'Per ritornar lâ, donde venne fora / L'immortal forma al tuo carcer terreno.'

[196] H.W. Beyer, *Die Religion Michelangelos* (Bonn, 1926).

[197] 'E se creata a Dio non fosse eguale, / Altro che 'l bel di fuor, ch'a gli occhi piace, / Più non vorria; ma perch'è si fallace, / Trascende nella forma universale. / Io dico, ch'a chi vive quel che muore / Quetar non può disir, né par s'aspetti / L'eterno al tempo, ove altri cangia il pelo.' LXXXIX, translated by A. Blunt, *Artistic Theory in Italy 1450–1600* (Oxford, 1940) p.67, n.2.

[198] 'Gli occhi mie' vaghi delle cose belle, / E l'alma insieme della sua salute / Non hanno altra virtute / Ch'ascenda al ciel, che mirar titte quelle. / Dalle più alte stelle / Discende uno splendore, / Che 'l desir tira a quelle / E qui si chiama amore.' Blunt, *Artistic Theory in Italy*, p.70.

[199] 'quanto magis censendum est coelesten immortalemque animum, quando ab initio ab ea puritate, qua creatur, momento delabitur, id est, quando obscuri terreni moribundique corporis carcere clauditur,' Marsilii Ficinii, ... *omnium operum* ... (Basilea, 1561) I, II, p. 837. Translation from Panofsky, *Studies in Iconology*, p.196.

[200] Cf. P.O. Kristeller, *The Philosophy of Marsilio Ficino* (New York, 1943) esp. pp.351 ff., p.208 passim.

[201] 'In Convivium Platonis de Amore', *Commentarium*. Ficino, ... *omnium operum* ... , pp.132 0ff. Hereafter cited as: *Conv.* Other editions: S.R. Jayne, *M.F.'s Commentary on Plato's Symposium*, University of Missouri Studies XIX, 1 (Columbia, 1944) and R. Marcel, *M. Ficin sur le banquet de Platon ou de l'Amour* (Paris, 1956).

[202] 'Formarum omnium, idearumque complexionem, Mundum Latine, Graece Kosmon, id est ornamentum vocamus ... Huius ornamenti gratia pulchritudo est. Ad quam amor ille statim natus traxit mentem: atque perduxit mentem ante deformem, ad mentem eandem deinde formosam ... Ideo amoris conditio est: ut at pulchritudinem rapiat, ac deformem formoso coniungat. Quis igitur dubitabit, quin amor statim chaos sequatur, praecedatque mundum.' *Conv.* I, 3, pp.1321, 1322. This and the following translations are taken from S.R. Jayne, *M.F.'s Commentary on Plato's Symposium*, see p.128 for this passage.

[203] Here 'god', because this does not refer to the God of Holy Scripture – although it is possible that Ficino had him in mind.

[204] 'bonum quidem ipsa supereminens dei existentia dicitur. Pulchritudo actus quidam sive radius inde per omnia penetrans: Primo in angelicam mentem: Secondo in animam totius est reliquos animos: Tertio in

naturam: Quarto in materiam corporum.' *Conv.* II, 5, p.1326. Translation by S.R. Jayne, p.140.

[205] Carolus Bovillus, *Liber de Sapiente* (Paris: Amiens, 1510/11), republished in E. Cassirer, *Individuum und Kosmos in der Philosophie der Renaissance* (Leipzig, 1927) p.301ff.

[206] 'In omnibus denique amor chaos comitatur, praecedit mundum, torpentia suscitat, obscura illuminat, vivificat mortuos, format informia, perficit imperfecta.' *Conv.* I, 3, p.1322. Translation: S.R. Jayne, p.129.

[207] *Conv.* I, 4, pp.1322, 1323.

[208] 'Circulus itaque unus et idem a Deo in mundum, a mundo in Deum, tribus nominibus nuncupatur. Prout in Deo incipit et allicit, pulchritudo; prout in mundum transiens ipsum rapit, amor; prout in auctorem remeans ipsi suum opus coniung, voluptas. Amor igitur in voluptatem a pulchritudine definit.' *Conv.* II, 2, p.1324. Translation: S.R. Jayne, p.134. Cf. A. Chastel, *M. Ficin et l'art* (Lille/Geneva, 1954) p.118. Panofsky translates *voluptas* here as 'beatitude', in *Renaissance and Renaissances in Western Art* (Kopenhagen, 1960) p.183.

[209] Kristeller, *The Philosophy of Marsilio Ficino* (Ficinii, ... *omnium operum*) mentions the term in a short passage only, not as a main thought or laden with meaning (pp.358, 359).

[210] 'Duplex est Venus. Una sane est intelligentia illa quam in mente angelica posuimus. Altera vis generandi animae mundi tributa.' *Conv.* II, 7, p.1326. Translation: S.R. Jayne, p.142. Cf. E. Wind, *Pagan Mysteries in the Renaissance* (London, 1958) pp.121 ff.

[211] Panofsky, *Renaissance and Renaissances in Western Art*, p.142 puts it like that without further ado.

[212] 'Utraque (Venus) sui similem comitem habet amorem. Illa enim amore ingenito ad intelligendam dei pulchritudinem rapitur. Haec item amore suo ad eandem pulchritudinem in corporibus procreandem ... Hae geminae vires duae in nobis sunt Veneres, quas et gemini comitantur amores. Cum primum humani corporis species oculis nostris offertur, mens nostra quae prima in nobis Venus est, eam tanquam divini decoris imaginem, veneratur et diligit ... Vis autem generandi, secunda Venus, formam generare huic similem concupiscit. Utrobique igitur amor est. Ibi contemplandae, hic generandae pulchritudinis desiderium. Amor uterque honestus atque probandus.' *Conv.* II, 7, pp.1326, 1327. Translation: S.R. Jayne, pp.142 f.

[213] Literature on this subject: A. Chastel, *Marsile Ficin et l'art* (Lille/Geneva, 1954); Kristeller, *The Philosophy of Marsilio Ficino* , p.403 ff.; A. Blunt, *Artistic Theory in Italy*, p.20 ff.; E. de Bruyne, *Geschiedenis van de aesthetica: De renaissance* (Antwerpen/Amsterdam, 1951) pp.38 f.; J. Festugière, *La philosophie de l'amour de Marsile Ficin et son influence sur la littérature française au XVI siècle* (Paris, 1941); J.L. Zupnick, 'The Aesthetics of the Early Mannerists', *Art Bulletin* XXXV (1953) p.305; E. Panofsky, *Renaissance and Renaissances in Western Art*, pp.129ff., pp.74 ff.; N.A. Robb, *Neoplatonism of the Italian Renaissance* (London, 1935).

[214] 'quaerimus creatorem. Perveniemus autem Deo duce ad hunc gradum naturae supremum, si modo ab ipsa materia, quae naturae gradus est infimus, affectum animi pro viribus segregabimus, ut quantum ab ea discedimus, tantum accedamus ad Deum, et cui nunc posthabito fallacis huius vitae momento quoad possumus vivimus, tandem eius vita vivamus in

aevum.' Ficino, ... *omnium operum*, p.424; cf. Kristeller, *The Philosophy of Marsilio Ficino*, p.215.

[215] Ph. E. Hughes: 'Pico della Mirandola, a study of an intellectual Pilgrimage', *Philosophia Reformata* XXIII (1958) pp.130 f.; E. Cassirer, *Individuum und Kosmos in der Philosophie der Renaissance* (Leipzig, 1927) p.90 passim

[216] E.g. G. Benevieni, cf. Robb, *Neoplatonism of the Italian Renaissance*, p.113 ff.

[217] Robb, *Neoplatonism of the Italian Renaissance*, pp.181 ff.; Panofsky, *Renaissance and Renaissances in Western Art*, pp.145, 146.

[218] Robb, *Neoplatonism of the Italian Renaissance*, p.206

[219] E.F. Meylan, 'L'évolution de la notion d'amour platonique', *Humanisme et Renaissance* V (1938) p.425.

[220] Hughes, 'Pico della Mirandola ...', pp.129 ff.

[221] 'Amor è desiderio di bellezza.' Meylan, 'L'évolution de la notion d'amour platonique', pp.426, 427.

[222] Cf. J. Burckhardt, *Die Kultur der Renaissance in Italien* (Bern, 1943) pp.463, 464.

[223] Meylan, 'L'évolution de la notion d'amour platonique', p.433; Festugière, *La philosophie de l'amour de Marsile Ficin* ..., pp.44 ff., p.60.

[224] Cited in Chastel, *Marsile Ficin et l'art*, p.123.

[225] Festugière, *La philosophie de l'amour de Marsile Ficin* ...

[226] 'Je suis Amour, / Le granmaître des dieux, / Je suis celui qui voient les yeux, / Je suis celui qui gouverne le monde, / Qui le premier, hors de la masse éclos / Donnais lumière et fendis le chaos / Dont fût batie cette machine ronde.' Nicolas de la Grotte, in the *Anthologie Sonore* 36.

[227] Wylie Sypher, *Four Stages of Renaissance Style. Transformation in Art and Literature 1400–1700* (Garden City, N.Y., 1956) gives a few examples, pp.131 ff. His treatment of mannerism is very worth reading, although it needs to be said that he sometimes puts geographically and chronologically very divergent phenomena together as symptoms of one and the same attitude. It is very questionable whether people such as Donne, Webster, Cellini, Tintoretto and El Greco can be lumped together just like that. He also has little consideration for the fact that movements that are very different in spirit can arise simultaneously. This is in keeping with being rather liberal with (historical) time and space. For example, Calvinism is not at all a mannerist view of reality, and is not similar to the spirit of Donne, not even at a deeper level (p.132 passim.).

[228] Very important in this connection is L. Febvre, *Le Problème de l'incroyance au XVI siècle, La religion de Rabelais* (Paris, 1942). Cf. also Cassirer, *Individuum und Kosmos* ..., p.106.

[229] G.R. Hocke, *Die Welt als Labyrinth, Manier und Manie in der Europäischen Kunst* (Hamburg, 1957) commits the same mistake as Sypher – going even further in this – by considering sixteenth- and twentieth-century phenomena, if they sometimes are comparable, to be similar just like that. Without a careful investigation as to meaning, significance and cause of all kinds of 'aberrations', they should not be lumped together. His book itself has become somewhat of a labyrinth because of this, no matter how much important material he has gathered together and how many typical phenomena he has charted.

[230] F. Hartt, *Giulio Romano* (New Haven, 1958) pp.158, 146, 147 ff.; E. Gombrich, 'Zum Werke Giulio Romanos, Versuch einer Deutung, II', *Jahrbuch der kunsthist. Samml. in Wien*, N.F. IX (1935) p.127 passim.

231 Hanover State Museum: Ill. 10 exp. Cat. *Fontainebleau e la maniera italiana* (Napels, 1952).

232 Uffizi, Florence: ill. 52 L. Beccherucci, *Manieristi Toscani* (Bergamo, 1944).

233 Florence, S. Felicità: ill. 40 idem. For Pontormo, see also E. Cecchi, *Diario di Jacopo da Pontormo* (Florence, 1956).

234 Uffizi: Hocke, *Die Welt als Labyrinth ...*, ill. 9

235 S. Stefano, Genua; A. Morassi, *Capolavori della pittura a Genova* (Milan, 1951) ill. 98–101.

236 Uffizi: ill. 74, Beccherucci, *Manieristi Toscani*.

237 F. Hartt, *Giulio Romano* II and E. Gombrich, 'Zum Werke Giulio Romanos I', *Jahrb. Kunsthist. Samml. Wien* N.F. VIII, p.98 ff.

238 Easily accessible literature on this subject includes P. Hendrix and others, *Ikonen* (Amsterdam, 1960); W.P. Theunissen, *Ikonen* (The Hague, n.d. – 1959).

239 Compare my short treatise about the theme that arose then of the Adoration (instead of the Birth) in *Lucerna* II (1960) p.334, together with the literature there cited, of which we only wish to repeat here: Millard Meiss, *Painting in Florence and Siena after the Black Death* (Princeton, 1951). See *Complete Works* 5, 'Book Review: Stellingwerff, Reality and Ground Motive in Vincent Willem van Gogh'.

240 Cf. my article: 'Drie Kunstwerken' ['Three Works of Art' in this volume] *Calvinistisch Jongelingsblad* (18 December 1959) pp. 275–277, which elucidates this condition from a single example, as well as the excursus in the beginning of this article (c.f. in text, preceding note 169).

241 T. Hetzer, *Die Sixtinische Madonna* (Frankfurt, 1947); M. Putscher, *Rafael's Sixtinische Madonna, Das Werk und seine Wirkung* (Tübingen, 1955).

242 Cf. E. Cassirer, *Individuum und Kosmos ...*, pp.106 f. If in this context we note what Kristeller emphasizes with respect to the difference between the Florentine Renaissance and the Renaissance in the North of Italy, which was directed more purely towards nature in a scholastic sense, it can become clear why Mannerism in the North – with a few exceptions such as e.g. Parmegianino – did not take on these Manneristic forms: Venetian art remains a Renaissance art that is deepened by the form-language of the High Renaissance, free or almost free from the tensions that characterized the contemporary Florentine art – we think here of Titian and Veronese. In: P.O. Kristeller, J.H. Randall: 'The Study of the Philosophies of the Renaissance', in *Journal of the History of Ideas* II (1941) pp.491 ff.

243 Respectively Pinacoteca Volterra and S. Felicità in Florence, ill. 40 and 70 in Beccherucci, *Manieristi Toscani*.

244 Palazzo Pitti, Florence. Beccherucci, *Manieristi Toscani*, ill. 14

245 Predella Retable of the Linaiuoli, Museum San Marco, Florence, ill. P. 50. G.C. Argan, *Fra Angelico* (Geneva/Skira, 1955).

246 The *Madonna della Rosa*, Museum Dresden, ill. 196. B. Berenson. *De italiaanse schilderkunst der Renaissance* (Zeist: Phaidon, 1957). Cf. Wylie Sypher, *Four Stages of Renaissance Style ...*, p.112.

247 For sixteenth-century art theory, see the literature cited in note 213. See also E. Panofsky, 'Idea', *Beitrag zur Begriffsgeschichte der älteren Kunsttheorie* (Berlin, 1924) pp.39 ff.; and Hocke, *Die Welt als Labyrinth ...*, pp.46 ff. – especially his new interpretation of the 'eclectic' in Zuccaro's theory of art is important, namely that eclecticism is, according to him, a typical

Mannerist phenomenon, whereby art is not fed from (the contemplation of) nature, but from the (older) art.

[248] In this context the remarks of a young, modern artist are interesting. He talks about the attempt to destroy reality – at least, in its meaning for us as people – by assaulting the figure: H. Platschek, *Neue Figurationen* (Munich, 1959) p.79 and passim.; cf. also Picasso's 'interpretations' of older works of art, e.g. Velasquez's *Las Meninas* – M. Leiris, *Picasso et les Ménines de Velasquez* (Paris, 1959); Henning Gran, 'Malergleden Personlig', *Kunsten Idag* 48 (1959) no. 2, pp. 21 f. (translation pp.53 f.).

[249] Cf. Hocke, *Die Welt als Labyrinth* ..., pp.189 ff.; Sypher, *Four Stages of Renaissance Style* ..., pp.149 ff.; Romans 1.

[250] Cited in note 234.

[251] Cited in note 232.

[252] Rafaello Borghini, *Il Riposo* III (Milan, 1807, 1st edition 1584) p.190 sums up some of them. As far as is known none has been preserved.

[253] A print dating from 1589 has been reproduced in *Gaz. Beaux Arts* s. 6 XXVII (March 1945) p.144.

[254] 'Buontalenti fece tante belle mascherate con abiti si bizarri, carriaggi si meravigliosi, che nè i romani abbino fatto tanto.' Vera D. Giovannozzi, 'La Vita di Bernardo Buontalenti scritta di Gherardo Silvani', *Rivista d'Arte* XIV (1932) p.518. From this article we also obtained the other biographical details. Further on Buontalenti: A. Venturi, *Storia dell' Arte italiana* XI 2 (Milan, 1939) pp.455–546.

[254] Webster Smith is going to discuss this matter in a forthcoming book. Smith wrote a dissertation about Buontalenti, in stenciled format. The book was announced in *Marsyas* VIII (New York, 1959) p.88: 'Studies on Buontalenti's Villas'.

[256] Book IV, ch. 9.

[257] Cf. E. Kris, 'Der Stil "Rustique". Die Verwendung des Naturabgusses bei Wenzel Jamnitzer und Bernard Palissy', *Jahrbuch Kunsthist. Samml. Wien* N.F. I (1926) p.198.

[258] G.Vasari, *Le vite de' più eccellenti pittori scultori ed architettori* I, Editor di G.Milanesi (Florence: Sansoni, 1878/1906, 9 vols) p.140.

[259] F. Hartt, *Giulio Romano*, p.146 *passim*; E. Gombrich, 'Zum Werke Giulio Romanos', *Jahrbuch der kunsthistorischen Sammlungen in Wien* 8 (1934) p.88.

[260] For more on grottos: B. Wiles, *The Fountains of the Florentine Sculptors* (Cambridge, Mass., 1933); C. Huelsen, 'Römische antiken Gärten des 16. Jahrhunderts', *Abhandlungen der Heidelberger Akademie der Wissenschaften 1917*, Phil. Hist. Klasse 4; M. Gothein, *A History of Garden Art* I(1928); H. v.d. Waal, *Drie Eeuwen Vaderlandse Geschieduitbeelding 1500–1800. Een iconologische studie* (The Hague, 1952) pp.66, 67.

[261] E.g. Vasari, about the grotto by Giovanni da Udine near the Villa Madama, cited by Kris, 'Der Stil "Rustique" ...', p.199.

[262] Kris, 'Der Stil "Rustique" ...', pp.202 ff.

[263] R. Haferkorn, *Gotik und Ruine in die englische Dichtung des 18. Jahrhunderts* (Leipzig, 1924); Kenneth Clark, *The Gothic Revival* (London, 1928).

[264] B. Palissy, *Récept véritable par laquelle tous les hommes de France pourront apprendre à multiplier et augmenter leurs trésors...* (La Rochelle, 1563). Reprinted by Anatole France in 1880.

[265] 'espèce ou manière d'architrave, frise, et corniche, non pas proprement insculptées, mais comme qui se moqueroit, en les formant et les insculptant à grands coups de marteaux.' 'ledit cabinet sera tortu, bossu, ayant plusieurs bosses et concavitez biaises, se tenant aucune apparence ny formé d'art, d'insculpure, ni labour de main d'homme: et seront les voûts tortues de telle sorte, qu'elles auront quelque apparence de vouloir tomber, à cause qu'il y aura plusieurs bosses pendantes.' From the work cited in note 262, quoted by Kris, 'Der Stil "Rustique" ...', pp.193, 194.

[266] Compare the figures in the Boboli grotto, about which we will say more later, with the description cited by Kris, 'Der Stil "Rustique" ...', p.193 and the fragment dug up near the Tuileries of Palissy's grottos, reproduced by Kris on p.191.

[267] F. Baldinucci, *Notizie de' Professori del disegno* (Rome/Florence, 1688) p.93.

[268] Wiles, *The Fountains of the Florentine Sculptors*, p.78; F. Bocchi: *Le Bellezze dellacitta di Fiorenza* (Florence, 1591) p.68; Vasari, *Le vite ...* VI, p.180

[269] Baldinucci, Notizie de' Professori del disegno, p. 93; Gaetano Cambiagi, *Descrizione dell' Imperiale Giardine di Boboli* (Florence, 1757) pp.20, 22, 23.

[270] The whole effect is not improved by the fact that in this grotto there are now plaster casts of moderate quality of the Michelangelo figures.

[271] Apart from the works already cited in this connection: Galeazzo Geraldo Priorato, *Relazione della citta di Fiorenza* (Cologne, 1668); a new, better edition of Bocchi, edited by G. Cinelli, of 1677; F.M. Soldini, *Il reale Giardino di Boboli* (Florence, 1789); *Nouveau Guide de la ville de Florence et ses environs* (Florence, 1837) pp.499–501; J. de Wolf Addison, *The Art of the Pitti Palace, Florence* (London, 1904); A. Venturi, *Storia dell' Arte italiana* XI 2 (Milan, 1939), pp.483–486; and furthermore a large number of guides, which all deal briefly with this matter but add nothing new. I would like to give my sincere thanks to the German Art-Historical Institute at Florence for permission to work through its magnificent collection of topographical materials. Since in fact only Bocchi and Baldinucci offer any substantial new information, and all other documents go back to these sources while using almost the same words, we shall continue to cite those sources that speak most clearly, without going into detail about where ideas were borrowed. There is no real development of thought in this literature, and after Bocchi no fundamentally new ideas about this grotto were introduced.

[272] 'nel quatro angoli ... situò quelle bozzate figure in atto di reggere gran quantità di spugne, accordando cosi bene la rozzezza di quiei naturali scherzi col ruvido di quegli abbozzi, che il tutto pare stato aperato dalla natura medesima, ed il rimanente della Grotta ornò egli stesso di sua mano con figure, ed animali composti delle medesime spugne con tale artifizio, che in quel genere non si può veder cosa più bella, ni più vera.' Baldinucci, *Notizie de' Professori del disegno*, p.93. Cf. Soldini, *Il reale Giardino di Boboli*, p.33.

[273] 'Piero di Tomasso Muti, scultore ... figure e maschere fatte nella grotta del giardino di Pitti, su disegno del Buontalenti.' *Cat. Mostra Documentaria e Iconografica di Palazzo Pitti e Giardino di Boboli*, Archivo di Stato di Fiorenze, 1960, no. 54 of 15 March 1584. Other sources relating to the building of the grotto are no.'s 53 and 55. Further sources on this topic have been published together by Vera Giovannozzi, 'La Vita di Bernardo Buontalenti ...', *Rivista d'Arte* XIV, 2, 4 (1932) p.510, n.1.

[274] 'Egli si mostra adunque la volta in sembiante che rovina, e che per li fessi, e per le rotture escano diversi animali, come serpi, uccelli, satiri, e molte

piante, che paiono così naturale, che quasi in verità del fatto recano altrui diletto, ma non senza terrore, posciache del tutto pare, che a terra rovino l'edifizio.' Bocchi, *Le Bellezze dellacitta di Fiorenza*, p.69.

[275] For example, in the grotto at Castello, near Florence.

[276] Cambiagi, *Descrizione dell' Imperiale Giardine di Boboli*, p.22.

[277] 'Cuncti homines natura et substantia s(u)nt similes et speciei e qualitate tantum unus Homo: vivendi autem modo, functione et arte varii ac dissimili. Alii siquidem mineralibus aut simplicibus elementis comparantur, vegetantibus alii, alii brutus animantibus; supremi soli merito Hominum similis, Rationis et habitu et functione rationales, veri perfectique Homines dictitentur' p.303. Cf. also the illustration on p.306. Bovillus provides an extensive explanation about this Neoplatonic view of humanity in the passages that follow

[278] Just as in our time Freudian-Jungian theories have also influenced art to a great degree, especially Surrealism. See, e.g. B. Nelson (ed.), *Freud and the 20th Century* (New York, 1957) and H. Read, *The Philosophy of Modern Art* (New York, 1955) pp.140 ff.

[279] Cf. Hocke, *Die Welt als Labyrinth* ..., pp.107 ff., pp.124, 157.

[280] Wotruba, *Feminine rock*, '4e Biennale voor Beeldhouwkunst', Middelheimpark, Antwerp 1957, illustrated cat. no. 183; Germaine Richier's work is presently owned by the Stedelijk Museum in Amsterdam, and illustrated in Catalogus Nummer 127 of this museum (1955).

[281] We can only mention the following as to the interpretation of such a modern work: W. Haftmann, *Malerei im 20. Jahrhundert* (Munich, 1954) pp.392 ff., 464 ff.; H. Sedlmayr, *Die Revolution der modernen Kunst* (Hamburg, 1957) pp. 85 ff.; and the work by Platschek already cited.

[282] 'Dubuffet ne considère jamais la Nature de l'extérieur. Il la prend au niveau de ses états les plus sommaires, à la limite de l'infime, dans sa fonction de natura naturans, inachevée et définitive, contenant en chacun de ses fragments toutes ses futures incarnations, ses schèmes universels, ses thèmes de permutation ... L'individu n'est plus qu'un accident de la matière, un détail surajouté, un accessoir superflu ... il porte la nature en soi. Il en est fait, il est marqué de ses empreintes, masqué de sa placidité hagarde, effaré, effacé, frappé de sceau de la corruption ... Cet art qui befoue la créature n'a pas davantage de respect pour la Création.' P. Volhoudt, 'Jean Dubuffet ou les métamorphoses de l'élémentaire' , *XXe Siècle*. N.S. XX, 11 (1958) pp.28, 29.

[283] Cambiagi, *Descrizione dell' Imperiale Giardine di Boboli*, p.22.

[284] O. Hiltbrunner, *Kleines Lexikon der Antike* (Bern, 1946), see under: 'Helena'.

[285] Even in his time people sometimes made a mistake with regard to this unknown subject. As such it is indeed not very important.

[286] 'da gli uomini dell'arte celebrate ... figurato Paride, quando rapisce Helena, con si gentile studio, con industria cosi discreta, che simili alle migliori statue ... E certamente si mostra Paridi di viva nel petto, nelle braccie, e pare non so in che modo, che sia il marmo carne diventato, così ogni parte del corpo è morbida in vista, e oltra ogni stima graziosamente delicata.' Bocchi, *Le Bellezze dellacitta di Fiorenza* , p.23. Later sources are also full of praise for this statue, albeit in different words. Borghini in his *Il Riposo* also commends it highly (III, p.171).

[287] Cf. Wiles, *The Fountains of the Florentine Sculptors*, p.78; about the statue itself: Elisabeth Dahnens, *Jean Bologne, Giovanni Bologna Fiammingo* (Brussels,

1956) p.1777: No. XXVIII – 130 cm white marble, c. 1572–1573. If this dating is correct, we may suppose either that Buontalenti found this statue as well, still without a good place, and adopted it for his grotto or that it was completed but had not yet been put in place by 1591.

288 '... una bella femmina, che fu posta sopra la tazza d'una fonte; figura attitudinata per modo, che osservata da quante vedute si vogliano, apparisce in atto maravigliosamente grazioso.' Baldinucci, *Notizie de' Professori del disegno*, p.128

289 Cambiagi, *Descrizione dell' Imperiale Giardine di Boboli*, p.24; the guide was cited in note 276 above.

290 'Sed divinitatis fulgor ille in formosis emicans quasi dei simulacrum amantes obstupescere, contremiscere et venerari compellit.' *Conv.* II, 6, p.1326.

291 'Illa enim amore ingenito ad intelligendam dei pulchritudinem rapitur.' *Conv.* II, 7, p.1326.

292 'Cum primum humani corporis species oculis nostris offertur, mens nostra quae prima in nobis Venus est, eam tanquam divini decoris imaginem, veneratur et diligit.' The second Venus, who is *vis generandi*, who 'formam generare huic similem concupiscit.' Ibid., p.1327. Translation: S.R. Jayne, p.142.

293 'La beltà, che tu vedi, è ben da quella, / Ma cresce, poich'a miglior loco sale, / Se per gli occhi mortale all'alma corre. Quivi si fa divina, onesta e bella, / Com'a sé simil vuol cosa immortale: / Questa e non quella a gli occhi tuo' precorre.' *Rime* XXXII.

294 Cf. Panofsky, *Studies in Iconology*, pp.174–176; Sypher, *Four Stages of Renaissance Style* ..., p.157.

295 As people of the twentieth century we could speak of non-figurative art here. Also with respect to these works we can easily find twentieth-century parallels. We think of the work of Theo Bennes (working in Amstelveen), cf. H. Wesseling, *Theo Bennes* (1959) and H. Sandberg, 'Op zoek naar het Abhumanisme', *Vernieuwing* VIII, 5/6 (May, 1958) p.4, and of Fontana, whose *Vase fantastique* (1936) was reproduced in *XXe Siècle* N.S. XXI, 12 (1959) p.76.

296 *Centraal Weekblad* 15 (1967) 42, p.7.

297 *Correspondentiebladen van de Vereniging voor Calvinistische Wijsbegeerte* 19, 1 (1955) pp.15–17.

298 The citations in this article have been taken mainly from Dürer's 'Doctrine of Proportions' (1528), a work very renowned in its time. A Latin translation appeared in1532 that was reprinted repeatedly; it was followed by translations into French (1557), Italian (1591), Portuguese (1599), Dutch (1622) and English (1660). A few citations are from notes for these that have been preserved in manuscript form. All may be found in E. Heidrich's *Albrecht Dürers schriftlichen Nachlass* (Berlin, 1908) pp.262–303.

299 'Aber unmöglich bedunkt mir, so Einer spricht, er wisse die beste Mass in menschlicher Gestalt anzuzeigen. Dann die Lügen ist in unsrer Erkanntnuss, und steckt die Funsternuss so hart in uns, dass auch unser Nachtappen fehlt. Welches aber durch die Geometria sein Ding beweist und die gründlichen Wahrheit anzeigt, dem soll alle Welt glauben. Dann da ist man gefangen, und ist billig ein Solicher als von Gott begabt für ein Meister in Solchem zu halten ... So wir nun zu dem Allerbesten nit kummen mögen, soll wir nun gar von unser Lernung lassen? ... darum ziemt sich ein vernünftigen Menschen, das Besser fürzunehmen.'

300 'nit bis zu dem Ende, dass es nit noch hübscher möcht sein. Dann Solchs steigt nit in des Menschen Gemüt. Aber Gott weiss Solichs allein, wem ers offenbarte, der weisst es auch. Die Wahrheit hält allein innen, welch der Menschen schönste Gestalt und Mass kinnte sein und kein andre.'

301 'so find wir doch in den sichtigen Creaturen ein soliche übermässige Schonheit unserm Verstand, also dass soliche unser Keiner kann vollkummen in sein Werk bringen.'

302 'Geh nit von der Natur in dein Gutdunken, dass du wöllest meinen das Besser von dit selbst zu finden: dann du wirdest verführt. Dann wahrhaftig steckt die Kunst in der Natur, wer sie herausreissen kann, der hat sie.... Aber je genauer dein Werk dem leben gemäss ist in seiner Gestalt, je besser das Werk erscheint. Und dies ist Wahr. Darum nimm dir nimmermehr für, dass du Etwas besser mügest oder wellest machen dann es Gott seiner erschaffnen Natur zu würken Kraft geben hat. Dann dein Vermügen ist kraftlos gegen Gottes Geschöff.'

303 'Doch hüt sich ein Jedlicher, dass er nichts Unmöglichs mach, das die Natur nit leiden künn. Es wär dan Sach, dass Einer Traumwerk wollt machen, in solchem mag Einer allerlei Creatur untereinander mischen.'

304 'mussen wir gar mit grosser Acht wahrnehmen und fürkommen, dass sich die Ingestalt und Ungeschicklichkeit nit in unser Werk flecht.'

305 'was anders hübsch sein soll.'

306 'Und das ist sunderlich zu merken, dass in einem idlichen Bild ein vergleichlich Nacket gemacht werd, also dass ein geleich Alter oder Jugend in allen Dingen erfunden werd, und nit werd das Haupt von einem Jungen, die Brust von einem Alten, Händ und Füss van ein Mittelmässigen abgemacht, oder aber der Leib hinten jung und vornen alt und wiederum.'

307 'Es ist ein grosse Vergleichung zu finden in ungeleichen Dingen.'

308 'zu mancherlei Bilder gehörn mancherlei Menschen abzumachen.'

309 'Dann so vertreibt der Gewalt der Kunst den Irrtum von deinem Werk und wehret dir die Falschheit zu machen.'

310 'Ich halt aber in Solchem die Natur für Meister und der Menschen Wahn für Irrsal. Einmal hat der Schöpfer die Menschen gemacht, wie sie müssen sein, und ich halt, dass die rechte Wohlgestalt und Hübschheit unter dem Heufen aller Menschen begriffen sei. Welcher das recht herausziehen kann, dem will ich mehr folgen dann dem, der ein neu erdichtete Mass, der die Menschen kein Theil gehabt haben, machen will.'

311 *Stijl* 2, 1 (1953) pp.22–24.

312 Warburg has studied this extensively. See his *Collected Works* II.

313 *Stijl* 1, 9 (1952) pp.187–192.

314 See the 'Prayer of Dürer' of 1521, which is printed in C. van der Waal's *Antithese of synthese* (Enschede, 1951) together with the woodcut by Dürer from the series entitled *The Revelation of John* from 1498. Although Dürer also created a series of woodcuts entitled *The life of Mary*, this does not imply that in 1498 he was not a child of God. He was certainly still caught up in the misconceptions of his time, until the time that the Reformation came along to shed light on things. Dürer not only believed in the true God, but his whole vision of life was soundly built on a proper foundation.

315 Anton Pieck!

316 *Signaal* 2, 7 (1960) pp.10–16.

[317] *Stijl* 2, 2 (1953) pp.37–43.

[318] From V. Cherbulier, *L'art et la Nature* (Paris, 1892).

[319] See 'Dürer and landscape' and 'Dürer's Melancholia' in this volume, Part I: The Art of the Sixteenth Century.

[320] *Stijl* 2, 10 (1953) pp.265–271.

[321] 'Primitives' is the name given to fifteenth-century painting by a nineteenth-century generation who saw it as nothing more than an awkward beginning. Since then we have learned that it is actually a very mature, certainly not awkward, art form that is very much in control of forms.

[322] We use the term 'European landscape' because Chinese landscape art, which developed in a very different way, is much older. Until at least the nineteenth century their development was completely unrelated.

[323] We might mention, for example, the frescos by Lorenzetti, Orcagna, and others.

[324] Taken from an article by E.H. Gombrich entitled 'Renaissance Artistic Theory and the Development of Landscape Painting', *Gazette des Beaux Arts* (1953) pp.335ff. This article was the source for much of the material here. Alberti was a remarkable author who indeed presented views which would not be realized in the art world until much later.

[325] Also taken from the previously mentioned article by Gombrich.

[326] By 'relevant' we mean: meaningful, significant, essential. See also volume 5: 'Reflections on Four Modern Drawings'. For an explanation of the term 'world view', see in this volume, Part I: The Art of the Middle Ages: 'Ecclesia and Synagogue in Strasbourg'.

[327] See also in the *Complete Works 2*, 'Philosophy of Unbelievers'. For a discussion of romanticism, see the article about Altdorfer in this volume, in whose art romanticism becomes expressionism and the tension or chasm between humanity and creation is much greater.

[328] *Stijl*, the journal in which this article was published was to come to an end a few months later. For a further discussion of these problems see in this volume 'Art and Beauty in this World' and in volume 1, 'Gauguin and Nineteenth-Century Art Theory'.

[329] *Correspondentiebladen van de Vereniging voor Calvinistische Wijsbegeerte* 19, 2 (1955) pp.15–19.

[330] This passage was taken from another article by Rookmaaker on Bruegel (Ruimte 1, 1, 1954) which for the rest largely overlapped with this article.

[331] See J. W. Tunderman, *Marnix van St. Aldegonde en de subjectivistische stromingen in de 16e eeuw* (Goes).

[332] 'Geestdrijvers' or 'enthusiasts' allowed themselves to be driven or led by the spirit – by their spirit – instead of subjecting themselves to God's word.

[333] After I had written this article a major article appeared that handles this theme in an affinitive way: C. G. Stridback, 'Bruegel's Fidesdarstellung, Ein Dokument seiner religiösen Gesinnung', *Kunsthistorisk Tidskrift* 23 (Stockholm, August 1954). The leading studies on Bruegel are written by K. v. Tolnay and include his 'Studien zu den Gemälden P. Brueghels', *Jahrbuch Kunsth. Samml.* 8 (Vienna, 1934) pp.105 ff.

[334] *Calvinistisch Jongelingsblad* 6 (1951) 6, pp.54–56; 8, pp.60–61; 9, p.67.

[335] See our previous article in the *Calvinistisch Jongelingsblad* (October-Nov. 1950) pp.199, 208, 214, 224; reproduced in this volume as 'Judging Works of Art' in Part I: Reflections on Art.

336 We could perhaps mention here the relevant chapters from Groen van Prinsterer's unsurpassed *Handbook of the History of our Fatherland*, or Zylstra's *World Politics in the Light of Scripture*. Also a reading of A. Janse's *Eva's Dochteren* can help us understand the tremendous influence of Christianity in our world; this wonderful little book is still available very cheaply from the publisher! Finally I wish to point out the lead article in the *Reformation* of 3 March by Dr Verburgh which I received after I had written this article.

337 One can read about this in the standard work by Burckhardt, *Kultur der Renaissance*, perhaps supplemented by Huizinga's *Herfsttijl der Midderleeuwen*. Both books give a good insight into the life and work of people during the century preceding the Reformation.

338 *convenance, bienséance, grande manière et bon goût, le grand effet.*

339 See J. v. Schlosser, *Die Kunstlitteratur*, pp.590–600.

340 Compare Revelation 11–13! Also those who are not born again can give God the glory. Let's be careful that we don't rob these words of their power with our theological hairsplitting that tries to distinguish between 'sort of giving glory' and 'truly giving glory'. Sometimes we make that distinction in our day-to-day lives as well. If people say 'You did that really well,' have they not then honoured you in your work, although they may not have agreed with its purpose or goal? Didn't Nebuchadnezzar sometimes give God the glory, even though he never truly repented?

341 Gerson, *Ausbreitung und Nachahmung der hollandischen Kunst des 17. Jahrhunderts* (Haarlem, 1942).

342 *Ad Fontes* 12 (1965) pp. 209–212.

343 See in this volume, 'About the Content of Medieval Works of Art'.

344 Also called *Rape of the daughters of Leucippus*. See reproduction in *Complete Works* 3, Plate 5.

345 *Ad Fontes* 12, 9 (1965).

346 Proceedings of the Fifth International Congress of Aesthetics (Amsterdam, 1964) pp. 708–711.

347 H. Wierix, Alvin, 1455.

348 H.135.

349 Malibu, California.

350 ed. Richardson (1779).

351 H. 73.

352 In series H. 113–122.

353 P. v.d. Heyden, H. 41.

354 In series Alvin 1296–1393.

355 Q. Van Regteren Altena, *Miscellenea I.Q. Van Regteren Altena* 16, 5 (Amsterdam: Scheltema Holkema, 1969) pp.130–132, 325.

356 That is, in fact, how it came about sometimes. Gianbologna e.g. painted a rape, and only later did the scholars give the picture the name *Rape of the Sabine virgins*. Cf. R. Borghini, *Il riposo* (Florence, 1584) pp.71,72,73; also E. Dhanens, *Jean Boulogne* (Brussels, 1956) p.233.

357 Karel van Mander, 'De grondt der edel vrij schilder-kunst', in *Schilderboeck* (Haarlem, 1604) ch. 6, 7ff., folio 22ff. Cf. also O.Pöggeler, 'Dichtungstheorie und Topoforschung', *Jahrbuch für Aesthetik und*

allgemeine Kunstwissenschaft 5 (1960) p.158, about Melanchthon's method of *loci communes*.

358 'De Moraale Tafereelen zijn waare geschiedenissen of voorvallen, alleen tot stichtinge of leerzame voorbeelden voorgesteld, te kennen geevende braave daaden of misslagen der menschen, welke daar in hunne rol speelen, door eenige bijgevoegde zinbetekenende Beelden uitgedrukt, welke de neigingen, die hen gedreeven en vervoerd hebben, uitdrukken: als by voorbeeld, bij Alexander, de Eerzucht: by Marcus Aurelius, de Goedertierenheid: by Augustus, de Godvruchtigheid.' Gerard de Lairesse, *Groot Schilderboeck* I (Amsterdam 1707) ch.15, pp.117–118.

359 J.J. Boissard, *Theatrum Vitae Humanae* (Metz: Abr. Faber, 1596) illustrations by Th. de Bry, pp.97, 105, 109. Cf. also D.R. Camphuysen, *Stichtelijke Rijmen* (Amsterdam: Jacob Colon, 1647).

360 Also called *Rape of the daughters of Leucippus*, see reproduction in *Complete Works* 3, Plate 5.

361 S.L. Alpers, 'Manners and Meaning in some Rubens Mythologies', *Journal of the Warburg and Courtauld Institutes* 30 (1967) particularly pp.285 ff.

362 Catalogue 1962 no. 1549. The subject finds its origin in Ovidius' *Metamorphosen* XIV, pp.623. See also K. van Mander, *Schilderboeck* (1618, 2nd edition): 'Uytleggingh op den Metamorphosis' in book 14, folio 103r.

363 E.g. Lorenzo Lotto, *Christ's farewell of his mother* (Berlin: Kaiser-Friedrich Museum, 1521), cat. *De Triomph van het Manierisme* (Amsterdam: Rijksmuseum, 1955) no. 77; and G. Romano's *Stoning of St Stephen* (Genua: S. Stefano), A. Morassi, *Capolavori della pittura a Genova* (Milan, 1951) ills.98–101.

364 Publication of Cats's works I (Amsterdam, 1726) *Houwelijck*, part 2, p.278.

365 For the Dutch versions of this theme, see the D.I.A.L.-series published by the R.K.D., under 98 A 18 (+13.1).

366 Rudolfinum, cat. 1889 no. 225. Cf. also the work attributed to G. Flinck from the collection Potocki (a print exists after this work, by Guttenberg, *Tiré du cabinet de Mr. Le Brun, d'après Ferdinand Bol*).

367 Collection of the Earl of Ellesmere, Bridgewater House, London, cat. 1907 no. 111.

368 Munich: Alte Pinakothek, cat. 1936, no. 317 (745). For this too, see the D.I.A.L.-series, under 72 H 4.

369 Madrid: Prado, no. 201, of 1618, ill. 35 in N. Grimaldi, *Il Guercino* (Bologna, 1957).

370 Figure 26 in V. Oberhammer, *Die Gemäldegalerie des Kunsthistorischen Museums in Wien* II (Vienna/Munich, 1960).

371 Brussels: Museum for the Fine Arts, cat. 1927 no. 296.

372 Budapest: Museum, cat 1937 no. 396.

373 Rome: Galleria Borghese, no. 27. Cf. also Guercino's piece of 1618 in the Palazzo Pitti at Florence (N. Grimaldi, *Il Guercino* (see note 355), ill.36), freely imitated by W. van Mieris, cat. 1908 no. 304 (Brussels, Museum for the Fine Arts).

374 Munich: Alte Pinakothek, cat. 1936 no. 595 (822).

375 Leiden: Lakenhal, cat. 1949 no. 288 as Lievens.

376 Cf. also Rembrandt's sketch in the Louvre, cat.1922 no. 2550.

377 See the D.I.A.L.-series under 71 H 66. Jan Metsys's composition, especially the posture of *Bathsheba* (Paris, Louvre, cat. 1922 no. 2030B), which is very closely related to his *Susannah* mentioned above.

378 See E. Kunoth-Leifels, *Über die Darstellung der Bathsheba im Bade, Studien zur Geschichte des Bildthemas 4. bis 17. Jahrhundert* (Essen, 1962) especially p.23 (see also the discussion by H. v.d. Waal, *Oud Holland* 81 (1966) p.194).

379 'Jessaeus rapido protinus igne furit. Nec satis est fraudare toros absente marito. Caeca Venus caedem iungit adulterium ... Omnium perturbationum fons est intemperantia ... David ... dum suis locum dedit cupiditatibus, in maxima peccata prolapsus est. Vidit è solario lavantem se Bathsabaeam Uriae uxorem: hanc concupivit et cum ea adulteratus est.' Boissard, *Theatrum Vitae Humanae* , pp.193 ff.

380 No. 31 from the series *David, hoc est virtutis exercitatissimae probatum Deo spectaculum, ex David pastoris, militis, regis, exulis, ac prophetae exemplis*, Amsterdam (Excusum apud N.I. Visscher), 1637; Leiden: Prenten-kabinet der Rijksuniversiteit.

381 Amsterdam: Collection H.A. Wetzlar, 1958; H.d. G. 814a.

382 Bielefeld: private collection, 1936.

383 Rome: Galleria Borghese, cat. 1945 (v. P. della Pergola) no. 4.

384 H. Reitlinger, 'The De Pass illustrations of Ovid', *Gazette des Beaux-Arts* VI, 27 (1945) p.25 ill.10, from *Metamorphoses van Ovidius* (Brussels: Foppens, 1677).

385 Antwerp Museum, cat.1948 no.709.

386 Leiden: Lakenhal, cat. 1949 no. 81

387 Hind 134 (1631).

388 Cf. Kenneth Clark, *Rembrandt and the Italian Renaissance* (London, 1966) pp.10 ff.

389 E.g. the series by C. Drebbel after H. Goltzius, Holstein VI, 4–10.

390 Even also with a degree of ambiguity. For example, in the *Frolicking Couple* by Jan Steen (Leiden: Lakenhal, cat. 1949 no. 405) the girl is the 'woman in danger' (also emblematically indicated by the birdcage), but at the same time, through the half-reclining posture, she is erotically inspiring or provocative.

391 Dresden: Gemäldegalerie, 1635.

392 *Nederlands Kunsthistorisch Jaarboek* 23 (1972) pp.61–66.

393 See the previous two articles, 'The Changing Relation between Theme, Motif and Style' and 'Woman in Danger, a Motif in Seventeenth-Century Art'.

394 'van 't affect der Liefden uyt te beelden'.

395 Volume I, p.117 (originally published in 1707, though we used the edition of 1740).

396 Ibid., p.70.

397 See my *Modern Art and the Death of a Culture* (London, 1970), especially p.57: 'The Death of Themes' – see *Complete Works* 5.

398 See Maria Wellershoff von Thadden, s.v. 'Caritas', in *Reallexikon zur deutschen Kunstgeschichte* III, colon 343–355, with bibliography.

399 London (1969).

400 See Martin, *Rubens*, p.72.

401 See the article mentioned in note 384, colon 349–350.

[402] B. Wind, *Giorgione's Tempesta* (London, 1969).

[403] See F. Antal, *Hogarth and his Place in European Art* (London, 1962) fig.45b.

[404] B.C. = bottom centre; C.L. = centre left; *Enc. W.A.* = *Encyclopedia of World Art; K.d.K.* = *Klassiker der Kunst.*

[405] *Ruimte* 1 (1954) 4, pp.52–54.

[406] Mannerism is the name for the sixteenth-century art of Florence and Rome which was very complex in nature. Perhaps we will have opportunity sometime to discuss its various characteristics.

[407] A.A. v. Schelven, *De Nederduitse Vluchtelingenkerken der 16e eeuw in Engeland en Duitsland in hun betekenis voor de Reformatie in de Nederlanden* (Den Haag, 1909, diss.).

[408] *Ruimte* 1, 8 (1955) pp.125–127.

[409] Which were engravings of drawings.

[410] *Ruimte* 4, 3/4 (1958) pp.1–5.

[411] *Calvinistisch Jongelingsblad* 11 (1956) pp.93,94; pp.99–101.

[412] Some relevant dates and facts concerning Rembrandt's life: 1606 – born; 1631 – moved to Amsterdam; 1634 – married Saskia van Uylenburch (she died in 1642); 1641 – birth of son Titus; 1645 – Hendrickje Stoffels became his housekeeper; 1652 – money troubles started; 1656 – declared 'insolvent'; 1656/1657 – his possessions inventoried and auctioned off; 1662 – death of Hendrickje; 1668 – death of Titus; 4 October 1669 – Rembrandt's death; 8 October 1669 – burial in Westerkerk in Amsterdam.

[413] Literally 'against the Reformation', namely, the counterattack of the Roman Catholic Church against the Reformation (restoration of order, Council of Trent, institution of the Jesuit order), through which the spread of Protestantism in various countries was reversed.

[414] A painting of 1636.

[415] See in this volume, 'Seventeenth-Century Dutch Art: Christian art?'.

[416] In the so-called *Hundred guilder print*, for instance, he explains the parable of the camel who needs to go through the eye of a needle just as his Anabaptist contempories would do, and in line with Erasmus. They considered the 'eye of the needle' to be the name of a gate in Jerusalem. The going through the needle's eye then became very easy.

[417] *Centraal Weekblad* 16, 50 (1968) p.10.

[418] Rotterdam: Pub. Lemniscaat.

[419] *Calvinistisch Jongelingsblad* (1959).

[420] *Ad Fontes* 13 (1965) pp.15–19.

[421] The other articles in this series are in *Complete Works* 4: 'About the Content of Works of Art'; 'About the Content of Medieval Works of Art'; 'The Art of the Fifteenth Century'; 'Baroque Art'; 'Theme, Style and Motif in the Sixteenth and Seventeenth Centuries'; and in *Complete Works* 5: 'Form and Content in Modern Art'.

[422] *Opbouw* 7, 34 (1963) p.276.

[423] Originally published in Dutch as *Ongeloof en Revolutie.*

[424] *Opbouw* (22 March 1957).

[425] *In de draeck* (April 1960).

[426] Illustrations from the Revelation of John, 1498.

[427] *Aksent* (December 1963) pp.9–15.

[428] *Stijl* 2, 7/8 (1953).

[429] 'Chose curieuse et vraiment digne d'attention que l'introduction de cet élément insaisissable du beau dans les oeuvres destinées représenter à l'homme sa proper laideur morale et physique.' 'L'essence du rire' in *Curiosités esthétiques* (1860).

[430] *L'histoire ancienne* me paraît une chose importante, parce que c'est pour ainsi dire la meilleure paraphrase du vers célébre: *Qui nous delivrera des Grecs et de Romains?* Daumier c'est abbattu brutalement sur l'antiquité, sur le fausse antiquité, – car nul ne sent mieux que luis les grandeurs anciennes, – il a craché dessus; et le bouillant Achille, et le prudent Ulysse, et la sage Pénélopé, et Télémaque, ce grand dadais, et la belle Helen qui perdit Troie, et tous enfin nous apparaissent dans une laideur bouffone qui rapelle ces vieilles carcasses d'acteurs tragiques prenant une prisede tabac dans les coulisses. Ce fut un blasphème très-amusant, et qui eut son utilité.' Taken from 'Quelques caricaturistes français' in *Curiosités Esthétiques* (1860).

[431] *'Phebus Apollon de Delos. Marchand d'instruments Poëtiques au Grand Magasin de Poësie et de Versification su l'Helicon*, maakt aan alle Heeren en Dames, begunstigers aen beoefenaars der thans zozeer in den smaak zijnde Rijmkunde, bekend, dat hij onlangs, zo wel uit Duitsland als Frankrijk, bekomen heeft, een aanmerkelijk *assortiment* der allernieuste *Intrumens Poëtiques*, Bouts rimez, Dictionaires Poëtiques, enz. dienstig voor allerlei soort van gedichten, welke, in deszelfs *Magazin Poëtiques*, daaglÿks voor ieder te zien, en voor de naaste prijzen zo wel te huur als te koop, te bekomen zijn: de brieven franco. N.B. den liefhebberen wordt bericht, dat het *Schip der Verbeelding*, geduurig vice versa vaart – '.

[432] Concerning the purpose of caricature, see Seldmayr's *Verlust der Mitte* (Salzburg, 1951) pp.118 ff.

[433] See article 'Surrealism' in *Complete Works* 5.

[434] 'cet homme, avec un courage surhumain, a passé sa vie à refaire la creation. Il la prenait dans ses mains, la tordait, la rerangeait, l'expliquait, la commentait: et la nature se transformait en apocalypse. Il a mis le monde sens dessus dessous. Au fait n'a-t'il pas compose un livre d' images qui s'appelle *Le monde à l'envers?* Il y a des gens superficiels que Grandville divertit; quand à moi, il m'effraye. Quand j'entre dans l'oevre de Grandville, j'éporouve un certain malaise, comme dans un appartement où le désordre serait systematiquement organisé.' 'Quelques caricaturistes francais' in *Curiosités Esthetiques.*

[435] Th.Th. Heine in *Simplicissium* (1910).

[436] *Signaal* 1 (December 1962) pp.18–21.

[437] *Calvinistisch Jongelingsblad* (December 1959) pp.275–277.

[438] *Calvinistisch Jongelingsblad* 5, 7 (1950) pp.55–57.

[439] I restrict my remarks here to the visual arts.

[440] Cf. K. Schilder, *Bij dichters en schriftgeleerden*, pp.17 ff.

[441] I have placed 'nature' in quotation marks here because what concerned such thinkers was physical-biotic nature, apart from its Lord and Creator and therefore incorrectly perceived and understood.

[442] 'Faustian' means a striving for unbridled possibilities of expression, a desire for control and omniscience, the will to realize fully all one's dreams and notions.

[443] For more on this subject I recommend J. Ruskin's *Stones of Venice*, in vol. 3 the chapter on the 'Roman Renaissance' and in vol. 2 the chapter on 'The Nature of Gothic'.

[444] *Calvinistisch Jongelingsblad* 5, 24 (1950) pp.199–202; 26 (1950) pp.208–211; 27 (1950) pp.214–215; 28 (1950) pp.224–225.

[445] The more one knows about the leading figures of this world, e.g. philosophers – who are like the prophets of old in our times – politicians, artists, writers, etc., the clearer this becomes. Especially many of the eighteenth-century pioneers of modern culture came from apostate Christian circles.

[446] 'Zelfstandig is de mens, die zichzelf tot wet is, die geen hoger gezag erkent dan zijn zogenaamd 'beter-Ik', die zijn wereld beheerst naar zijn willen en in zijn binnenste zit als een god, en die vanuit dit autonome, vrije, zelfstandige subject meent alles te mogen, alles te willen, alles te overzien en alles te kunnen regelen, en die de werkelijkheid der dingen vaak aanvoelt als een weerbarstig ding, dat zich eigentlijk moest voegen naar zijn wil'. See A. Janse, *Het eigen karakter der christelijke school* (Kampen: Kok, 1935) p.69. Better than anywhere else one gets here a clear insight into the difference between the humanistic and Christian lifestyles from examples taken from education, for instance when comparing how the two groups deal with the question of authority.

[447] The newest group of artists who carry on the tradition of the Dadaists call themselves Experimentals. We discussed the basic principles of this movement in an earlier article (see 'The Art of the Twentieth Century' in Volume 5).

[448] I dealt with this extensively in 'The art of the Fourteenth Century in France' in this volume.

[449] In this article we will not differentiate further between 'form' and 'content': in practice they are always closely linked with each other so that it is hardly possible to deal with one without the other. It would only lead to unneccessary complexity here and to lack of clarity.

[450] We leave Roman Catholic art aside here, although it was not unimportant in the new era: Baroque art is almost entirely the Roman Catholic art of the Counter-Reformation.

[451] I believe that Revelation 11:3 was fulfilled during the Reformation, after the voice of the faithful prophets was silenced for more than two centuries by the Inquisition and persecution. It is of course not possible to go into this more deeply here.

[452] More about this can be read in the unsurpassed book by Guillaume Groen van Prinsterer, *Unbelief and Revolution* and in his *Handboek der Geschiedenis van het Vaderland* (Leyden: Luchtmans, 1841–1846, 3rd rev. edition Amsterdam: Höveker, 1872). A. Janse briefly but clearly deals with the apostasy in our Dutch churches in *Van Dordt tot '34* (Kampen: Kok, 1934). How the revolutionary ideas got a hold over the people and increasingly dominated their thoughts is clearly expounded in L. Woolf, *After the Deluge* (Pelican Books, 1937) pp.62 ff.

[453] This applies also, perhaps even more so, to literature. But we wanted to limit ourselves here to the visual arts. However, an apostate attitude to life asserts itself the least in the applied arts, in industrial arts and architecture. In an earlier article we already mentioned that the modern manifests itself here in the most favourable fashion (see *Complete Works* 5: 'The Art of the Twentieth Century').

[454] *Stijl* 2,9 (September 1953).

[455] *Stijl* 3, 1 (1954).

[456] Aestheticism considers beauty as the most important, all determining element, to which everything else should be subordinated. 'Also a morally bad deed can be good if beautifully done,' a Renaissance person would say.

[457] This prompted Huizinga in his well-known book *The Waning of the Middle Ages* to see a contrast between the spirit and the art of this time.

[458] Strictly speaking I should not use the term 'art expression' here, as it alludes too much to art as a personal, subjective expression.

[459] The first verse of *Diaphenia* by Henry Constable (1562–1613).

[460] *Ruimte* 4, 6/7, 1958, pp. 15–21.

[461] In the Dutch text the word *materie* ('matter') is used here.

[462] See *Complete Works* 6.

[463] 'Teder en jong, als werd het voorjaar, / maar lichter nog, want zonder vruchtbegin, / met dunne mist tussen de gele blaren, / zet stil het herfstgetijde in.'

[464] F.W. Grosheide, G.P. Itterzon and W.E. Steunenberg eds., *Christelijke Encyclopedie* (Kampen: Kok, 1960, 2nd rev. ed), 'Schilderkunst'.

[465] E. Gilson, *Painting and Reality* (London, 1957); R. Berger, *Découverte de la peinture* (Lausanne, 1958); R. Huyghe, *Dialogue avec le visible* (Paris, 1955); F. Würtemberger, *Weltbild und Bilderwelt* (Vienna, 1958); H. Sedlmayr, *Kunst und Wahrheit, zur Theorie und Methode der Kunstgeschichte* (Hamburg, 1958); E. Panofsky, *Meaning in the Visual Arts* (New York, 1955); H. Read, *The Meaning of Art* (Penguin, 1949); idem, *Icon and Idea, the Function of Art in the Development of Human Consciousness* (London, 1955); E.H. Gombrich, *Art and illusion, a Study in the Psychology of Pictorial Representation* (New York, 1960); R. Arnheim, *Art and Visual Perception: a Psychology of the Creative Eye* (London, 1956); A. Pope, *The Language of Drawing and Painting* (Cambridge Mass., 1949); K. Boulding, *The Image* (Ann Arbor, 1956); W. Schöne, *Über das Licht in der Malerei* (Berlin, 1954); E. Panofsky, *Die Perspektive als symbolische Form* (Berlin, 1925).

[466] *Signs of the Times*, Architectural Ass. Stud. Union (London, 1966) pp.7–13.

[467] Very helpful as an introduction to these problems is also: E.H. Gombrich, 'Icones symbolical: The visual image in Neo-Platonic thought', *Journal of the Warburg and Courtauld Institutes* XI (1948) pp.67 ff.

[468] Panofsky goes into this at length in his *Early Netherlandish Art*.

[469] *Synthetist Art Theories*, 'Genesis and Nature of the Ideas on Art of Gauguin and his Circle' (Amsterdam, 1959) pp.192–196, quoted here from *Complete Works* I, pp.160–163 – also see volume 1 for notes and references which have been omitted here.

[470] [These lecture notes may have been published independently.]

[471] 1593, and many later editions.

[472] Even though he formulated his programme as 'In wie weit ist der Eintritt des stylistischen Umschwunges in den Vorstellung menschlichen Erscheinung in der italienischen Kunst als international bedingter Auseinandersetzungsprozess mit den nachlebenden bildlichen Vorstellungen der östlichen Mittelmeervölker anzusehen?' *Gesammelte Schriften* II (Leipzig, 1932) p.478; see also E. Wind, 'Warburg's Begriff der Kulturwissenschaft', 4ième Congrès d'esthétique et de science de l'art, *Zeitschrift für Aesthetick un Allgemeine Kunstwissenschaft* 25 (1931).

[473] See 'Two Kinds of Love and the Carcer Terreno' in this volume.

[474] *Ruimte* 4, 9 (1958) pp.14–20.

[475] *Signaal* 7, 2 (December 1964).

[476] In Don Brothwell (general ed.), *Beyond Aesthetics: Investigations into the Nature of Visual Art* (London: Thames and Hudson, 1976) pp.179–197.

[477] E. Panofsky, *Meaning in the Visual Arts* (Garden City, N.J., 1955); M.H. Segall, *The influence of Culture on Visual Perception* (Indianapolis, 1966); E.H. Gombrich, 'Expression and Communication', in *Meditation on a Hobby Horse* (London, 1965) pp.56 ff.

[478] Panofsky, *Meaning in the Visual Arts*, p.295; B. Dorival, 'Expression littéraire et l'expression picturale du sentiment de la nature au XVIIe siècle français', Revue de l'art III (1953) pp.44 ff..

[479] U. Price, *Essays on the Picturesque as compared with the Sublime and the Beautiful, and on the use of Studying Pictures for the Purpose of Improving Real Landscape* (London, 1794); D. Stroud, *H. Repton* (London, 1962); C.C.L. Hirschfeld, *Théorie de l'art des jardins* (translated from German) (Leipzig, 1780).

[480] *Art and Artists* IV (5 August 1969, special edition on Art and Revolution) 'Spencer', p.4.

[481] O. von Simson, 'Rubens' Maria de Medici cycle', *L'oeil* 125 (1965) pp.3 ff.

[482] A. Chastel, *Art et humanisme en Florence au temps de Laurent le Magnifique* (Paris, 1959).

[483] 'La surréalité sera fonction de notre volonté de dépaysement de tout.' See also *Art and Artists* IV, p.38; D.D. Egberts, *Social Radicalism and the Arts: Western Europe, a Cultural History from the French Revolution to 1968* (New York, 1970); J.A. Leith, *The Idea of Art as Propaganda in France 1750–1799* (Toronto, 1965).

[484] R. Assunto, Die Theorie des Schönen im Mittelalter (Cologne, 1963).

[485] 'Littera geste docet / quod credas allegoria. / Moralis quid agas / quo tendas anagogia.'

[486] J.D. Boyd, *The Function of Mimesis and its Decline* (Cambridge, Mass., 1968).

[487] Ricardi, (Vernaccia: Francesca Riccardi, 1822) p.2, introduction

[488] M. Levey, *Rococo to Revolution* (London, 1966) quotation on p.121.

[489] Boyd, *The Function of Mimesis and its Decline.*

[490] R. Kraus, *Das Künstlerideal des Klassizismus und der Romantik* (Reutlingen, 1925) pp.47, 37.

[491] L. Balet, *Die Verbürgerlichung der deutschen Kunst, Literatur und Musik im 18. Jahrhundert* (Leiden, 1936) pp.298, 303.

[492] H. Marcuse, *Eros and Civilization* (London, 1969, 3rd ed.) pp.143, 146.

[493] F. von Schiller, *Über die aesthetische Erziehumg des Menschen* (Herford, 1947, orig. 1795).

[494] G. Pelles, *Art, Artists and Society: Painting in England and France 1750–1850* (Englewood Cliffs, N.J., 1963) p.131.

[495] M.Z. Shroder, *Icarus, the Image of the Artist in French Romanticism* (Cambridge, Mass., 1961).

[496] J.E. Miller and P.D. Herring (eds.), *The Arts and the Public* (Chicago / London, 1967) p.27.

[497] See 'The Artist as a Prophet', in *Art and the Public Today* (Huémoz-sur-Ollon, Switzerland: L'Abri, 1969, 2nd ed.); republished in *Complete Works* 5.

498 J. Wilcox, 'The Beginnings of L'art pour l'art', *J. Aesthet, and Art Criticism* 11 (1953) pp.360 ff.

499 R. Williams, *Culture and Society 1780–1950* (London, 1960) p.167.

500 Ibid., pp.130ff.

501 Rookmaaker, 'The Artist as a Prophet', p.9.

502 J.A.C. Brown, *Techniques of Persuasion* (Harmondsworth, 1969); K. Haselden, *Morality and the Mass Media* (Nashville, Tenn., 1968); R. Williams, *Communications* (London, 1968, 2nd ed.); J.T. Klapper, *The Effects of Mass Communication* (Glencoe, Ill., 1960); J. Berger, *Ways of Seeing* (Harmondsworth, 1972).

503 See Berger, *Ways of Seeing*, pp.86 ff., 135 ff.

504 H.R. Rookmaaker, *Modern Art and the Death of a Culture* (London, 1971, 2nd ed.) republished in *Complete Works* 5; Rookmaaker, 'The Artist as a Prophet'; K. Pawek, *Das optische Zeitalter* (Olten, 1963).

505 Klapper, *The Effects of Mass Communication*, p.251.

506 M. Mierendorff and H. Tost, *Einführung in die Kunstsoziologie* (Cologne, 1957), pp.23 ff.

507 Panofsky, *Meaning in the Visual Arts*.

508 M. Meiss, *Painting in Florence and Sienna after the Black Death* (New York, 1964, 2nd ed.)

509 F. Antal, *Florentine painting and its Social Background* (London, 1948); Balet, *Die Verbürgerlichung der deutschen Kunst, Literatur und Musik im 18. Jahrhundert*.

510 See also F. Antal, 'Remarks on the Methods of Art History', in *Classicism and Romanticism and other Studies* (London, 1966) pp.175 f.

511 Review of R. Rudisill, by C. Chiarenza in *Art Journal* XXXI (1972) p.346.

512 Rudisill, review in *Art Journal* XXXI (1972); see also D.J. Boorstin, *The Image or, What Happened to the American Dream* (London, 1961); Pawek, *Das optische Zeitalter*.

513 *Time* (7 April 1975) 'The Mural Message' (on the impact of public murals in East Los Angeles).

514 Mierendorff and Tost, Einführung, *Einführung in die Kunstsoziologie*, p.57.

515 N. Shrapnel, 'The Porn Market', *Times Literary Supplement* (11 Feb. 1972) p.159; P. Fryer, 'The Death of Censorship', *Times Literary Supplement* (18 Feb. 1972); Longford Report: 'Pornography' (London, 1972).

516 *The Age of Classicism*, Exh. Cat. (London, 1972).

517 Berger, *Ways of Seeing*.

518 Z. Barbu, *Society, Culture and Personality* (Oxford, 1971) p.96.

519 Berger, *Ways of Seeing*; Pawek, *Das optische Zeitalter*, pp.249 ff.

520 Vance Packard, *The Hidden Persuaders* (New York, 1961, 16th ed.).

521 G.H. Hamilton, *Manet and his Critics* (New Haven, Conn., 1961).

522 Rookmaaker, *Modern Art and the Death of a Culture*, p.78; see also R. Rosenblum, *Transformation in Late 18th Century Art* (Princeton, 1967).

523 Berger, *Ways of Seeing*.

524 L. Eitner, *Neo-classicism and Romanticism* I: *Sources and Documents in the History of Art* (London, 1971) p.9.

525 *Age of Classicism*, no.188, reprod. p.44.

[526] Eitner, *Neo-classicism and Romanticism* I: *Sources and Documents in the History of Art*, pp.7, 8.

[527] Encyclopedia Pauly-Wissowa (1892); see also 'Phryne' and 'Nacktheit'.

[528] Cf. Balet, *Die Verbürgerlichung der deutschen Kunst, Literatur und Musik im 18. Jahrhundert*, pp.236, 424.

[529] See also *The Age of Classicism*, no. 84.

[530] *The Age of Classicism*, no. 263.

[531] Rookmaaker, *Art and the Public Today*, p.45.

[532] In *The Moralist* (1709), quoted in H. Huth, 'The American and Nature', *J. of Aesthet. And Art Criticism* 13, pp.101 ff.

[533] M.H. Nicholson, *Mountain Gloom and Mountain Glory: The Development of the Aesthetic of the Infinite* (Ithaca, N.Y., 1959); Price, *Essays on the Picturesque as compared with the Sublime and the Beautiful, and on the use of Studying Pictures for the Purpose of Improving Real Landscape.*

[534] Boorstin, *The Image or, What Happened to the American Dream*, pp.86 ff.

[535] S. Kauffmann, 'Michelangelo Antonioni's L'Avventura', *Horizon* XIV, 4 (1972) pp.49 ff.

[536] P.G. Kuntz, Review of A. Stokes: 'Reflections on the Nude', *J. Aesthet. And Art Criticism* 28 (1967) pp.103 ff.

[537] Williams, *Culture and Society 1780–1950*, p.145.

[538] Pelles, 'The Image of the Artist', p.121.

[539] H.R.R. Rookmaaker, 'Modern Art and Gnosticism', *Jahrbuch f. Aesthetik und allgemeine Kunstwissenschaft* XVIII (1973) pp. 162–174.

[540] J. Alford, 'The Prophet and the Playboy: Dada was not a Farce', *College Art Journal* 11 (1952) p.270.

[541] W. Sypher, *Loss of Self in Modern Literature and Art* (New York, 1962); C.S. Lewis, *Abolition of Man*: Riddell Memorial Lectures, Durham (London, 1965, 2nd ed.).

[542] See 'Commitment in Art' in Rookmaaker, *Modern Art and the Death of a Culture.*

[543] Tuli Kupferberg, 'When the Mode of the Music Changes, the Walls of the City Shake', *International Times* (Feb./March 1967).

[544] H.R. Rookmaaker (ed.), 'Nota: cultuur en kunst', *Anti-Revolutionaire Staatkunde* XL (1970) pp 489 ff.

[545] Rookmaaker, *Modern Art and the Death of a Culture.*

[546] F. von Schiller, *Über die aesthetische Erziehumg des Menschen*, p.57.

[547] *Art and Artists* (1969) p.62.

[548] *Kunstzinnig* 1, 1 (1976).

[549] *Opbouw* 6, 15 (1962) pp.117–118.

[550] Oxford: Clarendon Press, 1969, 55 pp.; review in *Tijdschrift voor geschiedenis* 84, 3 (1971) pp.430–432.

[551] Ladner, p.44 [probably G.B. Ladner, *Ad Imaginem Dei: The Image of Man in Medieval Art* (Latrobe, Archabbey Press, 1965)].

[552] [Might be John White, *Art and Architecture in Italy 1250–1400.* Pelican History of Art (Baltimore: Penguin Books, 1966).]

[553] See the reproduction in *Complete Works* 3, Plate 4.

Part II: The Christian and Art

[554] Note that the text of this book has been slightly edited for gender neutrality, in line with the whole of the *Complete Works*.

[555] I refer the reader to the excellent book by Linda Nochlin on the *Realism of the Nineteenth Century*, or the exciting lectures of Barzun under the title *The Use and Abuse of Art* (Princeton University Press, 1973).

[556] H.R. Rookmaaker, *Modern Art and the Death of a Culture* (IVP, 1970), see Complete Works 5.

[557] See Pevsner's book *Pioneers of Modern Design* (Penguin, 1960).

[558] Amos 6:4 ff.

[559] I should like to recommend Charles Webster's *The Great Instauration* (London: Duckworth, 1975) in which he tells at least part of that story.

[560] *Calvinistisch Jongelingsblad* 4, 36 (1950) pp.306–307

[561] In this series: 'Art and Beauty in this World' (volume 4); 'The Art of the Twentieth Century' (volume 5); 'Judging Works of Art' (volume 4); 'The Portinari Altar of Hugo van der Goes' (volume 4); 'Seventeenth-Century Dutch art: Christian Art?' (volume 4); 'We and the Kingdom of God' (volume 4); 'On being Salt that Salts' (volume 3).

[562] *The Calvin Forum* 17, 11/12 (1952) pp.226–227.

[563] Entry in *The Encyclopedia of Christianity* (Wilmington, Delaware, 1964) pp.418–423.

[564] S. Anema, *Moderne Kunst en Ontaarding* (Kampen, 1926); E. Doumerge, *L'Art et le sentiment dans l'oevre de Calvin* (Geneva, 1902); M. Grau, *Calvin's Stellung zur Kunst* (Wurzburg, 1917); H. Hasper, *Calvijns Beginselen voor de zang in den eredienst* (The Hague, 1955); A. Kuyper, *The Antithesis between Symbolism and Revelation* (Amsterdam, 1899); A. Kuyper, 'Calvinism and Art', in *Calvinism, Six Stone Lectures* (Amsterdam/Pretoria, 1899; also appeared in *Christian Thought* 9 (1891–1892) pp.259–282, 447–459; Pollmann, *Calvijns Aesthetica* (Den Bosch, 1937) K.S. Popma and N.W. Krol, 'Wijsbegeerte en Kunst', in H.J. and J.M. Spier (eds.), *Wijsbegeerte en Levenspractijk* (Kampen, 1948); M.P. Ramsay, *Calvin and Art, considered in relation to Scotland* (Edinburgh, 1938); C. Rijnsdorp, *In drie Etappen* (Baarn, 1952); H.R. Rookmaaker, *Jazz, Blues, Spirituals* (Wageningen, 1960; see Complete Works 2); H.R. Rookmaaker, *Synthetist Art Theories: Genesis and Nature of the Ideas on the Art at Gauguin and his Circle* (Amsterdam, 1959; see Complete Works 1); A.A. van Schelven, *Historisch ondersoek naar de levensstijl van het Calvinisme* (Amsterdam, 1925); K. Schilder, *Bij dichters en Schriftgeleerden: Verzamelde Opstellen* (Amsterdam, 1927); C.G. Seerveld, *B. Croce's Earlier Aesthetic Theories and Literary Criticism* (Kampen, 1958); L. Wencelius, *L'Esthétique de Calvin* (Paris, 1937); J. Wille, *Aesthetisch of "puriteins?"* (Amsterdam, 1925); J. Wille, Helman Dullaert (Zeist, 1926).

[565] Cf. Matthew 24:12; Isaiah 29: 13.

[566] Colossians 1:13, 14; 2:13, 14.

[567] Colossians 2:18–22.

[568] John 15; Colossians 3:1–4.

[569] Holbrook Jackson, *The Eighteen Nineties* (Pelican Book, 1950), writing about John Davidson.

[570] 1 Corinthians5:13.

571 Cf. 1 Peter 3:10.

572 *Opbouw* 6, 47 (1963) pp.373–374. This is a translation of the Dutch version of an article that Rookmaaker originally wrote for *Christianity Today*.

573 First published in *Woord en Wereld* 1, 19 (1964) pp.1–2; subsequently it was also published in *Informatie CCS* 1, (1969) pp.3–5 and in *Schering en Inslag* 7, 4 (1994).

574 *De Gereformeerde Vrouw* 24 (1966) pp.126–127. Rookmaaker was one of the founders and the first chairman of the Christelijk Cultureel Studiecentrum (CCS), the Christian Cultural Study Centre, which started in 1964. Its objectives were to set up a study centre and a training institute. Due to the efforts of the CCS an art academy was founded in Kampen in 1978, the Christian Academy for Visual Art Education (CBAK).

575 I examined these problems more closely in an article in the 1964 annual report of the N.C.R.V. that came out recently, 'Art and Entertainment on Radio and Television'; see the *Complete Works* 3.

576 I have discussed this attitude at greater length in my book *Art and Entertainment*, see *Complete Works* 3.

577 *Informatie CCS* 1, 1 (1969) pp.8–11. This is the text of a lecture that formed part of a symposium on 'Art and Society', held at the occasion of the opening of the Christian Cultural Study Centre (CCS) on 28 September 1968.

578 Should we perhaps also think in this connection of the powers of this dark world, the spiritual forces of evil in the heavenly realms referred to in Paul's epistle to the Ephesians?

579 Tuli Kupferberg, *International Times*, March 1967.

580 R.A. Bale, 'The Future of Music', *Journal of Aesthetics and Art Criticism* 26 (1968) p.481.

581 *Beweging* 37, 6 (1973) pp.4–5.

582 On modern art and neo-gnosticism see 'Do we Need to be Modern in order to be Contemporary?' and 'Modern art and gnosticism', both in *Complete Works* 5.

583 *Christelijke Encyclopedie* (Kampen: Kok, 1960). The original title of this entry was 'Reformatorische kunst'.

584 Published in *Christian Scholar's Review* 2, 2 (1972) pp.135–139.

585 Published in *Genesis* 2, 1 (1976) pp.40–45.

586 Finally, whatever is true, whatever is honourable, whatever is just, whatever is pure, whatever is lovely, whatever is gracious; if there is any excellence, if there is anything worthy of praise, think about these things.

587 Unpublished letter to the artist.

588 Unpublished letter.

589 Unpublished, 1965: A long discussion followed my lecture on Negro spirituals and gospel songs; especially David came with many questions. So I prepared, in the form of a letter directed to David, an addition to the recorded lecture in order to avoid misunderstandings.

590 As in the modern intellectualistic music of Webern.

Part III: Miscellanea

591 *Kerkbode van de Gereformeerde Kerken in de Provincie Noord-Holland* 4, 1 (1948) p.3.

592 Rookmaaker was at that time a member of the Reformed Churches in the Netherlands (Liberated or *Vrijgemaakt*), a denomination that had split off from the Reformed Churches in the Netherlands in 1945.

593 *Sola Fide: Blad voor Calvinistische Studenten* 2, 2 (1949) pp.1–5.

594 Ezekiel 3:7: 'But the house of Israel is not willing to listen to you because they are not willing to listen to me.'

595 1 Timothy 4:1: 'in later times some will abandon the faith.'

596 Cf. Numbers 15:22–25: 'Now if you unintentionally fail ... without the community being aware of it, then the whole community is to offer a young bull ... and they will be forgiven ... the whole Israelite community and the aliens living among them will be forgiven.'

597 Zechariah 7:9–14: 'They made their hearts as hard as flint and would not listen to the law or to the words that the LORD Almighty had sent by his Spirit through the earlier prophets.'

598 Isaiah 30:1: 'Woe to the obstinate children,' declares the LORD, 'to those who carry out plans that are not mine, forming an alliance, but not by my Spirit, heaping sin upon sin.'

599 Jeremiah 9:23; 1 Corinthians 1: 30–31.

600 Proverbs 28:9: 'If anyone turns a deaf ear to the law, even his prayers are detestable.'

601 Isaiah 30; Jeremiah 2.

602 Isaiah 29:13–14.

603 Revelation 11:7–8. I follow the commentary in the *Statenvertaling* (oldest Dutch Bible translation) here.

604 See, for example, Groen van Prinsterer's *Handboek der geschiedenis van het vaderland* [manual of Dutch history].

605 See Jeremiah 51 and elsewhere.

606 Revelation 18:4: 'Come out of her, my people, so that you will not share in her sins, so that you will not receive any of her plagues.'

607 2 Timothy 3:5; 1 Timothy 6:11.

608 Both the World Council of Churches and the International Council of Christian Churches were established in the Netherlands in 1948. The latter, meeting under the leadership of such figures as Francis Schaeffer and Carl McIntire, warned against the inclusivism and apostasy of the former. See also in this volume the article entitled 'The International Council of Christian Churches'.

609 *Calvinistisch Jongelingsblad* 6, 25 (1951) pp.200–201.

610 For Rookmaaker's terminology here, see G. Groen van Prinsterer's *Unbelief and Revolution*.

611 *Opbouw* 6, 47 (1963) pp.373–374.

612 The letter as it is given here is perforce a paraphrase based on Rookmaaker's Dutch translation of the original English text, which was not available to the present translator.

613 Where 'Reformed' is used in this article, it refers to the (various types of) Gereformeerden.

614 *Opbouw* 7, 6 (1963) pp.44–45.

615 See the previous article, 'Coming to Conversion – some Comments'.

616 *25 Bijbelstudies* (Amsterdam: Buijten & Schipperheijn, 1974).

617 *Aksent* 8, 4 (1970) pp.13–17.

618 *Stijl* 3, 2 (1954) pp.60–62. A book review of *Moa-Moa. Het moderne denken en de primitieve wijsheid* by C. H. van Os (Amsterdam: Meulenhoff, 1951).

619 Or 'assumption'. Science often makes use of such a working hypothesis, that is, an opinion that it forms intuitively and then tries to prove.

620 See in volume 5: 'Whence do we come? What are we? Where do we go?'

621 *Stijl* 2, 4 (1953) pp.124–125. A book review of *De verloren zoon als letterkundig motief* by J.F. Kat. Doctoral dissertation, University of Nijmegen, 1952.

622 *Signaal* 7 (May/June 1962) pp.32–34.

623 *Stijl* 3, 2 (1954) pp. 41–43.

624 See in this volume: 'A landscape from 1380', 'Dürer and landscape', and others.

625 *Ruimte* 3, 3 (June 1957) pp.1–8.

626 See the Belgic Confession, Article II.

627 *Drukkersweekblad Autolijn*, 52 (Christmas 1960) pp.7, 65–73.

628 Published in London, 1953.

629 Malraux: *La monnaie de l'absolu*, Paris, Skira, 1940, p. 40.

630 Malraux: *La création artistique*, Paris, Skira, 1948, p. 165.

631 See in this volume: 'Expressionistic and Normal in Altdorfer's Work'.

632 Amsterdam: Elsevier, 1951.

633 *Trouw*, 6 August 1955.

634 *Trouw*, 3 August 1953.

635 *Trouw*, 9 July 1953.

636 *Trouw*, 21 June 1956.

637 *Trouw*, 11 February 1956.

638 *Trouw*, 15 April 1954.

639 *Trouw*, 14 September 1955.

640 *Trouw*, 13 August 1949.

641 *Trouw*, 9 September 1952.

642 Published by Kroonder, Bussum, the Netherlands.

643 *Trouw*, n.d.

644 *Trouw*, 31 August 1949.

645 *Trouw*, n.d.

646 *Trouw*, 16 September 1952.

647 *Trouw*, 27 September 1956.

648 *Trouw*, 17 August 1951.